Two week loan

Please return on or before the last
date stamped below.
Charges are made for late return.

Books by FREDERICK R. KARL

MODERN AND MODERNISM: The Sovereignty of the Artist 1885–1925 1985

AMERICAN FICTIONS: 1940–1980 1983

THE COLLECTED LETTERS OF JOSEPH CONRAD:
 Volume I, 1861–1897 (general editor and volume co-editor) 1983

JOSEPH CONRAD: The Three Lives 1979

THE ADVERSARY LITERATURE 1974

AN AGE OF FICTION: The Nineteenth-Century British Novel 1964
 (revised 1972)

THE CONTEMPORARY ENGLISH NOVEL 1962 (revised 1972)

THE QUEST, a novel 1961

A READER'S GUIDE TO JOSEPH CONRAD 1960 (revised 1969)

MODERN
AND
MODERNISM

MODERN AND MODERNISM

The Sovereignty of the Artist 1885–1925

◆ FREDERICK R. KARL

ATHENEUM ◆ New York ◆ 1985

Library of Congress Cataloging-in-Publication Data
Karl, Frederick Robert.
 Modern and modernism.

 Includes index.
 1. Arts, Modern—19th century. 2. Arts, Modern
—20th century. 3. Modernism (Art) I. Title.
NX454.K37 1985 700'.9'034 84-45710
ISBN 0-689-11564-4

Published simultaneously in Canada by Collier Macmillan Canada, Inc.
Composition by Maryland Linotype Composition Co., Inc., Baltimore, Maryland
Manufactured by Fairfield Graphics, Fairfield, Pennsylvania
Designed by Cathryn S. Aison
First Edition

To the Three Women: DEBORAH
REBECCA
JUDITH

◆ CONTENTS ◆

*Notes appear at the end of the book and are identified
by a page number and a lead-in phrase.*

◆ ILLUSTRATIONS ◆

ix

◆ FOREWORD ◆

The critic must spread his net wide to express what the Modern movement was and is, just as in the past it was difficult to catch the sense of romanticism, realism, naturalism, symbolism. But we can make one broad assumption that holds true throughout its development: Modern, and Modernism, are characterized by their languages. In literature, whether poetry or fiction, there is the sense of new words and voices, fresh narrative devices that are the story-telling equivalent of new languages. In painting, we find innovative color systems, fresh arrangements and utilization of the canvas, new geometrics, new awareness of planes, and a dynamism of line, shape, and mass. In musical composition, we find novel sounds, groupings, and progressions, a fresh sense of harmonic sequence. In opera, because of Wagner's influence, dynamic visual experiences are one consequence of a new operatic language. The common thread for anyone who yearns to be Modern, whatever the medium, is the ability to refurbish the language of his art, whether through disruption and new formations, or through colors, tones, sound sequences, visual effects, neologisms.

Just after the turn of the century, in 1902, Joseph Conrad wrote to his publisher, William Blackwood, a defense of his slowness in producing a work. He pleads that he is new: "I am *modern*, and I would rather recall Wagner the musician and Rodin the sculptor who both had to starve a little in their day—and Whistler the painter who made Ruskin the critic foam at the mouth with scorn and indignation. They too have arrived. They had to suffer for being 'new' " (May 31). Conrad was following through on remarks he had already made late in 1897 in his Preface to the final installment of *The Nigger of the "Narcissus,"* published in William Ernest Henley's *New Review*. There, in

announcing that his purpose was to make you *see*, he was paralleling Henry James's dictum that the artist should "produce the illusion of life." Conrad stresses that his ability to make you see comes about through the "power of the written word," which will also make "you hear, make you feel. . . . It is to catch at rest each passing moment and to reproduce that moment so that it arrests the interest of men. . . ."

Whatever else Conrad had in mind, his emphasis is on finding new surfaces of words, on reshaping them, on defamiliarizing tired forms. Once language becomes the focal point, then matters of voice, tone, and narration are directly involved. Narrative forms must themselves change, not only in literature but analogously in painting, music, sculpture. New languages dictate innovative directions for art forms and mean that any artist hoping to be Modern must develop beyond influences, must leap into unknown territory which then becomes his. That "leap" which the artist is able to make becomes his membership card in the avant-garde. Modern is composed of just these avant-gardes.

Yet however innovative its forms, the constant in all Modernism is defiance of authority. Authority can be generational or governmental, or can represent, more ambiguously, the "state" or "society," or, simply, "an other." Much of the straining against authority that we find in Modernism is its effort to escape from historical imperatives. Modernists in nearly all their innovative phases view themselves not as part of a tradition but as ahistorical; as dissociated from the historical ties one expects in marketplace ideas. At any given stage, Modernism is to break not only with traditional art but with traditional humanistic culture, what is connected to historical process. The avant-garde, especially, is based on this assumption: to move so far outside the mainstream that historical development no longer applies. The militant avant-garde or vanguard—a martial term—may be connected by a thread to the main body, but it conceives of itself as separate, isolated, endangered, as having exposed itself to such danger that it can command its own rules. Thus, it floats free, secedes, becomes ahistorical. And those who explore such new methods—of language, narrative, modal shifts—inevitably must pay.

Such payment takes many shapes, as we can see when we move from Conrad in the vanguard to 1945, when much of European Modernism had more or less run its course. In 1945, Arnold Schoenberg, then, along with Igor Stravinsky, the premiere composer in the Western world, was refused a Guggenheim Foundation fellowship. He had submitted his work to a committee of composers who served as advisers for the Guggenheim Foundation specifically to gain funds to complete his opera *Moses und Aron* and his oratorio *Die Jakobsleiter* ("Jacob's Ladder"). He was seventy years old, recently retired from the University of California at Los Angeles, with three small children to support. *Moses und Aron*, which remained uncompleted at his death, would be, along with *Wozzeck* and *Lulu* by his disciple Alban Berg, the most significant operatic work of the Modern movement. His rejection suggested the depth of the antagonism the musical establishment felt for such work, at a time (1945–46) when Gian-Carlo Menotti and Samuel Barber were being funded and feted for their work. The Modern movement in music, apparently, was acceptable only in its

diluted forms, as in Copland or Barber.* Charles Ives, a truer descendant of Modernism, was as yet undiscovered.

Schoenberg had, in a way, undermined the aural sensibilities of the Guggenheim advisory committee. Their musical sense was still of large blocks of material presented with transitions or modulations, so that the ear could absorb what it had always assimilated. Schoenberg broke up the blocks, removed the easily assimilable modulations, subverted symmetry, and worked through his musical ideas in quanta, those small bits or units that physicists had also learned to deal with. Flow was no longer continuous. He had, further, eliminated consonance, that which resolves musical dissonance. By excluding dissonance, he could avoid consonance, and that elimination of first one and then the other meant that, like all Modern artists, he was an educator: educating the ears of his listeners by forcing them to respond to disturbing, threatening arrangements of a new language of sound.

Schoenberg, furthermore, was himself in opposition to Stravinsky, whose Modern mode was more acceptable. Stravinsky's neoclassicism had been ably supported by that great music teacher and educator Nadia Boulanger, so that through her and through music that was assimilable by more traditional audiences Stravinsky had disciples everywhere in the musical establishment. By 1945, he was, rightly, a classic. His music came to be designated as part of the school of Paris, that of Schoenberg the school of Vienna, and the twain did not meet, although composers such as Copland were already learning how to blend similar elements. The audience's bias was clearly toward Stravinsky's neoclassicism, which was assimilable, and against Schoenberg's atonality and twelve tones, which were aurally unacceptable. Thus, even when Schoenberg was bracketed with Stravinsky as a great innovator, his work in comparison was denigrated. He was, not only for *New York Times* music reviewers but also for advisory boards of his peers, moving toward a dead end; bringing music down, not developing it.

In a melancholy sense, Schoenberg's experience was that of many Modern artists. Innovative work meant not only rejection but ridicule. We recall the reception of Stravinsky's *Rite of Spring* at its Paris premiere in 1913; Joyce's difficulty in getting a publisher (and printer) first for *A Portrait of the Artist as a Young Man* and then for *Ulysses*; much earlier, the outcry from academic critics against impressionism in painting, against *Les Fauves* later, against developments in cubism and abstraction. Well before that, Baudelaire was tried for obscenity for certain poems in *Les Fleurs du mal* when it was published, in 1857. Although many of the poems dealt with forbidden subjects such as lesbianism—an early form of the volume was once announced, in 1846, as *Lesbiennes*—the main thrust of the volume was heuristic. Baudelaire intended to take the reader into an Inferno, deposit him there as if in a mine, let him quarry what he could, and then, through his own perceptions, burrow out. But the French minister of the interior, incensed that Flaubert had just been acquitted in the trial of *Madame Bovary*, decided to go after Baudelaire. The prosecution

* The years 1945–46 were banner ones for composers and the Guggenheim winners included Menotti, Barber, Norman Dello Joio, Lukas Foss, Louise Talma, Elliott Carter, Henry Brant, Dai-Keong Lee, and Alexei Haieff; many estimable composers, but no one close to Schoenberg's stature.

was relentless, and Baudelaire, despite support from several men of letters, was found guilty. The charge was based not on political subversion—the usual charge in antiliterary proceedings—but on outrage against public morality; in this respect Baudelaire served as a forerunner for Zola, Joyce, Lawrence, and others. He was fined 300 francs, and six poems were to be deleted from further copies of *Les Fleurs*: "Les Bijoux," "Le Léthé," "A celle qui est trop gaie," "Lesbos," "Femmes damnées," "Les Métamorphoses du vampire."

Baudelaire's trial comes at one of the earliest stages of the Modern movement; Arnold Schoenberg's failure to receive a Guggenheim grant in 1945, when we would think the battle of Modernism had been won, comes at the furthest reaches of the movement. In the middle, however, is another kind of rejection, far more ominous, and yet curiously related to Baudelaire's trial and Schoenberg's futile application. While Baudelaire's conviction was based, ostensibly, on public morality and Schoenberg's rejection on artistic decisions, the judgment midway between is the projection of a sick, megalomaniacal mind. Yet if juxtaposed, the three judgments indicate the degree of hostility the languages of Modernism met and would meet.

While in prison in 1924, one commentator on Modernism conceived of an entire counterattack on the moral rot and decay he observed in the art of his era. This art, in painting, theater, poetry, and fiction, was an overflow of the Modern tradition, in some senses a flowering of it not only on the Continent but in England and America as well. Our commentator, however, did not relish the moral and value systems he perceived, and he set himself against their every aspect.

His response went something like this (and it would, incidentally, become familiar for the next half century): No one would deny the prevalence of contemporary decay and corruption; society was rotten to its core, people were unable to discover values by which to order their lives, and political systems were open to Bolshevist invasion. This consciousness of decay could be attributed, in part at least, to the kind of art and culture that permeated the society or state in question. Such art was the epitome of spiritual decay, of negativism, of nothingness embodied as aesthetic significance, a denial of human values seductively packaged. Its languages did not speak to the people. This was the art of the end of things, the subverter of a Christian state and morality. With this insight into rot, the commentator could then attribute cultural developments to the large presence of Jews in the formulation of Modernism. While Modernism would have waxed without Jews—for most major writers were not Jewish—certainly Jews played a significant role; and if not Jews as such, then a "Jewish influence," which meant anything foreign to a Christian culture.

Further associations among Modernism, Jews, and the decay of the state and a people could be connected to Bolshevism, although, as we shall see, such connections make no cultural sense. Like Modern and Modernism, bolshevism became a code word, and by recalling it, commentators could create a response to Modernism by way of political fear. It was a method that worked not only in the years immediately after the Russian Revolution but in the post–World War Two years, when Bolshevism, Modernism, and contemporary decay were once again associated. Jews were not mentioned as explicit presences because of guilt over the Holocaust, but by implication they were still active elements, foreign subverters.

Our 1924 prisoner foresaw how these connections could be used for political purposes, although, in 1924, his own efforts had been frustrated. Nevertheless, his negative view of Modern and Modernism suggests how powerful and how threatening this artistic movement had become.

> . . . The saddest thing about the state of our whole culture of the prewar period was not only the total impotence of artistic and cultural creative power in general, but the hatred with which the memory of the greater past was besmirched and effaced. In nearly all fields of art, especially in the theater and literature, we began around the turn of the century to produce less that was new and significant, but to disparage the best of the old work and represent it as inferior and surpassed; as though this epoch of the most humiliating inferiority could surpass anything at all. And from this effort to remove the past from the eyes of the present, the evil intent of the apostles of the future could clearly and distinctly be seen.

The commentator, who is Adolf Hitler, sees these developments as the "spiritual preparation of political Bolshevism." His plan is to cleanse the putrid stables of their ordure: "Theater, art, literature, cinema, press, posters, and window displays must be cleansed of all manifestations of our rotting world and placed in the service of a moral, political, and cultural idea." Blame is laid at the feet of the Jews: "The fact that nine tenths of all literary filth, artistic trash, and theatrical idiocy can be set to the account of a people, constituting hardly one-hundredth of all the country's inhabitants, could simply not be talked away; it was the plain truth."

Hitler's way of ridding Europe of Modernism, perhaps more radical than most would accept, was to kill everyone associated with it; but his vehemence, hatred, virulence were not unusual, since for those who oppose Modernism, survival of their own world is at stake. Modern and Modernism had become so intertwined with social, moral, and political values that it was impossible to see where one ended and the other began. The 1897 movement in Vienna called Secession used a political term—one associated in America with the Civil War— to describe a movement in art. Vienna Secession, about which much more below, was an act of liberation led by the painter Gustav Klimt against academic art, one of many movements that rejected the academy in order to "emerge," "free," "release." Although such countermovements are directed against traditional art, they really appeal more broadly to a very different order of aesthetics. They are based on destabilization and de-ordering, having affinity to what Harold Bloom would call "daemonization": that advance made on the "parent-poem" that is, in effect, the artist's denial of that poem's contemporary power and the substitution of a countering force. The artist's effort is directed against his model, whose very existence made his own work possible. What emerges is a different quanta of energy embodied in a new language.

The extirpation of Modern ideas has been the policy of most contemporary states: not only Hitler's Germany and Stalin's Soviet Union, but South Africa, the Middle East, the Russian bloc, most of Black Africa, parts of the Bible Belt of America. The great writers of South America, for example, have nearly all gone into exile. Yet, while many of these countries have repressive regimes and militaristic or religious fanatics as leaders, their common aim is to "modernize."

South Africa illustrates such ambiguity, a country free at one level, a slave state at another. Here is a modern, technologically progressive country that struggles to restrain and contain modern ideas and modern images (in films, magazines, and television, banned until recently), modern concepts of social and political grouping. It maintains slave states (huge black ghettos, repressive laws) within one of the most progressive and successful economies in the world. We see a similar situation developing in Saudi Arabia, wherein modern technology exists alongside medieval ideas of women, of social and political life; with a quasi-slave work force of imported labor that can never achieve democratic rights, or even equality in a repressive regime.

These fears of Modernism, which associate so many countries in our century—totalitarian like the above, egalitarian such as our own—are intrinsic to its development. What Modernism has done, historically, has been to connect countries and cultures that otherwise had little in common. With the spread of modern ideas, culture bulged across borders. The old idea of a national literature which was defined in the nineteenth century in Fichte and Herder can no longer obtain. Nations now become linked, whatever their divergence of official policies, by way of modern ideas in literature, music, art, and technology. As a consequence, Modern for many countries—and not merely those on the extreme left or right—becomes a dangerous code word in political terms. For not only does it introduce into nations ideas that might be anathema ideologically, it also forces linkages with alien cultures.

The point should be stressed that, at the turn of the century, while these ideas presented real threats to closed societies, they also were perceived as menacing democratic and open societies. The reaction to anything new at that time went well beyond "This is not to my taste." Expressions of taste were connected to fears of subversion of one's very existence. To hiss, boo, and censor the new was to assert one's own form of survival, or to reject languages that spelled disruption. Thus, literature, music, and art in their more radical or avant-garde stages were contained not by outlawing them but by labeling them crazy, decadent, part of "contemporary decay."

In the arts, Modernism almost always corrupts ideas of social cohesion, for its aesthetic imperatives, warring against content or community and society, mean a perilous reorientation. No matter what its particularities, Modern was equated with the disorganizing principle associated with the thrust of Satan. Thomas Mann's *Doctor Faustus* is a summary expression of Modernism in that respect. The satanic can take many forms beyond the Faustian pact that underlies it. In music, it can be the lack of melody or different notions of harmonics; in painting, the absence of representational figures, the substitution of color masses or geometric shapes, the failure to fill the canvas; in fiction, the loss of traditional narrative lines, the lack of familiar values, the stress on marginal, outlaw figures and the defamiliarization of character, or the failure to reflect anything but itself; in poetry, the loss of easy accessibility, the reliance on pure language, the massing of jagged, unrecognizable images. In all the arts, the human voice seems to have been lost, and this is, clearly, the work of a satanic force.

These alterations of perception and aural experience seem small things in the life of a society, and yet to traditionalists they represented (and continue to represent) not advancements or progressions of experience, but decay, corruption,

rot. American censors of library books or of radical views of how we see and hear would agree, sixty years after Hitler's words. What we discover is that Modernism is associated, pejoratively, with "foreign ideas," Hitler's "Jewish element." Foreigners are blamed for subversion, whereas homespun native elements are blameless, loyal, full of integrity lacking in those from alien cultures. Yet the attack, with its racial overtones, is patently false. Most Modern movements at the turn of the century were organized by natives of particular countries, whether Modernism appeared in Vienna, Munich, Paris, Prague, Dresden, Berlin, or Budapest. All Europe fed into it, but each development was indigenous, a form of nationalism (in its way) and a counter to nationalism, since it nourished a larger idea than state or country. The idea of foreigners nourishing Modernism came from those who perceived Jews as outsiders even when they were citizens of a given country.

In still another sense, Modern and Modernism are linked with "avant-garde," a military term in its conception that became cultural coinage after 1870. Its association with Modern always tinged the latter with political connotations that suggested insurrection. To be the cutting edge of something, as avant-garde implied, was to become involved in possible fanaticism. We recall that at about the time the term avant-garde took on its cultural freight, it also had a radical-revolutionary dimension, for example in Bakunin's *L'Avant-garde*, an 1878 periodical. In both its cultural and political significance, the term meant antagonism to an existing order. This is a given of avant-garde, as it appears to be, also, of Modern and Modernism: to be adversary toward public and marketplace, to subvert the very idea of history, to be anathema to everything language represents in stability and tradition.

The avant-garde grows from history and yet denies its historical role. It is a movement, an idea, a style, a mode or fashion that arrives at a given time, its origins almost unknown until it appears; and it is not predictable. It survives by denying everything except what helped to make its life possible. Avant-garde differs from Modernism only in the sense that it shifts so rapidly. It is, as Renato Poggioli shows us, dynamic and romantic, whereas Modernism, like any longer-term development, is a relatively static, more classical movement which ingests avant-garde, gives it standing, as it were. Cultural avant-garde is on the move, mowing down enemies, denying its placement in history, and then, apparently, dissolving, as it becomes part of something else.

We can say, in a sense, that at all times in cultural history there has been a vanguard and that it stood in the forefront of whatever was considered Modern at that historical stage. When Defoe, in the 1720s, fashioned prose fictions, he and his kind came under attack from critics who saw the new as inferior. Defoe was deemed a subverter of literary order, a transgressor against language, an adversary to culture itself. Yet in the next generation, Fielding in his prefatory comments to various books of *Tom Jones* helped to turn the avant-gardeism of prose fiction into an acceptable literary form; and the emerging "novel" was no longer avant-garde but an aspect of Modernism for that time. The larger element had, as always, assimilated the smaller.

We are mistaken in perceiving the avant-garde, which is daring and disruptive, as interchangeable with Modernism or a Modern movement. We enjoy at present "a culture of Modernism," but we experience relatively little in the

way of an avant-garde.* Most of this book will be exploration of avant-gardeism in the last hundred years and the myriad of ways in which it became integrated into Modern and Modernism. Culture is incremental, not developmental or progressive; and to find those precise increments is the challenge for the cultural historian. If there is one constant in this study of Modernism and its several vanguards, it could be to capture what Nietzsche called the *Schein*. In *The Birth of Tragedy*, one of the first Modern avant-gardes, he speaks of illusions and dreams, but implies language also: "The beautiful illusion [*Schein*, also "appearance" or "gleam"] of the dream worlds, in the creation of which every man is truly an artist, is the prerequisite of all plastic art, and, as we shall see, of an important part of poetry also. In our dreams, we delight in the immediate understanding of figures; all forms speak to us; there is nothing unimportant or superfluous. But even when this dream reality is most intense, we still have, glimmering through it, the sensation that it is mere appearance. . . ." Our culture of Modernism lies in that pursuit.

* As I write in the early 1980s, Western culture seems to be in a holding pattern, with the arts confined to consolidating what occurred in the previous two decades. In theater, Robert Wilson (with or without Philip Glass's music) is part of the avant-garde; in fiction Italo Calvino, Gunter Grass, and Donald Barthelme; in the plastic arts, perceptualists such as Robert Irwin; in music, Luciano Berio and John Cage. If we can predict, I would see increasing experimentation in environmental arts—use of space, for example—rather than in the printed word or in music. The avant-garde will be located in a "total art," rather than in individual genres, perhaps recalling Brecht's idea of total theater. A good example is Pina Bausch's dance/theater, her Wuppertaler-Tanztheater, combining mime, dance, dramatic action, serious and song music, spectacle, mixtures of languages.

MODERN
AND
MODERNISM

◆ Chapter One ◆
Getting to Be Modern:
An Overview

THE ISSUE

AVANT-GARDE, Modern, Modernism, even Modernity are often used interchangeably. Let us make distinctions. As its name implies, the *avant-garde* is out front, the vanguard of any kind of Modernism. In a short time, however, the avant-garde is corrupted and assimilated to something more familiar, to which we can apply the tag *Modern*. Once Modern is no longer bizarre, but more or less associated with familiar landscape, we say it is part of *Modernism*— a kind of umbrella word. *Modernity*, however, is a different term altogether, suggesting the present, as against some historical past. Modernity also suggests a static condition, of having arrived at this or that; whereas avant-garde, Modern, and Modernism are a process, getting there. This study will be concerned with the latter three terms and the culture they have provided for us. Modernity we leave to the historians and sociologists. One side issue: Very possibly the health of a culture depends on its support of an avant-garde, however antagonistic the avant-garde may prove; when that support withers, perhaps we can say the entire culture is dying. That, however, like most intimations of mortality, is debatable.

The sense of Modern and Modernism in any era is always of becoming.* It may be becoming new and different; it may be subverting the old, becoming

* Several books are indispensable to any study of Modernism, and I acknowledge my debt to them here: Renato Poggioli's *The Theory of the Avant-Garde*, Matei Calinescu's *Faces of Modernity*, Carl Schorske's *Fin de Siècle Vienna*, Malcolm Bradbury and James McFarlane's edition, *Modernism*. Peter Bürger's *Theory of the Avant-Garde* requires separate treatment. Bürger's point is that Modernism and the avant-garde are separate phenomena. Modernism occurred as an attack on traditional language and writing techniques, the so-called aesthetic movement; whereas the avant-garde is intended to undermine and change "institutionalized commerce with art." Modernism, he stresses, is concerned with linguistic strategies; the avant-garde is involved in historical conflict and change, going much further than Modernism.

Bürger is driving a wedge between the pure aestheticians and those who follow Lukács's sense of art as a totality. If he accomplishes that, then Modernism becomes a "technical change," a linguistic strategy, and the avant-garde a deep-rooted adversary or subversive force against com-

an agent of disorder and even destruction. In curious ways, it parallels the astrophysical idea of "black holes." The black hole is a theoretical construct, an object whose gravitational pull is so strong nothing can escape. It results from a compression in which space and time become distorted, and a star that falls through the radius of such a compression is imprisoned. Even light is trapped inside, and the collapsing or compressed star appears totally black. While holes may increase in size as they gather more material, nothing imprisoned can emerge. A star so trapped has, literally, traveled out of the universe into a black hole, leaving an emptiness in space; and even that eventually vanishes. All space-time conceptualizations or continuums no longer hold true. Even further, no empirical evidence for black holes is available, although they are detectable in orbit around other stars.

Black holes engender multiple fears: the distortion or suppression of spatial and temporal expectations; the sense that something is occurring which cannot be directly apprehended or that an immense subversion is taking place; the mystery of vast changes that threaten the very stability of the universe; the apparent aberration of natural processes; the suspicion that worlds are headed for destruction that may not even be verifiable. In all of these we find analogues of Modernism. Kant once posited a world of things that *reason* could not comprehend, but he comforted us with *understanding*; and his philosophy outlining terrible mysteries fitted itself into a more stable world by giving us a faculty or category with which we could grasp those mysteries. The black hole philosophy has no such categories or comforts; analogously, neither does Modern. It, too, is open-ended, a vortex, as one Modernist labeled its devouring suction.

Yet what is surprising for the contemporary reader is how consistent the idea of Modern has been. It was perceived early, in Plato, Ovid, Virgil, Dante, before that by the Greek tragedians, as dangerous to the existing order yet as something to be embraced as progressive. It was aligned with change, but change was itself suspect, since it meant rethinking established priorities and upsetting authority. Modern is what everyone wants to be, but it is also what must be rejected. While Modern connects to the individual—one is a "modern man" or a "modern woman"—a society should not become modern or modernized too rapidly or intensely.

The historical confrontation with Modern reveals controversy and ambivalence. It is not defined well by the dictionary. The unabridged Webster characterizes it as that which exists at the present time, as not belonging to a remote time; similarly, the OED. Clearly, Modern, or its derivatives Modernism, Modernity, even Mod or Modish, has thrived on ambiguities. It has become part of

mercialization and, generally, a bourgeois-oriented culture. But if we see that art in the latter nineteenth century and thereafter has become almost purely process, if we cite the proliferation of manifestoes that assault traditional social forms of every kind, if we note linguistic strategies as having social roles and forms, then Bürger's distinctions are weakened, even collapsed.

A major flaw in his argument is his neglect of the unconscious as part of Modernism and his use of language as "stylistics" rather than as having social and political content. The languages of Modernism are frequently its social avant-gardes. It is impossible, as Bürger attempts to do, to speak of consciousness as independent of language, unless one plants oneself firmly in the anti-Modernist camp of Lukács. However subtly, Bürger shares the belief of neo-Marxists that Modernists would like to save the world through style, when, in point of fact, their sense of style exists for itself, independent of cultural revolution. Once we see art as process, as history itself, not as compensatory, or even as revolutionary, then Modernism and the avant-garde blend.

the Modern Spirit, Modern Sense, Modern Temper, Modern Man, Modern Times. The list is inexhaustible, and proliferates as each age invents a descriptive phrase. So inexhaustible has it become, in fact, since its first characteristic usages in the seventeenth century, that it is no longer solely a word or part of a phrase, but representative of an entire culture. We experience good Mod, bad Mod, dangerous Mod, safe or unsafe Mod, moral and immoral Mod, just and unjust Mod, artistic Mod, technological Mod. It has, for some, a powerful positive connotation, since it suggests change for the better, especially when it is associated with "progress," still another word of dubious intrinsic quality and yet suggestive of an entire culture behind it. Usually, those who connect Modern to progress simplify it, so that it becomes in their terms a matter of technology, or the "latest in science," or a series of devices that make life easier. Matthew Arnold called such users philistines, but they have determined one large aspect of Modern.

The philistine sense of Modern and Modernism flourished in the nineteenth century, especially in England, when the 1851 Exhibition in the Crystal Palace was the epitome of technological genius, i.e., modern and progressive thought. We often forget that England's sense of greatness at midcentury depended not on its leadership in the arts but on its prowess in technology. We can, I believe, trace some of our twentieth-century response to Modernism to the divisiveness such boasting created, when technology and science became the new gods, and all else was sacrificed for them. The argument was given its shape in the famous exchange between Matthew Arnold and Thomas Henry Huxley, each persuasive, each speaking for a large culture, but, ultimately, each stressing a different kind of world. *

The word Modern has, in the last hundred years, exercised so many functions, become part of so many conflicting desires, divided us in so many complex ways that it is indistinguishable from the way we live. It has passed well beyond vocabulary into an existence with rules, guidelines, consequences. The idea has become organic. It has invaded our thinking not only about the arts and sciences, but about social and political life; it controls, in its governmental forms, our thinking about the economy and our attitudes toward other countries and races. It provides a lever for condemnation or approval.

Not unexpectedly, Modernism expresses both hope and threat to the same people: in its technological phases spreading cheer, but in its political and social consequences—not to speak of its artistic potentialities—creating anxiety. This intense fear of Modern enters into every aspect of life, becomes itself a form of belief. Many, perhaps most, cults, from Nazism to Jim Jones's Jonestown, are associated with a revulsion toward Modern, even while modern advances are integral to their development. Whether as art or politics, Modern has become a revolutionary word, a rallying cry for or against, an association of conflicting, competing ideas. People will kill for Modern, or kill to oppose it.

Long before technology and progress, Plato feared the modern spirit and associated it with art, which undermines authority. His Socrates speaks of poetry's power to seduce or feminize the soul, to magnify the irrational. Poetry or art, therefore, encourages the lower element in man, that which is adversary to

* The early 1960s controversy between C. P. Snow and F. R. Leavis over Snow's "two cultures" of science and the humanities was a mere shadow of the Arnold-Huxley debate, although in both the question of Modernism and its role in modern life was paramount.

reason and authority. Plato was, of course, correct, and every society that seeks authority as its connecting force will also see art and, by extension, modern art, as a dangerous foe. For Plato, art was so threatening because it was so attractive.

Art, the artist, poertry, by association Modernism, are concerned not with essences but with the changing physical world of senses and sensations. Art rearranges our perception of things rather than stressing inherent qualities. The danger of art and, by implication, "modern art," is that it seduces, enervates, subverts. To broaden its appeal, Modernism is often connected to progress, and in this sphere it is given a label. In our own era, when Modernism and progress are yoked for political purposes, we have a New Deal, a New Frontier, a New Left. The "new" is a positive response to Modernism, but it also suggests that "old Modernism" is bereft of ideas, impotent, a shallow stream ready to run dry.

Modern and Modernism are given many roles. A society may try to justify itself by virtue of its assault on merely the term, since few societies actually attempt to turn back progress, although some, like Spain, have tried. Rather, most societies at crucial stages in their development attack Modernism as an idea even as they assimilate its technological advances. As we have seen, Nazi Germany, Stalin's Soviet Union, South Africa, Saudi Arabia, the mullah-run Iran, the American Moral Majority exemplify various aspects of that. Modernism and its associated idea, progress, have perhaps more than any other terms or ideas created divisiveness, separating those who open themselves to the new from those who find the new subversive of stability and authority. Kierkegaard revealed the dilemma as early as the 1840s, when he equated dread not to the loss of something but to the possibilities of freedom. The more open a person is to such possibilities, the closer he comes to dread. "He who is educated by dread is educated by possibility, and only the man who is educated by possibility is educated in accordance with his infinity." Little has changed.

HISTORICAL DIRECTIONS

Although we routinely associate Modern with the advent of modern life about one hundred years ago, the word was in the process of developing for centuries. Attitudes toward "Modern ideas" long preceded our era of Modernism, which is another way of saying that the movement followed upon the meaning of the word, rather than embodying what the word meant at any given time. What this signifies is that the word was bandied about in several societies—in the eighteenth century, for example, as part of the battle between "ancient books" and "modern ideas"—*without* becoming connected to any sense of a concerted movement. "Modernism" is not what older societies meant when they discussed or rejected modern thought; they did not perceive an entire culture in which Modern would be apotheosized. Whatever was modern in their terms was isolated, connected to something in the arts, dependably assimilable into larger units of traditional thought. How modern were Da Vinci's ideas and drawings, and yet they could be and were absorbed.

The idea of Modernism as an all-engulfing phenomenon is relegated to our own age. The word or its significance, in fact, is full of contradictory impulses in previous usage. Baudelaire, for example, whom we usually designate as the

beginning of the movement, denigrated modernity as transitory and fugitive, as only half of art, whereas the other half is eternal. And Stendhal, whose positions seem to straddle so many "isms," viewed romanticism as having a modern or immediate dimension, departing from the more standard view of romanticism as a phenomenon that opposed classicism. The term here becomes very fluid, even in the usage of those whom we expected to be more modern. Stendhal, of course, did loosen the word from mere opposition and give it a presentness, a sense of becoming itself that we associate with our own usage.

The word "modern" is itself an adaptation of later Latin usage, and we find a sixth-century *modernus* which takes on some of the Greek notion of "neo." The word *modernus* differentiates the present from an aging antiquity, a usage that would become increasingly popular as antiquity or the beginning of things receded into an era that could be opposed by modern. In the Middle Ages, we find just such a usage, with *modernus* (from *modo*, so close to our "mod") signifying the *novellus praesentaneus*, the "now." For the Middle Ages, *modernus* was that which opposed antiquity, and the word as such would be set for several centuries.

But even this tentative statement of modern as opposed to antiquity would not lie entirely quietly. It would become part of a long-running battle, starting in the early Middle Ages, with a rudimentary factionalism between ancients and moderns. We can go further than that and see the use of the vernacular—Dante's Italian, the Troubadour's Provençal, Chaucer's London dialect—as a version of the modern spirit. These writers' works were a break with Latin as the expression of antiquity, and they used language as a way of expressing the present day, no matter what their particular focus happened to be. We have, then, a constant: the use of language as a way of separating modern from antiquity, as a form of divisiveness and definition. By way of a modern language, rather than antiquity's languages, the writer expresses more than equality. He assumes the world has progressed, and a progressive world needs new modes of expression. That shift in languages is connected to slow shifts in modes of perceptions, really cultural earthquakes.

An image that persists to our day—often cited to characterize Freud's followers—is that of the dwarf sitting on the shoulder of a giant. John of Salisbury appears to have been the first to use the image, and it suggests that each age can see further and more profoundly than the previous one because it is like a dwarf sitting on the shoulders of earlier giants, those of antiquity. The later age is not greater in either vision or height but can perceive more because of the earlier age's achievements. Such an image inevitably carries over to language. The use of a vernacular suggests that "dwarf" resting on the languages of antiquity; but such usage also proposes greater complexity. The relationship between old and new is complicated, not only by the image itself, but by what it suggests in terms of language usage, and it is a complication that will remain in the development of Modernism. For the languages of the latter would be the very element making its advance so difficult to accept; and yet it is new languages that give Modern its energies and definition.

Montaigne, in traditional terms, saw Modern (the dwarf) as holding its high position not through personal achievement but as a consequence of earlier attainment. ". . . he who has mounted highest has often more honour than he deserves, for on the shoulders of the last but one he is only one barleycorn

higher." This depreciation of Modern continued throughout the seventeenth and eighteenth centuries; and when, as in Newton, the image was not denigrating, it did suggest that the Moderns saw further because they had the shoulders of the earlier giants to stand upon. At the turn of the eighteenth century, Swift expressed distaste for the Moderns, perhaps more vividly than anyone else, in his *The Battle of the Books.*

The "Battle" of the title suggests a military campaign; and much of Swift's argument is couched in martial terms. But his most memorable image is that of the spider and the bee. Swift foreshadowed the Englightenment and its stress on progress and reason, on individual human rights, on individuation itself. And his response to what he sensed was coming was feral. The spider is described as "That which by a lazy Contemplation of four Inches round; by an overweening Pride, which feeding and engendering on it self, turns all into Excrement and Venom; producing nothing at last, but Fly-bane and a Cobweb. . . ." The spider is associated with the Moderns, those authors of Swift's own era. The bee, however, is characterized as "That which, by an universal Range, with long Search, much Study, true Judgment, and Distinction of Things, brings home Honey and Wax." The bee is the Ancients, those authors writing two thousand years earlier.

The spider is a threat, for it feeds on itself; ego and pride, not production, are its qualities. The bee produces. It feeds not only itself, but mankind, producing "sweetness and light." Swift writes of the spider as "so Modern" in "his Air, his Turns, and his Paradoxes. . . . He argues in the Behalf of You his Brethren and himself, with many boastings of his native Stock, and great Genius; that he spins and Spits wholly from himself, and scorns to own any Obligation or Assistance from without." The spider is anarchic, self-indulgent, producing dirt and poison; whereas the bee chooses "to fill our Hives with Honey and Wax. . . ." Almost three hundred years later, the "Moderns"—updated and really modernized—were associated with Jewish elements, both characterized as "sucking vampires." As such, they (like the spider) undermine the good people, whether farmers or craftsmen or industrialists, and foreshadow Jewish Caesarism, that time when Jews will take over a depleted empire.

Yet even as such onslaughts on the Moderns continued unabated, one element viewed them as part of a linkage with the past and, therefore, essential in the preservation of a stable culture. Several commentators have cited Pascal, who, while not enchanted with Modernists, accepted them as part of a natural development of sentiments and ideas that advance upon those of the ancients. "Thence it is that we are enabled to discover things which it was impossible for them to perceive. Our view is more extended, and although they knew as well as we all that they could observe in nature, they did not, nevertheless, know it so well, and we see more than they." That linkage becomes so important because it gave credence to the claims of Moderns, which increasingly went beyond mere association with antiquity to a sense of superiority. Modernists would argue they were more progressive, that such progress comes about through both linkage and through the individual leap beyond such connections; that their view honors a historical sense allowing for human improvement and gives history significance when it might otherwise appear outdated.

Modern becomes "light" against the darkness of the past, an unjust frame of reference which nevertheless enabled Modernists to justify their work. This

sense of illumination would show up in the numerous manifestoes and periodicals that characterized later Modernism. To bring light to bear upon a dark age, as some Renaissance artists insisted, was little different from cleaning out the stables, that desire to overthrow the past we find in Modern artists. While the rebellion against authority was more muted in previous ages, a similar spirit began to prevail: to make progress, one had to denigrate history or even eliminate the past. To emerge from darkness is a constant metaphor; to awake after a long sleep is another aspect of the same figure. Later Modern was such an awakening, and it is perhaps not fortuitous that Freud's work on the unconscious and on dreams should almost exactly parallel the onset of the Modern movement.

But not Shakespeare, in whom we find mainly negative responses—"modern" as a trivializing experience. Used in *All's Well That Ends Well*, "her modern grace" denotes a certain deceitfulness; in *Othello*, "modern seeming" suggests active deception or else a trivializing of the truth. In *Macbeth*, indictment of modern is even fiercer, when a Scottish nobleman, Ross, says, "Where sighs, and groans, and shrieks that rent the air / Are made, not mark'd; where violent sorrow seems / A modern ecstasy." Modern is here connected to forms of language in which profound emotions can be turned into an erotic experience, and the word seems in league with all that has poisoned the atmosphere. In *Antony and Cleopatra*, attacks on modern are extended to "modern friends," signifying those who pursue with "immoment toys," that is, trivialities. In describing the beloved one's worth, in Sonnet 83, Shakespeare speaks of how a "modern quill doth come too short," the assumption being that an older, and greater, language is needed to accomplish the task.

The seventeenth century inaugurated what we know as the quarrel between the Ancients and the Moderns, memorialized by Swift in *Battle of the Books*. Such a confrontation of cultural values was bound to occur, even if it had not happened with books; Renaissance humanism was struggling to maintain itself against, not the "Dark Ages," but the fierce light of Cartesian rationalism and scientific precision. The quarrel between Ancients and Moderns, as in our own day, has a much broader context than a struggle over books or even literary values. In the seventeenth century, the idea of Modern was associated not so much with literary values as with scientific inquiry, the avant-garde of that time.

Such an inquiry, however inchoate, began with Bacon's *Instauratio Magna*, whose function was to redefine man's relationship to nature so as to demonstrate man's supremacy, apparently lost in the Fall. Bacon's plan, then, as the title suggests, was a grand scheme to reorganize the sciences and by so doing to redefine man. Bacon wanted to move us away from purely philosophical inquiry (really aesthetic contexts) into "operations," ways and means of locating man's place in the universe that would supersede the "quest for Truth." The true aim of science was "to endow the condition and life of man with new powers or works," or, relatedly, to extend the limitations of power. By pursuing utility, we can arrive at truth; for, in fact, truth and utility are dependent on each other.

Bacon proceeded by induction, and we could, very probably, write an entire treatise on Modern and Modernism from its relationship to and rejection of the inductive method—how, that is, Modern had ultimately to struggle to emerge in each generation against the seductive powers of scientific induction. While Bacon developed his classification of science for other reasons, we could argue

that his development of induction was an implicit attack on a potential Modernism. By spending the entire first book of the *Novum Organum* (1620) on clearing away the *idola* or idols, Bacon hoped to sweep out false notions—analogous at first sight, to Modernism's effort to establish its own hegemony. We are concerned chiefly with Bacon's third of four kinds of idols, since he associated these with marketplace words, what he called *idola fori* (idols of the forum). Such words mislead us because they may be merely names for things that do not exist, creating a presence by way of the name alone; or they may be abstracted from objects and then related only tentatively with these objects. The result is a confusion in language that leads directly to confusion of thought.

Bacon's location of confusion in language, although directed toward all received philosophies except his own natural philosophy, can be extended into what would be the struggle between Ancients and Moderns, and to an emphasis upon rules. In both Bacon's case and later developments, the idea was to rid man's mind of false precepts, misleading language, erroneous conceptions of culture. Bacon's stress on forms in the *Novum Organum* would appear in his later arguments stressing that rules inhibit Modernism, even though his emphasis was not on literary values but on man's relationship to nature (i.e., to the world). Such forms would appear to be physical properties themselves. "When I speak of forms," he writes, "I mean nothing more than those laws and determinations of absolute actuality which govern and constitute any simple nature, as heat, light, weight, in every kind of matter and subject that is susceptible to them."

Bacon's philosophy of man and nature would become diffused in that confrontation of conflicting values characteristic of literary endeavor. But his attempt to replace *idola* by inductive methods created guidelines for that future struggle. The point is that whenever Modernism tried to establish itself, not as a movement but as a suggestive play of ideas, it would encounter some aspect of scientific inquiry as enemy. This occurred even when an author like Charles Perrault in the late seventeenth century attempted to use scientific precision as a way of praising the Moderns. Perrault's stress on rules, his insistence that Modern was superior to Ancient because of its access to a greater number of rules, really did Modern harm because it exposed it to scientific inquiry. All this fed into the Ancient versus Modern antinomy.

By adding a new wrinkle to the polemic—that Modern was superior to Ancient because of its increase in rules—Perrault spread Cartesian rational inquiry into every aspect of literary endeavor. Subsequently, critics picked up from this and parallel points to suggest that taste was improving, that there was such a phenomenon as a progressive culture. Such developments fitted in with the Pascalian claim that Moderns were really older than Ancients, because further from the sources of knowledge, while the Ancients were themselves newer, since they came at the time when culture was beginning. All of this would seem to play into the hands of Modernists, since these arguments could be used to support their assertion that change is a constant in culture. But these arguments actually deepened the schism between Modern and Ancient and made the role of Modernism more confusing. The terms of the battle so consumed the opponents that not until the later nineteenth century was the time ripe for a culture of Modernism or a Modern movement. Before that, Modernist works appeared sporadically—that is, works that seemed an avant-garde of something or other, like Sterne's *Tristram Shandy* in the 1760s, parodying the novel even before the

genre was established. But these are merely unassimilated moments of avant-gardeism.

One point, however, can be made in favor of these destructive polemics: they helped to establish Modern by way of negation. Throughout the period following the Renaissance, Modern became fixed in Western culture in a context of rejection. It became, therefore, not only something in its own right, but something that existed because it posed a threat: it had to be negated in order to be given its own substance. It became, in some twisted way, one of Bacon's *idola*, to be exorcised before more stable values could be defined. In this respect, Modern begins to take on some of the metaphorical quality of avant-garde. We see forming, then, long before we have a culture of Modernism, a fear of the very term as something subversive and adversary; therefore, something that can be combined or interchanged with a military metaphor.

Yet before proceeding further, we must be careful to separate those writers whose attributes seem to be Modernist, like Sterne, from those who worked and thrived within a full culture of Modernism. Stendhal, whose irony, sense of taste, and definition of romanticism as part of modern life would seem to place him as an avatar of Modernism, is an excellent illustration of this point. Stendhal touches on Modernism in its secondary attributes, certainly in his defiance of neoclassical eternal verities, which *he* sees as part of changing fashion. But he does not follow through on Modernism; nor could he, since such work would have meant some verbal or linguistic development: a verbal equivalent of his notions of beauty and fashion. Stendhal exemplifies a writer who touches upon marginal issues, eschewing elements that would be the crux of the movement.

Baudelaire, however, stands at a crossroads. He was the first to glimpse (not embrace) a culture of Modernism: its obsession with the future, not the present; its ruthless treatment of history and historical method; its defiance of authority, to the degree it is revolutionary and iconoclastic; its insistence on radical difference from what preceded it, even when it incorporated aspects of traditionalism. * Perhaps because he viewed himself as isolated and helpless, Baudelaire was able to intuit that isolation, contempt, cruelty, hatred—not society or community—would characterize the movement of the future. He perceived, further, that such qualities were not negative, but attributes of beauty. Stendhal intuited some of this, certainly the sense that modern art will revolt against the academy, that such art embodies both change and the moment. But Stendhal was, to some extent, still arguing the old Ancient/Modern polemic; whereas Baudelaire, especially in his "On the Heroism of Modern Life" and "The Painter of Modern Life," sliced through all such older forms of debate and established that something new was about to be defined.

As we shall see, Baudelaire perceived Modern as a quality in itself, not only something in contrast to the past. This definition of Modern, or *modernité*, as sui generis removes the pejorative aspect of mere presentness, neutralizes the pull of the past and of history itself. He perceived, further, that each wave of the past involves successive avant-gardes with their unique qualities. Thus, each

* In "The Salon of 1846," for example, Baudelaire attacks the faddish use of *chic* and *poncif* (trivialization through repetition), which he sees, not as "mod," but as the worst of everything "conventional and traditional." For him, *chic* and *poncif* belong to marketplace modernism, not to Modern.

wave is itself a *modernité*, being modern in its own time. Still further, Baudelaire saw that in choosing to be modern, the artist has chosen a heroic role; Constantin Guys is such a figure, and of course Baudelaire to some extent tried to model himself on Guys. The *poète maudit* also becomes such a figure, a modern pirate or criminal defined by his adversary role.

Paris Spleen, prose poems that are adapted "to the lyrical impulses of the soul" and the "undulations of reverie," involves role playing for the writer at the beginning of a culture of Modernism. Baudelaire plays the role of an old clown. "I have just seen the prototype of the old writer who has been the brilliant entertainer of the generation he has outlived, the old poet without friends, without family, without children, degraded by poverty and the ingratitude of the public, and to whose booth the fickle-world no longer cares to come!" Baudelaire's images of marginal figures, whether the clown, widows, or an old vagabond, are directed not toward those socially outcast but toward those who have fallen out of rhythm with their own roles. By shifting the stress from society to individual or self, Baudelaire has intuited Modern's chief direction.

In another respect *Paris Spleen*, written between 1855 and 1867 and modeled somewhat on Aloysius Bertrand's *Gaspard de la nuit*, presents a voyage or journey, in which the artist in his various guises exposes his soul. That use of the voyage, or even the invitation to it, in *Les Fleurs du mal* embodies the idea of Modern as an endangerment; and we find after Baudelaire a half century of great voyage poems and prose-poems, including what I have called "spiritual autobiography." André Gide began his career with such voyage prose-poems modeled in large part on Baudelaire and the *symboliste* idea. He called it *Urien's Voyage* (1892), and its images of languor, despair, stagnation reach back almost directly to *Paris Spleen*.

Baudelaire also, in a poem such as "Hymne à la Beauté," suggested an aesthetics of antirealism and antinaturalism, a step toward Modern's self-consciousness. In the poem, Baudelaire seeks a Platonic ideal of Beauty by way of a journey into correspondences ("Viens-tu du ciel profond ou sors-tu de l'abîme, O Beauté?"*). In these associations, the artist seeks both his ideal and his doom; heaven and hell are equal goals. The creator is like an insect, dazzled, which seeks the candle flame as the greater reality and is cracked and burned, while he blesses the flame. Here we have the romantic artist as adversary, his life an act of hostility to bourgeois artifacts; and yet not so free he can escape the demands made on him by heaven and hell; both blessed and doomed, not liberated.

Baudelaire exalted the artificial, not as a means solely of degrading society's values, but as a way of exposing the inadequacies of realism. When the artificial becomes the norm or a religion—i.e., in Pater, Huysmans, and many of those I will cite as spiritual autobiographers—we have a foreshadowing of a culture of Modern. Baudelaire knew that what seems artificial for one generation becomes the realism of the next; and, therefore, it is necessary for each generation to keep the artificial alive. The importance of this perception and effort cannot be overestimated. Picasso reasoned that "through art we express our conception of what nature is not." Artificial is not a denial of life, not a sense of nil, but an affirmation of adversary values, much as those Baudelaire found in Poe. The idea of the dandy, which leads somewhat tortuously into Poe, was Baudelaire's

* "Come you from heaven or hell, O Beauty?"

expression of the person who makes art by way of artifice. Poe's "legend," the burning out of his health, his drug and alcohol addiction, his madness, all nourished not realism or true biography but a personal aesthetic. Poe was an American Cain, his life marked by what Baudelaire called "fatal destinies."

Yet Baudelaire in his advocacy of these ideas is caught in contradictory impulses. Past history must be rejected—Nietzsche's "death of God" as more a rejection of historical process than religious belief—and the present exalted. Nevertheless, even as the present is lauded, it is perceived as diminished, since the present has been created materialistically and technologically. Thus the Modern artist will find himself caught between at least two equal pressures: the sense that history no longer matters, that the present is all that should concern him; and an awareness that the present he exalts is ephemeral, a moment that passes even as art attempts to address it. Modern devours the present, so that, inevitably, Modern devours itself.

TOWARD MODERN MODERNISM

The redesigning of forms so characteristic of Modern's self-consciousness is an effort to break through the contradictions of time: to capture the present while denying the past, and yet to use every aspect of the past to develop ideas of presentness. Redesigning of form—whether discovering verbal equivalents of the pre- and unconscious, using geometric shapes as in cubism, or attempting new harmonic sequences—involved the quarrying of languages. Thus, a sharply defined culture of Modern and Modernism is located in Western history in a period of about thirty to forty years, and it is profoundly connected to the reordering of our sense of time and space through the use of new languages.

The avant-garde, as we shall perceive it, is the point in each phase of Modernism at which Modern becomes or achieves itself in its particular language: in Picasso, Braque, and Kandinsky's movement toward abstraction; in Schoenberg's atonal and then serial music; in Joyce's stream and free association. As the cutting edge of Modern, the avant-garde establishes the point at which Modern must enter its new phase in order to keep up with itself. The avant-garde points toward the future, and as soon as it is absorbed into the present, it ceases to be itself and becomes part of Modernism. It is, in fact, always contingent, in danger, endangering itself.

The weapons of the avant-garde as it helps to redefine the main body of Modernism are designed to play on the fears and hostility of those who accept only a culture of the familiar. Avant-garde, however, is, more frequently than not, a *new type of order*. Schoenberg's atonality and serialism could not be more in keeping with a mathematically or scientifically oriented society. His work is in many ways the epitome of twentieth-century science transferred to musical notation; and yet it is so threatening because of its departure from an aural norm, not for what it is. (Not atypical of the reaction it received is the composer Hans Pfitzner's description of "the international-atonal movement" as the "artistic parallel of the Bolshevism which is menacing political Europe.") The avant-garde's assault on the senses is confusing because it is based on order, not disorder. All art is based on order, and even Dada—which seems to test this assumption most radically—was an effort to turn extreme disorder into forms, alternate forms.

It made a kind of coherence of what we know intellectually to be the incoherence of the unconscious.

Not only does the avant-garde keep insisting on new languages to accommodate new voices, it constantly explores and exposes Modernism. The avant-garde rejects Modernism itself, for the latter is not a singular or monolithic body, but made up of many different forms all moving at different paces. What is Modern in painting or music may not find its equivalent in poetry or fiction. In the early 1980s in America, for example, we see a deepening of the Modern spirit in painting and sculpture, while literary effort is experimental or avant-garde only sporadically, not at all in those generally designated the "major writers." Parts of Modern are always ready to turn into Modern-ness or contemporary, which is antithetical to experimentation. We can posit a "moderate Modern," which is ready to turn into contemporary; a "radical Modern," which resists absorption altogether because it is either sui generis or failed experimentation. There is, also, "conservative Modern," which we find in artifacts, "now" objects, cloned elements turning into pastness and history. In the career of a given artist, we may find all three aspects. To remain in the present: in the work of Thomas Pynchon, we can see conservative Modern in V., indistinguishable from presentness; then moderate Modern in The Crying of Lot 49; followed by radical Modern in Gravity's Rainbow, in which avant-garde elements dominate, although intermixed with conservative and contemporary aspects. Joyce's movement from A Portrait to Ulysses to Finnegans Wake illustrates the same point.

Put another way, we can say that everything except the avant-garde can be turned into realism. What this means is that the avant-garde aspect of Modern is always out ahead of realism, which is the context for all absorption into the mainstream. When we label something realistic, we have admitted that we can accommodate it aesthetically, and are prepared to turn it into pastness or history. All works of art we absorb in social terms are elements of reality; which is to say, elements that have been assimilated into historical constructs, regardless of their distinctive qualities. Ulysses, the extreme avant-garde of its day, has become a realistic artifact in that respect, although painting and music avant-gardes have proven less amenable to absorption.

A related question is whether an acceptance of Modernism makes it possible for the avant-garde to get a foothold or whether the avant-garde—with its exaggerations, distortions, its assault on realism and proportion—makes us aware of Modernism. My argument throughout will be that it is the avant-garde that makes us aware of a culture of Modern; that without the avant-garde and its exaggerations, Modern at each phase would have settled into the realism of the present, into what we call contemporary or Modern-ness. Baudelaire's Les Fleurs du mal, which preceded any real culture of Modern, brings to our attention the fact that a response to realism and classicism (the Parnassians) was occurring; that is, that a Modern movement was potential. Similarly, Rimbaud's work in the 1870s, seemingly isolated, suggests an entire notion of change in our cultural coordinates. Such artists' works do not herald the new; they embody the new in such a way that we become aware it has already arrived.

Whatever its ultimate relationship to Modernism, the avant-garde is "anti"; it exists by trying to kill off the outposts and forays of previous artistic or intellectual ventures, including other avant-gardes. It is always preparing itself for the "death of" the most advanced units of Modern, and is, accordingly, a

countering element of Modern itself, so far in front that even before its prede-
cessors have been absorbed, it is threatening to subvert them. This vanguard
survives, however, not only by negating and redefining, not only by subverting
and defamiliarizing, but by actually thriving on the death of the arts. Avant-
garde, in this respect, is a form of cannibalism. With the establishment of Modern
culture as a distinct mode for our times, we can expect the avant-garde at every
moment. Further, when we say that the Modern movement is dying or dead,
we are claiming that the avant-garde has not appeared or is not discernible. Pop
art in the sixties, which seemed reductive and trivial, was a form of avant-garde,
not in itself of much aesthetic value certainly, but an aspect of that reaction
which forces us to rethink Modern when we feel it is enervated.

Yet even as we speak confidently about Modern as a movement, we must
insist on its diversity, its many styles, its nonmonolithic quality. We tend to
lump together many different styles, deformations, nonrepresentational factors,
varying color and compositional systems. But within the movement, these often
clash, as we can see if we parallel cubism of the first decade of the century with
the development of German expressionism, two movements of the avant-garde
with some overlapping ideology but with very differing results. Similarly, Con-
rad's and Ford's work with narrative time in their fiction up to 1915 is very much
an aspect of Modern; and yet this distortion of linear, sequential narrative is
quite different from what Joyce was preparing in *Ulysses* or Woolf in *Mrs.
Dalloway*. Such divergent developments can occur at basically the same time,
and while they share a culture of Modern, they nevertheless appear to pull
against each other.

All efforts to simplify Modern into a monolithic movement are doomed to
failure. Originally, the term *avant-garde* remained subservient to its political
function, or to its military connotations. Bakunin's journal *L'Avant-garde*, founded
in 1878 in Switzerland, was dedicated to political ends far removed from the
later aesthetic use of the term. But even as Bakunin co-opted the military met-
aphor for political ends, the term was passing into the aesthetic area, taking with
it most of its current usage as a radical movement. By the following decade,
political and military aspects had diminished and aestheticism was ascendant.
With this ascendancy, new vocabularies led to a blurring of generic lines between
fiction and nonfiction, novel and poetry, or music, dance, and decoration. Apart
from content, the page, the canvas, the composer's sheet took on a new look.
The search for different forms became frenzied.

Although symbolism is in several respects an avatar of Modernism, the
movement in most of the later arts is away from the romantic suggestivity of
symbolism. The thrust is toward hardness, firmness, impersonality; the significant
tone is based on an austere classicism intermixed with an aesthetic ideology. In
more contemporary terms, we find wholeness giving way to decreation. The
potential for this is already present in Baudelaire. But a more centrally located
figure was Mallarmé; the potential for decreation of meaning was, in fact, part
of his view of poetry and its aesthetic ideology. Mallarmé's use of white space
or the void, of emptiness confronting words, of words struggling to assert them-
selves against a sea of space, of language welling up not as expression but as a
survivor of emptiness foreshadows form and meaning in nearly every art form.
The note, the brush stroke, as well as the word, become outposts of meaning

in an emptiness. By breaking down the whole into such elements, Mallarmé has turned smallness into the significance we once ascribed to largeness, using the molecular structure, as it were, as a representative of the larger chemical structure.

There is in Mallarmé a contingency of effects, in which analysis and description serve not to limn an object but to keep before us an object in the process of becoming itself. Writing on Poe, Mallarmé said: "The intellectual working of the poem disguises itself and is witness to, is present in, the blankness which isolates the stanzas and in the paper's whiteness; a significant silence which is no less fine to produce than the lines." The stress here, more appropriate to Mallarmé than to Poe, is on seeing language as an intruder, like Satan in the Garden. Language is no longer the primary agent in its old form of communication or as creating subject-object relationships. The page or territory is primary, on which language wanders like a lonely adventurer hoping to survive emptiness and whiteness. Mallarmé lived in an age of great exploration on strange continents, and his view of language exploring unknown territory, where it might perish for lack of hardiness, has some of that pioneering spirit. The writer is a man of great courage—one of Baudelaire's heroes of our time—for he is willing to sacrifice language for the sake of filling emptiness, where it and he might be swallowed up. *

If we accept this view, then language turns into a form of music, becoming not only a visual image but an aural one as well. We hear the positioning of words on the page even as we see it; relocating and deconstructing have aural equivalents, which we supply from the subject side. Even while lines seek to form, they liquefy, redefined by the pressure of the blankness surrounding them. Put another way: When words are intruders on the page, they become like notes or sounds breaking the silence; and language becomes almost indistinguishable from musical notation. We see here so many facets of Modern we can only remark that in Mallarmé—but not in him alone, of course—we note language changing from its earlier use as analysis and description toward its new role as an agent of perception. Language makes us "see," and, not unusually, it lacks finality.

However early we date Modernism, whether in Baudelaire, Rimbaud, Lautréamont, or Villiers, we find self-reflective, self-conscious works. The voices emitted derive from deeply subjective states, and that is why they seem to tell us so little about the external world while being so insistent about other things. The images molded by these new voices are machines, cities, tombs or caves and hollows, streets, buildings; or the absence of these things. Nature is often defined not by its presence but by its intense absence. The self devours all. A "wasteland" is a nature poem hollowed out, denaturalized. Nature exists in such poetry to show that it has become extraneous, like the soul. Even a somewhat traditional writer like Hardy had peered into that abyss.

A key aspect of Modern and Modernism has been a stress on the moment, away from timeless perception toward "now." That emphasis on presentness—often accentuated by memory—is one reason why the language and voices of

* There is philosophical backing for this in Hegel's insistence on negative thinking: "Thinking is, indeed, essentially the negation of that which is immediately before us." Mallarmé turned this power of negation into a language.

the movement provide so little continuity or narrative function. We enter not only a world of contingency, but one of coincidence. The consequence is discontinuity, not as a structural element—as, say, in *Tristram Shandy*—but as part of our assumptions about all experience. To go from this to a stress on experience for its own sake, a self-consciousness that grows into solipsism, is not at all unusual. Consequently, we find that two extremes meet in Modernism: an impersonality and coldness of form allied with an extreme subjectivity which seems to exclude both reader and the world. Social/political considerations have almost no significance here and must be extrapolated from cold structures and extreme subjectivity. Georgy Lukács's view that the avant-garde was another form of realism practiced by the giants of fiction does not hold once we forgo his Marxist assumptions; nor does Ortega y Gasset's insistence that avant-garde (i.e., Modern) art is dehumanized art, once we reject his assumption about man and his relationship to the machine. Art does not reproduce the process of mechanization, but becomes a fresh mode of experience.

Lukács failed to recognize that Marxism became another form of the avant-garde. As an opponent of the bourgeois state, Marx believed it was necessary to dissolve the state, reduce it to ashes, and from that man would grow again, or perish utterly. The idea is poetic as well as fixed by sociopolitical considerations. Put another way, Marx deconstructed in his area as much as Mallarmé in his; the goal for both was to decreate so as to reexamine or redefine. The elements of Marx's method and of the methods of Modern artists that seem dehumanizing are not at all antihumanistic, but spring from a desire to find alternate ways in which man's humanity can find outlets. An art form, however bizarre, however avant-garde, however dehumanizing its surface appeal, is an expression of man's vitality and accommodation to process. It is keeping humanity alive in new forms.

None of this means the artist wasted away in the isolated armature of his creations. On the contrary, the Modern artist entered a world of kindred fellows, what the French have labeled the *milieu artiste*, the equivalent in political terms of the cell. What occurs is that the artist has rejected his historical context—associates, family, childhood friends, even his social background and name—for a "new name" and a fresh social context. The *milieu artiste* exists outside history and tradition, with its own rules. Artists create their own caste, a society within the society. The proliferation of journals and manifestoes in the Modern era is another indication of this world within a world; for each journal and manifesto suggested not the larger world but its own terms, the miniature as whole.

Within the *milieu artiste*, the artist carries out his forays against the larger world, the container of his. Within the immediate circle, the avant-garde becomes the norm, not the deviant; value systems are reversed. The bohemianism of artistic circles, what became manifest in the Picasso circle just after the turn of the century, is in reality the formation of alternate modes of behavior befitting those living on an island surrounded by alien waters. The hostility toward other value systems, the need to *épater le bourgeois*, is a matter of redefining human behavior within an alternate system. The artist must annihilate others' taste to justify his milieu. The avant-garde thrives on such annihilation, Nietzsche's death of the gods carried to all forms of behavior. Freud was such a member of the avant-garde, and the psychoanalytic circle around him in Vienna became

a brotherhood equivalent to many aspects of the *milieu artiste*. It had its meetings, its secret forms of treatment (hypnosis, at first), its rules; its survival depended on the banding together of like types. Freud's possessiveness and despair when members defected was connected to his realization that the *milieu artiste* is like a fort under siege, needing all its soldiers for defense.

That *milieu artiste* existed in various forms in Paris, of course, but also in Prague, Vienna, Munich, Dresden, Zurich, Berlin, even Budapest and parts of prerevolutionary Russia. London had its own kind of Modernism, but without the loose fraternal order we are speaking of. All Europe fed into Modernism. In the popular mind, the Modern movement is so associated with Paris that it neglects many other "islands" of avant-garde artistic fraternalism. What is equally clear, however, is that although most artists, writers, composers identified with their own cells or units, influences upon them indicated a cross-fertilized cultural movement. That is, behind each *milieu artiste* we find a similar body of literary influences: Baudelaire, French *symbolistes*, Mallarmé, Nietzsche, possibly Ibsen in some manifestations, Dostoevski for some. The commonality of influences, most of them French or French derived, created the sense that Modern owed its existence solely to French models. But we can ascribe several of its sources to German idealism as well, to Kantian models, their manifestation in Hegel, the sexual theories of Schopenhauer, and then the ironic synthesis of all this in Nietzsche; and out of this maelstrom of ideas, with some Marxism intermixed, we have the emergence of Modernist units. In music, of course, the most influential figure was Wagner, but Wagner's ideas and music were a synthesis of that German background indicated above. In art, the French impressionists were a point of departure, as would be the postimpressionists.

POINTS OF DEPARTURE AND ARRIVALS

Once Modern and Modernism began to gather momentum, from the 1880s on, it became in a larger sense analogous to the *milieu artiste* of the individual artists. That is, it became itself a large cell within the even larger cell of a hostile culture. Worth repeating is how Modernism reached across boundaries and nationalities, and how the cities of Modernism housed artists and writers from so many diverse places. Renato Poggioli has demonstrated how a culture of Modernism broke up into movements what had been, earlier, schools. Schools had been static and classical; movements were dynamic and romantic. "Whereas the school presupposes disciples consecrated to a transcendental end," Poggioli writes, "the followers of a movement always work in terms of an end immanent in the movement itself." In this formulation, a movement is a matter of creation, not an increment, an expanding moment of dynamic energy, not a series of recapitulations. In itself, it is the focus of activity and energy, without primary regard for history or tradition, however much it may nourish itself from these. Artists and writers move among the cities of Modernism, Paris or Zurich during and after the First World War, or Berlin and Munich; Paris, Vienna, Berlin, Munich before the War. Scandinavians like Strindberg poured into Paris and Berlin: Munch went to Paris; but Ibsen, from an earlier generation, remained in his homeland.

Not unusually, this dynamic flow of energy into art is paralleled by the

dynamism of new movements in psychology and psychoanalysis. Even here we note that schools barely form; movements, which are quicker to coalesce, are the main element. Freud's obsessive need to hold on to his followers, in fact, was his effort to build a school, in older artistic terms, whereas the trend within the decade of his major work was to fragment into movements. Yet central to all these movements, to Freud's "school" and to those more pragmatic about mind and body unity, was the principle of dynamic energy, what Alfred Wallace cataloged in his book *Wonderful Century* (1898). Basic to Wallace's conception of dynamism was the flow of information and energy deriving from discoveries in nearly all fields of knowledge, in the natural sciences such as physics, evolution, genetics, and astronomy, as well as in the social sciences.

This dynamic flow, with 1900 as the pivotal year, the Annus Mirabilis, impelled the proliferation of movements. If the unconscious was increasingly to be viewed as creative—a carryover from romantic belief—then the individual "loosens" himself for creative work which is pure energy. As a consequence, we can perceive the unconscious not only as a disturbing phenomenon or as a source of automatic behavior that interferes with conscious will, but as a source in itself for creative energy; a fount of images, an animus mundi. Carried into physics, the atom, for Einstein, would contain this almost unlimited energy; to split the atom and release its dynamism would be an analogue of that release of late-nineteenth-century creativity.

This awareness of release paralleled the peeling away of the unconscious as a repository of neurotic impulses, and by 1900 made the unconscious the new territory for exploration. Discoveries there, whether Pierre Janet's that prefigured Freud's, or those of Freud himself, established a kind of magnetic field. Such exploration fitted discoveries being made in the pre-Einsteinian physical world, so that Max Planck's quanta, as forms of separated bits of energy, parallel those piecemeal emanations from the unconscious which the analyst draws out. All aspects of human life are derived from forms of dynamic energy; movement and reshuffling of position become paradigmatic. The 1890s were the matrix for such dynamism, and in Freud's own life we can see such maneuvers, which will also be found in artistic movements: his rupture with Breuer, his breakup with Fliess, his period in the wasteland where he could have failed completely, his insight into his own self (the derivative of self-analysis), and his return from self-exile with interpretations of dreams and several other books which filled the first years of the new century. For Freud, 1900 was indeed the catalyst for the flow of energy.

Further, if we note four of Freud's essential ideas in the interpretation of dreams, we can see how his itemizations of dynamic energy eventually carry over into new ventures in the visual arts and literature. Initially, Freud divided dream content into latent and manifest, with latent in the distant past, manifest in the present. Those twin time zones, at once connected and dissociated from each other, feed parallel artistic premises about the breakup in time, from cubism in painting and stream of consciousness in fiction to use of images as narrative form in poetry or to Schoenberg's atonality. From this, Freud perceived that the latent content of the dream was repressed and, therefore, showed its manifest content in distorted ways. What we see on the surface is a deformation of what lies underneath: once again, twin realities forced into different paths, like identical twins growing up in different environments. Here we have analogies with

the artistic process, the growing presence, for example, of myth and mythical dimensions in literature: Hesse, Musil, the entire subgenre of spiritual auto-biography with its roots in a different kind of temporality; or the role of the primitive and African in Modern painting, the place of folk music in Bartok and others.

Third, in Freud's atomization of dreams, we have a free associational process of analysis: the dream is a body of various elements emerging piecemeal from the analysand's words as part of a process based on a verbal liberation. The aim is to loosen linear and sequential dimensions, so as to arrive at a truth based on irregularity. Although the literary and visual arts would have developed without Freud's insights here—from Bergson, for example—there is little question that the establishment of such procedures profoundly affected temporal/spatial re-lationships in the arts. Finally, Freud incorporated dream interpretation into a larger method of psychotherapy, so that dreams did not seem aberrations but became central items in the amelioration of neurotic behavior. The dream, accordingly, was seen as coexistent with the waking life, not as some secondary or primitive force. With that dramatic change, art could quarry from a vast reservoir of new images, sounds, visual effects.

Modern art is always on the edge of moving away from us even as we view or read it. Because it is so subjective—so connected in some respects to the unconscious—it seems to lack fully coherent boundaries even when it is hard and shaped. Since Modernism is so intensely aesthetic in its demands, we should expect that the rational and sequential boundaries that serve us so well in our routine expectations will be shattered, replaced by that new order of being which is precisely what Modern offered as substitute for tradition. One reason Nietzsche responded so negatively to Wagner after early idolatry of both man and music was Nietzsche's fear of that very loss of control implicit in Modernist exploration. For Nietzsche, Wagner became part of an irrational German process, a mythical, redemption-loving, falsifying man who believed his own myths.

Yet here we have not the extraordinary but the usual in Modernism, where lines and boundaries are effaced. The consequence can be an irrationality that, on one hand, Nietzsche (the defender of Dionysus) rejects, and, on the other, Hitler, as rationalist, attacks as a subverter of state and people. In *The Gay Science*, Nietzsche cited the demonic role of Bayreuth itself, for "throwing the political, social, and racial concepts built into the latter [into the drama] into deep shadow and illuminating their other, more tolerable—indeed, frequently universal—aspects." Thus Wagner, through Bayreuth, could play Satan, using the shadows of staging as a means of furthering dubious philosophical ideas.

Yet what Nietzsche attacks is what Modernism becomes. In its quest to defamiliarize, it must assault traditional unities, whether through staging in Wagner, growing abstraction in art, or the packing of subjective states into obdurate images in poetry. Further, that need for the artist to assume his own atomic structure creates a situation in which even Nietzsche's advocacy of Dio-nysian energy no longer obtains. One aspect of Modernism has certainly been dance, embodied in Isadora Duncan or in Nijinsky and the Diaghilev-promoted ballets; and the image there, the memorable one, is of the leap, that leap which Nijinsky made his own. That spatial arc characterizes not only dance, but the

entrance into Modernism itself.* It is a "bold leap," not obedient to the incrementalism by which earlier forms worked. Rilke spoke of "stretching one's powers until they extend between two contradictory positions," and the phrase is one of infinitude for the artist, a Promethean image. He meant not only mind, but energy itself: the artist as a dynamic source for connecting irreconcilables, an agent of form as well as ideas.

One difficulty in establishing a coherent chronology for the development of Modernism is that it partakes of many elements associated with art as a whole. Further, many previous ages had their sense of Modern—that art and those artists who strained against tradition. Yet we must make distinctions. In the past, a seemingly Modern movement normally coalesced into a school, as the seventeenth-century English metaphysical poets shared sufficient qualities to qualify as a group or a school, while still individualistic and rather different in practice. What qualified them was a certain reaction, in Donne, Marvell, Herbert, Vaughan, Crashaw, against existing poetic language, and an effort, in Eliot's words, to "find the verbal equivalent for states of mind and feeling." Eliot saw in them a Modernist force, comparing his generation with theirs: "The poet must become more and more comprehensive, more allusive, more indirect, in order to force, to dislocate if necessary, language into his meaning." Such must be the practice of the Moderns, as it was of the metaphysicals.

Yet those seventeenth-century poets of such divergent talents were not Modern for their time, certainly not part of a Modernistic movement. Even though Samuel Johnson reprimanded them for strange yokings, they were not the new, but fresh aspects of the old. They were, indeed, part of a tradition that had begun to develop new tentacles and new languages.

Such poets coalesced into a school, and this weakened them as a movement or as an avant-garde force. As a school, they continued a tradition; as a movement, they would have existed for their own sake, an existence predicated on their energy, not on their affinities. As such, they would have taken on the qualities of an avant-garde, or what Poggioli, always a fine phrasemaker, calls an "activist moment." He also sees this as a "nihilistic moment," which for him is slightly negative, whereas, for us, it will be the moment when the new has only disdain for what it is replacing. It arrives when the *milieu artiste* considers itself triumphant and waits for the crowd to catch up. Poggioli cites this later moment of triumph as part of the "antagonism" the artist feels for his audience. I would alter that to suggest the artist feels antagonism toward previous art, not the audience for it; that the enemy is not the bourgeois but the materials the artist has inherited. The seeming hostility Baudelaire, Rimbaud, Nerval, Lautréamont, later Mallarmé demonstrated toward a general public in their work is really directed at something more significant: the words and poems they had to reshape, the more general dimensions of language and communication.

The twentieth-century stress on the criminal mind and the criminal act, often portrayed wittily or positively, is not an advocacy of criminality, but the

* That leap in dance is "against nature," not integral to it, and it recalls Baudelaire's stress on Dandyism, Huysmans' on the artificial, Mallarmé's on dimensions of silence. We can, if we wish, view Modernism as successive acts of hostility against nature which stretch our sense of nature.

need to find anomalies or marginal creatures in society that are analogous to the artist's sense of himself as a Modernist. This is, of course, an intense romantic role he has chosen to play, part of that continuous line of development between romanticism and the avant-garde, what some critics have called the disease of romanticism. That emphasis on the criminal and the romantic outlaw is part of the need to stress or advertise the self, as if the world were born with the artist. Therefore, we find that intense interest in experience for itself, by extension an interest that disdains society in favor of the one who rejects it.

The conventions of the avant-garde are not disregard for order, but a reordering of seeming disorder. Within the avant-garde, we find conventions, attitudes, procedures. Poggioli describes such attributes as antiauthority, nihilism, antagonism, even infantilism. These are also close to the qualities of Modernism as Ortega y Gasset described them, with his characterization of the movement as "the dehumanization of art." But if we start with Apollinaire's "antitradition," or Rimbaud's "sacred disorder," or Jarry's "laws governing the exception," we see Modernism not as a threat to humanity or existing order but as the establishment of alternate modes of perception.

Modern art's so-called nihilism is less interested in denying the past than in redirecting the future. Marinetti's *futurismo* before the First World War was perhaps less important for its art and poetry—however significant some of the painting became—than for its location at the crossroads of the avant-garde. It caught a moment of order when machine and artist met, on the eve of the war, itself a watershed for Western culture. Apollinaire picked up the significance of the moment by parodying it, in 1913, in *L'Antitradition futuriste*, where he saw it as a phenomenon using art to suppress history. But *futurismo* was only a stage of Modernism, however well located, an instant of trembling order. Before the turn of the century, an analogous avant-garde, Alfred Jarry's 'pataphysics, had stood for a philosophy or art of exceptional things, of metaphysical or imaginary solutions. Italo Calvino, a contemporary Italian fictionist, is a wizard of such philosophies, both futuristic and 'pataphysical. Marinetti, hailing the downfall of museums, libraries, and academies, debasing all forms of authority, caught the moment; but the moment was the staple of Modernism well before his appearance, and it is something we must see as positive: Nietzschean ironic negation turned into matter for art.

Wherever we locate Modernism, whatever the city, whoever the forerunners, however we define the nature of the secession involved, one constant is that conversion of different kinds of energy into what appears to be disorder, but which is in reality a higher, more intense kind of order. Even in a political context, where Modernism seems misplaced, it is possible to see such a movement as having a positive nature. In another era, Shelley viewed the poet as "the unacknowledged legislator of the world." There is egomania here, a self-serving but, also, profound statement about the nature of the imagination and its uses. The poet in Shelley's terms is a prophet; not distant, indeed, from the sense in which Carlyle, who would arrive from a different end of the political spectrum, perceived him. As prophet, the poet is an elitist, a natural leader by way of his language, a person who sees into the future where change is continual. As a "legislator," he will set down rules for the future, and in his embodiment as a prophet of change he is a Modernist. Shelley sought to use poetry as a force for amelioration; he did not foresee that the poet as prophet, whether Baudelaire

or Rimbaud in the earliest stages of Modernism, would remove language from the arena and marketplace in order to vaunt self and spirit. For Shelley, poetry "enlarges the circumference of the imagination," a phrase that indicates the poet is a moral man dedicated to openness and change. In this respect, the poet is at the edge, always ready to embrace the new so as to transform it into liberal doctrines of renewal.

Shelley's use of the poet in this context is almost indistinguishable from our sense of the poet-artist as avant-gardeist. In his careful rendering of the history of the word "avant-garde," Matei Calinescu has discovered a usage as early as 1794, a periodical named *L'Avant-garde de l'armée des Pyrenées-orientales*, devoted to revolutionary rhetoric. Here, avant-garde in its military usage joins with a political context, and, by indirection, with a literary one. The French socialist Saint-Simon saw the poet-artist in the avant-garde as a leader who must fulfill a social role, clearly part of that context in which Shelley viewed the poet. For Saint-Simon, the artist is part of an elite devoted to the overthrow of an elitist government. Once his mission is completed, he will partake of a political/social utopia, the final stage of a kind of pre-Marxist dialectic.

This idealistic aspect of the avant-garde and of the poet's role in it has, obviously, been dissipated with time; but Modernist artists did reach for an absolute of sorts created through their art. They may have lost the sense of political mission, but through language they foresaw a "verbal utopia," or an aural one, or one of arrangement/color/light. Sociopolitical change gave way to expressions of self and to observations of phenomena that serve no direct function: Modernist art floats free of teleology. In that respect the earlier romantic function of art, whether in Shelley or Saint-Simon, vanishes. But that larger and more profound sense of the poet-artist as legislator and prophet, as elitist, will remain. Baudelaire's debasement, Rimbaud's "drunkenness," Mallarmé's disdain for the commonplaces of words, his captian floating free of destiny (in "A Throw of the Dice Will Never Abolish Chance") are all aspects of the earlier romantic vision of the artist. Once Modernism had become a movement, the advent of cubism in the early part of the new century was nothing less than the legislators of art redefining the very relationship between nature and man. The abstract movement that followed reordered nature and purged man. There is a profound renewal of forms through new conceptions of God: replacing an earth made by God is a world of redefined objects, wholeness broken into planes and forms in order to be regrouped by man's imagination.

That desire to remake images and objects is the positive side of Modernism; not at all Ortega y Gasset's dehumanization, but an effort to gain a different kind of visual-aural control over life. Once more, Baudelaire lies at the crossroads—Laius debased and awaiting his slayer. Baudelaire came readily by the military use of avant-garde, having a general as his stepfather; but it is a role he altered even while assuming it. Baudelaire, like Shelley, saw the poet as a prophet, but leading into dimensions of imagination: that is, away from General Aupick and into areas that he hoped were anathema to this considerable and successful man. That Baudelairean imagination is a labyrinth, in which only the poet sees correspondences. If Shelley perceived the poet as soaring upward, a god, Baudelaire defined him as exploring the nether regions, liberation in spleen. Shelley's poet personifies freedom and Baudelaire's enslavement, trying to break free like Laocoön or Michelangelo's prisoners.

The mission is passed on to the Modern era: poet as prophet, artist as leader, but caught in coils the average man is only dimly aware of. Although suffering and self-inflicted pain would diminish as Modernism established its cells, the poet—later painter and composer—struggles to break free, prophesies downfall, even apocalypse, and defines himself through the "death" of the old order. Nietzsche in the 1880s, a time when extreme lucidity preceded his madness, stands in the same relationship to development of the Modern movement that Baudelaire stood thirty years earlier. Nietzsche's prose-poems, those dithyrambic odes, are his "evil flowers." His splenetic explosions seem to range further than Baudelaire's, but actually cover much of the same ground: man as free to grovel, man as the highest form which debases itself, man as gaining stature through ironic negation, man as overcoming his deficiencies through acts of self-liberation. Nietzsche's *Übermensch* is Baudelairean man overcoming spleen. *

Perhaps the sole figure who represented Shelley's original mission for the poet was Rimbaud, a strange embodiment of the idea of the legislator. But for Rimbaud, the artistic and political merged with each other: a radical and nonconformist in both areas, a man sensitive to the Paris Commune in 1871 as well as prophetic and radical in his poetic mission. Rimbaud understood—although how profoundly we cannot say—that avant-garde art is a social/political statement. Ultimately, later Modernists came to believe and accommodate this. In that sense of the avant-garde, politics is not left or right. Politics as manifest in a Modernist work is beyond any social derivative; it depends on linguistic or other forms of manipulation and derives from a meeting of words and form. Rimbaud recognized that the avant-garde is the politics of the new. His vowels and their colors suggest how disordered we become when synesthesia rules, although he demonstrates that such disorder is a state for a new kind of as yet unperceived order. The "drunken boat," foreshadowing Mallarmé's "A Throw of the Dice," is Rimbaud's image of the disordered imagination seeking the new, which is yet another kind of order.

As Modernist art became more intense in its seeming disorder, it obviously ran up against traditional notions of time and space: in cubism, in the Joycean stream, in Yeats's and Rilke's manipulation of images, in Pound's theory of imagism, in serial music, in Proust's inner journey. In nearly all of these art objects or related theories, time flows from an irrational source: whether conscious, unconscious, or pre(sub)conscious. Yet irrational does not mean uncontrolled. The Bergsonian flux may offer a quasi-philosophical idea that appears to support disorder, but no artistic creation can survive in that atmosphere. The artist's compulsion is always to create order, and even Dada, as we shall see, is not quite the random phenomenon its supporters spoke of.

Those who attack the avant-garde (followers of Ortega y Gasset's "dehumanizing" factor) or its fashionableness (critics whose roots are traditional) see it as "against"; when, in reality, it is more interested in forming an independent style. *What it defines is not what it is as the result of being against anything else, but the matter of itself.* I spoke above of languages as the innovative elements

* For the reader who senses Kierkegaardian Dread and Dostoevskian suffering in the immediate background, a distinction must be made. Both Dread and suffering, respectively, preceded an illumination or a revelation, a leap into some association with an external force (God, love, the freedom that leads to faith). For Nietzsche and the Modernists, that leap was among internal elements; externals were foreclosed.

of Modernism, languages as varietals. Style is part of that: the avant-garde often seems to lack content because it is a style, the nature of which, whatever it is, is the content. Popular and social critics are disturbed; but then so are totalitarian governments. A major avant-garde movement flourished in Russia just before and after the 1917 Revolution, only to be superseded by so-called production art under Stalin. Once the avant-garde has been absorbed, and that is inevitable at any given time, its language or style has been overdefined, parodied, or reduced. What is absorbed is no longer a vanguard, only a semblance.

Modern was not even a response to a culture of crisis, and surely not an art reacting to disaster. The roots of Modernism lie well below such political and social upheaval. The sense of dissolution appears to offer great opportunities for art, but we must say that the social/political crises of Modern's formative years were owing to a consciousness of disruption and breakup well before such a phenomenon occurred. Viennese Secession before the turn of the century responded to no overt disaster, but it did react, as we can see with hindsight, to the widening rifts in the Austro-Hungarian Empire. Within historical contexts, Secession represented the cultural disruption that would occur later in the political sphere. But once we say that, we must add that while Modernism found the seams and faults that cause political earthquakes, it strained to move outside history.

EXAMPLES: AXEL, SILENCES, MALLARMÉ

One work, possibly, illustrates a meeting of several aspects of Modernism. It was cited by Edmund Wilson in his ground-breaking study *Axel's Castle*, the title based on Philippe Auguste Villiers de l'Isle-Adam's *Axel*, published in the review *Jeune France* in five segments, November 1885–June 1886. (Before his death in 1889, Villiers revised the text of *Axel* as he corrected proof for the book publication, which occurred posthumously, in 1890.) *Axel* reaches back into nearly everything that was shaping Modernism to that point, a time when Moréas would publish *Un Manifeste littéraire*, his manifesto on symbolism, declaring: "Enemy of explanation, or declamation, of false sensibility, of objective description, symbolist poetry tries to clothe the Idea in a palpable form, which, nevertheless, is not an end in itself, but which, while serving to express the Idea, remains subject to it." He adds that symbolic art never goes "to the conception of the Idea in itself," so that pictures of nature, men's actions, objects are not present for their own sake, "but as simple appearances destined to represent their esoteric affinities with primordial Ideas."

Behind this pretentious prose is the same sharp recognition of where Modernism was heading that we find in *Axel*. *Axel*, a dramatic prose-poem, was performed in Paris on April 6, 1894, with background music by Alexandre Georges; this performance had been preceded by two others earlier in the year (February 26 and 27). Performed with music, *Axel* thus gains affinities with, among others, Maeterlinck's *Pelléas et Mélisande* (1892), another dramatic prose-poem that lent itself to many musical versions, Debussy's being the most famous; also, with Ibsen's *Peer Gynt* and its music by Grieg. None of this is strange since *Axel* is in the larger tradition of Wagner's Ring Cycle and his *Tristan und Isolde*; the first an obsession with a treasure, the ring; the second with a destructive love

that punishes as much as it liberates. Part Four of *Axel* contain sections called "Renunciation," first the renunciation of God's love, then of a solitary existence.

Axel reverberates with avant-garde references. While it seems to nourish itself on elements of Shakespeare's *Hamlet*, it is more closely associated with contemporary versions of the Hamlet idea: Laforgue's, perhaps,* but especially Mallarmé's *Igitur*, Vigny's *Chatterton*, Lautréamont's *Maldoror*, Baudelaire's persona in *Paris Spleen*. In all is that destructive striving after the impossible, life on the edge of satanic cults.

The major influence on Axel is Rosicrucian doctrines expounded by his master, Janus; but while Janus can look two ways and choose the one of rejection, Axel is not so readily disposed. His two ways associate Gold and Love, not renunciation of them as Janus advises. Axel is connected to everything that will doom him. Unlike the Byronic hero, whom he superficially resembles, he must find the way in which he can destroy himself. His father, the Count of Auersperg, has been entrusted with a huge fortune, the very basis of the German economy, which must be kept from the invading Napoleonic armies. The Count is ordered to whisk the treasure away by the governors of the Treasury, so that, unknown to him, they can themselves raid it as their own. He takes his task solemnly and decides to secrete the hoard in the Black Forest near his own castle, in an underground keep, where it lies hidden until *Axel* opens, "around 1828." The treasure goes well beyond money, consisting of jewels, gold pieces, ornaments, a king's ransom, such as we associate with Solomon and Sheba. His deed accomplished, the Count dies, shot, under strange circumstances, so that it appears to his son he was assassinated in order to keep him and the men who helped him silent.

Axel grows up under the shadow of the treasure, whose precise location he does not know. Only an old servant, Zacharias, knows the full story, but even he cannot find the treasure, which lies in a vast cavern entered through a trick opening between boulders. The treasure is now that buried element whose mere memory will change the course of events, like the Rhine gold and the ring. Axel is indoctrinated by Janus, that master of Rosicrucian and other esoteric doctrines, and the young man, now in his mid-twenties, chooses celibacy. He protects his solitude by enclosing himself in the ancestral castle set deep in the Black Forest and guarded by an army of sympathetic retainers, laborers, farmers. He is, in effect, the leader of this army, used for defense of his castle and isolation. Interred in the castle, he makes his life approximate the treasure buried deep in its cavern.

But well before we encounter Axel, we meet a young woman who will parallel him in later episodes, Sara the novitiate. Sara, whose wealthy properties the Abbess covets, is about to be married to Jesus in the sacred ceremony that will make her a nun. Not only wealthy but beautiful, Eve Sara Emmanuèle de Maupers has been subject to harsh privation and mortification so as to discipline her spirit. Yet there remains, apparently, a residue of "self" which the Abbess

* Laforgue's *Hamlet* appeared in 1886, the same year as *Axel*, as part of a group called *Moralités légendaires*. The Laforgue creation is a Pierrot figure, not Villiers's morbid young man; but it, too, lent itself to music, by Darius Milhaud, in a 1939 production by Jean-Louis Barrault. However different Villiers's and Laforgue's young men are, both are trapped by a woman. Laforgue is insistent on Ophelia as a courtesan who sets out to ensnare Hamlet, analogous in a broad sense to Sara and Axel. Also, both young women foreshadow the "destructive female" who will become dominant in the 1890s.

insists on subjecting to the laws of Church and faith. For us, Sara remains unknown: a cowled, deferential figure, an Eve before the Fall; she radiates force not only through her beauty but by way of a self that refuses to be silenced. She goes along with the service that will make her a nun until she is asked the key question: "Do you accept the Light, the Hope, and the Life?" and her response is a grave, very distinct, "very gentle" No. The No derives from a maiden refusing to allow even God to enter her. Sara manages to escape the abbey. Entrances, exits, positioning will form the key symbolism of *Axel*.

When the scene shifts to Axel's castle, we enter a forest redoubt that is as well protected from forcible entry as Sara's maiden retreat. The castle has no entrance unless Axel wills it; and the treasure lying nearby has no entrance unless one can find the secret coordinates, known only to the dead Count. The castle has overtones of the Garden, an Edenesque place, the hut refuge that lies deep as an archetypal experience. Axel has obsessively provided for his solitude so that no interruption can occur, not only to castle life but to the entire territory held by his ancestors. The sole guest is his cousin, the Commander; the only inhabitants of the castle are old warriors, servants, a young page, Ukko. Axel has surrounded himself with those who will provide mirror images. In the wings waiting for his crucial scene with the master of the castle is Janus.

The dramatic form of the narrative—with stage directions preceding each scene and then with spoken lines—allows for a blending of elements: visual, aural mise-en-scène; plus the music, which accompanied the 1894 performance. The effects when we move into Axel's episodes are synesthetic, and the castle as an enclosure strongly suggests the tradition of Gothic. The melancholy young man recalls Byronic wanderers; the young novitiate at the abbey suggests a woman trapped in a de Sade novel; the deceit that lies behind the Commander's exchanges with Axel summons up a dispossessed Garden. Axel may be Adam, his creator's name, and Sara is Eve, her own first name; but it is a Garden trammeled by man, an atmosphere heavy with the Fall. In another way, the castle is like the ship conveying Isolde and Tristan to Cornwall just before the love potion takes effect and they are carried to their mad love, their Fall.

Axel recognizes that the Commander is deceiving him and covets the treasure for himself. He challenges him to a duel, but, before they fight, Axel dismisses every worldly premise of his avaricious cousin. It is a foregone conclusion that Axel will kill the Commander in the duel, but before he does it is necessary to disembowel him verbally. Axel's long speeches, his first in the dramatic offering, are mainly arguments for isolation, separation, solitude in his impregnable fortress. To every counterargument of the Commander's, he offers the loyalty of those close to him who balance the perfidy of the state. Dignity lies in isolation and silence. He disdains the buried treasure as unworthy of someone who desires "silence in the world." He considers himself "the Old Man of the Forest," a descendant of "the Old Man of the Mountains" in Middle Eastern mythology. He is a king who has refused to act as king, a leader who refuses to lead. On the edge of power, he has rejected it. His doubts are associated not with the uses of power but with preserving the integrity of his father's memory and being himself worthy of that memory, all the while denying the outside world and its marketplace vulgarities. We have, in Axel's words, an emblem of Modernism.

We are now prepared for Axel's induction into the Rosicrucian Order,

represented by Master Janus. But precisely as Sara has renounced the Church, so he renounces Janus's request to deny avarice, self, passion, desire, in order "to subdue through detachment." Janus counters forcefully by arguing for man's freedom, and it is a curious freedom, much more connected to ideas implicit in Modernism than that freedom suggested by later existentialists. Janus: "Who, then, is free—the man who can choose? No, he alone is free who, having opted *forever*—thus no longer able to fail—is no longer driven to hesitate. Freedom, in fact, is but deliverance. To complain about the absence of danger is to acknowledge the possibility of slavery. . . ." Freedom is not choice, but deliverance, the cutting edge of Kierkegaardian dread.

The new offers its own design. Axel objects, arguing that all things return to their cause, that whatever he decides, "the flame, remembering its nature, will strain toward the Heavens." Janus is not finished, however, and counters that the universe Axel wants to embrace exists only at the back of his mind, that he can never see it fully, "nor know it, nor even perceive one single point of it as that mysterious point must be in its reality." Conquer desire and isolate oneself: there lies deliverance. "Do you," he asks, "accept the Light, the Hope, and the Life?" "No," responds Axel, and with that, he and Sara are yoked by their common renunciation. Like Tristan and Isolde after the love potion, the lovers are destined for each other, doomed by love.

Part Four is called "The World of Passion: Ordeal by Gold and Love." Sara has discovered the cavern with the treasure, and when she sights Axel, she shoots him, wounding him slightly, while she herself suffers a negligible dagger wound. Both are bleeding, surrounded by vast, heaping treasure; both are beautiful and young, inhabiting a dispossessed Garden scene. They have had numerous choices and yet have not discovered deliverance. Sara has rejected the world represented by the Church's teachings, marriage with Jesus, a life of renunciation. Axel has renounced something even more mystical, that life of solitude and meditation offered by Master Janus. But these extremes merely disguise the several other possibilities. Axel scornfully rejects the Commander's vision of a social/political world in which he, Axel, could be a king of kings, supported by the riches of Midas. Axel disdains this world as the most hollow of all, and, although he utters his famous line much later to Sara, about letting our servants live for us, the statement fits in the context of the Commander's offer. The latter's suggestion is so ugly in its dimensions—that is, to enter the world—that it ends in the duel and the Commander's death.

Sara, too, has had the opportunity to live off her family's wealth and properties, but these prove meaningless to her and she signs them over to the abbey while rejecting what it offers. She, also, rejects life within the world, while simultaneously rejecting renunciation of the world. Thus, the two are headed for another dimension, another spatial and temporal area, where their union will carry them to poetry, art, creation; into an area of love where abstraction, not bodily satisfaction, lives. The debt to *Tristan* is clear, but also to *The Flying Dutchman* and, obviously, to the Ring Cycle. Axel is a version of Siegfried and Sara of Brunnhilde, although both disdain Wagner's vulgar stress on redemption. Wagner updated presents abstracted love without religious connotations, a *Parsifal* without the grail. Having chosen not to consummate their love in normal fashion, as two highly endowed and favored young people, Axel and Sara opt for a higher end. Axel has killed the Commander and rejected

Janus as well as the wealth of the cavern. Sara has entombed the Archdeacon. Their final scene is a *Liebestod*, lacking only Wagner's music.

The music, however, is replaced by a rose, the Rosicrucian rose, which has been a guide to Sara and emblematic of her destiny, a beauty to be plucked. The lovers pass through several stages, leaning toward each other, virginal, and yet fearful of destroying their virginity with an earthly mistake; so desirous of each other that only consummation, of some sort, can satisfy the yearning. Sex, however, would be a taint on everything they believe in. Axel argues that "we have consumed the future. All the realities, what would they be tomorrow, compared with the mirages we have just lived?" Keatsian "unknown pleasures" replace known. The earth has itself "become the Illusion." To live on would define us as no better than our servants. One desires oceans, not drops. The ideal moment has arrived for the exultant couple; they must hold it, for to try to reshape it day by day would pervert it. Their love is an artwork, perfect as it is. As long as they avoid consummation, their love is beyond time and space, a kind of Byzantium of passion. Like Romeo and Juliet, they die by poison, while beyond, life hums and buzzes, reality reduced to marketplace existence.

Although not quintessential Modern, *Axel* is clearly a departure and a crossroads. It came at a critical time when avant-gardeism was defining itself as culturally distinct from its military significance. Caught as *Axel* is between novelistic narrative and dramatic representation, the *mixture of forms* suggests what would become the focus of the new.* The use not only of treasure and caves but of alternate forms of living, in enclosures and isolated redoubts, indicates a renewal of Baudelaire's correspondences; and its exploration of Rosicrucian and other theosophical matters demonstrates its strong antirational pull. Further, the suicide of the lovers foreshadows that rejection of the world, that embrace of a higher reality, that would become such a strong attraction in Modernism. Withal, Villiers prefigures the Rilke injunction to stretch between extremes as a way of deliverance. If we jump eras, we can see something like John Cage's book *Silence* in a direct line from Villiers, however tortured the route. Silence was to be an essential ingredient of Modernism, the furthest extreme.

The silences we associate with the *symbolistes* were suggested by the first wave of Modernists before being turned into an imperative by the second: Proust, Kafka, Rilke, Yeats, Eliot, Schoenberg, Berg, the cubists and abstractionists. What occurred is the denial of sound as routine communication and, instead, its transformation into physical quanta, or bits. Much of the resistance to Modernism comes from those who cannot tolerate the silences and who, therefore, identify voicelessness with boredom or lack of inventiveness. The entire nature of invention underwent transformation in order to suggest silences, not massed

* Such mixtures come at the epitome of Modern and would be perfectly represented by the Diaghilev Ballet Russe performances in 1909 through 1913, with Bakst decor, Nijinsky dance, Fokine choreography, and Stravinsky music. The climax would be Stravinsky's *Le Sacre du printemps*. But another perfect blending would come with *Parade*, a collaboration among Cocteau, Erik Satie, and Picasso. These ballet performances were really new forms of opera, although still categorized as ballet, with dance replacing the usual function of voice—but becoming in its own right an abstracted form of voice. That is, Nijinsky was an instinctive "singer," turning what were often linear roles into meaningful voices by virtue of bodily movements; and a new kind of stage form was born, not the usual ballet nor the usual opera, but such a blending of elements that a new term is required. A parallel movement for that "blending" occurred with Stanislavski's Moscow Art and Popular Theater, founded in 1898, in which "scenic truth" founded on a "spiritual technique" evoked its own voice.

noise or voice. Gustav Mahler's music is usually described as the final stage of Wagner—and, therefore, as hovering on the edge of the new, but not quite Modern—yet Wagner was himself the great innovator of silence in music. He was *there*, silent, waiting for the audience to forsake traditional sound. The idea of the leitmotif is based on near silences building into eventual voices; but before we arrive at those voices, we experience, in the main, more silence than noise. Wagner prefigures *Le Sacre* by keeping most of the sound muted until massed voices create a wall between silences of previous segments and evocation of the present.

In painting, cubism serves a similar function. To transform aspects of reality into geometric forms or into planes cutting the canvas into segments, each of which must be experienced in its own right, is to break up totalities into fragments; and then to insist on the receiver's recreating those fragments into wholes, or else settling for fragments. But the great themes are silenced. The heroic age has vanished; the history of mankind is severed from his present experience. Cubism moves ahistorically, another way of saying it removes itself from previous noises and voices, into its own kind of voice, a silencing of the past. Heroic painting passed in impressionism, then almost disappeared in Cézanne and Van Gogh, and finally was annihilated in cubism and abstraction, in progressive stages of silence. Expressionism appears to present a larger voice, especially in its strong colors, but its subjects are part of that silence of the new; mouths full of aborted shrieks, bodies contorted into silent protest. In one of his few statements about art, Edvard Munch evoked silence: "A work of art can come only from the interior of man. / Art is the form of the image formed from the nerves, heart, brain and eye of man. / Nature is not only what is visible to the eye—it also shows the inner images of the soul—the images on the back side of the eyes." Munch's brand of expressionism comes very close to what Apollinaire would call "Orphic Cubism," structures that derive not from the visual sphere but from the artist; so that, in both, object is silenced in favor of subject.

That massing of voices and sounds in order to create silence was an inevitable consequence of the transformation of all experience into aestheticism, in which, to return to Munch, art is "like a crystal" with a soul and "the power to shine forth." By that process, matter becomes ahistorical, and the expected sounds of the past and present can be transmuted, like base metal into gold, and then reintroduced as absence or negation of sound. Yeats's Byzantium poems represent this aspect of the Modern movement: the desire to escape from history, the need to redefine oneself in some disembodied form, the new identity occurring where "A starlit or a moonlit dome disdains. . . . The fury and the mire of human beings." The ideal form is "Hades' bobbin bound in mummy cloth" with "A mouth that has no moisture and no breath," a shape that augurs the faint line between "death-in-life and life-in-death." Modern thrives on that edge.

Prefiguring this stress on absences was Hugo von Hofmannsthal's point that aesthetics had entered a new phase; no longer the ornamentation of a bourgeois society, aesthetics had become its own response to the pluralism and absorptive qualities of that bourgeois world. He described that larger world as basing itself on *das Gleitende*, a word that suggests skating, sliding, slipping; characterized by constant movement in which all is uncertain, nothing solid. Since all is fluid, reason, unable to comprehend the nature of many realities, must itself become encumbered. Even earlier, Hofmannsthal tried to define Modern as having dual

components: "Die Analysis des Lebens und die Flucht aus dem Leben," the analysis of life [reflection, mirroring] and flight from life [fantasy, dreams]. He goes on: Modern "ist die Zergliederung einer Laune"; Modern is the analysis of a mood. To be modern, one succumbs to "jede Offenbarung des Schönen," to every revelation of beauty. One surrenders to colors, metaphors, images, allegories, intense silences.

Best known, perhaps, as Richard Strauss's librettist, Hofmannsthal is often more prescient in his advice than in his work; and nowhere more than in his "Letter of Lord Chandos" did he focus on the problems of Modern and Modernism, with particular reference to voices and silences. Hofmannsthal's essay is concerned with the problematics of language: with the absence of suitable voices to express fragmentation and atomization. Chandos is a not so distant descendant of Villiers's Axel, and his advice is something Axel could have given if he had found suitable language for existence outside his castle and beyond his *Liebestod* with Sara. Hofmannsthal fears that even aestheticism will be unable to replace that disunity which has resulted from social breakup. Abstractions, concepts, ideas all have little function in this new society, and even the language of aesthetics is inadequate for expression. His pessimism is real, since in previous eras of collapse and crisis, he was able to discover forms of language that shored up the ruins. Now the ruins, as Rilke, Yeats, and Eliot would demonstrate, have swollen over the shore. Confronted by the true loss of history, Hofmannsthal panics at the idea we have nothing to replace it with, not even a voice.

Silence, however, is more than aesthetic response to fragmentation, more than an artistic reaction to the loss of historical process.* Silence is a valid response to the very elements that made Modern possible: the onslaught of new knowledge that forced rethinking in every field and which, inevitably, forced a reciprocal arrangement with the arts, both as reflection of other realities and as response in its own languages. The advent of artistic Modernism and its separation from its military connotations into forms of aestheticism coincided with the new knowledge: Darwin in evolution, Mendel in genetics, Faraday, Maxwell, Planck, and Einstein in physics, Lyell earlier in geology, Helmholtz in thermodynamics, Frazer in anthropology; even the formation of the new fields of sociology, social anthropology, criminology, psychoanalysis. Freud was, of course, crucial, but possibly less obvious was the radical transformation of psychological thought that would have occurred even without Freud and which quickened through the 1880s and 1890s, eventually working into Freud and into the period artists. When we speak of Modern's languages, we must, to be complete, speak of several kinds of language, varied voices.

If we take these parallel developments into account, each with its own voice, we see the arts as reciprocating with languages whose furthest dimensions are silence. The reach into *die nackte Seele*, the naked soul, was the way of Modernism, and the "naked soul" required muted voices. This is not to suggest muted voices lack intensity or thrust. On the contrary, what the Modernists

* Edmund Husserl's response in philosophical thought ran parallel to what was occurring in aesthetics. His phenomenology, in which consciousness and objects are intimately associated, was, as we shall see, a key element in avant-garde impressionism and, by implication, in the language of silence. In Husserlian "reductionism," pure consciousness would be pure silence. Such ideas carried later to Heidegger's "oblivion" and numerous theories of forgetfulness and memory (Bergson, Proust, Blanchot, Joyce).

discovered was that silence—and here Mallarmé is our archetypal early Modernist—could be as intense as noise. The minimalism that Stravinsky introduced into his earliest ballet music, and which often disconcerted even his supporters, replaced decibels with pauses, crashing chords with muted sound. Silence was a new form of ecstasy. It could be as sensual and passionate as music that yearned. One reason Le Sacre du printemps was such a scandal in its Paris premiere, with Nijinsky's choreography of stylized gestures, was that both Stravinsky and Nijinsky exploited the silences between ecstasies; sensation came by way of radical contrast. And while Stravinsky seemed in the very forefront of the new, he was, in part, applying Mallarmé's and Wagner's notation to the twentieth century.

That stress upon silence is, as I have already suggested, part of the Modern artist's need to define himself as outside history. The setting of oneself "beyond" owed its tradition to romanticism, and especially to the development of the sense of the artist—in Baudelaire, Poe, Rimbaud, and others—as a man who felt cursed. If we momentarily move ahead to the later 1910s, Dada was, perhaps, the furthest expression of the artist moving well beyond his society, community, and civilization toward areas that were, even for him, undefined and yet palpitating with silences. Dada is the ultimate blow to an ordered, stable culture, now made so disordered, so unstable, so uncertain by the First World War. Dada exposed all the illusions of stability, and Tristan Tzara's cutout or collage poems represented not only a mockery of art but a new art based on cultural insanity.

It is not at all surprising that Dada—as against surrealism, whose development was anti-Dada, constructionist as against Dada's deconstructionism—should have developed in Zurich, that bastion of Western order. The time was the war, the place Zurich, and the combination of order and disorder is itself synesthetic. Tzara, Hugo Ball, Richard Huelsenbeck, Arp, Marcel Janco, Giacometti (whose career overlapped several movements), Mme Arp, a little later Max Ernst, Karl Schwitters were all involved in that brief movement which was the perfect embodiment of Modernism and the source of its demise. Dada, a word with many connotations (baby talk or an obsession in French, an affirmation in Slav), was a positive expression of life, of the élan vital made popular by Bergson's philosophy. It incorporated silence into its assault on the senses of a bourgeois society, not to subdue feeling but to liberate it. Unlike Kafka, whose silences become moments of death, valleys of anomie and abulia, the Dadaists used silences as contrast, so that vitality could be more expressive. Yet, notwithstanding its incursion into negative voices, Dada is a last gasp idea. Despite its show of life, its contrast between silence and raucous voices, it is a dancing and playing while the game is already up.

Opposed to German expressionism, which the Dadaists saw as messianic, even redemptive, the latter put all their faith in process alone, without any belief in the redeeming power of social/political revolution or even change. Alteration was not amelioration. If Bauhaus was an expression of German "Seele," then Dada would bring it all down, not in the name of replacement but of process alone. It would be life without form, substance, or order; the very opposite of Bauhaus, which sold out to industrial society even while attacking it. The romantic derivation of Dada is apparent, but less apparent is how much it denied consciousness, how it attempted to put Husserl's and Freud's internality into art forms. It found seams in all dynamic psychologies, crevices in the area between

will and decision, and it mined the preconscious and unconscious, as Nietzsche's ultimate Dionysiac experience. But for all its energy, Dada was a danse macabre, the end of Western history in the name of a process of silencing that could last only a very few years. It developed into our quintessential avant-garde: both its dangers and its achievements. Nijinsky's abstract dance movements choreographed where Dada was heading.

We return to Hofmannsthal's "Chandos Letter," in which he reveals that the sense of community he once felt has disintegrated and even language is no longer a language. Those social supports had dissolved—as Conrad had already discovered in the Congo—and one was thrust into a Modern life, willingly or not. There is, implicitly, a very significant point here: even those who continued in an ordered, disciplined life and who opposed everything associated with Modernism had been drawn into it, were living it out. This was, chiefly, the consequence of language itself, which could no longer define what we meant. Social discourse and literary discourse, once thought to be continuous, were disjunctive, and the result was silence.*

Forms of discourse may earlier have been disjunctive, as Mallarmé recognized, but society and culture moved along as if these elements were continuous. Mallarmé, however, did locate the disjunction and called it *ptyx*. *Ptyx* was so meaningful for the poet *because* it meant nothing. It prefigured Dada collages and randomness, its meaninglessness pregnant with potentiality and possibility. It was the ultimate contingency in a society that consciously denied contingency in favor of structure and form. *Ptyx* was a deliverance from denotative meaning into possibility; through it one could enter a world of randomness and chance. John Cage's music in our own age is an attempt to capture *ptyx*, especially in his piano piece for silence.

In *his* silences, his deconstruction of language, his quieting of voices, Mallarmé did not denude the world. On the contrary, he prepared it for those great depths that would arise from Freud's dream interpretation, his theory of the libido, his plumbing of pre- and unconscious; from work in physics that moved toward ever smaller particles; from refinement of scientific techniques toward minuscule elements as arbiters of our existence. In these areas, the big bang comes only after we have penetrated deeper into silence.

Mallarmé's *ptyx* mocks language in order to redeem it in some undefined way. It clears away debris, takes us back to primitivism. It enabled the Dadaists of a later generation to start all over again, and it encouraged pre-Dadaists such as Alfred Jarry.† Dada's drugs and dreams, its synesthetic media effects, its

* Those who argue that the word has been displaced by other media (lamented by Marcuse, exalted by McLuhan) should have recognized that, historically, everything in Modernism nourished that disappearance. The avant-garde stress on silence began well before film and television influenced the printed word. The displacement of print is part of a long development of rapidly changing avant-gardes that favored voices over words, languages over sentences.

† The coiner of the "science of 'pataphysics," Jarry saw in *ptyx* not only an idea but a place. In his "The Isle of Ptyx," from the *Exploits and Opinions of Doctor Faustoll, Pataphysician*, Jarry describes *ptyx* as an island fashioned from a priceless stone that is hot, not cold, to the touch. When man walks on it, he encounters "the substance of the universe," instead of "the accident of things." Mallarmé wrote his *ptyx* sonnet (see page 34) in 1868 and then revised it for later publication, in 1887, entitling it "La Nuit" and finally having it appear untitled. In his brief explanation of the unrevised poem, Mallarmé stressed its "emptiness," saying that the content was of a vacant room at night and calling it "un sonnet nul," nothing. But like so much else in Mallarmé, the sonnet is about the making of a poem, the search for meaning, the creation of an "island" of language.

calligrams and disjunctive images and broken metaphors were all efforts to achieve *ptyx* in the plastic arts as well as in language. The Cocteau *Parade*, bringing together Picasso and Satie, was a visual and aural experience picking up not only from the Diaghilev productions but from a long tradition of Mallarméan deconstruction of language and sound. André Breton's numerous manifestoes and pronouncements reinforced, from the surrealist viewpoint, what we are saying about Dada. For even while Breton argued against Dada, for its exaltation of chaos, and defended his own sense of *le hasard objectif*, his territory overlaps with what we are defining here. Dada may be pure *hasard*, surrealism may be *le hasard objectif*, Dada may dispense with objects, surrealism may stress associations among objects, Dada may reduce, surrealism may construct, Dada may emphasize the loss of integrity, surrealism may stress mind and imagination; but, withal, *ptyx* lies behind both, its implications immense.

Ses purs ongles très haut dédiant leur onyx,
L'Angoisse, ce minuit, soutient, lampadophore,
Maint rêve vespéral brulé par le Phénix

Que ne recueille pas de cinéraire amphore
Sur les crédences, au salon vide: nul ptyx
Aboli bibelot d'inanité sonore,
(Car le Maître est allé puiser des pleurs au Styx
Avec ce seul objet dont le Néant s'honore).
Mais proche la croisée au nord vacante, un or
Agonise selon peut-être le décor
Des licornes ruant du feu contre une nixe,
Elle, defunte nue en le miroir, encore

Que, dans l'oubli fermé par le cadre, se fixe
De Scintillations sitôt le septuor.

Her pure nails very high dedicating their onyx,
Anguish, this midnight, upholds the lampbearer
Many vesperal dreams by the Phoenix burnt

That are not gathered up in the funeral urn
On the credences, in the empty room; no ptyx,
Abolished bibelot of sounding inanity,
(For the Master is gone to draw tears from the Styx
With the sole object which Nothingness honours).
But near the window void Northwards, a gold
Dies down composing perhaps a decor
Of unicorns kicking sparks at a nixey [watersprite],
She, nude and defunct in the mirror, while yet
In the oblivion closed by the frame there appears
Of scintillations at once the septet.

(translated by Roger Fry)

Silence, also absence, prevails, not as nil, not as denial of life, but as an alternate life, such as we find later in Kafka's sensate animals. In the latter, burrows and holes and underground tunnels are the topographical equivalents of states of mind; not negatives, but forms of existence with their own time and space. So, too, *ptyx*, caught between Phoenix and Styx, between resurrection and Hades, reigns. *Ptyx* is, in another guise, simply a further role for the roll of the dice, which permits, for the moment, the infinitude that silence and absence suggest.

◆ ◆ ◆

By way of such silence, we can arrive through another gate at the dangers of Modern, where crisis and catastrophe are imminent in every conflict, where so much is transition that at any given moment the center collapses. This play of silence and its parallel—absence—makes for intense extremes, affirmation and deflation, creation and deconstruction. At this meeting point, between minuscule and infinitude (a Mallarmé horizon, perhaps), Matthew Arnold's hopeful sense of "Modern," in "On the Modern Element in Literature," no longer obtains. For Arnold, the word suggested a quality of mind, a matter of mental repose, a kind of imaginative confidence, the utilization of reason and judgment. Yet these are the very qualities modern Modern eschews; not, as Lionel Trilling says, in order to vaunt the qualities of an anticivilization, or to demonstrate a distaste for culture, but as a truly alternative civilization of rapid change. "Modern," in our terms, is the way we live now. Modernism is not denial, but culture, and its novelty is what we have become, aurally, visually, vocally.

Strindberg, whose "spiritual autobiographies" in the 1880s and 1890s plumbed Modern before it became modish, prefaced his A Dream Play (1902) with an appropriate sense of the new theater as well as the new Modern:

> In this dream play, as in his former dream play To Damascus, the Author has sought to reproduce the disconnected but apparently logical form of a dream. Anything can happen; everything is possible and probable [Mallarmé's *ptyx*]. Time and space do not exist; on a slight groundwork of reality, imagination spins and weaves new patterns made up of memories, experiences, unfettered fancies, absurdities and improvisations.

He adds that the characters split, double, and multiply; they "evaporate, crystallise, scatter and converge." Between the stage events and the audience lies a mind or an authorial persona which also became so necessary in narrative fiction and spiritual autobiography. Such use of a mind that floats in the ether between event and receiver is an uncanny foreshadowing of Einstein's physical universe, at the mercy of relativity despite the accuracy of measuring tools. Uncertainty, on the stage or in the universe, rules. The "single consciousness," Strindberg says, holds sway, another way of saying that history has ended and the indeterminacy of the avant-garde has triumphed.

In the Preface to Miss Julie (in 1888, on the edge of Modern), Strindberg speaks of collapsing past and present, so that his characters live in "a period of transition." "My souls (or characters) are conglomerates, made up of past and present stages of civilisation, scraps of humanity, torn-off pieces of Sunday clothing, turned into rags—all patched together as is the human soul itself." The evocation of Baudelaire, and especially Paris Spleen, is startling. The remarks coincided with Strindberg's wanderings, so that, as in Joyce, his "exile" fitted into his sense of culture.

In his plays, Strindberg offers a potpourri of characters, actions, and staging devices, asserting he has borrowed from "impressionistic painting its asymmetry, its quality of abruptness," so as to strengthen the illusion. He wants to give the audience the "chance to guess at things," which locates him in the area of possibility suggested by *ptyx* and achieved by silence. There is, here, in this discontinuity and fragmentation, some Wagner and not a little that led into such

disparate areas as the Nijinsky "silent" ballets and the new music and poetry, based as much on intervals as on sound.

Another reason we must stress silence generally is that it is close to a culture of artificiality. One Viennese critic called the period a culture of *nervenkunst*, in which Modernism is an "art of the nerves," surely a term that derives from intensification of work in neurology and psychology. Freud and this critic, Hermann Bahr, here join; the year is 1894, and it is not yet possible to see what Modern will become. *Nervenkunst* is not only an internal phenomenon, deep within which only a physician or psychologist can probe. It is, in traditional terms, an artifice: not a society, community, or civilization but an art dependent on "strings." It assumes the negation of nature, an urban culture where "nerves" are constantly in play; an individuality, a self-enclosed art or culture; an art that will become centripetal, not centrifugal, moving into the irrational and mysterious. It assumes, finally, not only artifice and self-consciousness but the extremes of emotionality, since nerves, hysteria, and "running on" were all associated.

This still incohoate sense of Modern and Modernism would be associated, further, with decadence. The Viennese critic and watchdog of decadence, Karl Kraus, in his early years of *Die Fackel (The Torch)*, flayed everything, Modern and traditional values, as decadent. Old Vienna as well as New Vienna was his territory; "Old" being *fin de siècle*, "New" being *junge, junge Wien, Jugendstil*. Hoping to purify language and, by means of language, culture, Kraus refused to entertain the new or its silences. He offered the torch to burn out impurities, and he became, however against his intentions, another aspect of Modernism: its dedication to defiance, its bad manners, its commitment to purity.

JEWS AND OTHER SOLUTIONS

Since Modern and Modernism have been profoundly connected with nationalism and folk movements—the two settled into conflict almost immediately—they are also profoundly associated with the condition of Jews and what was called "the Jewish question." In nearly every society in which Modern was perceived (rightfully) as threatening authority, as a subverter of stability, Modernism and Jews were linked. The latter were perceived as playing an unusually large role in the development of modern ideas and, by extension, anarchy, political radicalism, socialism, as well as capitalism ("Jewish capitalism"). Anti-Semitic movements, accordingly, were often indistinguishable from anti-Modern movements. Captain Dreyfus, a focal point of nearly every development in European culture in early Modernism, can be viewed as a hostage to Modernism and, by implication, to anarchy and socialism.

Yet, as we shall note throughout this study, the role of Jews in the arts has been exaggerated, not only by anti-Semites who stood to profit by such exaggeration, but by present-day critics who vaunt Jewish contributions by selecting the more obvious Jewish figures. In reality, the forerunners of the Modern movement were, with some large exceptions, not Jews, although this is not to minimize the role that Jews did play. While some of the most significant figures were Jewish—Freud, Bergson, Durkheim, Schoenberg (a Christian convert), Mahler (a Christian convert), Proust (by half), later Modigliani, Kafka, Witt-

genstein—most others were not: Nietzsche, Darwin, Wagner, Frazer, Kierke-gaard, Baudelaire, Mallarmé, the other French *symboliste* poets.* The use of statistics and percentages that show a disproportionate number of Jews in Mod-ernism is misleading,† since it is almost entirely a subjective statistic, dependent on not only what one means by the arts, but, primarily, what one means by a Jew. Is an assimilated Jew, intermarried, who plans to let his children intermarry, whose parents or grandparents for convenience have converted to Christianity, who thinks of himself as a German or French nationalist, who identifies with German or French aspirations, who has rejected Zionism, still a Jew? Is it race or practice? How many generations of nonpractice does it take to eliminate Jewishness, if that is the individual's intention? Is Jewishness what a person is considered or what he considers himself? If the latter, then self-definition preempts labeling. In point of fact, only anti-Semitism kept many Jews aware of their background.

The effort to stress the Jewish role in the development of Modernism, whether as a matter of pride or as a way of demonstrating the Jewish threat to the state, is to use Jews as Jews; even when, as in Germany and France, they considered themselves nationals of a particular state, had converted to Christi-anity (for whatever reasons), and intermarried. Jews who did not practice Judaism and were not Zionists are often singled out as part of a Jewish statistic.

Jews are so vital in any discussion of Modernism not because their numbers dominated the movement—and surely not in the earlier formative years—but be-cause the opposition to Modernism identified whatever it hated with Jews. Thus, many who were not Jews were identified by anti-Semites as Jews. Whether present or absent, the Jew became central. Sartre saw the paradox: ". . . the anti-Semite is in the unhappy position of having a vital need for the very enemy he wishes to destroy." Otto Lueger, the mayor of Vienna, was succinct: "Wer Jude ist bestimme ich"—I determine who a Jew is. In post-Secession Vienna, the Christian Socialists cited Klimt and Franz Wickhoff (a supporter of Klimt's avant-garde paintings) as Jews, not as a racial identification but as a way of equating Modernism and Jewish-ness as analogous poisons. It was during this time that Gustav Mahler, a Christian convert, found it impossible to continue as director of the Vienna State Opera. Schoenberg had already left Vienna for Berlin (1901). Cézanne and Paul Cassirer (a prominent art dealer) were called part of "Dreckkunst," shit art; and with that bracketing with a Jew, Cézanne was tainted.

This was a consistent idea and an unvarying image, whether in Vienna, Munich, Berlin, Paris, or, more sedately, in London. We are familiar with Viennese, German, and French anti-Semitism, but Bloomsbury attitudes toward

* Or, to use Peter Gay's categories: "The whole sizable and brilliant catalogue of Impressionist, Post-Impressionist, Expressionist, and abstract artists between 1870 and 1914 contains only two Jewish names, Camille Pisarro and Amadeo Modigliani." Added to that: "We remember that none of Germany's true artistic rebels—Kirchner, Marc, Klee, Beckmann—was a Jew, and that the greatest of them all, Nolde, was a Nazi." As Max Liebermann, the leader of the Berlin Secession, would discover, there was no such thing as a Jewish German, only a German Jew.

† In his excellent study of Bismarck and his financial supporter, Bleichröder (*Gold and Iron*), Fritz Stern cites some statistics: "In 1881, Berlin Jews made up 4.8 percent of the population, .4 percent of the civil servants, 8.6 percent of its writers and journalists, 25.8 percent of those engaged in the money market, and 46 percent of its wholesalers, retailers, and shippers. In many cities in Silesia, Jews constituted about 4 percent of the population and paid more than 20 percent of the taxes. . . . by the mid-1880s, nearly 10 percent of all students enrolled at Prussian universities were Jewish—or seven times their proportionate number in the population."

Jews, while less virulent and more associated with class or caste than with race or religion, were also intertwined pejoratively with ideas of Modern.

The way into Modernism for all such societies was through Mammon, the materialistic God who threatened traditional values and was actively anti-Christian. In the popular image, Jews knew the way to Mammon's heart. Thus, Swift's contrast in an earlier time between spider and bee becomes a contest between a Mammonistic spider, associated with Moderns, and an artisan bee, connected with traditional values of self-sufficiency and social responsibility. Intermixed, in the later development of industrialization, commerce, and Mammon, will be the Jew. Marx, born from a long line of rabbis, but the son of a Jewish convert, was virulently anti-Semitic because he could equate haggling, which is to say Mammon, with Jews, and by extirpating both he could cleanse society. Fritz Stern notes that he called Ferdinand Lassalle, the distinguished German socialist, "a Jewish nigger." One way to locate Marxism in central European history is to see Marx as attempting to cleanse the area of both "haggling" and the people who made it possible.

That "Jewish nigger," as we shall see, is intimately a part of Modern and Modernism, distant as racism, caste hatred, and the converted Jew's loathing of the Jew, especially the Eastern European Jew, seem to be from the main theme. All roads—from Mammon to Jew, from support of nationalistic movements to fear of subversion, from desire for "clean progress" to detestation of antiauthority—lead back to Modern: a catalyst for everything hateful as well as everything inventive and progressive. Because "the Jewish question" is so intertwined with all of these issues, Jews appear to dominate, when, in point of fact, they opposed Modernism far more than they supported or invented it.

Withal, by 1885, the avant-garde, Modern, and Modernism were on the threshold. While anti-Semites kicked their Jews and anti-Modernists feared their avant-garde, all the isolated elements of Modernism were preparing themselves to become a movement. It all depended on one's point of view how one interpreted that "rough beast slouching toward Bethlehem."

The final word on this vast subject is yet to be written, but the exchange between Arnold Schoenberg and Wassily Kandinsky provides an ironic coda. Although the two had carried on an extraordinarily warm correspondence, and had met occasionally, the atmosphere suddenly became poisoned by Kandinsky's alleged anti-Semitism. While the record is not completely clear, it appears Alma Mahler-Werfel, then married to Walter Gropius, had told Schoenberg that "even a Kandinsky sees only evil in the actions of Jews and in their evil actions only the Jewishness. . . ." This, in any event, was what Schoenberg wrote to the painter on April 19, 1923, the year of Hitler's Putsch against Weimar. Kandinsky replied immediately, separating Schoenberg as an artist and a person from the "Jewish problem" (his words). In language that has ominous overtones, he speaks of a "sickness which can be cured," by which he seems to indicate the lump of Jews from which he excludes Schoenberg. "You have," he writes, "a frightful picture of the 'Kandinsky of today': I reject you as a Jew, but nevertheless I write you a good letter and assure you that I would be so glad to have you here in order to work together!"

Schoenberg had much earlier converted to Protestantism, but with typical pride was beginning to reassert his Jewishness in the face of intense anti-Semitism in Weimar Germany. His response to Kandinsky was both touching and pro-

phetic, and it severed both the correspondence and friendship. He begins by asking the painter if he should tell each person on the street whether he is one of the Jews "that Kandinsky and some others make an exception of." He says he cannot be rejected as a Jew. "Did I ever offer myself to you? Do you think that someone like myself lets himself be rejected?" He specifies that Aryans (the term that doomed European Jews) are judged by Goethe, Schopenhauer, and others, whereas Jews are not measured by Mahler, Altenberg, Schoenberg. When Jews do their work as businessmen, they are attacked not as businessmen, but as Jews. "And a Kandinsky will join in that sort of thing?"

Schoenberg then splits the painter into the Kandinsky he once knew and the "Kandinsky of today," a brilliant dissection that suggests the schizoid dimension of the entire situation. He closes by saying: "And if you would take it on yourself to convey greetings from me to my former friend Kandinsky." The present-day painter is now dead to Schoenberg. The exchange is itself a microcosm of the much larger social and historical issue; the key words are "even a Kandinsky." For if the well-born, liberal, cosmopolitan Russian shares in anti-Semitic feeling, then what hope was there for those with "hooked noses" (Schoenberg's words)?

◈ Chapter Two ◈
Toward 1885: Thresholds

IN HIS STUDY of self-destruction, *Le Suicide*, in 1897 Emile Durkheim introduced factors that curiously equate the early development of Modernism with modern suicide. Two elements, egoism and anomie, have a peculiar affinity for each other in suicide. In this interraction of egoism and anomie we find an individual who has some tendency to nonregulation, for "since he is detached from society, it has not sufficient hold upon him to regulate him." Inasmuch as he is separated from a larger body of feeling and thought, he senses a gap within himself, and often "the life of the passions languishes, because he is wholly introverted and not attracted by the world outside." He may, in his isolation, play both roles concurrently—the egoist and the sufferer from anomie—so that he is filled with hollows. To compensate or to fill the gap, he seeks "new sensations. . . but he also wearies sooner [than the man of passionate temperament] and this weariness casts him back upon himself, thus re-enforcing his original melancholy." Here we have what Durkheim calls mixed suicides, "where depression alternates with agitation, dream with action, transports of desire with reflective sadness."

The alternating phases of mania and depression that Durkheim outlines are descriptive also of Modern and Modernism, even before 1885. The idea of mixed suicides is particularly appropriate, where depression feeds agitation, agitation creates weariness, and weariness leads into irresolvable conflicts of desire and melancholy. A good deal of the mixed suicide effect, we can suggest, was the result of the "uselessness" Modernists conceived of as their function. An example of uselessness is that quality Sartre found in Baudelaire's *choice* not to function in expected ways. Lack of power, inner and outer, lowers expectation; desire for power, literary or otherwise, increases sensibilities, raises aspirations, and leads to that mixture of triumph and defeat that makes suicide seductive. To decide to be useless or functionless is, as Sartre says, to choose "without waiting for orders, notice, or advice." The loss of purpose that drove Baudelaire so close to the edge of suicide was also the very element that brought him to recognize Modernism, that nourished his sense of himself as, somehow, new.

40

We see that loss of function, so closely allied to suicide, as a metaphor for Modern. We can proceed from there.

Modernism is synonymous with freedom, however well the latter is submerged in discontinuous elements or technical experimentation. For Baudelaire, freedom or functionlessness meant hiding and disguising. He foresaw, in Sartre's words, that he was condemned to justify his existence "all alone, and endlessly eluding himself, slipping through his own fingers, withdrawn in contemplation and, at the same time, dragged out of himself in an unending pursuit." Baudelaire's horror of life "was a horror of the natural, a horror of the spontaneous exuberance of nature, a horror, too, of the soft living limbo of consciousness." To maintain this "horror"—not Kurtz's horror at the satanic depths in man, but the horror that nourishes a creative gift—Baudelaire had to shift between contemplation and enjoyment, that is, between *spleen* and *volupté*.

Since such a shifting and balancing is impossible to resolve, he was able to transform *spleen* into a perverse kind of enjoyment and *volupté* into an abnormal kind of self-torture. It was necessary for Baudelaire to preserve for himself those abuses (Jeanne Duval's presence; hatred of his stepfather, General Aupick; consciousness of self-abasement) so that he could continue to rebel. He needed the existing order not to transcend it, but "to rise up against it." In that alternating between extremes, in that rising up against what must defeat him, in that sinking into both *spleen* and *volupté*, Baudelaire achieved the inner freedom that defined him as person and artist. We are, with this, defining a paradigm for Modern.

Baudelaire saw that the natural and the spontaneous, existing on surfaces, were all ways of accepting authority. It was necessary, instead, to redefine one's autonomy by way of self-expression. What we must trace in the development of Modern, whether literary or political, social, musical, artistic Modern, is that set of coordinates in which different conceptions of the self emerged in different languages. The self would surface in unpredictable ways as a means of countering power and authority that also developed in unpredictable ways. The expression of whatever lay inside was the agent by which one could, by 1885, deal with a multitude of new elements: emergence of the modern state, loss of sustaining religion, growth of egalitarian ideas, radically shifting ideas of Nature and natural man, sense of exhaustion in older artistic forms, the parallel development of new ideas in dynamic psychology that redefined man in terms of himself and his relationships.

In these shiftings of power and self, roles changed. This sense of role playing expanded into the entire society, continuing up to the present time. These shifts permeated Europe, spreading perhaps sooner and more rapidly in France, which tolerated extremes despite political repression. As patriarchal and patrimonial societies quaked and withered, new roles had to be assumed. Property, blood lines, traditional values counted less, or else entirely vanished; the vacuum was filled by those who redefined themselves: by traditional males, in part, but also by artists, creators, criminals—marginal men and women all. Their *artistes milieux* became new centers of power, in conflict with remnants of tradition.

Power became so diffused—Nietzsche furnishes more insights here than anyone else—that freedom had to be redefined in terms of individual choice of roles. This movement toward what David Riesman and Richard Sennett call autonomy of self was in reality a move toward freedom, functionlessness, an-

archy.* That is, the individual for the first time might cohere as a whole, but he cohered at the expense of community and society. Here we have one of the many paradoxes of the Modern movement: that striving toward individual wholeness based on freedom, choice, liberation and expression of self; and its reciprocal, an ever growing anarchy in social/political terms, which can be contained only by regimentation and prohibition of Modern art. Modernism must be asocial in formal terms, apolitical in its anarchy, individualistic in its insistence on choice. The later embrace of Marxism by so many 1920s and 1930s Modern writers, like the embrace of Fascism by the French, was a way of balancing the fear of anarchy. At one end was total freedom (unachievable) and at the other end total control (also unachievable), both of which stood in for God, state, paternalism. The outgrowth of so many books on crowd or group behavior, of which Le Bon's *The Crowd* and Georges Sorel's *Reflections on Violence* are best known, derived from this sense of the autonomous, anarchic, controlless individual.

As Baudelaire and a long line of *symbolistes* influenced by him recognized, the quality of Modernism is measured by its ability to confront death: consider it, take its measurement, respond to its demands, rebel against its finality with forms of life that often themselves approach death. Since the avant-garde thrives on liberation and functionlessness, it is often a meditation on death; if not precisely that, then on life with the sense of death never too distant. This should not surprise us, since Modern has replaced a religious idea with an aesthetic one, both aware of existence as matter between long sleep. Yet like all ideologies, Modern has had difficulty dealing with death. Philippe Aries has remarked that we lack a vocabulary of death at present—for mourning, burial, sacrifices—and, therefore, Modern has had to provide a substitute for that. One substitute has been a vocabulary of self and the senses, a vocabulary that teeters toward death even while denying its finality. †

The death of God has led not to exaltation, but to serious strategies for dealing with his death, deployments that, in ultimate ways, still consider God a major factor. Those strategies involve exalting the world as "nihil" or "nil," "nada," nothing; and yet proceeding as if that "nil" can be overcome through

* Much later, Benedetto Croce would develop the idea of Modern as the movement toward ever greater individual liberty, as part of a dialectic of authority and a desire for liberation. But Croce saw this tension in terms of the creation of a free society: history as "the story [historia] of liberty." He broadened the idea of Modern to include the society and state, which in early Modernism were anathema to the free development of the individual artist

† Gerard de Nerval's "El Desdichado," the Wretch or Unfortunate One, is such a poem about dying and death, an 1853 lament for the self as it plunges toward its death. Not surprisingly, T. S. Eliot appropriated the second line for *The Waste Land*. "I am the dark one, the disconsolate widower, / The Prince of Aquitania whose tower has been torn down." We might also cite Tristan Corbière's "Paris Nocturne," with a Parisian necropolis serving as a metaphor for the self. Nerval laments the death of his star, his sole star, a reference apparently to the minor actress Jenny Colon, a relationship in his life analogous to Baudelaire's with Jeanne Duval. But the point of the poem is not her death, or even the ideal or chivalric overtones that permeate the poem, but the transference of her death to the poet: thus the chivalric tradition becomes transformed from object to subject, from loved one to the self suffering the loss. The poem is saturated with death images: his death, his Melancholia, his grave, his razed tower (an actual razing as well as a metaphoric phallic decline), his journey across the Acheron, his assumption of the role of Orpheus in the Underworld. The consequence is that the sun is "*le soleil noir*," a *black sun* emblazoned on his star-studded lute, a black sun deriving from Dürer's Melancholia. The very soul of nature is changed to accommodate his loss, his sense of dying; he experiences a reversal of whatever is considered natural. This 1853 poem is not, of course, isolated, for it prefigures Baudelaire's volume in 1857, Rimbaud's descents into hell, Lautréamont's *Maldoror* sequences.

self, senses, sensations, yearning for absolutes within. The denial of external gods has led not to denial of self, but to the opening of the floodgates of self. The individual is exalted even as modern life has denied the individual. The year 1885 would become a juncture of such elements.

This turning of "soul" and "spirit" into human desire and need, into a rising and falling self, is part of the transformation of culture that created a Modern era. The extremes are self and apocalypse, and one of the glories of Modernism is the artist's refusal to reconcile: Modern hangs between irresolvable extremes.

Another way to see this shift, which we will locate in individual authors below, is as a crisis in materialism, a crisis that scientists could no longer account for, since their methods measured it with the very tools that helped create the sense of crisis. As Alfred North Whitehead assures us, materialism had been an adequate explanation for three centuries; but that explanation depended largely on pointing out how things happened, not why. Once the "why" became paramount, materialism faltered, and organic synthesis, with its sense of unknowns, replaced it. At the meeting of two very different kinds of analysis, one objective, one subjective, the crisis was apparent in philosophy and in social and humanistic studies.

How did humanists, for example, deal with the discovery that the electron is not a continuous phenomenon in space; that, instead, it "appears at a series of discrete positions in space which it occupies for successive durations of time"? The idea of continuous existence is irretrievably upset, and in its place we find a view of life based on discontinuous bits. Spatial discontinuity underlies all explanations of natural and, by extension, human experience. Material existence, obviously, is no longer the same. Further, the stress on unknowns of organic synthesis parallels the rise of dynamic psychology, with its diverse and mysterious explorations of un—, sub—, or preconsciousness. Explanations become part of an infinitude that, in religious terms, is being denied. While social Darwinism pulls toward a deterministic and, therefore, a bounded view of man, organic synthesis and dynamic psychology pull in the opposite direction, toward a view in which man has limitless potential. Seams deepen, and Modern stumbles into them.

A little earlier, Marx tried to fill the seam. His description of the "alienated worker," distanced from his work, is not that different in theory from Baudelaire's idea of the marginal artist, what he perceived in himself and in Poe. Marx's attack on such alienation—in which, as he says in "Paris Manuscripts," the worker loses his sense of reality—is part of a negation of systems. For Baudelaire a similar negation has within it an affirmation, for the alienated artist or poet can function best marginally, some loss of reality for him being part of his artistic definition. Obviously, Marx and Baudelaire part, but their perception of man's role has common ground. Marx sees the worker as a slave, the result of alienation; Baudelaire sees the artist, also, as a doomed slave, but that is the role the artist must play to achieve himself. In Marx, one is doomed by the system; in Baudelaire, the doom leads to a productive curse.

Marx used two German words interchangeably to describe alienation: *Entaüsserung*, meaning dispossession, and *Entfremdung*, signifying estrangement. His usage indicates that while it is man's nature to control himself and his environment, in modern society man's relationship to nature has been disrupted,

the balance overthrown. The cash-nexus, Carlyle's term earlier, relocates man, turns him into an object to serve the money exchange. What was once man's destiny is now invested in things. In this relationship, man is dispossessed, estranged, alienated. Baudelaire's exploration of voids, in which emptiness and absence become a source of value, would be his equivalent, turning Marx's negative sense of dispossession into a positive source of ennui. Within that formulation, Baudelaire saw the Dandy as the man who, confronting estrangement, overcomes it with style; he perceives engulfment and yet expresses uniqueness.

But Baudelaire also recognized that neither the Dandy nor drugs nor dreams can finally overcome alienation. Hashish may convey joy and perception of sorts, but pleasure is undercut by the fact that the paradise is artificially induced. Unable to move toward Marx's social/political explanation, Baudelaire was caught by paradoxes. While Marx sought solutions in alteration of the social order, Baudelaire sought a means for the arist within an existing order. Although in 1848 he had manned the barricades, shouting "We must go and shoot General Aupick," his stepfather, he would look more to the sensibility of Poe than to revolution in the following decade. During the immediate aftermath of the 1848 revolution, when casualties went over 10,000, Baudelaire composed "Une Voyage à Cythère," in which all experience is transformed to him: "Ridicule pendu, tes douleurs sont les miennes!"—"Absurd corpse, your pains are mine." Or: "Je sentis, à l'aspect de tes membres flottants, / Comme un vomissement, remonter vers mes dents / Le long fleuve de fiel des douleurs anciennes";—"At the sight of your floating limbs, I felt, like puke mounting to my teeth, the long spleen-like stream of ancient grief."

By taking on Prometheus's agony, Baudelaire does not broaden the experience, but subjectifies it. This transformation of Baudelaire into a subjective spokesman is borne out by other mid-century works, "Paris Spleen," "Les Chats," Du Vin et du haschish, for example. Here was the point of departure: Marx's sense of dispossession and alienation was no longer applicable to the poet. The route Baudelaire traveled would become, by 1885, the very foundation for Modern; whereas Marx's way, however much in its earlier phases it picked up pieces of the Modern experience, would become by 1885 the enemy of Modernism, part of Social Darwinism, determinism, realism and naturalism—vultures nourishing themselves on the body of Modern. Both had begun with death of fathers (and stepfathers), but while Marx created the ground for new fathers (and by extension new victims), Baudelaire offered a personal process that would lead to creative achievement.

THE NEW UNCONSCIOUSNESS

By 1885, a new consciousness was shaping itself, or, we could say, a new unconsciousness, a substructure of experience that would well up as those developments we associate with Modern and Modernism. The significant element is that such developments were unmeasurable, beyond the statistical ability of scientists, and yet in themselves part of science, an area of knowledge. What Michel Foucault has called "the fundamental codes of a culture" began to be transformed, which means that the languages of the culture altered, along with

its values, hierarchies, priorities. In *Les Mots et les choses* ("Words and Things"), *
Foucault points out that the critical response in a culture arrives when its history
is not one of growing perfection, but one of "conditions of possibility." Our key
figure at the very center of the moment is, of course, Nietzsche. Foucault,
pursuing a different order of things, explains:

> . . . the theory of representation disappears as the universal foundation
> of all possible orders; language as the spontaneous *tabula*, the primary
> grid of things, as an indispensable link between representation and things,
> is eclipsed in its turn; a profound historicity penetrates into the heart of
> things, isolates and defines them in their own coherence, imposes upon
> them the forms of order implied by the continuity of time; . . .

The very network of signs that Foucault and structuralist/semiotic critics have
pointed to alters. Nature is itself trapped in linguistic confusion; to use Foucault's
words, "in the thin layer that holds semiology and hermeneutics one above the
other. . . ." What Foucault claims for *Don Quixote* can be said of Modern in
its inchoate, 1880s developments.

> *Don Quixote* is the first modern work of literature, because in it we see
> the cruel reason of identities and differences make endless sport of signs
> and similitudes; because in it language breaks off its old kinship with
> things and enters into that lonely sovereignty from which it will reappear,
> in its separated state, only as literature; because it marks the point where
> resemblance enters an age which is, from the point of view of resem-
> blance, one of madness and imagination.

At that phase in western culture, similitude and analogy arc no longer the
occasions of knowledge but of error and misjudgment. Knowledge has moved
to areas of real or potential confusion. Ways of perceiving and conceiving are
founded on "games"; comic illusions, satire, visions become ways of knowing.
Things take on meaning not from themselves but from their place in order or
arrangement, from holding on against something else. Resemblances and signs
"have dissolved their former alliance"; and while analogy and similitude are
necessary for corroboration of what is perceived, such analogies and similitudes
are also forms of deception, verging as they do upon the visionary or upon
madness. In this vision of things, which makes *Don Quixote* archetypal, language
becomes so important because it becomes an independent voice. When the
vision is mad or confused as a conscious device, what Lillian Feder refers to as
"madness as a goal," then language must carry the entire burden of commu-
nication. It becomes our one thread with the sanity or "truth" that underlies
illusions, visions, and dreams.

Literature, as we shall see as we approach 1885, is assuming "forms of
language." Language will confer on us our notions of time and space, our idea
of the laws regulating the world; whereas before this shift in perception, our
notions of time and space and our conception of things determined what the
nature of language would be. This is a major shift, equivalent to the tail wagging
the dog. Knowledge, ideas, conceptions, our ordering of the world in temporal

* The English edition was translated as *The Order of Things* to avoid confusion with other
works titled *Words and Things*, but the original French is closer to the idea.

and spatial modes are all dependent, increasingly, on altering modes of language, changing impressions. Modern experiments in this—Mallarmé's concretist poem "A Throw of the Dice Will Never Abolish Chance," as example—reorder perception, or intend to. Mallarmé's linguistic minimalism here is on the same track as Wagner's visual and aural experience in the Ring, or the flattening out of perception in cubism.

Minimalism also foreshadows developments in psychoanalysis, in which words—slips, oneiric languages, verbal forms of pathology—have a different weight; and, as dream words, a different temporal/spatial diminsion. Synesthesia, or the confusion of the senses, is part of this historical process in which words increase their sensory potential even as they lose traditional values. When words are used to describe dreams or to capture images from the unconscious, they are weighted quite differently from language that limns, describes, denotes.

As in everything else, Nietzsche caught the distinction. He asks what is a suitable inspiration for the new man, this drunken reveler, this visionary who is our new modern man: "The involuntariness of image and metaphor is strangest of all; no one longer has any notion of what is an image or a metaphor: everything offers itself as the nearest, most obvious, simplest expression." Old truths are approaching their end, and new truths are not yet visible. Everything old, in its tired language, lacks authenticity, Wagner most of all. The opera *Carmen* is more authentic than Wagner's coarse ideas of redemption. To express oneself in old forms is to embrace "the preachers of death." The Overman is a man of new languages; he is like the bark—a frequent Nietzsche and *symboliste* image—heading into the unknown, where "the great nothing lies" and where world-weariness can be overcome through transcendence. "The time of kings is passed." Modern man deserves no kings unless he can alter his language, his modes of perception of what he is and will be. Man who cannot be part of the process of becoming is contemptible. "I love the great despisers. Man, however, is something that must be overcome."

Modern in 1885 became, in its rudimentary phases, the meeting point of "the great despisers," when man must, somehow, be overcome. This assumption of new languages is a grand journey into unknowns. Failure to transform life becomes forms of death. Jean Moréas, in his 1886 symbolist manifesto, wrote that symbolist poetry is the enemy of explanation, of declamation, of false sensibility, of objective description. It must "clothe the Idea" in a palpable form, but not become subservient to the Idea—a kind of Hegelian journey that defies Hegel. Whatever is manifest in poetry, Moréas insists, is not there for the sake of appearance, but for its "esoteric affinities with primordial Ideas."

Despite its hard surfaces, its impersonal indifference, Modernism has the quality of dream because of its disruption of linear and sequential narrative, its blending of sensory experiences, its addition of color to what was once black and white, its tampering with temporal and spatial expectations. There are displacement and condensation, distortion and exaggeration, even within minimalism. Foucault locates this quality in a pre-Modern age, but its potentiality becomes apparent only in the later nineteenth century: "Thus, European culture is inventing for itself a depth in which what matters is no longer . . . permanent tables with all their possible paths and routes, but great hidden forces developed on the basis of their primitive and inaccessible nucleus, origin, causality, and history. From now on, things will be represented only from the depths of this

density, withdrawn into itself, perhaps blurred and darkened by its obscurity, but bound tightly to themselves, assembled or divided, inescapably grounded by the vigour that is hidden down below, in those depths."

That experience from the depths, however, is not restricted. It is, in fact, infinite, in contradistinction to economic and biological determinism which had, in parallel movements, gripped end-of-the-century Europe. The latter, a deterministic society, offered labor, production, predictable rewards finalized by death; what Modern came to represent subverted labor or production, and introduced into final things the moment of infinity as a substitute for death. While that moment is, as Foucault insists, "doomed to destruction," it does provide moments of revelation that transcend life. Proust is the most obvious example of this experience, of the sensation of the moment; but it had developed, as we have seen, throughout nineteenth-century France, in Baudelaire, Nerval, Rimbaud, Lautréamont, Laforgue, Mallarmé, Jarry, the Frenchified Poe, and others. It was epitomized by the *Liebestod* of Wagner's Isolde, that orgy of sensationalism on the edge between life and death where heightened awareness lay. It was even represented in Russia, by Dostoevski's insistence on those revelatory moments before the epileptic fit strikes, instants that have within them what we would later label "the Proustian moment."

The significance of these moments cannot be overstressed, for they are, in miniature, like images that give a poem its meanings; only here, in both sickness and health, they give modern life its experiential base. For the moment, as in *Tristan und Isolde*, seems to negate life as a whole while isolating an instant of joy and ecstasy. But in point of fact, the moment suggests another order of experience altogether, in which the play of opposites does not negate life so much as exalt it. The moment conveys intense feeling even while separating itself from all contexts. Although the will appears to be denied—in terms of achievement, obligations, responsibilities, labor—there is another will that nourishes itself on such denial. The self gains by way of destroying the self. The ego emerges from the submergence of the ego in another or in an experience. The conscious world of reason and thought (Kant's categories) is eschewed in favor of intuition, which has multiple personalities, as it were.

We can speak, as the dynamic psychologists did, of *polypsychism*, the idea of multiplicity in unity, of depths that lie piled underneath each other as in an archaeological site. The further one digs, the more sites one uncovers, and this becomes a model for the human mind. As Modern develops, these sites become moments of various duration. Freud was of course one benefactor of the theory of polypsychism, whereas earlier forms of psychology—as in Pierre Janet, an extraordinary man in his own right—depended on dipsychism; so that, by analogy, we can say that the moment in Modern has affinities to polypsychism, whereas dipsychism belongs to an earlier way of charting experience.

Although 1885 is our point of departure, it was shaped by several earlier figures, some of whom I have already cited. Baudelaire, Nietzsche, and Mallarmé we cannot stress too heavily, and they will continue to appear in various roles; but Lautréamont and Rimbaud are also central. One could argue, in fact, that nearly every aspect of early literary Modernism can be found in these five; for music, we would add Wagner, and for art, the radical break with academic painting that began with the impressionists.

Lautréamont* (Isidore Ducasse) in his *Maldoror* (1868–69) had evoked the world of *polypsychism* through the yoking of discontinuous images and the making of outrageous analogies. Maldoror could be "dawn's evil" (*Mal d'aurore*), but also a "bad gilder" (*dorer*, one who gilds), which is to say, one who combines "making" with "evil." He has broken through all limits and obeys animalistic instincts: rape, murder, disemboweling. He revels in scenes of cruelty and sadism. He roams the world seeking ways to subvert its limitations, so that law, rule, stability are anathema to him. He is the spirit of the deep, and yet achieves a kind of holiness in his Promethean desire to strip away illusions. He addresses the Creator, who sits on a throne "fashioned of human excrement and gold": "For how long will you maintain the decrepit cult of this god who is impervious to your prayers and the generous offerings you proffer him in expiatory holocaust?"

Maldoror is always on the edge of the "gratuitous act," ready to wield the weapon with "grace and elegance" as an instrument of death for another, male or female. When a ship is sinking, he shoots one of the swimming sailors, someone who is moving courageously, wounded, stalwart in his desire to save himself. "What pleasure could I feel at the death of this human being when there were more than a hundred about to present me with the spectacle of their last struggles against the waves once the ship had gone down?"

He chants to the ocean, "Old ocean, great celibate." While the ocean is, indeed, the mass to which Maldoror addresses his chants, these are not sea ditties. His ocean is "azure," which means it is full of ambiguous colors and meanings. He challenges it: "The fear you inspire in them [travelers on it] is such that they respect you. In spite of that, you make their heaviest machines waltz with grace, elegance and ease. You make them leap gymnastically into the sky, and dive marvelously down into the depths of your domain: a circus tumbler would be jealous." The conflict between nature, which is anarchic, and machines, which are masses at nature's mercy, suggests the chief mataphor of Maldoror's sense of life as waves. Such waves are experiences, moments, intuitions, sensations: the entire paraphernalia of Modernism in the making. While the ship is sinking, Lautréamont introduces sharks as the ultimate scythe of death, churning the sea and its flailing men into "an eggless omelette of all the human beings" who hope to save themselves. The shark is the last indignity, the final satanic force in that polypsychismic imagination, turning nature's realm into a creative mass or an "eggless omelette," perhaps our first nonrepresentational canvas.

Every part of *Maldoror*, images as well as chants, is filled with nature's monstrosities, which demonstrate its multiplicity, its limitless configurations as product of a surrealistic mind. Animals grow from human parts; there are deviations from nature's laws; an amphibian chooses to depart from mankind; cannibalism is a common practice, even to the eating of one's mother's arms. Maldoror has divested himself of conscience so as "to sail down the river of . . . [his] destiny, through a growing series of glorious crimes." The Almighty

* The name is an adaptation of Eugène Sue's Lautréamont, in the 1838 novel of that name. A solid forerunner of Lautréamont and his idea of Maldoror comes in the career of Petrus Borel. Borel's *Rhapsodies*, in 1831, and the publication *La Liberté, Journal des Arts* (in 1832), influenced generations of *poètes maudits*. His "Le Petit Cénacle" was one of the first Secession groups, as was its next stage, Les Jeunes France, and, finally, the Bouzingos.

appears before him, disguised as an edible crab, thinking he has gained Maldoror's repentance, but the latter is only feigning and his defiance intensifies. Body parts assume ominous overtones, becoming melodramatic elements: "the vast lips of the vagina of darkness" enfold him; "immense shadowy spermatozoa" take on the "vast spread of their bat's wings obscuring the whole of nature"; Maldoror disembowels a girl and pulls her organs out through her vagina.*

These obscene and ultimate acts disarrange not only vision and perception, but the very organization of the body in nature. There is, of course, a strong Sadean presence in Lautréamont, and not a little of Charles Maturin; but he is more concerned with dissolving and reshaping than he is with purely outrageous crimes. The crime is committed not for pleasure, but for the sake of transformation and multiplicity. People are malused as fodder for Maldoror's sadistic needs, but his aim is to demonstrate reflections of an image-making, multiple mind. He moves toward a solipsistic world, in which he is the ultimate poet or maker, and what he creates is more bizarre than what God accomplished in his six days. Like de Sade, Lautréamont must destroy the idea of the Creator, so that he stands independent of laws; yet he does so not to create a world of perverse pleasure but to demonstrate an ability to reorder nature itself. Himself half man and half beast, tormented by combat between man and God, Maldoror becomes that unearthly element which seems to pervade the whole of Modern, its whiff of satanic disorder. In one of his most compelling transformations, Maldoror is altered to animal and insect; but whereas Kafka's bug feels disgust, Maldoror does not. He considers the return to his former shape to be a misfortune.

This ordering and reordering of the self, and its reflection in a new physical arrangement, is a development of the 1880s. It is part of the lack of completion that will characterize nearly all aspects of Modernism, even when the artwork seems to fill the imagination. Organic fragmentariness is found in every mode, and we can argue it is a political/social idea as well as an artistic one. Socially, we noted it in Durkheim's study of suicide. Politically, it would be based on the following: that as nations adjusted and readjusted their roles in that twilight zone leading, inevitably, toward the first war, all was uncertain even when men seemed to move with certainty. The First World War was potential in the nationalistic movements and revolutions of 1848, a key year, as Baudelaire recognized. Victory of Prussia over Austria in 1866, then over France in 1870–71, consolidation of the German Empire, African colonialism by the major European countries, gradual erosion of English power through expansion of other nations, challenge to English strength in the growth of America, however removed, are all aspects of shaping and reshaping that reverberated intensely in the arts.

But even more, the need to spread into new roles or into positions of power and influence worked reciprocally to convey the sense of incompleteness. As

* In *Diary of the Seducer*, Kierkegaard's persona is less cannibalistic but no less ruthless in *his* desire to reorder nature as an act of ego. He pursues Cordelia (the name is not lost on him) until he becomes her emperor, she his servant. "I am intoxicated," he writes, "with the thought that she is in my power. A pure, innocent femininity, transparent as the sea and as profound, with no clear idea of what love is! Now she is to learn its power. Like a king's daughter who has been raised from the dust to the throne of her forefathers, so shall she be installed in the kingdom where she belongs. But this must happen through me. . . ." Even as he gains control, Kierkegaard must destroy the female image, a precursor not only of Maldoror's disdain but of the woman-hating of Weininger and others in the 1890s: "A man can never be so cruel as a woman. Consult mythologies, fables, folk-tales, and you will find this view confirmed. If there is a description of a natural force whose mercilessness knows no limits, it will always be a feminine nature."

political power increased or diminished, it brought with it the consciousness of vast areas that remained shadowy or undefined, *as if the world which we had thought to be so full was really only a sketch.* This sense of incomplete worlds or individuals that only art can fulfill becomes part of that 1885 milieu. Working along with that sense of the incomplete—Nietzsche is, once again, our best guide here—is the romantic obsession with originality and uniqueness.

The development of what I call spiritual autobiography, that shift in the traditional *Bildungsroman* or apprenticeship-to-life novel, is part of this movement toward originality, individual experience, the desperate need to isolate oneself from community and society. In *Ecce Homo*, which falls at the cultural crossroads, Nietzsche insists that "the truth speaks out of me." That truth is, of course, original, unique. Nietzsche justifies his assumption of such power by saying his truth is *terrible*; he adds that reassessment of all values is his formula, becoming "flesh and genius" in him.

Once lack of completion and the rage for originality at all costs become paramount, we will experience a growing sense of minimalism. In art, fiction, and music, even when fullness of performance is apparent, the underlying scheme or structure is miniaturization. Minimalism, not expansionism, becomes the mode by which size can be suggested; to express human life in smaller units is to reach for Nietzsche's "terrible truth" by way of what is omitted. In one of his brilliant asides, Nietzsche labeled Wagner "our greatest miniaturist in music," a composer who "crowds into the smallest space an infinity of sense and sweetness." With little shifting, this remark could be applied to Proust or Kafka or those postimpressionistic painters on the edge of cubism or to Schoenberg's twelve tones. Here we recognize minimalism as the glory of Modernism, and yet, through Nietzsche's remark, we can see that it began earlier, in Wagner's half shadows, his stress on colors and "the secrecies of dying light." From this, Nietzsche mounts his attack: that Wagner feared, not that his music would be too difficult, but that it might be understood too easily; that "one will *not* find it *difficult enough* to understand."

Minimalism is, of couse, a way of explaining Mallarmé and his extraordinary perception of what the moment would bear in literature. By stressing the absence of the very thing he was describing, Mallarmé led not to the buildup of the object described but to its decreation, its dissolution into elements. From this dissolution, which in Mallarmé we may call the absence of things, we find another key characteristic of Modernism: that fear of recognition, comprehension, familiarization. Robert Adams puts the point succinctly: "All Mallarmé's perception of the carefully chosen, precisely defined objects in his world is haunted by an emptiness, as a result of which perception is a dangerous venture, intricately compounded of memory, distance, misgivings, while expression is inevitable shipwreck at best."

Mallarmé's sense of the moment and of death—every moment is a dying, a movement toward death—gave him a grasp of nothing and nothingness that locates subject as well as object. He was, in effect, defining a new dimension of impressionism. Nothing, ungraspable for most because it balloons up to too much or else squeezes down to too little, is for Mallarmé a measurable commodity. While our senses recoil from defining nothing, even intuiting it, he could make it his standard of measure. All things in his vocabulary are associated with ultimate reductionism; and, therefore, all subject-object relationships—

inaudible conversations, the undertows of language—are negations of energy. For the French poet, all that we associate with energy is counterenergy; all that we associate with nothing is, for him, energy.

The Dandy was such a productive idea for both Baudelaire and, later, Mallarmé because he creates himself out of artificial elements, and in so doing recognizes the death of all styles as, one by one, he discards them. In artificiality, the denial of the real is simultaneously its death and an energy devolving from that death. Dandyism permits the writer or subject to play roles, with each role a negation of previous or analogous ones; each role kills off something, whether reality, expected spatial/temporal relationships, or objects themselves. All routine channels are suppressed in the name of something created, and created energy supersedes whatever it is structured upon, whatever it is potential for. Potency is turned to impotence: world power becomes a sign of weakness; weakness and artifice become signs of strength. Baudelaire and Mallarmé now, Rilke, Kafka, and Proust later, stress how the force of reality can be turned into the weakness of artifice, which then emerges as a new form of strength. In painting, we can follow a similar route in Kandinsky's emergence as an abstractionist.

We recall Flaubert's earlier placement of himself at the beginning of this nothing phase. Flaubert: "What I would like to do, is to write a book on nothing, a book without any exterior support, which would sustain itself by the inner force of its style as the world, without being held up, rides through space, a book which would be almost devoid of subject, or at least in which the subject would be almost invisible, if that were possible." That line of nothing goes straight through to Mallarmé and on to Joyce, whose Stephen Dedalus, in Ulysses, intones: "Dead breaths I living breathe, tread dead dust, devour a urinous offal from all dead." Seeing himself dead, he attempts to be resurrected through art.

Like his predecessors, Baudelaire, Lautréamont, and Rimbaud, Mallarmé would be the poet of necromancy: ever tightening the surface while disordering the invisible elements beneath. Characteristically, "Salut"—as much a greeting as a farewell—begins with an ambiguity, "rien," which means nothing, but whose origin is "thing." "No" turns "thing" into "nothing," which becomes, in its transformational ability, both an introduction and a negation of it. So turns Mallarmé's poem, in which linguistic derivations and ultimate meanings "make" the poem; are not the vehicle of meaning, but meaning. Further, that beginning with "rien" suggests the death principle, part of that Mallarméan vocabulary of abolition, purification, tomb-ifying, absence, nothingness.

We have in these writers and their tradition not only a new perception (often falsely attributed to decadence); but a new structure with its analogies in the physical sciences and in the growth of psychoanalysis and dynamic psychology. This is another way of saying that Baudelaire and Mallarmé—we can include Rimbaud here—found ways of turning the most unlikely phenomena into art objects, or into the potential for art. The process reverses itself from the traditional classic and even romantic one, in which the art object is consciously created; for Baudelaire and Mallarmé will strip mundane things of their reality and reveal roles, disguises, artifice—art. Art now becomes not a product but a process; not the result of resolution, but the "making" of it.

Color for Mallarmé as for the impressionistic and postimpressionistic painters in this movement is based on ever shifting light perceptions, a matter of style

in its largest sense. In *La Dernière Mode* (1874), Mallarmé perceived of color as entrance into a multitudinous world. It has social and ideological overtones; it cuts through all restrictions. Since "color" is a magical presence, it is a form of sexuality and at the same time ethical. Color also becomes the presence of things that are absent: color is defined, really, only by the object so colored, and yet it remains in our mind as something divorced from that object, as an idea or intuition. Certain colors are more insistent on themselves: red as archetypal, since it is associated with blood, and green, because it is part of nature, renewal, the life process. Yet all colors are part of a world of potentiality, contingency; we have an existentialism of color, so to speak. This visual image extends to painting in Van Gogh and Gauguin, and especially in *les Fauves*,* but also to aural experiences in the new orchestral "colors" of Bartok, Stravinsky, and Schoenberg.

The point about color is that its traditional attributes were disrupted, so that color in itself was no longer a form of support for received ideas; as, for example, red and green in academic art. Color was charged and recharged, implicit with meaning which had to be unraveled, as much as a discontinuous narrative or a series of seemingly disconnected images in a poem. None of this is surprising, since language had become a reflection of experience, not of analysis; of sensations, not of philosophical precision. When syntax began to alter—with foreshortening, concision, ambiguities—there was a comparable movement in visual as well as aural languages. Along with forms, color altered; so that flow, stream, the play of areas other than pure consciousness could be accommodated. Familiar places, like the Rouen Cathedral or Van Gogh's farm scenes, are made contingent upon elements other than themselves: not only the eye of the painter, but the way that eye is redirected because of sun, shadows, reflections, time of day, interplay of elements that lie outside the object itself. The latter no longer dominates what the eye or ear experiences.

Such interplays have their equivalent in new narrative devices in fiction, in which a narrator designs for himself a role in his story, thus implanting himself and his tale of events in the seams of a narrative complex. Something comparable occurs in music and in dance, in which certain instruments carry sound, or certain movements define the choreographic line, which had hitherto been partially muted or merely supportive. Part of the tumult over Stravinsky's *Le Sacre* at its first Paris performance was associated with that upsetting of traditional notions of what orchestral instruments should do and traditional dance lines accomplish.

Photography was being developed at this time, in the 1880s, to be a more precise instrument; that is, to reflect a more scientific viewpoint than anything in the arts, especially in painting. The middle class would embrace photography—it was clear-cut, everyone could do it, it preserved one's best image or pose, it was a "moral" act divorced from painterly bohemianism. It was, in brief, the perfect "art" for a technologically oriented society. Photographs told the truth

* So named—"the wild beasts" by the critic Louis Vauxcelles because of their wild and, for him, beastly colors. The group included Matisse, who breathed life into the group, Vlaminck, Rouault, Derain, Marquet, and Henri Rousseau. It was the latter's *Hungry Lion* at the 1905 exhibition of the Salon d'Automne that upset Vauxcelles.

in acceptable ways, whereas the "truth of art" involved passing through many distortions.

Yet photography had another side, which made it, I feel, an even more dangerous enemy of painting and, by implication, literature. Susan Sontag speaks of the discontinuity photography made possible, since a photograph exists separated, an isolated image: "Photography reinforces a nominalist view of social reality as consisting of small units of an apparently infinite number—as the number of photographs that could be taken of anything is unlimited." By presenting a series of photographs, one makes the world become "a series of unrelated, freestanding particles; and history, past and present, a set of anecdotes and *faits divers*. The camera makes reality atomic, manageable, and opaque."

The photograph is so accessible that it changed the way in which one could observe not only history, but the artwork: in painting, for example, one measured the scene or portrait against the shadow of a photograph. As this idea developed after the great advances in photography in the 1840s and 1850s, a literalness would dominate part of the viewing process. Not unusually, naturalism became a powerful element in literature and painting; not surprisingly, Baudelaire developed his theory of the artificial and the Dandy, as well as his idea of making history concrete. He opposed photography and yet embraced it, negated it with the symbolism of artifice, accommodated it with the naturalism of *Paris Spleen*. The very fact that photography is connected to reality, as Sontag says, and that painting is associated with the history of art creates an imbalance in which painting must suffer. Photography can be cited for its scientific precision—and, indeed, in high technology, the camera has become indispensable—whereas on this scale painting loses. In any direct comparison in a developed country, photography becomes the standard by which painting is measured; whereas in the development of Modern art, photographical realism subverts art.

The advent of photography in the early Modern period helped put painting on the run. It was not simply a case of painting being left to abstraction while photography took to realism. On the contrary, photography competed with painting at every stage and forced the painter to move further and further from reality. Thus, the painter had to deal not only with the inner demands of painting and its traditions but with the competitive nature of photography.* In one sense, this became a positive development, since it forced originality; but there was a negative side in that a public became confirmed in its taste for realism, and the more the painter tried to escape the more the public used realism as a standard. Artists took nourishment from their adversary role, but the art of painting became divided. Serious painting subverted realism, sought "truths" beyond the reach of photography, and eschewed a public. In literature, the growth of naturalism and realism parallels developments in photography, with somewhat similar consequences for the Modernist writer.

* In this passage from "Notes of a Painter" (1908), Henri Matisse defends the uniqueness of painting against photographic reproduction: "Expression to my way of thinking does not consist of the passion mirrored upon a human face or betrayed by a violent gesture. The whole arrangement of my picture is expressive. The place occupied by figures or objects, the empty spaces around them, the proportions, everything plays a part. Composition is the art of arranging in a decorative manner the various elements at the painter's disposal for the expression of his feelings. . . . A work of art must be harmonious in its entirety; for superfluous details would, in the mind of the beholder, encroach upon the essential elements."

Modernists know that photography falsified far more than did painting or poetry: that the art of realism, however refined, was a lesser technique; that photography and its precision belonged to the world of tangibles rather than to undiscovered territory. Yet even photography, as Sontag shows, was prey to some of the provincialism that confronted Modernism. For photography was relegated to "realistic art" when it attempted to break from realism into some of the elements we associate with Modernism. Both photography (for its realism) and the avant-garde in art (for its experimentation and singularity) were martyred to less extreme tastes. But whatever the parallelism of their fates, photography and its exponents moved in and out of Modernism, making the role of the avant-garde painter more difficult or more extreme, even when running interference itself as a "new art." Early on in its development, Baudelaire saw photography as "a mortal enemy," but eventually came to perceive it as a liberator. He seemed wrong on both counts. It was not an enemy, but still another phenomenon that the nonrealistic artist had to confront; and it did not liberate, for it created problems for both the enemies and supporters of the avant-garde.

When, eventually, photography became television, the screen image fulfilled that instant access to the real which we find preeminent in photography and which is singularly absent from novel- or poetry-making. With television, the divide becomes great indeed. The moment, whether family, news, social events, becomes so "real" in television that all art forms must gravitate toward realities in order to survive; and those that do not become so inaccessible to the public that avant-gardes come and go without a literate audience even being aware of them. Once television preempts image-making, as it began to do in the 1950s in America, then all art works being created are either enemies of the medium—forming themselves as opposition—or preemptors of its modes of perception. Just as photography, with its two-dimensionality, could erase distinctions in its earlier phases, flattening out realities, so television erases those distinctions that are the substance of art forms. Erasure itself is what pleases an audience, and simplification becomes a norm. Instant access does not become something we must caution against, but something we embrace.

The discussion of photography has taken us far from 1885, but the development of it and its destiny as television should alert us to what it meant in that earlier phase. It came to stand, as we have seen, for a kind of realism that could only goad the Modern artist into more extreme avant-gardes. We find those extremes in the stress upon nothingness, silence, absence and void, boredom, and artificiality; qualities that were a direct response to a world of everything, what realism purported to represent. Void and silence become, in the avant-garde, all; whereas in the realistic mode, everything is already *there*. Robert Adams puts the artist's dilemma wittily: "The nineteenth century is full of ecstatic isolates worshipping neutralities in projections. These projections are made through a third agent, which if it stands close to a projector we call a mask, if in the middle distance seems a screen, and if on the object can be called a guise." Deception and self-deception lie at the center of art-making: strategies for presenting the object, for dissembling the subject, for fudging differences between subject and object.

We can see all of these peculiar developments not only in poetry but in that subgenre I have called "spiritual autobiography," which comes in waves at the turn of the century. But it is in formation well before that time, in Villiers's *Axel*, Lautréamont's *Maldoror*, Rimbaud's *Saison en enfer*, Baudelaire's *Paris Spleen* and *Les Paradis artificiels*, Nerval's *Aurélia*. All of these recall the classical mode of a descent into hell, either literally or figuratively—more often a spiritual descent that evolves into the actual leap. At the crux of the idea and leap is Nietzsche, straddling the 1880s, at his most inventive and poised on the edge of madness: emblematic of several aspects of the Modern movement.* *Paris Spleen* is exemplary of an earlier phase. These are "prose poétique, musicale sans rhythme et sans rime, assez souple et assez heurtée pour s'adapter aux mouvement lyrique de l'âme, aux ondulations de la rêverie, aux soubresauts de la conscience. . . ." All is subconscious: the lyrical impulses of the soul, the undulations of reverie, the jolts (*soubresauts*) or plunges of conscience. All is part of the developing Modern mode: role playing, acting out on a stage, posing, stress on artifice, a radical break with the classical view of art imitating nature, layering of ironies upon ironies, paradoxes upon paradoxes. The poet's persona is a suffering soul that triumphs from its exposure to ridicule. The modern clown is born.

Baudelaire's "Chacun sa Chimère" is a paradigm. The prose-poem begins with an image of "without": a gray sky (an absence of blue), a powdery plain (absence of green or any other color), "sans chemin, sans gazon, sans un chardon, sans une ortie. . . ." No path, no grass or sod, no thistles, no nettles. We have something that is not even a desert but a wasteland beyond wastelands. Here the poet finds several men bent over with great sacks on their backs. This beginning will match a slightly later phase in which Baudelaire assumes the role of the poet as an old clown: without friends, family, or children, degraded by poverty and the public's ingratitude, a "hunger artist."

Yet even within these desolate places and situations, each man needs his chimera, his illusions, his antic disposition. Baudelaire asks one of the men where he is walking to, and the response is he does not know, neither he nor the others. But he and they are "pousses par un invincible besoin de marcher," urged on by some inner need which remains undefinable. What was in Hamlet an assumption of a role becomes in Baudelaire the very way in which life is lived. All men have their chimeras, as essential as nourishment. At the end of the prose-poem, Baudelaire speaks of how "the irresistible Indifference" struck him, and "j'en fus plus lourdement accablé qu'ils ne l'étaient eux-mêmes par leurs écrasantes Chimères," that weight of indifference crushes him more profoundly than the weight of the Chimera. To each his chimera, to each his burden.

Baudelaire weighted down is not simply a sentimentalized or romanticized

* Although several commentators have treated decadence as a separate movement—Richard Gilman and Jean Pierrot, for example—I see it as part of Modernism, one of its several avant-gardes. What is called decadence (Gautier, Verlaine, Huysmans, Wilde, the French Poe, Gustave Moreau and Odilon Redon in painting) characterized a pre-1885 group of writers who later became absorbed into the larger movement of symbolism; but many of these writers differed significantly from mainstream *symbolistes* such as Mallarmé. It is preferable, therefore, to view the so-called decadent movement as a form of avant-gardeism that feeds into Modernism and is, ultimately, dispersed.

outcast, nor is he solely the artist who must live burdened and isolated, the old clown reviled by all.* He is defining a cultural moment: that shift in human awareness of cities, environments, material things, people as subjects and objects, the self-reifying spiritual matters. He is seeking revelations and epiphanies of the "other world," which lies somewhere beyond such Paris scenes. But in seeking this other world, he will be frustrated, for it exists only in the making of it, in the process of trying to locate it; art in this pre-Modernist phase is a becoming. The poet as old clown is the new religious guru of the coming age. Mallarmé's poet-captain recognizes that a throw of the dice will never abolish chance, and, therefore, he cannot rely on happenstance even when he appears to have ultimate power. Power no longer rules. What counts is what one can make of the moment.

JOURNEYS INTO

Related to the moment, to each man with his chimera, and to the void is the invitation to drink, to voyage, to discover. That voyage image in Baudelaire and the generation following him—culminating in Rimbaud's "Le Bateau ivre" and Mallarmé's "Un Coup de Dés"—suggests an aura for Modernism. It is, first of all, an entrance into dreams; then the exploration of undiscovered territory; followed by the descent into the soul, with its concomitant descent into hell. It suggests a search for treasure and, as well, for one's mode of death. It is part of that exposure of the poet, or writer, to a "throw of the dice," which neither abolishes chance nor sanctifies complete anarchy. The voyage, not only for Baudelaire, but for those following, is full of spleen, of "long hearses without drums or music" which drag "in slow file through my soul. . . ." Silence, spleen, void, surface anarchy: all are involved in the voyage syndrome. The voyage's aim is to enter a lotos land and to be "sheltered from the swells," to lie at ease in the "still canals," where the "soul's loneliness" can speak "her sweet and secret native tongue." But the point of the voyage is that such an experience, like that under hashish, is an artificial paradise; it is contrary to the fact, and it can occur only as an oneiric fantasy. The poet addresses himself as "ma soeur," another self, as Prufrock will address himself; so that a divided individual can seek the whole. But it is temporary, and such momentary escapes from "treacherous eyes" can occur only through artificiality.

Rimbaud in his turn firmed up the Baudelairean voyage, made it a matter

* With Baudelaire's death in 1867, the legend began, and it was carried on by both supporters and antagonists. In the immediate years after 1867, an edition of the complete works appeared, including Gautier's appraisal of Les Fleurs. Baudelaire biography became more accurate, and letters were published. Then a series of literary figures began to shape the myth. Paul Bourget in 1881, praised the poet as the most significant writer of the modern era; then Verlaine wrote about Baudelaire in Poètes maudits, published in 1883 in the magazine Lutèce, and in 1884 in book form; followed by Huysmans' devotion in A rebours, where Baudelaire becomes one of Des Esseintes's preferred authors. But those hostile to the poet's reputation and influence also contributed to the legend. Maurice Barrès, the nationalist and racist, explained Baudelaire's reputation as the result of his sensationalism, which in turn sparked Decadence. The Parnassian Théodore de Banville acknowledged Baudelaire's "explosive force" with the younger generation. But the greatest accolade came from Brunetière, the old guard personified, who identified Baudelaire as a "great and disastrous influence on the younger generation in literature. . . ." To this, we must add Mallarmé's devotion and his translations of Poe's poetry, which would recall Baudelaire's of the prose. Mallarmé also wrote one of his greatest poems on Poe, "Le Tombeau d'Edgar Poe," with all tombs leading back not only to Poe but to the man who introduced him into French literature, Baudelaire.

of heroism the poet must experience in order to achieve his craft. His "drunken boat" has classical connotations, of the voyage between Scylla and Charybdis, the journey in which the imagination always has physical coordinates; unlike Baudelaire's voyage, which loses physicality in the dreamlike state. Rimbaud is tougher about the hazards and also about the achievements. Danger is ever present, for the "pine-wood hull" is like a coffin; it is also rudderless, full of "man's lost rule." The boat is anarchic in its tossings, so that it must plunge "into the Poem of the Sea." In this boiling experience, "The bitter reds of love ferment the way!"—but these "bitter reds" derive from a rising sun that stains "suddenly the blueness. . . ." In a sense nature is traduced, but it is also "fermented," or transformed, into another stage; so, too, the poet lurches toward a transformation, fermented by his juices. He lurches, however, always on the edge of anarchy, for he rejects communal support, the waves surging like "herds of insane cattle in assault on the reefs." He can only hope that the legendary three Marys will "force a muzzle on the panting seas!" but short of that, he must respond to pitch and lurch without cessation. The poem is of such deep reverie that it becomes a surrealistic artifact.

"He" is, eventually, a "lost boat in the hair of coves." The hair image, as prominent as voyage images in 1880s literature, becomes a spiderweb of infinite entanglements. It catches, but it also entraps, a suitable metaphor for the adventurous poet seeking his destiny in both anarchy and form. Once back into reality—he no longer can "bath in languors"—the poet fears for the future. He would prefer that his "keel might break and spend . . . [him] in the sea!" He desires "European waters," which are familiar and where he can sail his child's boat on "a black, cold puddle in a scented twilight. . . ." The poet is harbored in childhood memories which are the avant-garde of later years.

The great poem of journey, silence, nothing, and discovery is Mallarmé's "Un Coup de Dés," whose very appearance attempted a blending of the visual and aural arts, a Wagnerian "staging." "L'Abîme blanchi," the whitened abyss, is the name of the material or situation that the artist-captain must control; it is absence, but it is also desperate presence. Although "Un Coup," a combination of surrealism, concretion, late-nineteenth-century pessimism and worship of void, comes in 1897, it culminates Mallarmé's representative mode of the 1880s. Unlikely historical elements shadow it: political nationalism, Bismarckian authoritarianism, Wagnerian visions of art, *symboliste* doctrines, rebellion against all settled forms. In the background, the crushing defeat France suffered in the Franco-Prussian War, followed by the terrible experience of the Paris Commune, led to inevitable recoil from direct political action—Rimbaud is another excellent example here—and resulted in that intense interiority where French writers created the avant-garde of Modernism.

The concrete, staged appearance of "Un Coup" creates an early form of ideogram, in which words (presence) are contrasted to whiteness of page (absence). But more than that, typography creates waves, troughs, descents, ascents, horizons, even constellations, birds, fish. Type and white space suggest sky and water, the boat itself suspended between, with an artist-captain who must struggle against drowning. Mallarmé employed four modes of typeface: large, bold type in capitals; smaller, less bold type, also in capitals; and regular-size type in lowercase. There is, additionally, italicized regular-size type. The large, bold face announces the theme, and at the beginning features NEVER, before be-

coming smaller capitals. NEVER dominates the page on which it appears, centered, surrounded by white space, afloat in absences. NEVER is so appropriate ideogrammatically because its negative meaning (like "rien" in the poem "Salut") contrasts with its powerful presence in the center of the page.

The poem then shifts to LET IT BE, a subjunctive ("Soit"), which takes the form, in the next phrase, of a wing, or a wave from crest to trough. A ship careens from side to side, is tossed and "merges with the first which would grip it / destiny and the winds. . . ." The chief or captain is bereft of his ship as a wave mass flows over it, suffering "legs en la disparition," a disappearing legacy contracted "above his worthless head." A full page of commentary follows, directing us from unknowns down into plummeting madness. This leads into a whiteness, broken only at the bottom by a continuation of the large-type NEVER, now joined by N'ABOLIRA—NEVER WILL ABOLISH. The NEVER is repeated with five pages of commentary, plunging and careening, in between. Several more pages will intervene before we arrive at CHANCE. Thus the major words in bold typeface appear at intervals, as if the sole support the careening, sinking ship and captain will have. When lowercase letters or smaller capitals appear, the typeface itself suggests sinking or sinking into.

After N'ABOLIRA comes another subjunctive, AS IF, in smaller capitals, repeated on the opposite page at the bottom; so that matter hovers between COMME SIS. After the second COMME SI, a "toque of midnight" meets or grazes the "stiffened whiteness" ("blancheur rigide"); a meeting of night, death, sinking, and breaking foam of waves, all engulfing this captain who had expected to control his destiny. The poet-captain is plunged into a stunning series of disordering and disorienting experiences. An extraordinary image of "La lucide et seigneuriale aigrette au front invisible de vertige" (the lucid and lordly aigrette, or heron plume, on the invisible brow of intoxication) confronts the desperate poet-captain. Sights and visions vanish into gloom, falsity, melting—all metaphors of absence or voiding. The captain clasps his last throw, hoping to alter chance, but fearful that the throw—"IT WAS THE NUMBER"—will be squandered, and he will be shipwrecked with no further resource.

The page on which "Number" (masterwork, unique work of art) is mentioned is an area of a succession of contraries: "Even if" dominates, suggesting that whatever "may be" has been canceled by CHANCE, which now appears just below the center of the page in boldface capitals. CHANCE, however, is no better or worse than anything else, part of an indifferent, neutral universe in which "Falls the plume," ready to be buried in the primitive foam. Once again, the poet-captain suffers from a peaking delirium "flétrie" (blighted or withered) by "la neutralité identique du gouffre," the abyss. The turn of the page brings a void, RIEN, followed by eight words huddled in the center of the page, complemented on the facing page by a series of negatives, the contrariness of subjunctives. With that facing word, "du vague," a version of the void appears "in which all reality is dissolved." The final two pages recapitulate, as if a Wagnerian leitmotif, the captain-poet hesitating with his throw of the dice. THE MASTER "hors d'anciens calculs," is reluctant to merge his toss of "l'unique Nombre" with the toss and twist of the ship; for if that fails, he will be no better off than those nuns in another famous shipwreck poem, written in the decade before Mallarmé's. In Hopkins's "The Wreck of the Deutschland," God plays craps with the Deutschland, and a throw of the dice will also make no difference

to the neutrality of the void. For its part, "Un Coup" concludes in a visionary blaze, in the heights of constellations, so "loin qu'un endroit fusionné avec au-delà," far beyond human involvement.

There, in that infinite space, A CONSTELLATION—"froide d'oubli et de désuétude," like the poet-captain isolated, yet counting on "some empty and superior plane"—waits for a "compte total en formation," some final accounting. It watches, doubts, blazes, meditates, this constellation, before it halts at an ultimate point which "le sacre"—sanctifies it; and here "Toute Pensée émet un Coup de Dés," all thought emits a throw of the dice. In this final place, perhaps, a glimmer of light from that constellation will offer help to the poet-captain. All he can hope for is that there is something in that dying, crashing constellation; perhaps consciousness. Since the captain is without any other hope, all his "chance" rides on that final glimmering. In its faint, flickering light, he throws the dice. The poem ends without a period so we are left with the throw of the dice entering the void, man's final hope meeting the absence of an ending. Whether the captain has thrown in vain or whether he has chosen the right moment is left open, period-less.

The void-seeking "Un Coup" caps a phase of early Modernism deeply associated with Mallarmé. Although he published relatively little in the 1870s, his reputation by the 1880s made him a center of avant-gardeism. His les mardis, which began in the early 1880s, became celebrated Tuesdays by 1884 and 1885. Besides Villiers, Verlaine, Moréas, the evenings were attended by Régnier, Ghil, Arthur Symons, then in another wave five years later by Valéry, Gide, Louys, and many minor poets and novelists. Although none of the poets, except Valéry, achieved the significance of Mallarmé, the evenings were nevertheless important for establishing a milieu artiste. Mallarmé was also celebrated for his inclusion in Verlaine's Les Poètes maudits* and Huysmans' A rebours, as well as for many portraits (by Manet and Redon, among others) and paintings suggested by his work (Rodin, Gauguin, Whistler, Morisot). For young writers, the now legendary Rimbaud and the hieratic Mallarmé had outdistanced the giants of the previous age, Hugo, Heredia, Musset, the Parnassians and romanticists. By 1885, Mallarmé was preeminent, with only the memory of Rimbaud's precocity serving as complementary work. In actuality, Rimbaud was a kind of contemporary, with Les Illuminations not appearing until 1886 and Poésies complètes in 1895.

What the two poets had in common, besides their linguistic experimentation, was their sense of the artist's mission. For each, the role, whether the captain's in "Un Coup," the faun's in "L'Après-Midi," Hérodiade's, or Rimbaud's drunken boat, focuses on the artist's act of creation. The product is, in fact, the process; the how of art, not the resolution. What was often mislabeled decadent or fin de siècle exhaustion was concern with the creating, not the created. The mode for both was, seemingly, surface confusion between waking and dreaming or between sanity and insanity or even between reason and emotion; but beneath the confusion is a calculated technique, a precision of language, a dedication to the word as the world. Mallarmé directed his energies toward absences, tombs, hollowed-out elements; Rimbaud devoted his to sensuous experiences, to opening up and out. They would appear in their use of space

* The volume included Corbière, Rimbaud, Desbordes-Valmore, Villiers, and Lelia, with the largest space (twenty-six pages) given over to Rimbaud, sixteen to Villiers, fourteen to Mallarmé.

diametrically opposed, but they are, in fact, related. Space for Mallarmé—
although inner or exhausted—is quite extensive, and for Rimbaud momentous
in its reach. Both are horizon writers, Mallarmé's being inner, Rimbaud's a
yearning for beyond.

With Baudelaire's death in 1867, there is little question the forward move-
ment of early Modernism could have been temporarily halted. Yet Rimbaud's
achievements in the early 1870s—when he was still a teenager—serve as sig-
nificant linkage between Baudelaire and the eighties, when Modernism could
be descried and described. Rimbaud's theories are associated with energies that
went first into the Franco-Prussian War and then into the Commune rebellion
against the glitter and artificiality of the Second Empire. That is, the dissociation
of sensory experience which Rimbaud stressed in his poems and in his poetic
ideas finds its counterpart in the political upheavals France was undergoing.
 At the same time, in 1871, Rimbaud discovered Baudelaire's works, and
at sixteen or seventeen had himself completed an entire cycle of poems, including
"Le Bateau ivre." Even though he still admired the Parnassians and Verlaine—
"un vrai poète"—Rimbaud also knew and embraced Baudelaire's Poe transla-
tions. By 1871, his vision was in the main shaped, with the youthful poet
exploring both consciously and unconsciously a dream world. Consciously, he
could enter a dream journey by way of drugs and alcohol, but unconsciously
he made the trip by way of a new language welling up from secret sources. Very
possibly, Rimbaud misread, or rejected, Baudelaire's ironic entrance into arti-
ficiality; Rimbaud took as gospel the new religion, and identified an artificial
paradise with the real thing. Baudelaire perceived such a paradise as based on
destructive illusions, whereas Rimbaud, more attuned to the truly demonic, set
himself against the dominant culture to the extent that dreams became for him
the "greater reality," an intensification of and alternative to reality.
 In his youthful precocity, he wrote Georges Izambard on May 13, 1871,
that the latter's subjective work will always be "horriblement fadasse," horribly
insipid or mawkish. Rimbaud insists he will be a worker in the new, although
at present he is on strike. While he bides his time for the vision to come, he
writes, ". . . je m'encrapule le plus possible," I immerse myself in vice and
debauchery. From that will come his poetry, for he works to become a voyant.
"Il s'agit d'arriver à l'inconnu par la dérèglement de tous les sens." The sufferings
in deranging oneself are enormous, but one must be strong, so that the poet
can be born: "Je me suis reconnu poète." He adds: "Je est un autre." With this,
the teenager not only announces himself but helps define an era.
 In his presumption, Rimbaud sees himself as a Prometheus of the mind
who penetrates reality as we know it and ravishes celestial fire. As such, the poet
must pass his season in hell, analogous to the tortures Prometheus has suffered
for his gift of fire. He thus pierces lesser reality for the greater. This season in
hell, with its romantic implications, becomes the archetype of the modern
experience: a season in hell, or Verlaine's label, les poètes maudits.
 Rimbaud followed this May 13 letter with an overlapping one two days
later to Paul Demeny characterizing this new poetry. The Prometheus of the
future needs a new voice—in other words, a new language. In this conception,
each creator has his own language which must, in the main, outdo that of his
predecessors. The essence of Modernism is here, in that there must be not only

uniqueness, but a striving to vanquish others: one must remake the particular art form in each endeavor. One must not form a school but become a one-man movement. One must have something not to rise above but to go against.

Rimbaud stresses in the May 15 letter that he is writing the prose "sur l'avenir de la poésie." His will be a poetic equivalent of the derangement of reason that Nietzsche would describe in the next decade.* "Le Poète se fait *voyant* par un long, immense et raisonné *dérèglement de tous les sens.*" Rimbaud uses a marvelous verb: the poet *épuise en lui*, he exhausts or uses up in himself all the poisons so as to preserve the essences. The poet, thus, brings himself close to death in order to come closer to real life. To arrive at the "supreme Savant," the poet undergoes sickness, criminality, an accursed state. Rimbaud offers his apparent analogy: ". . . le poète est vraiment voleur de feu," a Prometheus. But to be such a thief of fire, he must "trouver une langue," discover a language. Eventually, the time of a universal language will arrive. "Cette langue sera de l'âme pour l'âme, résumant tout, parfums, sons, couleurs, de la pensée accrochant le pensée et tirant." Language must extend itself so that it serves the kind of function already being defined by Wagner's theory of music-drama, its inclusivity.

We encounter here Rimbaud's recognition of the uniqueness of the New, its voices. Language will suggest the impossibility of reality; and a shadowed reality will emerge only because language has approached the impossible. "La Poésie ne rhythmera plus l'action; elle *sera en avant.*" Rimbaud runs through the first stage of romantics, who were "voyants," but "sans trop bien s'en rendre compte": Lamartine, strangled by outdated forms; Hugo, too pig-headed ("cabochard"), although *Les Misérables* is a real poem; Musset, "quatorze fois exécrable pour nous"; and so on. The second stage romantics are indeed *voyants.* Rimbaud lists Gautier, Leconte de Lisle, Banville. But despite their *voyant* quality, they are incapable of seeing into the invisible and hearing the unheard; that is another thing, which "reprendre l'esprit des chose mortes": recaptures the spirit of dead things. For that, only Baudelaire is adequate: "Baudelaire est le premier voyant, roi des poètes, un *vrai Dieu.*" But even the divine Baudelaire is not sufficiently new, tied as he is to too artistic a milieu. His much vaunted forms are "mesquine," shabby or niggardly. "Les inventions d'inconnu réclament des formes nouvelles": to journey into the unknown requires new forms.

One must sweep out the literary stable, including those who have helped create oneself. Rimbaud is, we recall, still a teenager; but his procedures are very much in keeping with the more mature pronouncements of Modernism, its uniqueness and its ruthlessness toward predecessors and traditions. Unheard melodies and invisible elements can be encountered only by a unique, discovering self, armed with new linguistic tools. Rimbaud was preparing himself for *A Season in Hell.*

He begins *Une Saison* by looking back into his youth—he is now nineteen.

* Or that Rilke would suggest in his *Letters to a Young Poet* (Franz Xaver Kappus) three decades later: "We cannot say who has come, perhaps we shall never know, but many signs indicate that the future enters into us in this way in order to transform itself in us long before it happens. And this is why it is so important to be lonely and attentive when one is sad: because the apparently uneventful and stark moment at which our future sets foot in us is so much closer to life than that other noisy and fortuitous point of time at which it happens to us as if from outside. The more still, more patient and more open we are when we are sad, so much the deeper and so much the more unswervingly does the new go into us . . . so much the better will it be *our* destiny."

He must purge himself of all human hope: thus, clear out the poisons he mentioned to Demeny. He must exclude all joy, pounce on it with the "bond sourd de la bête féroce." In so doing, he will conclude his pact with Satan; he will play to the devil. Although he is physically connected to his Gallic ancestors, an inheritance he cannot escape, he proceeds through an array of images that present him as outcast. He must justify himself through his hand, which guides a pen and not a plow.

Like Nietzsche later, he excoriates what science and reason have done to create an inferior race. A vision of numbers means he must maneuver toward the *Spirit*. Bad blood must be purged, pagan blood must return. He must become an Overman: the member of a strong race; now, however, he is an outcast and "despises the Fatherland." His split is truly Nietzschean, caught as he is between loathing of the old and, as yet, his inability to become the new. He views himself as a Negro observing the white missionaries landing; but he recovers from that lowly vision, and he exalts himself through Christian love. "Dieu fait ma force, et je loue Dieu." But he recognizes such a role is farcical, that he is let down: he enters his punishment. Let's get on with it, he insists, and this wish leads to his Night of Hell.*

Rimbaud becomes a child screaming out in rage; if reason has led to this, let us be lawless. "Plus tard, les délices de la damnation seront plus profondes." He seeks a crime, so that by falling into nothingness he will reflect human law. He enters his delirium (I), in which he becomes the slave of "the infernal Bridegroom" who "undid the foolish Virgins." His sexual identity is in doubt, since a voice speaks as "I" in the form of a widow, either Verlaine or Rimbaud himself. One or the other is demonic, although he had thought of them as children wandering within "le Paradis de tristesse." With the absence of the other, terrible darkness, even death, beckons. "Drôle de ménage," the narrator comments.

Delirium II is the "Alchemy of the word." This is, perhaps, the pivot of the poem, reflecting the turning point in the narrator. With the invention of the "color of vowels," Rimbaud suggests that the poet possesses powers to pierce the secrets of the universe and then to unfold them in ways meaningful for poetry. "I invented the color of vowels!—A black, E white, I red, O blue, U green.—I regulated the form and movement of each consonant, and, with instinctive rhythms, I flattered myself on inventing a poetic language accessible, one day or another, to all the senses. I reserved all rights of translation." That latter sentence indicates that Rimbaud has aligned himself with the decipherers: Champollion, who unraveled the hieroglyphics, and was, incidentally, dead at forty-two; Keats, who experienced poetic gold as Balboa did the vast Pacific. Rimbaud is a reader of linguistic signs, an unraveler, an invader of the world's

* While Rimbaud is precocious, his "descent into hell" recalls that of another youngster, Keats, in his "Ode on Melancholy." Keats introduces his ode by taking the reader on a journey into a drug-ridden depth, although he balances it by cautioning against the trip. Yet the effect of the first section of the Ode is an embarkation into an inferno, part of that vast literature on sorrow and melancholy that began well before the mid-eighteenth century, which moves into gothic and, still later, into that romantic notion of the doomed poet. Keats earlier as Rimbaud later would be a perfect blend of such elements: youthful, doomed, living with poetic fullness, charging into those passions that lie at extremes. Keats's very message will foreshadow Rimbaud's, that pain lies at the edges of behavior, and that is a good; for experience of the extreme makes life, creates vitality, recreates joy.

magic. At first, he experimented; then he wrote the silences, the night. He recorded the inexpressible; he arrested "vertiges," madnesses, intoxications.

Somewhere in this journey into the unknown, through the decreation of language, down to its very vowels, one has the discovery of another kind of god. This god is as mysterious as the original One, accessible, however, not through faith, but through the tool the poet prides himself on possessing, his verbal ability.* Before arriving at this pivotal message, the poet has dreamed of a succession of powers, not unlike Nietzsche in *Zarathustra*. He lists his loves, many foreshadowing Huysmans': fairy tales and children's stories, old operas, stupid paintings, outmoded literature and church Latin, decorative panels, erotic books. His tastes are of the kind we would associate with Decadence later. But his loves are insufficient: he also must dream, and in the dream of journeys into godlike clairvoyance: "Je revais croisades, voyages de decouvertes . . . republiques sans histoires," suppressed religious wars, the displacement of entire races and continents. Rimbaud stresses that he believed in "tous les enchantements," all kinds of sorcery.

Through the decreation of language and forms, Rimbaud has become a magician, a seer and *voyant*. We note how close he is to the Parnassians: to their genius at composing poetry based on "nothing," on absences; their stress on purity of language, on verses created out of language rather than things. Their vision was of the world as a verbal universe. Rimbaud becomes "an adept"; he seizes on hallucinations. He sees not factories, but mosques; a school of drummers made up of angels; carriages plying the highways of the sky; a salon at the lake's bottom; monsters and mysteries. "Sophismes magiques" can be explained with the hallucinatory power of words. The disorder of his mind is sacred. The very rhythms of his life take on a different pace: sluggishness, the speed of caterpillars, the life of the mole, "le sommeil de la virginité." The mysteries of creation can be approached only through words that must themselves derive from a disordered, deranged mind. The person Rimbaud has been absorbed into the poet Rimbaud. We have, with this, more than a decade before 1885, approached the turning point that 1885 will embody. As Rimbaud says, he gave himself to the sun, "dieu de feu."

His discoveries, now, will be of correspondences. He is, of course, plumbing Baudelaire's associationism. Eternity is "the sea mixed with the sun." Embers are of satin. He becomes "un opéra fabuleux"; common morality results from a weak brain. Rimbaud, now the age of an American high school student, has nothing but contempt for the ordinary that cannot be transformed into visions, for the ordinary man who lives routinely. He expects Overmen, those who can be transmuted, as he has been. He perceives that men have a fatality for happiness; that every creature has other lives which he can achieve, which are his due. Everyone must escape as he escaped. Every man must expose himself so

* The verbal ability to build a meaningful vision from words and phrases, even from letters and syllables, has always been associated with alchemy, in which stages of purification lead to the golden object. Enid Starkie in her *Rimbaud* suggests that the seven stages of alchemy—calcination, putrefaction, solution, distillation, sublimation, conjunction, and finally fixation—are connected to the poetic process; and we can carry that association over to Rimbaud's "alchemy of vowels," black as dissolution, white the color of purification, red of success. Rimbaud has intuited a "creative process," and one can find in it—as in most acts of true perception—something that is true of all created things, poetic as well as scientific.

as to achieve angelic form and insight. Or else one ends up a Monsieur Prud-homme, that archetypal French bourgeois created by Henri Monnier in 1857. His name translates as "righteous man," created with Jesus, Rimbaud says as an accusation. Nietzsche attacked the same poisons, that contempt for the "last man" who was ordinary, routine, traditional, who had to be transmuted for life to exist. By rejecting God, one finds the self-god.

Rimbaud recognizes that in his descent into hell he is rebelling against Death. The paradox is there, the rejection of Death in the interpositioning of oneself between life and death. ". . . je me révolte contre la mort!" He feels weak, listless, enervated, his life threadbare: he touches bottom. He feels all celebrations he created in his vision have been for nought and he must bury his imagination and memories. He who has called himself "mage ou ange," seer or angel, devoid of morality, must return to the soil, with a duty to search "et la réalité rugueuse à étreindre." That rough reality he must embrace, like a peasant.

We are, of course, more interested in processes than resolutions. For processes, nothing in Rimbaud exceeds "The Drunken Boat," whose significance for Modernism cannot be overestimated. "The Drunken Boat," as we saw, along with Baudelaire's *Les Fleurs* and *Paris Spleen*, Mallarmé's early poems, some of Lautréamont and Verlaine, is a building block for the new movement. We have here a meeting of many key *symboliste* images and modes that force new ways of perceiving. Rimbaud begins with "Comme je descendais," so that the reader should not miss the nature of the journey as a descent into a maelstrom, the watery equivalent of an inferno. The descent is into "des Fleuves impassi-bles," a river not unlike the Congo in Conrad's story of a descent into hell, *Heart of Darkness*. * Even the images of the first stanza suggest the Congo, with the sense that the poet-captain was not being guided, that his haulers were being used as targets by shrieking redskins, that their nudity and the colored stakes to which they were nailed form a disunity. The journey itself is an escape from reality into a greater, more intense reality. "Les Fleuves m'ont laissé descendre où je voulais": the River gave him freedom to roam where he wished—outer freedom loosens up the inner man.

Yet the journey is fraught with danger. The sea seeps into the boat-coffin, scatters rudder and anchor, "dispersant gouvernail," breaking up human control. With that, the poet-captain plunges into the "poem of the sea," devouring "azure greens," where the bitter redness of love amidst this boil is fermented; where all nature enters into a process of fermentation. The unclear syntax of Stanza 7 serves as the very boil and effervescence that are characterized. From this point, the boat is indeed a drunken, careening object: the poet caught in synesthesia, in sensory disorder. The boat is liberated to experience its destruction. It follows a course of disarranged images: waves that surge like herds of "insane cattle," panting seas that he hopes can be muzzled by the three Marys, the sea's eyes, currents colored blue and gold—we have here, in the sea, the alchemy of the chemist's laboratory, the place of imagination and transmutation.

"J'ai vu fermenter les marais énormes, nasses": I saw the marshes and weirs

* Although *Heart of Darkness* comes thirty years later, many comparable works in Europe were more nearly contemporaneous with Rimbaud's "descent" nightmare, Dostoevski's *Notes from Underground* and Tolstoy's *The Death of Ivan Ilych* being best known. The virtual epidemic of works devoted to madness among poets and novelists is of parallel interest.

ferment, even the rotting of an entire Leviathan. His vision is of collapse, reformation through fermentation, the tortured syntax reflecting the anguish of the vision. "Et les lointaines vers gouffres cataractant": he saw, amid the ferment, "the distances toward the whirlpool cataracting." The image is complex, with distance itself becoming part of a fatal waterfall, falling off, as the horizon or a shelf lost in the maelstrom of boiling waters. The boat careens out of control.

To be lost is a necessary stage, or else one cannot recover. He is a "lost boat" in the "hair of creeks or coves," not to be retrieved. He has almost reached eternity, "a million golden birds." But that reach toward eternity is fraught with fear of the unknown. He longs for Europe, with its ancient breastworks. He is pained, bitter, swollen, full of torpor; he deserves to have his keel snapped, to have himself sailed into the sea. The fear of the future prevails; he returns to reality, where all is miniature and frail, away from the enormity of the abyss. "The Poem of the Sea" is rejected, although in his vision he has journeyed into it.

This extraordinary achievement has considerable meaning for 1885. The loosening of form as a way of achieving form is one direction. Paramount is the establishment of another kind of personal statement, what we will see flowering in spiritual autobiography later and in successive avant-gardes in all the arts. With this deepening of personal elements, this exposure of the poet's pre- and unconscious, is that intense concern with precision of language. The surface of such poems, as we saw in Baudelaire and Lautréamont earlier, is firm; language is both expressive and denotative. The sense of the poem, however, throws us inward, as it threw the poet; and there, in the labyrinth of the poet's soul or madness, we have our multifold meanings. An analogy can be made with impressionists and postimpressionists, whose colors, forms, and meanings are firm and directive, yet whose "sense of the scene" is expressive and directed inward.

The journey into hell or artificial paradises, into maelstroms or chance throws of the dice, forces innovations in both shape and language. Hell, not at all the singular experience of Christianity, becomes the refuge of Baudelaire, Lautréamont, Nerval, Rimbaud, Verlaine, even Mallarmé, as later of Nietzsche, Hesse, Rilke, and Eliot. Hell becomes what Robert Adams calls "a value-center," and its exploration is associated with one's detestation of the human sphere. This loathing of contemporary life, as we have seen with Baudelaire, accompanies a profound sense of boredom: boredom becomes, by the fourth quarter of the nineteenth century, a growth industry, not only in France but in Russia and England. A good many of Wilde's ripostes were based on boredom as a fine art. It is connected, bizarrely enough, with some of the same factors that fed into Marx earlier and that would nourish Freud later: the individual free of his work (or society or community); his intense focusing on himself as center of his universe; a solipsistic sense of oneself as the creator of his sphere; a concurrent awareness that one is devoid of interest, the center of a void, the embodiment of an absence.

In this void, which is both self and outside self, one experiences boredom and the neurotic-psychotic components of boredom, acedia, ennui, and abulia. The factors for suicide rise. The consequences of such consciousness lead to a reciprocal action: one's boredom or ennui is such that one must deny the world in order to live; yet such denial intensifies one's boredom. What is left, as

Nietzsche, the archetypal philosopher of boredom, expressed it is that one must overcome such consciousness by becoming superior to it, by becoming an Overman. Paul Gauguin, in 1884, turned the idea of Overman into the painter's use of color: ". . . I propose to make any drawing look larger or smaller, depending on the color with which I fill it in." Control color and one controls perspective itself. Similarly, Wagner's stress on redemption in his later libretti was often little more than a stress on himself as redeemer.

All nineteenth-century boredom, acedia, and ennui, even abulia, point toward the idea of the Overman. The latter is not Nietzsche's aberration, but the logical consequence of a buildup of loathing, of self and "the other," which had dominated in the two or three decades prior to Nietzsche.* But since it is art we are speaking of, such boredom led not only to political obscenity but to cultural achievement; it becomes, as it would later in Proust and Kafka, an affirmation once it is directed into creativity. That quest for nothingness leads, by 1885, into a flowering of the self, a Renaissance of the self floundering in the "fog which imposed a limit on infinity," as Mallarmé phrased it. The Russian Oblomov is excited and enthused by boredom, and he is a forerunner of those who find in Nothing a sense of the vastness that lies beyond routine acquisition, in that void which reciprocates mere objects. By 1885, the convergence of artistic activities would define the void more fully than ever before.

Maldoror, as we have noted, speaks of the very reshaping of nature. In his vision of things to come and be, animals grow out of human limbs; the relationship of human and animal worlds takes on a different significance. Man is thrown back into his animal beginnings, and animals are thrown forward to their ultimate potential. "Two jellyfish crossed the seas, at once enticed by a hope which did not prove mistaken. They closely inspected the twin buttocks which comprise the human rump and, fastening on to these convex contours, so squashed them by constant pressure that the two lumps of flesh disappeared while the two monsters which issued from the kingdom of viscosity remained, alike in colour, form, and ferocity." There is more here than blending of animal and man, there is transformation, and it develops out of Maldoror's celebration of boredom. From it grows a new world of fierce activity, reshaping, visions. Kafka's animal forms are implicit here.

Language by 1885 will define the way in which the world unfolds, whereas earlier the world, objects, events used language to define themselves. Foucault stresses that by the seventeenth century the relation between language and time became inverted: "It is no longer time that allots languages their places, one by one, in world history; it is languages that unfold representations and words in a sequence of which they themselves define the laws." The process has intensified, and language now means "languages," modalities in which thing and world and event are defined according to how words or shapes are used: through colors,

* The German philosopher was known and felt as a presence in France long before his work was translated into French. *The Case of Wagner* was, in fact, his only work in French until *Zarathustra* in 1898. Schopenhauer, however, had been translated by 1886 (*The World as Will and Idea*) and in extracts before that. His destruction of man's illusions and stress on the "world as idea"—a full generation before Nietzsche—led into many Modernist theories and practices. Another source helping to connect Schopenhauer with early Modernism, Nietzsche, Freud, and Decadence, surely an unholy alliance, was Eduard von Hartmann's *Philosophy of the Unconscious*, translated into French in 1877. A follower of Schopenhauer, von Hartmann expressed a pessimism that forced new definitions of the individual will and new roles for aestheticism.

tones, rhythms, even gestures. Saussure's efforts in 1916 at linguistic codification and his distinction between *langue* (the system of language) and *parole* (the use of language), which have so influenced generations of structuralists and semiologists, are outgrowths of attitudes toward words manifest by the 1880s.

In Freud's developing psychoanalysis, we have a branch of language as much as a branch of thought: language here decides what is scientific, and we measure the technical dimensions of the message by way of the language(s) in which it is unfolded. In a 1982 article, Bruno Bettelheim has spoken of the "German Freud" as containing a different message from the "American Freud"; the difference, according to Bettelheim, is that of language. English has made Freud sound more scientific and mechanistic than he does in German. The result involves quantitative change. * Part of the problem, as Freud meticulously developed his maps of the mind, is that the patient's language derives from an irrational source, which is then shaped by the analysand into rational discourse so as to make the analyst comprehend him. Then the analyst takes this a step further, by turning the analysand's efforts at rational discourse into scientific notes, which become his file—a kind of shorthand which has now utterly transformed languages emanating from an irrational source into scientific data. Then, if one is Freud, these data are further transformed into the language of articles and books, even more scientifically precise, or purporting to be. What began deep in the unconscious as unspeakable languages, languages of creativity, dream, and perceptions that lie beyond precise verbalization, is transformed, ultimately, into languages and texts that can be understood by a commonality of educated readers.

Another parallel development working into the very seams of language is the occult movement, beginning in the 1850s and 1860s with the work of Éliphas Lévi, but becoming influential and widespread by the mid-1880s. Not the least of its importance was its stress on matters of dreams, hypnosis, associations that were also of interest in psychology. Remarkable about this stress on occultism, which owes as much to Swedenborg as to Lévi, is its emphasis on what we have already noted in Baudelaire, the theory of correspondences.† What the poet explored in *his* language, the hermetics explored in *theirs*; but whichever we turn to, it is languages that become the entire vehicle of the expression. Even

* Although Bettelheim points to a real area of conflict, he overstates the case. For Freud— himself well versed in English—approved the Strachey translation and accepted whatever shifts in meaning language created. The Bettelheim argument is less compelling for its individual examples than for its demonstration of how an 1880s and 1890s discipline is a matter of its language.

† The occultist movement blended in elements of symbolist writers, decadents, and others who moved in and out of various *fin de siècle* theories. Later studies such as Max Nordau's *Degeneration* (*Entartung*, but published in French first) would see in occultism the rot and decadence that had to be swept away to prevent cultural collapse.

Theosophy, spiritualism, and occultism extended well into the next generation. We would expect Yeats and Kandinsky to be susceptible to the attractions of spiritualism, since they stressed that aspect in their theoretical writings; but even a rationalist like Schoenberg was interested in Swedenborg, whose occultism he perceived as essential to comprehending the hidden qualities of art. Schoenberg's reading of Balzac's *Seraphita*, in fact, helped lead into his oratorio *Die Jakobsleiter*.

As for Kandinsky, his comments on whiteness join language (Mallarmé, George, others) to sound and color. He describes the color white as "a symbol of a world from which all colour as a definite attribute has disappeared. This world is too far above us for its harmony to touch our souls. A great silence, like an impenetrable wall, shrouds its life from our understanding. White, therefore, has this harmony of silence, which works upon us negatively, like many pauses in music that break temporarily the melody." Unlike black, which is a silence with no possibilities, white has the appeal of the nothingness preceding birth.

more than poetry, occultism would be the healing force between science and religion; and if we probe more deeply, we note that the onrush of psychological developments at this time was part of the same desire: to create psychological languages to compete with languages of the occult, the scientist, the poet, the traditional religionists. We can, with some projection, see these developments as conflicts of language, since the ultimate aim was to define a sensibility in which subjects had shifted from external to internal. Such developments stiffened themselves against positivism, remnants of ultilitarianism, Social Darwinism, traditionalists in historical and religious thought.

We have here some of the transformations made when we view and then speak of an art object, or read the text, or listen to the progression of notes that may be opera, symphony, or chamber music. To the disclaimer that such has always been the case, that all art has been such languages eventually transformed by the one writing it and the one experiencing it, the response is that in the past there was a commonality of language, a community of more or less shared experiences. There were schools, not movements; traditions, not successions of avant-gardes. Languages were understood as such. But once that commonality and community were displaced by stresses on uniqueness, individual effort, the supremacy not of God but of self—as we see taking shape by 1885—then language emanates, as it were, from an unconscious, from an irrational source. If rationality is based on that very commonality we now see eschewed, then the natural function of language is replaced by an artificial function. Wittgenstein in the 1910s attempted to reverse this very element.

Once we perceive that language derives from irrational sources, we can search back into philosophical tradition and see such developments fifty years or more before its appearance in the arts. Kant, for example, created a revolution in language by challenging received notions of concepts and judgments. Whereas traditionally distinctions had been related to similitudes, that is, differences had been discerned against a common background, with Kant we have a stress upon the diverse, not the common; and, therefore, an emphasis upon judgment, not the concept. Kant offered not only individual judgment as the partial basis of knowledge, he also suggested that language determines the nature of perception.

When diversities rather than linked representations of man and nature are stressed, then the very "possibilities" of knowledge are questioned. Such a move toward possibility places the burden upon languages, which become themselves forms of knowledge. Heidegger noted the shift: "Die Sprache spricht, nicht der Mensch." Language speaks, not Man. He added: "Man speaks only to the extent that he conforms with language." Sartre, the heir to revolutions in language, called his autobiography *The Words* and named its two parts Reading and Writing. The "me" of the narrative is a historical recreation of the person by way of languages.

With this, languages become the discontinuities on which we base our perceptions, and creative work in words becomes the way by which we can see. During this renewal of language, we find early stages of Modernistic stress on "seeing" or perceiving, the role of the *voyant* as the ultimate in knowing. There is here, clearly, a discontinuity with previous modes of knowing. What Foucault calls the "tables of identities" were being destroyed, whereas earlier these "tables" had been the very sense of our world. With their destruction, we enter a new sequence of associations. Entire new disciplines develop: evolutionary theory,

scientific genetics, anthropology, sociology, criminology, psychoanalysis, quantum physics, finally the physics of relativity. And among known disciplines, mutations occur, and mutations are by their very nature unsettling, avant-gardes that lie beyond measurement.

A vanguard is only as good as its scouts, and the artist now becomes a scout, defining himself by his ability to discover, seek, venture further. Not unusually, explorations of the North and South Poles, treks ever deeper into Africa, Stanley's work in tracking the Congo, and other such openings up of dark areas run roughly parallel to the advent of Modernism. For these explorations were nothing less than definitions of new languages: not only the spoken languages of hitherto unknown places, but the languages of unknown cultures, past civilizations, new ways of associating technologically oriented cultures with those primitive ones reaching back toward beginnings.

Geographical daring coincided with archaeological digs downward, both of them paralleling another, related phenomenon: the widespread hatred of the modern city. Baudelaire had written of Paris as a necropolis and the subgenre of city writing was fixed, as we see in James Thomson's *The City of Dreadful Night*, later in Zola, and in a spate of 1880s and 1890s novels. Cities were mortuaries—Conrad's reference to Brussels as a "whited sepulchre" or to London as a "cruel devourer"; they were antinature, but, at the same time, they failed as artificial paradises. Thus the cultists of the artificial found cities burial places, and those who extolled nature found cities to be antinatural. Well before decline and downfall philosophers, Nordau, Spengler, et al., cities were viewed as degenerative, even as they were accepted as the matrix of culture. In Georges Rodenbach's 1892 novel, *Bruges-la-morte*, Bruges in particular—with its canals, alleys, and moist rot—is a physical manifestation of states of suicide and depression. The dead city is an objective correlative of the protagonist's death wish.

All of this led not to cultural connections, but to awareness of division, to uniqueness of experience. Alternative experiences replaced traditional roles. Words became detached from what they would ordinarily represent. We cannot even speak of a connection, for words and representation no longer inhabited the same world. Photography developed at a time when representation demanded expression, and words, it was felt, could no longer fulfill that function. Zola's naturalism in literature was a parallel response, to make the word and what it represented fulfill traditional functions.

When words split off into new roles, the world was desacralized: man, nature, and history were no longer a continuum. The process had begun centuries earlier, but had become apparent by the time of Nietzsche's "God is dead." Time and space in a sacred universe had been a continuous flow; now historical compartmentalization led to the separation of things and the languages to express them. In America, so far from Modernism, subtle changes were also occurring. Thoreau could not rely on words, but had to return to nature to experience stages that were once continuous. His book became so famous because he escaped a historical process in order to return to an earlier one, and we applaud his action although it has no connection to our own lives except as myth or fantasy. When Thoreau becomes for us part of myth, we can marvel at his choice even while we are dispossessed of the very nature he embraced. It no longer speaks to us in languages of flow and continuity, or of immanence. This is another

way of saying that man, by 1885, is becoming his own history. When he achieves this, when he individuates himself to such an extent that he becomes "all," then he carries with him very different notions of time and space from those that obtained before.

We spoke before of the "journey" poem, and we can see how this completes a cycle of "ship of fools," the title from Sebastian Brant's *Narrenschiff* in 1494. In his *Historie de la folie*, Michel Foucault uses this image of the ship as his first chapter, illustrative of how society rid itself of its madmen. But the image has splendid associations for the Modern movement, when forms of madness as journeys assumed the role of higher truth. Avant-gardes could be "ships of fools," and art could be the way society tries to rid itself of its lunatics. Nietzsche, on the edge of madness, becomes the conscience of his culture, and even during the onset of his illness, in *Ecce Homo*, "sees" into himself and his culture. More than anything else, the fool or madman has a sense of his and everyone's mortality, and yet he proceeds as if life were to be indefinitely extended. All men must meet their fate, but somehow the fool or madman is excluded from that: the journey he undertakes in so much nineteenth-century French *symboliste* poetry and prose suggests he can both embrace and evade his fate.

Mallarmé's "Un Coup de Dés" is nothing if not a poem about madness, with the very typographical arrangement suggestive of a disordered mind. But elsewhere we see a similar quest, to reach into madness as a way toward exclusivity; the path to uniqueness lies in becoming a passenger on that ship of fools. At the end of that tradition, Conrad's Marlow in *Heart of Darkness* presents a journey into madness, the shadows of the Congo region no less dark than the tracery of a madman's brain. The river is not a journey to somewhere, but a trek to the nowhere that reflects the lunatic's limbo. Similarly, Mallarmé's "azure"—in the poem of that name—is the challenge of "the other" for the poet: "De l'éternel azur le sereine ironie / Accable, belle indolement comme les fleurs, / Le poète impuissant qui maudit son génie / A travers un désert stérile de Douleurs." The azure overwhelms the impotent poet and "curses his genius" across "a fruitless desert of sorrows."

The images are those of oncoming or actual madness. In subsequent stanzas, the poet feels the azure strike into his empty soul as he seeks escape. But where? The mad chase is on. He longs for fogs, "cendres monotones," to chase nature and turn the universe into silence. From this deadly morass, the poet will emerge to stuff the blue holes created by birds. All his efforts are in vain, however, for azure triumphs, and the poet must seek deeper into his madness for some reason or escape, which is not forthcoming: ". . . l'Azur triomphe," its victory *méchante*, wicked. The poet recognizes there is no escape, his journey in vain. It ends: "I am haunted [hanté]. The Azure! The Azure! The Azure! The Azure!"*

A poem about the nature of creation and the role of the poet as he voices

* While azure overwhelms as the mystery above, there was a comparable mystery below, in underwater kingdoms. Jules Verne's *Twenty Thousand Leagues Under the Sea*, in 1870, is one aspect of the "oceanic dream." Probably Darwin was an influence on such work, but of equal importance was the *symboliste* journey and dreamwork. Flaubert in his *The Temptation of St. Anthony*, in 1874, wrote a hymn to underwater life, where gourds resemble beasts, trees have human heads for fruits, plants and animals are indistinct. We recall that Huysmans' Des Esseintes and Laforgue's Salomé both keep aquariums. The underwater tradition works into early Gide, in *Urien's Voyage* in 1892. Jean Pierrot points out that such images appear, as well, in Moreau's painting of *Galatée* and in Redon's album, in 1896, inspired by Flaubert's *Temptation*.

his fear of nature is also a poem about a journey into madness, in which basic nature must be effaced. Since the effacement is impossible to achieve, the poet sinks into madness even as he succeeds in capturing the process that reflects his "making" of the poem. The point is that achievement results now from the poet's assumption not only of another self but of a mad self; and his journey—Rimbaud's "drunken boat" and Mallarmé's rocketing captain-poet as archetypes—is into the circuitry of lunacy from which there is no escape except through the poem itself.

The idea of the madman is particularly rich for the development of poetry in the middle to later nineteenth century in France. Poe's reputation thrived on this attention. What poets perceived, and what they modeled on the journey, was a reflection of a mind that no longer relied on solely rational processes. This would be, of course, a major source of the Modern movement: that disordering and enjambment which suggested alternative forms of existence. Enjambment (*enjambement*) or running-on is a poetic term indicating that without syntactical break one line runs into another; but it has considerable appeal for Modernism as a whole, which dispensed with formal endings and beginnings. It carries over from poetry into fiction and drama as well; into opera and dance, finally into abstract art. With time and space no longer applicable in traditional ways, the flow that enjambment permits becomes the play of mind, the running on, which we associate with irrational "mad" processes. This literary view was part of a much larger one, and we have already noted that in psychology and early forms of psychotherapy there evolved two models of the human mind: dipsychism, based on dualities, then polypsychism, based on multiple personalities, or clusters.

A major point is the loss of wholes and the replacement by fragments, each of which may be as important as any other. In early theories of polypsychism, each segment of the organism had its own personality or ego. Dreams are, evidently, the best source of this multiplicity. When Freud investigated dreams systematically, he discovered how multiple the unconscious was, how layered it was with several selves. When he returned from *his* journey at the turn of the century, he had a taxonomy of dreams that poets had already intuited.

Paradoxes abound. As knowledge moved toward ever greater definition, it uncovered diversity, even infinitude. As knowledge underwent taxonomic functions in Darwin, Frazer, Durkheim, Marx, Freud, man yearned for unlimitables. Thus the journey or exploration took on a dualism that only the arts could attempt to bridge. For the journey was to join in a process that, the explorer hoped, would lead to ever greater riches, ever deeper into darkness, in the hope of finding light. Yet the journey was often made to seek something fathomable: depths, heights, locales, directions, even flow (as with rivers). When journeys were made into the mind, the desire to locate the perimeters of the mental process led not to definitions but to discoveries of what defied definition. Cesare Lombroso, beginning in 1876, attempted a science of madness, but was no more successful there than Mallarmé with azure or Flaubert with underwater seascapes. Freud constructed models of the mind, but, as we know, was dissatisfied with his models without biological bases for them.

The connection between inner (a journey into spirit or mind) and outer (what lay beyond mind or spirit) could not be made. Yeats's Byzantium, Gide's Biskra, Conrad's Congo, Musil's Vienna, Nietzsche's Wagner, Joyce's Dublin,

Rilke's Duino, Eliot's locales in *Four Quartets*, Mann's magical mountain, Valéry's Marine Cemetery are all continuations, in one way or another, of Mallarmé's azure, variations on his *ptyx*. They exist, but their dimensionality is called into questions by their relationship to the mind that recreated them.

Valéry, for example, was concerned with "le songe est savoir," dream is knowing, in the sparkling air of "the cemetery by the sea." There is even in the title a paradox; for the sea is energy ("Pure energies of lightning flash"), whereas the cemetery is energyless. The entire poem can be read as Valéry's effort to connect inner and outer, to find in the sea and the cemetery some associative linkage. But it can be made only in poetry, not in life. Dissociation of the real is complete.

By 1885, there could be only reciprocity, not resolution, between forms of knowledge and the infinitude of human aspirations and experience. The split which Eliot found beginning as early as the seventeenth century and which Foucault locates in the eighteenth was made finally. Man would seek knowledge obsessively; the age of scientific exploration in all areas was on, whether in anthropology or physics. The "science of man" was a catchword, but the science of man was precisely what could not be achieved. Modernism is born in the recognition that in the interstices of knowledge there lies an entire universe of unchartables; that in the seams of all these abundant data, there are other data that have no coordinates except in the mind of the artist; and that this disaffected artist is the only one who can, verbally, visually, aurally, bring together these multiplicities that make modern life so compartmentalized. Origins, sources, founts, while objects of great activity, cannot be discovered; for they recede even as sought. Stanley may have traced the source of the Congo River in his endeavors to find Livingstone, but Conrad knew that Stanley's Congo was not *the* Congo. *That* reality lay elsewhere, and Marlow, trying to discover it, almost loses himself.

The writer plays roles; art becomes staged. Each avant-garde, from Petrus Borel's Bouzingos to Jarry's and Artaud's mad stage, becomes a theatrical event. The reader or listener or spectator becomes an audience played to, no longer a participant. He cannot share because when the artist takes over the function of the avant-garde, the audience is excluded. The artist must satisfy his own urges, to a far greater extent than in previous ages, because now he no longer has a felt society or community to associate himself with. He is artificial, self-invented, a dandy; he becomes clown, wanderer, discoverer, acrobat, madman, even beast. Yeats's rough beast slouching towards Bethlehem is, in context, the portrait of some lunatic future; but in other ways it is part of the artist's vision of self, that upsetting of tradition and society, an anarchical force.* The military avant-garde existed by virtue of its contact with the main body; even as it moved out, it remained in touch. The artistic avant-garde will measure itself

* Even Kierkegaard's "Seducer," who comes before midcentury, is part of this dramatization of the self, as are Dostoevski's protagonists. Not for nothing is the object of the Seducer's theater a young girl named Cordelia, and not unusually are all the events part of a diary, itself a staged source. Kierkegaard writes of his performer: "I have held several rehearsals in order to discover which one would be the best approach. . . . The best thing is for me to transform the engagement from an act to an event, from something she does to something which happens to her, concerning which she must say: 'God only knows how it really happened.' "

by the distance it can put between itself and the main body; *its own main body is as much the enemy as is the enemy*. By 1885, there is the paradoxical use of the artist's role: he has found for himself a function beyond functionalism.

In a 1905 letter, Béla Bartók mentions a famous Paris tavern called Le Néant. Bartók describes it as celebrating death: "There are wooden coffins instead of tables, and the walls of the room are black and decorated with human skeletons or parts of skeletons; the waiters wear *pompe-funèbre* sort of garments; and the lighting makes your skin look wax-yellow, your lips livid and your finger-nails violet (in fact, you look like a corpse); and they entertain you, for instance, wrapping one of your party in a shroud up to the chin and standing him—or her—in a coffin, where, under your very eyes, he turns into a skeleton, etc." Although the still rustic Bartók is astonished, we find only two decades after the stirrings of Modernism how it has been assimilated into nightly entertainment. The tavern has taken on Modern's nihilistic aspects and turned them into amusement for a more general audience. Jarry's taunts, Lautréamont's and Laforgue's ingenuities, Rimbaud's descents into hell: these are now commonplaces of Parisian entertainment. One spends the evening by playing death.

By 1885, these games were still in the hands of a stirring avant-garde. We are, as yet, in the period before the huge onslaught on prevailing values. Nietzsche had already begun such attacks, but the 1880s preceded the key work of Freud, Frazer,* Durkheim, Renan, Weber, Sorel, Bergson, Mach, Croce, Pareto, Karl Kraus, in philosophy and religion, the emerging social sciences, and in ideas about language, which would parallel what would occur in the arts. We can see the direction, however, by the late 1880s, when Georges Sorel began his revisionism of Marxism, what H. Stuart Hughes refers to as his "decomposition" of Marx. By this process, Sorel disallowed Marx his integrity, splitting off his theories into segments or components, turning him into streams and tributaries—in fact, a very modern practice. With this, Sorel developed his idea of *diremption*, and we note how close this idea in sociopolitical thought is to what 1885 was becoming in the arts.

By *diremption*, Sorel meant the examination of parts of a whole, or a series of events, without taking primary regard of their connection to the whole. Sorel saw his atomization of knowledge as the way history arranges information, which is not the way our intelligence arranges it. The assumption is that while intellectually we seek continuity, flow, and unities, history and, by implication, all knowledge offer bits and pieces—what physicists would come to call quanta and what Saussure in linguistics would relegate to the diachronic study of language. This ebb and flow of pieces needs symbolic representation; it demands some way of gaining a hold on our mind, and Sorel tendered his theory of *diremption* as a methodology. It offered, he wrote, "a symbolic knowledge of what history creates by means incommensurate with our intelligence."

* His highly influential *The Golden Bough* did not appear until 1890, in two volumes. In later editions, it grew to thirteen volumes, and its bulk as well as anthropological and historical reach paralleled Freud's work as it developed after 1900. Although Frazer saw his monumental work as a summa, it really proved divisive, since it speaks of cultural, political, and social relativity, thus subverting European civilization already reeling from dozens of other blows. Like Darwin, Marx, and Freud—all "summa" workers—Frazer carried on a line of divisiveness that paralleled literary Modernism.

Diremption is a logical tool, a rational method of separation or isolation and definition; but Sorel perceived that it would prove inadequate. For just as Modernism became more inhospitable to "normal languages," so did social phenomena as Sorel understood them. As social phenomena became more thickly textured, ambiguous, and resistant to interpretation, Sorel forsook *diremption* as too rational a tool and moved toward mythical causation—reason supplanted by the nonlogical. I am simplifying what is a complicated process in Sorel's thought—and it is not always clear what he did have in mind—but parallelism to Modernism *is* clear.

For Sorel, mythical analysis led into several areas beyond pragmatism and empiricism; it led toward that mysticism which is never distant from the artistic avant-garde. Sorel worked intensely to find a vocabulary in which he could express himself, for the mechanistic languages he had inherited proved unsatisfactory, as they would for the avant-garde artist. Language was the key, even when languages that would confuse as well as describe had to be developed. Not unusually, Freud, a contemporary of all this, was beginning to seek a new language in which to describe hitherto immeasurables: dreams, the unconscious, even wit.

Sorel was himself ready to come full circle, after having in this middle phase approximated in the social sciences what Bergson was attempting to achieve in philosophy. Bergson advocated "the flux," the whirlpool of existence, the maelstrom that was man's fate; Sorel saw the beauty of this, but could not take the step, and he departed from his mythical mode—so close in spirit to Bergson's flux—back to a more pragmatic approach. A part of the generation that radically disavowed Cartesianism, Sorel later found its attractions, as did so many other Moderns. Eschewing the Cartesian foundation of their education and society, they moved to antipositions, only to revert, or else to stand back from the ultimate consequences of their original rejection.

Much of this movement against rationalism, pragmatism, and empiricism came in the 1890s, when attacks on every facet of a positivistic world intensified, even as positivism became the gospel of the middle classes. But well before the nineties, as we have seen, the nonlogical and irrational had made their mark. Moréas in his *symboliste* manifesto in 1886 had associated symbolism with the Platonic idea by way of its having become mere appearance. "Thus in the art, pictures of nature, actions of men, concrete phenomena are not there for their own sake, but as simple appearances destined to represent their esoteric affinities with Primordial Ideas." This is a garbled version of Mallarmé's very succinct: "Poetry should not inform but suggest and evoke, not name things but create their atmosphere." Also in 1886, Ernst Mach's influential *Analysis of Sensation and the Relation of the Physical to the Psychical* stressed a parallel theory, human sensations as the entirety of experience. If "substance" was unnecessary, then all was "becoming," and man needed only a language to immobilize it. We can characterize the 1880s as a time when disparate elements were being pulled together so as to be torn apart—what would be, in military terms, a staging area for a large-scale attack where the avant-garde forms itself for a break with the larger body.

Correspondences, associations, tangential moments, revelations, antira-

tional processes, nonlogical linkages, unconscious drives, mad moments, extremes of subjectivity, demonstrations of ego and self,* all were beginning to replace rationality and positivism as modes of thought. We must stress that these modes should not be considered antithought or nonthought. They were not, in the 1880s, an abdication of thought, but a recognition that thought was broader than believed; that its aspects—as newer stages of psychology were proving—included what had been in the past dismissed as outside real thought. For once and for all, thought was placed beyond pure reason; understanding—in a distinction made as long ago as Kant—included worlds, planets, universes that pure reason could not reach.

The world of spirit, the world of "soul" had to be distinguished from the world of science and pure knowledge, a distinction made by the Germans with their Kantian tradition; so that *Naturwissenschaft* or natural science was defined as one area of knowledge quite separate from *Geistewissenschaften* or the sciences of the mind or spirit. Implied in the German "Geist" is a whole range of nonpositivistic elements: not only mind and spirit, but intellect, wit(s), even ghost and specter. With this distinction, which was made both explicitly by social scientists and implicitly by artists, two worlds of knowledge exist. Although they exist side by side, only with the advent of psychoanalysis does one nourish the other. In fact, they orbit each other with hostility, these worlds of the natural sciences and those of mind, spirit, ghosts. The significance of this is overwhelming, for here we have formal recognition of the dissociation of sensibility that had begun over two centuries earlier but which could not be clearly identified until near the end of the nineteenth century.

What this meant for the artist, our chief concern, was that Modernism was not only a movement—it was certainly that—but an entire mode of thought and life. It brought forth "ghosts, spirit, soul, mind" into appearances, and its manifestations were considered not equal to those of science, but superior. They seemed to feed more basic needs. They were ghosts that inhabited every crease and seam of the human universe; whereas the natural sciences only nourished the surfaces, the outer man, not the self. We had, for the first time, the full recognition that all things that had been deemed fixed—history, psychology, human aspirations, et al.—were subjective modes.† It was a fictional world that Proust, probably the greatest of the Modern novelists, was beginning to capture as early as the 1890s, in his *Jean Santeuil*. But in painting, Van Gogh had

* Although "the woman question" did not peak until the 1890s, the eighties found a considerable display of the "new" female self represented in lesbian novels and stories. We can cite, among many others, Zola's *Nana*, Daudet's *Sappho*, Louys's *The Song of Bilitis*, Maupassant's "Paul's Mistress," Strindberg's *Le Plaidoyer d'un foi*. Although lesbianism in most such fictions is treated hostilely, its manifestation almost as a literary subgenre suggests that sexual inversion was a source of investigation, an unexplored field into which rushed writers, scientists, and pseudo-scientists. By the eighties, sex—as we would see with Krafft-Ebing, Freud, and Havelock Ellis—had become a type of archaeological dig. The metaphor is apt, since "uncovering" becomes the idiom, whether in Bachofen, Frazer, Freud, or others. Bachofen is, of course, first in line here, the contemporary of Darwin, a secessionist from received truth eager to base secular life on divine interpretation.

† If we look ahead, we can see how even history was becoming part of the Modernistic movement. Wilhelm Dilthey, as Hughes demonstrates, moved history from schematic meanings to the data of consciousness. But the largest movement came in Croce's theory that all true history was contemporary history, which is another way of saying that all knowledge is present, a position that makes history and the individual unconscious analogous, in that temporality in both is contemporaneous. These developments are, of course, aspects of Modernism, in which the retrieval of the past is part of a timeless mode. Surrealism will be the furthest reaches of this development.

already transformed self into color; and in music, Wagner had subjectified opera
even while turning it into a divine instrument. In poetry, a more natural mode
for subjectivity, the self had dominated since, at least, the English Romantics.

In actual history, theories were dim, while events played themselves out.
Such events in Germany are instructive. Although Bismarck had established a
state based on authority (his), it was a state that stressed capitalism and which,
accordingly, weakened old feudal ties. Mann's *Buddenbrooks* captures the milieu:
the generations of authority, their demise, and the dubious triumph of artistic
sensibilities. In his dependency on modern capitalism, Bismarck helped establish,
however unwittingly, those strains within the system that made the advent of
Modernism in Germany possible. In a comparable way, the French loss to
Bismarck in 1870 and the ensuing Paris Commune opened up the state and its
authority to radical modes of antiauthority, on which Modernism nourished
itself. One cannot view these historical trends as part of a cause and an effect,
nor can one predict what will occur. But we can say that in a more general
sense historical movements in France and Germany would lead to strains, schisms,
divisiveness that made it possible for Modernism to emerge and flourish, in the
teeth of opposition. *

Bismarck in his quirky way also protected Jews, as his means of protecting
Gerson Bleichröder, Germany's most influential banker; and while Bismarck
was hardly a Jew-lover, he did open up the Prussian mind sufficiently to let in
such antifeudalistic adventurers. No matter that Bleichröder was a "court Jew"
who fitted himself as necessary into Prussian assumptions; his triumph at the
Bismarck court indicated to the old guard that a fatal rift in society had occurred.
Once Bismarck's own authority began to wane, these rifts widened, for Jews
came to be identified not only with money and banking but with Modernism,
as we saw earlier in Hitler's remarks. Thus, history plays several tricks, and the
final losers were, of course, the Jews. But in the 1880s, they appeared to have
solidified their position, the old guard was on the run, Bismarck's authoritarian
state—with its strong social services—seemed to flourish, Bleichröder became
"von." Underlying rifts were enormous, but out of sight. When the rifts widened
sufficiently, the old guard struck, but so did Modernism. Modernism with its
antiauthority, its support of anarchy, its seemingly large numbers of Jews (many
of them converts, some intermarried and German nationals, or falsely identified
as Jews) poured through.

As we have seen, anti-Semites could turn easily from animosity toward
Jewish bankers and Jewish financiers to Jews, truly so or so-called, in Modernism.
Identification of the two areas became blurred, since much of the opposition to
Modernism was not only hostility to art but hostility to the sundering of traditional
ideas. This trend in German anti-Semitism, Fritz Stern says, began in the mid-
1870s and took the Jew as the symbol of modernity, of liberalism and capitalism.
Behind all finance, the Jew was seen skulking as profiteer, and the very term
"anti-Semitism" developed then. In both direct and indirect ways, this nourished
Modernism. For while Jews began to take on themselves the burden of anti-

* Such strains certainly existed in Germany before the 1880s, but since academic art flourished
and the academy was itself allied with the bureaucracy, the private painter needed government
support and recognition.

Semitism, which was as much anti-Modern as anti-Jew, authority was weakening, and the state itself was losing its central position. Power areas dispersed. Large historical processes were at work, in which modern capitalism—Marx's subject—was destroying traditional forms of power and allowing for that broadening which Modernism exploited.

Even the military perceived this, and Field Marshal Moltke, the German hero of 1870, saw in Modernism a breakdown of authority, a potential weakening of Germany itself. Moltke viewed Modernism, whatever shape it took, as a suitable vehicle for the advancement of Jews, and in this process he foresaw the subversion of the "true Germany." Bismarck came under attack, then, not only for pursuing state capitalism, but for giving Jews such power behind the state. And in the ironic way in which such matters work out, Bismarck, who detested Modernism and disliked Jews, had opened the rift, let in the new, allowed for the very elements he could not tolerate. Heinrich von Treitschke, a leading historian and a man whose ideas and career were a bellwether of German thought, made his famous assertion: "The Jews are our misfortune."*

These historical turns are worth mentioning to demonstrate the terrible fear Modernism engendered in the 1880s, even before it became fully manifest. In the French 1890s, all these fears would focus on the Dreyfus case, which came to involve every aspect of the society and government. While Dreyfus himself lay forgotten in confinement on Devil's Island, the real fight was over the penetration of Modernism (i.e., Jews, capitalism, the market) into French institutions. France was like a virgin queen shielding herself against "foreign" assault. Dreyfus was the pretense, Modernism the cause.

What Modernism accomplished in its earliest phases, in the poets examined above, for example, was a broadening of Marx's sense of alienation. Although Marx used the term to mean several things—not only the estrangement of the laborer from the fruits of his labor—he nevertheless saw "alienation" chiefly in the relationship of worker and his work. The Modernist writer, later painter and composer, extended this sense of alienation, so that it became, with all its experimental aspects, a metaphysical concept. Mallarmé's "azure" certainly rises to philosophical levels, and his captain-poet is a forsaken God holding on in order to justify his creation. Yet even in Marx, we have a recognition of a new relationship of man to his society which has become more subjective and, therefore, potentially more anarchic. Marx read Hegel's *Phenomenology* in ways that suggest what Modernism would bring with it, although the latter arrived without Marx's stress on "productive labor":

> The greatness of Hegel's *Phenomenology* and its final product—the dialectic of negativity as the moving and creating principle—is on the one hand that Hegel conceives of the self-creation of man as a process, objectification as loss of the object, as externalization and the transcend-

* More vehement German anti-Semitic feeling was rampant, in Wilhelm Marr, for example, in the early 1870s. Marr, however, was quite different from Treitschke; for the former saw Jewish strength as an indication of German weakness, and, seeking scapegoats, he became a professional anti-Semite. Treitschke slid into anti-Semitism; he did not make a career of it. Yet when he came to it, it was a more forceful thing: it had been identified with Modern, as part of that weakness of German life through which all the riffraff could pour. Hitler would begin to listen in very soon. So, too, would Ezra Pound.

ence of this externalization. This means, therefore, that he grasps the
nature of labour and understands objective man, true because real, man
as the result of his own labour.

The terms Marx uses foreshadow that shift we are charting: "the dialectic
of negativity," "the creating principle," "self-creation of man as a process,"
"objectification as loss of the object." Marx was not alone, for another Hegelian,
Max Stirner, at about the same time, saw in Hegel a potential freeing process.
In *The Ego and Its Own*, published in 1844—when Baudelaire was beginning
his "Salon" articles—Stirner wrote of man liberating himself and indulging in
conscious forms of egoism. Accordingly, man should recreate himself (that ever-
present term) by eschewing all forms of self-sacrifice, breaking loose of all bounds
of oppression, making conscious use of ego. Stirner perceived that oppression
was itself an illusion, that once man stressed his own ego such oppression fell
away. Stirner included in this vision everything the Modernist poets would attack:
religion, state, political ideology of any stripe, boundaries on man's "self-crea-
tion" of himself.

Marx saw the dangers of this kind of reading of Hegel, and he attacked
Stirner so as to distance himself from such extreme forms of egoism. He saw,
rightly, in Stirner's work not only antagonism to the state but also to organized
labor. Nevertheless, despite his eventual hostility to Stirner's egoism, Marx was
himself moving along a broad area of self-process, in his case toward organizing
that "self" in society. Even as he came to mount his polemic against Stirner,
Marx touched on the self-expression of the artist, whom he foresaw in some
future society as unconnected to any definite art; everyone will be free to express
himself as an artist. This is, also, an ego philosophy.

It is possible, I think, to trace in mid and later nineteenth-century political
thought—Hegel, Marx, Stirner, Proudhon, Bakunin, Herzen—uncanny par-
allels to the development of Modernism in the arts. That is, by following through
on political ideas, say, from Kant through Marx and Mill, we can discover many
of the same points established there that we find running through more advanced
forms of Modernism. This is not in itself so surprising, since one of the tenets
of this study is that all areas of knowledge underwent comparable shifts toward
self, ego, liberation, negation, creativity. Opposing Marx, or, perhaps, opening
up Marx, Mikhail Bakunin, for example, offered an ideological anarchy that
curiously parallels what we have seen in Rimbaud and Lautréamont. When
Bakunin applied his ideas of starting over—by way of negating everything that
had come before—the bourgeois assumptions of Marx are revealed. For despite
all his attacks on bourgeois culture, Marx saw continuity between his vision of
a new society and the matrix of the old. He may have spoken of revolution, but
he foresaw evolution. As a true Modernist, Bakunin advocated negation of the
old, the emergence of the new not as evolution but as revolution. He labeled
all forms of organization as authoritarian, and he stressed individual disengage-
ment. Avant-gardeism would become a way of political life. As in Modernism,
individual effort at emergence and/or liberation was sufficient statement. Bakunin
is our Rimbaud of early political Modernism. Not surprisingly, Marx had him
expelled from the First International, in 1872.

If we shift to a contemporary "politics of music," Wagner's musical drama
was also a form of ego worship, in which the composer perceived that he, a

hero conceived of as Siegfried, would redeem a base, materialistic culture. Associated with that base world were Jews and the French, and Wagner saw his mission as purging German music and thought (he was his own librettist) of these pernicious influences. This would seem to set Wagner against Modernism, but, in fact, he was an integral part of it; for his mission was premised on purely egoistic terms. Further, by *Parsifal*, he conceived of his role as a Christian knight purifying both art and artist. He would negate those who produced pseudo-art and seek creativity through the unfolding of his self into its true realm. Nietzsche foresaw the dangers and tried to blunt this aspect of Wagner, but in point of fact Modern passed its threshold with these very ideas.

◆ Chapter Three ◆
1885–1900: First Phases—
Issues and Novelties

TOYNBEE AND DEGENERATION

WITH THE YEARS 1885–1900, we enter the first major phase of Modern and Modernism. It was, also, the era Arnold Toynbee labeled "postmodern." This term, for us, has gained currency as descriptive of the post-Joyce age, those developments that characterize the arts after energies of the Modernist movement have dissipated themselves, when deconstruction, decreation, and atomization are the main qualities of our art. Toynbee's sense of the term was entirely different and, not surprisingly, totally negative. He used "postmodern" almost in the way Spengler would use "decline" and Nordau "degeneration." Postmodern was for him an era when a rational, orderly society had given way to one in which sensation and emotional forces were unleashed.

Western civilization prior to the 1880s, it was thought, was continuous with earlier stages of progress; but Toynbee located a new spirit in the air which he felt was destructive of most civilized elements. A society intent on amelioration, technological advances, growth of humanistic values Toynbee equated with modern; but postmodern was the end of things, the transformation of an orderly society into anarchy. His term has something of the apocalypse we find in Yeats's rough beast slouching toward Bethlehem, a new lunar phase in which anarchy is loosed.

Postmodern was a reversion to primitive savagery in human relationships, mainly because in the "post" era mind and rationality had succumbed to emotionalism and unreason. The very elements Freud would make the basis of his psychoanalysis were those identified by Toynbee as foreshadowing downfall. It was not only the literature of the age or its arts that subverted Christian humanism but the development of sociology, psychology, and other disciplines. These "distractions" were abuses of civilization, and their foundation could be placed in the final quarter of the nineteenth century, becoming more pronounced toward the very end.

80

For Toynbee, the abusers of civilization, the "postmodernists," were those we have identified as the leaders of Modernism: the avant-garde artists, Nietzsche as philosopher-historian of the era, Freud and those who nourished his ideas, Durkheim in sociology. Toynbee's characterization was accurate as far as the intentions of the avant-gardeists were concerned. To abuse civilization, to serve as demonic agents of change, to create forms of anarchy (which is not identical with forgoing form) were for them acts of purification; for Toynbee, fouling one's own nest.

Our pivotal Modernist, Nietzsche, hailed the new and decadent as a means of cleaning out the corruption of former cultures. But for Nietzsche, who made fine distinctions and spun careful paradoxes, there must be a true decadence. The latter is associated with all those matters of will that lead to negation, opposition, subversion; what he gathered around the term *ressentiment*. This was for him a valid protest against the very society Toynbee would identify later as the crux of civilization. Toynbee's postmodernism, which is negative and destructive, was Nietzsche's *ressentiment*, which was positive and constructive. What was for one an act of death was for the other a validation of life.

In 1885–1900, battle lines were drawn, and infighting became savage. It was an age of manifestoes, intended to stake out avant-garde lines, and countermanifestoes, intended to identify and strike down the avant-garde.* At issue in the fire and smoke of words, paint, and manifestoes was the very sense of civilization itself. Even as the avant-garde artist began to cut himself off, apparently, from all the sources that once fed art, so those defending another kind of culture went on the attack. The "new artist" reveled in defining for himself a legendary place where only he belonged. As seer or *voyant* or voyager, as one who punishes and is punished, as role player unique and inviolable, he becomes a one-person avant-garde. Baudelaire's "Heautontimoroumenos" is prophetic. His desire is "Like a proud ship, far out from shore. / Within my heart, which they'll confound / With drunken joy, your sobs will sound / Like drums that beat a change in war."

Half a century before Toynbee, Max Nordau described Modernism as corruptive. His *Degeneration* (1892), which we now see as insane distortions but which was then accepted as vatic, was dedicated to Cesare Lombroso, the Italian professor of forensic medicine who developed the pseudo-science of identifying criminals and insane people by facial structure and head size. Appearance was, for him, a method of character analysis. But even Lombroso, his "dear and honored master," fell short of Nordau's needs, for the Italian only pursued degeneration into human personality, not into culture. Nordau reviled an entire era: "Degenerates are not always criminals, prostitutes, anarchists, and pronounced lunatics; they are often authors and artists."

Just who were the Modernists who drew such venom, and what were the issues that created such fear? The single most significant figure in this pre-

* The response of Edouard Drumont is not atypical. His two-volume attack on Jewish finance *La France juive* (1886) and his newspaper *La Libre Parole* (founded in 1892) were ostensibly exposures of Jewish connivance to subvert French honor. But these publications as well as his National Anti-Semitic League (1889) were really assaults on Modernism itself as the adversary of a strong France. The Dreyfus case flowed naturally from these circumstances.

Freudian era, the one who more than any other perceived the meaning of the past, the moment, and the future, the man with historical grasp who saw the failures of history, was Nietzsche. The very appearance of Nietzsche's philosophical thought on the printed page is an effort to present a Modernist poem or novel, or a dramatic work. Always aware of roles, Nietzsche dramatized his philosophy—he is a more wide-ranging Ibsen, a more ironical Strindberg—and its appearance is not that of the continuous waves we associate with Kant or Hegel, but the seemingly discontinuous "pieces" or images we find in the *symbolistes*. His irony is analogous to that of Baudelaire, Laforgue, and Mallarmé; and, like them, he forged another language, one of appearance and one of reality, the latter shaded by the former. To read Nietzsche, one must comprehend what Valéry called a language within a language. Whatever we call Modernism or define as "the modern spirit" finds Nietzsche in attendance.

Possibly Nietzsche's preeminent insight which makes each of his works an avant-garde of Modernism was his profound sense of bankruptcy. The dominant society stressed the very real values of progress, technology, scientific discovery. Man was beginning to enjoy a better life, especially as medical advances (anesthesia, sanitation, hygiene, pasteurization, discovery of antibodies for killer diseases) decreased infant mortality and prolonged adult life. Statistically, one could measure progress, not simply profess it. Yet all of this activity was for Nietzsche physical energy which had little to do with true energy, which was psychological and psychical. Although not caught up in the spiritual and theosophical movements of the 1880s which Yeats—who was reaching comparable conclusions—found so compelling, Nietzsche understood that "another life" existed. In a foreshadowing of the Freudian unconscious, Nietzsche writes of that other world where physical energy has been transformed into psychical energy. That energy within was the source of a reality that, like a Platonic ideal, lay beyond physical dimensions; and that psychical energy could be released as drives, impulses, forces.

To describe the myriad ways in which one could get beyond physical energy—that is, move beyond progress and the values of a bankrupt civilization—was to limn the ways in which man could grapple with life. Science untransformed into such inner energy was a form of death; desire for such empty truths was a deformation of human need. The latter, as Nietzsche defined it in *On the Genealogy of Morals*, lay in that "other" where primitive or aggressive instincts were manifest, but whose drives had been weakened by civilization. We can see, only with this, how much Freud's sense of primitivism and civilization derived from a Nietzschean formulation. For all its benefits, civilization meant a dilution of a life that demanded fuller expression. For Nietzsche, any act of suicide, display of suffering, manifestation of illness were forms of dying which led to transformation; not final acts, but parts of a process through which man could save himself: "Man is something that must be overcome." With this, Nietzsche was struggling toward a vision of the unconscious. But this was not an element that could be understood and dealt with; rather, it was something that must be allowed to express itself as an act of life. One must live to the moment as if it would eternally recur. ". . . how well disposed would you have to become to yourself and to life *to crave nothing more fervently* than this ultimate

eternal conformation and seal?"* To embrace eternal recurrence opens one to the possibility of becoming an Overman.

Nietzsche was, in one sense, the synthesizer of several ideas that had been developing in the nineteenth century, ideas that stressed will (Schopenhauer) and the affinity of the body for magnetic forces (Mesmer and his followers). Nietzsche straddled questions of will, writing ironically of one's love of fate. One must confront, as we have seen, what he calls *Das grösste Schwergewicht*, a phrase of considerable ambiguity. The phrase can be translated as "the greatest weight," but it is also stress, in the sense of weight overloading something, or, in another sense, as emphasis. It is, in human terms, a form of fate, something laid on. Like so much else in his philosophy, it is on the edge of the Faustian pact, where doom lies furtively behind every offer of salvation.

Nietzsche's great discovery throughout his bouts of illness, physical and mental, was of forces of energy released, catapulted out, which had the effect of quanta. His emphasis on primitive drives was an attempt to move directly into that world, the *das Es* of his terminology becoming Freud's "id." What is remarkable about Nietzsche's various personae in his books is their affinity with the "cursed" poets of an earlier and contemporary generation and with the subjects of Freud's later case histories. Teetering on the edge, Nietzsche in the 1880s so blurred lines between sane and insane that he embodied Modernism: an avant-gardeist whose energies clearly threatened not only stability but sanity itself.

If we construct a metaphor, we can see Modernism as a kind of explosive waiting for its detonator, the explosive being dimensions of mind, energy, and powers that in the main lay untapped. Instead of a fixed being rooted in a time and period, Nietzsche envisaged an individual whose mind was a bomb ready to explode. As against the "last man," whose aim is to survive under any conditions, but who in the process trammels everything of value, Nietzsche offers the postatomic man, as it were: "You must wish to consume yourself in your own flames; how could you wish to become new unless you had first become ashes!" Zarathustra adds a little later: "Die at the right time," for "He that consummates his life dies his death victoriously, surrounded by those who hope and promise." Such death is for those who "cease letting . . . [themselves] be eaten" when they taste best. They are not food for others, but are those who ripen at their own pace and rot when they are ready. Some "rot already in the summer," but they have spent too much time on the tree—that is, they have died before they have lived. Nietzsche's metaphors of food and of the "tree of life" in passages of death presuppose that death—whether of the individual or God—is opportunity, not finality. What Zarathustra rails against is that man shows his love for God by crucifying man. Thus, as corpses "they meant to live." God, too, "has his hell; that is his love of man," and

* It is possible to interpret Nietzsche's "eternal recurrence" as determinism, not freedom, what in *The Gay Science* (section 341) he calls "the greatest weight." In this view, one is a slave to the past, to the recurrence. But I think Nietzsche meant something quite different: that "the greatest weight" or recurrence is what each man must confront, connected as it is to "amor fati," or love of fate. From that confrontation, which only the superior man can comprehend, will come a strengthening of will, that disgust for the weak and pitiful which Nietzsche defines as an early step in becoming strong.

"God died of his pity for man." The energies of Modernism, its trafficking with negation, death, nil, its apparent denial of all that emanates from a progressive society, its stress on rapid change are encapsulated in Zarathustra's apothegms.

If Nietzsche is our linchpin of early Modernism, who was propping him up and who succeeded him? Schopenhauer and Wagner, obviously, weave in and out of influential positions, and, in Wagner's case, there is the rethinking of opera and its presentation so as to create a synthesis or a new art. Thus, Nietzsche had to respond not only to Wagner's ideas but to their form, where innovation and musical genius could not be argued away. We have already mentioned several others, some more obviously Modern than their contemporaries, many of them, like Baudelaire, curiously caught between old and new. We note, indisputably, Rimbaud, Lautréamont, Mallarmé, whose life and work extend well into this first phase. In fiction, Flaubert straddled both older forms and newer ideas, and in *Sentimental Education* and *Bouvard and Pecuchet* threw in with early Modernism. His Frederic Moreau, with his sliding in and out of episodes, his shifting from one sense of himself to another, his refusal to be identified within any fixed role, is a pre-Modernist protagonist, although forms and language of the novel are not innovative. The Flaubert novel, while not avant-garde, is part of early Modernism which suggests that falling away from traditional mimesis.

Early Modernists are spread everywhere. All Europe, as I suggested above, fed into it. Ibsen among playwrights is clearly a standard-bearer, although the forms of drama would not change with him; that would come with a later contemporary, Strindberg. Marx was a paradoxical Modernist, for his theory of alienation has a richness and complexity that goes well beyond his primary sense of it with worker and his work. In painting, the impressionists (not a school, hardly a movement, often grouped merely for purposes of exhibition) indicated that break with academic art which was the quintessential avant-garde, and their role in middle- to late-nineteenth-century painting was profound. Those who derived from that break, such as Van Gogh and Gauguin, carried art into splinter groups, avant-gardes that changed every five or ten years; so that by the 1890s, we have "eras" in painting measured in less than decade changes. The greatness of Picasso can be measured, then, in his ability to intuit when a movement was dying and it was necessary to move on. *Les Fauves*, under Matisse's heavy influence, were the direct outcome of these shifts in color, intensity, shapings, as were the German expressionists forming at about the same time.

Not less significant than those exploring color and canvas were those in the "physical world," such as Planck and Einstein. What is so remarkable about Modernism is how we can see, in retrospect, a broad wave in every field of knowledge brushing away the past. That is, the past is perused for what is useful and then made expendable. Einstein's four papers in 1905 were more than a breakthrough to new views of time and space: they assimilated that sense of reordering the way we see which was intrinsic to the artists and theorists of Modernism. Apart from the technicalities of his demonstration, Einstein had achieved a reorganization of the way we observe the universe; in physical terms

as well as equations, he had, as it were , recolored the canvas. As a consequence, we had different visual, aural, and experiential senses of things.* Similarly, Freud was boring under, as much as Einstein was spreading outward. Each was an archaeologist of sorts, Freud peeling away to get at inner languages, Einstein peeling away the seemingly untouchables of older physics to create a new language of light, energy, mass.

Paralleling this massive work in physics, mathematics, and astronomy was tremendous activity in territorial acquisition, population growth, production of goods in the major countries. With its frontier finally secured, the United States openly looked for territories to annex—the Philippines, Cuba, Nicaragua, Panama. In the last thirty years of the century, Europe's population jumped by 100,000,000 and the American population doubled. Major European countries grabbed territory: Britain almost 5 million square miles, Germany 1 million, France almost 4 million; even smaller countries like Belgium were active. Per capita incomes rose, as did profits, and production of everything from steel to steamships increased geometrically.

These, too, are part of Modernism, although they are elements artists would disdain. Yet as rapidly as discoveries appeared in the social and physical sciences, whether quantum theories or Frazer's anthropology as a "phenomenon of consciousness"† or theories of the unconscious, Modernists assimilated them to artistic forms, in spatial ideas, African masks, color schemes, and temporal conceptions. The point is, always, reciprocity, the back-and-forth between a physical world the artists both rejected and, at the same time, absorbed as theory and practice. At no other time in history, except in the later seventeenth century, do we find such alternating attractions and rejections, hostilities and assimilations. As I have already suggested, it is impossible to speak of avant-garde arts without recourse to Modernists such as Durkheim, Sorel, Frazer, Freud, Bergson, Einstein, and other theoreticians of the nonartistic world; we can say that social and physical thinkers were themselves aspects of the avant-garde as much as were the creative spirits.

Below are listed the chief issues toward which the avant-garde directed itself in that critical staging area from 1885 to the turn of the century. The mise-en-scène included nearly all of Central Europe: Paris of course, Berlin, Vienna, Munich, Budapest; even London, where Decadence in this period was the shield behind which Modernism disguised itself. Yet of equal strength to the avant-garde was a countermovement. While the bourgeoisie, however defined, gradually accepted the idea of having an avant-garde, it opposed intensely its forms or styles and its implications of indefinite revolution. It is, in fact, impossible to comprehend the almost desperate thrusts of the avant-garde without taking into account the equally desperate thrusts directed against it. I have already

* Further, in the economy of Einstein's formulas—$E = mc^2$ being the quintessential formula of the twentieth century—we note a poetic dimension, even the imagist's eye for concision and trenchancy of language. His shaping of the physical world in such economic formulas has the acuteness of metaphor. One looks for an analysis of Einstein's mathematical style as an emblem of his Modernism.

† Frazer's words in 1894 were an obituary notice for traditional views of religion as each claiming the truth; there is no absolute truth, only the fact of worship itself. He wrote: "The idea of regarding the religions of the world not dogmatically but historically—in other words, not as systems of truth or falsehood to be demonstrated or refuted, but as phenomena of consciousness to be studied like any other aspect of human nature—is one which seems hardly to have suggested itself before the nineteenth century." The Golden Bough had already appeared, as a two-volume work, in 1890.

mentioned in passing Max Nordau, and the importance of his book *Degeneration* as a summa of the countermovement; but he was only the tip. With culture, civilization, history, the future of man himself at stake, we can understand the ferocity of the backlash.

Since ideologies in the last hundred years have not changed so much as moved in cycles with different labels, it is not unusual to find that the countermovement then was not dissimilar to the countermovement now. The opponents of avant-gardeism, of Modernism in any form, addressed themselves to familiar subjects: a culture of sex and sexuality, withering of the individual's role and of his moral fiber, intense nationalism (America and the Soviet Union today have their counterpart in France and Germany in 1885), racial questions (black-white today was Christian-Jew of a century earlier), the effects of a technological society and the resultant loss of moral/ethical issues (Henry Adams's virgin/dynamo), materialism as a singular goal, the search for a God—any God, the need to believe in something.

By concentrating momentarily on Max Nordau and Otto Weininger, we can see that the obverse of Modernism was degeneration. The focal points of most theories of degeneration were twofold: opposition to the "new woman," who was insistent on alternate roles, and formation of racial theories of inferiority; both points are linked by sexual theories of inferiority and perversity. Thus: women, race, sex; then, as now, volatile subjects when the focus of "revolutionary" ideas. Part of what makes Nordau and Weininger so compelling is not the validity of their theories—however seductive they seemed at the time—but the fact that both were Jews (Nordau as a leading Zionist) rigidly opposed to everything Modernism offered, whether progress or avant-gardeism. In some limited respects, we can see the struggle as good Jews against bad Jews: Nordau, Weininger, and those like them arrayed against Marx (in part), Bergson, Durkheim, Freud. But of course larger issues were involved, for behind all of them lay Darwin, the *symbolistes*, Nietzsche, and other major figures who were non-Jewish; so that what appears to be a Jewish struggle about culture is really a European drama played out on the largest possible stage.

While Nordau and Weininger were concerned with degeneration, the racial theories implicit in their ideas were developed by non-Jews, although there was no clear dividing line between those who foresaw decline of civilization and those who attributed that decline to the prevalence of Jews (i.e., Wagner, Gobineau, the anti-Dreyfusards, etc.). As the theory broadens, it includes sexual matters—for example, Krafft-Ebing's sexual deviants as "degenerates"; and when that occurs, Jews are absorbed into issues that go well beyond race or religion. In retrospect, we can see that theories of degeneration were the doom of Europe's Jews.

Men like Nordau (in *Degeneration* and in the earlier *Conventional Lies of Our Civilization*) and Weininger (in *Sex and Character*) would build large edifices on what they perceived as the changing relationships between the sexes; with Nordau stressing degeneration in art and culture as well as in traditional relationships, and Weininger focusing on what he felt was the destructive growth of the "Lulu" figure. What Nordau denies to modern culture as a whole, Weininger denies to modern woman. For both, the foundation of culture was a stable, traditional, unchanging relationship between a superior male figure and a subservient, childbearing female figure. This resembles Nietzsche's point about

women and their suitability for house and kitchen, but after their common assumption of female inferiority to the male, they begin to part ways. Nordau deals with a much larger sense of culture than does Weininger and, as a consequence, moves beyond purely sexual matters. And Weininger, for his part, once he momentarily forgets his diatribe against women, embraces some aspects of Modernism: i.e., Zola, at least the subversive Zola.

Nordau felt he was like the Dutch boy with his finger in the dike, single-handedly holding back the deluge. In another guise, he is a Noah figure, chosen by God to save the race; in his instance, by identifying what was consuming its vital energies. Central to this conservation of energy and its use, not misuse, is sexual stability: normalcy in and outside of marriage. "Marriage is a high advance from the free copulation of savages. To abandon it and return to primitive promiscuity would be the most profound atavism of degeneracy." Marriage, Nordau insists, was instituted not for the man, but for the protection of the woman and child. "It is a protective social institution for the benefit of the weaker part." He sees marriage as partnership, based on "reciprocal inclination, maintained by confidence, respect, and gratitude, consolidated by consideration for the offspring. . . ." His view of marriage, for the time, is not lethal, but traditional, giving the woman no other outlet but her husband, children, home—what we find, also, in Nietzsche.

With Weininger, stability depends on his obsessions. He fixes on female degeneracy and inferiority, with women aspiring to levels that morally and mentally they are incapable of achieving. What gives his maniacal book its energy and force is his enormous need to convince himself; so that he keeps intensifying his thesis not to make his point but to prove that his thesis is indeed tenable. Weininger's point of takeoff appears to be the character of Kundry in Wagner's *Parsifal*, the fallen, sinful woman waiting for a pure man to redeem her. She becomes the archetype of all women. When she is redeemed by the pure Parsifal, Weininger foresees the future path for mankind, as against the contemporary way of the emancipated, hateful, Ibsenite, Strindbergian woman. Weininger is compelled, by his own tastes and extremism, to emphasize the "moral" woman and to create a moral relationship between the sexes. What he cannot interpret, however, within his own theoretical frame of reference, is the obverse of *Parsifal*, which is the legend of the Flying Dutchman, wherein the eternally wandering Dutchman can be saved only by a pure woman. Where does this woman come from? How can Weininger explain her origins and presence? How does she derive from Lilith and Eve?

With Nordau and Weininger—whose ideas Bernard Shaw vigorously opposed—we go to extreme positions which, nevertheless, found a receptive audience. Nordau's identification of artists with cultural degeneracy is of the same pattern as Weininger's identification of women with moral degeneracy. Artists, if they can be saved, will gain salvation through embracing the logic of the natural sciences; women, who really cannot be saved in Weininger's world, can be given some balance through a virginal man. Weininger sees woman as "devoted wholly to sexual matters, that is to say, to the spheres of begetting and of reproduction," an echo of Nietzsche's view, although the latter could not explain away a woman such as Lou Andreas Salomé. Since the female is occupied and content with sexual matters, the male branches out to "war and sport," "social affairs and feasting," "philosophy and science," "business and politics," "religion

and art." Man is only partly sexual, and this difference reveals itself in various ways, all to the detriment of woman, who is monolithic as against man's many-sided nature. Therefore, women must be protected against themselves, inferior as they are in their needs. Weininger, in fact, denies women a soul.

> In such a being as the absolute female there are no logical and ethical phenomena, and, therefore, the ground for the assumption of a soul is absent. The absolute female knows neither the logical nor the moral imperative, and the words law and duty, duty toward herself, are words which are least familiar to her. The inference that she is wanting in super-sensual [supra-sensual?] personality is fully justified. The absolute female has no ego.

With no ego, no moral will, no soul, no ethical component, the female wanders the earth both a potential and an actual destructive force.

Weininger, however, goes further than denying woman a moral or ethical center. He attacks her physical being, asserting that her beauty or purported beauty is "disfigured by her genitalia." He says: "But even in the details of her body a woman is not wholly beautiful, not even if she is a flawless, perfect type of her sex. The genitalia are the chief difficulty in the way of regarding her as theoretically beautiful." Weininger's main point here is that when a man is obsessed with a woman, it is not the result of her physical beauty; the sexual impulse, however powerful, is not directed to her beauty but to the fact, merely, that she is a woman.

Obsessions and personal tastes aside, this is an element of great significance to Modernism, for if we look ahead to Proust's Swann and his domination by Odette, we can see how "modern love" had developed; or if we look at Weininger's contemporary, Wedekind, with his Lulu, we can see that the beauty of woman is not the issue. That has become a quaint nineteenth-century notion. Beauty has given way to femaleness itself; man is not obsessed by a lovely woman, but by a woman he may not even like, as Swann with Odette. He throws himself at her, desires her to destroy him, debases himself with her, forgoes all societal impulses in favor of personal needs. She represents not loveliness but allure: scent is more significant than sight. The man's senses are alerted by her presence rather than by her attributes, in which she may be significantly lacking—Baudelaire with Jeanne Duval, for example. In fact, her attributes, such as they are, may be negative factors. We are close, of course, to Krafft-Ebing's description of "psychopathia sexualis," to Freud's clarifications of fetishes and obsessional neurotic patterns, to Sacher-Masoch's Venus in Furs, to the array of masochistic and sadistic drawings, sketches, and portrayals that filled contemporary magazines. One need only cite the artwork of the Viennese Secessionist journals or its posters.

These are all conceptions that Krafft-Ebing identified as diseases, outside of moral choice, and therefore to be treated as pathology. Whereas artists perceived these new conceptions as a breakthrough, Weininger—and Nordau in most of these areas—saw them as breakdown, as did Toynbee later with his designation of "postmodernism." Such accusations extend far indeed from Thoreau's midcentury indictment of civilized behavior and mores, Carlyle's desire to relocate modern man in medieval times, Ruskin's stress on Gothic and its incompleteness as sign of living things, to Henry Adams's contemporary dis-

tinction between dynamo and virgin. These seemingly disparate matters have affinities with the later Wagner, the Wagner of the final stages of the Ring and of *Parsifal*, obsessed as he became with Christian redemption as the source of man's strength.

Weininger's assault on feminism and feminists, however, is special. His is the classic example of Jewish self-hatred, which extends to every aspect of life of which he is a part. Consequently, the attack on women is associated with the so-called womanish aspect of himself—his own sense of himself as a weak male; his attack on Judaism is part of his low estimate of himself as a Jew; his opposition to the Zionist movement is to remove heroism from Jewish affairs, so as to justify his own low profile as a Jew; his assault on whatever he feels to be degenerative is connected to his own need to defend the true faith, a kind of Knight Templar of the modern spirit. Weininger has located in himself all these weaknesses and then projected them on society and culture, using women as his chief scapegoats. Modernist artists accomplished the obverse. Searching out personal weaknesses, projecting those weaknesses as salient ingredients of their culture, they constructed alternate modes of perception. Weakness, thus, becomes not a source of debilitation, but a source of new sight, new sensory experience, new experiences.

"Our age," Weininger wrote, "is not only the most Jewish but the most feminine." We hear the voice of Bismarck, the anti-Dreyfusards, Hitler.

> It is a time when art is content with daubs and seeks its inspiration in the sports of animals; the time of superficial anarchy, with no feeling for Justice and the State; a time of communistic ethics, of the most foolish of historical views, the materialistic interpretation of history; a time of capitalism and Marxism; a time when history, life, and science are no more than political economy and technical instruction; a time when genius is supposed to be a form of madness; a time with no great artists and great philosophers; a time without originality and yet with the most foolish craving for originality; a time when the cult of the Virgin has been replaced by that of the Demivierge.

In these remarks, we have that hatred of avant-garde Modernism and scientific or technological progress which has pervaded Western culture for the last hundred years, and Weininger's sense of it is astute, however limited. As I write, there is, once again, an attack on the evolutionary theories of Darwin as an explanation of the beginning of human life; with "creationists" arguing for a biblical or neobiblical point of view as coequal with (actually superior to) evolutionary doctrine. While the debate in court is about evolution, it is really about Modernism, although the lines of thought have become hopelessly entangled. The creationists have equated scientific explanations with Modernism, i.e., the work of satanic forces which will brainwash their children and turn them into nonbelievers. Here, in this distorted sense of things, modern science and Modernism become synonymous, although in the development of the latter, science was usually perceived as an inimical force. For the evolutionists, in their defense of evolutionary theories, science, progress, and Modernism are equated; or at least viewed as part of the "modern world" and its culture. Once the lines have become so entangled, the entire idea of Modern and Modernism is corrupted, since the rush to support the "progessive" evolutionary theory preempts any desire to straighten the true lines of Modernism.

Weininger, and Nordau in his views, perceived Modernism in that confused way. By arguing that a "woman's demand for emancipation and her qualifications for it are in direct proportion to the amount of maleness in her," Weininger was directing the debate to questions of authority, to cultural fears of anarchy in family and home, to the ever present Eve factor in the male mentality, and, finally, to the paranoia that the state itself was threatened by an uprising from half of the population. The arguments have since become familiar. Weininger regarded women as succubi, seeking out unsuspecting men and then, as Amazons or whores, corrupting them. ". . . what is of real importance in the woman question [is] the deep-seated craving to acquire man's character, to attain his mental and moral freedom, to reach his real interests and his creative power." He adds, "Those so-called 'women' who have been held up to admiration in the past and present, by the advocates of women's rights, as examples of what women can do, have almost invariably been what I have described as sexually intermediate forms." Weininger cites Sappho, Catherine of Russia, Laura Bridgman, George Sand, Queen Christina of Sweden. The female devours, sucks out man's energy, takes over his form, lives in his body, and yet all the while poses as a female. In literature, Strindberg's various portrayals of his wife, Siri von Essen,* fit well into this precise pattern; as do Ibsen's Anitra, Kokoschka's "murderess," Wilde's and Strauss's Salomé, the latter's Elektra, Wedekind's and Berg's Lulu, Klimt's Judith, and others.

But the woman need not be so obvious to fit this scheme. She may be Ibsen's Nora, Hedda, Rebecca West, or, particularly, Hilda Wangel. Hilda (in *The Master Builder*, 1892), it is true, arrives at an already troubled home. Halvard Solness and his wife, Aline, have entered a phase of their marriage in which only the past holds them together. Their home life is sterile, its chief feature appearing to be three nursery rooms which remain empty. In the background, we learn, are twin boys who died very young, apparently from Aline's milk, which was affected by her illness. But, more significant, the "illness" in the household is Solness's paranoiac fear that the younger generation (the avantgarde) will replace him; he must be ever vigilant and ruthless in order to hold back the hordes of youth who are out to seize his architectural kingdom, his life itself. Also in the background is a fire that destroyed the house in which Aline Solness grew up, the fire providing Solness with his start as a master builder. Although he did not set the fire, he knows he wished it, and it has become the "fire" of his ambition. His personal life has been sacrificed to this ambition.

Now even his professional life as a master builder is being threatened, from within his office by Ragnar Brovik and from without by that gathering younger generation. Into this scene of frustration, threat, fear, and anxiety comes the young Hilda Wangel. Her costume of touring—mountaineering clothes, knapsack, and alpenstock—suggests her association with openness, as against the closed, stifling quality of the Solness household. She speaks of immensities, of breaking out, of castles in the air, of a master building massively and climbing to great heights. She is the spirit of trolls and mountains, and she tries to infect Solness with her vision. She brings home youth to him, the youth he has feared but which, now, seems to offer support.

Her effort to transform this anxiety-ridden man into a heroic figure is of

* Strindberg may have married Siri von Essen for her name: a vampirish woman named Essen.

course destructive; and she is, in her way, a yearning Lulu. Her female presence galvanizes Solness into actions that his age, position, and disposition cannot sustain. By climbing the tower at the end, he tries to reach things that are beyond his grasp. While everyone else is horrified, Hilda cheers him on. "Now I see him great and free again," she exults. "Hurrah for Master Builder Solness!" she shouts just before his body comes crashing down and is smashed in a quarry. Hilda is undismayed. In triumph, she cries out, "But he mounted right to the top." Her words end the play: "My—my Master Builder!" As the rejuvenator of Solness, she shows him a heroic path that must destroy him even in his moment of triumph. She is Eve in disguise, tempting him to try the fruits at the top of the tower, and then exulting in his fall. She survives him, ready to move on to different prey, the female principle of insatiable yearning, as against the exhausted, anxious male. While he suffocates, she offers immensities. While he falls to his death, she survives. This 1892 play has in it everything the supporters of the degeneration theory could acclaim. Nordau, further, saw Ibsen as intellectually weak, passing off a grab bag of ideas that came undigested from Darwin. He missed altogether both the irony and the grandness of Ibsen's vision.

A theme running through all degeneration theories is that the Modern Age has lost its belief in rationality. Nordau speaks of man's need to adapt to the total environment, since man and nature are governed by the same laws. Nordau found his ideas expressed earlier in Lombroso, Broca, Morel, all of whom in various ways regarded deviation from nature as signs of degeneracy. A decade before *Degeneration*, Nordau wrote a book called *Conventional Lies of Our Civilization* (1883), in which he offered natural science as man's guide for a stable and ordered existence.* He began, then, as a true Darwinian and Spencerian, that world which Freud would throw into disorder with his *Interpretations of Dreams*. We would expect, accordingly, that the female sensibility, however defined, would pose a threat to such a world. With some shifting of terms, women could be perceived as Lombroso perceived degenerates. Although the latter interpreted perversity on the basis of appearance and phrenological formations, other critics could shift appearance to sensibility and indict women for possessing a criminal soul.

The God of such theorists of degeneration and degenerative behavior was nature. The love of the artificial, which is such a strong component of Modernism, was perceived as a dispute with the very order of things. Huysmans' stress on the unnatural in *A rebours*, with its powerful influence on generations of writers afterwards, was nothing less than a plea for anarchy or unlimited revolution. Women were located in this world of the unnatural, since they lacked, in the eyes of the degeneration theorists, that total control and rationality given to men, literally given to them. There was, apparently, nothing women could do to alter this condition. Paul Julius Moebius argued that woman is intermediate between child and man, a circumstance that remains genetically fixed. Not surprisingly, Freud's letters to his fiancée, Martha Bernays, set her in this sphere, as helpful mate for her husband, unfit for anything that might

* Natural science, health, an orderly existence were all catchwords, thirty years later, of the so-called Fresh Air Art Society founded in 1913 by Joseph Conrad's friend Francis Warrington Dawson, but based on such disparate figures as Nordau and Teddy Roosevelt. Its key points (fourteen in all) stressed nature and reason, as against aestheticism, Modernism, modern life itself. Conrad refused to join, and the movement had a brief life.

tempt her innocence. Woman as Madonna was the sole alternative to a seductive Eve.

There was, in theories of degeneration, a terrible fear of sexuality. Sex was itself a means of perpetuating the human race, and tolerated for that; but *sexuality* became a question of ethics. Sex was necessary, sexuality an evil. One's attitude toward sexuality was in most respects the guide to one's rationality, as well as to one's usefulness to society. It could be argued that undue stress on certain forms of dynamic energy, on neurotic drives, on illness as aspects of energy— all of which degeneration theorists perceived as antilife—was, in fact, an intense kind of sexuality. In this regard, sexuality becomes obsession, passion, compulsive behavior toward one who may not even be loved. Swann's infatuation with Odette de Crécy is the culmination of a sexuality in which she is the source of his obsession, not liked or loved, simply hopelessly worshiped.

Sexuality was identified with mystery, which has usurped science as man's true guide; mystery is not unconnected to anarchy. Nordau associates mystery with those he calls *Ichsüchtigen*, egomaniacs or invalids who do not "see things as they are," who do not "understand the world, and cannot take up a right attitude towards it." The egomaniac is distinguished from the egoist who sees things as they are and is socially responsive. Sexuality for degeneration theorists was satanic, for it diverted energies from useful activities to matters with no social function. With a compulsive sexuality, the individual separates himself (or herself) from a comity or state and acts alone. His social energy, which should be the sum total of his personal energy, is dissipated. It would be interesting to speculate on what Nordau would have made of H. G. Wells, whose sexuality was compulsive and yet whose intellectual energy was spent on trying to remake society; degenerative on one hand, societal on another.

It is quite possible to see Freud's developing theories as ways of dealing with the social loss of energy through neurotic sexuality. By trying to allay neurotic drives, compulsive sexual behavior, obsessions well beyond the subject's control, Freud was diverting energy into useful functions, in the best manner of the degeneration theorists. He may have been anathema to them as the explorer of the unconscious, as the emperor or pseudo-scientist of neurosis, but in the larger sense, he becomes the conserver of lost energy, the doctor of society as well as of individuals.

This is an important point, this perception of Freud as, in part, the archenemy of true science, but also as the conserver of traditional forms of behavior by way of rediverting energy back into useful functions. In one sense, Freud was transforming sputtering sexuality into functional sex, which leads to stable personal lives, solid marriages, perpetuation of the race. In another sense, of course, he was opening a Pandora's box of sexual filth, permitting it to float out and corrupt purer souls. That opening up or unmasking was, apparently, perceived as the more evil purpose, and Freud and his epigones became celebrated for corrupting society, not for helping it to conserve. In a revealing letter to Lou Andreas-Salomé, Freud drew a distinction between the pathologically withdrawn man and primitive man, in which the sexual life of the former is perceived as part of breakup, that of the latter as continuous with the inner life. "The former [the pathologically withdrawn individual] arrives at these ideas [of regression and sublimation] in a state of inner disintegration, whereas in the case of primitive

man these ideas, despite their more illogical, plastic, 'dream-like' elaboration, are after all the living result of the healthy interplay of sexuality and intelligence."

In drawing out this distinction, Freud acknowledges that to speak of the sexual life of contemporary withdrawn man is to open himself to severe charges of venting terrible elements. Primitive man, whatever form his sexuality took, had some hint of holistic existence. Contemporary man has separated aspects of his life; and his sexuality, dissociated from other elements, is a forbidden, morbid subject. In this distinction, Freud views himself as a conserver, with sexuality assuming a societal, even holistic, function.

The break between Jung and Freud, in fact, apart from severe personality differences, derived from Jung's discomfort with Freud's insistence on the sexual etiology of neurosis; that is, with Freud's seeming lack of conservation of traditional energies and his dispersal of them in uncontrollable directions. Jung was, of course, an even greater conserver, his archetypes being modes of creating continuity and bringing tradition into line with contemporary psychological issues. His reputation would be based on associational studies. Freud's theories of sexuality, on the contrary, appeared to dissipate energies in the individual as a way of gaining insight into his problems. Jung's criticism here recalls degeneration theorists and their view of the unconscious. Such sexual research took Jung into areas he could not categorize, this very man whose own researches would become wilder and wilder, into mandalas and flying saucers; but researches, nevertheless, that he perceived as controllable and interpretable. As Jung wrote Freud in 1906: ". . . my upbringing, my milieu [Jung was working with uneducated insane patients, mainly those with dementia praecox or paranoia], and my scientific premises are in any case utterly different from your own. . . ."

We are not concerned here with the direction the association between Freud and Jung took, since it leads away from Modernism; and particularly away from the phase we are describing, in which theories of degeneration and antagonism toward women (and their sexuality) are intermixed, all as part of the opposition to Modernism. Once these connections have been established, it is clear that much of the material hanging on the development of Modernism can be molded to such associations. In this respect, even the Freud-Jung schism, mild and tentative at the start, increasingly bitter as their separation broadened, becomes germane. If Jung could not regard Freud's sexual theories as conservative, then, once we return to the 1890s, we can see how sexuality created fear of anarchy in far lesser mortals.

The degeneration theorists were obsessed not only with women and sexuality but, even more virulently, with race. Even here, Jung can be drawn in, since in later years he acquiesced to Hitler's Aryan theories; race, sex, women all mixed into a brew that was an antidote to Modernism. In other words, degeneration can be considered in a much broader sense, in racial theories of the nineteenth century: in Gobineau's midcentury "Essay on the Inequality of the Human Races" (1853–55), in Marx's diatribes against Jews, in anti-Zionist attacks that were really facades for anti-Semitism, in Wagner's rejection of "Jewish music," in theories of the inferiority of "foreigners" in general, which usually meant Jews in particular, in the anti-Dreyfusard arguments offered in the 1890s,

when such theories hardened and nourished rightists as well as "theoreticians" such as Nordau. *

Theories of degeneration, then, were often based on racial theories of inferiority: Jews in particular, foreigners in general (French cited by the Germans, Gypsies as open game for everyone, Italians cited by Northern Europeans, Slavs cited by Western Europeans). This citation of inferior races was part of a general awareness that traditional ruling classes had been displaced and that such displacement had been accomplished not only by Jewish bankers but by an alien culture: Modernism. It is precisely this alliance of racism and Modernism that Nietzsche endeavored to combat, and which, in a later generation, Houston Chamberlain and Hitler espoused, combining race and modern culture as aspects of degeneration. Yet even Nietzsche, who advocated an alliance of Jews and Prussians to infuse intellect into martial Germans, was as much a prophet of decline as he was of "overmanning" it. Decline was for him, as for Nordau, Weininger, then Spengler, associated with decadence. That word, as Richard Gilman has demonstrated, lost "any status it might have had as a moral, spiritual, or cultural term" as soon as it was connected with sensuality. So, too, Modernism lost its meaning as revitalization or transformation as soon as it was linked with decadence. The word "modern" itself became interchangeable with corruption when allied in the public's mind with breakdown; its next stage, that of "structuring," was dismissed. Modernism was regarded as the quintessential deconstruction.

The degeneration critics shrewdly debased Modernism by lumping it with elements society had agreed to oppose: feminism, racial equality, criminalism, anarchy, socialism and the radical left, disruption of family life, threats to tradition and custom. By establishing that equation, such critics could whip Modernism as a way of reestablishing historical traditions. The degeneration critics often parted ways on the kind of society they wanted, or even if they wanted any kind of society—Weininger, for example, seems beyond such social goals—but that was not the point; the point was their opposition to a word. Much of the real hatred of Dreyfus in the 1890s was displaced hatred of Modernism: over the kind of state one wanted and whether that state should run on traditional lines or be infiltrated, and nourished, by foreign ideas. If the former, one wanted Dreyfus (after the trial, a symbol, not a man) destroyed; if the latter, then one wanted Dreyfus found innocent and the French Army (and state) condemned as repressive. Once the lines hardened, degeneration, not Dreyfus, was the issue. Not for nothing were Proust, Zola, and Clemenceau allied, associated in the public mind with degeneration, even treason.

Gobineau had noted degeneration as the key element in European development as early as the 1850s—his friendship with Wagner did not come until the mid-1870s, too late for any direct influence. Gobineau associated three elements: degeneration ("the term is excellent," he commented), class, and blood. "Societies perish," he wrote, "because they are degenerate, and for no other reason." People wear down, and societies no longer have the same intrinsic value they once had. Blood is mixed, which is the source paradoxically of both

* Racial attacks were not the prerogative of the right or of royalists. Early nineteenth-century France was marked by socialist attacks on Jews as "conspiring Jewish bankers." Socialism and Zionism, of course, remained anathema to each other, and many socialist attacks on Zionism in the nineteenth century, as in our own century, were thinly disguised attacks on Jews themselves.

strength and degeneration. Traditional ruling or elite classes give way to the lower classes or rabble. A crisis arises, and there is no possible resolution: the result, a society in crisis.* Efforts at human unity, based on various social experiments, with their aim socialism or communism, are further signs of degeneration; cosmopolitanism was an additional enemy, as it would be for so many rightists. Migration toward big cities and the resultant urbanization of culture was encouraged by miscegenation. And while the mixture of blood often led to an infusion of energy into a dying culture, the miscegenation that resulted was also the source of degenerate behavior. From here to Lombroso's theories of criminality and Morel's stress on "mental degeneracy" is not far.

Gobineau suggested tragic potentialities in his recognition that Aryan blood was insufficient and that it needed an infusion of foreign elements. But he passes up the tragic sense of life—miscegenation as both life and death, what we will find in Faulkner's novels—in favor of, quite simply, an identification of crisis. Once he has defined the crisis, he is left with neither tragedy nor solution. Immobilization in the face of degeneration seems to be his aim, no less than Oblomov's in the face of progress. What is significant about Gobineau, nevertheless, is how progressivism, technological advance, movement toward perfection, all those ingredients of nineteenth-century civilization, nourished his sense of paralysis. By perceiving man within racial constucts, Gobineau did for racial theory what Darwin would do for evolutionary species. The individual counts for naught, since he is trapped within a deterministic pattern crcated by race. In Gobineau's view, man lies outside of moral designations because he is, as an individual, associated with race and blood, those predetermined patterns of racial identity.If he is so caught, then he cannot be held accountable for moral purposes. Here is, in one respect, Nietzsche's "beyond good and evil," foreshadowed by Gobineau in his racism and by Baudelaire in his theory of artificiality.

This strange admixture of ethnology with pre-Darwinian pessimism would have enormous consequences. For while Gobineau was himself taken over by the "Gobinists" and made to appear even worse than he was—a virulent strain of anti-Semitism was grafted on—by himself he identified a major preoccupation of early Modernism. This early strain was its degenerative potential, which in the avant-garde became an advantage, but which in its opponents as they hovered for the kill in the 1890s was a sign of its pathology. Modernism, thus, thrived on its opposition, as much as its critics thrived on *their* opposition. In this curious spiraling of hatred and misunderstanding, Modernist's critics were only one step removed from Gobineau's racial theories, and when totalitarian states went after Modernist art, they revived Gobineau with a vengeance.

In our day of course we read Gobineau in the light of Nazi extermination of Jews, Gypsies, and other "inferior" races. We find it difficult to disentangle his racial theories from what, ultimately, became of them in the hands of nations gone mad. But his racial theories, virulent as they were, were not the same as

* Although one may call a race by the same name it had during its time of heroes, its thinning out of blood has really altered that race: ". . . the name no longer connotes the same race" and degenerate man "is a different being, from the racial point of view, from the heroes of the great ages." The civilization allied to that race will die "on the day when the primordial race-unit is so broken up and swamped by the influx of foreign elements, that its effective qualities have no longer a sufficient freedom of action." Civilizations will fall because they have passed from the hands of those who founded them.

Hitler's, although they overlap. Gobineau, after all, saw nations' strengths as well as weaknesses from the intermixture of foreign elements. Nevertheless, his theory of degeneration is, like Hitler's, connected in a broader sense to his revulsion for modern life: "modern" both as progress and as avant-gardeism in opposition to progress. Gobineau is in that large category of haters who go beyond race to the entire culture itself, those who regard themselves as Messiahs. If we spread the net wide enough we catch figures as different as Carlyle, Thoreau, Tolstoy, Lawrence (both of them), Solzhenitsyn. Not surprisingly, several of our Messiahs were anti-Semites.

Gobineau's theory of racial degeneration has its later parallel in Krafft-Ebing's *Psychopathia Sexualis*. Krafft-Ebing perceived life as based not on chance but on natural forces: "The propagation of the human race is not left to mere accident or the caprices of the individual, but is guaranteed by the hidden laws of nature which are enforced by a mighty, irresistible impulse." Man's sexual nature must be sufficiently developed so that sensual indulgence is not his sole aim, but, rather, "higher motives" such as the desire to continue the species. Krafft-Ebing saw in sexual desire both the lowest (degeneration) and the highest, when sex serves "ideas of morality, of the sublime, and the beautiful." Whatever his noble aim, his study is a bible of pathology, as the title indicates; and many practices which we would hardly consider pathological—masturbation, oral sex, homosexuality—are treated as deviant behavior often connected to imbecility or diseased drives. *Psychopathia*'s importance, in 1886, despite its racier passages being in Latin, was its identification of certain energies with degenerative behavior. Pleasure, pain, emergence of the sexual drive, absence of it, its length, overabundance or underuse, all became associated with forms of degeneration or health. The individual, while favored, was fitted into a large cultural pattern, so that his sexual needs could be identified in terms of a society either declining or strengthening its resolve. Thus, sex and race blend, in that healthy sex and a healthy race free of taint will allow a society to prosper, not decline.

The terms sadism and masochism became common coinage from Krafft-Ebing's use of them, and while our own attitudes toward such practices and experiences have changed, they have remained as degenerative forms of sexual experience. Masochism, for Krafft-Ebing, derived from humiliation and mistreatment at the hands of a woman (not the physical pain thereof); such sexual pleasure came from something more primary than pain, which was humiliation by a woman. We note how Krafft-Ebing was firmly in the line of Morel, Magnan, and others who stressed mental degeneracy. He viewed all sexual practices that were not socially sanctioned as part of pathology; and in subsequent editions of his book he provided a nosology of perversions, including homosexuality, autoeroticism, fetishism, et al.

How can we connect this theory of sexuality, which is really a theory of degeneration and inferiority, to the development of Modernism? First of all, Krafft-Ebing's study was part of that venting of discussions of sex, especially of sexual practices, supposedly abhorred by the bourgeoisie; second, it and others that followed made possible a more explicit imagery in painting as well as in word; third, it furnished a point of attack on abnormalcy, however distorted, and simultaneously provided the base for arts that separated themselves from "normal" life; fourth, it allowed for more open expression by those who had

been cited as perverted: that is, so-called perversions became public and, eventually, more acceptable—Wilde's misfortune being the most obvious; fifth, and most important, it supplied a cornucopia of new themes, new kinds of behavior uninhibited by rational processes. Krafft-Ebing created a taxonomy of the irrational, and his work suggested an unconscious, which was gradually to assume such great significance in Modernism.

In the history of psychological thought, Krafft-Ebing, who as a forensic expert testified in court, stressed, like Morel, that psychological disturbance and sexual imbalance were associated; and yet, through it all, he based such disturbances on organic functions. Thus, his theory of degeneration started with body and led through mind and sex, where it had its outlet. What the racial degeneration theorists assumed about miscegenation, Krafft-Ebing assumed about sexual perversion: in both areas, degeneration and decline were perceptible. The West was going downhill. The avant-garde of Modernism, as its opponents saw it, was the agent by which such perversities were spread.

Whatever the ultimate effect of Krafft-Ebing's work, it ran counter to what the positivists—Modernists of another stripe—were telling the same audience when the book appeared in 1886. Positivism was a parallel force with Social Darwinism, utilitarianism, the growth of the social sciences and of historical determinism, the discrediting of Hegelian idealism and spirit. The new gods of that realm were Mill, Spencer, Marx, Comte, Taine; in fiction, Flaubert, Maupassant, Balzac, but especially Zola. Positivism became very daring when it entered fiction as naturalism and defied bourgeois moral canons; but it was, at the same time, old-fashioned for its reliance on principles of determinism, on cause and effect, on the physical aspects of man at the expense of psychological depth. Zola became a great novelist of surfaces, and even his most significant symbols—mine, dram shop, city—were solidly part of a naturalistic world, where rambunctious man is not allowed freedom, but is tied to causality.

The Modernist war was now on three fronts: the avant-garde, with the main body of Modernists not far behind; its vocal opponents among the bourgeoisie, the right, royalists, and some of the left; and the progressives, who regarded science and technology as the avatars of a better civilization. The opening up of the sexual unconscious, theories of degeneration based on racial inferiority, sexual pathology, and emergence of the new woman, advent of the avant-garde and Modernism in the arts, and positivistic progressivism had all, by 1895, coalesced.

By 1918, when Oswald Spengler's *The Decline of the West** first appeared and when avant-garde Modernism was beginning to run its course, the extreme individualization that characterized the movement was held responsible for the fall of civilization. Spengler asserted that the destiny of Modern life "lay in the race or the school," not in the private tendencies of individuals. "Under the spell of a great tradition full achievement is possible even to a minor artist. . . ."

* Paralleled by Karl Kraus's 800-page drama, also in 1918, *The Last Days of Mankind*, an apocalyptic epic of Europe's demise. Such tragic decline, he saw, was not of surfaces, but was part of the carnival that "raged within life itself." Kraus focuses on the moral decay of Vienna—Schnitzler's theme—and creates a riot of Brecht-like images demonstrating disgust, all in the ironic and sardonic voice of Kraus himself as commentator. As he observes it happening, civilization destroys itself. Perhaps not by chance, George Orwell's original title for *Nineteen Eighty-Four* was "The Last Man in Europe," an idea that reaches back to Spengler and Kraus.

Whenever individual achievement replaces schools or traditions, we enter a decline. Wagner was a particular villain, but Spengler could be speaking of all aspects of the avant-garde: "Everything merges in bodiless infinity, no longer even does a linear melody wrestle itself clear of the vague tone-masses that in strange surgings challenge an imaginary space." Motifs come up from "dark terrible deeps," so that this art "really signifies a concession of the Megapolis, the beginning of dissolution sensibly manifested in a mixture of brutality and refinement." Spengler speaks of three kinds of nihilism, of which the first, Faustian nihilism, claims Ibsen, Marx, Nietzsche, Wagner, all shatterers of religious, artistic, and political ideals.

The most fragile element here, because so isolated from power and social position, was the avant-garde, and it struck back. Its ferocity intensified as it gained ground in the 1890s, and Secessions, manifestoes, journals, the entire paraphernalia of visual effects, verbal displays, aural demonstrations subverted everything the degeneration theorists held vital for the survival of civilization. The struggle was on. European culture was in the midst of a huge convulsion, as one city after another rushed to clear away the past and step, however momentarily, outside of history. The avant-garde was the instrument of this extreme individuality.

LANGUAGES

To begin: The cornerstone of all efforts to reflect the unconscious, explore the irrationalities of sexual energy, stress the instinctual life, assault reason (not intelligence or understanding, however), mirror woman's "soul," attack tradition, custom, history itself, was language. For the purposes of art, languages had to be reinvented. We can cite Valéry's comment that poetry is a language within a language* or Rimbaud's obsession to "find a tongue," and say that *Modernism was a language within a language*. It was for the writer, painter, composer a second language. The artist had his own, a nationalistic tongue, and he had to acquire or develop another, that language of Modernism suitable for his particular genre. Only when he acquired that language did he become an avant-gardeist or Modernist. In one respect, the avant-gardeist had to be aware, initially, of all the linguistic conventions of his genre, what later linguists speak of as its *Vraisemblablisation*, or its cultural stabilizers and probabilities; then, he must upset those stabilizers in what becomes his own forms of expression, disposing of previous probabilities and opening up the linguistic medium. He differed from previous generations of innovators in that he had to destroy previous languages rather than draw upon them, or subvert language in order to demonstrate his own voice.

The manifestation of a whole subgenre, what Poggioli calls "graphic figurativeness," is related to the need to rediscover or recreate language. The most

* Or else Valéry's comment that literature is "a kind of extension and application of certain properties of language." This is an extension of Saussure's doctrines, so close to developments in the languages of Modernism, that matter or meaning is a residue of signifier and signified interacting. It leads, indirectly, into Derrida's later distinction that meanings cannot be derived, the sole derivation being what he calls *différences* or differences coming from interpretive processes that distill or reduce such meaning.

obvious here is Mallarmé's "Un Coup," but we can find an earlier form in Rimbaud's vowel poem; then later in Jarry—especially "The Surface of God," with its witty formulas of infinity; later, the futurists, Apollinaire, Pound, and others. The companion to these visual experiments is cubism, futurism, and abstraction in painting, and the music of Schoenberg, Stravinsky, Webern, Ives, and Berg. Reading, visual arts, and aurality are associated by way of a new synesthesia—what Pierre Reverdy would call a "plastic lyricism." A further revelation of this subgenre comes in the ballets staged by Diaghilev in the 1910s, a staging of every phase of Modernism.

The languages the artist needed to acquire were, in a broad sense, metaphysical, since they went beyond any spoken or written language of sight, sound, and understanding, existing outside or beyond the syntax of his own tongue. The ideas of William James, Bergson, and Freud, *and their languages*—whether James's stream of consciousness, Bergson's definition of new energies, or Freud's stress on unconscious motives—could be translated to aesthetic use only by way of the development of new tongues. What makes Joyce in fiction, Picasso, Braque, Kandinsky in painting, Stravinsky and Schoenberg in music quintessentially modern in their respective genres was that they "heard" languages that had not existed before; and once heard, these languages were not associated with previous ones, but were given vocabularies, rules, syntax. They were shaped as carefully as any regular spoken language, with the one caveat that they existed, usually, in only five- or ten-year spans before passing into mutations or oblivion.

As an analogy: In the nineteenth century, a group of philologists, for example Bopp, Grimm, Schlegel, Rask (a Dane), found affinities among languages, grouped as Indo-European, that had nothing to do with discourse. They set out to make language "visible," which means they cited syntax, roots, affixes for language *which had little or nothing to do with meaning*. They created, so to speak, another language, which had significance only in linguistic studies, not in literature or in regular discourse. Their substructure was a language beyond that which we use to read or to write; and their researches provided another order of being which lay outside representation, poetry, image-making, metaphor, or whatever we consider the function of language to be. Many Victorian scholars and philologists of other persuasions considered their body of work to threaten the very existence of order. Here, linguistic studies become an early avant-garde warning system. Foucault captures that threat or subversion of order when he says that each language has "an autonomous grammatical space"; and that it is possible for these spaces to be "compared laterally, that is, from one language to another, without its being necessary to pass through the common 'middle ground' of the field of representation with all its possible subdivisions."

The important element here is that a language exists outside of the language we take for granted in discourse. And even if we do not fully accept Foucault's point that such a linguistic science must be treated phonetically as a "totality of sounds" liberated from the letters used to transcribe them, these views set sound (or "color") against letter. With this premise in mind, we can see that writing and language are antithetical; that discourse and linguistics move along different axes. Our aim here is not to pursue these metalingual points, but to note that the role of language had a long and troubled history. In the nineteenth century, divisions occurred as distinctions between language itself and expression in discourse or writing. In the later part of the century, that division took a somewhat

different shape, in that the differentiation comes between the languages of Modernism, with their own roots, syntax, affixes, and one's own spoken or written language, whether French, German, Italian, English, et al.

An extension of this, and yet significant for early Modernism, is Jacques Lacan's effort in the 1950s to define the nature of the languages of the unconscious, so as to substantiate his point that the structure of the unconscious is analogous to the structure of language. For Lacan, whatever resides in the unconscious must be verbalized before we accept its existence. We can see how close this is to our studies in Baudelaire, Rimbaud, Lautréamont, Mallarmé, and Jarry. If we move in a little deeper, we see Lacan's structuralization of the unconscious not solely as some contemporary development, but more aptly as a derivative of Modernism's languages in the later nineteenth century. Even Lacan's reliance on the Freudian unconscious for its repository of languages carries us back before the turn of the century.

What Lacan has perceived is the critical point that every poet assaulting the language in the avant-garde has realized—that *his* language is not *the* language. For Lacan, this recognition leads to the idea that the unconscious as verbalized is very different from "the unconscious"; that, in fact, the unconscious does not exist except as a verbal medium and that, by inference, our stress on words distorts whatever the unconscious is. Lacan's strategy—and here we see him as part of early Modernism—is to separate language from dialogue, i.e., from discourse. Then we can see that language has within it elements of the unconscious and of dream: displacement, condensation, transference, et al.

In the psychoanalytic interview, Lacan defines an event that comes very close to the "event" of language in the early stages of Modernism, when the idea was posited that Modernism and language were inseparable. Lacan insists that all language is relational. By this, he signifies that "there is no language in existence for which there is any question of its inability to cover the whole field of the signified. . . ." For it is in the nature of language to "necessarily answer all needs." The very structure of what occurs in language occurs in the psychoanalytic interview, when normal discourse is suppressed. In this scenario, we have archaic language in its primal form: when the analysand speaks, but *not* to the analyst, and the latter replies that the "patient usually means something other than what he says. . . ." In this form of transference, in which neither really responds to the other, but, as it were, each speaks past the other, we have the very sense of a Modernist language as our poets envisaged it. If we align Lacan's comment with remarks by Rimbaud in his two key letters or with Mallarmé in his obiter dicta or, later, with Valéry's view of poetry as a separate language, we can see how intrinsic language theory is to early Modernism.

If we extend the line of reasoning, this acquisition of "new languages" beyond one's own national tongue is reinforced by everything we associate with Modernism. We have mentioned the dream itself, well before Freud, as becoming one of the stepping-stones of reality. But in physics, unimaginable quanta posited a discontinuous matter—so that another language of matter, motion, and time was discovered. As physical reality receded into smaller units, order decomposed; whereas the earlier nineteenth century prided itself on composition. Deconstruction of matter paralleled deconstruction of ordinary life. Man was reduced and stripped in order to be reconstituted on different grounds, and language, colors, sounds had to be devised as a sign of this. Languages took on

qualities of "the world," not the word; and this development was different from any previous alterations of language. We are speaking not only of the arts but of what became the social sciences.

In the 1880s and 1890s, Henri Bergson had, of course, intuited many of these changes in his explorations of memory, what he called *l'émotion dynamique* or *l'émotion créatrice*; duration, aesthetic intuition, new languages by which to re-view forms of reality. In *Mind-Energy* and *The Two Sources of Morality and Religion*, Bergson recognized that to capture the sense of the soul—the work of poet and novelist—a new language would have to be invented. The writer would have to demonstrate the way in which words could be dissociated from their traditional functions and reenergized with different meanings, part of that process of "dynamic emotion" and "creative emotion." In a sense, Bergson intuited the most radical of all such literary creations, *Finnegans Wake*, by foreseeing that novelty would need both new words and new ideas about language, to the extent that such developments would no longer be "writing" as traditionally understood. Yet the writer must strive for this uncommunicable element, what we will find in various degrees in Proust, Woolf, Joyce, Ford, Broch, and Faulkner.

In nearly all his mature writing, Bergson was seeking some way of conveying a language of unconsciousness, just as in previous eras writers had striven to capture the full breadth of a language of consciousness. This is a critical reason for linguistic experimentation in the latter quarter of the century. In this respect, Bergson was reaching into ideas and elements also associated with such different thinkers as Nietzsche and, before him, Kierkegaard. Bergson's sense of a comic logic is deeply associated with a dream logic, comic illusion with dream illusion. From this, we return to Nietzsche's attack on scientific man as "an old maid," as lacking authenticity: ". . . he provides inauthentic, fragile, questionable, and worm-eaten" opinions, because he lacks a self.* As a consequence, the philosopher observes a sickness of will which he extends broadly, what Bergson perceived in less grandiose or apocalyptic terms. Nietzsche was of course seeking for ways of power, Bergson for ways of individual development, creativity, expression; but they connect in their common recognition that such incremental gains can be accomplished only through new tongues. Even Nietzsche's emphasis on the philosopher, as opposed to the scholar—as someone who must move beyond good and evil—suggests an emancipation or liberation. This leads, inevitably, into new modes of expression, new forms of language: Nietzsche's novelty, a new kind of philosopher.

In several respects, while Kierkegaard was concerned with the "leap" into faith when traditional languages of religiosity no longer functioned, he was, also, concerned with definitions of new forms. In *Fear and Trembling*, for example, his persona, Johannes, speaks of the suffering alloted to genius, which "is the

* That lack of a self gains nothing but scorn in *Thus Spoke Zarathustra* (written for the most part in 1883–84, the first three parts), but it requires a special language; as much as Mallarmé's work requires *its* language. "The earth," Nietzsche writes, "is full of the superfluous; life is spoiled by the all too-many." These are the "selfless," those without a self who preach a doctrine of the weak, the sick, the decaying; those who, in rejecting earth, exalt "the heavenly realm and the redemptive drops of blood." They are "the preachers of death." They seek contentment, Nietzsche says, with their destructive doctrine of "happiness and virtue"; as a result, they "have become smaller, and they are becoming smaller and smaller. . . ." In effect, that lack of self is man's inability to find new means of expression, a language, for himself and, more directly, for mankind: he must express himself through his unconscious.

expression of the divine favor." Johannes continues: "So from the start the genius
is disoriented in relation to the universal and is brought into relation with the
paradox—whether it be that in despair at his limitation (which in his eyes
transforms his omnipotence into impotence) he seeks a demoniacal assurance
and therefore will not admit such limitation either before God or men, or else
he reassures himself religiously by love to the Deity." Kierkegaard would seem
to be moving toward some novel definition of faith, but he is at the same time
suggesting the limitations of tired forms of communication. For when he as-
sociates madness with genius—he asks, "What relation has madness to genius?
Can we construct the one out of the other?"—he is, in effect, associating the
languages in which madness and genius communicate to us. With this query
and association, Kierkegaard is clearly in the line of nineteenth-century "mad"
poets, Baudelaire, Lautréamont, Nerval, Rimbaud, and looking ahead both to
Nietzsche's assault on tired forms and to Bergson's efforts to liberate the self with
new forms of emergence. *

For Kierkegaard, every legend or myth requires refreshening and redoing,
whether it is of Abraham and Isaac or Oedipus. In the latter, accordingly,
Oedipus accomplishes what he does in the Sophocles version, marries his mother,
lives an honorable life with Jocasta, and remains unsuspicious of the reality. His
days are part of a good dream, not a nightmare. Only Antigone knows it, although
how she has learned of the facts lies beyond the tragic interest. The audience
can make its own surmise. Even at an early age, dark hints gripped her soul;
she is filled with intimations which finally become certainty, which, says Kier-
kegaard, cast "her into the arms of anguished dread." When Oedipus dies, he
is honored, and Antigone is more bound than ever to keep to herself the secret
of the crime—that is, the truth. She falls in love with a man who cannot
understand her aloofness and self-torture. Antigone is a person guided by truth,
but to publicize the truth would be to dishonor her father's memory; and she
decides she cannot marry this man, for such a marriage would lack openness.
Her secret damns her, although it has been Oedipus's act, not hers.

This is a tale of guilt, useful for Kierkegaard, of course, not to speak of
Baudelaire, Kafka, and several other "spiritual autobiographers." It carries over,
in Kierkegaard's own life, to what he called the "great Earthquake," his discovery
of his father's sensuality, his awareness of paternal sinning. But beyond the
individual life, the tale suggests how very worn and tired legends are, even the
greatest, and that they must be defamiliarized through novel means; that Kier-
kegaard will be the agent through which the familiar will be rejected and re-
defined in fresh terms. That is, a new language will be discovered for the worn.
Although this is a somewhat different sense from linguistic analysis, it becomes
part of its para-apparatus, in that it applies the idea of a reinvented language
and redefines the familiar in the modes of present thinking. It is part of what

* One should not make too much of Kierkegaard in this area, however tantalizing a direct line
through Nietzsche, Bergson, and new forms of expression may appear. For in *The Sickness Unto
Death* and elsewhere, he also stressed a bounded self. That is, unlike his successors, he did not seek
unlimited personal liberation or more general exploration of the infinite. On the contrary, he
cautioned against seeking an infinite self and located profound despair in man's desire to penetrate
into the unpenetrable. The desire for a limitless self is, for him, the desire for a negative self, an
act of hubris which dooms the quest itself. The quest for infinity inhibits the very identity of the
individual self; it leads not to growth but to rejection of oneself.

later linguists would call "recuperation" and "naturalization," the recovery of something so that it may be assimilated into a discursive order.

While Kierkegaard's aim was to create the recognition of choice in Antigone, choice right on the edge of dread and despair, the effect is even broader. For it creates in each individual faced with choice the need to reinvent himself— i.e., reinvent the languages by which he explains phenomena. In *The Sickness Unto Death*, Kierkegaard, foreshadowing Matthew Arnold by a few years, separated poetry from religion by distinguishing between the languages of each. Kierkegaard admitted that Christianity in comparison with poetry is often prose, and "yet is precisely the poetry of eternity." The paradox applies, with the distinction, and it suggests that Kierkegaard was concerned with the languages in which we find new expression; that while poetry appears to have the advantage, ultimately that which is immeasurable contains the greater poetry of truth.

This paradox carries through even a work that appears to be far removed, *Diary of the Seducer*, in which languages are once again involved. Part of the narrator's effort to seduce Cordelia derives from his ability to distinguish between different kinds of passion, each regulated by its own language. His approach to seduction is indirect and strategical, suggesting a man interested in building linguistic models. Before he can offer himself to Cordelia, he decides he must interest her in "ordinary love" (represented by Edward), so that "through him she might get a distaste for ordinary love, and thereby go beyond her own limitations. . . ." He will present her in the shape of Edward with outworn phrases—no caricatures, but ordinary words—so that when he, seducer, makes his move she will recognize fresh language and respond. An alternative would be to raise an "erotic storm" and with this "snatch her out of her historic continuity. . . ." This, too, would be a form of language, a distinction between *langue* (language systems, "historic continuity") and *parole* ("his move," the contemporary work). He will educate her to the differences in discourse between the historical nature of the work (in Edward) and the unconventional nature of language (himself). Language is form perhaps more than substance; or, alternately, substance follows on form, and the seducer will begin with form. She will intuit the substance from his mode of presentation. He will seduce through semiotics.

In Kierkegaard's formulations we can find secreted away an entire code of linguistic communication, located not in words themselves but in the nature of acts that always lead up to dread, i.e., choice.* The infinite possibilities of freedom contained in dread are the infinite potentialities of a language which brings us to the brink of choice. "Dread is a qualification of the dreaming spirit, and as such it has its place in psychology." Dread, dream, language, recognition, choice are all intermixed in the caldron of man's desires; and from this Kier-

* Elements in Kierkegaard seem to foreshadow Strindberg, especially his insistence that the association at first will be "a war of liberation," to be followed by "a war of conquest" for "life and death." The Dane, however, sees the relationship as going beyond the martial arts into areas of imagination and liberation, which Cordelia will experience for the first time. Although condescending to female intelligence, Kierkegaard nevertheless sees her as expanding under the seducer's pressure and manipulation. While we must be clear she is so much putty in his hands, we must also recognize she will comprehend certain things that a more conventional relationship would hide from her. The man manipulates, but the particular woman, in the grip of the seducer, experiences growth, i.e., the consciousness of new modes and languages.

kegaard retrieves what must come forth. Dread is associated with the stretching of possibility until its potential enters man's psyche as coexistent with freedom.

Kierkegaard is on the edge of linguistic experimentation when he says that he who is a student of possibility may find, where nothing happens, great significance in the slightest event; whereas he who is not open to possibility will experience less profoundly even if he is located on the stage of universal history. This is a commanding distinction, for it suggests the openness that leads to new forms. The man open—the man of artistic sensibility or imagination—may pick up experience from the slightest hint; man without that equipment of possibility may be in the most advantageous situations—that is, admired, popular, accepted—and lose the profundity of it all.

The word contains within itself correspondence to infinitude; so that in the process of discourse and writing we note the attempt to break through limitations of traditional usage into that beyond where other languages, still invisible, exist. This is, roughly, what Kierkegaard had in mind for Dread—it was aural, verbal, soulful, visual, the entire range of of sensory experiences which, ultimately, went beyond the senses. He stressed that he could not marry since he lived in a "spirit world" and he would be too heavy and she too light: they would speak tongues that crossed without communicating. These differences in language indicate he would speak with the accents of the artist, she with languages of tradition. To communicate, they must both sink into "education by possibility," which is to sink into something limitless. *

To reach those other languages, whether in word as in Mallarmé, or color as in Matisse, or sound as in Mahler, Stravinsky, and Schoenberg,† was an effort comparable to moving beyond routine discourse into syntax and linguistic principles subservient to another order. Writing to his brother, Theo, in 1885, Van Gogh speaks of "glorying in 'real artists' " who are "real" because "they do not paint things as they are," whose works are characterized by "deviations, remodellings, changes of reality" so that they become "untruth" and "more true than the literal truth." Kandinsky spoke later of the "spiritual life" of art, which is to cite the languages of art that go beyond discourse into an alternate reality. Nearly all such explorations have within them a Platonic component, that search for perfect forms at odds with routine.

In this search for languages of communication or for a "second language" of expression, we find that words, colors, sounds are no longer vehicles of anything but themselves. Language attempts to become consciousness itself. *Words (or colors) become charged and overloaded with themselves, so that their nonlinear, nonsequential forms become not reflections of the world, but the world.* Abstraction was inevitable. In this respect, abstraction was the ultimate goal of

* In one of those unexpected cultural cross-referrals about infinitude, Ibsen wrote to Leopold Sacher-Masoch (on December 12, 1882), "In these times every piece of creative writing should attempt to move the frontier markers." In giving substance to the term "masochism," Sacher-Masoch was possibly carrying out Ibsen's injunctions in ways the Norwegian playwright might not have meant.

† Wedded to the language of the "new music" was also a new language, the *Sprechstimme* of *Pierrot lunaire*, which passed into Alban Berg's *Wozzeck* and *Lulu*, as well as into Schoenberg's unfinished *Moses und Aron*. The final chords of that opera with the doom-filled words of Moses, "O Wort, du Wort, das mir fehlt!" ("O word, thou word, that I lack!"), indicate that the "talking voice" is as dramatic as music itself. *Sprechstimme* is the human voice speaking tones backgrounded by music. In this, the singer speaks in pitches that approximate the contour of the melody, or what there is of melody. It is of course difficult to control and to repeat.

Modernism, since that second language or language within had to pull away from discourse into some artistic equivalent of syntax and roots. A good deal of the attack upon Modernism as a form of degeneration derived from its stress on abstraction. In effect, its effort to redo languages was incomprehensible to those who, following Darwin or Zola, saw natural science as man's fate. The philosopher of such languages would be, inevitably, Wittgenstein, who became a spokesman for abstraction, his apothegms a response to its detractors.

Wittgenstein's linguistic philosophy was, in many ways, the culmination of Modernism; his disagreements with Bertrand Russell on all fundamental points stress the meeting of nineteenth-century logic and rationality with twentieth-century abstraction. A fundamental perception was that the language we employ in everyday life and the modes of thought that this language is supposed to reflect and express are unbridgeable. This led him to believe that the "ineffable" and "unsayable" were of genuine value, *since they were the very elements that cannot be verified by language.* With this alone, we return to Kierkegaard's "leap"—for him, into faith; but the point applies to Wittgenstein also, since he brings the individual to the edge of faith on a vehicle of new languages, different from and outside of conventional ones. Wittgenstein's thought was saturated with the ideology of abstraction, the languages of Modernism which are, like the unconscious, untranslatable. By this means, we have a devastating repudiation of positivism: thus Russell's sense of his pupil's brilliance and his inability to follow him. Wittgenstein's defense of alternate languages, which express what positivistic language cannot, was his consolidation of twentieth-century ideas against Russell's valiant defense of the best in an earlier age.

These repudiations of an expressive or discourse-oriented language in the later nineteenth century toward a para-language, as it were, had profound significance in the shaping of the content of Modernism. They were, *in a real sense, Modernism itself.* The consequences are apparent in several areas. History is reduced, even displaced: Modernism as language is neither *diachronic* (historical) nor *synchronic* (lateral and contemporary). Roland Barthes has attempted to define this shift in sensibility, as did Eliot before him. In *Writing Degree Zero*, Barthes stresses that breakdown of conventions in which language provides the means by which an author, for example, Balzac, can do his writing. The conventions once employed a "single écriture classique," but Barthes defines a shift by the early nineteenth century, what we are charting in the latter part of the century; so that by this time *écriture* (writing) is moving alone in a different world from *lecture* (reading). This is, in more abstruse terms, Eliot's "dissociation of sensibility," which he located fully two centuries earlier.

Language falls in between diachronic and synchronic, for by its very nature it cannot describe historical or contemporary events. History was altered in other ways besides linguistic, since every form of knowledge stressing the self diminished historical contexts for the self. Even as Marx argued his case against capitalism from history, citing historical statistics, emerging movements in art and philosophy (for example, Bergson, later Croce) denied not only Marx's history, but pastness itself. The unconscious and the instinctual life are ahistorical. Jarry's 'pataphysics swept out: it was a broom action, an exclusion, not an inclusion.

In these new languages, kings and fathers—even without Freud—are to be

killed, the state itself brought down to individual need. Secessions across the
map of Europe were such disengagements from paternity. We find ourselves on
a battleground of fathers and son, Baudelaire and General Aupick recycled, each
speaking a different language. And yet all this occurs not at cross purposes but
out of sight, in the darkness and shadows of a barely penetrable self/ego. In
remarks to Fliess which he later repeated in *The Interpretation of Dreams*, Freud
speaks of Hamlet's languages as "hysterical"; that is, he has transferred his sexual
coldness, his rejection of instinct, and his feelings about his father to Ophelia,
and this has resulted in a metaphorical language full of unconscious motives.
He has created a "new language" which speaks in sexual metaphors but which
is not about sex. Hamlet has derived a code that Ophelia (the reader) cannot
comprehend. Further, even efforts to penetrate this darkness rest on "approximate
languages," words that express biological needs, instinctual drives, thrusts of the
ego. Historical sweep and breadth, not to speak of theory, have given way to a
compartmentalization based on language that is itself approximate.

That is one dimension of ahistorical development: history and self-expres-
sion transformed into diverse languages. Of possibly greater significance is that
fragments come to hold the sense of the whole. Linguistic and visual develop-
ments in the arts parallel researches into the atom, the cell, even smaller particles.
The discovery in the 1950s of the DNA double helix is the latest step in the
recognition that ever smaller elements control the whole of life. We must unravel
a series of paradoxes: that to open up meaning or to expand knowledge, we must
move toward ever smaller elements that hold the key to wholeness. In the arts,
well before the 1880s, this trend was apparent. Wagner's expert use of the
leitmotif as building blocks for broad swathes of sound is, fundamentally, a stress
on miniaturization as the embodiment of the whole—as if phonemes embodied
the totality. It is possible to "read" Wagner in terms of the development of
language. Schoenberg's later twelve-tone system, perceived as an anti-Wagnerian
step, is really the repetition of limited sounds within a contained fragment,
which embodies the whole.

We have already analyzed how poets have reached this stage, with sound,
word, phoneme as embodying entire worlds of suggestion. In painting, Kandin-
sky's theoretical discourse upon point and line, and in dancing, Nijinsky's em-
phasis upon abstractionism made visible in clenched fists or bent-in knees were
all part of that detail suggesting immensities. Nijinsky, as we recall him in photos,
is curled in upon himself, making his body ever smaller, clenching and bending
in, as if containing energy itself in his poses, all as ways of suggesting not smallness
but vastness. Kafka's Joseph K. crouching in attics is Nijinsky without dance.
By containing and enclosing, Nijinsky was able to move closer to infinitude.
Body language and the new science are implicit in each other: the arts paralleling
quantum theory and the energy principle of the atom. Once split, the atom will
release an empire of energy; analogously, a sound, a contained visual effect, a
word or even its syllable will release worlds.

We are in the presence of the transformation of matter. As language played
double and triple games, as it came to be concerned with senses, sounds, colors,
tones that had previously seemed inexpressible, as it created arrangements, shapes,
and associations never before conceived, *internality became matter*. Each artist
found himself in the presence of the Creator, with the next stage up to him.
And each stage brought with it a new language, or else it failed to express

anything. The stress on impressionism, which many critics have denied as Modernistic, not only in painting but in literature and musical composition, made a strong political and social statement. It brought down large events to forms of language.

For the impressionists had discovered nothing less than a language more significant than matter. Each painter in his own way was transforming "content" (state, ideologies, politics, social thought) into intangibles such as light, shade, color, ambivalent forms that blurred representation. A purple tree in Van Gogh and Gauguin, forerunning Matisse and *les Fauves*, is an audacious attack upon everything the state represents. It forces a new way of visualizing, which is in itself an element of anarchy. By turning expected content into aspects of light and association, the painter has disrupted reality (one kind of language) and reconstructed it along lines ideology cannot touch (in another kind of language). This is quite different from earlier traditions of heightened, distorted, or intensified realism.

People, too, are eliminated as representative, since there is little need for discernible human contexts. That is, the artwork is set *beyond nature* or its dimensions even when ostensibly concerned with nature. The artist's eye is raised just over the horizon of recognizable form, whereas the layman's eye is set precisely on "what he sees" or "what he likes." The artwork exists in its own frame of reference, an encapsulated language, an assault on authority, the determiner of its own empire. Proust is the great beneficiary of this development. It is not happenstance that impressionism, one of our earliest Moderns, formed in and around the time of the Paris Commune, and that French traditionalists originally ridiculed its representative examples on social, not artistic, grounds. That it finally took hold with such intensity in France—while lacking authority in Germany, England, and the United States—and then became part of bourgeois art is connected to an antiauthoritarian strain in French thought that was always ready to deny matter; that is, to create languages in which matter could be subsumed. While the Germans were still fighting battles over impressionism, it had already ended, becoming, as postimpressionism, the earliest stages of cubism and abstraction.

The real revolution created by impressionism and then by successive waves of analogous or interrelated movements was in the creation of another language of expression. Such new languages were more than ways of saying things: they were like syntactical areas in pure linguistics. They separated themselves from casual discourse—words, phrases, sayings—and became secret tongues with structures and frameworks of their own. This is Saussure's distinction, an act of Modernism in itself, between *parole* and *langue*, or between his *signifiant* (form) and *signifié* (meaning). The languages of Modernism took up a phenomenological middle ground; which is to say, they touched not only on the usual associations between subject and phenomena but also on relationships among phenomena. They rejected all efforts at historical or philosophical frames of reference, while, at the same time, drawing heavily on them. In this context, even a relatively conservative thinker such as Durkheim evokes the languages of Modernism when he helps to found the discipline of sociology; or, later, Max Weber picks up where Durkheim left off and extends the discipline into socioeconomics, ultimately into a para-politics and, there, becomes linked to the very kinds of art that his conservatism would make him suspicious of.

SECESSIONS AND OTHER FORMS OF REBELLION

If new languages are the crux of Modernism in its early phases, then they meant confrontation with more traditional discourse. Confrontation led to Secessions; and Secessions were themselves forms of successive waves of avant-garde-ism. Each avant-garde movement, the edge of Modernism, was a demonstrable attack on what had preceded it. While each element in the movement was itself a secession, it is a mistake to emphasize the larger Secessions, in Vienna and Munich, for example, at the expense of those *individual secessions* critical to the Modern movement.

A secession is, in psychological terms, a desire not only to attack and muzzle the father (tradition, state, bourgeois value systems, the very concept of history), but to make the father inoperable (an act of parricide and regicide). In this respect, avant-garde secessionism was not benign, but ferocious, intense, lethal in its intentions. When Bergson, in *Matter and Memory*, stated that ". . . the psychical state seems to us to be, in most cases, immensely wider than the cerebral state," he was smashing icons. He then insisted on something equally revolutionary: ". . . our psychic life may be lived at different heights, now nearer to action, now further removed from it, according to the degree of our *attention* to life."* Bergson was negating the mainstream, killing off traditional philosophies. Not surprisingly, our proliferation of avant-gardes coincides with a period of anarchy and assassinations in the political spheres. The two are spiritually, if not politically, connected.

Regicide or attempts at it naturally created great fear, and we find numerous examples of regicide: Czar Alexander II in 1881; President Carnot of France in 1894; Empress Elizabeth of Austria, Franz Joseph's wife, in 1898; King Humbert of Italy in 1900; President McKinley in 1901. Of greater interest for us, however, were the motives behind such assassinations. Nearly all of these killings were prompted by anarchist aims attributable to Prince Kropotkin and his followers. Kropotkin, whom Conrad satirized as Peter Ivanovich in *Under Western Eyes*, pleaded for revolt and deeds, for acts demonstrating that men were willing to move outside of history in order to shape their destinies. In some deep sense, each act of anarchism, each bomb or bullet, each thrust of the dagger, regardless of target, was part of those impulses that created waves of avant-gardes. Karl Kraus called his journal *Die Fackel*, the torch, and his intention was to serve as a blowtorch burning out all that was false and hypocritical, all that in the name of the new traduced language and clear thought. Although he found himself opposing most of the avant-garde, he embodied in his journal the spirit of the avant-garde, based as it was on torching. Like the artists he excoriated, he was an arsonist.

Political anarchism and avant-gardeism, however dissimilar in their consequences, were fed by individual desires to extirpate the past—to prove oneself a secessionist, someone beyond history, fate, destiny. These are Modernist stir-

* This will be echoed in Proust's *Jean Santeuil*, whose beginning is almost an exact contemporary of *Matter and Memory*. Proust was no less devastating to existing forms, for he asks whether he should call his work a novel. "It is something less, perhaps, and yet much more, the very essence of my life. . . ." The "novel" has lost its social reality and now reflects a soul giving up its secrets, a spirit becoming immanent, a "garnering" of internal details. Yet even as he stresses these aspects, Proust says that it is "a mere presence of nothingness." The traditional novel has been obliterated.

rings, wherein art (or assassinations, or other acts of anarchy) is not primarily to change history, *but to move beyond it*, what was once part of a divine experience or a religious revelation. But here the revelation circled back to the self: anarchism and secessions were gratifications of self, however noble the motives one might read into one's deeds. They became such fearful acts because they reflected an uncontrollable self, in which the individual would do anything to express what he felt, even to the extent that he would, willingly, bring down the temple on his head. * Ravachol, the bomber, a French Jew (born Königstein), combined anarchistic activities and plain murders, including a Raskolnikov-like murder of an old miserly type and his housekeeper. His career of killing suggests that anarchy became its own function and could nourish nonpolitical acts— Kropotkin repudiated him—and that, analogously, the avant-garde could not stop even when pure destruction became its (theoretical) goal. The end products of 1880s and 1890s political and artistic anarchy are futurism, Dada, and surrealism, not to speak of Hitler and Nazi Germany.

What fed the anarchy of secessions—even when they became groups and movements—was their stress on uniqueness. Each movement, as each individual in it, was sui generis, regardless of borrowings and influences. It may have been an assault on what came before, or it may have been, as in the Munich Secession, a reaction against salon art, i.e., manufactured market art. Even when cities were only a few hundred miles apart, a movement or secession had its own character. Munich was very different from Berlin or Vienna, although all three secessions occurred as a kind of fission in the 1890s. The Munich Secession dated from 1892, when 106 painters and sculptors resigned from the Munich chapter of the Allgemeine Deutsche Kunstgenossenschaft. This group then split into further segments, so that shortly after 1892, we find separatist movements in Düsseldorf, Weimar, Dresden,† and Karlsruhe. In 1897, a major secession took place in Berlin, once again setting the seceding group against salon art. Each secession, however, even though it seemed to be triggered by opposition to the salon (the marketplace), had its own derivatives in differing social and institutional processes. Nearly all had their manifestoes, and these manifestoes were intense, obsessive documents, intended to prove oneself "outside" or "beyond." Each manifesto becomes a brief course in the expression of self in Modern and Modernism, a sample of the volatility and anarchy that lay behind artistic or sociopolitical expression.

Further, the Munich Secession and those others that followed in Germany—especially the major one in Berlin, in 1897—differed considerably in

* The scenario for this drama is the marvelously ironic Henry James novel *The Princess Casamassima*, in 1886. James surrounds his protagonist, Hyacinth Robinson, with figures of control, an entire network of rational, logical people. Yet the central act of the novel will be the assassination of a duke, for which Hyacinth is to be responsible. As he gains in perception, the poor young man cannot fit the numerous pieces together, so that he fluctuates between an order that seems increasingly attractive and a socialistic-anarchistic society to which, in a moment of daring, he has committed himself. Hyacinth recognizes that he cannot reconcile the uncontrollable nature of the assassination with the order he perceives around him, and he puts a bullet through his heart as a way of dealing with a self he cannot understand. In a later scenario of just such contrasts, when cowardice, not assassination, is at stake, Conrad's Captain Brierly, in *Lord Jim*, kills himself because he cannot reconcile his passion for order with his recognition of a potentially anarchic self that might lead to a cowardly desertion. While one question is the quality of the individual life, a major issue is the way in which an anarchic impulse can carry that individual outside history itself.

† Dresden was noted chiefly for *Die Brücke*, after 1905, forerunners of the expressionist movement; Munich for the *Blaue Reiter*, in 1911; Dessau for the Bauhaus after the war.

ultimate aim from the most famous one of all, in Vienna, in 1897. The Munich Secession was the culmination of a long nineteenth-century struggle over control of the major exhibitions and halls; that is, over being included in those exhibits where more modern work could be shown. Thus, the struggle was often over elements that had only partially to do with style. The issue may have been patronage itself, or else associated with personalities or, more generally, with creativity in conflict with academic realism. The potential for secession was here, and in this respect we can label several nineteenth-century movements as secessionist: impressionism in painting, which had to battle for exhibitions; symbolism and decadence in poetry and fiction, which had to establish their own journals in order to be heard. Later on, after the turn of the century, secessionist groups in this larger sense would include cubists, futurists, vorticists, German expressionists, eventually Dadaists and surrealists. In all of these, the goal was, often, merely to be seen; style itself was not the sole distinction. All of these groups or movements were formed as protest against mass marketing, which the salon and academicians represented; but they were, also, voices against realism. Another way to observe secessions is to see them as successive waves of protest against realism,* whether of the formal, academic kind (now once again coming back into fashion) or even of the realism implied in the groups labeled secessionist. The historical drift, as we can see in hindsight, was all toward abstraction, which becomes the great art form of the twentieth century.

The Berlin Secession—once we note it was quite different from the one occurring in Vienna at the same time—was precipitated by a typical exhibition impasse. The Verein Berliner Künstler, in September of 1892, invited Edvard Munch to exhibit in its headquarters, Rotunda, a one-man show of someone unknown to most members. Munch hung the fifty-five paintings and etchings himself, and when the members of the Verein saw his work, the majority of them voted to close the exhibition. Their opposition to Munch was based on several factors: color, content, morbidity, lack of "beauty," however they defined it. But more than that, the Verein, mainly conservative artists, saw in Munch an iconoclast little different from the anarchists and assassins who had spread fear throughout Europe in the nineties. The question was not solely his different style but the fact of his existence among them that unsettled them and led to their decision to close the exhibition.

But from the Verein membership of about 225, seventy—almost one-third— voted to secede and to form their own rump group. Without leaving the Verein— we note the tentativeness of this early secession—they decided to form what they called "a free association of artists." The aim was not to further Munch's type of painting, which would have been an aesthetic goal, but to insist on the right of Munch to be exhibited, which was more a social and political issue. With this, we have the first stage of the Berlin Secession, the model for later secessions, until the one in Vienna became a question not only of exhibitions but of style and matter. The Berlin Secessionists well knew that the Verein had both the

* We saw how impressionism, seemingly so harmless, now so totally absorbed into our historical sense of painting, was a devastating attack on realistic values. Its breakdown of formal scene into areas of color patterns expressed social and political breakdown and, at the same time, challenged realistic versions of that dissolution of social forms. Since a public could not fight light and color, it restricted exhibitions.

power and money, and their gesture would have serious repercussions in that several of the protesters lost their academic positions. But it is clear that the issue was exhibiting, as Peter Paret shows:

> Our vote [that of the 103 who voted not to close the exhibit] was guided by the consideration that Herr Munch, invited to show his work by a committee that had been freely elected by the members of the Verein Berliner Künstler, must be regarded as having been invited by the Verein itself. For that reason, and without wishing to take any position whatever regarding the aesthetics expressed in Munch's paintings, we condemn the closure of the exhibition as a measure that contravenes common decency.

The Secession was on, and, historically and aesthetically, it became an important moment: not simply because artists had protested—surely impressionists and postimpressionists mounted protests of equal intensity—but because this protest had occurred in the heartland of conservatism, in Bismarck's Prussian state. Further, although the issue in the beginning was exhibiting, the Verein's intransigence was followed by a more frontal assault on aesthetic values themselves, leading to the more fully fashioned Berlin Secession of 1897–98. Along the way, a magazine called *Pan* had been formed, its name and content indicative of its rebelliousness. It was, in a sense, a forerunner of Vienna's *Ver Sacrum*, the bible of that Secessionist movement.

Although the detailed working out of each Secession is not part of our plan—it has been done with great skill by Peter Paret (Berlin) and Carl Schorske, Peter Vergo, and Allan Janik and Stephen Toulmin (Vienna)—some particulars are necessary for us to appreciate the volatility and inevitable hatred involved in these breaks. They were, we should stress, figurative acts of parricide and regicide. Efforts at negotiations between Vereins (salons) and secessionist groups broke down, as they would everywhere: dissolution of parent-child relationship was inevitable, although in these instances the Prodigal Son did not return. When money came in to support the new developments, contributors were frequently Jewish bankers and financiers. Since Jews were considered to play large roles in development of the new, they were perceived as subverters of state and country; a "foreign" element even when the contributors were as prestigious as Walter Rathenau, the founder of the German equivalent of Consolidated Edison.[*]

Walter Liebermann, in the main a journeyman painter and not an earnest Modernist, a Jew who tried to slide into a purely Germanic role, was instrumental in making the first showings of Modernist art possible. In the catalog copy for the first Secessionist exhibition in Berlin, Liebermann expressed the note of defiance: "In selecting the works for our exhibition, talent alone, whatever its style, was the determinant." Liebermann stresses that any work that expresses feelings honestly "seems to us to constitute art." They would reject routine

[*] A disproportionate number of art dealers who were willing to handle the new art were Jews, the most prominent and influential probably being the Cassirers, cousins of Ernst Cassirer, the philosopher. Cassirer would formulate ideas in his *Philosophy of Symbolic Forms* in the late 1920s that derived, clearly, from his early association with the family of dealers. In 1902, Bruno Cassirer published the journal called *Künst und Künstler (Art and Artist)*, and the defense of the new was on. One of the earliest favorable reviewers of the new gallery run by the Cassirers was Rilke.

craftsmanship and superficial production. However mild these comments, they savage realism, since the criterion will be feeling, i.e., subjectivity.

Before we move on to the much more significant Vienna Secession, we should stress that the Berlin version was, as befitting a Prussian stronghold, very sedate. None of the Viennese sexual volatility was present; nor did the artists try to subvert morality or the state. The chief artists represented were Liebermann, Leistikow, Böcklin, Corinth, of whom only the latter two had broken free of their historical era. While the exhibition was not offensive to public taste, its significance was expressed in its very existence. And opposition was to its existence, not to the content of its art. This is an important point, because antagonists saw in the split and in the independence of a new set of artists a threat to social and political stability. That is, art by its presence became a social/political form of subversion, *even when* the art was not itself threatening.

We have a phenomenon here that is intrinsic to the avant-garde: its positioning of itself as a form of id, a kind of libido working through the body of art and culture. In this formulation, if an avant-garde, however lukewarm, is id, then the main body of the Verein would be the superego, a conscience for the state, most likely an apologist. These were the extremes, with the id-factor as liberationist, and the superego-factor as repressive or conserving. Accordingly, form and color, line and deployment of objects on canvas became political statements, destroyers of authority in art, just as Marx, Freud, Durkheim, later Einstein ("Jewish physics") became the "destroyers" of the new German state.*

With the Vienna Secession in art, architecture, and literature, beginning in 1897, we find a far more radical break; no longer is it merely a reaction against official salons and exhibitions. We now have matters of taste, style, cultural outlook. The Vienna Secession is the avant-garde moving into position, whereas the various German forms of secession had been, mainly, forms of protest. Furthermore, much of German Secessionism was a matter of showing foreign works: impressionists or Aubrey Beardsley (at the Paul Cassirer Gallery), more Munch, a little later a large Cézanne representation. Thus, we do not find German painters, as yet, in this display of opposition; we find, instead, already established foreign painters being exhibited to alter German taste. In the Vienna Secession, the matter is one of native artists developing their styles in opposition to salon painting.

The Vienna Secession, as Schorske, Janik and Toulmin, and Vergo have shown, occurred on a broad front, with *Jugendstil* modes fitting themselves into the seams of a society already gone rank. The official secession came when Gustav Klimt led nineteen students in withdrawing from the academy to form

* Secessionist movements as they proliferated after 1900 introduced the major French impressionists—long after the movement had lost its luster in France. That is, Germany imported French impressionists—hated in Germany as in France—at a time when the loose group had already dissipated its energies into postimpressionism, which shortly became transformed into *les Fauves* and cubism. Yet this already seemingly passé art—Monet, Manet, Pisarro, Renoir—became the focus of hatred for foes of Modern art, representing to them the very enemy of beauty. Wilhelm II withdrew his support of these exhibitions and those German impressionists based on French models. The reason given was almost always its "foreign" nature, its un-German (read "Jewish") quality. Wilhelm had already learned to use art for nationalistic purposes. He was, of course, correct in that assessment, since the new art spoke across borders and left little room for German militarism or the state. We get some idea of the ferment and confusion when we realize that even an antiestablishment painter such as Kaethe Kollwitz protested against Matisse's work.

the Secession. Their idea was that twentieth-century painters needed their own style, that such styles could not develop in the stifling atmosphere of the academy. At stake, in reality, was the entire culture, and critics of the Secession perceived the threat to the state in the development of a countering splinter group. In America, we find it difficult to understand how any artistic group or its medium can be politically threatening, since the separation of the serious arts from political life is complete. But in Europe, and perhaps especially in Franz Joseph's Vienna, the subsidization of the arts meant that there was an official aesthetic line, and a threat to that was a blow at the very life of the state—i.e., a mode of assassination. The same was true for most European countries.

We find a parallel development to Klimt's radicalization of art in Mann's *Buddenbrooks*, written just before the turn of the century. Mann's development first of Christian, then of Hanno, effeminate, frail, aesthetic, suggests the artistic milieu that will not accommodate the business of the state. When business and art clash in Mann, the meaning is clear: not that art will necessarily triumph, but that business will be subverted. Mann's novel is about the decline and fall of earlier nineteenth-century German values, but it has resonance also for the Austro-Hungarian Empire, of which Vienna was the glittering capital. Mann's Hanno, especially, is everything a martial state fears; he is defined not by what he essentially is, but by what he represents to the older Thomas. His very presence "deconstructs" the sense of the family firm and destroys its historical traditions. In his person, he suggests what was occurring aesthetically outside this northern German seaport, where business is the order of the day. He is the foreign element that represents whatever disease is eating at the Buddenbrooks soul, just as the Vienna Secession would expose every weakness and fatuity of the creaking empire.* Hanno Buddenbrooks's involvement with music instead of statistics, his slender build and light coloring, his lack of manliness, all suggest that avant-gardeism or Modernism threatening Thomas, the firm, the idea of Buddenbrooks itself.

Hanno dies of typhoid while a schoolboy, but his improvisations on the piano indicate his subversion of Buddenbrooks values. His life is indeed part of those improvisations, each too fine to stand by itself, as he himself is too slender and frail to survive. Thus, his early death, in which life just slips away from him, is continuous with his entry into aesthetics. The life of art is evanescent— improvisation today, death tomorrow, as against the former solidity of the firm.

The Vienna Secession led by Klimt was very much a betrayal of fatherly values in the name of art. Part of the label attached to Klimt and his colleagues was based on their alleged sexual perversity. Klimt, in particular, establishes that man's inner self is reflected in sexual images, metaphors, tropes, even colors

* Perhaps ironically, perhaps by chance, the Secession preceded by one year the celebration of the Imperial Jubilee, which had been long in the planning. The period is covered with all due attention to matter and tone in Musil's masterpiece, *The Man Without Qualities*. Hermann Bahr's benediction on the era is apt, especially since he wore several coats of multiple colors, from socialist and liberal to Pan-German nationalist and Catholic monarchist, intermixed with bouts of anti-Semitism and atheism. "Our epoch," he wrote, "is shot through with a wild torment, and the pain has become no longer bearable. . . . It may be that this is the end, the extinguishing of exhausted humanity, and these are but the death-throes." Such attitudes, while accurate in their assessment of the decaying empire, are politically ominous, since they suggest the need of strength, a Führer, a powerful well-run state as an alternative.

and shapes. He uses women, *fin de siècle* women, to express an unconscious that rises to the surface as perverse passion—for example, his Judith with the head of Holofernes, a head grasped far down in the righthand corner of the painting. Thus, we have Judith and her expression of sexual pleasure (à la Salomé) intermixed with an immediate loss of interest, all centered on the canvas; and the man, represented only by his head, is pushed aside as no longer a meaningful factor. The Judith of the Apocrypha, the heroine Judith, is displaced by an image of a wanton woman who is not satisfied even with the head. One sees in her Medea and a long line of raging, castrating females of myth and literary history whose contemporary is Lulu; and yet, at the same time, Klimt glorifies her wantonness, makes her a goddess of indifferent passion. The result here and in his other representative work of "romantic agony" was bound to stir up outrage and opposition. In this respect, he succeeded and seceded. In this image, he caught Schopenhauer's devastating idea of the female as an irresistible life force, and yet he contained that image in history, as part of the Judith legend. Like Freud, Klimt was not interested solely in the instinctual; he had to break through to the erotic, and then take the next step beyond the erotic into masochism and sadism.

The implications are overwhelming. At stake was nothing less than man's entire being, not only his reason but his soul, not only his sense of community but his instinctual life. Viennese Secession, however, had several forms, not all of them quite so threatening. For example, when we think of Richard Strauss, we do not recognize a figure of the avant-garde, certainly not when he is measured against his contemporaries, Stravinsky and Schoenberg. We may, even, think of the old man who remained loyal to the Hitler regime and did its bidding. Yet his championship of Liszt's music when he conducted and his own *Don Juan* in 1889 marked him as the newest of the new, a supporter of experimental music, castigated by critics as diverse as Hanslick, Wagner's tormentor, and Kaiser Wilhelm, who sought to keep German music pure. Strauss's rise was meteoric, but it was against a solid phalanx of adverse criticism, which heard in his symphonic poems the kind of discord and dissonance associated with anarchy, degeneration, even assassination. While he appeared to a growing public, his use of instruments, sounds, orchestral clashing struck away at traditional forms and isolated him from court and academic music; that is, defined him outside in a distinct culture of his own, however differently we now regard him. From the traditionalist point of view, Viennese culture was still best represented by the other Strauss.*

We recall that when Richard Strauss characterized himself in music in 1898–99, he called the work *Ein Heldenleben* (*A Hero's Life*): himself portrayed as Man, Mankind, heroic in his endeavors, a Nietzschean refutation of Scho-

* The "other Strauss" was alive and well, with one huge success following another. In 1885, when Richard Strauss succeeded Hans von Bülow as conductor at Meiningen, Johann Strauss had *Der Zigeunerbaron* (*The Gypsy Baron*) on the Viennese stage. We have as contemporaries two kinds of music pulling in quite different directions, for Richard Strauss in the 1880s produced not only *Don Juan* but *Aus Italien* and *Death and Transfiguration*. The point is not to show the superiority of one composer to another, but to demonstrate how, given the nature of popular taste, Richard Strauss was daring and experimental.

penhauer, a paean to selfness. The final of six sections is called "Escape from the World and Fulfillment of Life," which establishes this hero's asylum as having occurred in art, as a triumphant Siegfried. The stress on this self-willed aspect of experience was fraught with danger for society. Society would become challenged ever further, of course, by Freud, whose psychoanalytic technique gave to the individual's internal life the stature of history itself. Other Secessionists insisted, in similar ways, that life on the edge or within was *the* sole life, and their manifestoes outlined which "edge" they chose to be represented by.

Still another form of secession was the loose group known as *Jung-Wien*, young poets who celebrated their independence from the values of an ossified Hapsburg Empire. They included Hugo von Hofmannsthal, Arthur Schnitzler, Hermann Bahr, and Stefan Zweig; but they were by no means only an art for art's sake movement. They identified with political liberals who hoped to transform the Empire into a constitutional monarchy roughly based on the English model. The affiliation of art groups with political liberals had its own ironies, since the latter hoped to build upon nationalism—the aspirations of the Czech, Slovak, and Hungarian elements in the Empire. Such aspirations were profoundly, even virulently, anti-Semitic, while many in *Jung-Wien* were Jews. Further, the *Jung-Wien* were European in their art and poetry, interested in breaking away from the very bourgeois ideas that lay at the heart of nationalism and, indirectly, liberalism.

Still further, the liberals—like their contemporaries in England—stressed science, rationalism, a free economy: elements toward which the art movement found itself in an adversary position.* Nevertheless, both *Jung-Wien*, with its stress on independence through art, and liberalism, with its emphasis on bourgeois democratic institutions, were parallel opponents of the Empire, fated to develop as twin adversaries of an even larger threat. The final, perhaps inevitable irony is that while *Jung-Wien* contained many Jews, the beneficiary of the nationalism sweeping Austria was Otto Lueger, the virulently anti-Semitic mayor of Vienna.

From this nationalistic fervor came another form of secession: Theodor Herzl's Zionism. Hungarian by birth, Herzl came to Vienna and identified strongly with German culture; he saw.in the German language and its poetry and music an alternative to his Jewishness. One of the striking ironies of Herzl's Zionism is that if the host culture had been less hostile, Herzl would have embraced it fully and Zionism would have perhaps derived from a later era. Herzl's stay in Paris, as correspondent for the *Neue Freie Presse*, showed him another side of European anti-Semitism, especially in the Dreyfus affair and in the writings of Drumont, whose words were an incitement to destroy the Jews. At this point, Herzl felt a Jewish secession was the answer to the failure of all political solutions. Nationalism or folk movements left no place for the Jew in

* Secessionists join in paradoxical ways. As *Jung-Wien* rejected both Empire and elements of liberalism, it joined across Europe with an unlikely ally, Zola. Zola's naturalism seems anathema to the arts movement in Vienna, and yet Zola began by asserting we are "malades de progrès," sick with progress. This sickness derives from our uncertainty about the future, "nos sociétés aveugles en face d'un avenir inconnu." His words—not his practices—can be taken as the motto for Viennese groups.

Europe, and Herzl's response was a return to Palestine as a way of solving the Jew's estrangement. *

In more ironic terms, Arthur Schnitzler, a bourgeois Jew, a doctor and a writer, was to provide a kaleidoscope of Viennese hypocrisy, what Musil did later more ambitiously. Schnitzler became concerned early in his career with the role of the Jew under the Empire and the role of sex in a bourgeois culture. His early work, especially *Reigen* (*La Ronde*), in 1896, stressed eroticism both in its individual phases and as a social phenomenon that disallows love or enduring relationships. His peculiar power—what made his body of work so attractive that Freud referred to him as "a colleague"—derived from his equation of the erotic and death, Eros and Thanatos; and, once again, we note his similarity to far greater Austrians, Musil and Hermann Broch. Schnitzler was very much part of Viennese Secession in his analysis of decadent splendor which sacrificed morality and ethics to sensation and sensuality. But unlike the more mainstream Secessionists, he created little, except perhaps *Reigen*, that endured beyond period pieces. †

The other main area of Viennese Secession came in architecture, and its complicated story has been told well by Carl Schorske. Central to the struggle over architecture were three figures; and their ideas—carried over to the look each had in mind for Vienna—represented the public side of Modernism. Otto Wagner saw Modernism as a streamlining, a rejection of historical flow, embodying an architecture that reflected a new life. Like parallel figures in painting with their experimental use of color and techniques, he tried new building materials, which led to a reductiveness of the earlier monumental Ringstrasse style. He helped pioneer in the use of aluminum and poured concrete; but, even more adventurously, he attempted that functionalism of line which relates inner and outer design. This was equivalent, in architectural terms, to the rejection of fathers and their buildings; so that Wagner and Freud are reaching similar conclusions at the same time, one outwardly, the other internally.

Although Wagner began to formulate his plans for Vienna in an 1893 competition—before the advent of the automobile—he was, like our own Robert Moses, interested in traffic flow. He foresaw that a large modern city is dominated as much by its road building as by the traffic moving through it. And in his designs, he stressed a kind of grid that guaranteed that vehicles, whatever they should be, would have primacy over pedestrians. This is a crucial moment in urban architecture, since it recognizes that the pace of modern life will increase, and the "walk" of the pedestrian will no longer suffice.

Camillo Sitte, on the other hand, sought a different face and feel for the city of Vienna. His effort was not a break with tradition or history; it was, in fact, a desire to make Vienna a spiritual experience and, at the same time, cater

* Janik and Toulmin repeat the story of Herzl's "conversion," which occurred during a performance of Wagner's *Tannhaüser*. According to the legend, Herzl recognized the illogic and irrationality of German nationalism and "in a flash of intuition" perceived that Jews had no role to play in it; that, in fact, Jews would always be alienated in such an environment. The solution was to found a state in which Jews provided their own alternative both to a moribund aristocracy and to a lower-class nationalism which offered up mindlessness for true Jewish culture.

† Not surprisingly, *Reigen* could not find a publisher who dared to issue it, and Schnitzler had it privately printed, with two hundred copies distributed to friends. In 1904, *Reigen* was banned in Germany and in 1921 officially banned in Vienna, one year before *Ulysses* was banned in most of the Western World.

to the working classes and their folk-nationalistic aspirations. Sitte stressed the square as an intimate living and melting area. This plan of small communities within an impersonal urban sprawl was, in conception, anti-Modernist. As a man whose loyalties were to the artisan and working class, he identified more with the limiting nationalism of a folk culture than with the broadly conceived Europeanism of Modernism. Schorske sees Sitte as the architect of beauty, Wagner as the builder of utility; but the equations could be reversed if we ask what beauty? what utility? In England, Ruskin and his defense of Gothic had posed comparable questions.

The very point for Modernism is that the nature of what constituted beauty and the beautiful was undergoing revision, as was the idea of utility. The connection of beauty to a moral and ethical dimension was passing into a new phase, in which beauty was identified, neutrally, with sensation and experience. Thus, beauty was no longer a moral entity or the embodiment of a higher truth; it was associated with individual taste and individual striving. By the mid-twentieth century, beauty would become identified with an extension of sensation, with validity, relevance, authenticity—all individual, not eternal, qualities.

In Otto Wagner's eyes, this new sense of beauty was served by utility; whereas for Sitte—deeply influenced as he was by another Wagner, the composer—beauty was defined by community, entities, spirituality. He pointed to the past as much as Otto Wagner did to the future, although the simplest way to differentiate them is in their opposing sense of what beauty is. Wagner recognized beauty as motion, flow, rhythms of movement; Sitte identified beauty as stasis, historical balance, a kind of architectural *gemütlichkeit*.

Different, but not totally distinct, was Adolf Loos, not only an architect but a benefactor of Kokoschka when the latter's artistic primitivism identified him as an enemy of the Austrian cultural establishment and lost him his stipend. Loos used the pages of *Ver Sacrum*, the Secession's journal and manifesto, to lambast the stylistics of the Ringstrasse; i.e., to ask for nothing less than a total rejection of the Empire's taste. Loos carried Otto Wagner's functionalism and utility to the next stage, to an early view of what would become eventually the Bauhaus style. Loos insisted on a strict unadorned functionalism, an architectural minimalism which was also a kind of purification. His vision of a city—of the entire country—was heuristic. Like Thoreau's vision of life at Walden, it was to change a society's sense of its comforts and, by extension, the ways in which it chooses to live. Loos insisted that individuals can decide their future, and, thus, like the Modernists in other areas, he rejected the past, history, even the palpable monumentalism of the Ringstrasse. Loos wanted to start anew, eschewing adornment, decoration, stylistics, removing architecture from art and art from architecture. Art, he asserted, serves revolution; the house or building serves comfort. Loos was the ultimate rationalist. And, in fact, like Skinner in our own age, he turned rationality into a radical idea.

For Loos, the nadir of architectural concepts was the Kunstschau 1908, a pavilion organized by Klimt for exhibiting not only the fine arts but the whole range of crafts from clothes to ceramics. Inside the pavilion was a feast, what Schorske calls a *Lustschloss*, a pleasure palace, and even its facade, with the three decorative statues, was an effort to bring inside and outside together as art and style. The significance of Loos is that he shows us also another side to Modernism: a benefactor of Kokoschka who argues for a different kind of avant-

gardeism; a contemporary of Klimt, whose "life of art" was anathema to Loos's architectural concepts. Loos's was the sleek, streamlined aspect of Modernism; his vision of clean lines would pass, as architecture, into Bauhaus and, as pure form, into the lines of cubism and abstraction.

Although secessions were defined as such in Berlin, Munich, Vienna, and other German cities, we are, in fact, in the presence of a wave of less clearly labeled secessionist groups, each with its own "self" and its manifestoes. Within a fifty-year span, we can list symbolism, Decadence, naturalism (subdivided into pure forms, lyric forms, and symbolic), *Jung-Wien, Die Brücke, Blaue Reiter,* expressionism, fauvism, cubism, the "new science," quantum mechanics, relativity, imagism, vorticism, Italian futurism, Russian futurism, Dada, surrealism, tactilism, dynamism, Russian imagism, Russian symbolism, Orphism, serialism, constructivism and neoplasticism, abstractionism, and others. Many of these movements obviously owe a great deal to previous or parallel forces, with symbolism and naturalism nourishing several movements in the later nineteenth century, cubism and expressionism fueling numerous others in the early twentieth. Still others are natural outgrowths of what preceded—futurism from the "new science" or, later, surrealism deriving from Dada and from Freud's theories of the unconscious. Once abstractionism with Picasso, Braque, Kandinsky took hold, then it became the measure of all plastic art, and its influence appeared in a number of other areas: in literature, which became increasingly internalized, in stream of consciousness and related methods; in music, which depended increasingly on "pure sound," the schools of Stravinsky, Schoenberg, Webern, Berg. These influences would continue well through the century, except in literature, which began to lose much of its secessionist thrust by the time of the Second World War.

The sole exception was *Finnegans Wake,* wherein the word becomes the residue of avant-gardes in painting and music: sound, color, reshaping. Joyce's "summa" can be considered as part of the same movement that created Kandinsky's four panels for Edwin R. Campbell's circular reception hall, in 1914.* Such is the nature of Modernism that we can move ahead twenty-five years, across genres, and still find analogous generating ideas active. One reason perhaps is that these waves of artists, poets, novelists, and composers, as well as those in the new social sciences, offered not only beauty but truth, in fact TRUTH. This "truth"—the authenticity and relevance of later generations—was often of the kind one had associated with religion, the received truth of God's existence which served as ethical and moral guide. Manifestoes (together with prefaces, introductions, Tuesday night gatherings, et al.) were, in fact, presented like Mosaic laws, truths handed down from Mount Sinai. Art, and its parallels in philosophy and psychology, insisted that greater validity lay not in the accepted forms but in the artifact of the artist's creation. This was an ideology of senses and sensations, and it reinforced the idea of self-ness and anarchy—Nietzsche's

* Although I am not primarily concerned with background data, it is noteworthy in Modernism how major elements have almost trivial beginnings. Campbell commissioned the project from Kandinsky for the sum of $500; then, after Campbell's death, the larger pair of panels was sold to a New York dealer for $400, and the smaller pair of panels went at auction at $15 for one, $25 for the other. From such an inauspicious start, the Campbell panels have become a watershed in Modernist art, not solely as paintings but as avatars of an entire culture of avant-gardeism.

response to Schopenhauer's rejection of individual will. But even Schopenhauer, while sweeping away the individual in the universal, had recognized that uniqueness resulted from artistic expression, that it was the sole form of affirmation in a world swept by a generalizing will.

Each manifesto associated with a movement was concerned with rejecting historical contexts so as to root out the truth of its own and only its own existence. We see that manifestoes are extensions of self, of senses and sensations. For the development of Modernism, perhaps the most significant of "manifestoes" was the length of a book, Nietzsche's *The Birth of Tragedy*, in 1872, itself inspired by Wagner's *Tristan*.* Nietzsche was seeking a new form of thought that went beneath and beyond texts, one that, moving outside normal restraints, defined itself as having come from a different source. Such a quest was implicit in his *Birth of Tragedy*; written at the beginning of his career, it, understandably, created great hostility in his academic colleagues.

Particularly significant in *Tragedy* was Nietzsche's division of man's existence into a bifocal experience: that of the mind, that of the senses, so that there is a perpetual struggle of one with the other for supremacy. R. L. Stevenson's *The Strange Case of Dr. Jekyll and Mr. Hyde* in 1886 is a popular manifestation of bifocalism, as are several of H. C. Wells's science fictions, especially *The Island of Dr. Moreau* and *The Time Machine*. This division, made as early as 1872, prefigured all such dichotomies and led significantly into Freud's psychology. We can say, perhaps hyperbolically, that Modernism would not have developed the way it did if Nietzsche here, and later, had not insisted on bifocalism, each with its own energies and its own denials. Nietzsche's work, in the larger context, was part of nineteenth-century insistence on dialectics, whether Hegel and Marx earlier, Nietzsche himself in the final quarter, Freud at the very end and then in the early years of the new century. But we can extend that bifocal dialectic to Darwin and Frazer as well. As soon as the dialectic became not solely a mode of argument or debate but a methodology for locating unresolvable human experiences, then we have one matrix of Modernism.

In the process of structuring his dialectic of Apollonian and Dionysian, Nietzsche speaks of leveling, of deconstructing "stone by stone," until "foundations become visible." In attempting to find that "unconscious life," which he affirmed—as against Freud's later perception of the unconscious as anarchic and, therefore, something that must be harnessed†—Nietzsche offered the satyric

* Although *Tragedy* and most of Nietzsche's other major works were not translated into English until well after 1900, their influence should not be measured on English writers but on continental Modernists. The latter had ample opportunity to read Nietzsche or hear about his ideas secondhand. Even in England, Havelock Ellis wrote "Nietzsche" in 1898, in his *Affirmations*, an essay running to over eighty pages. André Gide, for another, helped to introduce Nietzsche's thought into France, in *Prétextes*, at the turn of the century. Once the initial breakthrough had been made, nearly every major Modernist bowed to Nietzsche's influence; as noted, he entered deeply into Freud and, later, Jung (i.e., "The Apollonian and the Dionysian," in *Psychological Types*).

† Before harnessing the unconscious, Freud in his dream theories had to discover the role of the id in them. His dream theories were of two kinds. The earlier theory lacked the id-model and, therefore, minimized censorship and repression. It was concerned, in the main, with guilt, as in Freud's own dream of Irma's injection. The later theory, in 1900, picks up the Nietzschean dialectic and incorporates the id, a Dionysian force. With this, Freud entered into the dynamism of an individual's psychological and sexual life. Early life and later life are telescoped into the self-expressiveness of the infantile id. The earlier theory sufficed only for normal dreams, whereas the later theory, in which Freud had assimilated Nietzsche, applied to anxiety dreams, nightmares, the id screaming to break through a rational facade.

chorus. "The metaphysical comfort—with which I am suggesting even now, every true tragedy leaves us—that life is at the bottom of things," he writes, "despite all the changes of appearance, indestructibly powerful and pleasurable—this comfort appears in incarnate clarity in the chorus of satyrs, a chorus of natural beings who live ineradicably, as it were, behind all civilization and remain eternally the same, despite the changes of generations and of the history of nations."

This "chorus of satyrs" is not in itself the spirit of Modernism; it merely helps shape Modernism because of its dialectical opposition to civilization, that is, to the Apollonian mind. The Dionysian state, in Nietzsche's terms, annihilates "the ordinary bounds and limits of existence. . . . This chasm of oblivion [a lethargic element that sucks up all personal experience] separates the worlds of everyday reality and of Dionysian reality." Nietzsche asserts that Dionysian man resembles Hamlet, in that both have peered into essences, have gained knowledge, and "nausea inhibits action." They experience nausea precisely because they feel they have been asked to set things right, and yet their very "knowledge kills action." Action, Nietzsche emphasizes, requires illusions; deep knowledge, "an insight into the horrible truth," precludes action. Nietzsche here prefigures that small army of Hamlets who will emerge in the latter part of the century and culminate in Eliot's Profrock, Pound's Mauberley, Rilke's narrator in *Duino*, Sartre's Roquentin, and Camus's Jean-Baptiste.

However important other dialecticians were in the nineteenth century, Nietzsche's bifocalism established both distinctions and terms that captured the Modern imagination. In the possession of Dionysian man, one "sees everywhere only the horror or absurdity of existence . . . he is nauseated." While this particular translation of Nietzsche's words points toward a much later development, Sartre's existentialism, it does suggest that man has passed a point of no return; his will is negated by a force that transcends will. Only art remains as "a saving sorceress, expert at healing." But art *is* a sorceress, as Mann would perceive it, a satyric chorus, and it is this potentially destructive element that gets us beyond the nausea that prohibits action. Having based himself on Schopenhauer, Nietzsche then moved into new areas, transcending the sheer pessimism of his predecessor in the jauntiness of the satyric chorus and the freeing of the individual from his abulia and ennui.

It is, as the existentialists would later call it, a leap. When Nietzsche finally turned against Wagner, it was to exhibit the composer as a false satyr; not as a guide to those profound elements outside of rationality but as "the Victor Hugo of music as language." We have, with this book in 1872, a manifesto of sorts, possibly the most significant of all for Modernism.

One could, I suspect, write an entire history of Modernism and its avantgardes by way of developments in forms of madness and how these developments are interconnected with acts of purification, so central are these ideas. Madness was not contained in Modernism, but given its potential as act, gesture, discourse, subversion. The Marxist view, held by Foucault, that the semi-mad were identified so they could be used as cheap manpower or the really mad put away because they could not work, is contradicted by the thorough way madness dominated the arts and its forms of discourse. On the contrary, madness was not contained by the bourgeois: it threatened the bourgeois culturally at nearly every turn, until in the second half of the twentieth century—after seventy-five

years of running rampant—madness has become virtually the way we perceive. The argument remains that all avant-gardes are "mad," and, therefore, all avant-gardes are aspects of a strange purification, of discourse as well as of act.

The argument runs parallel to the one that identifies Modernistic movements as various degrees of the unconscious, unleashed, partially muzzled, often rambunctious. Modernism gave itself life by trafficking not with knowns but with unknowns, and the greatest of human unknowns was no longer God but the unconscious. After a century of religious worship, God had been identified as white, male, a powerful father figure. The unconscious upset all such identifications by substituting for such beliefs a "swamp," an infinitude of time, space, and madness; a place of magical languages.

MANIFESTOES AND THEIR PROTOTYPES

Some of the "madness" not feeding directly into art was channeled into manifestoes; and developments in Modernism after 1885 are frequently indistinguishable from such manifestoes. Perhaps because the printed word became the primary medium in the nineteenth century—here began the idea that he who controls the mimeograph machine controls the revolution—every movement and subdivided movement turned to its own manifesto in the form, usually, of a journal. Or else, if not journals, then writers and artists turned to prefaces, as with Conrad's Preface to The Nigger of the "Narcissus" in 1897 or Max Jacob's Preface of 1916 or Apollinaire's various essays defining aspects of Modernism; or, in Joyce's case, even a letter, such as the one he wrote to Ibsen in 1901, following his article in the Fortnightly Review on When We Dead Awaken. These letters, prefaces, articles, outright manifestoes, journals, both simple and embellished (like Vienna's Ver Sacrum, with its lovely artwork), run parallel to the artworks of Modernism as a varied and multitudinous force.

Several of these manifestoes will be picked up in later chapters, and here I will only suggest some of the range and depth of their achievement. I have already referred to Jean Moréas and his Un Manifeste littéraire, which appeared in Le Figaro littéraire on September 18, 1886. The controversy begun by this overwritten and overcharged document can be attributed as much to its definition of symbolisme in the arts as to its timing. It came at the height of Mallarmé's influence and, also, at a time when Mallarmé was being challenged by naturalists, the Decadent movement, the first stream of consciousness novel (Edouard Dujardin's Les Lauriers sont coupés), and a host of other movements. Much of this opposition to Mallarmé's dominance—even while he was included in its pages—came from the Revue indépendante. The latter included work by Zola and Goncourt, Huysmans, Laforgue, as well as essays by its chief literary editor, Téodor de Wyzewa, on the Russian realists.

Moréas was intent on strengthening the position of symbolisme against all opposition. His manifesto is a Platonic defense of the symbol, which he perceived as something clothed in a form that did not disguise the idea behind the garment. His defense, recalling Carlyle's in Sartor Resartus, is that clothing, garments, garb, et al. are brought forth as the ways in which the real world presents and distorts the ideal. Moréas argued that "the pictures [which are] provided by

nature, the actions of men, all concrete phenomena" are mere strategies whose function is really to "represent their esoteric affinities with primordial ideas." This is to say, symbolism is a safeguard against identification of objects with what they represent; form is only a stratagem, not the thing in itself. Spiritual truths, legends, myths, all those aspects of a supranatural belief are the true matter of symbolism. Eschewing the real, it uses reality solely for purposes of presentation, as a means of gaining entrance into a world we can comprehend only with our senses.

Moréas's statement is clotted and ambiguous, but, as we have seen above, it was significant. For it captured one side of Modernism: its use of analogy and correspondence, its spiritualizing of matter, its thrust into different spatial and temporal dimensions such as we associate with legend, myth, and allegory; its affinities with what was becoming increasingly identified as the unconscious. In one sense at least, Moréas's manifesto became the jumping off place—one agreed, disagreed, or walked away.

One direct outgrowth of Moréas's manifesto was Conrad's Preface to *The Nigger of the "Narcissus,"* in 1897. Clearly nourished by the ideas of the *symbolistes,* and adding to that his views of Flaubert and Polish romantic writers, Conrad wrote a brief statement primarily for his own direction. But it turned out, also, to be a kind of archetype of prefaces, manifestoes, and statements that professed a distinctive point of view, as separate from those essays or journals that simply introduced a new body of work. Ford's *English Review* exemplifies the latter, James's "The Art of Fiction" the former. We are concerned here with turning points not only in an individual artist's direction but in the way his transition to another kind of art foreshadowed an entire movement. Such prefaces and manifestoes are right on the edge, grappling with avant-gardes, if not themselves avant-garde.

Conrad's Preface, then, was not solely a guide, it was a catchall. Feeding into the Preface are several overlapping elements: Flaubert, *symboliste* suggestions and planned ambiguities; Pater, with particular reference to "Style"; James, especially "The Art of Fiction"; a strong post-Wagnerian aesthetic, derived from Wagner's amalgamation of the arts; 1890s language and attitudes about aesthetic ideals and artistic elitism. What was uniquely defined was that impressionism which would both heighten and lessen in order to make the reader "see" with the peculiar intensity we call Conradian.

Although Conrad's Preface and James's essay are separated by thirteen years, they meet at several points. The latter had offered the novelist as a kind of priest, with a seriousness of purpose hitherto brought only to poetry and poetic drama. The novel's raison d'être was nothing less than to represent life, the novelist enjoying what James calls "a sacred office," all this preparatory to Conrad's injunction that he must, like a god, "make you see." Like music, the novel must be united in texture and interwoven; this absolute wedding of parts stressed by James, as it was by Flaubert before him, Pater after, and by that small army of Wagnerites, including Mallarmé, who had gathered in Paris both before and following the composer's death. For James, the artist's experience is never finite, since his imagination is always catching new hints. "Try to be one of the people on whom nothing is lost" has become one of his most famous dicta. The mind of imagination "takes to itself the faintest hints of life," convert-

ing "the very pulses of the air into revelations." Experience is "an immense sensibility." Within these considerations, the artist must be absolutely loyal to art, beauty, and truth, and from this fidelity will derive a morality and an aesthetic.

Conrad's Preface to *The Nigger* reflects this idea of the moral and aesthetic allying with each other, although we cannot be certain if he obtained it from James, Flaubert, Pater, or even Keats, if not from his other reading in French literature and in the literature of the 1890s. Conrad does echo James on the necessity of artistic awareness, remarking that to show intelligence at every moment and to search out the fundamental, the essential, and the enduring are the work of the artist. The latter appeals to what is in us a gift and not an acquisition. All art appeals emotionally, primarily to the senses: to our senses of pity and beauty and pain and mystery. And how, Conrad asks, can art, particularly fiction, catch this aura of sensory reality; how, in short, "does it penetrate to the colors of life's complexities?" Art must "strenuously aspire to the plasticity of sculpture, to the colour of painting, and to the magic suggestiveness of music. . . ." It is, Conrad says, "only through complete, unswerving devotion to the perfect blending of form and substance . . . that the light of magic suggestiveness may be brought to play for an evanescent instant over the commonplace surface of words: of the old, old words, worn thin, defaced by ages of careless usage."

Then Conrad made his now famous declaration, which serves, also, as a motto of the new, a manifesto of the avant-garde. Repeating James's dictum that the artist should "produce the illusion of life," Conrad said: "My task which I am trying to achieve is, by the power of the written word, to make you hear, to make you feel—it is, before all, to make you *see*." This foreruns not only Virginia Woolf's efforts to define the new fiction but Kandinsky's remarks concerning the spiritual in art. Kandinsky would write:

> If the emotional power of the artist can overwhelm the "how?" and can give free scope to his finer feelings, then art is on the crest of the road by which she will not fail later on to find the "what" she has lost, the awakened spiritual life. This "what?" will no longer be the material, objective "what" of the former period, but the internal truth of art, the soul without which the body (*i.e.* the "how") can never be healthy, whether in an individual or in a whole people.*

We hear in this, also, Mahler and Schoenberg, not to speak of Matisse: "Composition is the art of arranging in a decorative manner the various elements at the painter's disposal for the expression of his feelings." Conrad goes on that the artist must catch at rest each passing moment and reproduce that moment so that it arrests the interest of men; that function, he says, is the aim "reserved only for a very few to achieve." At that moment—Kandinsky's moment of spiritualization in art—the aesthetic aims of the creator assume a moral importance, achieving a sense of grandeur and of something

* Or as he wrote to Schoenberg (August 22, 1912): "The fact is that the greatest necessity for musicians today is the overthrow of the 'eternal laws of harmony,' which for painters is only a matter of secondary importance. With us, the most necessary thing is to show the *possibilities* of composition (or construction) and to set up a general (very general) principle."

fully *done* which captures the moral significance of what otherwise vanishes. *

The cry that goes through all manifestoes of the new is that need to blend form and substance. The seams and separation between the two stressed in the nineteenth century were to be transformed into the seamlessness of Modernism. This is, also, a political idea, since that blending the artist speaks of means that politics no longer has, simply, "content," for its matter must be disentangled from images, languages, tones, colors, et al. There is implicit here a threat to the state if matter is not discerned as such. Official opposition to the new was not only to specific content—i.e., sexual liberality or satiric images of society and government—but to that closing up of means and matter. Even here, however, Kandinsky has his warning, that *"The artist must have something to say, for mastery over form is not his goal but rather the adapting of form to its inner meaning"* (italics his).

Conrad's Preface was an archetypal document, not only a means by which he could combine *symbolisme*, Flaubert, Maupassant, Polish romanticism, Wagnerites, et al. It was, indirectly, also a commentary on those, like Schopenhauer, Darwin, and Nietzsche, whose work lay just outside the creative function. Although it associated itself with all three, it substituted for their "life processes" an aesthetic vision of wholeness. Darwin's views more than any others are countered in Conrad's effort to provide an aesthetic vision holistic in its aims. Even Nietzsche—whose work Conrad may or may not have known directly—emphasized a bifocalism which Conrad tried to resolve through the artwork. And Schopenhauer, who had been such a profound influence on Conrad's father, Apollo, as well as on the son, was counterbalanced by the novelist's insistence on individual experience, sensations, and the uniqueness of the creative spirit, i. e., of the individual unconscious.

Coming at the same time was the Viennese Secession, and only one year after Conrad's Preface we have the first issue of the Secession's journal, *Ver Sacrum*. However different the journal and the Preface were to seem, they overlapped at several critical spots. *Ver Sacrum* was part of that movement in manifesto journals which attempted to provide an entire environment of art: graphics, page presentation, artwork, as well as selections and point of view. Its predecessors are, among others, *The Yellow Book* (1894) in England, where Aubrey Beardsley was a satiric counterpart of early Klimt, and *Pan* (1895) in Germany, which combined avant-gardeism in contents and design. These manifesto journals would differ from later "little magazines,"† whose function was

* Pater's "Style," in 1884, was a manifesto of sorts. In Pater, music and prose literature are, in one major sense, compatible. "If music be the ideal of all art whatever, precisely because in music it is impossible to distinguish the form from the substance, the subject from the expression, then, literature, by finding its specific excellence in the absolute correspondence of the term to its import, will be but fulfilling the condition of all artistic quality in things everywhere, of all good art."

† I have in mind *Poetry, Dial, Little Review, Criterion, Egoist, Littérature, Broom,* and others of that type. Although *Ver Sacrum* has become well-known in recent years, *Pan* has not and deserves further attention beyond Peter Paret's brief description in *The Berlin Secession.* Another art and literary magazine deserving of mention is *La Revue Blanche,* which ran from 1889 to 1903 and was published by the Natanson Brothers (Alfred and Thadée). *La Revue Blanche*—whose title picks up the "whiteness" of *symboliste* poetry—included among its contributors Gide, Mallarmé, Jarry, Apollinaire, Toulouse-Lautrec, Félix Vallotton (who painted a portrait of Thadée Natanson), Vuillard,

in the main to present new materials, without regard for that total environment of art; but most of those little magazines came in and around the First World War, when the first thrusts of Modernism had become a beachhead and needed less packaging.

Ver Sacrum as a title conveyed the idea of a sacred or holy spring; it foreshadows in some ways Stravinsky's *The Rite of Spring*. Both are concerned with a holy ritual in which the young are consecrated to save a given society or culture. In Stravinsky, they have no chance, since they are literally to be sacrificed; whereas in Vienna, the title suggests the Oedipal pull of the younger generation away from an ossified Empire of elders, whose captive is Franz Joseph himself.

Ver Sacrum, then, was to serve in something of the same fashion as Conrad's Preface, in that its aim was to break away from old or familiar things and "make you see." One of the first artworks for the journal was Klimt's *Nuda Veritas*, a kind of witch-woman whose kinship is to Beardsley's drawings and Gustave Moreau's paintings and who had distinct association with the Salomé, Judith, Lulu figures that would follow in music, painting, and literature. Klimt's nude has the dimensions of a woman, but she is brutally cold. Her long black serpentine hair covers her breasts; so that while the breadth of her hips and thighs suggests her as a sexual woman, the motherly aspect has vanished. At her feet, flowers in their stiff, erectile position are unnatural, an aspect of nature portrayed as mechanical, outside of nature.

In the nude's right hand is a mirror, which is suggestive of the reflected Medusa figure or of Narcissus adoring his image in the pool. She is not, however, seeking truth, for she does not look into the mirror. Rather, she stares past it right into the viewer's eyes. It is as if she has a mirror in hand because she is a woman, but without any desire to reflect things as they are. The mirror may be empty, or it may reflect fullness; but the image we gain is one of waste—a well-formed young woman who lacks even the attributes of sexual appeal. She is in every sense, the "new woman." If the function of *Ver Sacrum* was, as stated, to strike through encrusted mold in order to create art, and through art to suggest freedom, then Klimt's nude represents an ambiguous art and freedom. She may make you see, but it is unclear what you will see.

But *Ver Sacrum* was far more than Klimt's nude. It became a bellwether of the Secession and a model of the journal as total environment. The latter aspect would be repeated in *Die Aktion* and *Der Sturm*, the first devoted mainly to German expressionism. *Der Sturm* appeared earlier, in March 1910, under the editorship of Herwarth Walden. Its function was primarily concerned with displaying graphics, although later it branched out into a more fully cultural journal, an environment of the new. Kokoschka's *Murderer, Hope of Women* first apeared in *Der Sturm* along with the artist's pen and brush drawings. The latter were of such violence and primitivism that Walden's championship of

and Bonnard. Gide served on occasion as its literary critic, and Léon Blum—later referred to by Pound as "Blum . . . defending a bidet" while Pétain defended Verdun—was a book reviewer and sports reporter. The *Revue* was eclectic, not narrowly avant-garde, and it vaunted artists as different as Picasso, Pissarro, Redon, Gauguin, and Seurat.

Kokoschka took considerable courage. From the first, *Der Sturm* intended to live up to its name, to create a tempest and to present a new environment without regard for traditional feelings.*

Unlike most other journals, *Der Sturm* sponsored exhibitions of new paintings. It became avant-garde in the truest sense: to exhibit the latest work without regard for ideology or content. Thus in successive months (March and April 1912), *Der Sturm* sponsored exhibitions by *Der Blaue Reiter* and the Italian futurists, with the latter show creating a riot at its premiere. This, too, was part of the new: that violent response to a particular artwork, whether in the early days of French impressionism, or Cézanne's work, Jarry's *Ubu Roi*, or the real riot in Paris at the first hearing of Stravinsky's *The Rite of Spring*. If the avant-garde was in part spectacle, role playing, acting out, then the riots blended well into the original intention; not anomalies but aspects of avant-gardes themselves. After the initial storms, *Der Sturm* continued in its messianic function of educating the public with exhibitions of whatever was now, whether books or painting. Through traveling exhibitions, *Der Sturm* created attention for German Expressionism, among other movements, and brought it to several European cities. It reached, in fact, into Zürich at the very time Dada was to originate, and, in one of those twisted cultural sequences, many of those who had worked in the expressionist movement helped to begin Dadaism.

The function of *Der Sturm* was to stir up, regardless of direction. This was its expression of the new. Another title based on stirring up, *Die Aktion*, under the editorship of Franz Pfemfert, was more concerned with expressionism. Its first issue, in February 1911, however, had a political slant, in that it represented a left wing or radical commitment that carried over from an earlier runaway group. Many of its enthusiasts were disaffiliated academics as well as painters, poets, general dissidents; and in its tortured history *Die Aktion* remained loyal to its origins as an expression of left-wing ideology. Although it attempted to be literary and sponsored lectures and readings as well as print, it began to change into a total environment, including graphics with literary and political messages. In its development, *Die Aktion* remained more narrowly based than either *Ver Sacrum* or *Der Sturm*, and in its immediate postwar years trailed off into an almost exclusive politically based journal. By 1918, it was dominated by radical manifestos, and in the following year, as antileftist and antidemocratic forces began to gain strength in Germany, it vanished.

I have moved beyond the borders of 1885–1900 to include *Der Sturm* and *Die Aktion* since they appear to be natural outgrowths of *Ver Sacrum*. What they all had in common was a secessionist spirit, regardless of what they were seceding from. Theirs was the Oedipal battle of generations, and in the case of *Die Aktion* a struggle that stressed political ideology. The shared intention was renewal and regeneration of a moribund society. Similarly, we could cite Karl Kraus's *Die Fackel* (*The Torch*) as connected to this same desire for renewal; for Kraus in his caustic, cynical way saw himself as a Diogenes torching out the misapprehensions and deceptions of the past in order to purify his times. His emphasis was on purity of the German language, but his desire for purification spread further, into nothing less than a cleansing out of mold and decay.

* When the Nazis came to power, they published a journal of hate called *Stürmer* or "Forward"—an ironic epitaph on the "tempests" or *Stürme* of Modernism.

These publications, carrying us from Viennese Secession into the years before the First World War, were quite different from those like *Mercure de France, La Nouvelle Revue Française,* or *Revue des Deux Mondes,* whose aim was to publish what its editors considered to be the best of contemporary literature. The editor of the latter, Brunetière, for example, was antinaturalist in his sympathies and published what he considered would be a literature that neutralized naturalism. Such literary politics, as we have noted, would characterize that succession of little magazines right after the war and in the 1920s, what we associate with *Criterion, Egoist,* et al. If we consider for now only those who specialized in avant-garde or modernist material, we find a succession of violent titles. Added to *Die Aktion, Der Sturm, Die Fackel,* and *Pan* are titles such as *Broom, Secession, Blast,* the various "anti-" manifestoes of Apollinaire. Marinetti and the futurists, of course, provided an entire catalog of such violent images, whether titles or sentiments. Such publications preserve the militaristic idea of the avant-garde, since they suggest culture as a form of war in which sides are drawn and one either attacks or is besieged.

Marinetti's *Futurist Manifesto,* which appeared in *Le Figaro* in February 1909, was, like Kraus's publication, a torching of the old. "Futurist" was used as a battle term, a red banner to be waved before the eyes of traditionalists. More than a shibboleth, it was a form of action in itself. Although I have already commented on the manifesto, it is worth repeating that its key images are those of speed and change, of purifying. Before futurism took hold, the loose group around Marinetti had thought of calling the movement "Dynamism." The *Futurist Manifesto* was, in a sense, that total environment we associated with *Ver Sacrum* in that its ideology encompassed all modern life, and its effort at amalgamation—a gesture, perhaps, toward Wagner—was the visual arts, chiefly with the new art of cinematography. In this ideology of speed, change, and cleansing, logic and rationality would be replaced by intuition; grammar was to be dissolved and verbs superseded by infinitives—which move more rapidly than inflected verbs; analogy would suffice where sequential thought once held; language would be automatic writing, what Marinetti called "Parolibere."

Marinetti's manifestoes, along with the paintings that accrued around them, were the matter of futurism. It was a curious movement in that its chief literary distinction can be attributed to the manifestoes that brought it into being. It also helped bring into life subgroups or offshoots of itself, Apollinaire's *Futurist Antitradition,* among several others, and Wyndham Lewis's blast in his vorticist manifesto *Blast.* But to return to Marinetti, the peculiarity of his achievement was that it would have died shortly if he had not led it into politics; and then once it had been defined with the Italian political future—i.e., fascism—Marinetti was careful to distinguish between artistic futurist or avant-gardeism and the futurism that pointed toward a regenerated Italy. With that, he passes into history as the ally of Mussolini, the enemy of futuristic art, the supporter of pseudo-Roman monumentalism.

Kraus's *Die Fackel,* which has also been briefly described above, deserves attention here, since like *Pan, Ver Sacrum, Die Aktion, Der Sturm,* and others, it attempted purification. Kraus, however, was more polemic than the others. That is, he felt he represented a higher or more sacred form of purity than they and, therefore, whatever he offered was a critique not only of what Modernism was against but also of Modernism. In a sense, he came to stand for nothing

except the purification of the German language, for his polemics tended to cancel each other. His importance is less as an avatar of anything, least of all Modernism, than as a caustic, parodic voice insisting on truth, as he perceived it.

Kraus began *Die Fackel* one year after *Ver Sacrum*, in 1899, also in Vienna. Although he was a poet and dramatist, his name is connected almost completely to the thirty-seven years of *Die Fackel*, until his death in 1936. Since Kraus opposed, and misunderstood, Klimt, it is clear he began his journal as a way of casting doubt on both sides of the cultural struggle, secessionists and conservers alike. Kraus took an active role in the running conflict between Klimt and his opponents over his depiction of Philosophy in his university ceiling paintings. * Klimt's *Philosophy* is, like Schnitzler's *La Ronde*, almost a sexual daisy chain, with intimations less of love or learning than of sex, birth, and death—a kind of Brueghel-inspired *Liebestod*. The painting consists of an ascension, in which we are drawn not to angelic faces but to sizable buttocks and haunches.

The prevalence of so much anterior flesh on a level with the haunted eyes of the figures and of *Philosophy* herself transforms a hallowed academic discipline into a Secessionist manifesto of sorts. While Klimt's painting may mean many things, one subject is clear: the vision is an ironic, parodic, caustic view of a subject that under the Empire is more whore than wisdom. In some deep, painterly way, he has used the commission as a way of establishing the Secession point that the older generation (its "philosophy") has no meaning in the "new world" of will, thrust, sex, and experience. What the authorities observed, and rightly, was the kiss of death for their views. Life had, quite simply, passed them by, and yet they fought furiously to defend the system that had sentenced them. † Analogously, we recall Kraus's line about psychoanalysis, that it is "that spiritual disease of which it considers itself to be the cure."

Since Kraus took a role in all this, *Die Fackel*, which had begun the year before, was drawn into the developing cultural crisis. Here we have, right on the edge of Modernism, the meeting point of Secessionist artist, the state's protest, a painting of considerable power and distinction, a critic (Kraus) of the state and its hypocrisies, and the positioning of this critic against the artistic vision. Also positioning himself against Klimt's work was a well-known philosopher, Friedrich Jodl, not at all a state flunky, but a man in his own right representing the new, in his case the rational new. Jodl was a liberal and progressive—the spokesman for the other side of Modernism, its "modernizing" powers. Yet, withal, Jodl found himself supporting the state and supporting, as well, the religious and moral forces attacking Klimt. As Schorske observes, Jodl tried to shift the ar-

* The commission called for "Philosophy," "Medicine," and "Jurisprudence." The latter two would prove no less unsettling and controversial, although they fall outside of our immediate concerns.

† Schorske perceives the overwhelming presence of Nietzsche in Klimt's presentation of *Philosophy*, particularly Nietzsche's sense of blind will, represented by Zarathustra's "Drunken Song of Midnight." With its setting of "deep midnight," "deep dream," the world itself as a dark deepness, the poem has Woe speak: "Go, die! / But desire wants eternity—/ Wants deep, deep eternity!" Schorske also cites Mahler's use of this song as the center of his Third Symphony in 1896. The analogy is suggestive, in that it blends Klimt with two other very powerful prevailing figures; but *Philosophy* seems less in any philosophical tradition than it does in the decadent mode. Therein, all art is Secessionist, and to do his job, the painter must mock, satirize, play the enemy. The need to turn traditional disciplines into parodic forms seems to me to preempt any particular philosophical tradition, however much Schopenhauer and Nietzsche may have lurked in Klimt's mind.

gument to one of aesthetics, calling Klimt's work "ugly art," so as not to ally himself with a moribund state; but, nevertheless, he represented the state position and Kraus agreed with him. The latter in his effort to strike a blow for reason took on Klimt directly and said he lacked any comprehension of philosophy. But Kraus, one of the period's great ironists, missed all irony in the painting, all matters of tone and point of view, and failed to see that he and Klimt were in reality on the same side, not opposed.

Kraus *was* a great ironist, a critic of the same deceits and hypocrisies that Musil would write about in *Törless* and *The Man Without Qualities* or Mann in *Buddenbrooks* and his early stories; but even as ironist he lacked the self-understanding that would have allowed him to see irony and wit in others. He was so serious about criticizing that he failed to welcome fellow critics, even though he did champion a lesser artist in Schnitzler. Kraus, however, was in one way consistent with himself, since in his compulsive desire to cleanse the German language, he saw art and aesthetics as the enemy, as turning the language into something impure. Kraus had a vision, in his peculiar way, of the Garden: somehow to return to it via cleansed language—a rationalist in language who did not observe that "purification" when it came would have no role for him. A Jew seeking purification of anything German becomes, even well before Hitler, a man with blinkers.

Kraus was no fool, of course, but he was a man so attached to his own vision he missed much of the larger historical surge. The enemy was not aestheticism or "ugly art," but the very forces of rationalism he hoped to achieve. In brief, he hated the wrong things: aesthetes, Zionism, feminism (and women), Freud and psychoanalysis, and his own Jewishness, since he renounced Judaism, eventually to enter the Catholic Church, at the same time he founded *Die Fackel*. During the first twelve years of his journal, he published a broad selection of mainly German writers, Schoenberg, Wedekind, Stewart Houston Chamberlain (the English racist*), Lasker-Schüler, Liebknecht (who with Rosa Luxemburg was to be murdered by fascist thugs in 1919), Werfel, Hugo Wolf, Heinrich Mann (a liberal and progressive), Loos (a man with whom Kraus shared many qualities). But beginning in 1911, he wrote the rest of the issues, 650 in all, with the exception of one which had Strindberg as a contributor. His driven quality is similar to Weininger's, and Kraus was, in fact, an admirer of that doomed writer, sharing indeed his twin obsessions: Jewish self-hatred and hatred of women.

With these examples of manifestoes, we have gone well beyond our early stages of Modernism, for especially with *Die Fackel* we find a reach extending into the pre–World War II years. Essentially, however, we discover certain common or overlapping issues, focusing on either a manifestation of the new as in *Ver Sacrum* and the journals deriving from it or a critique of the new as in *Die Fackel*. The journals that made the largest difference in the fate of the

* When Kraus published Chamberlain, the latter had already published, in 1899, in Munich, *The Foundations of the Nineteenth Century*. Central to Chamberlain's thesis is the need for racial purity and for German folk movements that would be avatars of the future when Modernism and Jews could be expunged. In *that* Garden, German purity would save not only the nation but the world. Kraus's fascination with Chamberlain is not unusual. Although a Jew, Kraus was a troubled one, and his view that the Jewish use of German polluted it with Yiddishisms and jargon recalls Richard Wagner's diatribe in "Jews in Music." (See page 162n.)

avant-garde were, of course, those that presented a total environment, and the prefaces and manifestoes that helped develop Modernism were, analogously, those that kept seeking new techniques and new points of view, however destructive (like futurism) they might eventually become. One element we have not examined—and this is a matter to which Kraus responded—was that the exponents of Modernism would have to pay and pay hard for their daring. For they were tempting fate, demonstrating hubris, bringing down the temples, sometimes with glee; and when the ruins were apparent, it was not always art that would, so to speak, pick up the pieces. It could well be a state in reaction. Governments did not, like fathers, simply fall over dead because sons attacked them; they answered in kind, and they had the counterforce to destroy the very world that made such avant-gardeism possible. The bourgeoisie rarely gives up, and if it cannot find literary answers to such prefaces, manifestoes, or secessionist journals, then it rallies around a government, which can.

THE INSTINCTUAL LIFE

If each movement or secession, and its corresponding manifesto, insisted on uniqueness, then a good part of that uniqueness was associated with a freer, even more sinister, sexual life; and that, in turn, with the more or less obscene display of the unconscious. This is characteristic of the first phases of Modernism, in the 1880s. Even when avant-gardes were not specifically sexual in nature, as in postimpressionism or cubism, implicit in the public and critical hostility was an awareness of some sexual disturbance in the medium. As we note a growing use of the color red not as representative but as an outrage to nature, we can see that red and reddishness have associations with body, blood, secret parts, in some way continuous with and yet disruptive of nature. But a good deal of the avant-garde was more explicitly sexually oriented—not only through colors and arrangements, but in words, sounds (passionate, orgiastic, on the model of Wagner's *Tristan*), and direct images (Gauguin's natives, et al.). Strauss's opera based on Wilde's *Salomé* encapsulates a culture within a culture. Experimentation reflected a more open feeling about sex and its so-called abnormalities; homosexuality (however much Wilde paid for his frankness) was flaunted; lesbianism (with an outpouring of such literature, as we have seen, in the 1880s and 1890s) could be spoken of; "free sex" as options for both women and men, and which included considerable bisexuality, appeared in all media.

An extraordinary episode took place in Prussian Germany. The Kaiser was in attendance at a party when the chief of the Military Cabinet, Count Hülsen-Haesler, appeared dressed in pink ballet skirt and with a rose wreath. He then proceeded to dance. On its completion, he dropped dead of a heart attack, and even while rigor mortis was setting in, the celebrants had to remove the ballet outfit and replace it with his military uniform. The story foreshadows the Oxford antics of Brian Howard and his friends in the 1920s, and, more generally, the confusion of sexes that was so characteristic of Modernism.

Marriage as an institution was not so much attacked as bypassed, and it became irrelevant as the subject matter of the new art. Covert affairs, such as we associate with Dickens and Ellen Lawless Ternan, went public; and in artistic circles there was a freedom and an equality of sex that threatened the social

structure as the general public and church saw it. It took on a flouting of convention that had once been connected only to the aristocracy. These various "openings up," matters of anarchy in the eyes of most, paralleled the extraordinary interest in sexual functions shown in psychology—Janet, Krafft-Ebing, and others, culminating in Freud's stress on the sexual etiology of anxiety, hysteria, and neurosis.

Many aspects emphasized by Freud—omitting his synthesizing genius—had emerged in previous work on sex or in fiction and poetry. In art, Klimt's Secession works foreshadow, parallel, and justify Freud's ideas on sex. Klimt's poster for the first Secession exhibition in 1898, in Vienna, manifests a combination of threatening images: Theseus and the Minotaur in a death struggle, observed by a female warrior carrying a spear and shield. The center of the poster is dominated by a large white area, half of the poster's dimensions, recalling the whiteness and void we associated with Mallarmé. It is invaded on the right only by the warrior's shield and spear and on the left by "Gustav Klimt" in tiny capitals. The large white space becomes silent threat, absence: a kind of white death. The lack of center in the poster is, of course, as much presence as absence; and it reinforces, in some mysterious way, the sexual content; as if the viewer can supply whatever sensory experience is stirred up by whiteness juxtaposed with a death struggle and an observant female warrior.

That whiteness, in fact, is an apt pictorial representation of the unconscious; for linking avant-garde art with sexual daring is the unconscious unleashed. For many, the real villain behind the sexual revolution was identified as the unconscious, itself anarchic and uncontrollable. We could, if we wished, call the period an "Age of the Unconscious," and extend its range from the 1880s to its exhaustion in surrealism and *Finnegans Wake*. The Joyce novel, in its writing extending from the 1920s to 1939, is the beneficiary and delineator of the furthest reaches of the unconscious in the written word; but nearly every aspect of it is implicit in 1880s and 1890s developments—dream, sexual content, linguistic experimentation. Further, like Modernist works in their first phases, it signaled its completeness by its own form. It was all. The language of the novel, as Stephen Heath suggests, does not direct us to external meanings, but becomes its own end; that is, meaning in *Finnegans Wake*—analogous to our model, the unconscious—does not derive from elements beyond it or from anything language translates into. It derives from words themselves and from their association with each other, what Heath refers to as a "theatricalization of language," in which communication is undone and replaced by indeterminacy, a field of language like a field of force in physics.

This is, apparently, the furthest reach of the unconscious as we attempt to recover it in words. In art, it appears in several guises: particularly in post-impressionists—Van Gogh, Gauguin, late Cézanne, Matisse, *les Fauves* (when color was no longer descriptive of natural objects), then in cubism and expressionism, finally in abstraction, the rightful embodiment of the unconscious before surrealism. The chief beneficiary of surrealism and the unconscious in the written word is Joyce and in art Jackson Pollock, whose "drippings" shape themselves as brain waves and their synapses. In music, we find stirrings of the unconscious in Wagner's silences, in Richard Strauss's frenzied orchestral colors in *Salomé* and *Elektra*, in Debussy's *Pelléas et Mélisande*, in Schoenberg's extraordinary lieder, such as *Gurrelieder* and then *Pierrot lunaire*, his *Pelleas*

und Melisande and *Erwartung*, culminating in *Moses und Aron*. Of equal importance would be Stravinsky's *Le Sacre du printemps*, the gestures of Nijinsky's choreography and dancing, the abstractions of Picasso and his settings for Diaghilev, and that stress in early parts of the century first on Japanese prints and then on African masks and art.

Premiered in 1913, in Vienna, *Gurrelieder* ("Songs of Gurre") was completed, except for the full orchestral score, by 1901, and it provides an excellent entrance into the unconscious by way of musical composition. While indebted to Wagner and his *Tristan*, Schoenberg's "opera" is more vague and ambiguous, all shades and shadows. Gurre is itself a castle, and the doomed lovers move in a Gothic setting of death, tombs, and retribution. But the particular quality of the piece rests on Schoenberg's use of colors in his massed orchestra, so that the levels of dream and unconscious implicit in the story are translated into musical terms. Schoenberg penetrates magic and passion to their source, using tonal structures to roam the unconscious, where all the shadows gather prior to expression.

All of this is inner art, bringing the interior out in colors, forms, shapings, gesture; nonverbal or aural as well as verbal articulation. The aim—despite program notes, libretti, story lines—was not clarification of man's role or definitions of man's destiny, nor was the goal classical balance or cohesion. It was the opposite: interiors made visible, epiphanies as structural concepts, internalities (the unconscious itself) as containing their own language and associations; what we identify as the unconscious and preconscious pushing out to create their own horizons and networks of meaning. In these areas, despite the waves of avant-gardes, the alterations of focus in five-year eras, the rejection of historical modes, we perceive a coherence to Modernism, even a pattern.

The reason impressionism in painting is so significant as a forerunner of Modernism is that it was an early regulator, giving Modernism a way of looking at itself. When impressionists stressed qualities of light and color and combinations of hues, the object in the painter's eye superseded what nature had provided. Impressionism not only negated what the normal eye saw in nature, it negated realism. It fostered subjectivity and self. Monet was not one of the last realists, but the beginning of that rejection of realism which parallels Baudelaire, Rimbaud, Mallarmé, and others using the word to baffle, not to represent.

One example will perhaps suffice. Until the impressionists, painters used their palette to mix primary colors, say yellow and blue, to create green, or some aspect of green. The impressionists discovered that through use of light, perspective, and placement they could create a green in the eye of the beholder. They did this by placing blue next to yellow on the canvas, not on their palette, suggesting the intended effect through juxtaposition. Then if the spectator removed himself to a significant distance, the blue and yellow served as green, or as the green expected by the viewer. There was, of course, a vague area, in that the spectator might not "see," which was often the case with critics in the early days of impressionism, certainly with responses to Cézanne. The process, which has become familiar to us with language, is decomposition; here it is of colors, in that a "new color," as it were, is created not on the palette but by way of a magical juxtaposition which the spectator either sees or does not. Once impressionism had taught people how to see—and one should not minimize its ped-

agogical, heuristic dimension—they had no trouble with color decomposition; but by then, color decomposition had given way to other forms of decomposition: that of traditional shapes melting away, finally nonrepresentation.

This example may appear to move us some distance from the play of unconscious; but such developments in use of color as in uses of language in verbal modes are connected to that release of the unconscious; that parallel freeing up of both pre- and conscious so that very different sensations can emerge. If we balk at the unconscious here, we can substitute for it the sense of emergence.

A corollary is that the painters associated with impressionism, or the writers later connected to a literary impressionism (James, Conrad, Crane, Ford), had found a means by which social and political statements could be transformed into artistic abstractions. That is, with naturalism subverted and realism negated, the psychological apparatus was liberated. Not only nature but the very basis of the state became modified into forms of language (color, sound, image) which seemed to negate it. As early as 1863, a decade before the impressionists emerged as a loosely formed group,* Manet's *Déjeuner sur l'herbe* was a social as well as moral threat. Manet had discovered the means to turn a social event into the language of paint, and by way of an arrangement of men and women on a picnic he could make a large point about society, class, caste, the sexes.

Since Manet did not fit in with the illusions maintained about society, he was castigated by critics and general viewers alike, indeed for much of his artistic life, despite the general mildness with which he is viewed at present. But such castigation of his work went deeper than moral or social disapproval. It was connected to a rejection of his transformation of reality into languages that suggested the unconscious (or hidden sexual nature) and that would come to be associated with Modernism. Impressionism has so blended into bourgeois art as we now view it that we forget how much of a new language it created and how radically it transformed matter. Not only in questions of light, broken colors, primary colors recreated through juxtaposition was it one of our first Modernisms, but in transitoriness of most subjects and commonplace content, angles of perspective, antiheroism and deconstruction of elevated life. Many of these qualities can be used, analogously, to describe dreams or to locate the unconscious.

In its various mutations, impressionism remained a significant element in Modern art for three-quarters of a century. It controlled the viewer's eye (whether in paint or word), but, more than that, it manipulated the very way reality could be perceived. It comes, in its purest stages in the 1870s and 1880s, approximating on canvas what Bergson would characterize as the matter of the world being an aggregate of images. By images, Bergson meant something between what the idealists call a representation and what the realists call a thing. Matter, then, exists somewhere in the seams of that dissociation which idealism and realism have wrought—an intermediary between existence and its appearance. For Bergson, memory relates matter and spirit, and, accordingly, we never experience the simple perception of an object. When the mind grapples with an object, the former is impregnated with "memory-images which complete it [the object] as they interpret it." This is not only an attempt to define something embedded

* The impressionists in painting were hardly a group and really came together only to exhibit— the term itself was applied to them derisively in 1874; whereas they had called themselves the "Société anonyme des artistes, peintres, sculpteurs, etc."

in the unconscious as it surfaces when the mind grapples with an object; it is, also, something close to what was occurring during the height of impressionism.

Precisely as Bergson was eager to subvert the notion of matter as existing alone, so the impressionists, unlike the academic or purely realistic painters, moved us from outside to within. Despite impressionism's commonplace subjects—seaside resorts, church facades, beaches, grass and trees, still lifes and flowers—and its rejection of emotionalism, it sought to make objects melt into subjectivity and to suggest early stages of stream of consciousness. Some of this came about through a conscious lack of definition, which helped to release the unconscious. Renoir, for example, eliminated black, and several other painters eschewed shadows and outlines; all of which meant a running together of elements just below the realistic level of nature itself. The viewer's eye, accordingly, was drawn in as participant.

International Modernism had its roots in these several elements: impressionism in painting, however defused and transformed its ideas became; naturalism in literature, however much its kind of realism in Zola was opposed and mocked; symbolism in poetry, however diverse its symbols came to be; music-drama in Wagner and Debussy, however different it became in the practices of Schoenberg; a more generalized spiritualism, a coverall that includes work as divergent as the dream plays of Maeterlinck and Strindberg, the poetry of Yeats and Rilke, the antagonism of technology and mechanism characteristic of virtually every movement and its manifestoes. Nearly all of these elements except perhaps naturalism helped nourish a growing impressionism in literature, in which surfaces are transformed into colors, evanescences, shifting realities, spatial repression, temporal disruptiveness. These are, by extension, all elements of the unconscious and, not a little, sexual components.

As we have already seen, Bergson was a central figure in the later transition from impressionism into Modernism. He warned that the logical mind created continuity where none really existed; that this logical mind shaped mechanistic theories of existence because it had no other way of dealing with life; and that, besides this mechanistic impulse, there was another which tried to understand vital phenomena. This latter Bergson attributed to intuition. As Modernism develops in this early phase, the nature of reality or matter drifts not only toward abstraction, but toward a void which life seems to have created especially for things. This void is very close to how the unconscious was perceived in the years before Freud, and very close indeed to how the layman still perceives the unconscious. The shadows, hazes, ambiguities one associates with Mallarmé, Jarry, Wagner, pre-1900 Mahler, early Yeats poetry and plays, Maeterlinck, and others are, given their contexts, comparable to the mists one associates with an unconscious process.

If we move back to 1884, when Bergson began to form his ideas on laughter—as the academic lecture Le Rire: de quoi rit-on? pourquoi rit-on?—we can see how even laughter is part of the unconscious process that underlies the early phases of Modernism. Insofar as he sees dream logic and comic logic as deriving from the same source, an unconscious, Bergson is stressing a connecting link between conscious behavior and behavior triggered by an uncontrollable element. As an antimechanistic device—that is, laughter derives from our response to mechanical bodily movements—the comic is associated with whatever resists

mechanization. Laughter keeps us human to the extent it corrects an imbalance on the side of automatism, or movement without life.

Although Bergson's essay was not published until 1900, its etiology places it early in the Modern movement, and it connects with his other major works, *Time and Free Will*, in 1889, and *Matter and Memory*, in 1896; foreshadowing *Creative Evolution*, in 1907. In *Time and Free Will*, Bergson spoke of concepts as interrupting the flow of reality without giving us anything "of the life and movement of reality." They substitute for reality a "patchwork of dead fragments," an "artifical reconstruction." By the time of *Matter and Memory*, the conscious mind is always a lie: ". . . the brain state indicates only a very small part of the mental state, that part which is capable of translating itself into movements of locomotion."

Bergson inveighed against associationism, that relationship between large blocks: "The capital error of associationism is that it substitutes for this continuity of becoming, which is the living reality, a discontinuous multiplicity of elements, inert and juxtaposed." This "becoming" is a philosophical unconscious. As against associationism is duration, that sense of "the real, concrete, live present," which occupies the ground between past and future. Matter is always becoming, a psychological idea that links Bergson not only to Freud's later synthesis of the unconscious but to physical theories of energy impacted and ready to explode into being.

This is not too different from William James's comments in *The Principles of Psychology*, only a year later, in 1890, that even though the process of stimulation and response was automatic or reflexive—part of the process he called the "reflex arc"—reality was itself indeterminate. Even neural activity contained will, and consciousness exists apart from its emergence in conduct, or at least cannot be explained by its manifestation in conduct. James was of course more pragmatic than Bergson, but in both we detect an analogous rejection of "pure consciousness" as a guide to our behavior.

James believed that consciousness resembles a flowing stream (somewhat analogous to Bergson's duration); that the content of the conscious mind is always being penetrated by new images or thoughts, so that it is always changing, or flowing. Space and time, accordingly, are intuited by the senses, a countering idea to Kant's and Hume's contention that the mind constructs its own space and time. This stress on intuition was also Bergson's only shortly before, in *Time and Free Will*. Not unusually, James and Bergson became good friends, despite James's insistence on habit, that quality of adaptation which the individual's system makes to its environment—which is to say, James's bow to Darwin. Bergson, of course, departed from this, but he could agree with James's conception of what is left over after habit is activated, that "leftover" which permits man to turn matter into self.

If we move one step further, toward Freud's cautious reasoning in the early 1890s, we can see how the theoretical groundwork of Modernism is being laid parallel to the practices of writers and artists who have intuited their own sense of the unconscious. We also note how Freud was drawing on ideas already thrown out, and that his genius was as yet in synthesizing. The record of Freud's development of the unconscious in the 1890s comes, as we have noted, in his letters to Fliess. The great connection of concepts comes by

1893, when Freud announces to Fliess—in what would begin to split them as friends and collaborators—that "neurasthenia is always only a sexual neurosis. . . . I am now asserting of neurasthenia that every neurasthenia is sexual." Further, "a *sexual* neurasthenia is always at the same time a *general* neurasthenia."

Sex, the unconscious, and the artist further connect when Freud writes a few months later (May 21, 1894) that he perceives himself as a solitary figure, with a sense of mission: ". . . I am pretty well alone here in tackling the neuroses. They regard me rather as a monomaniac, while I have the distinct feeling that I have touched on one of the great secrets of nature." He stresses this obsessive need to have a hobbyhorse or tyrant. "My tyrant is psychology. . . . I am plagued with two ambitions: to see how the theory of mental functioning takes shape if quantitative considerations, a sort of economics of nerve-force, are introduced into it; and secondly, to extract from psychopathology what may be of benefit to normal psychology."

Freud's image for the transference of sexual tension into anxiety has something of the artist's sense of how a creative idea is expressed, or how it must emerge: he speaks of the accumulation of physical tension as water piling up behind a dam that blocks dispersion. We have, here, a very complex metaphor, one that has associations with psychological needs, but also with the very nature of matter, of energy that can be released under certain conditions. It has reference to Einstein's equation of energy and mass, of elements under such tremendous pressure they must emerge. With this, we find, once again, that linkage of sexual tension, anxiety, and mechanical or physical energy, part of an unconscious process suggestive of the artistic as well as psychopathological mind.

We switch our medium and turn to Robert Musil's Viennese image in *The Man Without Qualities*: Diotima, the patroness of art, the leader of a great salon, is enjoying a reception of the highest intellectual level and from the street outside her salon, "everything looked wonderful," ordered, and in place. But behind the backs of the spectators "the great darkness began and only a short distance further on rapidly became impenetrable." She has glimpsed the unconscious, not only of man but of men and societies; and she has glimpsed in that darkness what Conrad's Marlow had perceived only a few years before: jungle and the deception of man's motives, of course, but, even more, an impenetrable wall. Freud attempted to delineate that blackness, but he only approximated its dimensions, an approximation that was occurring in parallel terms in the early phases of avant-garde Modernism.

Mallarmé's protégé René Ghil* tried to penetrate the unconscious by way of colors and words, as Rimbaud had attempted earlier and as the impressionists would continue to do. Ghil stressed that the vowel *u* corresponded to the color yellow and, therefore, to the sound of flutes. Ghil castigated Rimbaud for equating the *u* sound with the color green instead of yellow. He is not equivocal

* An entire study, in fact, could be made of how Mallarmé's protégés and followers—Ghil, Jean Moréas (author of the symbolist manifesto), Francis Vielé-Griffin, Stuart Merrill, and Henri de Régnier—pursued aspects of the unconscious by way of symbolism through the 1880s and 1890s. Their work, like Mallarmé's, provided an aesthetic and quasi-philosophical foundation for the unconscious as a vital element in man's imaginative life. Furthermore, their work kept the Mallarméan aesthetic-philosophical basis of the unconscious alive well after Freud was charting it on psychological grounds; leading, inevitably, to those clashes between aesthetic uses of the unconscious and efforts at more scientific exploration.

about his assertion, and he dedicates his work to Mallarmé. What seems somewhat remote and even ludicrous has serious overtones, for we find Josef Breuer, Freud's collaborator and correspondent, using language analogously. Ghil may have been half mad, but he comes close to a truth. As early as 1880–82, when Breuer was treating Anna O. (Bertha Pappenheim), he discovered what would prove momentous: that if he repeated to his patient, when she was experiencing autohypnosis, the hysterical words she had uttered during her daytime "absences," she could recall the language and detail of her hallucinations. With this recall, couched in the languages of hallucination and the unconscious, she experienced catharsis and her destructive symptoms vanished.

Such a discovery in the early 1880s was a definite link between language and the unconscious, an association among words, memory, and senses, what Freud would later label the unconscious (*das Unbewusste*), and the recreation of the patient's self, a redoing of the past by way of a present act. These so-called forgotten traumas lay deep within, forms of artistic visions with their own languages which were creating terrible anxieties and hysteria until released. Freud coined the term *freier Einfall* to indicate that severe pressure of the pre- and unconscious upon the conscious. We translate the phrase as "free association," but it is closer to a pressure that is free of restraint, with the corollary of an anarchic impulse that seizes the individual until he must respond to *it* and not to his conscious mind. Freud's sense is not one chiefly of liberation, as free association appears to indicate, but one of pressure and weight, a kind of determinism which locks in the consciousness. Of course, part of that locked-in material was sexual—in fact, for Freud the major part, while less significant for Breuer.

Not unusually, Freud prepared himself for such revelations with his self-analysis in 1897. That self-analysis, referred to above, was his vast poem of self, territory we have already charted with several artists in the early phases of Modernism. What Baudelaire had indicated about the Dandy Freud suggested about himself, in that both created a cult of "oneself," a unique individual whose unconscious, once penetrated, revealed an unduplicable work. That 1897 exploration of what lay within was, in its larger dimensions, different only in degree from what we are tracing in secessionists and their manifestoes. Further, that sounding of depths led to sexual theories that connected Freud not only to what was occurring in poetry and painting, but to other sexologists. By 1897, Freud had abandoned his neuroanatomical research, for by this time his psychoanalytic phase had begun; his leap from biological studies to speculation about mind isolating him while also giving him unique material. The great leap occurred when he measured neurosis by its repression of sexual energies; that is, when he brought together the pre- and unconscious, the sexual life, and the language by which all of this could be understood and expressed.

The unconscious did not lie still awaiting exploration. It and its corollary, sexuality, were intrinsic parts of avant-garde anarchy, or what seemed anarchy in the public mind. The fifteen-year crescent at the end of the century was revolutionary. Secessionists and manifesto writers threatened everything, as did Freud in his quiet, bourgeois way. This was an inevitable consequence of that stress on sex, unconscious, and art as something unique. Despite his ostensible devotion to family life and appearance of order—has it been sufficiently em-

phasized that Freud was a great philosopher of the family who thoroughly undermined it?—he held to revolutionary ideas. We find several: primarily, the establishment of a language of the unconscious and of sexology; but also in the Oedipal conflict a hatred of royalty—part of those assassination attempts in the 1890s; an equal hatred of the aristocracy (the empire under which he lived and worked); contempt for traditional religious beliefs; admiration for both Napoleon and Cromwell, the first a cleanser of the old order, the second the killer of a king.

Common to secessionists, manifesto writers, and Freud was the need to "speak the truth," to strip away disguises and to eschew false roles. In his case histories, brief dramas or novellas, Freud the writer became the contemporary of Ibsen, Strindberg, Schnitzler, Hofmannsthal, Maeterlinck, foreshadowing Pirandello, Kafka, and Zweig. Illusions were the enemy, reality the goal, although in art the pursuit of the real led further from it. Similarly, in Freud, the desire to strike gold in the unconscious—Wagner had already mined this territory—would lead not to *it* precisely, but to a verbal scenario with its affinities, as we have suggested, to the verbal scenarios of Modernism. Nearly all secession artists and writers dared the opposition to silence them, especially since many of these artists were functioning in repressive societies, Franz Joseph's Vienna or Bismarck's Berlin, or, earlier, under rightist pressure in France's Third Republic. For even France, in the aftermath of the Paris Commune, when Courbet was driven into exile, and the Dreyfus case twenty-five years later, was not open to ideas that threatened order. There was, of course, no real order, only the illusion of it which had to be preserved.

Further, like Freud once he separated himself from Breuer and Fliess, the avant-garde reached into areas that had rarely been described before *on any sustained basis* either in literature or painting: areas of enervation, anomie, negation, alternate forms of existence often close to death, or on the edge of suicide; journeys with unlimited possibilities, including those involving the "end of things." Unlike the earlier romantics, who were concerned with similar experiences, the later groups attached little or no political or social weight to their ideas, nor did they express their beliefs as forms of individual amelioration. The unconscious was the self "laid bare," to adapt Baudelaire's phrase, and purified of virtually everything except language. The break with the tradition of Shelley and Byron was complete, as it would be, also, with Hugo. Elements that had hitherto been considered as building blocks of civilized life became matters of indifference for the avant-gardeist. In one thrust after another, the state, political life and the idea of a citizenry, ideology, sexual mores, family life, individual and state justice were subverted or tossed aside. By 1895, any artist who wished to make his personal mark had to be avant-garde and, as well, conscious that every form of art or social thought had reached an impasse which his work had to get beyond.

With reason belittled, with so many themes based on individual states of feeling, whatever they were, the instinctual life and its languages offered to the lay eye what appeared to be insanity. The mutation or breakup of traditional forms into new structures, sounds, colors was part of that renewal which also seemed disintegration, as we observed in Mallarmé and, before him, in Rimbaud and Lautréamont. In a movement only slightly later, in the 1890s, Jarry and his discovery of 'pataphysics attempted the breakup of language, narrative, thought patterns into waves, rhythms, seemingly arbitrary segments, foreshadowing both

Dada and surrealism in their withdrawal from conventional discourse. 'Pataphysics, as Jarry described it in 1898, in *Exploits and Opinions of Doctor Faustoll, Pataphysician*, was "the science of the realm beyond metaphysics." He said it would "study the laws which govern exceptions" and would "explain the universe supplementary to this one." More formally, he defined it as "the science of imaginary solutions, which symbolically attributes the properties of objects, described by their virtuality, to their lineaments." 'Pataphysics, to be properly understood, must be seen as deconstructing the world and word.

In this way, we can see Jarry's major creation, Ubu, as becoming an alter-self of Jarry, who, eventually, will devour him. Once devoured by his own self, once inside like Jonah, Jarry can speak of what the world looks like from that perspective. Needless to say, all perception becomes symbolical and hallucinatory, for he has forsaken his self for a new identity, with its own experiences and languages. The latter become the basis of another self freed of reason ("waking") and based on dream, hallucination, the unconscious. Jarry moved outside biology, at the same time as Freud, and into an interior life where the unconscious reigned.

His brief novel, *Le Surmâle*, in 1902, contains a remarkable episode of pure 'pataphysics. The "super male" of the title is engaged in a race between a bicycle team and an express train. The team is to be fed on Perpetual Motion Food, a basic ingredient of which is alcohol, so as to demonstrate the superiority of the human mechanism to the machine. The episode describes the great speeds the team achieves as it races against the train, over 300 kilometers/hour, even when one member dies in his seat. The distance is 10,000 miles, and, of course, the team wins. But the quality of the segment depends on the hallucinatory nature of the trip (surrealism here), the sense of speed (futurism there), the retrieval of Jewey Jacobs from the dead (symbolist in that); even the anti-Semitism of the name is prophetic. In every sentence, Jarry plumbs "laws which govern exceptions" and describes a "supplementary world" of the unconscious. An excerpt:

> . . . Jewey Jacobs was under contract to be fourth man in the great and honorable Perpetual Motion Food Race; he had signed a paper that would have set him back twenty-five thousand dollars for nonperformance, payable on his future races. If he were dead, he could no longer race, and would be unable to pay. So he had to race, then, alive or dead. One can sleep on a bike, so one should be able to die on a bike with no more trouble. And besides, this was called the *perpetual motion* race! . . . Indeed, not only did he catch up with us, he increased his speed beyond ours, and Jacobs' death-sprint was a sprint the like of which the living cannot conceive.

Portrayal of instinctual life did not mean anarchy in the arts, no more than Freud's self-analysis and pursuit of the unconscious led to disintegration of the individual; but such explorations did mean displacement of expectation. By 1895, the instinctual life was being translated into every form of artistic life, even into architecture, as Schorske so ably shows in his description of the Viennese Ringstrasse and later opposition to it. Monumentalism warred with vitality, institutionalization with individualism. Questions of Modernism arose, with Camillo Sitte arguing that the original builders had betrayed their aspirations to the demands of modern life, whereas Otto Wagner believed that the original monuments were architecturally illiterate for a modern age. With Sitte backing

archaic or older forms of space and Wagner insisting that only functionalism would suffice, an early Bauhaus argument, we have two of the extremes of Modernism well before the word had even become established. Ultimately, what Sitte stood for was spirit or the spiritual life as against Wagner's science and technology. As Schorske puts it: "Where Sitte had tried to expand historicism to redeem man from modern technology and utility, Wagner worked in the opposite direction. He wished to roll back historicism in the interests of the values of a consistently rational, urban civilization."

We find, only with this, the true dissociation of sensibility which Eliot had perceived as having already begun in the seventeenth century. Musil, the explorer of Kakania, his term for Austria and Empire, wrote that "a man without qualities consists of qualities without a man." Center? there is no center. Man? there is no man. The reason: everything has split and dissolved into conflicting factions, so that qualities exist but lack the man to contain them; or else the man exists without the qualities to apply to him. *Modernism had as its task to bring together the centerless center and the manless man*: that is, to reconnect the individual and his unconscious, to link the rational or waking man with his instinctual, dreaming, hallucinatory life.

DEFAMILIARIZATION

Of critical importance in the development of the unconscious in literature and art (later on in the languages of music) is that gradual displacement of scenes familiar from the nineteenth century. Baudelaire's Dandy had established a major stress point which continued throughout the century in the Pierrot, Hamletic, comedic figure as a persona of the artist and, indirectly, as a persona of the society itself. The Dandy's need to be original at any cost created a cult of oneself. Further, the need, in Baudelaire's words, to "combat and destroy triviality" demonstrated man's transcendence of the merely material. There is "greatness in all follies, a strength in all extravagance." Baudelaire located the Dandy in periods of transition, between weak democracies and teetering aristocracies. "In the disturbance of such periods a certain number of men, detached from their own class, disappointed and disoriented, but still rich in native energy, may form a project of founding a new sort of aristocracy," based on talents and gifts. In this respect, "Dandyism is the last gleam of heroism in times of decadence. . . . Dandyism is a setting sun. Like the great sinking star, it is superb, cold and melancholy." Heroic though he may be, the Dandy resolves "not to feel any emotion." He subverts emotion in order to project it in style.

With this, the Pierrot figure of the nineteenth century gains sustenance; with this, also, social and political matter must be subverted to style, that is, to aesthetics. What this means is that social/political commentary becomes subsumed in the artwork, and there is a sharp division between those interested in using the arts to comment on the state and those interested in using the state as a way of commenting through the arts. The Pierrot figure has impressed itself on us in several ways, the most familiar being the twentieth-century adaptations in Chaplinesque figures, Eliot's Prufrock and Pound's Mauberly, the Marx Brothers' tableaux; the Pierrot image, in fact, fitted well into early films. But in the nineteenth century, the figure—a combination of comic elements, weakness,

and strength through innocence—was even more pronounced and more complicated.

Laforgue's Hamlet, dating from 1886, is characteristic, a clown and an artist figure combined, a redoing of the most famous creation in English literature as a legend (part of Laforgue's *Moralités légendaires*) reaching into our unconscious. In this transformation, Hamlet has become not only a Dandy and a clownish figure, but an emanation of the most profound reaches of the comic. With superb timing, the Laforgue Hamlet was performed on the eve of the Second World War, by Jean-Louis Barrault, a stage Pierrot figure.

Hamlet's "To be or not to be," its familiar words moving into every nook and cranny of human sensibility, has a second parallel in Laforgue's "Another Lament of Lord Pierrot." The piece recalls a Browning dramatic monologue, but without Browning's heartiness and, more radical, without his balance of challenge and response. Laforgue's "Lament" is both a monologue and dialogue, with "we" becoming "I" and "my," what we see later in Eliot's *Prufrock*. Modernistic practices are evident. A basic metaphor is that of a piano keyboard whose keys are souls, and the twin characters throw out words without response; dialogue without communication. Elevation of sensibilities is rendered ludicrous. When "she" accuses him, Pierrot, of not loving her and tells him others are jealous, he responds: "Thanks, not badly, and you?" In the fourth stanza of this free verse circus, the speaker is not identified and the exchange of responses is deliberately ambiguous. The final stanza turns all to farce. "She" goes from a person to a character, then to an invention of a girl flitting through Laforgue's work. Nevertheless, he can still respond that they have sufficient substance on which to base a relationship; but, he asks, was it in earnest? Presented as a question, his words question the question, question the reality, and place in dubiety the very relationship Pierrot is concerned about. Hamlet passes through here, filtered into Pierrot, emerging thirty years later as Prufrock, Petrushka, Mauberly, and others.

The importance of Laforgue, as part of early exploration of the unconscious, comes in his displacement of the familiar, his assessment of our traditional ideas, and his witty, free verse presentation of tragic events—that is, turning all into Dandyism of a sort. Images of sordidness and morbidity are counterbalanced by lines that undercut, the rise and fall we associate with Eliot, Wallace Stevens, and so many other mainstream Modernists. Involved is a death ride into the unconscious formulated as a witty journey—the beneficiary of so many journey or invitational poems throughout the nineteenth century. We find a progressive use of wit for nihilistic purposes, part of that tradition of explorations and treatises on wit which culminates in Freud's "Wit and Its Relation to the Unconscious."*

* Tristan Corbière also fits here. Although not well-known, he was rediscovered when Verlaine included him in his *Poètes maudits*, in 1884. Corbière was less radical than either Lautréamont or Laforgue and rejected, also, their extreme theatrical aestheticism—that is, their insistence that all of man's efforts should nourish art. Nevertheless, he demonstrated that a clash of images can suggest the unconscious and a journey into death. "Paris at Night," with its recall of Baudelaire's Paris poems, is invitational, its images of death and degradation nourishing Paris's vitality. Life and death join through oxymoron and paradox. He writes of dead life, of living dead, "d'un dieu marin"—a sea god—"stretching his limbs on a morgue bed," his head slimy and his limbs naked and green. This sequence of images which reaches into our unconscious as aspects of slime, death, transformation of matter (familiar from Lautréamont), is of a piece with the death ride past the conscious so characteristic of early Modernism. This is more, however, than Gothic foreshadowing of Freud and later Modern movements; it is, in miniature, the movement itself.

Laforgue's method is, apparently, very dangerous, for it washes away the old by burying tradition through parody. It foreruns the most radical of those individuals who will disengage the present from the past, whether Bergson and Proust, or Jarry, or Van Gogh, Matisse, and *les Fauves*. It has its countermovement in cubism and abstraction in painting, and atonality and serialism in music.

While perhaps the most significant in terms of developments in the Pierrot pattern, Laforgue is hardly alone. In and around his *L'Imitation de Notre Dame de la Lune*, in 1886, with twenty-three of its forty-one poems dealing with Pierrot, we have Verlaine's Pierrot verses, Huysmans' "Pierrot sceptique," a review called *Pierrot*, run by Adolphe Willette, Mallarmé's *Igitur* and *Hamlet*, both in the Pierrot tradition, and, a little later, Schoenberg's *Pierrot lunaire*, a musical setting for twenty-one Pierrot poems by Albert Giraud. This list only touches the surface and does not include those works that indirectly owe their existence to Pierrot ideas, such as Jarry's Ubu plays or Picasso's and Rilke's clowns. In all of these works, Pierrot is suitably a fantasy figure associated with Baudelaire's Dandy, who, in turn, derives from that need to get beyond the real and natural, which is another way of denying the rational and conscious. Although the cool Dandy may seem the ultimate in control of his destiny, he is, nevertheless, a blow against the rational self or the superego, and a display of that ironical "other self" we associate with mythical presences, the unconscious, the making of a legendary figure without ties to the conventional world. Thus, the Dandiacal figure of the 1840s in Baudelaire travels throughout the century and ends up in the irrationality and "other worldliness" of the Pierrot figure, who then dominates one entire segment of avant-gardeism in the early twentieth century.*

If Jarry's *Ubu Roi* in 1896 and 'pataphysics in the later 1890s seem to be the epitome of the Dandiacal-Pierrot line, with its desire to violate whatever seems rational and conscious, there were parallel developments that violated reason and suggested the unconscious life. Part of this development—what Shattuck calls "the combined qualities of comedian and wizard"—owes its existence to Frazer and his work in anthropology and to Nietzsche's stress on Dionysiac strains in the human psyche, elements already referred to above. Right on the brink of mainstream Modernism, Conrad's *Heart of Darkness* gains its power not only from what Conrad creates literarily but from the mythic journey into primitivism and savagery that Marlow takes—i.e., into the unfamiliar, into successive layers of the unconscious. The journey recalls Freud's self-analysis only two years earlier, in which the key metaphor is that of "peeling away" or "digging into." The metaphor has archaeological reference, as it is supposed to, but it is also deeply personal. For it assumes that the individual life—Marlow's

* In his *Children of the Sun* (1976), Martin Green presents a suggestive outline of the early Pierrot material and its further reaches into the twentieth century, but without sufficient basing of it on the Dandiacal tradition. Also, he overemphasizes its reach, citing Proust as a Pierrot figure. Cocteau is more to his design. There is simply too much hard headed social commentary in *Remembrance* for Proust to be fitted into a tradition essentially without direct social or political content. Proust is not at all the aesthete—unlike Cocteau—eschewing the conscious, rational world; on the contrary, his art depends on his full awareness of that world as counterpoint. Proust kept his balance during the Dreyfus period, whereas someone like Cocteau, who posed as apolitical, flirted with fascism when it came. No Pierrot, Proust at least knew who and where he was. Green also exaggerates when he suggests that the Pierrot tradition and the homosexual tradition are almost synonymous: in error, at least, in extending his analogy so that nearly every homosexual is turned into a Pierrot, when in point of fact Proust disproves this equation at the highest level.

own sensibility as he experiences bizarre events and people—is all that matters. Modernism is often indistinguishable from subjectivity.

Further, as Marlow proceeds deeper upriver and peels away each personal layer, he needs language to express what he sees and feels; and Conrad's ability to find a suitable language of "inexpressibility" is the measure of his success, or failure, in the novella. That need to find suitable language for the workings of pre- or unconscious experiences strikes at the very heart of Modernism as it develops in the 1885–1900 period. For, as we have suggested above, once the unconscious and its sexual, personal, mythical potential are tapped in these early developments, everything after that depends on the creation of personal styles. There is no longer a school or grouping. Each writer or painter or composer stands or falls not on his reference to tradition or convention but to his own devices.

This displacement of the familiar, with its analogy in Freud's other kinds of displacement, was more than that which was being expressed by the new look found in the *Jugendstil* or Art Deco of the *fin de siècle*. Rather, it was a remaking of aurality and visuality with emphasis on what lies beneath, that is, below consciousness. Valéry only a little later spoke of art as based "on the abuse of language," language as the creator of illusions, not language that is precise or that transmits realities. The poet's language, as Valéry was fond of expressing it, was hermetic, especially as literacy and technology combined to make words international. Words had to be purged of familiarities and impurities, and the consequence, for all forms of artistic expression, was hermeticism that disallowed easy comprehension.

One such language was impressionism, which, as we have seen, led in succeeding generations to a redefinition or reperception of nature that accommodated discoveries in physical science, however much the latter seemed the enemy of art. Cubism and Einstein, for one such pairing, belong to an analogous frame of reference. Abstractionism, already implicit in cubism, had its political component in the politics of pre–World War One Europe, in both of which new languages reshaped reality. The clearest example of how the new stretches reality perhaps comes in Cézanne's later work, beginning with his oil of Mont Sainte-Victoire in 1885–87, and continuing through successive versions of this scene: the Mont, including the Quarry, in 1898–1900; then the Mont in 1904–6, shortly before his death. For each successive version, Cézanne was assaying a new language, but in all he was gradually effacing nature and its conventional appearances and reordering it not as visible nature but as shapes. That is, recognizable objects were expressed not as conventional visibility but as forms of nature, structuralist and objectified elements that the viewer himself redefines as natural objects. This is archetypal Modernism, with Cézanne's painting of this particular scene so valuable since it charts the movement of a language through one artist's mind, until he moves beyond the visual into the structures of nature. He incorporates what physical science was telling him and at the same time rejects scientific objectivity in favor of more ambiguous shapings.

Analogously, the "romantic chord" of the nineteenth century, except in a composer like Sibelius, was no longer expressive. Mahler becomes the pivotal figure in this transition, being far more Modernist than he is usually given credit for. Mahler used the chord but broke it, creating a contrapuntal sense between the music-making of one era and that of another which he had intuited as early as the 1890s. In an 1893 letter to Gisella Tolney-Witt, then a child, but later

a music critic, Mahler wrote about how new orchestral sounds are connected to the need to explore unique personal feelings. He traces this development to Beethoven, that "new era" when the composer's emotional life was related to the era of his creativeness. In this, fundamentals "are no longer mood," but transitions from one conflict to another: sadness, humor, poetic ideas, et al. In successive letters to various musical figures, Mahler laments how the press lambasts him for trying something innovative, how he lacks an audience that comprehends him, and how he is concerned mainly with feeling, with "the parallelism of life and music."

In another letter, Mahler writes of how dramatic music and the symphony must part ways. Although Wagner had taken over symphonic music's "means of expression," there is a movement away which will, Mahler suggests, make symphonic music increasingly abstract. Mahler is truly that rare bird, a transitional figure, with Wagner and the whole of nineteenth-century music on one side and, on the other, Schoenberg (deeply influenced by Wagner) and Stravinsky (a student of Rimski-Korsakov). In this parting of ways, Mahler personalized his type of music, that unique quality we have associated with avant-gardeism and the exploration of one's unconscious as a reflection of the whole world: ". . . one is oneself only, as it were, an instrument played by the whole universe. . . . At such times I am no longer my own master." Mahler speaks of himself as suffering "terrible birthpangs," and then describes the emergence of a symphony as a "surging up" from a completely self-immersed individual, "dead to the outside world."

The choice of image and metaphor places Mahler with Kandinsky, who argued in his comments on the primitive painter Henri Rousseau: "The outer shell of the thing, presented with complete and exclusive simplicity, is already the separation of the thing from the practical-purposeful and is the ringing forth of the sound of the internal." Or compare Mahler with Matisse's remarks, quoted earlier: "Composition is the art of arranging in a decorative manner the various elements at the painter's disposal for the expression of his feelings. . . ." Or Edvard Munch: "A work of art can come only from the interior of man. Art is the form of the image formed from the nerves, heart, brain and eye of man." All such organs are, for Munch, the "unconscious."

Across Europe, Schoenberg (and, in parallel developments, Klimt in painting) saw the need, with Brahms and Wagner dead, with Mahler's giganticism unacceptable to him, for a new musical language. He moved back to Berlin, advertised for students, enrolled Alban Berg and Anton von Webern in his classes, and started, loosely, a movement. The essence of this movement, as of others, was languages, although its most radical form, the twelve tones, would not surface for another decade. Even though *Verklärte Nacht, Pelleas und Melisande,* and the still unfinished *Gurrelieder* were heavily influenced by Wagner and Mahler, they were, at the same time, a breaking free toward a new economy of statement. *

* At the risk of some stretching, we can state tentatively that performing styles also changed to fit the new. Alterations in violin playing reflected some stage or level of Modernism. Leopold Auer placed stress on tonal purity, on economy of execution and matters of good taste. What we find is a shifting away from the romanticism of Sarasate and even the individuality of Joachim. More attuned to a modern leanness and economy, Auer insisted on a "mental" approach—which is to say, he was bringing principles of minimalist intensity to violin playing, somewhat parallel to that intensity and minimalism characteristic of so many other aspects of Modernism. This is not to claim that one can find Modernism everywhere, but there was a shift toward a certain economy, a full sound without the excesses of romanticism.

To switch the genre, we can cite Stanislavski, who wrote that the founding of the new Moscow Art and Popular Theater in 1898 was a means of sweeping out everything associated with the old: "habitual scenery," the "customary manner of acting" and "bad manner of production," a "star system which spoiled the ensemble" or the "light and farcical repertoire which was being cultivated on the Russian stage at that time." Instead of what was external or artificial, Stanislavski emphasized "inner truth," the "truth of feeling and experience," what he called ambiguously "spiritual technique." He recognized such surges from the unconscious required monumental preparation and training to prevent bathos, and, therefore, he lamented that "because of necessity and helplessness, and against our desires, [we] fell now and then into an outward and coarse naturalism."

At about the same time, Isadora Duncan was expressing herself through dance "as the divine expression of the human spirit," by which she meant something more than what traditional artists had always meant. She was seeking a new wellspring for her sense of movement, which was to achieve perfect harmony between inner and outer; to destroy once and for all that dance movement which expressed only the body—that is to say, classical dance. Duncan perceived dance as the means by which the body serves "as the conduit through which the soul can flow," and this flow "must not be impeded." The "sentiments and thoughts of the soul" that she expresses are really those internalities associated with the unconscious or preconscious, qualities that made all of these diverse artists loyal to whatever lay below or beyond. With his breakup of classical dance into wrists, fingers, ankles, and knees, Nijinsky discovered that regulated, minute movements could be more expressive than sweeps and runs. The minimalism or economy we associate with Nijinsky, as with so much Modernism in general, was an effort to search out the most expressive of places, those internal areas that were huge cavities of potentiality.

If we return to Mahler, we note in his nine symphonies (plus one uncompleted) the entire range of effects operating in nearly all the contemporary arts: a deeply personal symbolism; the uses of colors comparable to those found in the postimpressionists—Mahler was an orchestral fauvist; aspects of abstraction— silences, white spots, unfinished beginnings, an incomplete canvas—lots of space remaining in corners and borders; in brief, the entire range of displacement occurring broadly in the arts, in social thought, in the physical sciences. If Schoenberg's and Berg's later twelve tones are musical forms loosely corresponding to Einstein's relativity, then Mahler's earlier reshapings are analogous to Planck's quantum theory. For all, arts and sciences alike, had slowly moved toward invisible things. By 1900, when Freud was to begin systematically dismantling the unconscious in order to restructure the individual's conscious, the arts had already found that "area beyond" as the well-spring of creativity.

WOMAN, NOT FEMINISM

Once Modern and Modernism began to define themselves in the last fifteen years of the century, one of the fiercest of all personal battles, apart from Jews and their roles in developing the new, came over women. Here it is not a question of women's participation in Modernism—few female writers or artists

were avant-garde—but, rather, a question of the portrayal of women in Modernistic works. One can say the conflict was not over women, but over woman. We note a profound paradox: that while Modernism stressed the individual achievement and the unique artist, its chief male figures and many of its theorists denied individuality to women. Freud is, of course, central here, with his studies on hysteria based on women and their inability to achieve sexual harmony; and then grouped by him and his circle into some composite woman fit for kitchen and children, but for little else. In this respect, Freud was following Nietzsche, who, despite his relationship with Lou Andreas-Salomé, was even more insidious.

But coequal with Nietzsche and Freud was the large number of poets, novelists, painters, playwrights, and composers who perceived woman as Earth Mother, on one hand, as destructive Eve, on the other. We have, then, really three views of woman from the male point of view, all converging in the 1890s: woman as keeper of the hearth, loyal, supportive, always waiting, Freud's fiancée Martha Bernays; woman as Earth Mother, robust, figurative creature of man's desire for the Great Mother—Yeats sought her in Maud Gonne, Lawrence married her in Frieda von Richthofen, and everyone seemed to touch her in Alma Mahler Gropius Werfel, who had also been involved with, among others, Klimt and Kokoschka; and, finally, woman as destructive Eve, in Wilde's Salomé, Wedekind's Lulu, Klimt's Judith, in Berg's opera based on two parts of the Lulu plays or Strauss's *Salomé*. Lulu, moreover, was prefigured by several strong women in Ibsen, by the Strindbergian "monster," paralleled by female characters in work by Kokoschka and others.

Although several kinds of material—literary, social, anthropological, psychological—fed into these three divergent views of women, some ideas were more significant and influential than others, apparently. Certainly among "mythic" sources, the work of J. J. Bachofen, along with Frazer's and Darwin's, was critical.* In his analysis of female roles, Bachofen's work fitted into that larger role of "uncovering," whether of fossils in Darwin or the unconscious in Freud. In Bachofen's case, uncovering meant a reading of what occurred in pre-Hellenic times. Like Darwin, Bachofen sought discoverable natural laws for phenomena that had hitherto been assigned to "spirit"; also, like his contemporary, † Bachofen tried to show that these laws, once discoverable, operate continuously, without miraculous or divine intervention. He would attempt to do for myth what Darwin was doing for evolution.

Bachofen's importance for us is that he established that "mother right" or

* Jane Harrison's *Prolegomena to the Study of Greek Religion*, in 1903, was a testament to and celebration of Bachofen's views.

† Overlapping of dates among our theorists of female and other major issues in and around Modernism shows how discoveries were not unique, but part of a shared cultural heritage. Bachofen lived five years past Darwin (d. 1882); Freud was a grown man when Darwin and Bachofen died, and he was only twelve years younger than Nietzsche, who died in the same year as Freud's interpretation of dreams. Bergson was born the same year as Darwin's *Origin* and died two years after Freud. Durkheim was born one year before *Origin*, two years after Freud. Max Weber was almost an exact contemporary of all: Nietzsche, Freud, Durkheim, Bergson. Bachofen was himself connected, through his teacher Friedrich Karl von Savigny, with Goethe and his memory, and, more indirectly, with the Grimms and Ludwig Achim von Arnim, who edited the famous ballad collection *Des Knaben Wunderhorn*, which Mahler later set to music. Bachofen's first published piece was *An Essay on Ancient Mortuary Symbolism*, in 1859, the same year as *The Origin of Species*.

a matriarchal era is "not confined to any particular people but marks a cultural stage. . . ." Mother right belongs in a "cultural period preceding that of the patriarchal system . . . and it began to decline only with the victorious development of the paternal system." For Bachofen, this matriarchal era was noted for its nobility: ". . . the heroic grandeur, even the beauty to which women rose by inspiring bravery and chivalry in men . . . and the chastity and restraint that she exacted of young men"—female qualities which Bachofen exalted and which, at the end of the nineteenth century, were being lamented by antifeminists but challenged by feminists. Bachofen was seeking the "noble achievement" which was suppressed and frequently destroyed by later developments. Even more significant for his argument, Bachofen locates matriarchy as part of the mystery of the chthonian religion, that is, the mystery of the underworld, whether or not it invokes the orderly Demeter; and it is this chthonian mystery, with its anarchic potential, that later Hellenic culture tried to cover over with rationality.

As we move along Bachofen's sense of mother right, we can already see the outlines of the later nineteenth-century struggle over woman's role. For those like Weininger, Strindberg, and Nordau who saw femaleness as actually or potentially demonic, woman was a creature who swirled up out of the underworld, a figure analogous to Mephisto in her capability for subversion. Strindberg cast his demonic women in swirls and mists, so that they seem protected by Satan himself. And even Ibsen has his strong women—for example, Hilda Wangel, Rebecca West, and Anitra—come from nowhere in order to tempt men to what may prove their doom. The destructive woman is almost always a figure who has traveled from a long distance or who is surrounded by a haze having underworld connotations.

But Bachofen did stress motherhood, which he saw replaced by Hellenism with its completely different stress on social forms and ideas. He also emphasized woman's vocation for devotion and justice, and for similar qualities that have been given feminine names. His repeated point is that "matriarchy everywhere grew out of women's conscious, continued resistance to the debasing state of hetaerism" or concubinage; which is another way of saying that to counter men's lusts, women needed a more regulated ethical order, one caught by a purer strain. Out of this developed the idea of chastity and motherhood, with Dionysus as the great adversary, for the latter continued the Bacchic and hetaeric trend. Bachofen cites this development as equally degrading to men, putting them ethically and morally below women.

Dionysiac worship—and here we can see how in more than one way it fitted Nietzsche's thought—forced women into matrimony, reducing them to the "natural life of Aphroditism." The point is that marriage served men's functions and debased women. Yet women also welcomed Dionysus, first resisting and then embracing—since this provided them a modicum of safety in sanctioned marriage. Here we have one of Bachofen's critical ideas, where he is working both sides of a paradox and establishing a point that is of considerable interest to us after his death. He describes women's situation as fluctuating from one extreme to the other: from rejecting Dionysus as demeaning, but then to embracing the cult since it protected them against hetaerism within the confines of chastity and marriage—although in roles subservient to men. Thus, women are trapped and fall into roles defined not by them but by men.

This is, according to Bachofen, woman's tragedy, although we would go

too far in identifying him as a champion of women's rights in the modern sense. He perceived the bind into which women were forced, but at the same time saw their sensual life from a male point of view. He does, however, identify clearly the dilemma: woman forced to forgo the "chaste, Demetrian character of a life grounded in strict order and morality" and forced to accept "the new form essentially rooted in the Aphroditian principle of carnal emancipation." The older order offered "lofty virtues" and a well-directed life; the new order, despite a rich material life, "concealed a diminished vitality, a moral decay," which Bachofen feels contributed more than any other cause to the dissolution of the ancient world.

Bachofen asserted that when paternalism became primary, the woman was relegated to a material stage of motherhood, while man was liberated for a more spiritual calling. We note this in 1890s attacks on women as lacking spirit or soul and as having voracious, vampirish appetites.* Bachofen continued that with this liberation, man "breaks through the bonds of tellurism and lifts his eyes to the higher regions of the cosmos. Triumphant paternity partakes of the heavenly light, while childbearing motherhood is bound up with the earth that bears all things. . . ." The man becomes identified with the uranian solar hero, whereas "mother right" is the "first duty of the chthonian mother goddesses." The new ethos has transferred the divinity of the mother to that of the father; her previous Apollonian purity and spirit give way to Dionysian materiality.

Bachofen lamented this shift, but precisely this transformation fueled antifeminists later in the century. Woman's uselessness for intellectual and/or spiritual achievement made her suitable only for maternity; but, even here, the father's "heroism" makes him the authority. This is, in effect, what Freud wrote to Martha Bernays. It was woman's failure to heed this categorization that created the conflicts we find in end-of-the-century literature.

Otto Weininger, as noted above, perceived woman in her pervasive sexuality as demonic Eve. His hatred of women transformed them into everything destructive and denied them the right to be "a woman." They were, for him, "woman." Karl Kraus, the influential Viennese journalist and preserver of German linguistic purity, was not so perverse as Weininger, but he, no less, viewed women as totally sexual beings. He said that while man has sexual urges, "the woman *is* sexuality itself." Lacking rationality, she brings the disorder of her sexuality into everything. How remarkably close Kraus's woman is to Freud's sense of her as hysteric! Unlike Weininger, however, Kraus did not see woman as nihilistic, but as "the source." Women make men fecund, becoming a kind of fertilizer for men's genius or the grease that keeps men from squeaking.

Such women in Kraus are part of that broader development which includes Strindberg's destructive creatures, who feed off men's souls as hyenas off animal carcasses; or Wedekind's Lulu, a life force of inexorable sexuality and seductiveness; or Wilde's and Strauss's Salomé. Such a woman can be stopped only by killing. She feasts off men: men as "food" or nourishment dominate in this

* Scientific "evidence" was offered to support these distinctions. It was asserted that a woman's brain, since it was six ounces lighter than man's, was not educable, unless one wanted her hysterical. Women who did achieve were called lesbians, as some were, and by that label consigned to pathology—by Carl von Westphal as early as 1869, later by Krafft-Ebing, who asserted that lesbianism was the result of "cerebral anomalies" and a "functional sign of degeneration." Such ideas nourished men as different as Havelock Ellis and Strindberg, or Weininger and Nordau.

imagery. A similar element occurs in Oskar Kokoschka's brief play *Murderer, Hope of Women*. Even when women are supported, they are, at best, fecund creatures, women of the earth, unbridled, lacking rational impulses and safeguards. Equally compelling and mentioned above is Gustav Klimt's painting of *Judith I*, the Judith of the *Apocrypha*, which appeared in 1901. In the *Apocrypha*, Judith does a grisly job in cutting off the head of Holofernes; but in Klimt's version of the incident, she gains orgiastic pleasure from the deed. Her expression is one of lust, expectation, sexual ambiguity. We note Judith's half-open mouth, her sensual pleasure from the deed, recalling Salomé with the head of John the Baptist in the Wilde play.

There is, in fact, considerable cross-referring between Salomé and Judith, with Wedekind's Lulu not too distant. Behind such created women are not the females of Ibsen or even Zola's Nana and Thérèse Raquin, but mythical Eves and Liliths, destructive figures revenging themselves, like Medea, on men in bloodlust and gaining from it orgiastic satisfaction. Such women are beyond redemption, for they have, in their exercise of the unconscious, gone beyond civilized behavior, as Kokoschka demonstrates in his intense play.* The assumption of their creators is that whatever bloodlust men have—in battle or in acts of revenge—women surpass in irrationality because of uncontrollable sexual impulses. Klimt surrounds his Judith with gold, in fact almost strangles her with a gold collar, but what this does is to dress up irrational sexual impulses in the trappings of art: equate the unconscious with the art object itself.

We have already discussed the presence of the lesbian in middle to late nineteenth-century fiction—from Gautier, Baudelaire, Balzac, through Louys, Daudet, Zola, on to Strindberg. In these, the female presence is exaggerated, so that feminism and femalehood are turned into threatening forms of behavior: female devourers, sensuality unbridled. Lesbianism here is always tuned to sexuality, never to achievement or forms of sensibility. Thus, it is always negative, in that it is primitive, unconscious, antiorder, and subversive of civilization. In art, we have the Judith-Salomé image in the work of Beardsley and Moreau, as well as Klimt. The spirit of the Marquis de Sade surfaces in *Sonyeuse*, in 1891, and in Mirabeau's *Jardin des supplices*. But de Sade was not necessary to evoke

* The Kokoschka play appears to be a spinoff of Weininger's ideas, transformed by Kokoschka's own forcefulness. The Man brands the Woman (no names); she then stabs him, almost to death. He does not die, but instead gains strength and becomes an avenger, killing, in superman fashion, both men and women who get in his way. All action takes place at a Nietzschean level of will to power and Darwinian will to live. The play is a remarkable forerunner of Stravinsky's conception of *Le Sacre*, with its primitive rhythms and its ritual sacrifice. In Kokoschka, the Woman is not killed, but vanishes in the darkness of the bedlam initiated by the Man now in the grip of bloodlust. This ritual mating, leading to a dance of death, has brought out the "real Man" and the "real Woman."

In this vein: In his mathematics notebook, Paul Klee drew a number of women along the right side and edge, some only heads, some full body. All are characterized by witchlike faces, long, flowing hair; the full-body ones are posed as fairies or witches, arms half-stretched, akimbo. They are clearly *fin de siècle* ladies, vampire women, *dames sans merci*; typical figures of the nineties, fitting with Salomé and Kokoschka's vision. William de Kooning's "Woman" sequence in the early 1950s is part of this tradition: woman as devourer. Large breasts here are not motherly, but threats; warnings to the male that proximity is fatal.

Even more central are the Kafka female portraits—I have in mind not only the fictional women of *A Trial* and *The Castle*, but a real one, Felice Bauer. Kafka's letters to her reveal that she is, in his imagination, an eerie, devouring female out of Weininger or a Freudian case history. In Kafka's case, as in so many others, we see the woman transformed into a monstrous being as the result of the male artist's response to his father, a kind of displacement of bad energy that surfaces as profound sexual disturbance.

the antifemale tradition; Baudelaire was sufficient. Woman was the very opposite of the Dandy, and Baudelaire's distaste for George Sand was the result of her effort to escape her sexual status. In the above Sadean books, the roles are reversed, and the women are voracious. Narcissus became a dominant image in the arts at this time, not the least because Narcissus, transformed from a Greek youth, embodied the destructive qualities of the new woman.

The onslaught against the "new woman" did not go unanswered, and the other side, while less sensational, was equally forceful. Olive Schreiner's *The Story of an African Farm*, in 1883, although not well-known in its day, was part of that making of the new image. Lyndall, a lovely young woman, refuses to marry the father of her child because she rejects him morally and intellectually, while still finding him sexually exciting. Her rejection is on sexist grounds: that marriage to him will place her in his power. Schreiner is working literarily and by conviction in and out of lines developed by George Eliot and then Hardy. She carries through on what Eliot heroines could never do, and she avoids being trapped as Hardy's strong women are. Lyndall does die—as in Hardy all strong or rejectionist women fail—but Schreiner establishes her point about her heroine's integrity.

In a career that stretched into the prewar years, Schreiner wrote another book, *Woman and Labor* (1911), which became the bible of the woman's movement. In it, she provided a trumpet call for all women who thought they were destined to be useless, who did not even know what they had to force open to gain power. ". . . there is no closed door we do not intend to force open" and ". . . there is no post or form of toil for which it is not our intention to attempt to fit ourselves." In the English world, one must return to Charlotte Brontë's remarkable *Shirley* to find a comparable statement of intention and defiance of the male world. Schreiner's book had an extraordinary influence upon, among others, Vera Brittain, the suffragette and author, who rode the wave of Modernism in recognizing that *her* progress and *her* need preempted the needs of the great world. The First World War was itself not "a superlative tragedy, but . . . an interruption of the most exasperating kind to my personal plans."

But far more pressing in terms of the "new woman" was the woman who developed in Czarist Russia, around political ideas. Here because of a different political climate from that in the West, women found themselves in profoundly Modernist struggles against authority. The new woman is associated with defiance of authority, establishment of new terms of discourse between the sexes, experimentation in social philosophies. They were working out new arrangements in society, and by so doing they helped transform that society's expectations. While far more political than their Western counterparts, they filled out roles that fitted the negative view expressed by Weininger, Nordau, Strindberg, Nietzsche, and others. The Russian equivalent of those critics was made up of Dostoievski, Leskov, Goncharov, and Tolstoy.

The key document for the emancipated woman, especially among the nihilists, was Chernyshevski's *What Is to Be Done?*, which dates back to 1863. Chernyshevski gave what was in effect a clarion call to women who aspired to independence, whatever their particular focus. He appealed to those who thought of themselves as feminists, nihilists, revolutionaries, working women. Further, he appealed to women to use their freedom to remake society in a social revolution; thus, his appeal was on two interconnected fronts: for women to liberate

themselves and then to use that freedom to remake society through revolution. This program is repeated in Simone de Beauvoir's *The Second Sex* nearly a century later, where "revolution" is turned to socialism. Chernyshevski's call had both an immediate effect and a long-range one. At the time, he gave support to those women who joined nihilist groups and dedicated themselves to disruption of political Russia.

Such women as Elizaveta Kovalskaia were liberated by two events, the freeing of the serfs in 1861—she had been born a serf—and Chernyshevski's book. She wrote: "I set up a circle for self-education among the girls. It soon merged with a group of young male students. We concentrated on social issues, but we also read papers on the natural sciences, astronomy, physics, and other branches of knowledge. Chernyshevski was one of our favorites—particularly in his novel *What Is to Be Done?* with its exploration of the woman question." Women such as Kovalskaia, Vera Vasulich, Praskovia Ivanovskaia, Olga Liubatovich, and especially Vera Figner, who became famous, were concerned not only with personal liberation—which they came to take for granted—but the use of that liberation for political and educational purposes. They assassinated repressive officials, particularly police chiefs, and they petitioned and organized to obtain educational opportunities for women.

These were the immediate consequences of Chernyshevski's book. The longer-range consequences were of several kinds, but they focused on sexual emancipation. This took several forms, but much of it derived from the "fictitious marriage." This was a marriage created solely to allow the young woman to escape from her familial situation and to enter the larger world, as a young man would have taken for granted. Although the marriage might never be consummated, it created a tremendous break with the traditional expectations of both the woman and her family. She married not only a man, but a situation which she could then explore as she wished. Liberation from family gave her some of the leverage men customarily enjoyed. Dress codes among such women immediately fell, and they dressed to please themselves rather than to catch the eye of a young man. In Chernyshevski's novel, Vera Pavlovna uses her newly won freedom in the artels, socialist communes or cooperatives; in her case, a sewing artel enables her to raise the consciousness of her fellow employees. The novel stresses that women must take their situations into their own hands. Once this occurs, then love outside of marriage is sanctioned, and, in fact, sexual ecstasy or orgasm is equated to an act of love: the woman is freed to enjoy sex.

From this point, the woman's question fragmented, as it would, somewhat later, in the West. No formal woman's movement was organized until 1905, although emancipation had been actively sought for the previous fifty years. By the time of the 1905 movement, there were two main branches: those who, like most women in the West, stressed nonpolitical activities or else only the franchise; and those who, following socialist injunctions, wanted to draw in women as the avant-garde of the class struggle. In the latter view, women would put aside their personal needs in favor of remaking a new society. Such women were profoundly influenced by August Bebel's *Woman and Socialism*, which appeared in 1897. Bebel fitted the woman question into Marxist terms, stressing loyalty to the working woman. Many such followers of Bebel's ideas, such as Clara Zetkin, fiercely opposed the cooperation of socialist women with feminists, calling for a class war, not a "ladies' rights movement."

The fragmentation of the emancipation movement into either political or more personal groups does not concern us here, although we should recognize that the liberation of women (in a certain class) occurred at a far more intense level in Czarist Russia than it did in the West. For our purposes, the liberation movement helped nourish, both directly and indirectly, the revulsion toward the new woman that characterized so much of anti-Modernism. Ibsen's Nora was, in this regard, a faint reflection of the Russian woman slamming the door; the latter not only slammed the door, she went back to assassinate her oppressors. One should emphasize here that opening up of sexual mores which was a necessary concomitant of liberation, the alteration of dress codes, the raising of political consciousness, the use of fictitious marriages for the sake of freedom from familial restrictions. The result was a "fearful" new creature who could be reviled as part of that degeneration associated with Modernism. This meeting of elements was so significant because it led to the entanglement of issues in the mind of those who assailed Modernism for its moral degeneracy as well as for those who opposed it on aesthetic principles.

Thus, we have the grounds of sexual conflict. This struggle really has three aspects: the new woman, whether politically oriented as in Russia or insistent on avoiding domestic slavery, as in the West; theories of degeneration, which are chiefly based on deterioration of traditional values, embodied in part in the growing liberation of this new woman; and, finally, the identification of emancipation, deterioration, and voracious sexuality with the advent of Modernism. We have, in fact, a triangular-shaped movement, wherein the three sides are of unequal length, although critics tended to make them equal so as better to assail Modernism.

By assailing women and attempting to put them back into their place, anti-Modernists could turn aesthetic issues into social and political ones; further, they could strike at elements that, they felt, were disruptive of civilization itself, that revolutionary war between the sexes. Strindberg, who is often perceived as a Modernist in his techniques, was, in reality, concerned with feminism as part of a process of disintegration. As such, he explored Modernist themes even as he opposed them, using Modernist materials, both thematically and technically, by way of his opposition to what they signified. Writing at the same time as Nietzsche, in *Ecce Homo*, Strindberg in his *A Madman's Defense* (in 1887–88) offered up that God is dead and Woman has replaced him. But his sense of this is curious, for he says that once he recognized the primacy of woman, he worshiped her as "a soul incarnate, a soul pure and unapproachable, clothed with one of those radiant bodies with which the Holy Scriptures endow the souls of the dead. I worshipped her—I worshipped her against my will." He adds that he wanted to adore, to sacrifice himself, to suffer hopelessly "without any reward but the ecstasies of worship and suffering." He will immolate himself on the idea of woman's purity.

What Strindberg is creating is, of course, the edifice that will prove false to his view of it. Once woman replaces God as an object of worship, she must fail, just as God failed; only woman fails even more completely since through personal experience Strindberg can cut her down. Not surprisingly, as Mariolatry intensified, leading eventually to the dogma promulgated in this century that Mary's body had ascended into heaven, Mary became the woman by whom other women could be measured and found wanting. Mariolatry provided a

convenient form of worship against which the "new woman" could be assailed, a context, also, for antifeminism one hundred years later. By 1854, Roman Catholic dogma had declared that Mary was free of original sin, a doctrine that moved, as it were, on a tightrope. According to this theory of immaculate conception, Mary was not only free of sin in her birth and in her life, but at the moment of conception, a freeing process made possible by the grace of God brought about through his agent Jesus Christ. This promulgation led to a flood of petitions asking for her bodily assumption into heaven, and it was this atmosphere of Mariolatry that prevailed finally in 1950.

Misogyny was inevitable. Once cited as angelic, women would prove faithless and corrupted: creatures who should remain imprisoned since, lacking reason or logic, they were incapable of dealing with reality. Strindberg writes: "I surpassed myself in heaping insults on the head of my Madonna." The narrator, a madman defending himself, sees himself as Adam duped by a wily Eve. Eve and Lilith become, of course, the other side of Mariolatry. Man exists to be deceived and seduced; so that madness becomes his defense against women. A madman can escape what would otherwise entrap him. She (Siri) "sucked my brain dry, consumed my heart [her surname *was* von Essen]. In exchange, she looked upon me as a garbage can into which she threw all her rubbish, all her grief, all her troubles, all her cares." Food imagery persists, he the foodstuff, she the consumer. After eating his matter, she excretes him and then refills his empty husk with herself.

Here we have Modernism in the form of a new association between men and women, but implicit in that relationship is a morbid critique of the terms, a typical late-nineteenth-century brew. Swann with Odette is its greatest manifestation. It gained momentum, of course, with the Ibsenite and even Shavian woman, and culminated in its most destructive phase, as we have seen, in the female who devours men, Lulu. Such a woman is a distillation of everything Modernism points to. Her disruption of all traditional notions of family is a synecdoche of apocalypse. Although Ibsen's woman does not fit this bill—Ibsen was only one stage or dimension of the phenomenon—his much earlier *Peer Gynt*, although chiefly focused on a male, *curiously suggests what certain females will become*: how they will threaten all those who expounded the development of Modernism as a rage for degeneration.

Peer Gynt, completed in 1867, is a remarkable avatar of the new. Ibsen telescoped all dramatic modes, moving from realism-naturalism into fantasy and illusion, stretching dramatic probability in ways that prefigure many aspects of Modernism.* Peer, almost literally, runs away from the stage. He is perceived as an unconscious force beyond, so that he is barely contained. Whatever we say now as descriptive of Peer and *Peer* is applicable, later, to the way Modern woman and her role in the unconscious would be perceived. *Peer Gynt* begins in established time and space, with his mother at a wedding, and then veers off into an open-ended experience of fantasy. In this encapsulation of Modernism, Ibsen moves from representational scenes to poetically conceived ones. He has intuited that the well-made play can no longer contain the sense of Modernist consciousness.

* Jarry, the 'pataphysician, paired his *Ubu Roi* and *Peer Gynt*, having adapted the latter for the Paris stage.

Ibsen is after Gynt's spirit, what has become known as the "Gyntian Self." This spirit or soul—that "naked soul" German critics and artists would later speak of in Berlin—is a kind of purification, for the individual becomes disembodied and represents a force. By putting his mother on the roof, he frees himself of parental authority, symbolically killing her in order to allow himself to live; equivalent, later, to the new woman slamming the door, symbolically killing the husband, and then evolving into a death force for all men in the figures of Lilith, Eve, and their progeny. Free of parent, Peer can open himself to his vision. He restages himself, as it were, on different grounds, and the stage itself becomes increasingly fluid. If he pledges to the Troll King that he will forget everything except what is within those hills, he will accept a Garden on Earth. But, foreshadowing Nora, Peer refuses, cherishing his freedom above security and comfort. By Act II, naturalism has, like Peer, fled.

He becomes a wanderer, the archetype of the Modernist artist and "free woman," as her critics saw her. His life veers into a series of contingent episodes, in which he is both maker of his life and at the mercy of his choices. He moves along the same waves that impel Rimbaud's drunken boat or Mallarmé's poet-captain. His movements have left the regulated world and entered an open universe. Peer's direction is controlled by what Ibsen calls "the Boyg," the "Great Boyg." The "Great Boyg" confronts Peer and must always triumph, for it represents the life force; it dwindles in significance only when Peer is saved by women. We have, in some sense, an analogue of the Flying Dutchman legend, in which only the love of a woman can save the Dutchman from eternal wandering. Women can save Peer, as, later, with roles reversed, the contingent woman is besieged by men trying to save her. That later woman is in part Anitra, the temptress and dangerous counterpoint to the domestic; ever abiding Solveig.

The interaction of Peer and women is, of course, only a single aspect of the play; but it is crucial: for Peer becomes, as the "Gyntian Self," the embodiment of anarchic life forces which will later be ascribed to the soul of feminism. Ibsen views Peer as a cosmic fool, a kind of clown, although also, in part, a tragic fool; so that his release from rational thought and from logic removes him from a civilized world in almost precisely the same terms that would characterize the unconscious and the release of sexual energy. "I am a citizen of the world," he brags; all Europe has contributed to the making of Peer. He must, however, remove himself from the traditional or normal flow and relocate in a different temporal dimension. "I'll trace the story of mankind! Float like a feather upon the stream of history; and live again, as in a dream, the days of old; see the fierce fights the heroes waged—but from a vantage-point that's safe, that of an onlooker. . . ." Although Peer careens out of control, there is a mechanism for balance lying deep within, and this mechanism is activated when he recognizes there is a "real Peer." With this, he comprehends he must live within limitations; and, at this point—this is, after all, 1867—Solveig is waiting to receive him. At the end of the play, she becomes a wife-mother, rocking "my dearest boy" to sleep and dream. Unlike Anitra, she is a keeper of the hearth.

Having journeyed into the chaos of the raging sea, Peer has been saved. But in that experience of the voyage, he has moved outside of restrictions, and his situation in that limitless spatial and temporal dimension will be precisely

where the anti-Modernists locate woman and the unconscious: a raging, tormented, irrational, destructive and self-destructive force. It is only another step to Strindberg's transformation of the spirit of Gynt into the spirit of woman and a chaotic life force of insatiable, blind sexuality. Strindberg offers role playing, solipsism, posturing; so that external phenomena seem to derive only from the self. Once we acknowledge that ultimate subjectivity, we can transfer it to the female spirit, which, according to its critics, lacked all moral dimension.

We are, then, within that realm ready for the equation of women with the worst aspects of Modernism. Only Shaw held firm. Looking back at generations of women trapped by such male definitions, Vera Brittain asserted: ". . . but probably no ambitious girl who has lived in a family which regards the subservience of women as part of the natural order of creation ever completely recovers from the bitterness of her early emotions." As a consequence, she tells her diary she would be satisfied with nothing less "than a mutually comprehensive loving companionship. I could not endure to be constantly propitiating any man. . . ."

Yet she was struggling against a tradition that stressed the "medical fact" that women should not use for their brain the blood needed for menstruation, as well as an entire medical tradition which supported whatever the culture decided was necessary to maintain women in their routine roles. The medical profession went even further, viewing lesbians as a third sex, thus countering achievements by attributing them to inversion, neurosis, and hysteria. Most women, intimidated by medical documentation and such cultural attribution, accepted the definition, although the few who defied such definitions of "abnormality" found in opposition a means by which they could define themselves and rally their forces. And even those writers, like Gautier and Zola, who seemed sympathetic to the rebellious side of the lesbian, were really less interested in the individual than in the nature of rebellion against a bourgeois culture. Such is the import of Gautier's Preface to *Mademoiselle de Maupin*, in 1835, or Zola's redoing of the idea in *Nana*. When Strindberg picked up the theme, he stripped it entirely of its cultural rebelliousness and turned it into personal venom; but Strindberg was solidly in the Modernist phase of the issue, when social or cultural values became secondary to the redefinition of individual woman's role.

This new concern with woman as devourer and hysteric as well as Earth Mother influenced narrative in many ways. Since, as many assumed, women were irrational and "total sexual beings," or fixed in their roles as nourishers, their reflection in narrative needed innovative techniques: i.e., techniques that could enter the pre- or unconscious. The developing use of stream of consciousness was one way of capturing that sense of women—what we find in Joyce, Woolf, Ford, Dorothy Richardson, among others. Molly Bloom's soliloquy at the end of *Ulysses* has its origins at the turn of the century in Weininger, Nordau, Kraus, Wedekind, Strindberg, Klimt, Kokoschka, Wilde, and Strauss. Bertha in Joyce's *Exiles* and Yeats's various inspirations for Maud Gonne fit into the genre. An idea that was deeply European becomes international—extending as far as America, in Dreiser's Carrie or, somewhat later, in Hemingway's Lady

Brett. Roots return us to Wagner, his Venus or Isolde when drugged; behind him Schopenhauer and Nietzsche, their view of woman's role as that of a Venus-trap. *

In a more speculative sense, it may be possible, with some projection, to connect abstract art, the loss of narrative line in fiction, the poetic fluidity of character, the forsaking of traditional melody in music to similar impulses. That is, such forms of abstraction can be associated with those impulses that directed women away from family and home, making her temptress, Earth Mother, Whore of Babylon. In past literatures, woman as temptress and whore of course existed, but as distractions; woman in traditional roles as maiden, wife, mother, keeper of the hearth was the norm. Now the norm has shifted, with marriage and children as marginal. Kafka's fictional women keep no homes, tend no hearth, mother no children; they are temptresses, abstractions of life forces with only sexual curiosity. Swann's Odette is not a mother force, but the opposite; her attraction lies in her separation from everything associated with the hearth. Swann's obsession with her is in direct relationship to her Salomé-Judith qualities; he serves up his head to her for delectation, and she does not even kiss his cold lips.

We could argue, accordingly, that the focus of fiction, as well as that of poetry and painting, shifted under the pressure of the woman issue. Subjects were no longer love and attainment or rejection but meditations on impotence, contacts with mysterious sources of strength, abstractions about human relationships, explorations of the unconscious. Very possibly, in the greatest operas of our century, Berg's *Wozzeck* and *Lulu*, Schoenberg's *Moses and Aron*, traditional themes, arias, melodic lines have been effaced because in all three, traditional women have been effaced or (in Berg) transformed into a destructive force for their men. Analogously, the focus of attention in the written word shifted entirely. If we compare *A Doll's House* with Strindberg's *Miss Julie*, we see the theme shifting from a woman insisting on her personal rights to woman as devourer, with narrative means and language shifting analogously toward the symbolic, ambiguous, and mysterious. We proceed from the physical and cognitive to the unconscious.

The visual arts, as we have suggested, did not escape either. In dance, Nijinsky shifted roles from those related to romance (woman as maiden sought by prince, woman in traditional feminine role pursued by man who has glimpsed her) to roles depending on marginal creatures: clown, faun, fool. Man's balletic role has changed because women are no longer present with customary support systems. Also, even Nijinsky's "line"—based on ankle, foot, hand—demonstrates that the male is no longer a total being, but parts. He is responding to new roles by deconstructing himself—that is, perceiving himself as a different being from the one that once engaged the female in dance. The avant-garde has responded

* The popularity of Orpheus and Oedipus-Sphinx paintings in the last decade of the century fits well; since the interest in Orpheus was not primarily as the savior of Eurydice but as the man torn to pieces by maenads. Similarly, in the Oedipus-Sphinx theme—especially in Gustave Moreau—we note the Sphinx as a superwoman (body of lion, face and breasts of woman) who destroys all men who cannot answer her riddle. The stress is not on the man who responds correctly and then seeks his own doom, but on the destructive powers of the Sphinx. This extends even into such popular art as Puccini's *Turandot*.

to the radical shifts in female roles by moving the focus to other areas, whether in word, paint, musical notation, or dance step.

AVANT-GARDE SUICIDE

With roles changing so rapidly, with displacement of customary expectations, with avant-gardeists serving as disintegrators, with death and "the death of" ever present in the arts, not unusually we find an atmosphere of suicide, which was the pivot of chapter 2, above. Durkheim's work on the phenomenon of suicide coincides with the advent of a literature of suicide: if not of actual self-destruction, then of the man who is a would-be suicide, or thinks of himself as having killed somebody or something that is part of him. The suicide theme extends into several areas, but particularly into what I call spiritual autobiography. In that extensive subgenre of the apprenticeship novel, there is, ever present, suicide as an idea, a persuasive theme running parallel to ideas of progress that surround the protagonist and his creator.

It is a premise of this study that each avant-garde is a kind of suicidal charge. Its thrust is a kamikaze attack in which both the art and artist are burned up or burned out. Tradition is always what the avant-gardeist must move against, until he himself proves expendable. The avant-garde indeed does not forsake tradition, but uses it to demonstrate its expendability and disposibility. Each avant-garde movement incorporates what it must replace, until all we recall from it, after study, is the residue. This residue, far more than in previous eras, is made up of what the artist has given of himself, out of *all* his resources. The personal reserve we associate with earlier literatures has vanished, and the artist to survive in the avant-garde must put his entire being on the line—i.e., become a willing sacrifice or suicide.

Modernism has as one of its fundamental tenets the death of itself. We can say that implicit in Modernism and its ideologies is the principle of self-destruction. Each exploration or avant-garde lasts for perhaps only five years, so that exploration is itself an act of termination. Further, since each aspect of Modernism as we have already developed it derives from rejection, subversion, the need to remake, it is based on denial: of history, past, even present. With avant-gardeism always a suggestion of the future, every venture is doomed by its very nature.

Part of the unease felt by critics of Modernism—aside from the usual reasons—was its "all or nothing" quality, its lack of flexibility, its insistence on extremes. The artist was forsaking all safety nets. The theme of suicide in Modernism touches nearly every major phase and most writers except Joyce; and it can also be found in several painters—in the German expressionists, most apparently, but earlier as well, in Van Gogh—and in musical composition, in Mahler, Debussy's *Pelléas*, Schoenberg's early impressionistic music dramas. *Erwartung*, the monodrama deriving from 1909, is an interior monologue about the death of expectation, but, even more, the scenario of a suicidal venture. *Gurrelieder* is more closely allied with suicide, since the love of Waldemar and Tove combines ecstasy and a longing for death, a Wagnerian *Liebestod*. We saw the theme abundantly in Baudelaire, in his interest in Poe, in the group loosely

affiliated with symbolism, in Lautréamont, Laforgue, Rimbaud, Verlaine, in aspects of Mallarmé. It emerges, later, in Rilke, Kafka, Woolf, Gide, Hesse, Musil, and seems somehow connected to forms of madness. Conrad attempted suicide at twenty, a real and final effort with a revolver; Hesse attempted suicide; Mahler thought of suicide and his brother, Otto, succeeded in it; later, Alban Berg allegedly attempted suicide, as did his sister, Smaragda; Wittgenstein played on the edge of madness and suicide, and his three older brothers all committed suicide. In the public sphere, the apparent suicide at Mayerling Lodge, near Vienna, of Crown Prince Rudolph, in 1889, was the most sensational of what seemed an epidemic of self-destructiveness. *

Durkheim argued that his statistics show suicide as the product of social forces; madness, though, is more connected to personal temperament. However, with madness and suicide so closely associated in Modernism, it is impossible to see where social forces leave off and personal temperament begins. That is, the very nature of avant-gardeism, both the type of work done and the type of artist involved in doing that work, blurs distinctions between madness and suicide, as it blurs distinctions between sanity and madness.

Durkheim's two factors in suicide, egoism and anomie, are key elements that make avant-gardeism possible. The egoist, he explains, inevitably "has some tendency to non-regulation; for, since he is detached from society, it has no sufficient hold upon him to regulate him." He may not be purely egoistic, nor purely anomic; he may play both roles concurrently. If anomic, he is outside all forms of regulated life by virtue of several kinds of rejection. We have seen how both egoism and anomie, which nourish suicide, also nourished Modernism.

Durkheim speaks of how poverty works against suicide. ". . . the less one has the less he is tempted to extend the range of his needs indefinitely. Lack of power, compelling moderation, accustoms men to it, while nothing excites envy if no one has superfluity." Such poverty is the extreme opposite of Modernism; so that we can use an economic analogy to see how Modernism thrives not on images of poverty but on those of power, range, breadth: the elements associated with high suicide statistics. The avant-gardes whose waves made up the movement we call Modernism were like projectiles of energy. Suicide was itself a kind of power; while poverty, which seemed to preclude suicide, was a negation of power and expectation.

If we follow Durkheim's theories near the end of the nineteenth century, in the first phases of Modernism, then any phenomenon that increases potentiality and expectation of power, or promises energy, will, also, lead to suicidal impulses. Modernism, there, was a component of those social forces that worked reciprocally with suicide. This is significant not only as social data but for the implication that Modern and Modernism, especially in extreme avant-garde phases, were allied to death itself, not only as words or paint or sound but in deed.

None of this disputes the social matrix or peculiar personal conditions that lead to suicide, although the phenomenon is such a multifaceted act that no single explanation suffices. Our association of Durkheim's views on suicide with the Modern movement, however, suggests that energy, which we assume is good or vital, can also lead to personal demise. The death of God, which had been

* We can add to the list: Weininger, Walter Benjamin, Stefan Zweig, George Trakl, Ludwig Boltzmann, Kurt Tucholsky, Ernst Toller, and many others.

noted long before Nietzsche's seemingly offhand remark in *The Gay Science*, may have made people despondent and wary; but our avant-garde artists moved outside of any divine presence and were made despondent by the very forces and energies that nourished their art forms.

Freud, for one, often wrote of himself as coming close to death, and his self-analysis in 1897, while heroic in its intentions, was also close to personal and professional suicide. By forcing himself into recognition of his true feelings for his father, he moved ever nearer to ideas that could destroy him; or ideas in which his father might have triumphed. Much of Freud's career, in fact, in the mid to late 1890s, when his greatest ideas were incubating, was on the edge of self-destruction, conceived of in those very terms. Further, his stress on the id in his mature dream interpretation, in 1900, led him to a force that had almost limitless potential for self-destruction, its energies pulsating to escape and create personal chaos.

In another respect: we often think of the "Proustian memory" as a phenomenon owing its existence *only* to literature, based as it is on similarity and contiguity of experiences. Yet Proustian memory, or Proustian time, signaled a radical break with traditional notions of time. In emphasizing recall at the expense of the present moment, it created an art suspended outside voluntary coordinates of time (and space); it seemed to disintegrate experience and it turned narrative or storytelling based on linear sequencing into a kind of monotony which rejected all forms of progressivism. It was an act of dangerous exploration, with the implicit sense that it destroyed traditional notions of time without offering compensation.

In a broader political sense, Proustian time helped to destroy ideas dear to the Third Republic. The argument: If Modernism was a reflection of the deepest levels of what was occurring in the social/political sphere, then Modernism was not only a representation but a causal factor, not only a reflection but a symptom. The Third Republic of France eventually capitulated because of its schisms, in which antidemocratic forces helped bring it down. But we must add that Modernism fed into those antidemocratic elements; not in any crass or direct political way, but as energies that kept alive the schisms in society and pressed both right and left wing to extremes. Even though the France of Modernism was superficially a republic and a democracy, the government was itself a chimera, since the National Assembly elected in 1871, as an aftermath of the Commune, was two-thirds monarchist, not democratic. What permitted the Republic to hold together was not its Assembly, but the fact that its Assembly could not agree on which monarch it wanted, whether the Comte de Chambord, the legitimate Bourbon heir, or the Comte de Paris, the Orleanist pretender. Some, in fact, wanted another Bonaparte, whoever he might prove to be.*

We find here a type of state or governmental suicide, a national condition that, if brought down to individual terms, could be diagnosed as suicidal. It all came to a head, of course, in the Dreyfus affair in the 1890s, when national suicide seemed more direct and straightforward; when army, state, and influential individuals pulled the country apart, even as the truth about Dreyfus began to

* Democracy or republicanism in France was itself an anomaly. Before the Third Republic, France had enjoyed a bare dozen years of republican political life, in the years previous to Robespierre and then after his fall before Napoleon's First Consulate, and, finally, in the four-year period between Louis-Philippe and Louis Napoleon, 1848–52. The Commune, socialism, and communism combined to keep the republican idea close to anarchy, and France during these years when Modernism developed was always close to right-wing fanaticism.

become apparent. If this is a form of suicide, then Modernism with its own suicidal impulses—impelled by the disintegration of traditional temporal and spatial ideas—becomes not the shadowy reflection of the culture, but culture itself. Our example is France because Modernism began here first, but it would be possible to find similar elements tearing Franz Joseph's Vienna and Austria apart, not the least of which would be the senility of the regime itself and its inability to deal with Prussia's military presence or with liberal progressivism and nationalism in its own domain.

I have described the Dreyfus affair elsewhere, but here, in an explanation of how suicide interpenetrated the state and Modernism, we must see it as official suicide. The great thing about the affair for the cultural historian is how it defies precise analysis, and how the very elements that struggle against each other in Modernism—traditional and avant-garde forces—were opposed to each other in Dreyfus's situation. It was not simply a question of left and right, for while of course those who represented right-wing interests—army, business, banking— called for Jewish blood, we know that the left laboring classes likewise called for Jewish blood. Thus, we have a strange merging of groups with each other, and the divisiveness moved not vertically but laterally, creating schisms that were nothing less than forms of national suicide.

Even while the right attacked the avant-garde in particular and Modernism in general, and saw Jews as the element sapping national strength, the left itself split drastically. While labor agreed in the main with the right, many of its subgroups split off and disagreed among themselves as to where truth and honor lay. We have, then, on the national scene that disruption and adversariness which were the very goal of the avant-garde; a kind of reciprocity between Modernist "madness" and the national desire for suicide. The only thing on which everyone seemed to agree was that Dreyfus, as Jew, was allied with Modernism, the new, the conspiracy against traditional France. So that even when Dreyfus was defended by Clemenceau, it was against the latter's true feelings: he disliked Jews and himself worried about their loyalties. *

The affair revealed the corruption and suicidal impulses at the heart of the French republican idea, its failure to practice democratic forms even within a constitutional frame of reference, and its devotion to army and tradition even when these had been discredited. Charles Maurras, in *Action Française*, con- tinued to praise Colonel Henry, the linchpin of the government's case, even after Henry was exposed as crooked. An American equivalent, on a smaller scale, would be the McCarthy charges of communism in government which, for a time, split American public opinion in the early 1950s. The similarity arises in the desire of a public to believe in a matter well after it is disproven, or after the evidence is proven to be a tissue of deception. We can perceive, in retrospect, that France's tearing herself apart over Dreyfus, in the face of the Prussian military threat and the inevitable buildup toward new confrontations, was a suicidal analogue on the state level to Modernism's ripping apart of authority and stability at the cultural and aesthetic level.

We have, in a sense, enlarged Durkheim's categories of suicide to include

* Although Emile Zola has been historically linked with the phrase "J'Accuse," certainly the most famous label of the Dreyfus affair, the phrase as a headline was of Clemenceau's making. It appeared in the latter's *L'Aurore* on January 13, 1898, and became a turning point in the affair.

both governmental acts and new artistic forms. The avant-garde as the avatar of revolution turned the arts into elements that had to die or self-destruct in order to make way for the next phase, whatever its characteristics. While this had always been true, with one movement or school succeeding another, with a new tradition overtaking the previous ones, never before had successions been so rapid or so lacking in common ideas. We wrote above of how Modernism moved along in its avant-garde phases well before schools could form, certainly before traditions could be established. Inherent in this rapid exchange of one development for another, in which movement has been replaced by individual effort, is the end of things as we have known them. Certainly, much of the opposition to Modernism resulted from the latter's insistence on the indeterminacy of existence, its obsessive need to break down without regard for reconstruction.

Parallel to the rapid changes the avant-garde initiated was the rapidity of turnover in the French government. Governments rolled over on an average of every six months to a year, the six-month figure more frequent. Aristide Briand was premier eleven times, foreign minister seventeen times; and most other premiers and cabinet ministers simply exchanged seats in a game of musical chairs. It has been estimated that by World War One, the Third Republic had experienced fifty governments, or one a year, then after that, two a year. This turnover and rapid change in the state and its leadership conveyed a shakiness and instability which Modernism either mirrored or paralleled.

Whether there was actual reciprocity between the state and the arts, with each vying to out-destroy itself in a kind of competitive heat, is very possible, but unprovable. The Marxist could argue that conditions of capitalism, technology, industrialization, the role of the worker vis-à-vis his job, disparities in wealth, everything associated with progressive modernism had created a suicidal impulse. Accordingly, this impulse moved evenly throughout the society, whether to its governmental functions or to its arts. But such theories, while partially cogent, can be moved to nearly any country after 1885 and will reach similar conclusions. We are, here, concerned more with particularities than with a theory that roves all over Europe to reach the same judgment. This is not, of course, to discount an economic or social causation for Modernism and avant-gardeism—much of our analysis has been rooted in such detail—but to deny such movements any particular theoretical basis, especially one so reductive as Marxism. For while the latter may be cogent about the state, it tells us almost nothing about the arts, or else subsumes the arts under state functions.

In point of fact, the avant-gardes that proliferated after 1885 were forms of ideology. The technical developments in use of language, color, sound, movement were indistinguishable from ideology; they assimilated the way one looked at the state, the society, the community, nature. Innovation and ideology were wedded, not separated, and if revolution in the arts was the artist's aim, then he opened the possibility for revolution—in styles of life, in attitudes toward culture, ultimately in the relationship of individual toward the state. The artist—from Mallarmé to Zola in this particular period—was an ideologue whose means of expression were, in this case, an apolitical language, whether the language of a recessive symbolism or that of an exploitative naturalism.

All of this is part of suicidal impulses, not only of the individual involved in avant-garde Modernism but of Modernism as ideology and mode of communication. We could, if we wished, trace out the lines of Modernism as each

ending in inevitable disaster for itself: with *that* as the very ideology of Modernism, not happenstance. A related aspect we have only tangentially touched upon and yet that feeds into suicidal impulses is the secularization of life implied in Modernism, its rejection of formal institutions, and its embrace of its own value system as an end in itself. Implied in Modernism's secularization was its divorce from formally divine matters, its attack upon Church and clergy; until it achieved its aim of divisiveness when by 1905 France separated church and state. Modernism did not lead directly to such separation, but it exploited the antagonism to Church that had already been established in France's history since 1789 and surely since the Commune years. This exploitation of rifts, whether made consciously or not, gave Modernism its cutting edge and its reputation as a dangerous force, as a suicidal element in modern life. Modernism and avant-gardeism, once set afloat, were nothing less than drunken boats heading for the shoals—and prepared to take everything else with them.

PURIFICATIONS

Most of the points mentioned above are connected to Modern's need to "purify." Wagner "purified" opera of its Meyerbeerian and Verdian or broadly Italian aspects (Bellini, Donizetti, for example).* Schoenberg's twelve tones would purify music of its Wagnerian grip, returning it to fundamentals. The seven-tone harmonic system having been exhausted, Schoenberg saw himself as a modern Moses, deliverer not of his people but of his art from depletion. Kandinsky's abstractionism was nothing if not purification, toward a spiritualization of art:

> When the conditions necessary for the ripening of a precise form are fulfilled, the yearning, the inner urge acquires the power to create in the human spirit a new value which, consciously or unconsciously, begins to live in the human being. From this moment on, consciously or unconsciously, the human being seeks to find a material form for the new value which lives in him in spiritual form.

We are speaking of course of the artist's intentions, not of his results, however memorable they may turn out. It was only in Wagner's mind that Italian opera was decadent; it was only Schoenberg's need to insist that Wagnerian music was depleted. In *their* assessments, they were correct, for music (or art or poetry) reached an epitome in earlier hands and needed replenishment. These are personal assessments necessary for the artist to do his work, but irrelevant to

* Wagner had in mind not only musical but racial purification. Having been befriended by various Jews, it was inevitable for him to turn on Jews in music. In his essay of that title (1850), Wagner attempted to demonstrate that as outsiders to the German language and history, Jews could not achieve anything in the arts, but most of all in music. ". . . he [the Jew] merely listens to the barest surface of our art, but not to its life-bestowing inner organism; and through this apathetic listening alone can he trace external similarities with the only thing intelligible to his power of view, peculiar to his special nature. To him, therefore, the most external accidents on our domain of musical life and art must pass for its very essence; and therefore, when as artist he reflects them back upon us, his adaptations needs must seem to us outlandish, odd, indifferent, cold, unnatural and awry; so that Judaic works of music often produce on us the impression as though a poem of Goethe's, for instance, were being rendered in the Jewish jargon." As we have seen, Karl Kraus will pick up this argument fifty years later.

ultimate value or final reputation. In any final sense, there is no purifying or "measuring." Schoenberg does not supersede Wagner because of his need to purify music or to liberate it from the latter's music-drama.

Similarly, at about the same time, Wittgenstein saw himself as "freeing" philosophy from depleted forms and theories, from exhausted language. But, then, half a generation earlier, G. E. Moore had paved the way for linguistic analysis or "critical epistemology" as a means of comprehending the relationship between acts of consciousness and the objects we know. This, too, was an act of purification, here of inessentials and encumbrances. In another verbal medium, Mallarmé had perceived himself as purifying poetry of Hugo and other romantic excesses, as had Baudelaire before him. The great cubist experiments in the first decade of the century, similarly, began that early abstractionism which was to purify painting of its representational excesses; as, earlier, impressionism attempted to liberate light and color from academic realism. With abstractionism, the last remnants of heroism are vanquished, and with it, nature, event, action; everything is purified, except motion and space.

The concept of purification, with its basis in chemistry—the creation of gold by a series of purifying stages—fitted very well into the theory of decomposition, into deconstructing elements and objects that had become "too present," too evident. Modernism prided itself on simplifying, although its simplifications were so purified of commonplaces, of narrative elements that live in expectation, that it created its own immense difficulties. We could, if we chose to do so, plan entire treatises on purification as a key aspect of Modernism, connecting to it language, subversion of society/state, et al. Such purification can be accommodated only by an elite and understood only by fellow artists.

Purification or its more modish term, deconstruction, winds back to an earlier point: *authority of style was based not on the assimilation of other styles but on the expression of honest feeling which is then transformed into individuality of style.* Authority, tradition, even a movement all become secondary to the individual style, one-man avant-gardes in many instances. In Berlin, a new magazine called *Pan* was founded, in 1895, with a name intended to indicate the direction: panic, uniqueness, disruption. It would serve in modern society as Panurge had served in Rabelais's time. The magazine and what it suggested was the cannibalization of whatever preceded. In this view, those who broke with previous art forms had to keep up the disruption—had to move along with Pan as iconoclasts—or else find themselves lambasted. The German impressionist Max Liebermann, for example, had first rejected the authority of previous art, then when he fell behind the avant-garde was himself cooked to a turn by those who viewed him as no more than an academic minion. He was, simply enough, unable to move sufficiently fast, and his early rebellion was quickly forgotten. Since Modernism was a proliferation of individual styles that lasted only a few years before passing, those who purified earlier styles either continued to progress within their own means or else were discarded on the dust heap. Art forms passed into fads within years of their iconoclasms. Not only did movements rarely have the opportunity to form into schools, individuals had little chance to form into movements.

Profoundly connected to ideas of purification and to proliferation of styles is the question whether the development of avant-gardes in the arts connects to ideas of progress. Can we say that the avant-garde—however antisocietal it may

appear—is part of the same impulse that nourishes ideas of progress? Progress is, after all, an act of purification, primarily in its subversion of earlier ideas and practices, even in its adversariness to society and state. If we suggest that acts of purification, the avant-garde, and progress are parts of the same impulse, then developments in art are not unique, but elements of a unversal process in which everything moves along, but at different paces and in different contexts. I would argue, however, that from about 1885, when Modernist thought was shaping itself in sociopolitical and psychological areas as well as in the arts, the avant-gardeist was creating unique instants: revelations and privileged moments. The idea of progress is, of course, connected to the future becoming "now"; as it is commonly put, we are the future. The avant-garde artist partakes of that meaning, but he embodies in himself a significant extension of the idea, the sense that utopia has arrived purified of pastness and historical arguments. His work, whatever shape it takes as poetry and fiction, or as musical composition, painting, and dance, is the utopian moment. It is far more than the "future is now," and it has leaped beyond progress. Baudelaire saw it early in the gaze of a cat who returns his gaze: "Je vois avec étonnement / Le feu de ses prunelles pâles / Clairs fanaux, vivantes opales, / Qui me contemplent fixement."*

This moment of achievement signifies a stilling of time, a clearing of space, the creation of a mythical time and place. In that erasure of everything except his perception of a future, in his self-sacrifice for the greater glory of self, in his forsaking of an audience in favor of readers or viewers who embrace him, the artist has tried to embody in himself the mythical moment. Like a shaman, he has, of course, peered into the future, but he has gone well beyond it, outside common perceptions, progress, even temporality. It is that movement beyond, which means moving outside the future even while using the future, that characterizes Modernism from 1885 on.

The avant-gardeist, in his desire to purify, is always seeking a still moment or a spiritualized moment in which time and space are disconnected from past, present, future. One key ingredient of developing Modernism is the need for the artwork to move "outside"; not merely into Bergson's sense of *durée* or durational time, but into a temporal component that belies the needs of human reality. In an interview, Mallarmé—always the spokesman for that disconnected moment beyond—said that to his mind the "case of the poet in this society [the Third Republic] which will not let him live is the case of the man who cuts himself off from the world in order to sculpt his own tomb," or, in Kafka's case, to sculpt his own burrow. †

Mallarmé's "Tombeau d'Edgar Poe" is the creation, in words as well as sounds, of that encapsulation which lies even beyond the grave, where myth and legend cross in a purification rite. The latter is so far beyond that it is only memory, a moment cleansed of all historical detritus. But through language,

* "I see with awe the fire of its pale pupils, luminous beacons, living opals, which gaze on me relentlessly."

† The obverse of that internal rite is the larger sense of purification: Nietzsche and his need to purify the entire race of Prussians by marrying them to Jews; Zola and his desire to cleanse literature of illusions, even while muddying his readers in his form of naturalistic realism; Klimt and his "decadent sensualism" as a cleanser of a moribund society, his didacticism interpreted as perversion. Examples proliferate. Karl Kraus wanted nothing less than to purify the German language, and Freud attempted to cleanse Vienna of sexual repression in its hysterical and neurotic manifestations.

syntax, alliteration, suggestion, Mallarmé could evoke a particular kind of purification—a verbal tomb that is, also, a literal cenotaph. Poe will be "mythicized," purified, and buried in "Tombeau." There he will lie, as in most purification rites, outside time and space.

Such time and space "beyond" is common in Modernist purification rituals. Besides Mallarmé, we think of Musil and his Törless buried in a school wedged deeply inside "Russian Austria." Further, the purifying aspect of the novel occurs in an even deeper tomb, the attic where the sadomasochistic rituals occur. Here, in the attic, that tomb within an entombment, we have an equivalent to what will appear in Kafka's "Der Bau," wherein the mole seeks an ultimate purification; or in *Der Prozess*, whose ambiguous title alone suggests a "trial" in distorted time/space.

The tomb analogy for purposes of purification is a compelling one since it confirms how close death was to ideas of progress, or how intermixed suicidal impulses were with progress. The latter, here, is connected to purification; so that we have, in this bizarre mix, an interlocking death-suicide-progress-purification ritual: a significant metaphor for Modernism in its avant-garde phases. The association of suicide and purification, further, demonstrates that even the most final of adversary positions—saying No to one's life—had for the Modernists a sense of expanding energy. To oppose was so strong an ideology that purification, as if in some religious ritual, could be achieved only by suicide.

Essential to these rites, suicidal situations, and forms of purification are those aspects linked to distorted or parabolic time and space, one example of which is the tomb, another the attic, a third the burrow. The move beyond traditional notions of time and space is apparently connected to a variety of energies and influences—Bergson, Freud, the new quantum physics readily come to mind—but in most ways it is sui generis. That is, the avant-garde is defining its own terms, and these terms dictated a statement about progress in ways that move such work "outside." Thus, purification, whether of feelings, artistic forms, or intellectual ideas, involves a radical change in the way we visualize or sense those deepest elements, time and space.

This radical reshifting was nothing less than a purification rite of all traditional forms. In two of our three areas of avant-garde Modernism—Bismarck's Prussia as the exception—we have states resting on shaky ground indeed. Franz Joseph's Austria-Hungary, including the Vienna within, was a frail vessel, based as it was on authority that had turned moldy and was incapable of being politically renewed. The assassination of the emperor's wife in 1898, at the height of the Vienna Secession, was only one indication of how the state was losing authority even as the arts indicated a further weakening of tradition. Similarly, France's Third Republic, as we have seen, was divided so radically that the Dreyfus case tore the country in two, only twenty-five years after the Paris Commune had generated a civil war.

That purification had more than artistic ramifications and that it extended to society and state as a whole is now apparent. It stretched, as we have suggested, to language itself, an inventive economy in which languages were purged of historical baggage. This economy was based on new destroying old, or turning it into tradition. Language, however, was not only something to be purified; it was the enemy which must be decomposed, on the model of the military vanguard dislodging an enemy force so as to resettle the territory. Matter as once

located in Kantian time and space was now an aggregate of images, or, in Bergson's words, a "continuity of becoming." This redefinition of matter, whether in Mallarmé, cubism, Freudian analysis, or quantum physics, was linked to that redefinition of the state occurring simultaneously. "Duration," the corollary of purification, becomes not only a psychological condition but a language itself.

William James's "indeterminacy," as a reality located consciousness as a separate entity from conduct; which is to say that there is a split in the logical progression or association of ideas, a division also implied in Bergson's *durée*. The split between consciousness or the word and its concept or a form of conduct has a long literary history. We need only cite Kleist's "inexpressible man" as a recognition of that division three-quarters of a century before Modernism. The point is that the undermining of associationism for purposes of clarifying or purifying the old opened the arts and culture itself to new opportunities. Here the avant-garde led its forces into battle simultaneously to destroy and to open up. The twin function becomes clear. Avant-gardeism in this respect encourages progress, since by stretching the culture it allows new ideas to enter *even when* such ideas contravene the avant-garde aspects of Modernism. Karl Kraus was a figure caught precisely here, with his *Die Fackel* a torch burning out the old and yet providing light, he hoped, for the end of Modernism.

Similarly, the spiritual autobiographies I discuss in the next section are all such *"Fackel"* activities. In each, there is the need to make a leap into a new kind of experience based on the inadequacy of the old—i.e., the fact that time/space, history, et al. no longer function for contemporary conditions. Each spiritual autobiography, from Proust's *Jean Santeuil* to Hesse's several novels, is an act of purification and a sign of individual progress. At the same time, it leads the protagonist into a form of desolation (the tomb or burrow) close to death; so that we see, once more, the connection of purity, progress, and death as a self-defined aspect of Modernism. Concomitantly there exists that insistent need to move outside or beyond, to stretch categories and to experience indeterminacy.

Freud's self-analysis, strikingly, had an analogous function. In his case, he was to enter the valley of death associated with his morbid sense of his father and to face spiritual annihilation; but by so doing, strengthening his resolve by way of self-purification. For Freud, purification was a form of progress and an effort to disprove indeterminacy; it meant a confrontation with things as they are. This confrontation, based on exploration and purging, led away from a static condition—that is, the range of feeling from anxiety to hysteria—to a new stage based on a dynamics of behavior, or acts of purification. In this respect, self-analysis was little different from its fictional form in spiritual autobiography, in that both led from stagnation and/or sickness to the awareness of a "new self" lying beyond. The unconscious and preconscious are brought to the surface in the languages intrinsic to them and then transformed into the language of consciousness, where purification, potential or real, lies.

The route we have charted so far combines several elements seemingly disparate and divergent. The quality of life defined in these early Modernist purification rites involves a spiritual crisis that can be ameliorated only by negation of past history and exploration of new temporal sequences having little relationship to daily or routine activities. This sense of time is connected, instead, to what we find in a shaman's or hypnotist's duration; it forces first a displacement,

then a renewal. When Freud moved from hypnosis and cocaine to self-analysis and analysis, from disorderings to reorderings, from displacement of time and even space to a renewal of self, he followed, in brief, the same path as the avant-garde.

There is, of course, no clear congruency for this comparison, the avant-garde being an amorphous, unshapely element, analysis being the process of an individual. But, nevertheless, it was Freud's genius to perceive that the individual psyche went through stages that allow for generalization followed by particular elements: that is, ontogeny recapitulates phylogeny, part of Freud's heavy indebtedness to Ernst Haeckel's "biogenetic law." So, too, the avant-garde in its desire for purification and renewal: recapitulating the entire history of art in an individual's particular work. It mutated far more rapidly than in Haeckel's formulation or in Darwin's natural process of selection, and it created fossils as fast as it recapitulated, but it entered that process of renewal at the heart of every major nineteenth-century philosophy, whether that of Darwin, Nietzsche, Freud, or, diluted, Wagner, Gobineau, and the racial purists who followed them. Astonishing about avant-gardeism is its consistency with mainstream nineteenth-century thought even as it insisted on its sui generic quality. Amelioration, which seems so distant from its aims, is implicit in its insistence on renewal and transformation. This is true not only of the spiritual autobiographers (including Nietzsche) but of those far more iconoclastic, from Jarry to Zola, from Van Gogh to Freud, Einstein, and Kandinsky.

I remarked above that rapid artistic movements came when two of our three avant-gardes were located in moribund states. Austro-Hungary was itself a fossil: a state so ingrown it had almost ceased to respond to outside stimuli; so fossilized it could be described by Musil as Kakania, or "shit-ized," already a remnant outside history while still ostensibly alive. The French state was newer, but full of traditional royalist elements biding their time for a reactionary return. Pastness and history pulled against the need to change. The state's existence was precarious, with replacement of ministers and other officials like replicas of avant-garde turnover, but without the latter's sense of renewal. Its volatility was such that most politics were reactive, aspects of containment rather than constructive; and its ability to self-destruct was closer to the surface than its ability to transform itself. Revenge upon Germany, seething hatreds, personal and racial vendettas characterized its diplomacy. It was ripe for exploitation, dissolution, or purification.

Bismarck's Prussia, however, was revising itself, purifying the past in both economic and political senses, creating the frame of reference for racial purification. It was, indeed, a state, but by the 1890s it was pulling away from Bismarck, not coincidentally at the time Hitler was born and growing up in Austria. Bismarck had held the government together by the power of his autocratic nature, his ability to provide astonishing social measures, and his juggling of the treasury through Bleichröder, his financial adviser. But Prussia could not remain leashed, for it was a jingoistic society waiting to try out its military, put down its Jews, unseat Bismarck's reforms, move beyond its borders. It, too, was ready for a purification ceremony.

Comparably, the artistic response in Berlin, Munich, and elsewhere was to clean away, strip, bare the soul: the kind of purification a state cannot undertake. Bismarck papered over differences and held together incompatible ele-

ments. The avant-gardes springing up in nearly every major German city demonstrated a common theme: the essential nature of incompatibles, so that we discover art forms emerging that struck in waves at apparently smooth surfaces. The aim was to unsettle, as we find in *Die Brücke* group and then in the expressionists in painting; in literature in both Manns, the society in Thomas, the ideological and political in Heinrich; in music in Strauss and, more so, the young Schoenberg in Berlin.

Modernism was archaeological in breadth: stripping away levels of deceptive growth and revealing the soul of things lying deep beneath the rubble, Proust at one end, Kafka at the other. The rubble was everywhere, and to clear it away was not only an aesthetic quest but an ideological one. However outside the political mainstream the avant-garde appeared, it was deeply ideological in its thrust. Purification of what preceded and then of its own creation was nothing less than a cry of revolution, a plea for anarchy, reaching for chaos. Such was the nature of renewal as Modernism teetered on the edge of discovery.

In this idiom, Modernism was a savage god. Its thrusts were self-righteous and self-serving—although these were creative, transformations of the commonplace. Essential to the avant-gardes of Modernism was that need to revolutionize the past through exertion of the individual will; that need to disclose falsities of historical expectation. Expectation in itself had to be purified, not only of its bourgeois assumptions, but even of its most revolutionary ones. The avant-gardes were always ready to jump on the pyre to incinerate themselves along with discarded matter.

Connected to these diverse acts of purification, in some profound way, is the preponderance of "mad" figures in Modernism: the actually mad and the mad pretenders, real people as well as characters in poems, novels, and painting. A culmination of this is the clown in Picasso, Rilke, Stravinsky, and others; but the clown is a tame version of the mad outsider, the spectacle side rather than the actual thing. The real thing involved, as we have observed elsewhere, the Pierrot figure—naive and mad, innocent and lacking ability to live in the real world. But besides artists and characters, it also involved the purification of reason. "Folie" in its various guises served as an antidote for the worst excesses of rationality; that is, one extreme, the mad figure, acted as ballast for the other extreme, reason. With positivism, science and technology, as well as pragmatism offering up logic and rationalism as the new gods, the countermovement tendered a particularly savage and bitter god, the madman.

As Shakespeare noted, the madman seemed to offer a greater truth. We are familiar with Lear and Lear's fool, the mad Don, and others in this cast who offer madness as a higher order of perception unknown or impenetrable to those devoted to reason. Yet madness is not simply a blithe element, nor solely contrast; it involves threat, danger, subversion, menace, and mockery. Parodic forms dominate so forcefully in avant-gardeism because, in one respect, the madman and/or his vision is in such a radical adversary relation to the larger society that his only form of discourse is parody, irony, wit, burlesque. All of these latter forms of discourse are, of course, acts of purification, efforts to cleanse a marketplace culture.

What is needed more than anything else is not solely ridicule of ordinary men, but that extreme position which defines itself simply by being or by providing a process. The madman in a slightly different sense indicates that while

all men are mortal, they have access to other realms, both temporally and spatially. This positioning is ambiguous, as Rimbaud attempted to demonstrate when under the influence of drugs, or Baudelaire through his "artificial paradise." There are special madmen's media: the haze and bloodscream in Poe or the white discourse of Mallarmé's various personae, the masks we find in Jarry (Ubu and others), the early clowns of Picasso and Rilke, the pigment frenzies of Van Gogh, later of *les Fauves*, the lunatic acts of pre- and early Modernists (Borel, Lautréamont, Rimbaud, Verlaine).

We have in these languages, acts, characters, and creations something of that world which Peter Weiss caught in his play about de Sade, a summa of Modernism. There is a long tradition to this *Comédie des comédiens*, a theater of theater, whose aim is purification. Each group of actors (writers, painters, etc.) is a pretender, an impersonator, and the line between actor and spectator is blurred, which is to say, the line between madness and so-called sanity, between time beyond and time here. Genêt's *The Blacks* is a contemporary version of this spectacle. Every position is put into jeopardy by this blurring of roles between actor and spectator. Real and illusory become interpenetrated by each other, and the intention (if there is any intention) is to demonstrate the corruption of the real, the taintedness of the sane or rational.

Madness, accordingly, serves as a great weapon of discourse, since it can be given shape, speech, gesture, demonstration, even an ideological frame of reference. As menace, the madman or what he represents is like a wild beast: the painterly reference here conveyed by Le Douanier Rousseau's beast inset in the jungle, peering, menacing, immobile, *there*. That beast is contained within the confines of a framed setting; but his primitive nature serves as purifier for spectator and *his* frame of reference. That beast becomes, even in his immobility and seeming passivity, the measure of all things: the potential for violence, destruction, and, ultimately, purification through apocalypse. That beastly image returns us to a menacing Garden, a beginning that also seems like an ending.

We entertain a curious phenomenon, in which the mad or fool or radically primitive has taken on a shamanistic function, beyond rationality and civilized values. In this distant territory, the traditional lunatic and fool are given over to Modernism's madness. In the latter, as we have noted, parody, irony, wit have become norms of discourse in which the mad figure—either author or character—has overwhelmed rational discourse. Dada and surrealism are natural developments, then, of this phenomenon.*

* The development of this "mad" form of discourse is a long one, and I will chart many of its other aspects in later sections. But we can see its extension in music as late as John Cage, Luciano Berio, and others. An interesting development of all this occurred in the 1940s, in the movement— if it can be called that—*Lettrism*, the idea of Isidore Isou. The basis of *Lettrism* was the phoneme, or letter, and Isou hoped to build art based on sounds. His work for soloists or various groups used letters as isolated sounds as well as other noises found in snoring, snorting, breathing, over one hundred such sounds. Similarly, while the use of silence in Cage or pauses in Merce Cunningham's choreography is not associated specifically with this *Lettrist* group, all derive from Dada and surrealism and efforts to move beyond those now defunct groups.

◆ Chapter Four ◆
Spiritual Autobiography and Modernism

THE MODERN MOVEMENT brought with it, as we know, multiple reshapings of old literary forms, not the least in the form known as the *Bildungsroman*: the novel of the formation or development of a young man or woman. The young man may be Tom Jones, Pip, Pendennis, or Richard Feverel, the young woman Romola, Jane Eyre, or Maggie Tulliver. Common to all of these developmental novels is a young person who must experience several stages of growth before he or she achieves some social position: as a questing adolescent or young adult, as a writer or artist (in the genre known as the *Künstlerroman*), as a youth in sequences of general growth without any specific end (sometimes referred to as the *Entwicklungsroman*). The nature of such growth usually takes the form of personal quests on several levels: first, for survival in an alien society or in a difficult or hostile family; then for space in order to grow, which involves numerous obstacles and pains—a brother or sister, a stepparent, or parents who are unresponsive, or no parents at all—the Dickensian orphan; this followed by a need to gain some education, often in an atmosphere in which education is superseded by the need to work or one in which education is made so difficult it seems hardly worth obtaining, for Jane Eyre at Lowood, for example.

At each stage of development, the protagonist is involved in serious generational conflicts: with father, older brother or uncle, or stepparent; or else in broader social terms of the young person against "older society": modes of rebellion and secession. Sexual temptations run parallel to the generational conflict, so that someone physically appetizing may not be socially acceptable; or else the person socially acceptable to the older generation is not attractive to the young person. Individual desires and social needs are crossed, circuits broken. These obstacles, the sexual archetype of which is Venus and Tannhäuser, must be worked through by the young person without support from his elders. Like all other tests, this one must be passed individually. In this traditional form of the *Bildungsroman*, *Künstlerroman*, or *Entwicklungsroman*, the individual, having developed these qualities, ordinarily makes his peace through career and

170

selection of loved one and assumes a place in society; once his choices are approved, he becomes part of the establishment, albeit critical of hypocrisy and cant.

In this older form of the developmental novel, the young person must find his niche, or else, as in Hardy, come to grief in failing to find it. The stress is almost always on accommodation between individual and society or state. Once this accommodation is acomplished, the novel can end; sometimes, the blend is merely suggested, which is sufficient.

By the turn of the twentieth century, the novel that we are describing began to respond to the same elements that nourished the Modern movement in general. The previous form of the novel, which was based on individual and society, with the assumption that a mature individual will be a social asset, finds its focus shifting, from individual and social well-being to matters of spirit, soul, self. The traditional *Bildungsroman*, which was nearly always a form of disguised autobiography, now becomes far less disguised as matter shifts to spirit. The shift is from physical well-being, happiness, stability to intangibles like mental health, sexual discovery, and, chiefly, spiritual needs.* The protagonist, now a mere shadow figure for the author, no longer shapes himself into a social unit, but exists solely for himself, a cell without reference to any group or person unresponsive to his needs. Narrative itself would reflect the change, with linear becoming convoluted, incidents occurring simultaneously or in memory, present tense giving way to past, ends implicit in beginnings.

This split between old and new can be illustrated not only in the developmental novel, but in what was occurring just beyond it, in areas that would have profound influence on this literary genre. The schism, for example, between Freud and Josef Breuer over the causes of hysteria provides a miniature for schisms that would occur throughout the entire range of literary endeavor, although in some instances literary shifts preceded formal psychological theory. Breuer represented the traditional aspects of psychological theory, insisting on the physiological origin of hysteria, whereas Freud represented Modernism, stressing instead the psychological aspects. Freud was eager to go forward despite a failure of precise biological evidence for his views, goaded by his desire to make a great discovery, like Rimbaud's poet as a drunken boat seeking new experiences without consolidating what was discovered. For Freud, discovery established its own reason, whereas Breuer remained cautious until physiological evidence was forthcoming.

Freud spoke proudly of his "splendid isolation." This is a phrase and an idea that applied, also, to the *poète maudit*, the isolated creator who sets himself

* Parallel spiritual journeys are numerous, for example, in Mahler and Bruckner's long, expressive symphonies, in Munch's deeply introspective paintings, besides the poets mentioned below, for whom Hamlet is the prototype. Still other parallel developments occurred in what Robert Wohl calls the 1914 generation. These young men (and some women) were, as a generation, undergoing a spiritual crisis that made them embrace the war as a purification, as an idealistic gesture. In many ways, their revulsion at the old order of things—technology, materialism, the West and its culture in general—was manipulated by the state. Authoritative states discovered that youth could be used against democracy, socialism, and other such movements. Spiritual crises led to political and ideological splits that left many wandering in a malaise until fascism and communism beckoned. Something comparable occurred in the early 1960s when students who would later be active in the Students for a Democratic Society ran for national office in the national Student Association, which turned out to be controlled by the CIA. The "Port Huron" statement that followed in June 1962 became a rallying point for those who found both the old left and the right spiritually corrupt.

aside in rejection and even subversion. Freud was himself, romantically, as a man holding out against masses and philistines. He would, like Samson, pull down the temple, assert his theory, impose his apartness. He was, in these respects, like the avant-garde artist; only by 1895–96, materials were not only printed words or paint and brush or musical compositions, but anxiety, neurosis, obsession, hysteria, and neurasthenia. His self-analysis in midsummer of 1897 is a form of spiritual autobiography. Self-analysis uncovered layers of formative material and then reassociated these memories in the development of the individual: analogous to what we will see in Hesse, Gide, Mann, Joyce, Proust, Musil. Self-analysis gave Freud the opportunity to discover anomalies in a normal childhood, to uncover both traumas and spontaneous sexual activity, to make associations of earliest feelings with present attitudes, to pinpoint areas of libido (toward his nude mother), to acknowledge jealous hatred of a younger brother who died at eight months. That ruthless analysis of the self is paradigmatic of the 1890s secessionist movements, out of which grew so many spiritual autobiographies.

The years 1895–1900 were, as we know, the period of Freud's great journey. We have, here, the avant-garde in action, new methods and modes based on the recognition of irrational impulses from an unconscious which serves as source for behavior.* What we find there is always present in spiritual autobiography: the author's irrational impulses imposed on a barely disguised spokesman who undertakes an internalized journey. This experience of the new was accompanied by a tremendous sense of adventure in all the physical and social sciences, and Freud was himself not immune to his role as an avant-garde, military leader, referring often to his colleagues as comrades in arms, speaking of desertions, battle orders, partisans. Some colleagues, like Stekel, spoke of sacrifices, marching orders, supporters, and used other tag words from the martial arts.

Examples of Freud's avant-gardeism can come from his work on Anna O. or Dora, but I think the best illustration is Sergius Pankejeff, the Wolf-Man. Freud's sessions with the so-called Wolf-Man—given that name because of his key dream in which white wolves sitting in a walnut tree before his window seem to threaten him—are, indeed, a "work" in the Modern mode. The analysis is part of the New, in its way as much as Proust's novel, cubism, then Dada and surrealism. By transforming the Wolf-Man's information into psychiatric data, in 1914–15, Freud discovered in the process of analysis what was comparable to developments in word, paint, musical notation. In Freud's analysis of the subject's dreams, in his seeking for dominant images, in his establishment of some objective basis for behavior, he has ventured into the unknown, dared existing data or theory, and returned with his own shaped artwork.† In a true artwork, the artist supplies the shaping force, using materials that are available to anyone who can observe or hear or feel them; in Freud's case history, the raw material derived from another's psyche, from the unconscious dreamworld

* Freud's discovery during self-analysis of the so-called screen memory (a memory shielding another one, superimposed upon it) is an earlier version of the Proustian "involuntary memory."
† So that we do not underestimate the "shaping" quality of Freud's effort, we need only recall Ernest Jones's description of the first analytic session, which reads like something from Jarry's Ubu Roi or "King Turd": "From the age of six he [the Wolf-Man] had suffered from obsessive blasphemies against the Almighty, and he had initiated the first hour of treatment with the offer to have rectal intercourse with Freud and then to defecate on his head!"

Giorgio de Chirico, *The Nostalgia of the Infinite.*
(1913–1914? Dated on painting 1911.) Oil on
canvas, 53¼″ × 25½″. Collection, The Museum
of Modern Art, New York.

Giorgio de Chirico, *The Great Metaphysician.*
(1917.) Oil on canvas, 41⅛″ × 27½″.
Collection, The Museum of Modern Art,
New York. The Philip L. Goodwin Collection.

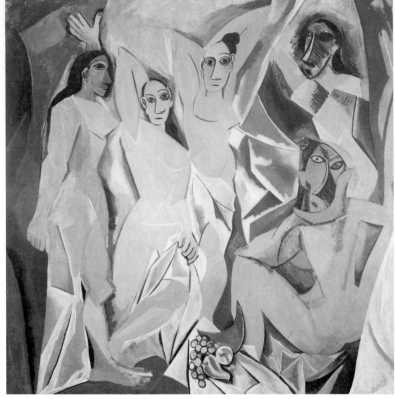

Pablo Picasso, *Les Demoiselles d'Avignon.* (1907.) Oil on canvas,
8′ × 7′8″. Collection, The Museum of Modern Art, New York. Acquired
through the Lillie P. Bliss Bequest.

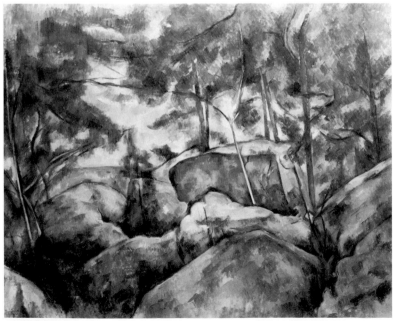

Paul Cézanne, *Rocks in the Forest.* (1904–1906.) Oil on canvas,
28⅞″ × 36⅜″. The Metropolitan Museum of Art. The H. O. Havemeyer
Collection. Bequest of Mrs. H. O. Havemeyer, 1929.

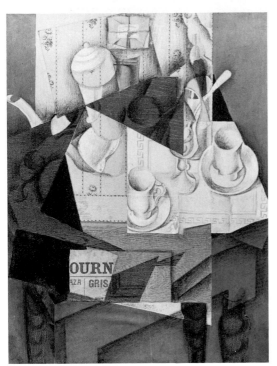

Juan Gris, *Breakfast*. (1914.) Pasted paper, crayon, and oil on canvas, 31⅞" × 23½". Collection, The Museum of Modern Art, New York. Acquired through the Lillie P. Bliss Bequest.

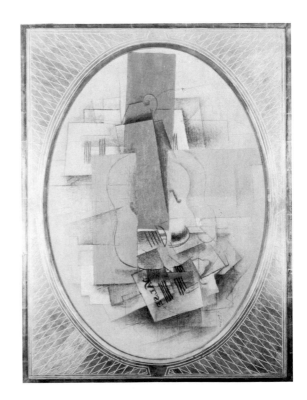

Georges Braque, *Glass, Violin, and Notes*. (1912.) Wallraf-Richartz-Museum, Köln.

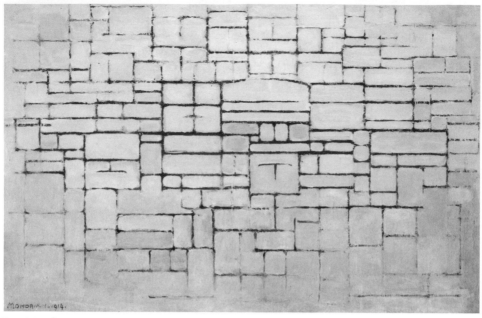

Piet Mondrian, *Composition*, V. (1914.) Oil on canvas, 21⅝″ × 33⅝″. The Sidney and Harriet Janis Collection. Gift to The Museum of Modern Art, New York.

Marcel Duchamp, *The Passage from Virgin to Bride*. (Munich, July–August 1912.) Oil on canvas, 23⅜″ × 21¼″. Collection, The Museum of Modern Art, New York.

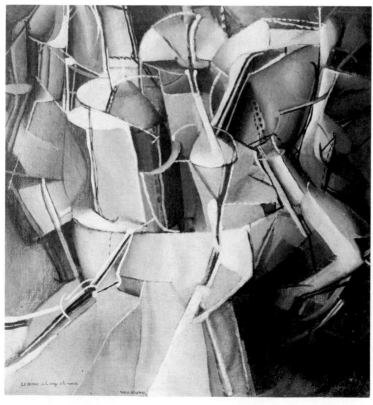

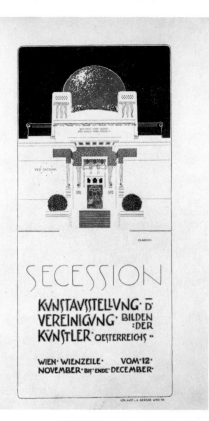

Josef-Maria Olbrich, *Secessionism/ Kunstausstellung.* . . . (1898.) Lithograph, 33⁷⁄₁₆″ × 20″. Collection, The Museum of Modern Art, New York.

Gustav Klimt, *Hope, II.* (1907–1908.) Oil and gold on canvas, 43⅜″ × 43⅜″. Collection, The Museum of Modern Art, New York. Gertrud A. Mellon and Ronald Lauder Funds.

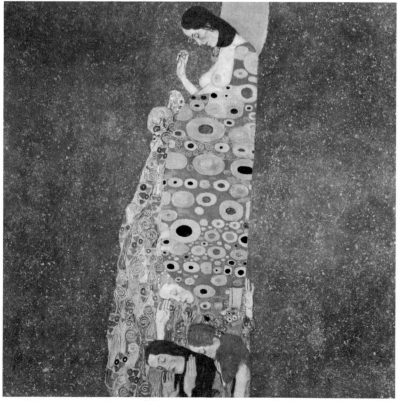

Giacomo Balla, *Automobile: Noise + Speed.* (1913.) Peggy Guggenheim Collection, Venice (The Solomon R. Guggenheim Foundation). Photo: Mirko Lion.

Gino Severini, *Red Cross Train Passing a Village.* (Summer 1915.) Collection, Solomon R. Guggenheim Museum, New York. Photo: Robert E. Mates.

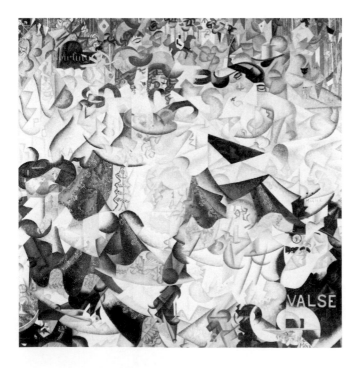

Gino Severini, *Dynamic Hieroglyphic of the Bal Tabarin.* (1912.) Oil on canvas, with sequins, 63⅝″ × 61½″. Collection, The Museum of Modern Art, New York. Acquired through the Lillie P. Bliss Bequest.

Wassily Kandinsky, *Pastorale*. (February 1911.)
Collection, Solomon R. Guggenheim Museum,
New York. Photo: Robert E. Mates.

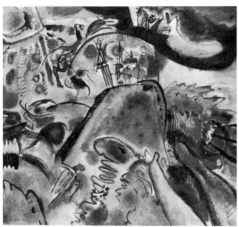

Wassily Kandinsky, *Small Pleasures*. (June
1913.) Collection, Solomon R. Guggenheim
Museum, New York. Photo: Robert E. Mates.

Wassily Kandinsky, *Painting No. 201*.
(Summer 1914.) Oil on canvas,
64¼″ × 48¼″. Collection, The Museum of
Modern Art, New York. Nelson A.
Rockefeller Fund.

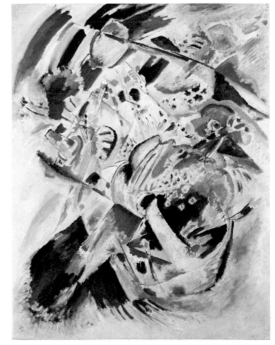

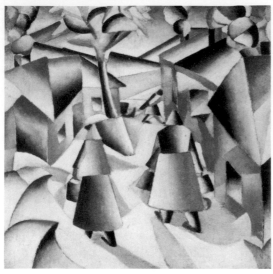

Kazimir Malevich, *Morning in the
Village After Snowstorm.* (1912.)
Collection, Solomon R. Guggenheim
Museum, New York. Photo: Robert E. Mates.

Kazimir Malevich, *Suprematist Composition:
White on White.* (1918?) Oil on canvas,
31¼″ × 31¼″. Collection, The Museum of
Modern Art, New York.

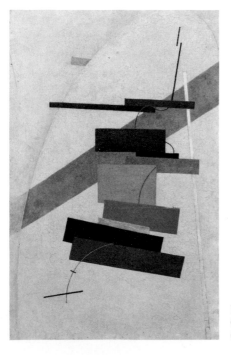

El Lissitzky, *Untitled.* (ca. 1921.) Peggy
Guggenheim Collection, Venice (The Solomon R.
Guggenheim Foundation). Photo: Carmelo Guadagno.

of the Wolf-Man, but in drawing out that material Freud was committing a creative act. By paring away irrelevant material and digging ever deeper like an archaeologist into layers of personal history, Freud honed his analytic method; for success lay in getting to the bottom of things, as Schliemann insisted on getting to the bottom of Troy.

Although the personal elements belong to the Wolf-Man, the analysis is, in fact, Freud's spiritual autobiography. Once the Wolf-Man presents Freud with images of white wolves, the latter takes over the dream sequences and transforms them into something shaped by his own analysis and imagination. Freud speaks of what his task is: We are assured, he says, "that some part of the latent material of the dream is claiming in the dreamer's memory to possess the quality of reality, that is, that the dream relates to an occurrence that really took place and was not merely imagined." Having established at least these coordinates, Freud must now dare the reader. He has reached the stage at which he fears "it will also be the point at which the reader's belief will abandon me." Freud's interpretation moves into the primal scene, those memory-traces springing out of the dreamer's unconscious which formed "the picture of copulation between his parents. . . ."

What Modern artists were doing with color, arrangement, deployment on canvas, distortion of reality, Freud was doing with sex: using sex not in its traditional modes as associated with love or physical relief, but sex in an almost entirely new role, as connected to neurosis and hysteria, to repression and shame. * Freud's sense of his mission here, to find coherence in what appeared to be incoherent materials, placed him with the Modern avant-garde: "The description," he says, "of such early phases and of such deep strata of mental life has been a task which has never before been attacked; and it is better to perform that task badly than to take flight before it." Even his forceful metaphors—"attacked," "take flight," "perform that task"—suggest, once again, his alliance with the language of the avant-garde work with its military and militant function.

When we return to literary endeavor, we find numerous parallels between Freud's avant-garde work with a patient's dreams or fantasies and the literary work: Nietzsche's *Ecce Homo* (a pioneering work, in 1888), Hermann Hesse's several personalized novels, Proust's *Jean Santeuil*, Gide's *L'Immoraliste*, Heinrich Mann's *Professor Unrat* (transformed into *The Blue Angel*), Joyce's *Stephen Hero*, Strindberg's various autobiographical memoirs, especially his *A Madman's Defense* (which appeared originally in French as *Le Plaidoyer d'un fou*), Musil's *Young Törless*, Conrad's *Lord Jim*, Mann's several early stories and parts of *Buddenbrooks*, Pater's *Marius the Epicurean*, and even Wilde's *The Picture of Dorian Gray* and Huysmans' *A rebour*. Obviously, these works differ in quality and aim, as well as scale and achievement; but they all have in common qualities that redirect the traditional *Bildungsroman*.

Spiritual autobiography is, as we shall see, a secession from nearly everything naturalism/realism purports to reflect. The "new man"—unlike the striver in naturalism/realism—is disaffected, effete or aesthetic, outside social coordinates,

* Freud's own German language was a rich source for his ideas of sexual dichotomies; for the word for shame, *Scham*, is associated with genitalia: *Scham* itself as private parts; *Schamleiste*, groin; *Schamgang*, vagina; *Schamgegend*, pubic region; *Schamglied*, penis; *Schamlippe*, labia; *Schamteile*, genitals.

himself a coordinate of emptiness, often a "nil" man. He is a person for whom the outside world, however defined, has ceased to function, for whom it has become a dark place. For many of these new men, Mallarmé and Nietzsche were prototypes, whose deaths, respectively, in 1898 and 1900, reinforced their legends as disaffected creatures; as, earlier, Poe had been for a generation of poets. Not unusually, Huysmans' A rebour became a rallying cry, especially for the aesthetic movement. We must see his autobiographical book not as leading the novel into an impasse, but as an opening up, as Huysmans explained his purpose two decades after its publication. Without overemphasizing his achievement, we must view it, along with the "spiritualized" books it influenced, as catching a moment when literature had ceased to express all levels of human experience; when naturalism/realism, however powerful in Balzac, Flaubert, Hugo, and Zola, was no longer representative.

It is possible, I think, to view the entire career of Joyce as a manifestation of spiritual autobiography, from *Dubliners* and *Stephen Hero* through A *Portrait* and *Exiles*, on into *Ulysses*, possibly the most "worked" of any in the genre, culminating in *Finnegans Wake*, the last hurrah of avant-garde Modernism. If we see Joyce from this perspective, we lose little, but we gain a good deal. Part of the early response to his work had been to its avant-gardeism; but by placing him in the long tradition of the *Bildungsroman* and its Modern reshaping as spiritual autobiography, we can note, also, Joyce's historical role in helping to redefine the novel genre. He is, like the other great Modernists, working in and out of traditional forms, mutating rather than shattering them. Even his quasi-dependence on naturalism, obvious as late as *Ulysses*, demonstrated his ongoing struggle with one of the major tenets of Modernism—its simultaneous assimilation and violent rejection of naturalistic/realistic techniques and modes of representation.

Yet despite this affinity with Hesse, Gide, even Rousseau, Joyce, finally, should be bracketed with Proust and, especially, Mann. Along with Kafka (possibly Musil and Broch), they helped create the Modern novel; and in *Ulysses* and *The Magic Mountain*, we have two *Gesamtkunstwerke* which both sum up and help end Modernism. They have, these four, provided the lens through which we must see ourselves if fiction is to have meaning for our time.

Along with Rousseau, other predecessors of spiritual autobiography in the loose genre of narrative writing can be found as far back as Hölderlin's two-volume *Hyperion* (*oder der Eremit in Griechenland*) in 1797 and 1799. Hölderlin's Diotima (Susette Gontard), in fact, is a distant predecessor of the Diotima of Musil's *Der Mann ohne Eigenschaften*, itself a kind of extended spiritual autobiography with vast social and political implications. A descendant of *Hyperion* in the same genre is Büchner's *Lenz*, a fragment of a novel published two years after his death in 1837. Like so many of these early versions of spiritual autobiography, Lenz combines naturalistic detail with visionary or supranatural elements. Kierkegaard's *Diary of the Seducer*, which appeared in *Either/Or* in 1843, is also a loose version of a similar phenomenon, a spiritual crisis presented with great attention to detail but whose real purpose is a metaphysics of sexual relationships. Even Nerval's Aurélia and Lautréamont's *Maldoror* have connections to this genre, as does the poet that one can extrapolate from *Les Fleurs du mal*.

The question, apparently, is how these early versions of spiritual autobiog-

raphy differ from the turn-of-the-century phenomenon I am describing here. The answer is that the difference lies more in the form than in the actual matter. While inwardness characterizes the genre's entire tradition, in Modern versions we find an effort to merge the subjectivity characteristic of the type with more traditional forms of the novel: that is, the writer maintains the intensity of spiritual crises within the framework of realistic characters, real places, more or less sequential narratives. The earlier versions—although not all—tended to contain imaginary characters in imaginary locales: middle states of consciousness and behavior. The presence of a realistic frame of reference means that the protagonists' problems, whatever their kind, do not exist solely as intense episodes or brief periods. They must now be integrated into his life as a whole, so that the spiritual crisis finds coordinates in all types of relationships: friends, relatives, professional associates, even courtship and marriage. Thus, the blending of intense moments with traditional forms occurs in the Modern version; as against the older kind which foreshadows the new version but which excels in intense moments floating free, as it were, of generic modes.

We have, then, a two-part breaking away in the Modern version of the *Bildungsroman*. First, we have the separation from those works, like the above, which foreshadow the genre—from Hölderlin to Büchner and Kierkegaard; and, second, we have the more formal break with the socially oriented *Bildungsroman* of the nineteenth century, what we associate with Dickens, Eliot, Thackeray, Meredith, Hardy.

The archetype of spiritual autobiography is Rousseau's *Confessions*, in which the subject observing the subject while writing about himself and what is being observed becomes a kind of phenomenology of self. What matters in Rousseau is the passage of self through various stages, all marked by the self; everything is personalized, so that objective phenomena are displaced. This displacement of objects and external realities is a key element in the development of the modern mode of this genre; in fact, a miniature of Modernism. We can draw a direct line from Rousseau to Proust and, allowing for distinctions, to works by the writers noted above.

There is little question some of the redirection of the genre from outward achievement to inward states results, as we saw with Freud, from psychological discoveries, especially those that were beginning to uncover the unconscious. Such discoveries, analogous to the explorations uncovering archaeological sites and finding ever smaller particles in the physical world made "laying bare" or "scraping beneath" part of the culture. Intermixed with that was the sense of dynamic energy, a mental concept in which the mind released bits or quanta of energy which had been inhibited. This is a phenomenon very close to Nietzsche's belief that such energy can be transferred from one drive to another, drives that can be associated with each other, or, contrariwise, conflicted one against the other. The mind was a battleground of such quanta, each representing forms of energy, either connecting or conflicting.

Such questions of uncovering, disguise or dissembling, façades, the emergence of selves, and others are connected to modern spiritual autobiography and to its archetype, Rousseau's *Confessions*. Here, confession is a form of spiritual journey. Rousseau promises us something "hitherto without precedent," something "which will never find an imitator." He will establish a unique individual,

and his revelations about masturbation, exhibitionism, sexual adventures and inhibitions, or failures and successes are of utmost significance because they are *his*. About a quarter through his *Confessions*, Rousseau indicates that he "makes" things occur; that without him, energy would be missing. "My obstinate nature," he writes, "is unable to bow to facts. It cannot beautify, it must create. Realities appear to it nothing more than they are; it can only embellish the objects of imagination. If I wish to depict the spring, it must be in winter; if I wish to describe a beautiful landscape, I must be surrounded by walls. . . ." The self is primary here, and we are not that distant from developments 150 years later in the genre: Rousseau does not relate or associate things, he creates them from his own forms of energy. He is, in this respect, like a godhead, the source of energy itself, Promethean. Life may exist, but only he can quantify it.

Nietzsche's iconoclastic *Ecce Homo* (in 1888) is a major turning point in the genre we are limning. The title, with its ironic reference to Jesus, suggests the extreme self-consciousness characteristic of the genre, that aspect of Modernism which would emerge despite numerous impersonal devices in the arts to disguise the self. What charaacterizes Nietzsche's confessions more than anything else is the obsessive need to clarify his own position and, once defined, to use it to make the world fall into place as a consequence. The reality of the world, as well as its resurrection and resurgence in human terms, depends on the individuals recreating it in his mind as he wishes it to be. Phenomenology preceded ontogeny. Nietzsche's theory of *amor fati*, which seems to contradict this, actually nourishes his solipsism.

The phrase indicates a "love of fate" and would appear to lead to a kind of determinism, as it did for the Greeks, a submission to what fate or destiny holds in wait for both individual and universal man. But for Nietzsche, it meant that man must work within his own fate, that he cannot attack what is outside of his own fate. Man must embrace and love it. This insistence, here and elsewhere, put Nietzsche's philosophy solidly into a world of will, where the power of will allows the individual to assert himself despite a fate imposed from without. It establishes a radical dialectic, not within the society, but within the individual; so that he attacks, and attacks as a sign of good will, indeed of good faith. By so doing, he negates that dismal, bourgeois "last man" philosophy.

The significance of this cannot be overstated, since it defines individual variation within a recognizable scientific type. Darwin is not denied, but given some free play. Nietzsche's theories of "attack" are directives for acts of will, aimed not only at a deterministic Darwinism but at Schopenhauer's presence in later nineteenth-century thought. Associated with this is Nietzsche's willingness to assume the mantle of the fool. "I do not want to be a holy man; sooner even a buffoon—Perhaps I am a buffoon.—Yet in spite of that—or rather *not* in spite of it, because so far nobody has been more mendacious than holy men— the truth speaks out of me." But his truth is "terrible," for "so far one has called *lies* truth." That revaluation of all systems, the reversal of truth and lies, and acts of "supreme re-examination on the part of humanity" all become "flesh and genius" in him. He asserts he was the first "to *discover* the truth of being," as well as the first "to experience lies as lies—smelling them out." He adds that his genius is in his nostrils. The Garden of Eden is effaced in favor of the Garden of contradictions. What was divine order becomes divine disorder when reorganized by Nietzsche. "I contradict," he says, "as has never been contradicted

before and am nevertheless the opposite of a No-saying spirit. I am a bringer of glad tidings like no one before me. . . . It is only beginning with me that the earth knows *great politics.*"

This is followed by a key passage for the genre of spiritual autobiography, for Modernism in general: "And whoever wants to be a creator in good and evil, must first be an annihilator and break values. Thus the highest evil belongs to the greatest goodness: but this is—being creative." This goes well beyond the usual *épater le bourgeois*, since it is based on that disordering of the perceiver, virtually a conscious madness, that will enable him to reverse values and seek truths. Like the *poètes maudits*, Nietzsche declares: "I am by far the most terrible human being that has existed so far," but he sees in his terrible aspect the chance of salvation for mankind, a benefactor from below. As an "immoralist," he takes on all the nausea one must feel at man. There is, in this romantic stance, a good deal of Christianity inverted: martyrdom restated in terms of Satan. Pride in decadence achieves pride of place. As a consequence of a "long period of sickness," he "discovered life anew." He says he "tasted all good and even little things, as others cannot easily taste them."

He can do this because he is a *Doppelgänger*, that dualism which gives him "access to apparently separate worlds" and which is repeated in his nature in every respect. But not only is he a *Doppelgänger*, with a "second face in addition to the first," he is, perhaps, a "three-facer." The facets are, in fact, unlimited, since he assumes he can, despite love of fate, renew and remake himself by way of will. His basic sickness gives him a movable base of operations. Whereas with health one is limited, with sickness one is unrestricted; as, later, Gide, Mann, Kafka, Hesse, Rilke, and so many others recognized in their work. *

To have access to this freedom of play, one must be free of *ressentiment*, a term Nietzsche borrowed from the French and then made his own. *Ressentiment* can burn one up—with rancor, jealousy, hatred, spite, feelings of deprivation—and yet it is a talisman, a miniaturized world, what Joyce in *Stephen Hero* defines as epiphanic. He is himself free of it because of his illness, and he gives a remarkable illustration. "Against all this [*ressentiment*], the sick person has only one great remedy; I call it *Russian fatalism*, that fatalism without revolt which is exemplified by a Russian soldier who, finding a campaign too strenuous, finally lies down in the snow. . . . This fatalism is not always merely the courage to die; it can also preserve life under the most perilous conditions by reducing the metabolism, slowing it down, as a kind of will to hibernate." He adds: "Nothing burns one up faster than the affects of *ressentiment.*"

The use of negative energy—in effect, hibernation as denial—connects Oblomov to Hesse, Gide, Kafka. Crawling into bed or a hole and burrowing in is not necessarily a rejection of life, but a renewal of oneself on grounds other

* Strindberg's pose as a madman in his *Le Plaidoyer d'un fou* (an exact contemporary of *Ecce Homo*, in 1887–88) gave him leverage in his battle against destructive, wily Eves. The Strindberg memoir of "a madman's defense" is, of course, barely disguised autobiography; and the strategies he devises bring it into line with spiritual autobiography. For in addition to writing about himself, Strindberg made his subject matter consciousness itself. He has extracted from the world of reality the world of the self, and the self as presented is all. The text is like a dramatic presentation (coinciding with *The Father* in 1887, *Miss Julie* in 1883), posturing and turning, so that all we know of phenomena comes from the observer. Truth is subjective, and yet subjectivity is itself caught by indeterminacy, by one spiritual crisis after another. The narrator/Strindberg plays multiple roles, Nietzsche's *Doppelgänger*, including that of the Hamletic madman in his obsessive need to shape the world to his ego. Madness is a form of spirit.

than those an activist can comprehend. Nietzsche sees that such so-called ne-
gativism—what becomes dicing with death in Kafka—is not a rejection, but an
acceptance on other terms. Hibernation is not a final stage; it does not lead
toward death, but toward renewal on terms different from the original premise.
In this "disordering," Nietzsche discovers life. Decadence is the opposite: pres-
ervation of life on conditions that demean the body and will.

These remarks in *Ecce Homo* locate Nietzsche as a remaker of the *Bil-
dungsroman*, which has become, at the turn of the century, spiritual autobiog-
raphy. *Ecce Homo* is not alone in this, of course, for *Thus Spoke Zarathustra*
or *The Gay Science* could serve as well. All three works reveal, even revel in,
those contradictions that Nietzsche asserted were matters of necessity for the
"man of tomorrow." The enemy, clearly, was the ideal, and the way to counter
it was in "being the bad conscience" of the time. The single soul, Nietzsche
indicates in *Genealogy of Morals*, is a battleground of a master and slave morality.
These are not simply matters of class distinctions, as between an upper and lower
class—Nietzsche had only contempt for such Marxist tenets—but matters of
feeling. Alongside each other in the single soul are the slave morality, which is
essentially "a morality of utility," and the master morality, which feels contempt
for the former. The slave allows himself to be maltreated and humbled. The
master views himself not in terms of action but as a human being: he determines
values, he does not fit himself into others' values. He does not seek approval;
he approves. The slave, however, acquiesces. Nietzsche sees the soul as at-
tempting to mediate between these two moralities. In the mediation or struggle
lies life, the movement that enables one to go beyond good and evil, beyond
the deadening limitations of Christianity.

To avoid idealism, Nietzsche insisted, was to avoid death. "He can be
greatest," the philosopher posits, "who can be loneliest, the most concealed,
the most deviant, the human being beyond good and evil, the master of his
virtues, he that is overrich in will." Those riches of the will are connected to
one's struggles to overcome the "will of the day" or the taste of the time, which
weaken and thin down the will. The dangers, ideologically and politically, are
immense; and we can see here not only that vaunting of self* which was so
instrumental in defining Modernism, but that stress on self which, feeding into
anti-Modernism, helped ignite a half century of hatred and persecution. The
philosopher, as defined by Nietzsche, is contemptuous of the crowd, "feeling
separated. . . . from its duties and virtues," finding himself outside the "affable
protection and defense of whatever is misunderstood and slandered, whether it
be god or devil," where he can practice "the art of command, the width of the
will, the slow eye that rarely admires, rarely looks up, rarely loves. . . ." Nietzsche
without the irony leads not to spiritual autobiography but to despotism.

We could argue that the proliferation of so many manifestoes at the turn of
the century or shortly thereafter was part of this need to express the new self that

* Self-consciousness and emphasis on self-enrichment were all part of the earlier romantic
movement, of course; but in this later manifestation of self we find a separation of individual will
from social/political causes; a runaway self, as it were. That is why this later period, which just
preceded the experimentation we associate with Modernism, is often referred to as neoromantic.
Freud's unconscious—a "self-psychology"—owed much to earlier, romantic ideas of the unconscious
and did not spring spontaneously from Vienna; but Freud's insistence on the demands of the sexual
unconscious created a new dimension, an irrational self, which appeared more powerful and dan-
gerous than even Nietzsche's conscious will.

led into spiritual autobiography. Whether Strindberg's Foreword to *Miss Julie*, Mallarmé interview in 1891 ("Réponses à des enquêtes sur l'evolution littéraire"), Conrad's 1897 Preface to *The Nigger of the "Narcissus,"* Marinetti's futurist statement of 1909, Max Jacob's Preface of 1916, or the several pronouncements of Apollinaire, the manifestoes were dual efforts: first, to explain a new movement or a new tendency in the arts, one's own or another's; but, also, to compete against those staggering experiments in the physical and social sciences that were altering modes of perception and threatening the emergence of the self. Most of the manifestoes, in keeping with the avant-garde metaphor, speak of movement into new territory, the writers and painters acting as scouts for the new.

As statements, manifestoes provided theoretical background and foreground, laying the foundations for new disciplines or new ways "to make you see," in Conrad's words. This urgent need to define and redefine is very much in keeping with developments in spiritual autobiography—a kind of parallel effort to mark out in prose statements what was occurring metaphorically or poetically in this new form of the *Bildungsroman*. We note in all this that dualism: the expression of personal need which has taken over the traditional apprenticeship or educational novel, and more generally, the expression of new modes of perception.

Gide's *L'Immoraliste* follows closely on Nietzsche's example. On the surface, it is deceptively simple, but Gide was working with complicated materials. He dissembles the spiritual autobiographical element by removing his main character to an inner ring while a narrator who has no active role becomes the voice of the novel. The function is to disguise the very thing the book is about: its subjective, spiritual autobiographical journey. The Gide method follows upon that of Conrad's contemporaneous use of Marlow in "Youth," *Heart of Darkness*, and *Lord Jim*, but with a major difference. Marlow, the narrating voice, is also participant in the first two stories, although less so in Lord Jim. *Heart of Darkness* is, in fact, his tale, an inner story as much as one of ivory and exploitation. Gide has retained the narrating function in order to provide a "cooler" frame for his inner tale, and put the intensity within. Like Conrad, he needed to provide distance from the real event, to mitigate some of the terrible inner flame, and to reroute the fictional mode by way of both external and internal conflict in the narrative process.

Shortly after the start of *L'Immoraliste*, the narrator has dropped into the seams, and we have the voice of Michel, Gide's protagonist. Michel's "spiritualization" is not concerned with his breaking out or gaining his freedom; such a dimension would mean a social/political function, which Gide eschews. His problem is quite different, one that echoes Kierkegaard's Dread and Nietzsche's *racune*: ". . . the arduous thing is to know what to do with one's freedom." But before he can achieve that choice—and choice is central—he must revolt. With a Faustian cry, he demands to exercise his emotional life, whereas earlier he had been a learning machine. Spiritual autobiography is embedded here in Faust/Michel's cry, first of liberation from knowledge which has not proven fulfilling, followed by decisions about how to utilize this newly won freedom.

To break from rules is a metaphysical act. Michel's developing illness, in this respect, becomes the "happy fall," the breakdown that enables him to find his métier. The fall before the thrust forward is the middle of the journey, the pause or break, the low point from which he can, or cannot, recover, once

again recalling Kierkegaard's Dread. Such a spiritual quest involves the trial or obstacle familiar from traditional growing-up modes; but the significant difference is that once the obstacle is overcome, one had moved only in terms of the self, not as part of any larger association.

Like many others in this mode, Gide stresses the moment: not the past, as in Proust, but the moment; not memory, but sensation.* For Proust, an experience was validated by one's memory of it; for Gide's Michel, an experience carries its own validity and terror. Contradicting Freud's point that we gain civilization by way of repressing our instinctual life, Michel argues that repression of such feelings is monstrous. His view is akin to Nietzsche's "last man" theory: that the man who plays according to the rules and survives is actually dead. "What would man's effort be worth," Michel speculates, "without the savagery of the power it controls? What would the wild rush of these upswelling forces become without the intelligent effort that banks it, curbs it, leads it by such pleasant ways to its outcome of luxury?" Here, Michel has lost his rebelliousness and is counting on intelligence and mind; yet these moments are not for him affirmation, but a needed awareness of how futile such intellectual efforts will prove to be in his happiness. Thus, he voices lines of traditionalism so that he may better refute them later. He moves, he says, like "a stranger among ordinary people, like a man who has risen from the grave." The quality of *Bildungsroman* defined here is a mode of autobiographical fiction concerned not with community or society but with degrees of soul and spirit, the inner life as narcissistic and solipsistic.

If we turn, once again, to Freud's "Case of the Wolf-Man," we note the similarities between *his* pathological development and the modulations of spiritual autobiography. The source of both modes is the displacement of sexual energy, so that the individual must confront taboo feelings, whether those of incest with the Wolf-Man or social prohibition with Gide's Michel and his tribe. The Wolf-Man early in his narrative speaks of his becoming ill so as to attract his mother's attention. He tells Freud how the suicide of his sister Anna created such turbulence in him because of incestuous feelings; he stresses his being thrust away by a servant woman, and other "defeats." We have, also, the suicide of his wife Therese, and his fascination with Lermontov, the Russian author who died in a duel at twenty-eight. Lermontov's death was actually a kind of suicide, since he shot, first, into the air and then exposed himself to the other's pistol. The Wolf-Man himself felt suicidal impulses after the death of Anna. We have already alluded to his dream of the white wolves sitting on the walnut tree before his window.

The Wolf-Man's raw data make him a "character" in Freud's mystery story, created by the analyst as a means of transforming seemingly incoherent detail into a cause-and-effect narrative. To put it another way: the latent material of the Wolf-Man's dream and his memories is turned into forms of reality, into occurrences. Freud's use of latent material to connect to reality parallels the way in which the novelist brings mysteries to the surface. The process is circular, not linear; and just as linear narrative was a hostage to Modernism, so circularity was its beneficiary. We go, with the Wolf-Man, from unconscious up the dream

* Cf. Joyce's Stephen Hero: "Life is now—this is life. . . . To walk nobly on the surface of the earth, to express oneself without pretence, to acknowledge one's own humanity!"

ladder to preconscious and then to consciousness, a circuitry of Wolf-Man-ness. He becomes a self-enclosed process, just as Gide's Michel ingests the world in his desire to break out and complete himself on alternate terms. Passiveness gives way not only to dynamic energy, but to different levels of expression, all generated by the protagonist and self-directed.

Of course, the development of each protagonist differs. The Wolf-Man is led back toward discovery of masculine and feminine distinctions that are socially supported, whereas earlier he had assumed feminine traits, which in Freud's terms meant passivity and the desire to copulate with the father, et al. For Gide's Michel, the transformation of sexual energy, which is equivalent to resurrection for him, is into a homoerotic sensibility; and *that* becomes an emblem of his spiritual development. In Normandy, where Michel tries to run the family farm, he flirts with anarchy and lawlessness, not in actions, but in changing mental attitudes. In a sense, he permits his unconscious to float to the surface. The experience is a form of dream or fantasy in which latent materials are given freedom, since he is the owner of the farm and can experiment. The growth of anarchic feelings in Normandy foreshadows what will become his breakthrough in Biskra. And reminiscent of *Dorian Gray* and its stress on mirror images, as Michel's wife, Marceline, declines, he recovers. If Marceline is the "normal" replica of Michel, then she is doomed by his choices; and since she has chosen to be passive, his active life can be sustained only by her withdrawal from life.

Internality supersedes all else. The action is not even in the mind, but hidden deep in the body, within Marceline's lungs, as, earlier, in Michel's, when he coughed blood. That internal journey would be repeated in a more sophisticated version of spiritual autobiography, in Mann's *The Magic Mountain*, when Hans's love for Clavdia means his being captivated by her pulmonary X-ray. The surface symbols for the lungs in Gide are the black holes of Marceline's nostrils. These are pits into which Michel can plunge or from which he must escape: they are emblems of death for Marceline and potential life, through desertion, for Michel. These pits of hell are repeated several times, as loss of vitality, emblem of disgust and pity. All of Marceline now is poured into those "black holes of her nostrils." Her existence has been organized and miniaturized; yet the holes also indicate a journey of sorts, a journey into death. Images, unknown areas, metaphors all attract through repulsion.

The nature of the symbol or emblem in spiritual autobiography, or in works closely allied to it, is quite different from symbols in traditional *Bildungsroman*. Earlier, the symbol was something close to nature (as in *Tom Jones*), or else associated with the city (Dickens), or with water (Eliot)—symbols with broad social dimensions that helped wed protagonist and society/state. We can argue that shifts in kind of emblem—derived from psychologists, or from Bergson, Durkheim, Frazer, et al.—inaugurated the transformation of the genre. Nostrils, in *L'Immoraliste*, have extensive sexual connotation, since they create that disgust of female illness and femaleness itself which is part of Michel's spiritual journey.* The revulsion Michel feels for the nostrils—a more benign vagina dentata—signals the displacement of the uxurious in him, pointing him toward a homo-

* Nostrils, also, are associated with the olfactory sense, which contemporary psychologists such as Krafft-Ebing and Freud were labeling sexually "perverse," as part of man's earlier phase when he walked on all fours and the anus was a source of sexual stimulation.

eroticism, which will become his focus. Marceline has in his respect eased the journey for Michel, for she has changed from an attractive young woman into the repulsive nostrils. Since Michel's spiritual quest, like that of Pater's Marius, is for beauty, he is able to reject her on aesthetic as well as sexual grounds.

The dominant image in spiritual autobiography, whether nostrils here, lung X-rays in Mann, or secretive places in Kafka and Musil, is almost always grotesque; and its grotesque quality is usually associated with sexual tastes, either attractions or repulsions, extremes, not middles. The stress on sexual matters is, in part, connected to work in psychology and psychoanalysis undertaken well before the turn of the century, although accelerated by Freud and his followers. Yet it is possible to demonstrate that the emphasis on sexual imagery of the above kind would have eventuated without the radical psychological movements and their literature; that such imagery, symbolism, and stress were inherent in the way culture was itself developing.

Apart from pre-Freudians and Freud himself, or his followers, interest in the unconscious was gaining although it had not yet been formalized (by Pierre Janet among others). In that uncovering of the unconscious was the etiology of sexual impulses, whether manifest in hysteria, schizophrenia, paranoia, or other morbid symptoms. As soon as such symptoms were investigated—and most researchers were convinced there was a sexual etiology—there had to emerge into the larger culture a sense of sexual preference and performance hitherto kept private. There was running parallel, in Bergson's early work and in Frazer's anthropological theories, a philosophy of "another life" that went beyond reason and logic, a life in which vital elements poured into sexual energies in order to help create another life. It may even have gone "beyond sex," as it did for Nietzsche, where such other lives were connected to a variety of drives manifest in the *Übermensch*.

Once the culture began to assume the existence of such energies, whether they were called élan vital, libido, or, in the physical sciences, quanta, it was natural that they would enter everyday life as images, symbols, emblems. That they would enter as homoerotic images, or as displacements for the socially acceptable sexual drives, was also inevitable, given other cultural factors working parallel to those above. If we back up from the 1890s, when such imagery proliferated in the various "counter" movements, we can see in typical English Victorian figures a considerable capacity for such manifestations: Ruskin's inability to consummate his marriage to Effie Gray, his almost certainly having sexual preferences he could not permit to surface actively; Carlyle's celibacy during his marriage to Jane, whatever *that* ultimately meant; Lewis Carroll's propensity for photographing young female children in the nude, soliciting them from their mothers, romancing them with his camera, as it were; Mill's need to be surrounded by women named Harriet, the name of his grandmother, his mother, and the woman he eventually married. Such lists can be expanded, and what they prove is that the elements that became manifest at a later time were of course already present in the culture.

In France, obviously, such restrictions did not exist, and poets like Baudelaire, Rimbaud, Nerval, Lautréamont, Laforgue had already presented images and symbols of morbid sex that would come to dominate literature and painting. Baudelaire speaks of Lethe oozing from the kisses of the beloved one; or sucking forgetfulness at her nipples; or the kisses of Lesbos. In Poe, introduced into

European culture by Baudelaire and Mallarmé, nymphomania is romanticized not because of its sexual content but for its lack—thus sexual preference becomes manifest by way of what it is missing. The closer we come to the turn of the century—when we can add Schnitzler and Strindberg, or a painter like Klimt and a composer-painter like Schoenberg—the more we encounter the bizarre or distorted image of sexual energies. Not unusually, spiritual autobiography stressed those aspects of unhealthy associations over those that led to marriage and family. Since so much of Modernism was based on defiance of authority, sexual tastes were a mode by which such defiance could be expressed; but it went well beyond *épater le bourgeois.*

This is, nevertheless, only one dimension. For spiritual autobiography thrived on protagonists who come up to borders or frontiers, peer over into the abyss, step back, and then decide to plunge. With this, we move into Hesse territory, the land of self-destructive, spiritualized young men. A version of this was foreshadowed in Nietzsche's great passage on rancor in *Ecce Homo.* Nietzsche's use of the word, *racune,* precipitates an internal confrontation that liberates the individual from all defensive energies, suspending the energy that goes into defensiveness so that it may now go into creative acts. The passage is full of Nietzschean irony and counterpurpose, and its significance lies in its paradoxes. He writes: "There is something I call the *racune* of what is great: everything great—a work, a deed—is no sooner accomplished than it turns *against* the man who did it. By doing it, he has become *weak*; he no longer endures his deed, he can no longer face it. Something one was never permitted to will lies *behind* one. Something in which the knot in the destiny of mankind is tied—and now one labors under it!—it almost crushes one. —The *racune* of what is great."

The deed has purged one of will. Yet once purged of will, the protagonist or creator is in a dangerous position vis-à-vis not only himself but whatever is beyond. With all defensive energy depleted, he may move in any direction; in fact he may become a danger to society, or else he may create something extraordinary. Violence, however, may eventuate, the rancor having been purged by the work. Nietzsche is foreshadowing, in his ambiguous way, that complex of feelings which makes the Modern movement so dangerous in social terms, so beyond control that dictatorships, as well as some quasi-democracies, would find in it a threat to their existence.

When we turn from Gide's *L'Immoraliste* to Hesse's fiction, written at the same time, we discover a comparable need to search for spiritual rejuvenation within a physical or material setting. Old selves must be displaced to make room for new ones, the process recalling not only Freud but Marx, Frazer, Durkheim. The paradigm could be Marx's description of the worker's alienation from old forms of support. Not unusually, the idea of alienation gained wider usage, based first in Marx and Freud, then taking on a more generalized social/political sense, metaphysical as well as mental and professional. Nietzsche's ironic insistence that a bourgeois society must elicit its opposite, that scientific or objective man must evoke an adversary "irrational man," has its counterpart in nearly all spiritual autobiographies. Gide's Michel letting go in Biskra, although still contained in his Normandy farm, recalls the Nietzschean counters; yet such experiences move well beyond Apollonian-Dionysian polarities.

Wedded to these developments and perceptions—in Hesse, Proust, Musil, Wilde, Joyce, Mann—was the new role art was itself to play. "Playing a role"

has its theatrical component, and man was indeed viewed as living in a gigantic theater in which he performed. Such theatrical images multiply, from Hesse's actual theater in *Steppenwolf*, to Kafka's warehouses and burrows, to Proust's aristocratic homes. Protagonists are performers in this respect, although in very different contexts. That need to perform recognizes art would fill the vacuum created by the rejection of state, society, politics, materialism, and, for some, science itself. Earlier perceptions of this came from such disparate sources as Matthew Arnold, Huysmans, Pater, Mallarmé. *Fin de siècle* and aesthetics movements, as well as the numerous secessions throughout Europe, were such forms of recognition. Even the term "secession," with artists as secessionists, indicates a performance, the act of withdrawing from one scene to another, the response requiring grace and balance. Secessions also call up intimations of an "other," that world of mystery, undefined shapes, explorations, and discoveries that is the way art counters the material and objective.

This stress on the power of art as a displacement of any other reality leads to the formation of a world within a world; all in keeping with the artist as performer. But still another, related phenomenon was apparent: so close was art, and in our instance spiritual autobiography, to the irrational nature of society that we begin to note a reciprocity between art and state. That is, the state, which considers itself a rational process, begins to vie with art. As much as the latter withdraws in order to stress what it feels is the truer experience, so does the state follow to outdo art—i.e., plumb the irrational. We note the twists and turns of the Austro-Hungarian Empire as it tried to consolidate power that was already slipping away to nationalist movements. Trench warfare in World War One, also, can be comprehended only as the sociopolitical/military component of Hesse's spiritualized protagonists with their underground existence, or as official extensions of Freud's explorations into the unconscious. Men living in trenches become mythical creatures, tied to Mother Earth, hugging the ground for their very existence. The war shaped itself in the form of those trenches, a kind of earth sculpture, an artistic medium of sorts.

We can, further, see the war in many of the same generational terms in which we see art. If spiritual autobiography was a mode in which younger men and women destroyed the image and reputations of the older generations, the war was the means by which the older men could eliminate that troublesome younger generation. The war, in some profound way, was the revenge of the old on the new. The roll call of artists themselves killed or wounded in those four years is impressive, a generation of the young and new killed in far less than a generation. The numerous poems and descriptions of the Abraham and Isaac tale imply that Abraham, even when given the substitute ram for his son, preferred to sacrifice Isaac.* The war would attempt to restrain, through slaughter, the very self implicit in a new art.

That self was the enemy: not only the individual self, but the metaphysical self which is a process, an unfolding. Even as secessions succumbed to clearly defined movements—cubism, imagism, Dadaism, futurism, surrealism—the factor

* Probably the most famous lines are those of Wilfred Owen, from "The Parable of the Old Man and the Young": "Offer the Ram of Pride instead of him, / But the old men would not so, but slew his son, / And half the seed of Europe, one by one."

associating all was the self, whether restructured, unfolded, redefined, dis- or reconnected. Unlike the more traditional *Bildungsroman*, in which the world enjoyed its independent existence, in this new manifestation as spiritual autobiography, the world is created by the "I," by the self. It exists within, in the spirit of the woods in Hesse, in iconoclasm in Nietzsche, in underground holes in Kafka, in aestheticism in Joyce, in memory in Proust. Proust's Marcel, implicit in Jean Santeuil, is the highest form of this new expressionism: whatever is inside, is; whatever is external exists as memory or as raw materials for art.

Well-known is Hermann Hesse's novel of 1927, *Steppenwolf*, which developed from the Steppenwolf poems, concerned with an outsider, a lone-wolf, howling on the fringes. The figurative connection to Freud's Wolf-Man seems obvious. Yet Hesse's Harry Haller is not a new literary figure, but continuous with his own spiritual autobiographies of the early part of the century; segments of his life which he cut off and labeled novels, although they could also be viewed as memoirs or autobiographical documents. In the later novel, Haller's life is a sequence of night journeys "though the chaos of a world whose souls dwell in darkness"; it becomes a journey undertaken "with the determination to go through hell from one end to the other, to give battle to chaos, and to suffer torture to the full." Haller perceives himself as a "beast astray," one unable to find home or joy or nourishment in a strange world, his journey analogous to the trips of Rimbaud, Lautréamont, Baudelaire, Nerval. The inner need for Harry to integrate himself becomes not only a question of mental health but a metaphysical issue: that alliance of individual and spirit which characterizes so much of early Modernism.

If we work back from Harry to earlier Hesse fictions, we find in *Peter Camenzind* (1903–4), *Beneath the Wheel* (1906), and *Gertrud* (1910)—little-read books at present—the materials that helped shift the nature of the genre. With these fictions, the *Bildungsroman* definitively passed into spiritual autobiography. We are less interested in the results—which are a mixture of intense episodes with rhapsodizing that rarely reaches dramatic effect—than we are in the way Hesse turned back one type of *Bildungsroman* in favor of another mode. This was, indeed, the method of Proust, Conrad, Gide, and others, not influenced by Hesse, but as parallel actions.*

Hesse's work is deeply indebted to Nietzsche, and this influence in itself can explain part of the transformation of the genre. For Nietzsche's work, whatever the precise impact, turned all activity inward, toward an intense spiritualization of life and thought. In one of the most significant passages in *Thus Spoke Zarathustra*, Nietzsche speaks of those things occurring far from the marketplace: ". . . it is only in the market place that one is assaulted with Yes? or No? Slow is the experience of all deep wells. . . . Far from the market place and from fame happens all that is great: far from the market place and from fame the inventors of new values have always dwelt." The marketplace is an arena where ideas are resolved in vulgar fashion. Distant from that is a quiet place, where for Nietzsche a more intense life takes place. Here we have, also, Proust's

* Foreshadowing many of Hesse's spiritual concerns was Knut Hamsun, in the 1890s, with novels such as *Hunger* and *Pan*. But Modernism bypassed Hamsun, his use of spirit and mystery still trapped by naturalistic forces. He is, however, a now forgotten author whose novels can be viewed as bridges to spiritual autobiography.

memory, Conrad's "leap," Joyce's epiphanies, Hesse's internal struggles. Hesse writes of daily life, for Peter Camenzind, as demanding "its due and . . . [devouring] the abundance of optimism I had brought with me."

Peter's real moments occur in that internalized, spiritualized place where poetry is made. When his mother is buried, he is caught between the demands of his village and father and that outside place where a more dangerous world exists. His yearning for that world parallels Stephen Dedalus's in Joyce's novel: "Everything I had thought and desired and longed for since childhood appeared for a brief second before my mind's eye. I saw great beautiful tasks awaiting me, books I would read and books I would write. I heard the Föhn sweep by, and saw distant blissful lakes and shores bathed in southern lights and colors." While this is not so evocative as Stephen's reverie on the banks of the Liffey,* it does suggest that Peter's soul is a battleground of Nietzschean polarities, also of what Jung would later define as *anima*. *Anima* invests the universe with magic, foreshadowed in the novel's first line: "In the beginning was the myth." That myth or *anima* means each man is created with some mysterious element that he must, as a given of existence, discover in himself. Peter's quest is to seek out the myth that will define him.

Hesse's novel dramatizes a dualism, of Modernism rejecting the very elements that have made it possible. In what would become sacred words for Hesse, Peter describes this irresolvable conflict:

> I wanted to teach people to listen to the pulse of nature, to partake of the wholeness of life and not forget, under the pressure of their petty destinies, that we are not gods and have not created ourselves but are children of the earth, part of the cosmos. I wanted to remind them that night, rivers, oceans, drifting clouds of storms, like creatures of the poet's imagination and of our dreams, are symbols and bearers of our yearning that spread their wings between heaven and earth, their objectives being the indubitable right to life and the immortality of all living things. Each being's innermost core is certain of these rights as a child of God, and reposes without fear in the lap of eternity.

Although these sentiments recall Wordsworth, their immediate background can be perceived, once again, in Nietzsche, in the very title of his autobiographical writings: *Ecce Homo*. "Here is a man"—which means a new man, a new creature for our times. Jesus used these words, and he meant a holy man for a parlous, material era. On the edge of madness, Nietzsche saw himself as Jesus's "new man," as would a generation of writers after him, by connecting their vision to the unique self. Hesse's Peter owes his desire to be different to both Nietzsche and Jesus. In *Zarathustra*, which Hesse mentions, Nietzsche describes man as "a bridge and no end: proclaiming himself blessed in view of his noon and evening, as the way to new dawns. . . ." We recall Goethe's sense of man as becoming, as a bridge. Nietzsche portrays man's existence as a bark heading into the unknown: ". . . over there perhaps the great nothing lies. . . . Not one of you wants to embark on the bark of death. Why then do you want to be world-weary?" World-weariness, a form of death, is contrasted with "becoming,"

* The Hesse passage does not lose in translation. The original German does not evoke the range of colors, tones, modulations one finds in Joyce.

with "bridging." Not surprisingly, the young Hesse decorated his room with pinups of Nietzsche, cut from magazines and publishers' catalogs.

Hesse's aim was not to find a way for man in society, but to expose lies and illusions. "I realized with astonishment," Peter says, "that man is distinguished from the rest of nature primarily by a slippery, protective envelope of illusions and lies. In a very short time, I observed this phenomenon among all my acquaintances. It is the result of each person's having to make believe that he is a unique individual, whereas no one really knows his own innermost nature." Even children are enveloped by this delusion about self, protecting the self against the truth. Hesse's relationship to the *Jugendstil* movement at the turn of the century strengthened his desire to turn life into process, into a bridge.

Beneath the Wheel (1906), Hesse's second novel and third book, is a "school novel." It has certain affinities with Musil's *Young Törless*, Heinrich Mann's *Professor Unrat*, and Emil Strauss's *Friend Death*, although with differences. His protagonist, Hans Giebenrath, tries to avoid falling "beneath the wheel," *Unterm Rad*, although the arrangement of his society is such that he must fall. As a top scholar, he can escape the wheel of drudgery by succeeding in school, which he does; but to succeed in school, he must work so hard he falls beneath *that* wheel. His successes take their toll, and he drops out, to become a mechanic's apprentice, a job in which he files obdurate metal knobs: the fate of a young man who finished second in the state exam and knows Latin, some Greek, and Hebrew. He has fallen beneath the wheel and dies, either by drowning or by willing himself into an "accidental death."

As part of Hesse's Apollonian-Dionysian juxtaposition, Hans has an "other," a double. The counterpart is Hermann Heilner, a boy who refuses the controls imposed by the seminary. As a poet, a person of spirit and a rebel against the conditioning imposed by the institution, Hermann finally leaves in disgrace. But he exits by way of a positive act of rebellion, as part of that Goethean "bridge" or "becoming" which indicates a person still in the making, not made. His wildness is untamed, but when Hans leaves, it is as someone passive. He turns mute in class and slips to the floor, unable to function. Hans does not question the right of authority, whereas Hermann "practiced the mysterious and unusual art of mirroring his soul in verse and of constructing a semblance of life for himself out of his imagination." Joyce worked out a similar pattern in Stephen and Cranly, in *Stephen Hero*.

Images of the mirror are particularly significant in Hesse's work, whether his early fiction or the later *Steppenwolf* and *Magister Ludi*. The mirror image— as language or as metaphor for existence—is usually in the form of a double, or another or opposing self, which suggests a form of salvation, although it may also offer an emblem of what is unachievable. Hans comprehends that Hermann is the "other," but the latter's identification with poetry gives him an opportunity to seek a selfness denied to Hans. Natural man, Hesse writes, "is unpredictable, opaque, dangerous, like a torrent cascading out of uncharted mountains. At the start, his soul is a jungle without paths or order. And, like a jungle, it must first be cleared and its growth thwarted." This is the school's task, to subdue and control, so as to make man a useful member of society. Yet youth is like the *Föhn*, the wind that sweeps out of the south and meets the north in a great destruction of wind, flood, avalanche. It is that other side of nature which must express itself. The *Föhn* is primitive, the school is society; and, as Freud would

define the conflict, one advances by controlling instinct and primitivism through order. The result, this denial of otherness, is repression, neurosis, inability to hear what the teacher is saying.

Hermann can express the primitivism of the *Föhn* because he trusts himself, as poet, rebel, anarchist. Hans does not, and so he wanders between two worlds, both of which will, like the juggernaut, crush him beneath the wheel. This motif and emphasis return in *Gertrud*, Hesse's third novel, in 1910. *Gertrud* is a far more complex novel than the previous two, running parallel to Proust's *Jean Santeuil* and Joyce's *Portrait* as a form of *Künstlerroman*, although, like them, turned toward spiritual autobiography. In this novel, Hesse has split his experience of self into three elements, each in conflict with the others, and yet each fitting itself for a time into the others; roughly, id, ego, and superego. The narrator is an older man, the composer Kuhn, recalling things past. Like Tonio Kröger, he has made the sacrifice of being outside society to gain that objectivity which is the vehicle of true creativity. Such work "demands something that has to be subtracted from the enjoyment of life."

Opposed to his desire to gain distance is the need of Heinrich Muoth to enter so intensely into life he must conquer every aspect of it, either with his magnificent voice or with his fists. He devours women—seduces them with his magnetism, then beats them as necessary and discards them. His is the heedless will to power which must lead to self-destruction. Drawn to Muoth is Gertrud Imthor, whom Kuhn sees as eternal woman. Gertrud seems pliant, but she has depths, and, despite her sweetness, she requires what Muoth represents: passion, danger, his satanic aura.

Kuhn perceives Gertrud as prelapsarian Eve, associating her with the Garden experience which dominates the novel. She is for Kuhn the place of rest, part of the "hut dream," the mythical woman; he wants to play Adam and Eve with her in defiance of all laws of mankind. "When I entered the garden from the road and went past the old, darkened statues in the drive toward the house, which was surrounded by greenery, it was for me each time like entering a sanctuary, where the voices and things of the world could only penetrate to a slight degree."

Although Kuhn's name suggests boldness or daring, he has been slowed by temperament and a tobogganing accident that has left him crippled for life. As a result, he is, like Philoctetes, symbolic of the wounded artist, and, therefore, pure "I," everything consumed by his imagination. Despite his stress on isolation, solitude, pure thought, he is, in his way, as lacking in spirituality as Muoth. His desire for solitude, rather than a fully conscious choice, is the result of passive wishes. Hesse's novel pursues a paradox inherent in spiritual autobiography. If Kuhn's isolation is the consequence solely of his accident, then he has let life carry him; whereas, for Hesse, he must choose his way, which may also end up in isolation and sterility.

Kuhn's dangerous journey to uncover himself has begun. The vehicle for his way of knowledge is a former schoolteacher, Lohe (to "flame" or "fan"), who encourages Kuhn to study a small book called *Theosophical Catechism for Beginners*. Although the latter is interested, especially in the explanation of causality through Karma, he is still caught among his own conflicting desires, unable to put them aside for the new way of knowledge. "I soon realized that these teachings could only be of solace and value to those who could accept them literally, and

sincerely believe them to be true." In his confusing sense of himself, his mixed desires for isolation and a more active life, Kuhn dreams of what he is missing, as well as of former times and places, recalling, once again, Tonio Kröger and Jean Santeuil. ". . . it suddenly occurred to me that it all signified—that it was the return of those strange remote hours of which I had a premonition-filled foretaste when I was younger. And with this memory, that wonderful clarity returned, the almost glasslike brightness and transparency of feelings where everything appeared without as mask. . . ."

This admixture of memory, uncertainty about an active life, involvement with Muoth and then Gertrude becomes the basis of Kuhn's pilgrimage toward perception of himself. In a sense, he is as yet incapable of working through the bold meaning of his name. He is carried, does not carry. He considers suicide when he concludes that Gertrud and Muoth are together; suicide for Hesse characters always serves as an alternative, as it almost did for Hesse himself. Another means of escape from himself for Kuhn is his artwork, his opera, in which all his power and emotion have been transformed. Although his opera will be his masterpiece, it, too, is a passive way of dealing with life, an evasion for him through an outpouring into something else.

A later meeting with Lohe shows Kuhn he is practicing "moral insanity." That which is called "individualism or imaginary loneliness . . . has insinuated itself into your imagination; you are isolated; no one troubles about you and no one understands you." The need is for bridges. Not only is the individual himself a bridge, he forms a bridge with others in his "best self." With this, Hesse has rejected Nietzschean duality in favor of a spiritualized commonality. "What people have in common with each other," Lohe says, "is much more and of greater importance than what each person has in his own nature, what makes him different from others." With this, Kuhn is helped to escape from the destructive triangle: Muoth, the demonic artist whose golden throat gives him power over others; Gertrud, whose presence is positive as long as she is not associated with a prelapsarian Eve and the Garden; Kuhn himself, trying desperately and unsuccessfully to reconcile Dionysian and Apollonian elements in his nature.

Hesse attempted to put these contradictions—what he called a "blessed motley"—into alignment through language; and here, too, he has entered into the heart of Modernism, that stress on language where philosophy and theology had been sovereign before. Hesse writes:

> Constantly I desire to point with delight to the blessed motley of this world, but equally constantly to bring to mind the fact that at the basis of this motley there lies a unity; constantly I desire to show that beautiful and ugly, light and dark, sin and sanctity are opposites only momentarily, and that they continually pass over into each other. For me, the highest words of humankind are those few mysterious phrases and images in which the great opposites of the world are seen to be both necessary and illusory at one and the same time.

Not only Proust and Joyce come to mind. Mallarmé had foreshadowed this in the 1880s, and Baudelaire before him, with his theory of correspondences, in which image, sensory perception, memory are interconnected, with language as the vehicle of experience.

In *Demian* (1919) and *Steppenwolf* (1927), Hesse was building on his earlier spiritual autobiographies. He published *Demian* anonymously under the name of Emil Sinclair and won the Fontane Prize as a first novel, a mode of entry that confirms that he circled around to his earliest work in order to present his latest. When his disguise was pierced, he returned the prize, but had made for himself the personal point. Although *Demian* was a product of the First World War, the protagonist (Emil) is very much a *fin de siècle* creature, an emblem of barely disguised autobiography. Hesse touches on most of his now familiar themes. The image of the Garden recurs: the place of solitude where one can refuse to grow up, like the bed of Jean Santeuil and Marcel. The introduction of Max Demian creates divisiveness, for Demian (the demonic) argues for Cain and for the predatory sparrow hawk he perceives on the faded coat of arms above Emil's house door. Such aggressiveness demands action, not passivity. Further, the relationship between the two young men, as in so much of Hesse, suggests a strong sexual attachment, a kind of spiritual homosexuality, based on the worship of one for the other. The strong one is the masculine element, the weaker one or follower the feminine; while women are themselves intruders.

What is unique in Hesse, however, is that he suggests not bisexuality, but unisexuality; the sex, perhaps, of Modernism. But there is another aspect, spiritual or not, in that the feminine is made less threatening by giving it a masculine cast. Woman must be redefined by way of her masculine shadows. All this is in keeping with Demian's advice to Emil, that what is forbidden "is not something eternal." It can change and therefore "each of us has to find out for himself what is permitted and what is forbidden. . . ."

A predecessor for the Hesse novel, as for Gide, is Wilde's *The Picture of Dorian Gray*, even to the presence of the picture that Emil paints. The location of *Dorian Gray* in this tradition of spiritual autobiography may seem curious, but the novel has rarely received its due. It is, clearly, more important as a document than as an artwork, but so significant is it as a document it demands its place in literary history. The Wilde novel, in 1890 (in *Lippincott's Magazine*, in 1891 as book), is part of a subgroup of fiction within this larger category, including Villiers's *Axel*, Huysmans' *A rebours*, Pater's *Marius the Epicurean*, an early story of Proust's, "Filial Sentiments of a Parricide," Proust's tentative *Jean Santeuil*. The subgroup would appear to be located, mainly, in homosexual authors, although it would be incorrect to define it in those terms alone.

While writing a technically conventional novel, Wilde touched on several Modernist themes. Lord Henry's advice to Dorian that he must live for the individual experience, in defiance of social constraints, is part of that experiential, sensory shift we have noted. In a preface reminiscent of Gautier's to *Mademoiselle de Maupin*, Wilde speaks of an art that lies outside morality. There are only beautiful things, with music the highest of the arts because of its form and its lack of definable morality or ethics. "All art is quite useless." In his anti-Ruskin, anti-Carlyle thrust, Wilde is interested in separating art from sincerity, which, he feels, characterizes outmoded forms of art. "Now, the value of an idea has nothing whatsoever to do with the sincerity of the man who expresses it." The real aim of art is the achievement of authentic feelings. One of the great Modernist struggles, which carries profoundly into spiritual autobiography, was to focus on art forms that were not connected to social or political function.

"The aim of life is self-development." Henry's advice to Dorian when they

first meet is echoed by James's Little Billum to Lambert Strether, to live intensely, and paralleled by Pater in the Conclusion to *The Renaissance*. The emphasis is upon a pseudo-Hellenic ideal—the need to live out one's life completely—but without the Hellenic counterbalance of an ethical life. The extraction of hedonism from Hellenism is, of course, a distortion, a kind of Greek worship without Hellenic thought. The "Hellenic ideal" for both Wilde and Pater seems more a form of carte blanche for self-indulgence than the balance Hellenism demanded. The new hedonism, however, no matter its faulty derivation, was to become a strong element in Modernism, allowing for suitable modulations. That experience lies outside of ethics and history would be supported by a reading of Freud's theory, by new work in anthropology, by developments in art, especially cubism and abstraction.

The quest for unattached experience in Dorian becomes a quest for sin. This passion dominates his nature so that "every fibre of the body, as every cell of the brain, seems to be instinct with fearful impulses." Gide's use of the *acte gratuit*, in *Les Caves du Vatican*, is an obvious derivation. Once sin enters as the result of the desire for experience, then the conscious will withers and an unconscious or preconscious takes over and "orders" the protagonist to commit some act that may seem antithetical to what he is. This development in Wilde and in Modernism in general parallels Freudian discoveries, although it parodies Freud's tightly conceived ethical theories. Free will is suspended, as it were, for an even greater act of will; whereas earlier in the century, it had been Schopenhauer's influential world as will that dominated. In Wilde, the painting, which changes as Dorian changes, and which also expresses an unachievable perfection, a perfect image, is the unconscious, outside time and morality, definable only in the same mysterious terms in which art can be defined. Not unlikely, *A rebours* is a key document in Dorian's fall into experience, although Lord Henry insists that no book can do that. Art, he says, "annihilates desire to act." But Lord Henry is not Dorian, and while the former talks, the latter disintegrates.

Also in the literary background of Wilde's creation is Villiers's *Axel*, for whom servants will do the living; for Dorian, the painting will live for him, serving as the timeless object denied man. Time is quite ingeniously restructured here, in keeping with what Bergson was describing in his philosophical work. The painting of Dorian remains in one temporal dimension, the subject in another; the subject experiences, through involuntary memory, another dimension, thought to be lost. These two temporal dimensions, the one in which the subject lives, the one in which the artwork survives, touch at the very end of the Wilde novel, as they would, later, in Proust's episode with the tea and madeleine. In *Dorian Gray*, they meet for only an instant when Dorian plunges a knife—the same knife with which he killed the painter, Basil—through the portrait. When knife, subject, painting, memory of Basil's murder meet, all temporal dimensions cohere, a privileged moment. That meeting becomes a moral point: Art returns to its ideal state, matter crumbles with time and age, corruption has done its work. All of Dorian that remains after the rotting corruption of his life is the painting, in its original freshness, a "Dorian." Like Keats's urn, it preserves an ideal moment while the subject putrefies. Life as art fills a spiritual vacuum.

What Wilde sought in painting as a criticism of life, Proust would discover

in the involuntary memory, in that dependence on the past as a pivotal experience:*

> It is said [Jean Santeuil narrates] that nothing in our lives is ever lost, that nothing can prevent its having been. That is why, so very often the weight of the past lies ineluctably upon the present. But that is why it is so real in memory, so wholly itself, so far beyond replacement. And philosophers say, too, that no tiny scrap of recollected happiness, no simplest occurrence of the past, can be felt by others as it is by us, that we cannot enter into their way of feeling, nor they into ours—a thought which sometimes brings so sad a sense of loneliness to those who brood upon it, can, nevertheless, give to our past the unique character which turns our memories into a work of art which no other artist, however great, can hope to imitate, but can only flatter himself that he has inspired us to contemplate within ourselves.

With this sense of memory and past, or the function of painting, or Joyce's use of the epiphanic moment; with this redefinition of man and the self; with such stresses on the unconscious and preconscious even before Freud, we enter new areas of narrative. Narrative, in fact, becomes the repository of all these changes; not plot, which is dissipated, not character, which becomes a function of telling, not setting, which sinks into narration. Not only has spiritual autobiography altered our perspective of human life, it has also changed our way of relating it. When narrative becomes the arena, to a large extent the way a novelist responds to narrative and its modalities will determine whether or not he is Modern.

When, in the 1920s, Virginia Woolf addressed herself to these questions in her talk at Cambridge, "Mr. Bennett and Mrs. Brown," or described what she felt Modern fiction should be in an essay of that name, she was responding to issues that had been worked through and settled more than twenty years earlier. In the latter essay (written in April 1919), her description of life, not as a series of "gig lamps symmetrically arranged; but a luminous halo, a semi-transparent envelope surrounding us from the beginnings of consciousness to the end" is an effort to define new narrative modes. So, too, in her description five years later of changes that took place in life and fiction, which she locates in about 1910. She is speaking, clearly, of the English scene, but these changes which brought about such radical shifts in literature came well before, at the turn of the century or earlier. Conrad's manipulation of Jim in Lord Jim, for example, clearly indicates the ways in which narrative modalities nourish Modernism. The emphasis on point of view, which is directly associated with narrative strategies, is connected to spiritual autobiography and the changes it heralded. Although Lord Jim cannot be considered autobiographical in any formal sense, Conrad's handling of narrative, his dependence on oblique presentation, and his use of multiple points of view to focus on his main character are all manifestations of Modernism that spiritual autobiography helped to pioneer.

* A decade before Proust, Pater, in Marius, suggested experience as memory; that is, the objective world as already contained in moments, in acts of memory. "And while he learned that the object, the experience, as it will be known to memory, is really from first to last the chief point for consideration in the conduct of life, these things were feeding also the idealism constitutional with him—his innate and habitual longing for a world altogether fairer than that he saw."

Wrapping itself around the turn of the century, *Jean Santeuil* is an equally good example. Jean is spirit moving toward matter, whereas in the earlier *Bildungsroman*, nearly all is matter absorbing spirit. In Proust, the protagonist must bridge spirit and matter, while always stressing the former. This is evidenced in the meeting of Jean and his father with M. Duroc. Duroc is everything a parent wants his son to be, successful at the highest levels, academically, professionally, financially. Completely organized and disciplined, he reveals one flaw; he cannot understand Baudelaire. His failure to comprehend what Baudelaire really means as a cultural figure displays to Jean that Duroc, despite his learning and success, is a hollow man. Jean stresses the poetic life: " 'What I need,' " he says, " 'is an opportunity for concentrating my mind, of digging deep into myself, of occupying myself with what is genuine, and not, like what you have been describing, essentially futile.' " Duroc counters by offering the wisdom of material things, cloaked, however, in learning and achievement. When Jean stresses that Baudelaire repeatedly failed in his examinations, the failure being a sign that such material things do not count, Duroc responds: " 'Which is why his poetry has so strongly morbid a strain and is, if I may say so, ridiculously overvalued by our young decadents.' "

The word "decadent" sticks as an epiphanic moment. For that word locates Jean in *his* world, outside matter, while it places M. Duroc solidly in the world of matter. To pursue the path of Baudelaire is to be Modern, however one may be castigated for that; to deride Baudelaire—to misunderstand what his failure on examinations means—is to deny Modernism. *Jean Santeuil* is full of such aperçus, which grow from sudden points into revelations. The revelation of such spiritual dimensions, however, is not divorced from things; things also matter. Immediately following the exchange on Baudelaire, the threesome come upon a fight between a soldier and a cabman, and Duroc urges on the soldier to hit the civilian. With this, Jean is released with finality from whatever Duroc represents, while firming up his own judgments and decisions.

How Jean will negotiate in this "other world" will determine his career, as much as, in earlier fiction, how the protagonist managed school and job would there determine his fortunes. The world has not narrowed down, but, on the contrary, has expanded internally to infinitude. In Section VI, Chapter 9, called "Impressions Regained," the spiritualization of Jean is almost completed, despite his penchant for social activities. Involuntary memory, still inchoate up to this point, becomes significant: "What has happened is that behind the indifferent spectacle of the present we have found on a sudden a memory of the past revived, the feeling that filled it, a charm of the imagination which attaches us firmly to life and makes us part of it, as though the past, let slip by happiness, not understood by thought, and only vaguely reproduced by memory, had been recaptured once for all by contemplation."

The life of the poet lies there, as in their differing ways Tonio Kröger, Stephen Dedalus, Pater's Marius have also discovered. "Those are the happy hours of the poet's life when chance has set upon his road a sensation which holds within itself a past, which promises the imagination that it shall make contact with a past it never knew, which never came within the range of its visions, which no amount of intelligence, effort, or desire could ever have made it know. What the poet needs is memory, or not strictly speaking memory at

all, but the transmutation of memory into a reality directly felt." Then Jean speaks of a smell, as, later, Marcel of a taste or flavor:

> A smell meets me as I enter a certain house where to be sure I had not come expecting to find beauty—but suddenly it is of a beauty that I am conscious . . . all [elements of that past experience and its evocation] were caught up and made present in that smell. And so it was that when it came to me again I felt a whole life rise up which my imagination had never known, but now after so long a space of time had battened on and savoured, I cannot say whether I felt this recovered life in the smell, or whether my memory gave it to me *accompanied* by the smell. . . .

Jean is, in a sense, trapped by this perception; he could not be M. Duroc now even if he tried, just as Tonio Kröger could not dance even if he wished to. "When a sensation comes to me in the present though as a sensation belonging to the past, there springs from the impact of that clash something that seems as it were to be a sensation freed from the trammels of the senses, and within the field of the imagination which, having now offered to it an eternal object, can know it, and know it so well that in a flash I find myself confronted by a reality liberated from the temporal circumstances of my life. . . ."

Once this is achieved, not long after the turn of the century, Jean has defined for us a journey into spiritual autobiography that, whatever other turns the genre may take, has permanently altered the *Bildungsroman*. This will be, with Jean's description, the farthest reaches of the "alternate life" that spiritual autobiography has developed into. With imagination freed from time, real life occurs in that "sudden leap which follows on the impact between an identical past and present." Modernism is an avoidance of mediocrity, which thrives in the marketplace. "It is mediocrity," Jean says, "that leaves us without hope." Great events, great men, great creations restore our confidence in life; thus, we must seek significance in imagination, where we can hope to find beauty. This is Pater's aestheticism with a vengeance. The Modern movement unsettles, opens us to such significance; whereas the other way denies exaltation. If alive, one has "a craving for Rembrandt," moments "when the thought of Rembrandt, a craving for Rembrandt, sweeps over us." At that moment, we "long for his dark shadows, his especial manner of treating light, we conjure up a vision of his gold-tinted flesh colours." The same thing, Jean posits, is true of places. That craving—whether for Rembrandt or places —removes us beyond that reification which deadens response; locates us, instead, where time, space, spirit, and things are resolved, in that "craving for Rembrandt."

There is still another kind of spiritual autobiography, one less effete and less tuned to words that lead only to art. This type of novel, characterized by Robert Musil's *Young Törless* (1906), while confessional, is more active, more shaped by external episodes. The German title of the Musil novel is *Die Verwirrungen des Zöglings Törless*, or "The Perplexities [or Embarrassments or Confusions] of the Pupil Törless." The title suggests a larger frame of reference than it does in English: "Perplexities" lays claim

to a philosophical dimension, and "Pupil" rather than "Young" indicates his apprenticeship to those who can "master" him while he is their pupil. The meaning of the novel is closer to the original German title than it is to the catchier English version, and the original also conveys the sense of spiritual autobiography, that internalized experience which struggles against action.

This is a deeply philosophical novel, much in keeping with Hesse's work at the same time. It is acutely associated with changes in our sense of the physical world, mainly with how we perceive it. It uncannily suggests an intellectual milieu ready to be affected radically by Einstein's theories in his four 1905 papers published in *Annalen der Physik*. The perplexities of the title are so significant because they foreshadow not only Törless's vagaries but those of a world that has to learn to think of itself and of causality differently from before. Also, "Pupil" takes on added significance when Törless momentarily shifts from pupil to teacher, lecturing his headmaster and mathematics teacher. The epigraph, from Maeterlinck, indicates this shifting reality: that what we reach for and what we grasp are quite different; what seems a treasure refracted in water turns out to be false stones or chips of glass in the true light of the sun.

The setting of the novel, an unnamed, isolated gymnasium, on the long railroad leading from Austria to Russia, creates itself as a world, a Kafkaesque enclosure. Foreignness prevails, as if the school were in Russia and not Austria. Parents are at least a day's journey away, so that pupils must develop without interference; even the teachers remain at a distance, as if in another country. but there is a space even within this isolated location, as in a Kafka novel, where the enclosed, suffocated environment contains even more enclosed, suffocating areas within it. This is an attic room, at the top of the dormitory, where secret rites, torture, hazing, the real action of the school occur. Here, Törless, Reiting, Beineberg, and the hapless Basini carry on their sexually ambiguous activities. This little attic area becomes a mythical location, a kind of "hut dream" for the boys who must submit all day, and who then use the raised area as their Eden or, in Basini's case, Inferno. That upper region is a kind of privileged place, not quite what Proust meant, but still in all a place where every sensation is heightened. That is its real function: to provide intense feelings in a general situation where feeling is missing, to create a sense of religious/poetic awareness that fills a vacuum.

The Russian word *shlug* indicates a void into which one is drawn, a spiritless, soulless void. When he comes to the gymnasium, Törless finds in himself nothing to contribute, "nothing for him to experience, and his life passed along in a blur of perpetual indifference. . . ." The *shlug* beckons all those who live neutrally, i.e., outside commanding feelings or sensations. Törless must fight this "horror of emptiness" which is a corollary of growing up; but, even more, respond to Austria in 1906, the meeting point of old and new when *Jugendstil* ran up against Empire, and Empire was disintegrating. Törless feels torn between two worlds: that solid refuge of respectable citizens, where all went well and was logical, regulated, the world of home; and the "other," a world of adventure, "full of darkness, mystery, blood, and undreamt of surprises." Not only Nietzsche, Hesse, Proust, and Joyce, but also Mann and Hamsun (especially in *Hunger* and *Pan*) perceived this dichotomy as central to all human experience and in

need of new forms of expression.* This meeting point between an order that no longer functions and a disorder that is an open Pandora's box cannot be reconciled by agreement among the gods; it offers a terrible intensity which the individual must encounter, unresolved except through physical violence or through some exaggerated belief or ideology.

Into this void rushes Beineberg, his experiments with Basini going well beyond homosexual experience into cultism. Beineberg represents the completely amoral man who will turn Basini into an object for the benefit of an idea, playing on man's lower desire to be debased and used. Reitling also enters into it, but the chief figure is Törless, who, while not initiating the debasement, perceives it as a means of exploring his own vacuity. Törless sees himself as both witness and victim. All experience becomes like a mirror for him: "He himself no longer knew whether it was only his imagination that was like a gigantic distorting-mirror between him and everything, or whether it was true and everything was really the way it uncannily loomed before him."

Although Törless wants to distance himself from Beineberg, he, too, is drawn to an experiment that relates him to "the great universal process." Denying the individual being, Beineberg stresses that "merely being human means nothing—it's a mockery, a mere external semblance." He is more of an annihilator than Törless, who wants, mainly, to fill emptiness. But their needs overlap in that Nietzschean dialectic where negation is one side, fullness the obverse. Beineberg is a great destroyer—here, of Basini—whereas Törless is a potential poet seeking salvation through damnation. Beineberg is Nietzschean without Nietzsche's irony, an incomplete part of the dialectic; Törless is a potential fulfiller, the practical side of Nietzschean denial.

The arena is occupied by a helpless Basini, a sexual victim wherein sexuality is not central. The novel's complexity is such, though, that one can argue sexual urges lead to ideology, or that ideology is at the base of the sexual abuse of the young boy. Political power cannot be disentangled from sexual need. Crowds themselves (here, a small unit) take on the sexual urgency as well as ideology of a leader. In these areas, we can view the novel as a spiritualized precursor of fascism or some other form of totalitarianism.

The sequences with Basini become modes of perceiving for young Törless. Through the episodes in the attic, he becomes the pupil, not of the school, but of the perplexities and ambiguities of existence. He plays with imaginary numbers, and we note how Musil, himself a mathematician, can utilize numbers theory as sociopolitical or philosophical discourse. Törless perceives that where he had expected causality, had indeed demanded it, he discovers "a black hole" which neither he nor anyone else can explain. As he posits it, one begins with real numbers and ends up with real numbers, only to discover that "these two lots of real numbers are connected by something that simply doesn't exist. Isn't that," he asks, "like a bridge where the piles are there only at the beginning and at the end, with none in the middle, and yet one crosses it just as surely and safely as if the whole of it were there?" In order to move from sterile thought to meaningful action, Törless must know. The mathematics teacher explains

* Musil's great work *Der Mann ohne Eigenschaften* would explore this theme more fully, especially in Ulrich's attempt to be an extraordinary man in Kakania (*Kaiserlich und Königlich*), "land of excrement."

that the problem is beyond Törless's comprehension, that such concepts "are nothing more or less than concepts inherent in the nature of purely mathematical thought." When Törless is dismissed with a gentle pat, he enters into the torture and humiliation of Basini as part of his desire to understand this broken connection.

Musil is able to provide philosophical depth to these matters not only through numbers but through brief episodes, which serve as imagistic suggestion. One such scene occurs when Törless holds a volume of Kant in his hand, the volume belonging to the mathematics master. Törless is, of course, too young to have made anything of the philosopher, and Kant is only a name, the "last word in philosophy." The scene lasts fewer than four pages, although it is profoundly evocative. We can suggest that Kant had offered a universal view of forces, but had admitted there were elements we must accept on faith; that although we can isolate some experiences based on empirical evidence, there remain those we accept as having existence and meaning beyond our senses. Kant, then, overlaps with numbers theory, which offers real numbers linked by an imaginary middle. With that insight, Törless destroys his copybooks, his youth over; a new phase begins in which he must confront not only the personal black hole but the universal *shlug*. The lack of a bridge between perspectives corresponds to something occurring in the physical realm: in physics, quantum theory posited pieces rather than continuum,* and in Einsteinian theory, absolutes are superseded by relativity.

As a consequence of doubts which create dread, Törless undertakes a morbid relationship with Basini; for, unable to know himself or the world, he hopes to discover himself in "wild contemptuous debauchery." Musil writes, as would the Mann brothers after him: "He had got into the way of hoping for extraordinary, mysterious discoveries, and that habit had brought him into the narrow, winding passages of sensuality. It was all the result not of perversity, but of a psychological situation in which he had lost his sense of direction." What is so distressing for Törless—that "our thinking has no even, solid, safe basis"—fits Beineberg's nihilism. The latter takes for granted that "in all fields our knowledge is streaked with such crevasses—nothing but fragments drifting in a fathomless ocean." Rather than creating anxiety for Beineberg, such ideas reinforce his negativism.

Beineberg wants to live through the points at which others rest. His is, in fact, the extremism Törless must reject in order to survive. Beineberg argues that we hop over thousands of death-seconds every day, while we seek life only "in the points of rest." He is, apparently, describing Nietzsche's "last man," who survives because he knows when to hop, when to rest. For such people, death must be postponed. For Beineberg, we must not live in the points of rest, we must become overmen. "One must awaken the feeling of one's own life in oneself as if something peacefully gliding along. In the moment when this really happens one is just as near to death as to life." One is then fully alive: "This is the moment of immortality, the instant when the soul steps out of our narrow brain into the wonderful gardens of its own life." Beineberg offers an intensity

* Cf. this passage: ". . . the soul isn't something that changes its colours in smooth gradations, but . . . the numbers jump out of it like numbers out of a black hole." That lack of smooth gradation in physical theory parallels jumps in spirit and/or thought processes.

based on the negation of everything associated with bourgeois life, the last man's base. He also offers a prewar death ideology, so that when his kind found their métier in war they embraced it not for nationalistic purposes but for what it meant to their soul. Musil is fearful of this, and yet he perceives that it has strength in a context that is itself so weak: the school, the lackluster faculty, the vacuum created by the lack of an authority that under better conditions could facilitate individual growth.

For Törless, one phase ends, the soul, like a young tree, having formed another annual ring. Human life and nature join, each accruing growth. The epitome of this spiritual autobiography comes in a scene near the end of the novel, when Törless is interviewed in the headmaster's office as the Basini scandal breaks. A personal quest for spirit becomes that of the era. Törless has demanded, as would a generation of spiritualized protagonists, some explanation of how thought and behavior are connected, where the missing arc lies. He speculates: "although a thought may have entered our brain a long time earlier, it comes to life only in the moment when something that is no longer thought, something that is not merely logical, combines with it and makes us feel its truth beyond the realm of all justification, as though it had dropped an anchor that tore into the blood-warm, living flesh. . . ." Flashes are only half completed in the mind; the other half occurs "in the dark loam of our innermost being."

Here is a meeting, in human terms, of physical and psychological theory, Maxwell's quanta, Freud's early structuring of the unconscious, Einstein's relativity, a foreshadowing of Heisenberg's theory of uncertainty or indeterminacy. This is true spiritual autobiography for Musil in that he uses the novel to trace a journey of the soul, an analogue in modern terms of the medieval journey of the mythical hero or knight. Here the grail is the self reaching toward achievement or self-recognition; not a form of conduct, but a way of believing, a source of self-comprehension. That stress on me-ism, on ego or the Freudian "Ich," on self and individual need is all too apparent in this transformation of the genre. It is self-reflexive, self-oriented, narcissistic, even solipsistic; and yet it is something—part of the culture attempting to understand itself by turning inward, and expanding.

◆ Chapter Five ◆
1900: Annus Mirabilis—
A Gathering of Forces:
Schoenberg, Kandinsky, Yeats

ALFRED RUSSELL WALLACE, whose work on evolution paralleled Darwin's, looked back in 1899 and called it "the wonderful century." As a scientist, Wallace was concerned not with humanistic studies or the creative avant-garde in the arts, but with the avant-garde of a different kind: the cutting edge of science and technology, what they had meant and would mean for mankind. Although Wallace's listings of accomplishments are also accompanied by warnings about greed, militarism, unhealthy types of work, and imperialistic plunderings of the earth, his book nevertheless becomes the obverse of Durkheim's on suicide, with its anomie, depression, and succumbing to uncontrollable elements. Wallace was a humanist, but he was also carried away by the magnitude of scientific discovery.

His point is that nineteenth-century advances more than add up to the total of all preceding eras: ". . . that to get any adequate comparison with the nineteenth century we must take, not any preceding century or group of centuries, but rather the whole preceding epoch of human history. . . ." Wallace cites the gains, among them railroads, steam navigation, electric telegraph, telephone, friction matches, gas lighting, electric lighting, photography, phonograph, roentgen rays, spectrum analysis (determining relative heat and chemical constitution of stars), use of anesthetics, use of antiseptics. To these "practical" advances, we must add a second list: principle of conservation of energy, molecular theory of gases, measurement of velocity of light and experimental proof of earth's rotation, discovery of the function of dust, nature of meteors and comets, theory of definite and multiple proportions in chemistry, proof of the glacial epoch, proof of man's great antiquity as against speculation based on the Bible, theory of organic evolution, cell theory and recapitulation theory in embryology, germ theory of the zymotic (infectious or contagious) diseases, discovery of white blood corpuscles.

Some of the practical effects of scientific discovery made a huge difference in the quality of life—for example, the use of anesthetics and antisepsis; and

199

other gains, whether medical or otherwise, would lead to further advances that would seem to justify Wallace's claims for a "wonderful century." That second list, moreover, is a true avant-garde, matching in theoretical science everything we have been charting in artistic endeavor. These efforts to understand man and his physical background are, in fact, paralleled by that radical redefinition of the arts emerging toward the end of the century. The year 1900, in both science and the creative arts, is an excellent time to stop and take stock. For not only do we have an array of great scientists, along with Freud, Einstein, Durkheim, Weber, we have Yeats, Kandinsky, Schoenberg,* Proust, Gide, Mann, Conrad, Cézanne, Rilke, Musil. Yet the overriding point, from the artists' point of view, is that the above group of scientific miracle workers had failed society miserably; that for all of science's advances, life was not intrinsically improved—man's greed and desire for power still superseded humanism; that art and literature were on an inevitable collision course with the scientists and their work.

This point had been intimated and established much earlier by Baudelaire. His "artificial paradise" and theory of the Dandy were, implicitly, acts of war against practical or political/social man. By the 1890s Baudelaire's "war" was being updated in every artistic movement. Painters were starting to take apart the visual universe, while composers denied traditional sounds and harmonies and writers were using words as if language had to be newly discovered. Conrad's lines to Cunninghame Graham were to be prophetic for the coming decades; written in 1897, they caught the right tone of pessimism, historical disjunction, social and political discontinuity, the sense of personal misfit—all while science marched on from discovery to discovery. For Conrad, the world is itself a machine, which evolved "out of chaos of scraps of iron and behold!—it knits."

> I feel it ought to embroider—but it goes on knitting. You come and say: "this is all right; it's only a question of the right kind of oil. Let us use this—for instance—celestial oil and the machine shall embroider a most beautiful design in purple and gold." Will it? Alas no. You cannot by any special lubrication make embroidery with a knitting machine. And the most withering thought is that the infamous thing has made itself; made itself without thought, without conscience, without foresight, without eyes, without heart. It is a tragic accident—and it has happened. You can't interfere with it. . . .
>
> It knits us in and it knits us out. It has knitted time, space, pain, death, corruption, despair and all the illusions—and nothing matters. I'll admit however that to look at the remorseless process is sometimes amusing.

These lines, too, were a view of "the wonderful century." In a letter only three weeks later, Conrad disavows even the saving grace of art and beauty:

> If you believe in improvement you must weep, for the attained perfection must end in cold, darkness and silence. In a dispassionate

* While having chosen these three as my pivotal "1900" creative artists, I could have also selected Rilke or Proust, and others, equally poised for work that would make us see differently. Yeats, Kandinsky, and Schoenberg, however, influenced the arts well beyond their own work and, in addition, had exceptionally long careers, factors that seemed to justify their selection.

view the ardour for reform, improvement, for virtue, for knowledge, and even for beauty is only a vain sticking up for appearances as though one were anxious about the cut of one's clothes in a community of blind men. Life knows us not and we do not know life—we don't know even our own thoughts. Half the words we use have no meaning whatever and of the other half man understands each word after the fashion of his own folly and conceit. Faith is a myth and beliefs shift like mists on the shore; thoughts vanish; words once pronounced die; and the memory of yesterday is as shadowy as the hope of tomorrow. . . ."

Despite his pessimism about amelioration, Conrad did offer art as an adversary to the scientific view; like James and Pater before him, he did see forms of beauty as ways of holding off the onslaughts of a scientific ideology. But his words are deeply embedded in the ongoing struggle between humanistic pursuits and scientific ones, part of the dialogue between Matthew Arnold and Thomas Henry Huxley. It would continue for the next century, and its main thesis was that while we are increasingly being defined by a technological universe—that "knitting machine"—art, beauty, humanism, belles lettres offer alternatives, however transient, however uncertain. Yet further than that, this ongoing struggle indicated that science and its application had somehow become the enemy even while it made life easier and better; that for all their saving graces, the sciences were leading us into lives that—while extended and improved—were less and less our own, part of that machinery dehumanizing us. Wallace catches some sense of that aspect of the "wonderful century," but since he has come to praise he suggests that science holds clues for amelioration. His belief in reason is not shaken despite his recognition that in political and social life it does not work.

By 1900, the avant-garde in the arts had set itself against everything Wallace's "wonderful century" stood for. Music, painting, poetry, fiction, and the drama, together with nearly every aspect of social thought, found themselves as adversaries. Durkheim's "suicide," Freud's "unconscious" and "dreams," Weber's "charisma," Bergson's "memory," Nordau's "degeneration," Mallarmé's *ptyx*, Marx's "alienation," Ibsen's "gyntian self," Schoenberg's atonality ("pantonality"), Yeats's "imagism," Jarry's 'pataphysics, Kandinsky's "line and point," all so vastly different from each other in implication and stress, were, nevertheless, associated as part of that adversary movement. Even Nordau, whose decline theory was aimed at the very artistic movement we are limning, recognized that while natural science offered man salvation and rationality, there were forces— such as those he observed at the Dreyfus trial—which fell outside of scientific solution.

As we have seen, the establishment in 1899 of Karl Kraus's *Die Fackel* was an effort to bring back rationalism, by way of torching out the present so as to open it up to common sense. Kraus's method was corrosive irony, scathing contempt, satire. Even in his exaggerations and excesses—in his antifeminism, his hatred of psychoanalysis, his attacks on Herzl's Zionism—Kraus carried his rationalism where Wallace hoped science would enter. Yet Kraus's own personal beliefs were part of the chaos, part of the ever shifting scene: the rationalist who attacked others' zigzagging beliefs was himself the prey of inconsistency. A Jew,

he converted to Roman Catholicism, then left the Church in 1922 (the year Hitler began his rise to power), and indicated support for Catholic doctrines even as he left Catholicism. In politics, he constantly sought a new god, who then failed: liberalism, socialism, atheism, Pan-Germanism, Catholicism itself, even monarchism. He sought them, perhaps, because they were destined to fail; or perhaps as aspects of personal growth, part of a spiritualized journey.

Kraus hoped to capitalize on reason, but frequently capitulated to the very fickleness he associated with avant-garde Modernism. By that "annus mirabilis," 1900, Kraus recognized that the very achievements Wallace lauded had created the backlash we have associated with the avant-garde in the arts. The greater the achievement, in fact, the more intense seemed the negative reaction of the arts; the more clearly a scientific century emerged, the less responsive became the arts. Take color alone; even as more precise instruments were developed to examine and measure, painters were perceiving color in nature in completely antithetical and personal ways.

By 1900, Modern was completely dependent on avant-gardes. The latter would no longer be the sporadic achievement of artists; the avant-garde took on a life of its own, in that the serious artist separated himself from a public art to go his own way or else was relegated to the academy. Kraus, who so desired change, renewal, self-development, integrity, supported the anti-Klimt side in Vienna, failing to perceive that the party his authority reinforced was moribund; that no matter what he thought of Klimt's work—decadent, even degenerative— it was discarding forms that had failed to express the age. Kraus's great effort to bring reason into everything failed miserably once he applied it to art and literature. By 1900, the avant-gardes were intense forms of renewal, sweeping away, their greatest enemy that world of science and reason Wallace had hailed.

When Conrad came to write *The Secret Agent* shortly after 1900, he satirized the public's worship of science. When his double agent, Verloc, visits the foreign embassy, the Russian Vladimir tells him that if an outrage is to be successful, it must be directed against the new god, science, and, therefore, a bomb must be planted to create meaningless destruction. The target should be Greenwich Observatory, the "first meridian," time itself. Conrad dedicated this ironical novel to H. G. Wells with an elaborate presentation—an appropriate way of mocking science and the man who created the time machine.

The professor of philosophy who gained Hegel's chair at the University of Berlin, Wilhelm Dilthey, also saw what was occuring and analyzed those dis- tinctions between the wonders of natural science and developments in cultural science. Dilthey's ideas culminated well before our Annus Mirabilis, but their influence reached their epitome at the turn of the century, possibly influencing Freud and surely reaching out to William James. Dilthey distinguished between types of research: *external*, with natural science, *internal*, with cultural science. External research sought absolutes, but internal research depended on time and place. Dilthey understood there was a world beyond externalized research which was supported by a shifting sensibility of consciousness. In this respect, he paralleled Bergson's stress on the unschematic consciousness. Consciousness— rather than purely objective work in scientific research—demanded that closer relationships between subject and object be recognized.

Once we grant the preeminence of consciousness, we can introduce all kinds of "other" elements into ways of perceiving. Not only are subject and

object more closely associated, but history itself hangs on personalized experience. Since the historian must himself take into account different sorts of data, his objectivity shifts, becoming intermixed with art, aesthetics, and their dimensions. The observer's or historian's time and place help shape his experience of what he is studying; and with this, we see Dilthey moving toward the ever shifting relativity of perspective so characteristic of all phases of Modernism.

The Annus Mirabilis, then, was not only a gathering together of great adversary talents in the arts, it was also a meeting point of several philosophical ideas that undermined at every stage Wallace's sense of that wonderful century. So great was the crisis in perceiving data that the great "holies" of Wallace—science, discovery, progress, human amelioration, experimental research—became sources of ridicule, targeted as the enemy. For example, Max Weber's mental breakdown in 1897 can be attributed to many causes, personal as well as professional, but it is fair to say some of it was owed to his perception of new dimensions. Weber realized more dramatically than most scientists or social scientists that the very nature of the material he was devoting his life to was altering shape even as he viewed it. Weber was being caught up in the great revolution of thought marking that wondrous year—when Freud, Bergson, Durkheim, Einstein, Sorel, Dilthey, Croce, William James, Lévy-Bruhl, Janet, and many others of almost equal stature helped to undermine in politics, science, and social thought the very elements Wallace lauded. Such men also inadvertently helped create the climate in which avant-gardes became the sole way an artistic process could express itself: through rapid change and almost continuous renewal, through fragmentation and dispersal, through the breakdown of movements into atomic particles of individual effort, through the creation of works that seemed isolated from any mainstream.

H. G. Wells echoed Wallace's wonder. Wells foresaw the real future as one of great scientific advancements accompanied by fearsome wars and a new race of technicians capable of running these new societies and their wars. His predictions were accurate, but he made them within a frame of reference of praise: this new society would indeed be a brave new world if only men could learn to curb their martial instincts and utilize advancements for amelioration. Then the new race of men would eliminate peasants and parasites alike; a new middle class would be affluent and enlightened.

Henri Ellenberger mentions a now forgotten French writer, Albert Robida, who carried Wells's prophecies even further in his own novels. Robida was an original who illustrated his books with futuristic drawings of marvelous machines and buildings—a kind of expansive Chirico. Robida's vision was based on continuous amelioration of the human lot, with particular reference to French and Parisian life. But his view went beyond better housing and more regulated cities. He foresaw the uses of technology to control weather, irrigate deserts, make arid land arable. Not all, however, was Edenesque. Books would be replaced (creating verbal and informational confusion), meals would be prepared in central institutes, and the pace of life would be stepped up, to the detriment of those who could not maintain the pace. There would be equality of sexes and opportunity; but this would be accompanied by a new kind of community, with privacy and individuality missing. Multinational wars would occur to capture overseas markets, since commerce in this social Darwinian vision was the linchpin.

Intermixed with this vision of future life are technological advances that

make anything possible—voices from the past recaptured, new forms of art. Yet Robida hedged on Wellsian optimism. Science and technology had for him dualistic implications—capable of great good, but also of great evil and destruction. Robida's illustrated novels were indicative of the various facets of that "wonderful century": avant-garde objects in themselves but part of that world the avant-garde was dedicated to subvert. Like Wells, Robida was enthusiastic for what science was capable of bringing about, but unlike his English contemporary, he perceived it would create adversary positions. In this respect, he was more artist than scientist, more humanist than technician; and his critique of science, whatever his other intentions, indirectly nourished artists as dissimilar as Jarry, Rilke, Schoenberg, Kandinsky, Yeats, and Proust. The list can, of course, be extended.

That "wonderful century" had its foes who did not need to know either Robida or Wells directly, or any of the scientists on Wallace's lists. These adversaries, seemingly, have little in common except their opposition to a world based on technological advance; and yet once we group them we find that they, too, overlap beyond their commonality as subverters. In their respective genres, they are bringing about something comparable to those other "advances," themselves creating alternate worlds and experiences. Two entities come into being which exist on parallel lines; even so, that artistic world is, concurrently, a terrible critique of the scientific-technological one.

Our examples may seem an unlikely yoking: Schoenberg in music,* Kandinsky in painting, Yeats in poetry. At this particular stage, there is no equivalent novelist—Joyce, Musil, Broch, Woolf would emerge later—since the novel, apparently, followed upon other developments, taking its cues from poetry and music rather than leading. What the three above suggest is a shift in style that coincides with our Annus Mirabilis, 1900: in or around that very year, as with Yeats, or in the decade beginning with 1900 and extending a little past it. With Schoenberg and Kandinsky, a crucial moment arrived in a decision: Schoenberg's move to Berlin in 1901 and Kandinsky's move to Munich in 1896, to begin his study of painting, then his founding of the Phalanx group in 1901.

Common to all is the fact that while they were deeply romantic in their materials—Schoenberg under the influence of both Brahms and Wagner, Kandinsky in his mystical, fairy-tale phase, and Yeats indebted to English Pre-Raphaelites as well as French symbolism—newer styles that would alter all this were implicit. Unique languages were shaping themselves even as older ones were being exploited; even when, as with Kandinsky, the medium was itself being assimilated for the first time. If we use 1900 as pivotal, we find three exemplary turning points in the arts as Modernism made its shift. It took hold tenaciously although its enemies were manifold: the materials of art itself, those old, worn materials which were no longer expressive, that had once themselves been great forms, whether Wagner, impressionism, or symbolism; the public for that art, which in each wave had to be seduced anew and which, as Schoenberg found out, resisted anew; the critics, who in every age insist on using the

* I indicated above that Rilke could also have been one of our representative figures, and we see this even in the uses Schoenberg made of Rilke's powers. In 1913–15, Schoenberg used "Vorgefühl" ("Presentiment"), from *Das Buch der Bilder*, in four orchestral songs based on poems by Rilke and Ernest Dowson.

status quo as a weapon against the new, who represent not education and learning but resistance*; other artists themselves—so that when Mahler was fighting for recognition, Schoenberg found his work distasteful, although the latter would in time become deeply devoted to Mahler, and very possibly *Gurrelieder* and *Das Lied von der Erde* parallel each other. Schoenberg even dedicated his manual on harmony, *Harmonielehre*, to Mahler after the latter's death, and a Mahler fund established by his widow provided Schoenberg with income. Such acts of "redemption," however, were rare.

We begin with *Gurrelieder* and its ambience. Schoenberg had completed its composition by 1900–1901, although full orchestration was not finished until 1911. In that decade, while Schoenberg was working sporadically on *Gurrelieder* and reshaping his musical language in other works, an entire generation of composers came of age. By the end of the decade and shortly thereafter, we find: Stravinsky's *Petrouchka* and *Firebird*, and early stages of *Le Sacre du printemps* under its working name of "Glorification de l'élue"; Mahler's fully mature career, his Fourth Symphony at the beginning of the century, his Eighth at the end of the decade; Strauss's tone poems of the 1890s, *Don Quixote* and *Thus Spake Zarathustra*, becoming fully operatic in *Salomé* (1905) and *Elektra* (1906–8), the latter of which Stravinsky found "completely ecstatic."†

In that same decade, while orchestration of *Gurrelieder* continued and Schoenberg was by the time of the Second String Quartet altering his musical style, we note other explorations of "color," Ravel's *Daphnis et Chloé* and his *Schéhérazade* song cycle in 1903. Debussy was even more illuminating in terms of Schoenberg's work, having turned Maeterlinck's drama into the opera *Pelléas et Mélisande*, material with which Schoenberg would become engaged shortly. Strauss suggested the play to him, and Schoenberg turned the "inner tale" into a symphonic poem in 1902–3. Like his work before and after, it is in D Minor, recalling Liszt's tone-poem genre, and uses large orchestral elements (64 strings alone) for minimalist effects. Characteristic of his developing work in the period, it stresses a polyphonic technique. While Schoenberg worked on "colors" and tonal variety as a new language which would develop into atonality (what he called "pantonality"), Debussy in *La mer* (1905) and the earlier *Nocturnes* (1899) was utilizing the whole tone scale and himself creating new harmonics and dissonances.

What this signifies musically is that Schoenberg's immense work—part oratory, part song cycle, part symphonic poem, part opera—was mirrored in numerous other musical compositions of the same decade. What makes this

* A remarkable exception was James Huneker, who reported his response to *Pierrot lunaire* in *Ivory, Apes and Peacocks*. Huneker filled the true critic's role: he struggled to understand what was new, startling, even distasteful. "What kind of music is this," he asked, "without melody, in the ordinary sense; without themes, yet every acorn of a phrase contrapuntally developed by an adept . . . keys forced into hateful marriage that are miles asunder, or else too closely related for aural matrimony. . . .?" Huneker perceived in the new music elements no other musical composition had accomplished; with that, he tried to find words to approximate what he had heard.

Stravinsky, however, on hearing *Pierrot lunaire* decried its "Beardsleyan aesthetic," apparently repelled more by the text than by the score.

† Unlike Schoenberg, who came to revere what Mahler was doing symphonically, Stravinsky, for whatever personal or artistic reasons, failed to appreciate Mahler's Eighth Symphony. Robert Craft reports that he wrote: ". . . Imagine that during two hours you are made to understand that two times two is four." Part of the lack of sympathy, whatever personalities had to do with it, was that Stravinsky was forging a new musical language as a minimalist and Mahler was blasting out the last of the nineteenth century.

remarkable is how Schoenberg, starting with a deep involvement with Wagner, especially his *Tristan*, subsumed all the developments of the decade in his work, *even while forsaking this style before completing its composition*. *Gurrelieder*— the songs of Gurre, a Danish castle—caps this entire phase of music-making and yet at the same time overlaps in Schoenberg's work with very different forms, those leading to atonality. Schoenberg pursued the major route of the avant-gardeist, in that he forsook what Charles Rosen calls "large blocks of prefabricated material in music," the very substance of *Gurrelieder*, in favor of that note-by-note composition which would consume the rest of his life. We conclude, then, that *Gurrelieder* is both culmination and finale, a climax for Wagnerian influence and signification of its end. Beginning in 1900, Schoenberg would assimilate the entire decade of music-making, which was, in effect, stretching Wagner to extremes in order to bury him.

For this and other reasons, which follow, *Gurrlieder* becomes the perfect foe of that other, scientific part of the wonderful century; the very pivot of our Annus Mirabilis. Concerned formally with styles, *Gurrelieder* has a content that on first look seems functionless, without point. It concerns the hopeless love of Waldemar (meaning "woods and sea"), king of Denmark, for Tove, a maiden who returns his love. Based on a poem by Jens Peter Jacobsen, *Gurrelieder* then follows Waldemar and Tove as they seek love amidst the everpresence of death, charting how every moment of love is intermixed with premonitions of its end. Waldemar's queen arranges to have Tove killed, and Waldemar curses not her but God: "False Thy way, and false Thy heart: / Thine a tyrant sway, no Lord art Thou." This condemns Waldemar to damnation, and his death follows. After death, he is forced to take a ghostly ride with his vassals across the land, frightening his peasants and souring even his court jester. Then just when the ride seems to forebode disaster, the summer wind becomes alive. The wild riders return to their graves, those "shadows of death and bitter sorrow" seeking rest and dreams. *Gurrelieder* ends with nature triumphant, with "morning dreams," as the sun climbs higher and "Decks his shining brow with flying / Golden looks of light."

The tale is a miniature, akin to Debussy's *Pelléas et Mélisande*, full of *fin de siècle* forebodings of death, a *weltschmerz* resulting from unrequited love. Yet even though a miniature in its content, the frame or orchestral score is huge, as though Schoenberg hoped to compensate for the small story with orchestral coloring or meaning. We should add, however, that despite the seemingly vague content, its implications are large: blasphemy against God; defiance of authority; a post-Nietzschean scorn of the ordinary; the need, Dionysian in its thrust, to assert passion over conventionality; the theme of infidelity, carried over from *Tristan und Isolde*; the involvement with magic, nature, and fate—all intermixed as if in some grand tragedy. Thus smallness here takes on the deceptive look of minimalism which will characterize much of Modernism.

Schoenberg gained his orchestral effects not only by adding instruments— oboes, piccolos, clarinets, bassoons, horns, trumpets, et al.—but by massing large vocal groups. Like Mahler during this period, Schoenberg placed solo singers (five of them) plus a speaker against the massed orchestra and (four) choral groups—so that we hear a form of opera. We can, in fact, see with hindsight that these symphonic effects, in which opera and symphony merge with each other, are the beginning of the end of opera. One side effect of Modernism was

the destruction of older forms of expression, and opera, as we can note in our own era, is no longer a major form of musical expression. Although Puccini was to write *Tosca* during this period and Schoenberg was to contribute to the genre with one of the greatest operas of the twentieth century, its forms were subsumed in the kind of symphonic oratorio we see developing in *Gurrelieder*.

Of particular interest is the penultimate section called "The Summer wind's wild hunt (Melodrama)." The "Speaker" recounts how the wind shifts the force of nature from the death ride to resurrection. It is an operatic solo of sorts, but declaimed as *Sprechgesang*, or *Sprechstimme*, sung speech. *Sprechgesang* was, of course, to become a staple not only of Schoenberg's own later declamatory works, but critical in the operas of his chief disciple, Alban Berg. The importance of this development in Schoenberg's work, as early as the turn of the century, was that he had discovered for himself a new type of musical language. Even within the caverns of grandiose orchestral resources (140 players), *Sprechgesang* was an effort to "reduce," to remove the pretentiousness of opera and oratory in favor of more ordinary discourse.*

This "bringing down" or minimalizing which we find occurring in *Gurrelieder* was also taking place in other Schoenberg works written during this period, notably in *Erwartung*. In this confrontation between the worlds of psychology and art, we have a Freudian monodrama, written in 1909 in a matter of weeks. If *Gurrelieder* demonstrates Schoenberg's dialectic of extending and reining in romantic largeness, then *Erwartung* is its obverse, indicating changes in the composer even as he completed the orchestration of *Gurrelieder*. Both pieces, however, negate everything understood by Franz Joseph's Jubilee in Austria, or, for that matter, Victoria's in England. Without referring to politics or even to an external world, Schoenberg found ways of sounding very Modern. In fact, he went in the opposite direction from "content", toward states of mind, internal fears, passionate attachments, all of them nonreferential.

Although *Erwartung* moves us beyond 1900, it is a sufficient extension of Schoenberg's turn-of-the-century career to be included here. It demonstrates that Schoenberg, like Yeats and Kandinsky, moved inexorably toward economy of form; that mature development meant an ever "cleaner" sound (or look). Coming on the very edge of his atonal experimentation, *Erwartung* carries the Wagnerian influence to its logical end and locates Schoenberg at a crossroads: whether to continue to do what he did effectively or to insist on such economy of composition that he would be isolated.

Erwartung not only negates Wallace's wonderful century, it insists on the primacy of the sub- and unconscious. A woman, disordered in mind and emotions, searches a dark wood for her lover, expecting to find him, but somehow knowing her expectation—or *Erwartung*—will be frustrated. That her quest even takes place is doubtful; more likely, it is a night or dream drama, a freely associated stream of consciousness which Joyce would develop more fully in *Finnegans Wake*. The Schoenberg piece, based on a poem by Marie Pappenheim, uncannily foreshadows the latter.

The entire work is a search for someone who is dead, whose death is suspected in everything the woman says, and does not say. Her interrupted expressions; the

* *Gurrelieder* was, we recall, orginally planned as a simple song cycle with piano accompaniment, as an entry in a prize contest.

frequent tempo changes (Robert Craft says he counted 111 metronome indications, as well as 65 additional tempo controls) in the 427 measures of music; the sense of bewilderment on the edge of madness—all of these imply a death even before her lover's body is discovered. What Schoenberg succeeded in achieving was an "inner" music: the musical development of a theme that never gains external shape. It could be, also, the music for *Finnegans Wake*, at once both economical and expressive. What gives the music its eerie quality, as accompaniment for the subconscious half-singing, half-*Sprechstimme* of the woman, is its brevity of development and those continuous alterations of tempo. So much of Schoenberg's work is programmatic in this phase of his development—*Gurrelieder, Erwartung, Pierrot lunaire* a little later, the so-called *George Lieder* or *The Book of the Hanging Garden*, with poems by Stefan George; even the final movement of the Second String Quartet—that voice and instrumental sound counterpoint what the subconscious would sound like, if it had sound. The sung-speech has the effect of the analysand bringing forth great secrets.

It is imperative in Schoenberg that the singer's voice be taken into account as an instrument; that is, words are no longer simply to be accompanied by orchestral sound. In this respect, Schoenberg broke with Wagner even while influenced by him. The "pretty sound" we find in Wagner as voice and orchestra blend is negated by Schoenberg's use of the voice as itself an instrument in conflict with the instruments accompanying it. In *Erwartung*, the woman does not "sing along," but "sings against"; so that we have in the line of the drama the very thing it is expected to communicate: that struggle of her sub- or unconscious to break out into reality. She never succeeds, of course, since the method is self-defeating, the point being that her experience is self-enclosed, circumscribed by who and what she is. The forest paths, the tree trunks, the body itself are all projections of her imagination, real enough for her, but not part of the solution; rather, the problem itself. She explains her mental state by her lover's unfaithfulness, even suggesting the possibility she may have killed him; but such "explanations" are beside the point given her emotional disorder.

The music picks up the inwardness of the experience, reinforcing the idea that resolution of her problem, or even definition of it, is impossible. The singer "speaks" of her "endless life . . . in this dream without limit or color," and "diesem Traum" is accompanied by a dense musical texture that, in effect, "buries" the voice, analogous to her being buried, as it were, in her nightmarish experience. The uncanny quality that Schoenberg evokes, here and elsewhere, derives from this alternation of minimalism and density, this evocation of a single life against the background of large forces—orchestral, vocal, massed silences. We note the same effect in *Gurrelieder*, and it would recur in his career in *Moses und Aron*.

The consequence of this, as suggested above, is to remove Schoenberg's work from external reference.* He has blended together, for purposes of inner examination, the lieder tradition, the isolated song, with immense forces we

* Unless we speculate and see his movement toward minimalism and compactness as political acts. In this way of thought, Wagner was *the* composer of high empire, representing power, size, scale; as that world dissolved, a new musical form on a different scale would represent diminuendo. Wagner, in this equation, stands for the state and all its glory; Schoenberg, Webern, Berg, the scale of the individual decrying the state. Wagner foreshadowed Bismarck; Schoenberg and his circle the defeated Germany and Austria.

associate with opera and oratorio. Schoenberg has extended musical forms by crossing over, by bringing to bear on one kind the sense of another. He had done this in *Pelleas und Melisande* in 1902, turning opera into a symphony in one movement. This abstracts him from any clear tradition; it makes him sui generis, and it is here we can sense his use of art to impede and negate everything the wonderful century meant. In practice, Schoenberg creates an alternative to that wonder, making it take on *his* qualities, *his* wonder. And as he moved toward greater economy of means, minimalism, and atonality in that decade after 1900, he tightened the screws on the old century, blocking it off so that its considerable achievements—those Wallace recognized—became secondary to successive artistic avant-gardes.

Wassily Kandinsky said about Schoenberg that he worked not "in order to paint a 'pretty' or 'charming' picture, but in an effort to set down his subjective 'emotions' *alone* in permanent form." He added: ". . . dispensing with objective results, he uses *only* those means which, at the moment, appear to him to be indispensable. . . . Schoenberg goes directly towards his goal, or through his goal proceeds only to that result which is necessary in this specific instance." Kandinsky was referring not to his musical compositions, but to his paintings, to Schoenberg's intuitive expressionism which he developed without instruction, as he had also developed his music. Yet Kandinsky's remarks, which define painting or art without social-political reference, could as readily refer to Schoenberg's music.

Kandinsky made his remarks in an essay on Schoenberg called "Die Bilder," in a volume dedicated to the composer, edited by Egon Wellesz. By this time, in 1912, Kandinsky had himself shifted to another mode of painting, toward abstraction, and Schoenberg had moved on to atonality, or pantonality, as he preferred to call his method. * Abstraction in painting and atonality or pantonality appear to have little technically in common, although philosophically and aesthetically they are related, both the outgrowth of developments in new languages. For Kandinsky, new language was part of his basic credo: that the subjective in art (the personal, emotion, inwardness) and the objective (line, point, color, painting materials, as well as the objects created) are a single unit. Kandinsky spoke of art whose form is "subjective content in an objective envelope," which is another way of saying the personal must infuse the created object, whatever the final shape the latter takes. This credo covers not only representational painting but abstraction. Kandinsky never felt his colors and lines and organizations were bereft of personality; much as Schoenberg never considered his tonal rows or series as cerebral music alone, but as a full manifestation of the composer's personality.

* In one of those cultural paradoxes, the Nazis grabbed hold of the term "atonality"—as they did of "abstractionism"—as part of their justification for prosecuting the new and Modern. If Schoenberg's preferred term "pan-," not "a-," had been conferred on his method, it might have been viewed as less destructive of tradition, of tone itself. For while the Nazis saw "atonality" as subversion—leading to chaos—"pantonality" has overtones of Pan-German, reconciliation rather than undermining.

Eleven years after Kandinsky's essay, when the painter was established as one of the founders of the Bauhaus in Weimar, he invited Schoenberg to join the faculty. But the Bauhaus was known as an unfriendly host to Jews, and Schoenberg rejected the idea of being made an exception. See below for further details of the relationship.

This credo was in place almost from the moment Kandinsky declared himself for painting, when he came to Munich in 1896. What did Kandinsky bring with him when he came to Munich? What did he find there, in culture generally, in painting in particular? One thing we stress with Kandinsky, as with Schoenberg, was that desire not to be sucked in by naturalism—whether of painting or word. Naturalism was, of course, a major force in all areas of culture, intensified by the post-Darwinian influence, Zola's powerful novels, postimpressionists, like Van Gogh, for whom the universe glowered over the individual. Naturalism has been loosely associated with the Modern movement—it was antiauthoritarian in some senses, atheistic, subversive of order and stability—but in its major thrust it was anti-Modern. Modernism had to struggle against naturalism, which in aesthetic terms was its greatest enemy: representational, a denier of individualization, a traditionalist in form.

From the start, as we can see in his fairy-tale paintings, Kandinsky moved outside the reach of naturalism. Unlike Munch, whose beginnings Kandinsky's early paintings recall, he was on the edge of something new in representation well before he discovered the new. The French Critic Marcel Brion calls Kandinsky's manner "poetic pictorialism," which is a "style" in which the artist's soul infuses the work. The more mechanical aspects of naturalism are bypassed. In a 1902 painting called *Bridge at Kochel*, Kandinsky has turned a natural scene into a fairy-tale setting. The bridge is presented as receding into a mountainous terrain, as if an illustration for an Ibsen play. Although the style at first seems to replicate Munch or Van Gogh, it is already expressionistic in its bold strokes. While not neglecting arrangement, Kandinsky has infused the scene with something more than arrangement.

All Kandinsky critics speak of his affinity for fable, fairy tale, the supernatural. Early paintings such as *The White House* (at Fort Worth Art Center Museum) and *The Young Couple* (at the Städtische Galerie in Munich), especially the latter, are intensely real, and yet other worldly, associated with mystery even while part of us. *The Young Couple* is a kind of costume party, with a quasi-medieval setting. This style is also found in a color woodcut from 1903, *Farewell. The Arrival of the Merchant*, tempera on canvas, has something of the same intimation of medievalism intermixed with even greater remoteness: some primitive or fabulous, undefined era.

These early efforts indicate that well before Kandinsky moved toward abstraction, he had rejected forms of realism and naturalism. He had, in fact, transformed Russian fables and fairy tales into light, color, and form and this transformation had as its prime function the voiding of representation. *The Old Town* (in a private Paris collection), from 1902, seems almost mechanistic in its formulation: towers and gables in background; huge bush in center, which dominates; softening of focus with a figure to the right; a second background in the shape of an attenuated wall of similar bushes; to the right front, fence posts that duplicate the background towers; ground cover of matted grass that blends into the orange-yellow walk, that coloring a slight variation of those background towers and walls; sky and clouds framing upper part of the canvas. Yet the apparent simplicity demonstrates an almost cubist technique. The shapes only remain to be turned into geometry, and the arrangement awaits the emptying out of objects. The element also missing is Kandinsky's "soul," that subjective quality which he said the artist must breathe into his work.

The Old Town is comparable in his development just after 1900 to the Second String Quartet in Schoenberg's. Both point in more than one direction; the artist is leaping ahead at once to reflect and to be the avant-garde. We can see something similar occurring in Yeats—even a brief poem such as "Moods" mirrors large poetic changes. Even more in the three-stanza "The Song of the Wandering Aengus," with its suggestion of balladry, we find a pivotal poem in Yeats: that similar use of fairy tale or the fabulous, that simplification of line which accommodates both fairy tale and Modernism, that purging of excess to achieve economy or minimalism of diction and outline. In all three artists under discussion, the dream quality of the work seems to derive from realistic materials, and yet that so-called realism is misleading because its net effect is dreamlike.

The Blue Rider (in a Zurich collection), in 1903, is possibly our best example of Kandinsky's deceptive simplicity shortly after the turn of the century. The "Rider" motif, which appears frequently in Kandinsky's work and which culminated in his collaboration with Franz Marc on the Blue Rider group, is of course a romantic image: the rider isolated against an infinite background, the rider and horse stretching out to achieve some chimerical goal, the landscape itself a blend of elements almost swallowing up horse and rider. Like Yeats, once again, Kandinsky remained a romantic even as he reached toward Modern.

The Blue Rider is detailed, but the chief sense we carry from the painting is its lack of realism despite a realistic, representational subject. What is striking is that Kandinsky has created a double horse, as it were: the horse that is off-white, but also the horse of shadow, which is, like the rider, blue. Yet the shadow horse is shaded toward black as much as blue, giving the rider a reflection in color but not in form. In this way, horse and rider are joined by a third figure, that blue-black horse shadow which creates the sense of speed, since in the main it is a kind of elongated nose for the real horse. The edging of blue visible under the horse's body only serves to accentuate that nose cutting the air.

The blue of rider and shadow horse is picked up in touches throughout the painting: next to some rocks on the left, then in the immediate foreground, where it is shadowed, finally in the full background of trees, leaves, landscape. The blue is far more pronounced as leafage than it is as sky; the main use of blue is the blue of these objects, not the sky blue, which is watery and indifferent. Key blues are both deep and ethereal, both intense and unlike nature's blues. They serve in a way like Matisse's purples: making us accept a way of viewing, an essence; perhaps as, later, Kandinsky will make us visualize lines, colors, and forms instead of objects. We discover an artist struggling to achieve a new language, while still hanging on to older ideas. This painting falls between existing modes, neither postimpressionist nor expressionist, outside definition except in terms of Kandinsky's own development after 1900.

A further dimension of the *Blue Rider* canvas is Kandinsky's use of space and spatial relationships. Although the theme is romantic, his way of handling it is not romantic, but caught between styles: the way Schoenberg's Second String Quartet starts out tonally and then becomes atonal or pantonal. Kandinsky's overall vision appears to be an analogue to Browning's poem about Childe Roland riding to the Dark Tower; but he has softened the landscape while maintaining its isolated, receding, dissociated aspect. Although the blue carries over from rider and horse to background landscape, the two elements are dissociated by a broad sweep of green knoll. The latter, although limited by

the canvas, has infinite spatiality; the rider, as he gallops, appears as motion itself—not as having any special goal. He is simply a "blue rider" and he signifies nothing else: no purpose or function, no direction or goal, no clearer identity. It is this peculiarity of lack of identity that marks him as Kandinsky's 1900 man. He is, apparently, not part of that wonderful century.

It is difficult to look at Kandinsky's early canvases without the awareness of what will occur in a few years. All his styles are inherent in an artist's work once we apply hindsight. We cannot see him freshly in purely chronological terms, any more than we can hear early Schoenberg without listening for what is to come later, or read early Yeats without looking for signs of economy and compactness. This is especially true for an artist whose early work is a springboard for a major shift in a genre, whose apprentice art is already a questioning of what is received. In Kandinsky, we are viewing work that, whatever we think of its intrinsic worth, is valued for what it leads into; the same thing occurs in 1900 with Picasso's early development, his realism, his blue period, his pinks. What really counts is cubism, planes, geometry; and however much Picasso is the master of other materials, we look forward to the time when he will define himself and the genre as cubist.

In this respect, the avant-garde establishes its tyranny over Modern*; for this is not a process or development that concerns us so profoundly in other eras as it does in Modernism. For previous eras, the tendency is for criticism to evaluate a career or a body of work in its own terms, so that developments are not always "toward," but for their own sake. In Modernism, however, perhaps because genres were being transformed, we are concerned more with change: the aspect of transformation preempts, often, the single artwork. Once abstraction, for example, begins to appear in Kandinsky, or, before that, in some cubist work, painting has been altered in a way that never occurred before. It is comparable in historical terms to Europe after the French Revolution or Russia after its 1917 Revolution: the whole nature of experience, perception, shaping was changed. This new mode of perception holds whether the particular method catches on or not. After all, the tonal row did not sweep away all other serious music; but it did establish a dimension in musical composition that remained long after more popular composers insisted on traditional values.

We are claiming for Modernism that the prevalence of those movements that we associate with the avant-garde makes us seek out pivotal areas. And all such careers in music, art, and literature that contain radical breaks we judge, more or less, in terms of the break: Kandinsky and abstraction, Schoenberg and atonality and serialism, Yeats and economy, compactness, Joyce and Woolf and the stream, Braque and Picasso and cubism, et al. Modernism forces a dramatization of cultural events: a beginning, a development, then the climactic moment when the radical break occurs, followed by a denouement, in which the artist either moves on or is thrust aside by the next avant-garde. Replacement occurs almost as soon as change itself, those five-year shifts in sensibility char-

* So tyrannical, in fact, that often the terms move too rapidly even for their founders. Just as Schoenberg preferred pantonality to atonality, but lost out, so Kandinsky thought that "concrete" was more designatory than "abstract" for nonrepresentational painting, but lost the battle of words. Concrete, in time, came to mean something quite different.

acteristic of Modernism. Spengler's later definition of cultures undergoing life cycles owes much to this concept.

These remarks are particularly apt when we consider what Kandinsky found when he arrived in Munich and then seek what effect Munich had on him. My argument is that Kandinsky was abstracting a full decade before he became an abstract painter; that his years in Munich reinforced that imaginative thrust; that abstraction was implicit in several other forms of art—such as cubism— well before Kandinsky's shift; that, finally, the major development in all Modern art, music, literature is toward an abstraction suitable for that particular genre. Abstraction, in these senses, parallels minimalism, both dependent on a powerful matrix of structure/shape/form.

If abstraction is the fate of Modernism, then abstraction was Kandinsky's fate, and we are justified in seeking it everywhere in his experience. When Kandinsky in 1896 left Russia for Munich, the latter was entering a cultural renaissance. * Besides its large assortment of cultural activities, its museums, its reputation as a city responsive to artists and liberal ideas, Munich in and around 1896 saw visits from Rilke, Thomas and Heinrich Mann, Wedekind; it saw the development of the periodicals *Simplicissimus* (cofounded by Wedekind) and, more important, *Jugend*. The latter would become associated with the style we identify as Art Deco, *Jugendstil*. These magazines, preceding the Viennese Secession by a year, published work by Hofmannsthal, Richard Dehmel (whose poetry entered into several Schoenberg works, including *Verklärte Nacht*), Rilke (some of whose poems, as we have seen, Schoenberg set to music), Ricarda Huch, several caricaturists and cartoonists, and others of note. When Karl Kraus started *Die Fackel* in Vienna, three years later, he had the Munich magazines as precedent.

In architecture, intellectual thought, as well as in the arts, Munich offered young artists unusual opportunities for growth. As Secessionist groups formed all over central Europe, avant-gardes exercised their tyrannies but proffered potential resources. Survival for an artist depended on his ability to change, but change reinforced the necessity for change. Kandinsky came to Munich not only to shift country and profession (from law), but to open himself to the entire range of artistic development. Only shortly after he had settled into apprenticeship work in Munich, he could write he was seeking "a new international language," and that that language would not be called Esperanto, but *Malerei*, painting. He wrote these words in 1904 after he had worked with Anton Ažbè, the great Schwabing teacher and advocate of fresh, innovative coloring. Alexei Jawlensky was a fellow student.

Unlike Schoenberg, who was self-taught except for some work with Zem-

* Peg Weiss in *Kandinsky in Munich: The Formative Jugendstil Years* has excellent chapters on Munich and its cultural life, and I am indebted to her account for certain details. Our points of reference, however, differ, especially in the stress she places on the arts and crafts movement and its influence on Kandinsky's shift toward abstraction. Also, she slights Kandinsky's early interest in fairy tales and fables in favor of the Munich experience.

In Thomas Mann's "Gladius Dei," we receive a very different view of Munich. Written in 1902, the brief story first establishes Munich as the center of art, but then demonstrates how this art is ostentatious, glittering, a veneer over real values, a tribute to the devil and his work, *Jugendstil* as artifice as much as art. For Hieronymus, the God-obsessed young man of the story, Munich and its stores are godless, and even the crafts have been transformed into blasphemy.

linsky, Kandinsky absorbed Ažbè's almost apocalyptic lessons on color: his insistence that the art of painting was the art of color, that pure colors should be applied directly to the canvas rather than mixed on the palette. Ažbè was very much the product of an era that had learned lessons from Van Gogh and Cézanne and which created *Les Fauves*. Color was the basis of painting, not subject: broad strokes made with a wide brush, the development of individual sensibility, the transference of emotions into paint and object; in effect, that new language Kandinsky spoke of in 1904 and then in his first book, *Concerning the Spiritual in Art*, a language of color. Kandinsky celebrated the love of color in his statement that the palette is "often more beautiful than any painting" and that "the living soul of colors emits a musical sound when the inflexible will of the artist's brush snatches part of their life away." As if some latter-day Rimbaud intent on synesthesia, Kandinsky writes of hearing "the colors whispering as they mix," an experience he associates with the magical experiments of the alchemist. There is, here, the spiritualization of art, so that the step into abstraction is a logical development. Objects, representation, the picture are no longer what matters; line, color, point do.

The thrust of imagination and brush was to eliminate objects without eliminating the world from which objects derived. Macke spoke of combining colors on a panel without "thinking of any object." For Kandinsky, as for his colleagues in Munich—Klee, Marc, Jawlensky—the object or representation interfered with spiritualization of the whole.* Objects in this respect vulgarized the artist's expressive vision. If we apply an analogy to what Schoenberg was "hearing" at about the same time, we can say the need to eliminate dissonance from music was roughly equivalent to the need to eliminate objects from painting. Any analogue that crosses genres is obviously inaccurate; yet what we find in both instances is that elements which resolve the whole—consonance in musical composition, objects in painting—could be eliminated in favor of a new necessity. Without dissonance, there was no need for consonance; lacking objects, nature was itself transformed when it reached the canvas.

For Kandinsky at this time, nature had not receded in significance; it had, in fact, become so powerful a vision he could capture it only by effacing the particulars that filled it. There is a paradox here, but paradoxes should no longer surprise us. Possibly Kandinsky resisted the use of the word "abstract" to describe his new style because abstraction seemed to delete nature, when, indeed, he devised different ways of including nature: not as objects but as line, space, and color. This was the next stage of what *les Fauves* were doing with their isolation

* An early admirer of Kandinsky's more mature style, Guillaume Apollinaire, in 1912, said that he carried Matisse to extremes and now "the only thing he obeys is chance"—which is another way of expressing "spirit." But well before Apollinaire, in 1901, André Derain, who was to become identified with *les Fauves* in France, recognized "that the realist period in painting is over. . . ." Writing to Vlaminck, he said: "I believe that lines and colors are intimately related and enjoy a parallel existence from the very start, and allow us to embark on a great independent and unbounded existence. . . . Thus we may find a field, not novel, but more real, and, above all, simpler in its synthesis."

Albert Gleizes and Jean Metzinger, in fact, in *Du cubisme* (1912), make these claims for Cézanne: "His work, a homogeneous mass, shifts under the glance, contracts, expands, fades or illumines itself, irrefragably proving that painting is not—or is no longer—the art of imitating an object by means of lines and colors, but the art of giving our instinct a plastic consciousness." Here are the spiritualization of Kandinsky, the early stages of cubism, and the foreshadowing of abstraction. They characterize Cézanne's realism as plunging "into the profoundest reality, growing luminous as it forces the unknowable to retreat."

of "color blocs" to indicate objects and the direction the cubists would take in spatializing objects.

In the decade or so when Kandinsky was reaching toward his mature style, we have a period of tremendous incandescence, in which the move toward abstraction is the catalyst. Derain's remarks on line and color, made in 1901, lead not only toward abstraction but toward cubism. And Vlaminck, to whom he addressed his comments, was to claim he began the interest in West African masks, fetishes, and sculptures that suggested cubist shapes. But even these masks would not have emblemized the shift from representation to geometric forms without the "posed" objects of Gauguin, the "color blocs" of *les Fauves*, the angularities of late Cézanne, the color experiments of Matisse.

Derain, whose work has taken second place to that of Picasso and Braque in this development, was the cementing force. He was the connection with *les Fauves*, by way of Matisse, and with cubism, by way of Picasso and Braque. Matisse was himself deeply involved in these shifts toward nonrepresentation, for he is reputed to have given the name to the cubists when he saw Braque's 1908 exhibition of six paintings at the Salon d'Automne.* Once the new style was named, it picked up new members, and it became, for the time, a movement; although even as it formed, Derain broke away, as would Picabia and Marcel Duchamp.

These were French developments, and they would, for Kandinsky, preempt his other interests, including Munich's colorists, once he became aware of them. That is, once he had already shaped his style with his own versions of cubism and abstraction in the earliest part of the century, he came into the sphere of influence of the Paris avant-gardes. Kandinsky had been moving, in terms of abstraction, toward a similar resolution of the problem we discover in late Cézanne, *les Fauves*, the cubists, and even the futurists, different though these particular developments seem in isolation from each other. The common problem was not how to represent objects, but how to replace them; not how to compete with impressionists and postimpressionists (whom the academy still opposed in the name of true-blue realism), but how to eliminate the need for objects. Theirs was, for good or ill, to be an impersonal world. The object, as well as person (another aspect of object), would be superseded by color masses, lines, points, forms—the art of our time. As Apollinaire remarked, "geometry is to the plastic arts what grammar is to the art of the writer," what, we may add, Schoenberg thought atonality was to the art of musical composition.

Even as Kandinsky moved in what now seems like a natural progression, opposition among critics and general audience mounted to the so-called dehumanization of the arts. Such opposition came not only from "degeneration" critics but from more balanced theoreticians. The pattern was threefold or triangular: those who supported Wallace's wonderful century of technological advances; those in the avant-garde who challenged every aspect of such wonder; those who wanted art to reflect the real world of achievement. Once we get beyond the rhetoric, however, what was in fact occurring was an expression of man in the only ways that could matter; all of these avant-garde movements were in a sense humanistic linkages between *Jugendstil* or Art Deco in the nineties and Bauhaus after the war. From an art that seemed decorative and ornamental

* I pick up this episode in chapter 7, where I discuss cubism more fully.

to an art that introduced objects functionally, we have art forms that tried to resolve (however temporarily) the problem of objects.

This crisis in objects was not an anomalous development in Modernism. It was quite consistent with the spiritualization characteristic of the movement, in one phase, and of the animosity toward the material world, in another. Nevertheless, developments after 1900 are of a different dimension, partaking of previous hostilities, but going beyond them. For such hostility was now being transformed into ways of thinking and seeing: matters of what we see, hear, say—that is, transformed into dimensions of language. We have noted such transformations as a distinct aspect of early Modernism, very possibly its major characteristic. Occurring now, in Schoenberg, Kandinsky, and Yeats, our representative threesome, is a more radical sense of the same development. The tyranny of the avant-garde suggested that the new involved a more forceful negation of the old; so that post-1900 languages were even more annihilatory of the past.

Politically, the era was characterized by repeated acts of anarchy and terror. Anarchy at that level—politically and socially oriented—was indeed an aspect of avant-gardeism. Playing with guns and dynamite, killing, staking out, exposing one's own life, defying authority, transforming oneself through acts of violence were nearly all acts that had avant-garde equivalents. "Killing" in the arts was accomplished through attempts to annihilate the past, through acts of language that, as it were, disenfranchised earlier languages.* One succeeded to the extent one eliminated older forms, an Oedipal situation transferred to creative work.

Connected to this was the intense inwardness of the arts, which Kandinsky stressed as the incandescence of the soul, the "Geistige in der Kunst." He had first become directly aware of this spiritualizing, subjective phenomenon when he viewed Monet's *Haystacks*, which "dematerialized the object"; in which, somehow, nature was disengaged from matter and became its own agent of form. Kandinsky relates another telling example, when he saw a Maeterlinck play in St. Petersburg, and the playwright represented a tower by a piece of hanging linen; so that the material world is suggested by the imagination and the theater is spiritualized. There is little question Kandinsky was intensely influenced by the inwardness that was, in different areas of research, leading to Freud's books, beginning with the interpretation of dreams at the turn of the century. Kandinsky also cites Cézanne as having divined "the inner life in everything," as having raised "still life to such a point that it ceased to be inanimate." Picasso, too, has "achieved the logical destruction of matter," not by dissolving it, however, but by "a kind of parcelling out of its various divisions . . . about the canvas."

For Kandinsky, those years after 1900 were a pivotal time for developments in his mature vision, which began to emerge with the first abstract watercolor in 1910. Earlier we cited his painting of *The Blue Rider*, in 1903, in which there is already implicit the spiritualization of subject, the "lightening" of matter. By 1910, he reperceived this symbolic form and abstracted from it. The "blue

* Recalling Rimbaud's vowel-poem, one of Kandinsky's contributions to *Der Blaue Reiter Almanach* in 1912 (ed. Kandinsky and Marc) was the play called *Der gelbe Klang*, "The Yellow Sound." Other contributors included Schoenberg, Webern, and Berg, besides those writing on art and sculpture. *Der gelbe Klang* has often been bracketed with Strindberg's *Die Glückliche Hand* ("The Lucky Hand"), both of them efforts at "total works."

rider" became, of course, connected to the *Blaue Reiter* group.* While Franz Marc would turn the emblem around and move it toward a cubist vision, Kandinsky would increasingly abstract it, liberating the canvas from both horse and rider. This process deserves elaboration since Kandinsky's relationship to this emblem in a sense is characteristic of his entire development.

Even as Kandinsky explored "blue rider" imagery, he had to divest himself of it. That is, he had to shift from descriptive means to essences—precisely what Schoenberg hoped to do with tones and Yeats would do with language. We are in the midst of major Modernistic developments—what opponents associated with dehumanization. *Yet what Kandinsky was doing was nothing less than seeking forms of energy in objects and then attempting to paint the energy rather than the objects.* He had, in this respect, absorbed the most recent discoveries in physical science, not the least of them Einstein's equation of matter and energy. We can see that Kandinsky was attempting with paint and canvas what had become the major development in physics under Einstein. Once Kandinsky comprehended that to capture the sense of energy was to capture the life within or spirit, his style became that quest.

Objects, then, did not have to be replaced or even resolved, for they came to mean something besides representation. The blue rider became less of an emblem and, indeed, was to become, as one critic wrote, "a form whose forcefulness depended principally on its denial of all direct plastic relationship with the image that had inspired it." But in its denial, the emblem lost none of its energy; spiritualization did not mean effeteness. On the contrary, the emblem takes on more meaning as it leaves behind representation; in the way that energy harnessed, as Einstein saw, gains power from the smallest element.

Just as Einstein's theories upset traditional notions of time and space, so did Kandinsky's spiritualization of objects. Once internalization became the source of control, external space and time gave way—processes deriving not only from Einstein's physics but from Bergson twenty years earlier and from Freud's definition of the unconscious. Once objects are turned into "volume" or "area," they are autonomous, dissociated from ordinary temporal and spatial considerations. What Kandinsky hoped to achieve was the location of objects outside of reality, which is another way of reorganizing our perception of the things of the world. Part of the process is "lightening," extracting the weight from things. This is, apparently, one goal of spirituality. A by-product of spiritualization is that the emotionality of an object is retained even when the object is dissipated; by emotionality, Kandinsky meant its essential energy, what lay beneath all objectified forms.

Intrinsic to the spiritualization of object and form was the desire to reduce or eliminate narrative in painting. We have in all the arts a parallel need to go from narrative (or melodic line in music) to more isolated or autonomous entities. Part of the reason for this movement away from narrative was the influence of

* Of the original group, only Kandinsky and Klee survived; Macke and Marc were both killed in the First World War. The Blue Rider lasted only three years, from 1911 to 1914, and was, in its short life and its sense of doom, a typical, almost archetypical avant-garde. That two of its members should be killed, while personally tragic, meant in artistic terms the movement had to be superseded by new inventiveness; it would have no opportunity to grow stale.

psychology, the recognition that experience and information are not arranged in long sweeps; part from physics, with quanta and broken waves, discontinuous energy; part from an antihistorical imagination, which denied not only historical detail but history itself; part from a compartmentalization of research and experience which had been developing for decades. Elements that are a long time preparing eventually link up in artistic developments, and Kandinsky's use of objects as movement, rather than as things, was one such development.

Once objects become forms of energy, dependent on the artist's personal view of them, then the canvas becomes pure movement—simultaneity of lines, colors, forms moving toward and away from each other according to their own rhythms. Rhythms are not established by any other association except what the dynamics of the work suggest. In this respect, the surge of modern dance at much the same time is a parallel development: movement and energy as autonomous, without any narrative thrust.* Some of the difficulty people had in watching, reading, listening to these new forms is that they were conditioned to seek narrative, not simply movement or dynamics, and they tuned their antennae for what was no longer there. The reality lay beyond, as Kandinsky recognized, beyond the object in some metaphysical realm.

Abstracting from objects in favor of energy and movement recalls the theories of the *symbolistes*; and, like Schoenberg, Kandinsky was indebted to Stefan George. George, we recall, wrote the poems for which Schoenberg, in 1908, composed his fifteen songs, *The Book of the Hanging Gardens*, for piano and voice. What drew both composer and painter to George was his emphasis upon a spiritualized art, which he introduced as early as 1892 in his *Blätter für die Kunst*, a journal devoted to art for art's sake. But George's ideas evolved from stressing art as a withdrawal from reality to viewing art as forces and energies no less powerful than the physical world. In the late 1880s and early 1890s, George had been part of the Mallarmé Tuesday evenings, and he translated *Les Fleurs du mal* into German. In a sense, he carried the entire French *symboliste* tradition back to Germany—not only Baudelaire and Mallarmé but Rimbaud, Verlaine, and, of course, the "French Poe." A strong personality, a handsome figure, with pronounced features—which Kandinsky reproduced in several woodcuts—George developed a circle, which became known as the *George-Kreis*.

As it spread, that circle would come to include figures as diverse as Rilke, Buber, Hofmannsthal, Stefan Zweig, Thomas Mann, as well as others of somewhat lesser stature. The salon where the *George-Kreis* met was that of Karl Wolskehl, where Kandinsky was a frequent visitor. The 1911 *Blaue Reiter Almanach* would contain references to George, together with three songs by Webern based on the setting of a George poem from *Das Jahr der Seele* (1897). In that same 1911 almanach, Schoenberg published an essay in which he referred

* The Nijinsky leap, already noted, served an analogous function, which was to transform narrative or story line into energy. Movement became its own justification, embodied in the scissoring of legs, the turn of a hand or foot. In dance terms, this is as clearly abstraction as object-lessness is in Kandinsky's paintings after 1910–11. Isadora Duncan's freedom-seeking dance movements are comparable. We recall how she insisted that the body expressed not only movement but "also the sentiments and thoughts of the soul." Line, point, and color are turned into dance.

to the George poems he had set to music. * Apart from his forceful, commanding person, the appeal of George was his ability to bring together *symboliste* ideas with a late 1890s defiance of authority—the Secession spirit, first in Munich in 1892 and then throughout most of central Europe. Kandinsky himself repeatedly stressed the George profile in his knight figures: George as St. George, either riding or charging, or slaying the dragon. The German poet played two roles: spiritualized as "St. George" and, also, as savior of art, the denier of functionalism. Other artists also drew George as a kind of saint; and St. George, or a simulacrum, decorated the front jacket of the *Blaue Reiter Almanach.*

George's poetic language was so attractive because it compacted experience, condensing image, experience, and word into a kind of unholy alliance. George of course recalls Mallarmé, in his utilization of ordinary objects as symbolic— thus his appeal to Kandinsky, who was searching, well before 1900, for a means of expressing objects without the object. George was able to stretch the German language to suggest dimensions beyond word and thing, creating a kind of Hegelian world of spirit in which lines and poem loomed and then vanished. Although Kandinsky was working in a medium in which paint could only approximate such appearance and disappearance, he found in George that veiling of meaning, that disguise of significance, which was for him, Kandinsky, an early version of spiritualization. From the woodcuts with George's profile or the symbolic St. George to a spiritualized art was still some distance to go. But Kandinsky sensed that a *Gesamtkunstwerk* or total artwork was possible only if he could stretch out beyond George and reach some level of spirituality. The *Gesamtkunstwerk* need not have the hugeness of Wagner's Ring; it could be as small as an abstract painting. Yet whatever the outcome, it was in every respect a refutation of Wallace's lists.

This returns us to 1900–1901, to Alfred Wallace and technological achievement, but also to when Kandinsky cofounded the Phalanx Society, whose intention was to capitalize on Secession and *Jugendstil* movements. Kandinsky was at this time deeply influenced by Ažbè and by Arnold Böcklin, the Munich colorist and "spiritual" painter who died in 1901. For the first exhibition of the Phalanx, on August 17, 1901, the publicity poster showed a phalanx or Roman formation, warriors' heads bowed, their shields and spears overlapping, meeting the foe, strewing bodies around them—a literal interpretation of the avant-garde and a warning to opponents. In the second exhibition, Kandinsky himself showed *Dämmerung* or *Twilight,* with its reference to Wagner's final Ring opera. It is highly stylized, a knight with lance before him charging something beyond the canvas; almost childlike in its pose and aspect, it owes a good deal to Böcklin, perhaps, but even more to William Morris and the renewed interest in medieval scenes. In 1903, Kandinsky broadened the Phalanx and showed sixteen paintings by Monet. The Society included several other painters with large careers, such

* Besides *The Book of the Hanging Gardens,* Schoenberg set two songs in 1907, then a Dowson poem translated by George, which became "four songs" in 1913–15. Several of George's poems as early as *Das Jahr der Seele* (1897) move in and out of Yeatsian "spirit" and "soul"; recalling that withdrawal we find also in spiritual autobiography in the novel. Like Yeats, George used vagueness and spiritual journeys as a testing of personal limits, as a means of seeking outlets. Language became supreme. Three years later, in *Der Teppich des Lebens (The Tapestry of Life),* he wrote: "The word of new delight and pain, the shaft / That breaks into the soul and jerks and quivers." Poetry is now supreme, embodied in the form of an angel, a vision that consolidates—as it did for Yeats—spirit, shape, and the word.

as Lovis Corinth and Alfred Kubin; but it is chiefly remembered for Kandinsky's role in it. For it was in these years that the Russian-born painter perceived—as would Yeats—that art and nature are separate and different. As he wrote in *Rückblicke*, his memoirs, every "resting point and every moving point . . . revealed to me its soul." Wallace's world of nature had no place for that perception.

A major turning point in Yeats's development of a new language which would turn him from a journeyman poet into a great artist came in his rejection of his father's rationalism. The process described in chapter 4, on spiritual autobiography, a development toward the end of the century, could as well contain Yeats. However, he underwent this inner turmoil somewhat earlier, perhaps accelerated by the need to stand up to an accomplished, witty, strong-minded parent. What Yeats did, by about 1885, was to find alternatives—aspects of adversariness that grew into subversion. His rebellion against rationalism, positivism, science itself came when he was twenty, when he failed to continue his education at Trinity College. That was in 1885, and we can date a critical time for Yeats just then—a critical period that led to artistic results almost two decades later. What occurred was not only rebellion against John Butler Yeats, but revolt against everything identified with fathers—thus the parent emblemized the age. Yeats's growing mysticism, a key factor in spiritual autobiography, became then a matter of personal belief, but, also, a more general weapon against an excess of rationalism. In this respect, the son was in the line of Victorian prophets, Carlyle and Ruskin among them, although he would go in directions neither Carlyle nor Ruskin would applaud.

In Yeats's case, rebellion against values of his age and father focused, eventually, on words. The critical point for him as artist came at the turn of the century, and it was, as for Schoenberg and Kandinsky, a crisis of language. All of his internal or personal shifts—mysticism, interest in *symbolisme* and Mallarmé, et al.—would have been artistically meaningless if he had not been able to transform such internal maelstroms into new forms of language.

He set the stage for this transformation in the dichotomy he established as early as 1885–86 between two personae, Michael Robartes and Owen Aherne. It was a time that produced more than one such dualism, the most famous, of course, being Jekyll and Hyde, the two faces of Dorian Gray, and Valéry's M. Teste. Richard Ellmann also points to another interesting British phenomenon, the use of pseudonyms by an inordinately large number of writers: Wilde using Sebastian Melmoth; George Russell, AE (from Aeon); William Sharp, Fiona Macleod, not only a pseudonym but a gender change; W. K. Magee, John Eglinton.* Joyce was caught in this syndrome. Although not using a pseudonym, he did employ a persona, Stephen Dedalus, to such an extent he and Stephen are often discussed interchangeably; also, like Wilde, he took up the name of a martyr. Part of the use of such dualism, personae, and pseudonyms was connected to sexual ambiguities—the writer had always considered himself as living in more than a single world because of sexual tastes. But that was only one

* John Galsworthy published as John Sinjohn, and, of course, Jozef Korzeniowski became the writer Joseph Conrad. In a slightly different sense, Proust started out as Jean Santeuil and then disguised himself as Marcel.

distinction, and not the chief one. For Yeats, it was more complicated, more associated with role playing and with his inability to decide what kind of person (and writer) he wished to become.

In the stories he wrote in the mid-1880s, Yeats's interest in the occult, his desire to retreat and dream away his life is shared by Michael Robartes; Owen Aherne is a more practical man, a Catholic, fearful of anomalous behavior. We are reminded, somewhat, of the two worlds represented in Dostoevski's Grand Inquisitor scene, the practical world represented by cardinal and church, and the idealistic, more dangerous world designated by Jesus. The split in Yeats is based on the struggle between abstraction and convention, dream and practicality, poetry of a sort and a life of action. This split, which recalls what we find also in the spiritual autobiographers, goes very deep, and reflects on the personal level what we have noted in the larger world. There, the war between science and the humanities or avant-garde arts divides how men see, live, order their careers and their ideas of the state.

For Yeats to transform himself, then, he would be engaged in a spiritual struggle whose resolution could come only in language. Although the personal element—especially after he met Maud Gonne in early 1889—was tearing him apart, the true resolution came not in his feelings but in his expression of them: in the language he forged for his poetry. Possibly with far less pain, Kandinsky went through a comparable testing period, in the decade after the turn of the century when spirituality fought against a painting style still founded on objects. Schoenberg, a more tortured man than either Kandinsky or Yeats, needed that musical break with convention or what was considered "natural," that renunciation of symmetry and prefabricated order, in order to express the "other" side of his creative genius; in brief, to express, not to resolve, the split.

Yeats sought resolution in several societies and orders, many of which he founded or infused with his energy. We need not downgrade these activities since everything forming Yeats's poetic power is significant; but we should stress that his 1890s memberships and organizations, and even beliefs, took on meaning for Yeats only when they helped him create a language to express them. To return to Kandinsky temporarily, we can say the same of his immersion in Russian fairy tales and fables, his association with the arts and crafts movement in Munich, his experimentation with *Fauves*-like color patterns; essential as all these activities and influences were, they took on importance only to the extent Kandinsky absorbed them to create his own language. In this respect, Yeats, too, was ruthless about that part of himself. He may have mooned around Maud Gonne and engaged in activities he hoped would please her, even making extremist political statements, but however painful all this was, it was preparation, not the real thing. The real thing was his forging of a language that would express what all this signified to him, and it would reach another level altogether.

When Yeats foresaw he could not remain a Theosophist, part of Madame Blavatsky's organization, he joined in 1890 the newly formed Hermetic Students of the Golden Dawn. The dominating force there was the Abbé Constant, better known as Eliphas Levi, whose writings on the Kabbalah had generated considerable interest in circles involving spiritualism and magic. Levi's method intermixed Jewish biblical exegesis with spiritualism (tarot cards, for example), superstitions, myths, legends, fables, whatever came to hand. The main struggle, according to Levi, was between elements of spirit and elements of matter: the

farther one traveled from a spiritual core, the closer one came to matter—on a descending scale. The system is Platonic and neo-Platonic in its stress on a spiritual ladder; one travels upward from matter toward spirit, although ultimate spirit is ineffable and unattainable. A spin-off of this phase of Levi can be found in Villiers's Rosicrucian *Axel*, where magic has replaced spirit, but with the common goal of eschewing matter.*

Yeats's activities in the following decade were more or less devoted to those same struggles, between spirit and matter, approximating Kandinsky's parallel need to achieve object-lessness.† Of course, Yeats had one eye on Maud Gonne as he moved among Irish patriotic activities, but in nearly every instance his moves were tempered by literary-spiritual considerations; until the time came when he professionally resolved what was personally irresolvable by achieving a language, not happiness. The complex symbolism of the rose became, at this time, the dominant element in Yeats's poetry, standing in for the divine principle itself. Parallel to the rose, once Yeats was enchanted by Maud Gonne, was the Irish Republican Brotherhood, nationalism, patriotic duties. Yet his peculiar way of demonstrating nationalism was through books and a literary tradition: his effort to establish a cultural standard even while fellow rebels advocated murder, bombing, and other acts of terrorism. Maud Gonne was, of course, part of the latter group, and yet Yeats courted her by way of literary organizations such as the National Literary Society, which he cofounded in 1892. Its aim was to publicize the Irish literary tradition, with the further goal of relinking those politically sundered by the Parnell divorce case. But even while the immediate goal was literary and political, it was, in more personal terms, Yeats's effort to resolve the schism in himself: to make political statements by means of literary expression.

Once resettled in London, where he spoke before the English branch of the Irish Literary Society, Yeats intermixed literary standards with attacks on materialism. Although he tried to move audiences, and often succeeded, he was really pursuing his personal voice, not Ireland's. Inner turmoil superseded all exhortation, and it was inner turmoil, in the latter half of the 1890s, that propelled Yeats into his quest for language. For as he attacked materialism, praised heroism and nationalism, hopelessly wooed Maud Gonne, joined the IRB and sanctioned violence, spoke of Wolfe Tone and the need for action, it was not by any means the main arena. Yeats's imagination lay elsewhere.

More than either Schoenberg or Kandinsky, who were experiencing similar transformations of methods, Yeats had to act out roles; for while they dealt in sound and color/line/form, respectively, he dealt in common coinage. His words to various patriotic groups were also the words of his poetry. While as painter

* Yeats's 1901 essay "Magic" proves an excellent guide to his use of magic and enchantment as a means of nourishing not belief but imagination, and, eventually, language. He calls poets and musicians the successors of the masters of magic and adds: "Whatever the passions of men have gathered about, becomes a symbol in the great memory, and in the hands of him who has the secret it is a worker of wonders, a caller-up of angels or of devils."

† In a development almost too bizarre to be true, Alfred Russell Wallace—coiner of "wonderful century"—turned, also, to spiritualism. Like Newton, who turned to alchemy, Wallace—codiscoverer with Darwin of evolution by natural selection—attempted through seances to communicate with the dead. He devised experiments to convince scientific colleagues that such communication was caused by spirits, not by deceptive mediums. He even altered his evolutionary ideas by asserting spirits had intervened in the evolution of man from ape. In this part of his life, Wallace came to distrust the evidence of science and, like Yeats temporarily, to rely on emanations from people.

and composer they could refurbish elements not so familiar, he had to work with words which were completely familiar and yet defamiliarize them. To be Modern—that is, to break away from the stereotyped sense of words, words worn smooth in the marketplace, as Joyce put it—Yeats would have to invent a language within a language. This was, as we have noted, Valéry's definition of how the poet had to work. In some way, Yeats had to reach toward the equivalent in words of Schoenberg's atonality in music; and if not that, then a kind of *Sprechstimme*. For the language that exhorted, that had its political and social origins in Ruskin and Morris, or Carlyle, was altogether wrong for Yeats's deeper purpose.

The language he needed after 1900 was, like Rilke's, to reach deeply into spiritual matters while whipping like a lash. He had to grapple with the age-old problem of the poet, but, as Rilke recognized, as Eliot would also realize shortly, the problem had intensified. For while poets had always had to forge a language to be distinctive, words had not been so demeaned, nor had they been so wrung through the marketplace or used so deceptively. A poetic style by the turn of the century had to vie with all those other styles—some ennobling of language, but most pejorative. In effect, even as Yeats hoped to rescue Maud Gonne from men like MacBride, his real mission was to rescue language, a quest she could not possibly accept while she moved in the world of action and he dipped ever more deeply into spirit, immateriality, everything that was the enemy of rebellion.

Yeats confronted an additional dilemma. The style he had forged for his spiritual ideas in his late 1880s and 1890s poetry was the wrong kind for the spirituality that developed after 1900. That is, he probed a different degree of spirituality in the later period from that associated with magic and Druid rites. This is a difficult point to grasp, since it would appear that spiritualization demands its style, and Yeats had achieved that. But the style in which he expressed "The Rose of the World" (the Rosicrucianism of the Order of the Golden Dawn) or "The Lake Isle of Innisfree" (a more personal mysticism or spirituality) could not provide the language he needed for the more profound spiritualization of the later decade. That period is foreshadowed, nevertheless, by a poem such as "Who Goes with Fergus?" in which Yeats had, even as early as 1893, begun to move toward that compactness, condensation, and epigrammatic tone which marked his mature style. The "wood's woven shade," "the white breast of the dim sea," and, especially, the "dishevelled wandering stars" suggest a maturing Yeats. The "Fergus" poem coincides with Yeats's investigations into William Blake's symbolism and occultism, and this activity may have shown him integration of spirit and mysticism.

Yeats's earlier spiritualism was, frequently, a response to 1880s and 1890s degeneration, or what he perceived as Irish degeneration of soul and spirit under the influence of English and broader European materialism. In this respect, he was responding—via Ruskin, Carlyle, Morris—to what Nordau and Weininger, among others, were reacting to on the continent. We enter thickets of paradoxes. The Yeatsian response to "degeneration," like Nordau's, was a denial of everything Wallace's wonderful century suggested, its achievements on virtually all levels. What Wallace considered as man's technological triumphs would become, in the words of these critics, signs of decline. This goes much further than a criticism of the quality of life in which art is cited as an alternative—

what we find, for example, in Wilde, Beardsley, Dowson, and others like them. It goes further than Yeats's own words to AE in 1898, that morality rests upon "the law of one's art."

We have a more far-reaching awareness of degeneration, and the paradox is that Yeats discovered it while seeking for Irish soul, in attempting to disengage Ireland's fate from England's. The paradox, however, is more complicated, for his need to make this disengagement was part of his quest for Maud Gonne—whom he saw as generative, but of himself far more than of Ireland. To pursue her for himself, he had to delve ever more deeply into Irish soul, but this very investigation was leading his poetic style into a dead end. To achieve his "true poetry," he had to forgo the language and style that enabled him to pursue Maud Gonne; that is, he had to go after degeneration in quite a different way, not by means of *this kind of spirit*, but by way of another.

As Yeats would discover shortly, true degeneration was that of language, for the language he had himself used in the 1880s and 1890s was tired, an English derivative of continental *fin de siècle* weariness; an aesthetic language, with parallels in Art Deco, that could no longer be expressive of the new age. Once Yeats awakened to another kind of language, with new images, leaner lines, concision of thought and representation, routine words made angular, he was responding to degeneration in the deeper sense. Like all major artists, he refurbished the language of his medium. Yeats became "Modern" when he awoke to this perception, when, in effect, pursuing language assumed priority over pursuit of Maud Gonne. To achieve what he called "utter simplicity," that striving for clarity and iron hardness, he had to forsake the heroic and/or pre-Raphaelite styles with which he had hoped to woo his Irish heroine.

Another style Yeats had to forsake was the "folk idiom" he cultivated mainly in his plays. His effort in these dramas was to call up a more heroic time in Irish history and to reproduce the sense of speech, life, and tradition in the peasant class. The form these displays of nationalism took was shadowy and mysterious. The reason, apparently, his folk idiom did not prove a meaningful style was that, unlike Synge, he quarried his subject in artificial, rather than poetical-realistic, language. The collaboration with Lady Gregory and the founding of what came to be the Abbey Theatre led to a production of *Countess Cathleen*; but then, as Richard Ellmann reminds us, Yeats subtitled it "A Miracle Play," a quest for the invisible and the occult. While Yeats's efforts here led to an Irish national theater, in terms of his own development such work had to be overcome; quarried, then put behind.

As early as 1898, he seemed to be aware of the dead end he was in, telling AE that "good writing is the way art has of being moral." In 1900, he repeated this new morality, also to AE, saying vague words are "rather a modern idea of the poetic," that he seeks the "definite and precise." Yeats is here rejecting a Modernism associated with the Pre-Raphaelitism and aestheticism that had nourished his own voice, in favor of what he calls "ancient vision[s]." By 1900, whatever his subject may be, we must take all his words as self-defining. As he stood on the edge of his life's greatest disappointment, Maud Gonne's marriage to Major John MacBride, in 1903, he wrote Lady Gregory of "new thoughts" and feelings of being "far more masculine." The loss of Maud Gonne would reinforce those elements in Yeats that were leading him to change styles, to go from folk and *that* language to Modern and *its* languages. Once the loss soaked

in, he moved, however disappointed and let down, toward what he called his "new art," whose precise direction, as he wrote in an essay on the psaltery, he could not foresee.

The period after 1902 or so, when he turned to Irish heroic tragedy, was also a temporary involvement, although very significant for Irish theater as a whole. The substitution of the heroic for spiritualism and the occult was not a false direction but a necessary development: the cultivation of those things a major writer must do to drain his system of them. Nothing is a false start for a writer in the process of development, and for Yeats immersion in heroic theater and vicarious heroism helped him develop the several roles he would play, shortly, in his poetry. For Yeats, all these personal elements had to be transformed into an impersonal art; just as Kandinsky had to discover how to put intense emotionalism into forms that expressed it. Often the outlets or forms of expression have little to do directly with what nourishes them.

In his heroic phase, as earlier, Yeats needed a dialectic—two opposing selves played off against each other. The nature of Yeats's thought as he developed a new style after 1900 was based on polarities: before it was Robartes and Aherne, now Cuchulain and Conchubar, roughly a rational self and an emotional one. Ellmann, in fact, sees four elements in *On Baile's Strand*: warrior and opposite, wise man and opposite, helpless blind man, with fool and blind man as chorus. In his personal life, Yeats went from holding himself celibate for Maud Gonne to having sporadic affairs when he had lost her. Whatever existed in Yeats did so as extremes, which he now perceived as irresolvable except in words. In social and political arenas, he attacked middle class materialism and allied himself with the peasant class and the aristocracy; once again, an irresolvable conflict. He would, in time, develop the concept of the mask, in which he could adopt different "appearances" so as to play this role or that; and he would develop his "phases of the moon" so that he, and others, could be relocated out of their time phase. But around 1900, he was still fighting more fundamental battles of style, moving away from Decadence, which he identified as "a womanish introspection." The vagueness of his thought and poetry disturbed him, and he wrote of the need for "an athletic joy." As he told AE, "We possess nothing but the will & we must never let the children of vague desires breathe upon it nor the waters of sentiment rust the terrible mirror of its blade."

A style that Yeats depreciated as "womanish" was giving way, in his perception of himself, to a more forceful manner, of self as well as prose and poetry. The attachment to Maud Gonne had weakened him, and her marriage—while not breaking the knot of his desire—did loosen the bonds of his poetic imagination. A good place to see the change is in the play *Deirdre*, started in 1904 and completed three years later. Here most of the tensions are dramatized (barely), and perhaps showed Yeats the impossibility of going on this way even as he went on.

Deirdre was begun the same year as the publication of *On Baile's Strand*, and yet the two, woven so closely in conception and writing, depart. That departure, still within the frame of reference of Yeats's indebtedness to romanticism and its offshoots, marks his movement toward the different sensibility we identify as Modernism. We must always stress that for a major poet, possibly the most important poet in English in our century, Yeats was not avant-garde; unlike Eliot, for example, he eschewed unexplored terrain. Like Eliot, he was

voracious about his antecedents, but when it came time for forays, he polished and tightened, clipped and snipped; he did not follow Pound into poetic experimentation.

On Baile's Strand illuminates the two Yeatses: the new sensibility and the style looking back. Withal, Yeats is still ringing the bell on his relationship with his father, generally on fathers and sons. In the literary background is "Sohrab and Rustum," Arnold's fine poem about an older man killing a young man in combat and then discovering it was his son. Here it is Cuchulain and a son he fathered by wild Aoife, a Scottish queen, who is using the son for vengeance. In the play, that is the shadowy past, secondary to the chief conflict, which is between Cuchulain and Conchubar. The latter insists that Cuchulain swear allegiance to him, and with that oath they will achieve a unity of kingdoms. For Cuchulain, this is humiliating, since in combat he would be supreme, and this peace means his sword is stilled.

Even as Cuchulain agrees, the background begins to emerge. The structure of the play recalls Sophocles' *Oedipus Rex*, with its slow increment of discoverable information. Yeats is interested in wringing every bit of irony from the situation; and the eking out of information after Cuchulain has, first, made peace with Conchubar and then killed his son in combat shapes our view of his warrior existence. That existence provides both triumph and terrible personal defeat. The final scene of Cuchulain fighting the waves, trying to master or understand nature itself, is in one sense the end of Yeats's own phase of heroic romanticism.

With Cuchulain losing the struggle against the waves and discovering not only human affairs but nature ineluctable, Yeats was preparing himself to dramatize something rather different. For while in some respects he had attempted to tame the waves, he had recognized that he could either succumb to them or else regroup his energies and locate the fight elsewhere. With *Deirdre*, we find him making precisely that decision.

In formalistic terms, *Deirdre* (begun in 1904, completed in 1907) displays no real advance on Yeats's part. But it stands in association with poems that do demonstrate formal changes, and reflects him on the edge of change, or possibly on the threshold of fragmentation. It is unclear, from this, whether he would achieve resolution; but *Deirdre*, whatever else, mirrors Yeats's preoccupations at their zenith, foreshadowing the breakup. The breakup, in fact, comes within the play: Yeats has dramatized a personal dissolution of his world up to the time of its writing.

This is not to claim *Deirdre* is precise autobiography, not that in some modern way it is an allegory of the author's soul. But its arrangement of characters, events, and tensions does point toward a deeply personal document which suggests Yeats has questioned everything he has stood for up to 1907. Further, the nature of the writing is such that Yeats enters into more than one charaacter; he has, in actuality, dramatized himself in various shapes or personae. He has, this early, donned the masks of self, turned himself into other shapes, and contemplated various roles. The big question for him, now that *Deirdre* has closed off the past, is what role he will play in the future. By writing this play, Yeats separated himself from his personal history, and if he was to continue, he had to discover a future role. *Deirdre* has no future role or actor; the play ends the past without looking ahead. We can say Yeats had to find other selves in order to reflect them. If we agree on that, then *Deirdre* was part of the same

mental set nourishing the "new" style of poetry he was tentatively writing. In a sense, it meant no going back.

The play has a simple outline. Seven years before, Deirdre was to marry Conchubar, the old king of Uladh, but on the eve of the wedding had eloped with Naoise, himself a young king. When the play opens, Deirdre and Naoise have returned on the promise of safe passage from Conchubar, although she suspects treachery. Fergus is the intermediary between the couple and the old king, and he promises that Conchubar means what he says. But the chorus of musicians who introduce the play and comment on the events suggests a more ominous turn of events. Having planned the deception, Conchubar's men trap Naoise in a net, although the king promises the young man's life in exchange for Deirdre's renewal of vows. She assumes all blame for what has happened and tries to reason with the old king, while Naoise prefers death: "Oh my eagle! / Why do you beat vain wings upon the rock / When hollow night's above?" Even as she accepts blame, however, Conchubar motions for Naoise to be killed. With that, Deirdre remains perfectly calm and requests only that she be allowed to bid farewell to the dead body. Conchubar permits, and Deirdre, with a knife obtained from a musician, kills herself, even as Fergus and a small army arrive to help her. As the play ends, Conchubar holds his ground and defends his deception.

With its intimations of the lovers and old King Mark in *Tristan und Isolde*, Yeats's play has sufficient literary antecedents; but what is more remarkable is how he could transform Irish myth in order to establish the terms of his own life and work. The play is an act of disembowelment of Yeats's world. Deirdre has forsaken the old king—here Conchubar has elements of Yeats pursuing and losing Maud Gonne. Deirdre is apparently Maud, who has opted for the young, handsome warrior, Naoise. Naoise is the principle of action, Major MacBride, or anyone representative of the martial arts. Yet while the triangular relationship recalls these aspects, the fragmentation is more intense even than the breakup of a nagging personal problem.

We perceive Yeats was forcing himself into situations that would illuminate everything he believed in. He avoided self-deception by dramatizing not only his own deepest feelings, but the larger sense in which such feelings meet the world—the history of Ireland itself. For Yeats had found in the dramatization of inner needs a historical role, that of Ireland in its association with England and that of Ireland in relationship to its historical past. Not that the play is so large or grand, but it does suggest vast sweeps of matter even while contained within somewhat small personal terms. Yeats has achieved that sense by creating an "other" for every self, forerunning his later use of mask and phases of the moon.

In *Deirdre*, Conchubar—who represents deception and guile—has right on his side; he is the injured party, the man whose bride has eloped. He is, also, as an old king, attempting to retain power, and reacquiring Deirdre is not only personal but regal, his refusal to be displaced. As source of conflict, the woman becomes both bait and reward. Conchubar represents, then, a complicated mix of elements, not a little of which Yeats sensed in himself. Naoise, who is part of the problem, is presented flatly, a character whose one-dimensionality is perhaps suitable for the warrior type Yeats could not enter into. His role is to be caught in the triangle, and his willingness to be duped into returning results

from his warrior's code of honor, his disbelief that a fellow warrior could dishonor himself by lying. In his needs, he is straight as an arrow, and here Yeats demonstrates his inability to penetrate that manner, style, or ethic.

As the centerpiece, Deirdre is the focus for all action and feeling. She breaks out of the order of a marriage to Conchubar to express personal feeling, and yet her need for such expression dooms everyone who touches her. Yeats has stressed the havoc and ruin Deirdre spreads; with all her qualities as a woman, she has divided men and led to bloodshed, *even while justifiable* in her expression of self. When she assumes blame for what has occurred, she is trying to save Naoise from Conchubar's Libyans, but also in some way to justify herself. So entangled does she get in motives and intentions, she has no recourse but suicide; her guile deceives the guileful Conchubar once again. But the old king holds his ground, and his words of self-justification ring out at the end: "Howl, if you will; but I, being King, did right / In choosing her most fitting to be Queen, / And letting no boy lover take the sway."

Yeats has positioned himself everywhere. For the force of the play on stage must not be the righteousness of the young lovers, nor the heroism of Naoise, nor even the power of Deirdre's presence; but, rather, the distribution of feeling among characters, the paralleling sense of justification underlying all behavior and the depth of fault attributable to everyone. Once Yeats has accomplished this, then he has indicated the death of old attitudes; he is dramatizing his refusal to go on with his illusions about beauty and power. The former equations which pitted reason against emotion, or poetry against warrior, are no longer valid. With *Deirdre*, Yeats may not have seen his way clear to new equations, but he has allowed old ones to crumble. He has demonstrated their ineffectiveness to work for him; and by 1907, three years after having begun the play, he is left with a stage littered by the bodies of the principals, an apt symbol of his own circumstance.

Paralleling the shift we note in the plays and especially in *Deirdre* is the alteration we begin to discover in Yeats's poetry. Something of this hardening of lines, or tightening of concepts, can be attributed to maturity, some, perhaps, to a shifting of interests. Writing to Lady Gregory in 1902, Yeats speaks of Nietzsche as "that strong enchanter," saying that "Nietzsche completes Blake and has the same roots—I have not read anything with so much excitement since I got to love Morris's stories which have the same curious astringent joy." Yet coexistent with this Nietzschean excitement—whatever it meant for Yeats— was the haunting sense beauty must be the goal of life. "Beauty is the end and law of poetry," he wrote AE in May 1900. Ideas for their own sake should appear in prose, not poetry. The latter "exists to find the beauty in all things, philosophy, nature, passion,—in what you will, and in so far as it rejects beauty it destroys its own right to exist." Thus Nietzsche would have to compete not only with remnants of Blake but with Pater.

Yeats was flailing around, as the revision of "The Indian to His Love" demonstrates, this poem first written in 1889 and then altered for 1901 publication. When he made final revisions, Yeats was moving toward some of the same qualities we find in this decade in Schoenberg's atonality and in Kandinsky's ineluctable advance toward abstraction; although in Yeats's case, the movement was snaillike. Nevertheless, we see him working his way into a kind of imagistic shorthand, well before imagism, well before Pound got to him.

Writing some of his deepest thoughts to AE, this time in 1903, two years after altering "The Indian to His Love," Yeats admits that his aim, like that of his contemporaries, was to achieve "some kind of disembodied beauty" which lay outside of form. Now, he senses not "a strange desire to get out of form," but "an impulse to create form, to carry the realization of beauty as far as possible." Using his newly found Nietzsche, he says that while the Dionysiac enthusiasm preceded the Apollonic, now the order may be reversed, as once he had reversed the Transfiguration and the Incarnation. The remark suggests a new order of thought and feeling, within a new order of form.

The first impression of revision is tightening, part of this resulting from excision of the second stanza. In that, we found "dreamy Time," "sleek young Joy," and Yeats's favorite, "murmur." With deletion of those five lines, the poem's structure is not only tightened, the entire thought is altered and com-pacted. The tone has hardened even while the language remains soft—still "murmuring," "woven," and "burnished," language familiar from the early poems along with familiar images such as islands, isolation, the "Crusoe syn-drome." The revision also removes some of the Browning influence. Part of what gives the revision its Modern sound is that Yeats has moved from explicit dramatic monologue (the invocation to "Oh wanderer") to implicit dramatic monologue. The latter—what we find, for example, in Eliot's "Prufrock"—is a Modern style, since it mutes realism and moves toward stream of consciousness. In the later version, the speaker lies within the poem, whereas earlier he had been positioned somewhere external to it. The difference in speaker location is an enormous factor in the tightening of the poem and also, once we note the change, inevitable.

Except for deletion of the second stanza, chief alterations occur in the first and final stanzas. Elimination of the invocation leads to direct entrance into the poem. Yeats also rewrote the first two lines, going from "Oh wanderer in the southern weather, / Our isle awaits us; on each lea" to "The island dreams under the dawn / And great boughs drop tranquillity." Then in the final two lines, he shifted a verbal to a verb, changing "swaying" to "sways" and a verb to a verbal, "Rages" to "Raging." The tone becomes more impersonal, closer to the muscularity that the entire revision is striving for.

In the last stanza of the original poem, the first line picks up from the final lines of the previous stanza, "One with," a continuation that smoothes the transition to the end passages. There are, in fact, three "one with" phrases; whereas in the revision for 1901, the final stanza is more isolated. The "one with" introductory phrase is gone, and it begins: "The heavy boughs, the bur-nished dove / That moans and sighs a hundred days. . . ." That first line foreshadows many later Yeats lines which, as it were, float free of their context to become free-standing comments—part of that hardening and concision which characterize one aspect of Modern. Since Yeats is still tentative, he smoothes out the rest of the final stanza with "How when," "when," and "with," transitional words he would later eschew. We see him, however, already moving toward form, away from what he would disparage as "disembodied beauty." Yeats's sense of poet-reader was shifting; he was losing his fear of not being understood, and as his confidence grew, so did his sense he could lose sight of his reader when he plunged ever deeper into *his* kind of language. What characterizes Modern, finally, is that assurance of the creative artist that he is a guide to the unexplored.

Another poem demonstrating how Yeats adapted his romanticism to a new mode is "Adam's Curse," published in 1902. This poem is somewhat like the second String Quartet in Schoenberg's canon, in that it looks both ways, back toward former practices and yet forward toward a style not yet achieved. In the Schoenberg, the quartet begins more or less conventionally and then breaks toward atonality in the final movement; in the Yeats, the early stanzas point ahead, whereas the final two stanzas seem to revert to the style of "The Wind Among The Reeds" (1899). The poem, in these technical respects, also recalls some of Kandinsky's work at about the same time, when his fairy-tale scenes took on a geometrical angularity that suggested cubism well before cubism could have penetrated to him.

A distinct achievement was Yeats's use of ordinary speech: "Better go down upon your marrow-bones / And scrub a kitchen pavement, or break stones / Like an old pauper, in all kinds of weather; . . ." Yet flat as the language seems, "marrow-bones" and "break stones" are extraordinary. Yeats was moving inexorably toward language, tone, and voice that would become distinctive. The subject of the poem is beauty, the burden of beauty, the nature of its time span and its truth or falsity—Keatsian territory. To achieve beauty is not easy work— it is indeed better to scrub floors—and yet the poet, the begetter of beauty, is thought an idler in the marketplace. To this, a listener, a beautiful woman, says that women have always understood the burden of beauty: "That we must labour to be beautiful." The narrator replies that all fine things, since Adam, need much laboring; lovers once thought love needed such hard work and yet they, too, are deemed idlers.

The subject now turns to love, and with that Yeats reverts to his older style and tone, that of his pre-1900 verse. The language of the final two stanzas is brimful of "trembling," "moon," "time's waters"—the old vocabulary that earlier stanzas had eliminated. Nevertheless, the language is cleaned of "thou" and "thee" and other archaic forms, and the lines are themselves leaner, although not yet epigrammatic. Much of Yeats's later Modernity comes in the confidence with which he presents an epigram of Shakespearean concision embodied in an image of complex intensity. Then, words, image, potential meaning are so inextricably wedded that significance is like a chord in music or a colored form in painting. There is little of that here, but we should not minimize Yeats's reaching toward this kind of voice. The final stanza is nearly all "as if," with the statement caught up in a series of subordinate clauses beginning with "that." While the effect of this is not epigrammatic, it is not quite the old style; on the contrary, it yearns for epigram without achieving it: "That it had all seemed happy, and yet we'd grown / As weary-hearted as that hollow moon."

While we should not make too much of "Adam's Curse," we should recognize that even as Yeats went about his Abbey Theatre business and wrote for the heroic stage, changes were occurring in his poetic sensibility as early as the years following the turn of the century. Similarly, in "No Second Troy," which appeared in the 1910 volume, *The Green Helmet and Other Poems*, we find a startling development for concision. He speaks there of beauty as "a tightened bow," as being "high and solitary and most stern," images that are caustic, tight, a departure from earlier expansiveness. The poem has snap, its tautness like the tightened bow that lies in the middle.

In the same volume, furthermore, we find "The Fascination of What's

Difficult," which contains at least one very complicated and very Modernistic image. Beginning with the fourth line, Yeats mediates a "colt," or Pegasus, between the speaker and the person addressed, and this image of colt dominates the remainder of the poem. He speaks of it as ailing, and despite having "holy blood" and leaping "from cloud to cloud" as shivering "under the lash, strain, sweat and jolt / As though it dragged road-metal." "Road-metal" is a new image for Yeats, and not simply a hard substance; it stands in a complicated relationship to the poet. Whatever restrains Pegasus is dragging him, Yeats. The daily war of theater business, "management of men," and his oath indicated he will "find the stable and pull out the bolt"; that is, run away, like the original Pegasus.

By 1900, Yeats, like Schoenberg and Kandinsky, was moving, however slowly, toward poetry that would define his mature achievement. And he, like the others, was doing it in the face of social and political ideologies, even cultural assumptions, that presented quite a different world. Even when Yeats touched on that external world, its politics and nationalism—implicit in Wallace's vaunting of the century's wonders—his interest lay elsewhere, in that inward turn in which externals are being absorbed and transformed. All three of our representative artists used fairy/folk/heroic tales as ways of getting outside Wallace's perimeters, as a means of moving into personal and spiritual matters even as the drift of the period was toward the opposite. The Annus Mirabilis was cradled, then by subversion: Schoenberg, Kandinsky, and Yeats become our fundamental anarchists, and art in its avant-garde phase becomes the ultimate weapon.

◆ Chapter Six ◆
Stream of Consciousness and Enclosure: Infinitude and Labyrinth

I AM NOT interested, primarily, in attempting full definitions of the stream-of-consciousness technique, or in analyzing deeply its manifestations as interior monologue or narrated monologue or any of the other devices used to bring forth verbally what may prove to be indefinable mentally. I am not trying to create iron-clad definitions, but to seek how the stream can be used as *both* technique and content, as both form and matter. Unlike most other critics of the stream—its detractors and its supporters—I find it revelatory *not only as words, but as situation and scene.* The stream, which lies in some intermediate form of consciousness, between the conscious person and, ultimately, a verbally unreachable preconscious or unconscious, can be defined situationally in what I will call "enclosure."

Enclosure, as we shall see, is not symmetrical with the stream, nor a congruency. It is, however, a scenic analogue of the stream in holes, depths, memory, dream, and we find it primarily, although not exclusively, in the full flower of Modernism, in Kafka, Proust, Woolf, Joyce, Faulkner, Broch. The greatest single instance of an enclosure analogue of the stream, outside the *Wake*, is in the Circe episode of *Ulysses*. There, we have not only the verbal stream, but the scenic equivalent of it. Also, I say "outside the *Wake*" because that entire novel is in a sense a model of stream and enclosure, of language and scene finding the equal of the other. By burrowing into stream and night thought and striving for a language that is truly an intermediary form of consciousness, Joyce created an entire novel in which stream and enclosure, encountering each other, link.

Stream of consciousness in the arts goes well beyond literary culture. We see it developing in painting, in music (as mood and atmosphere, in works such as Debussy's *Pelléas et Mélisande*), as well as in the word. *By stream of consciousness, I mean that area of expression which blurs boundaries between rational and irrational, logical and illogical, intuitive and mechanical.* It is an emanation not only from a state of mind, but from a particular state of mind. William

232

James perceived it—and labeled it—as "memories, thoughts, and feelings existing outside the primary consciousness." As such, it is in a real sense another language, not merely a flow or a stream. It is a level of consciousness that needs to be interpreted by a fresh arrangement of words, sounds, colors, rhythms. In these respects, the avant-garde in all Modernist culture is represented by the stream of consciousness.

We should be clear, then, that by the stream we mean an idea as much as the way by which that idea becomes manifest. It is the imagination behind the word, note, color, arrangement; and it is, also, the way in which that imagination becomes immanent. This is, I recognize, a novel way in which to observe the phenomenon, and it certainly will not satisfy those who identify it chiefly as a "mental process" or as a technical achievement, what we find first in Dujardin and, later, in Richardson, Woolf, Joyce, Döblin, Broch, and others. Such a view of the stream is suggested by Robert Humphrey's definition, which, while certainly able, is insufficient for the longer view: ". . . we may define stream-of-consciousness fiction as a type of fiction in which the basic emphasis is placed on exploration of the prespeech levels of consciousness for the purpose, primarily, of revealing the psychic being of the characters."* By "prespeech,"

 * It is axiomatic that no one agrees with anyone else on the phenomenon of the stream, either its source or its ultimate meaning. In a closely argued book, Dorrit Cohn offers an anatomy of the stream, more indebted to Humphrey's position than she seems willing to grant. She states that interior monologue does not imitate Freudian unconscious, nor Bergsonian inner flow, nor William Jamesian stream of consciousness, "but quite simply the mental activity psychologists call interior language, inner speech, or, more learnedly, endophasy." Endophasia, however, has a particular meaning, in that it is inner speech without vocalization, so that we have there a somewhat different sense from the stream, in which we hear a voice, whether partially muted or disarranged. Cohn offers her own categories, replacing stream by other means: *psycho-narration* (the narrator's discourse about a character's consciousness); *quoted monologue* (a character's mental discourse); and *narrated monologue* (a character's mental discourse in the guise of the narrator's voice). Her book, alongside Humphrey's, provides the best introduction to stream literature.

 In his pioneering *The Modern Psychological Novel*, Leon Edel established some of the categories that later critics could disagree about. Edel distinguishes between narrated monologue and the stream, which he cites as the mind's flux, "its continuity and yet its continuous change." Edel quotes from Dujardin, especially the latter's point that interior monologue comes closest to the unconscious, discourse that reproduces the mind in its original state. Internal monologue, Dujardin concludes, is unheard and unspoken speech, expressing thoughts that lie nearest the unconscious. Edel cites this to disagree, asserting that the unconscious can only be inferred, that language can suggest only marginal areas, "outside the central stream of thought . . . which is the 'halo' or 'fringe' of impression described by William James." For Edel, internal monologue and the stream are different, for the latter is more freed up, more liberated from syntax. Proust, here, would be the finest example of a writer who attempts to achieve "a reality out of the unconscious."

 Erich Kahler sees the raising of consciousness as leading to the shift toward interiority in the novel. He calls it "an increasing displacement of outer space by what Rilke has called inner space, a stretching of consciousness." By this means, the outer world is integrated into the inner, and new modes of manifesting interiority are inevitable. Kahler perceives this development as part of a process beginning with earlier literatures, not as a radical departure of Modernism. Although he analyzes inwardness, he is not concerned with narrow definitions of stream, interior or narrated monologue, et al.

 Wayne C. Booth really has little use for the stream, which he sees as an effort to "give form to what is really formless. The invention of a structure becomes a kind of rhetoric to support the illusion, rather than the other way round." Booth insists on treating the stream as another form of rhetoric, which makes it into discourse close to narrative lines. Since he is not really interested in the stream, as a nonrealistic device, he attempts to graft it on to his other forms of realism.

 Ortega y Gasset touches on the stream tangentially, as an element in Modernism that he defines as dehumanizing. Modernism, or interiority, by making the self and the individual so significant in his "creation" of the world, has put demands on man he cannot meet. Such interiority divests man of community, society, state, so that he can relate only to his own condition, which, for Ortega, is a dehumanizing process. Yet, in rebuttal, one can see the problem from the other side, which is that man, so beset by dehumanizing forces outside, needs interiority as the sole way of survival.

Humphrey suggests that irrational area which preceded rationality, what he calls levels that "are not censored, rationally controlled, or logically ordered." But the weakness of that argument is its claim that "prespeech" levels eventually give way to "speech" levels which are rational and controllable by mind. My view is that the stream, in all of the arts, indicates only an ephemeral resolution of the constant conflict between rational and irrational. It is, indeed, a liquid solution of struggling, polemical elements. In this view, the stream is in itself a reflection of the avant-garde, that tension of forces emerging in styles, fashions, manners, or modes as swift and evanescent as flow.

Further, in identifying the "psychic being" of the characters as the material that the stream reveals, Humphrey ignores a very significant point, which is that the stream is rarely consistent. My correction suggests that the stream, like nearly every other mode of communication, is capable of such variations that in several of its aspects it bleeds over into other forms of narration: first and third person, for example, or narrated memory or pastness. The stream is not easily identified, not always the innerness of Woolf's characters, nor Molly's soliloquy in Joyce, nor Tietjens's meandering in Ford, nor Benjy's in Faulkner. It can, in fact, be quite clean, hard, and precise as in Eliot's Prufrock, or as the inner poetic voice in Yeats, Rilke, and Valéry.*

That voice lies in some middle region, neither rational nor irrational, located, instead, in the relatively undefined area we understand by Freud's sub- or preconscious. In this model, the irrational would be whatever emanates from the id, the rational whatever emerges from the superego; itself a conflicted area caught between warring elements of id and superego. The model is imprecise; but the stream is not intended to be an instrument of measurement; rather, an instrument of expressing what cannot quite be expressed in any other way.

A first step is to distinguish interior monologue from stream. Although different from each other, they do overlap; yet although they overlap, they are not, as Dujardin considered them, congruent. Dujardin's confusion started when he placed the unconscious under the larger category of "the whole of consciousness," instead of perceiving them as conflicting elements; or, if not conflicting,

In *The Poetics of Reverie*, Gaston Bachelard breaks with all formal criticism of stream and interior monologue. For him, the poetic image is an absolute, "an origin of consciousness." Reverie removes us from reality, in this respect serving as an "irreality function" and becoming even more intense than interiority as a narrative method. For Bachelard, reverie has phenomenological overtones: through reverie and poetic image we gain insight into the very workings of mind and imagination, what Shelley meant when he said that imagination is capable of "making us create what we see."

* Valéry's entire "Le Cimitière marin" derives from an inner voice, neither the author's narrated monologue nor the speaker's consciousness; rather, from some intermediary range lying just beyond both and yet contained within. The poem is thrown, like a ventriloquist's voice, outside of any particular speaker, while belonging to the voice of the poem. It comes as an accumulation and yet is particularized, a meditation moving well beyond the meditator.

Into heavy absence they [the dead] are blended,
White species unto the red clay descended;
The gift of life is passing to the flowers.
Where are the well-known phrases of the dead,
The personal art, the souls distinguished?
The source of tears the tracking worm devours.

(Ils ont fondu dans une absence épaisse, / L'argile rouge a bu la blanche espèce, / Le don de vivre a passé dans les fleurs! / Où sont des morts les phrases familières, / L'art personnel, les âmes singulières? / La larve file où se formaient des pleurs.)

then as occupying distinctive areas. The confusion rests here: interior monologue really lies close to the consciousness of the character or to a memoried scene. It is the communicable expression of an inner consciousness, more rational surely than irrational. *The stream, on the other hand, is closer to the unconscious, or, preferably, in that middle ground of pre- or subconscious, and it cannot be captured solely by a standard method of communication. It is not simply the inner person thinking aloud.* It lies in the difference between Woolf and later Joyce, between early and late Ford, between the apprentice Faulkner and the Faulkner of *Absalom, Absalom!* and *The Sound and the Fury.*

The stream is the emanation of words, colors, sounds, freely associated, not always with any clear point of reference, often voice and language massed and undifferentiated. That stream is not quite in the control of the speaker or voice once it flows, and, at its best, is freely associated. Thus, in fiction, as we have noted, *Finnegans Wake* is the finest example we have of the stream, since Joyce carried that inner voice to language, which bent to communicate what were no longer conscious words and reason.* In poetry, Mallarmé, at the very beginnings of Modernism, moved into those inner areas, especially with "Un Coup de Dés." Proust, for all his achievement with memory, did not touch the stream; his interior monologues are surely the greatest of their kind, but they represent, not flow, but narrated memory, pastness, clearly narrated interiority.

In matters of color, light, and arrangement, the scene or situation is more difficult to identify as stream. In the impressionists, we find that point of reference or point of demarcation has been replaced by massed colors or forms defined not by what they are but by what they represent. Impressionism helped eliminate what painters call "fixed-point relationships," which implies a particular kind of spatiality, in favor of another kind based on a different system of reference and

* Certainly one of the finest examples of stream literature is the final passage of the *Wake*, in which the River Liffey, as a woman, meditates her monologue which will end, and begin, the novel. Earwicker is now left behind, he and the woman Anna Livia Plurabelle (Alma Luvia Pollabella) divided from each other; and the Liffey speaks. No longer wife, she is now the age-old carrier of Dublin's dirt to the sea. Her monologue is lament, elegy, almost an unconscious address to those who have been carried on the stream thus far in the novel: "We pass through grass behush the bush to. Whish! A gull. Gulls. Far calls. Coming, far! End here. Us then. Finn, again! Take Bussoftlhee, mememormee! Till thousendsthee. Lps. The keys to. Given! A way a lone a last a loved a long the riverrun. . . ." The river winds back to its source, and the novel begins with the line that ends it. The "self" becomes its own circuit, the stream its own stream; words melt around the bend, like the river, and Joyce ends, as he began, as close to the unconscious as literature has ever approached.
Hermann Broch's *The Death of Virgil* is surprisingly similar to the *Wake*, both being written at about the same time. Broch's Virgil, at the beginning of this novelistic tone-poem, is returning to Rome via Brindisium. In semidelirium, he lies on a litter, for these are his final twenty-four hours, and he is not only ill but sick at heart and enervated by what he sees. The novel, then, is a filtering of objects, people, events through the wandering mind of the dying Virgil, and the emanations from the latter's semiconscious, preconscious, and conscious are perhaps our finest examples of the fictional stream except for the *Wake*. Descriptions derive from Virgil's poetry-making ability, but they lie just outside or beyond him. ". . . in this doubled nocturnality [night and his death-darkness] he swayed on his litter as if it were a bark, dipping into the wave-tips of the vegetal-animal, lifted up in the breadth of the immutable coolness, borne forward to seas so enigmatic and unknown that it was like a homecoming, for wave upon wave of the great planes through which his keel had already furrowed, waves-planes of memory, wave-planes of seas. . . ." The sentence, like the wave it describes, flows on past us and through Virgil for several hundreds of words.
Once on the litter being borne toward Augustus's palace, Virgil feels life stream over him; yet the words for this flow do not derive from any particular source. Rather, even while seeming to emanate from him, they lie just beyond his voice. "The hob-nailed boots of the porters trotted along, clattering on the stone walks, grating on the gravel; the torch of the young guide, who swung round now and then to smile up at the litter, glimmered and glowed ahead; now they are thoroughly on the march and progressed quickly, too quickly for the aged servitur. . . ."

plane. The latter are, in the main, determined by color; so that arrangement is no longer geometric or "measured," but spatialized in terms of a commodity that is not space but sensation. That transition in Van Gogh, Matisse, and *les Fauves*, for example, from fixed-point relationships with their types of spatiality to planes determined by color masses with *their* spatiality, is roughly analogous to what occurs in the written word in stream of consciousness.

In musical composition, we can begin to "hear" the stream, I think, in the music of impressionists, particularly, as already noted, in Debussy. His opera *Pelléas at Mélisande* is, very possibly, our best example of stream of consciousness in sound until Berg and Schoenberg. By this, we mean that the words spoken by the characters are adapted to fit the line of the music, or vice versa; so that what emanates is not language in ordinary discourse, but a language molded to the line of a different kind of communication. While this is true of all opera, nevertheless in Debussy we are more aware of a vocal pattern that fits itself to the musical line than we are, say, even in Wagner, who had also moved in this direction. The *Sprechstimme* of Alban Berg and Schoenberg later in the twentieth century is part of the same phenomenon, in which neither speech nor music is strong enough by itself, nor is either intended to be. They are molded together as a single voice, and that voice appears to derive from a level midway between consciousness and unconsciousness. Thus, we have that somewhat eerie experience in which ordinary speech takes on a haunted quality because words and music have become, in practice, one.

We could, as I have suggested, argue that all avant-garde art was heading toward the level of the stream. For when the unconscious entered the vocabulary of every major artist, it became apparent that the inevitable goal for Modernism was, in one sense, stream of consciousness, as it was, in another sense, abstractionism. Abstraction is the stream of consciousness of art in which method and matter are inevitable aspects of the same thing. The implications for this, as for so much else, lie in Bergson, whose *Matter and Memory* is a holy text of Modernism. For example:

> More generally, in that continuity of becoming which is reality itself [a state we must take on faith], the present moment is constituted by the quasi-instantaneous section effected by our perception in the flowing mass; and this section is precisely that which we call the material world. Our body occupies its centre; it is, in this material world, that part of which we directly feel the flux; in its actual state the actuality of our present lies.

But there is more, and it is clearer. In this "occupation of the center" of the process, we must deal with past and present, and the way we handle the past is through memory. Bergson, however, needs to distinguish pastness from memory—and this distinction will have a far-reaching effect on language, literary technique, on our way of thinking about thought, even if we note his imprecision and disagree profoundly. He argues that once we actualize the past, turning it into "image," it has left pure memory; we have turned pastness into a "present state, and its sole share in the past is the memory whence it arose."

Consciousness is continuity of existence in which pastness is not actualized, but made part of a flow or stream. If you actualize the past into memory images, you "are compelled to extend to the totality of the states of the material world

that complete and independent survival of the past, which you have just refused to psychical states." For Bergson, since everything is in movement, he can argue that even mathematics does not express "the fact that it is the moving body which is in motion rather than the axes or the points to which it is referred."* In pursuing the nature of man as process and flux, he has intuited relativity as Einstein would develop it in the following decade; and he foreshadows the new physics, that all "division of matter into independent bodies with absolutely determined outlines is an artificial division." He goes on: "Real movement is rather the transference of a state than of a thing."

Fact is not reality as intuition experiences it, but adaptation "of the real to the interests of practice and to the exigencies of social life." Intuition, on the contrary, is part of an undivided continuity. For the sake of communication, we break up this continuity into elements that, in one case, correspond to words, in the other, to independent objects. The obverse of this is that if we cease such a breakup, we have in some way reentered the process. That is, we can experience life as if intuition and not "artificial divisions" reigned. One way we can gain entrance into process is through the stream of consciousness technique in words, color and arrangement, or sound. Such an entrance is, of course, temporary, since most of our waking time, our consciousness, is an effort to break away from flux into that division of words and objects Bergson labels artificial. Matter is connected to space; spirit or intuition to time. Matter, a scientific and mathematical component of space, seeks definition; spirit remains distinct as pure memory and works out its destiny temporally. Interior monologue, then, would be identified with words and objects; stream of consciousness with spirit, memory, intuition, undefined areas hovering near Freud's unconscious.

Bergson's thought is vague, his language imprecise and ambiguous, his views solely backgrounding, surely not prescriptive. Yet he did illuminate something we accept as a given of Modernism: that distinction between a conventional ego (the social, outward-turning ego) and a fundamental self (something uniquely individual). That conventional ego is demarked spatially or in linear modes, based as it is on clearly defined memories and perceptions, stimuli and responses, whereas the fundamental self is temporally oriented, operating in the resonances of its own definitions. Laughter itself derives from that distinction, for as soon as we move closer to mechanical replicas and seem inelastic, we become objects for the comic spirit to mock us. "L'émotion dynamique" is an early form of nonmechanical flow, in that it represents rhythms and dynamics that the stream later on would try to carry.

Those who speak of the stream as emanating from the mind as a kind of direct quotation must be careful about what they mean by mind. Bergson was already turning the human being into bifocalism, and Freud would further separate categories of mind itself. Inevitably, the view an author holds of man, spirit, and mind will determine whether he really comprehends the stream or interior monologue. Much of what we find in Dorothy Richardson's pioneering

* Or add this related, prophetic statement: "Homogeneous space and homogeneous time are then neither properties of things nor essential conditions of our faculty of knowing them; they express, in an abstract form, the double work of solidification and of division which we effect on the moving continuity of the real in order to obtain there a fulcrum for our action, in order to fix it within starting-points for our operation, in short, to introduce into it real changes. They are the diagrammatic design of our eventual action upon matter."

work *Pointed Roofs* is not stream at all, nor is it even interior monologue. It is, instead, the mind being opened to objects and impressions that are received passively—that is, recording them without acting upon them. One critic calls this process "sensory impression," which suggests it is the author transferring her own descriptions of things to the inner world of her character, here Miriam. It is a simple process of shifting from outward to inward, without making the inward uniquely different from its outward manifestations. There is no true internality; merely the shift of point of view from what is essentially phenomena to the internal world. We can call it authorially narrated interiority.

Even what Bachelard calls "reverie" is missing, for reverie involves an opening up of our sense of wonderment; whereas here the mind is making a transcription, as if in a realistic painting. This transfer from one area to another cannot create the stream, which is always more than "inner fact." The stream derives from what Bergson calls "pure memory," which he carefully distinguishes from sensation. The latter is "extended and localized"—that is, it is movement. Pure memory is intensive and powerless, beyond movement and beyond sensation. It allows penetration into spirit, in some perceptive, intuitive way that Bergson cannot define. What is necessary is to separate memory from cerebralism. Cerebralism leads to the adoption of reference points toward objects and terminates when one relates to them; what emanates from pure memory seeks an intuitive relationship to objects so as to possess them. His distinction between cerebralism and intuition is close to the distinction Virginia Woolf would make, in the 1920s, when she separated Wells, Bennett, and Galsworthy from those she considered to be the new writers.

In this distinction, the former, the realists, appeared to derive their notions of character from a cerebral desire to establish points of reference. The new writers, on the contrary—i.e., Woolf herself—moved intuitively and from pure memory. They presented their characters holistically by entering them spiritually. Woolf, of course, made it appear as if she were pioneering here when the "new writers" had been practicing holistic presentation for over twenty years. We can, nevertheless, note her proximity to Bergson's ideas when she says, forcefully, that "In one day thousands of ideas have coursed through your brains; thousands of emotions have met, collided, and disappeared in astonishing disorder." Yet, withal, you, the audience, permit novelists to "palm off upon you a version of all this, an image of Mrs. Brown, which has no likeness to that surprising apparition whatsoever." Mrs. Brown is by no means limited to what you see, but capable of that world of perceptiveness, intuition, pure memory which Bergson defined before the turn of the century; "for she is, of course, the spirit we live by, life itself."

In *An Introduction to Metaphysics*, Bergson himself drew distinctions between those novelists who remain outside their characters and those who identify so faithfully with their subjects as to follow every twist and turn. For the latter, the question is to capture inwardness, which Bergson relates to life itself. Of course this quest for inwardness would, later, in artists as different as Joyce and Pound, lead to conflicts between the subjectivity of their material and the "impersonal art" which they sought. Joyce insisted, in *A Portrait* and elsewhere, that the artist must sit above his creation as a God above his subjects; and Hulme and Pound spoke of the impersonality of art. Somehow, the stream that results

from emphasis on inwardness must be reconciled with an artistic process that had as its goal impersonality, even coldness, what we see in the growth of abstraction in painting, nonrepresentation in sculpture, twelve tones in Schoenberg, and elimination in modern music generally of nineteenth-century notions of harmony.

If the stream is the epitome of Modernism, let us be clear what we consider its manifestations to be. In stream narrative, the reality of the artwork, whatever its genre, derives from some middle area, beyond realism (cerebralism, consciousness) and yet not the unconscious, which remains impenetrable except through approximation. Joyce, Woolf, Faulkner, parts of Ford come to mind; but, also, Hermann Broch in *The Death of Virgil*, Alfred Döblin in *Alexanderplatz*; Kafka and elements of later Hesse; Conrad Aiken's *The Great Circle*; Conrad's early experiments with narrators, which throw the reader into the seams of the text; Eliot and Pound in their 1910s poetry; Rilke's third voice in *Duino* as well as Valéry's "middle" voice; aspects of Yeats's plays.

In art, we find manifestations of the stream in that later nineteenth-century shift, indebted to the impressionists, from painterly "point of reference" to defining objects by means of color and arrangement. Thus, later Cézanne, Van Gogh, *les Fauves*, Matisse, and then the greatest experimenters of the early century, the cubists, were all moving toward the intermediate area we have identified as stream territory. Cubism in particular is a form of stream since it turns familiar shapes into structural forms, familiar shapes deconstructed. As such, they reach into that area of preconsciousness belonging to the stream, later becoming an abstractionist flow of shape, substance, and arrangement.

Similarly, in music, Debussy, certainly, is recognizably a stream composer, indebted to the Bergsonian flow, merging musical narrative with verbal narrative into an intermediary form which, being neither, is both. Stravinsky in *The Rite of Spring* moved toward the stream, although the clear outlines of musical sound and the fact that it was programmed as ballet music make it less stream-like than at first meets the ear. But Berg and Schoenberg, particularly in their masterworks *Lulu* and *Moses und Aron*, were stream composers, their use of *Sprechstimme* alone bringing them into alignment with stream writers such as Joyce and Kafka. Also, Schoenberg's early symphonic poems, indebted to Wagner and paralleling Debussy, were bona fide efforts at new sounds and arrangements, not at all alien to what Joyce would try with Molly's soliloquy and, even more, with the entirety of the *Wake*.

These examples, by no means exhaustive, create a different sense of stream from what we usually associate with the technique. Here it is not only the "voice" of the particular genre, but its thought and its structure as scene, episode, image. When such developments coalesced in movements as clearly defined as Dadaism near the end of the war and then surrealism, which built in part upon Dadaism, we note how stream ideas blended word or image and idea.

Yet the stream could not have existed without the stress on self which we have identified throughout as so essential to the development of Modernism. The pressures of modern life which could lead to loss of self or dehumanization of self, in Ortega's phrase, resulted in the protest of self. This meant not its annihilation, but expressiveness, of which the stream is perhaps the purest. We have, then, that phenomenon I call enclosure, in which an apparently lost self recovers through retreat. Baudelaire's Dandy, and all his successors, were efforts

to find in artificiality at least temporary responses to the self's loss. In this view, the Dandy is personally substantial only to the extent he reflects a response to loss. He cannot stand in other respects. From Baudelaire's Dandy to Musil's Ulrich and Kafka's K. is only a brief journey, although they are seventy-five years apart in history. The use of the stream, however imperfectly devised, allowed for the self to flourish, whether it is the River Liffey, Clarissa Dalloway, or the idiot Benjy.

The stream always carries with it a profound paradox. For a primary quest in the nineteenth century (from Hegel to Bergson and Heidegger) has been toward the release of spirit from matter. The hope is that once they are sundered, spirit will find its own level, will spiritualize the universe, as it were. The spiritualized self, in Hegel, will be the new matter, and the spiritualized self in Bergson will find itself deep in pure memory, amidst streams and flows. Yet this splitting of spirit from matter led not to spiritualization, but to self-ness. Generations of writers sought ways in which that self-ness could be integrated; or else, if not integrated, the means by which man could live split, his self cut off from those elements that, traditionally, have nourished self-ness. Beginning in the latter part of the century, we have legions of artists trying the slopes of that mountain, from the spiritual autobiographers to poets like Yeats, Rilke, Eliot, Valéry. Broch's *The Death of Virgil*, in the 1930s, is perhaps the logical successor to this entire tradition, its roots deep in early Hesse, Musil, Kafka. In Broch, even the self of Virgil, Rome's greatest poet, cannot be integrated; and he drifts off, divided between self and his work, split between his desire to integrate and the way of the world.

The key image or scene for sundering is the tunnel (cave, hole, burrow, labyrinth); embodying an effort to bring together a self circling back to itself even as it splits off from objects and transcends matter. To see how all these paradoxical elements come together, where irreconcilables are integrated temporarily, we might look at the obverse of the stream, which is enclosure.*

An enclosure literature is one that, while stressing inwardness, makes that inwardness into a culture of its own, adversary to the main culture; in many cases not only undermining it but providing alternatives to it. It is not merely negative, not merely part of the movement toward nada and nil we examined in nineteenth-century French poetry. Enclosure provides an entirely different perspective on life, turning passivity and inwardness into points of departure, perceptions, critiques of the larger culture. The development of the stream, or its approximation, means that its inwardness could be contained in a series of hard, compact, concise images—holes, attics, hollowed-out structures. These images would be held together by a precision that would seem the opposite of the extreme flexibility and even softness of the stream. But they were not opposites. For enclosure images, symbols, situations were working on much the same kind of material as the stream; which is to say, reverie, dream, nightmare, the sub- and approximate unconscious. *Both were complements of inwardness at levels beneath or beyond normal discourse. Enclosure images were efforts to*

* Gaston Bachelard's use of reverie (in *La Poétique de la rêverie* and *La Terre et les rêveries de repos*) is superficially similar to my sense of enclosure. But Bachelard is interested in using reverie as the act behind the poem or artwork, as part of the landscape of the imagination, whereas enclosure is both phenomenological and thematic.

capture physically that inwardness which the stream attempted to capture in words.

The essential characteristic of enclosure, as image or situation, is its ability to remove itself from the routine world, not only geographically, of course, but psychologically or spiritually. It exists in a middle ground of expression, where we have also placed the stream, or even some forms of interior monologue. Enclosure is, basically, a spatial metaphor of recessiveness, with a staying of external time accompanied by withdrawal into rooms, mazes, and labyrinths. Implied in such retreat are narcissism, solipsism, voyeurism, even paralysis— all as part of that trek inward so characteristic of Modernism generally and of the stream in particular. Enclosure has, also, other dimensions, since it is not only a form of discourse but a place, a locale, a situation, perhaps a scene. While the retreat or withdrawal may provide a refuge from the larger world and from the swirl of activity, the refuge itself suggests its own traps and snares. In this tension between refuge and trap, we have an entire culture, not simply a "getting away" from things, but an alternate culture in counterdistinction to the larger. Enclosure, once again, has striking similarities to the stream—which as discourse is self-contained, circumscribed, even while a vocal weapon of extension.

Perhaps our century's archetype of enclosure fiction or the enclosure idea comes in Kafka's parable-story called *Der Bau*, "The Burrow." Since its voice or narrative line seems to derive from some middle ground of discourse, we can view it as approximating in space what interior monologue and stream achieve in time. We have, in fact, in that display of Modernism, a meeting of spatial and temporal modes, what we also find in Proust and characterized by Georges Poulet's study *Proustian Space*. In Kafka's parable, the inhabitant of the burrow is a molelike creature, a modern-day Crusoe, whose twin poles of existence are safety and food. In his chief hole, a castle keep, he surveys his half-year supply of foodstuffs, enjoying their "plenty and the various smells," reckoning up "exactly how much they represent." Even while savoring his food, however, he (or she) is preoccupied with defensive measures; so that food alone is no solace since he must always protect it against predators, as if he were defending his self or ego.*

That castle keep, which gives so much pleasure and yet simultaneously creates such apprehension, is both real and symbol, refuge and prison, retreat and trap, tomblike safety and potential source of destruction. For even as Kafka's creature relies on the room's security and pleasure, he is involved in defensive measures. Although his greatest joy is to concentrate all his stores in that one large room, common sense suggests he must disperse his goods; he must forgo immediate gratification for long-range protection against those enemies hovering outside, waiting for one false move. There is a siege mentality to enclosure, but there is, also, to the stream, although less apparently so. In enclosure, the active

* Samuel Beckett has updated the Kafkan burrow in his own flattened cylinder "fifty metres round and eighteen high for the sake of harmony." Like Kafka, Beckett conceives of unending motion caught in perpetual waiting, while disruption is imminent. Beckett's work as a whole provides excellent examples of enclosure as well as of the stream—the two combine in his novelistic trilogy; but he comes at the end of the Modernistic tradition and, therefore, Kafka, nearer the beginning, seems a more suitable subject.

life of the individual has been transformed into watching and waiting, so that his very existence is resistant to the idea of the larger culture. But in the stream, also, we have an individual so sensitive to his own needs and to the callousness of the surrounding society that his or her solace must come from that inner communication, the stream. We realize that such flow is not a form of communication; it sends out no word to others. On the contrary, it embodies those reflections, sensibilities, sensitivities, psychological and emotional needs that lead back to the individual. They are circular emanations, having their reception in the same place as their source. That as readers we happen to listen in is only a happenstance. We are there because the character is in a book, not because of something intrinsic about that internal communication.

This circling around and back, so that the stream's function is not to communicate with other people, is apparently associated with the enclosure idea. For in the latter the individual is represented by the hole or hollow containing him, and his communication is solely within his own psyche. It is as if, in analysis, he were the analysand without the analyst, the speaker without the listener; and as spectator to this we are incidental to the process, since what he says and does are for himself, not for us. We absorb what is already implicit in him. He does not develop or expand, he simply is, and that "is-ness" is represented by the condition of his enclosure.*

Staying with Kafka, if we move on to *The Trial*, we find one of the more remarkable passages occurs when Joseph K. visits the painter Titorelli. Not only is it compelling as an example of enclosure, it is equally remarkable as an analogue to stream of consciousness; for the discourse of the scene comes from a middle ground beyond the physical presence of the protagonist and, as well, beyond what the reader can fully grasp. The scene has overtones of such intensity we are thrown back into innerness, of Joseph K., of general scene, of particular attic room, where our understanding is located somewhere within the maelstrom of the stream. What gives the scene its momentum is Kafka's careful control of those elements that make up the stream: not free associational material here, but, rather, a precise and logical presentation of stream materials by way of a scene.

The episode is led into by a series of sensory impressions, images of hell: "disgusting yellow liquid," fleeing rats, an untended shrieking infant, a deafening din from the tinsmith's workshop, apprentices beating on a sheet of tin which casts "a pallid light," stifling air, the presence of the scurrying children led by a "slightly hunchbacked" thirteen-year-old. Salvation, Joseph K. had led himself to believe, lies here. It is typical Kafka despair: deeply urban, full of corruption of civilization and human values, not unlike an animal's noisome lair, replete with his detestation of human progress and modernity. Neither light nor space nor expansive time enters here. Yet Joseph K. is seeking a painter.

Even before K. enters Titorelli's suffocating quarters, we have noted Kafka's denial of time and space. Once into the scene, however, he does not simply negate; he denies routine against a backdrop of the painter's "wild heathscapes,"

* Proust by way of Art escaped the entrapment implicit in enclosure. Proust achieved such transcendence through the use of two Marcels: the one who has gained an overview and is recalling, and the other, who is experiencing what the first can recall. With only *one* Marcel, who experiences as he goes along, Proust would have taken the reader directly into the discovery of enclosure, as Kafka does. (Many Proust scholars dispute this interpretation, however.)

the outside world that exists somewhere as a lost paradise. K. can only obtain the wild heathscape through payment; he cannot experience it. The room itself—from which Joseph had intended to "soar" beyond the confines of his case—only further confines his case. A mockery of a room for a painter, its one window allows almost no light, no beyond.

The spatial conception of the painter's attic is a standard one in Kafka. That is, space *up* is negated by space enclosed. The former may be a room at the top of something—building, warehouse, tower—but it is, also, space denied. There is no vista, no horizon, no sense of things opening out. We shall see this point demonstrated most obviously in *The Castle*, which dominates the village and is situated somewhere in heaven, and yet its very spatiality in the distance is negated by the stuffy rooms that, apparently, lead toward it, or so K. thinks. Kafka rarely gives us a true feeling of space but presents only enough of it for purposes of denial.

In a curious play of spatial-temporal concepts, Joseph K. in the painter's studio is swallowed up not by immensity and endless horizons, but by a "wretched little hole." Titorelli's attic is representative of all space in *The Trial*. Few critics have commented upon Joseph K.'s bank as a locale, and yet it, too, consists of a maze of rooms, a burrow, even though the end function of the bank is to convey limitless wealth to a seemingly unending procession of clients. Once again, we have a large, apparently ceaseless organization or function embodied in tiny stages, small rooms, cramped quarters. Joseph K. in his bank is little different, given the physical change, from Gregor Samsa in his room. Double doors, openings, entrances, exits, labyrinths, paths, roads, and their like dominate. The endlessness of space and sweeps of time become enclosed spatiality and severely restricted temporality.

In these and other ways, Titorelli's attic is the perfect setting for the choices the painter will offer Joseph K. We note K.'s deepest insights into his case derive from the painter and come in that stuffy attic. For the first time, he is presented with alternatives, and what had before been incomprehensible chaos (the stream) becomes, now, comprehensible chaos (interior monologue). Also, when K. does learn of the three alternatives, he is so uncomfortable, so near suffocation, he barely listens. Titorelli has to keep repeating. The alternatives are themselves enclosure patterns, since the choices offered are not really choices. The three possibilities are "definite acquittal, ostensible acquittal, and indefinite postponement." The first is out of the question, so that choice fixes on the other two. The second, ostensible acquittal, calls for great but temporary concentration, whereas the last, indefinite postponement, is less taxing, but requires steady application. All involve escape; all are traps. Even with knowledge, K. is in limbo. For our immediate purposes, the three have spatial-temporal dimensions indistinguishable from their conditions—a scenic analogue of a stream function.

The placement of these choices in the attic indicates a correlation between the space and time dimensions of the locale and the space and time considerations implicit in some form of pre- or consciousness. Part of the suffocation we feel in Kafka's work is not merely physical; it extends to the intimate relationship between locale and content, place and voice. His is a philosophy of life stretched out between points that go everywhere and nowhere. Titorelli, after explaining these choices, then opens up startling new vistas of the case for Joseph K. A new arrest is possible at any time after acquittal: "Even while they are pro-

nouncing the first acquittal [he tells Joseph] the judges foresee the possibility of the new arrest."

As befitting a painter, Titorelli speaks of "distant" prospects and "foreshortened" ones, "vistas" and "immediate" objects. He speaks of not letting the "case out of your sight"; he tells Joseph to keep the case going "only in the small circle to which it has been artificially restricted." He mentions that the "judges foresee" new possibilities and vast considerations, which they can deny. Being caught in such uncertain dimensions reinforces the terrible loneliness and isolation that every Kafka protagonist experiences despite his considerable activity. With space and time so different from his expectations, he walks the paths of a world that lacks color, texture, and affect. The landscape of a Kafka novel is absolutely flat, even though there are steps, buildings, and attics.

These enclosure images, stifling and suffocating as they must be, are scenic equivalents of the stream of consciousness; little different in their effects from the interior monologues we find in Woolf, Joyce, or Ford's Tietjens series. We are trying to equate seemingly disparate elements, for a voice without an authorial presence would appear to be one medium, whereas scenes, described by the author, would appear to be another. But once the psychological mode of the novel was established, innerness tended to collapse both time and space: the temporal medium of words, the spatial quality of scenes. If we seek precedents, this is an outgrowth of the idea of synesthesia, which so dominated French poetry after Baudelaire and which in its latter forms overlaps stream sensations. We recognize that these phenomena, once considered separate from each other, have found a focal point in the mind; so that words, scenes, character, along with voice, are layered and interwoven rather than differentiated.

Virginia Woolf is also exemplary. In *Mrs. Dalloway*, the interior monologue seems to be a third-person narrative turned into emanations from Clarissa's psyche, addressed to no one and absorbed by the reader only because he happens to overhear. Compare to Kafka the following passage in which Clarissa, in the opening scenes, has entered her house:

> . . . as she paused by the open staircase window which let in blinds flapping, dogs barking, let in, she thought, feeling herself suddenly shriveled, aged, breastless, the grinding, blowing, flowering of the day, out of doors, out of the window, out of her body and brain which now failed, since Lady Bruton, whose lunch parties were said to be extraordinarily amusing, had not asked her. / Like a nun withdrawing, or a child exploring a tower, she went upstairs. . . . So the room was an attic; the bed narrow; and lying there reading, for she slept badly, she could not dispel a virginity preserved through childhood which clung to her like a sheet.

Clarissa Dalloway observes herself like a nun in her conventlike room, not so different from Joseph K.—both lives constricted to tiny spaces that are enclosures, that is, refuge and trap in one. Both authors describe experiences that are innerness speaking; so that interior monologue weds itself to enclosure locale.

In *To the Lighthouse*, Woolf prepares the reader for interiority, saying "he thought," "she thought" as guides. But the section called "Time Passes," written

with a bow to Bergson and Proust, is a good example of stream meeting enclosure. Mrs. Ramsay having died and her husband stumbling around aimlessly, the Ramsay house is now empty, a ghost house. But even though she dies, life does move on and others will die shortly in that collapse of time which is so essential to both stream and enclosure. Woolf has provided a temporal canopy, as it were, over the Ramsay family, who move outside or beyond the time of others even while history claims them in childbirth and war. The narrative line itself derives from interiority, without introductory words to indicate authorial presence. In its streamlike implications, the section is analogous in prose to a Mallarmé poem. One hears less anguished echoes of his "Curtain": "Let the wind blow; let the poppy seed itself and the carnation mate with the cabbage. Let the swallow build in the drawing-room, and the thistle thrust aside the tiles, and the butterfly sun itself on the faded chintz of the arm chairs. Let the broken glass and the china lie out on the lawn and be tangled over with grass and wild berries." Death is so measured off against previous active life that the separating line is removed. The final sentences of the episode suggest that middle area between consciousness and unconsciousness. "The sigh of all the seas breaking in measure round the isles soothed them; the night wrapped them; nothing broke their sleep, until, the birds beginning and the dawn weaving their thin voices in to its whiteness, a cart grinding, a dog somewhere barking, the sun lifted the curtains, broke the veil on their [Lily Briscoe, Mr. Carmichael, Mrs. Beckwith] eyes, and Lily Briscoe stirring in her sleep." "Awake" ends the passage.

Kafka, however, is even more appropriate. In his *Diary* entry for December 19, 1914, he wondered how a story, which has its own properties, can fit into the shape of the world, which has already closed itself off. He is seeking both metaphysical and epistemological truth: to see how a form of knowledge, a fiction, can be joined to another form—a fiction also posing as a truth—which already considers itself complete. We have in his description, analogous to the birth of a baby, the sense that language is an undifferentiated mass, a flow or stream, which must be given a form, the scene.

> The beginning of every story [he writes] is ridiculous at first. There seems no hope that this newborn thing, still incomplete and tender in every joint, will be able to keep alive in the completed organization of the world, which, like every completed organization, strives to close itself off. However, one should not forget that the story, if it has any justification to exist, bears its complete organization within itself even before it has been fully formed; for this reason despair over the beginning of a story is unwarranted. . . . Of course, one never knows whether the despair one feels is warranted or unwarranted.

The mole's situation in "The Burrow," as we have noted, is exemplary in this respect. The shape of its inner workings is a maze, part of tunnels of knowledge that enable an art form to fit itself into the existing world labyrinth. Shapes are wedded to forms of expression in "The Burrow," since the language maze is somehow equated to the world's maze and, within that, the tunnels created by the mole for survival. Kafka searches interiority by way of explaining how a story comes alive, and that interiority is language wedded to conception of scene, stream wedded to enclosure. Two examples will suffice, one from the earliest story we know he wrote, "Description of a Struggle," in 1904-5, when

he was twenty-one; and *The Castle*, written in January to September of 1922, the product of his mature craft. We take *The Castle* first, for by then Kafka had perfected his blending of stream and enclosure scene; so that in fiction, he was writing the equivalent of new forms in painting and music. At this level, *The Castle* finds parallels in Berg's *Wozzeck*, Breton's surrealistic poems, Eliot's *Waste Land*, Joyce's *Ulysses*, and other such representative works of Modernism.

The Castle above ground is somehow associated with the burrow beneath. Kafka needed extremes in order to capture that sense of temporal and spatial disordering which gave his imagination content and shaping. He was fascinated by the Tower of Babel, which he called the Pit of Babel, by the Great Wall of China, by the tower in "The City Coat of Arms." The great need for extremes of height and depth in his work is possibly connected to his measuring himself against other people, first the puny self measured against the gigantic father, but in other ways, as well; not only physically but ethically and spiritually. He always considered himself an incomplete person, for whatever reasons, and that incompletion carried over to his need for extremes: heights and depths, wall and holes, attics and insects. He is, in this respect, the perpetual surveyor, the last role K. in fact played, in *The Castle*. In a *Diary* passage written when he began that novel, Kafka describes radii, circles, gaps, as though such tools of measurement were acts of language itself.

> It was as if I, like everyone else, had been given a point from which to prolong the radius of a circle, and had then, like everyone else, to describe my perfect circle round this point. Instead, I was forever starting my radius only constantly to be forced at once to break it off. (examples: piano, violin, languages, Germanics, anti-Zionism, Zionism, Hebrew, gardening, carpentering, writing, marriage attempts, an apartment of my own.) The center of my imaginary circle bristles with the beginnings of radii, there is no room left for a new attempt; no room means old age and weak nerves, and never to make another attempt means the end. If I sometimes prolonged the radius a little farther than usual, in the case of my law studies, say, or engagements, everything was made worse rather than better just because of this little extra distance.

This passage, incidentally, coincides not only with *The Castle* but with "The Hunger Artist" and "The Investigations of a Dog," and just precedes "The Burrow," the four of them works of great extremes. In all, the language emanates from enclosures and is neither conscious nor unconscious, but part of the middle ground of interior monologue.

The paradox of *The Castle* is that while it describes an infinitude open to the sky, it is not for that less labyrinthine. Distancing and denial of distance are implied in K.'s role as a land surveyor—one who deals in dimensions, horizons, measurements. Kafka always put into geographical settings the dimensions of his inner vision, and, as suggested above, infinitude and labyrinth are twin qualities of the stream. The "space" of K. is always a matter of limits, in the way the spatiality and temporality of the stream are quantified by the resistance and limitations of words to fit the subject. We can say that *The Castle*, despite its reach toward infinity, is a novel of inwardness, a stream book.

In actuality, K. uses the outside spatiality surrounding the castle approaches as a means of getting from one small space to another. He lives in measured,

cramped quarters, even though his mission is to survey large distances and measure *them*. Early in the novel, K. calls out to Barnabas, the castle messenger, and the name rings out into the night, only to echo from a great distance. Nevertheless, distances have no relationship to human capability, for Barnabas has just left K.'s side and yet is already so far off K.'s voice seems to carry for miles. The effect upon us and upon K. is disruptive of normal spatial expectations, so that even in this scene, which occurs outdoors, we are carried back into hollows and concavities, into Kafka's world of space exaggerated and distorted. The result is that "confusion of realms" associated with an enclosure experience and connected, also, to the stream of consciousness.

About midway through *The Castle*, K. tries to grapple with the idea of freedom and/or imprisonment, although the formulation is full of his typical paradoxes. He is almost completely ignored:

> . . . it seemed to K. as if at last these people had broken off all relations with him, and as if now in reality he were freer than he had ever been, and at liberty to wait here in this place usually forbidden to him as long as he desired, and had won a freedom such as hardly anyone else had ever succeeded in winning, and as if nobody could dare to touch him or drive him away—or even speak to him; but—this conviction was at least equally strong—as if at the same time there was nothing more senseless, nothing more hopeless, than this freedom, this waiting, this inviolability.

This mixture of liberation and imprisonment within a restructured space and time characteristic of enclosure is, apparently, the subject of *The Castle*. We note the religious, political, and social overtones, but we must resist seeing Kafka's work as more or less than the tensions and conflicts themselves. These tensions are implicit in language also, in the verbal stream, between that content which belongs to consciousness and that content which suggests another dimension beneath or beyond consciousness. Kafka apparently was aware of the paradoxes arising from his emphasis not on ideas as such but on the tensions between them. In a letter to Felice Bauer, in 1913, he speaks of writing as akin to death itself: "Writing . . . is a sleep deeper than that of death, and just as one would not and cannot tear the dead from their graves, so I must not and cannot be torn from my desk at night." A few months earlier, he had written: "I have often thought that the best mode of life for me would be to sit in the innermost room of a spacious locked cellar with my writing things and a lamp. Food would be brought and always put down far away from my room, outside the cellar's outermost door. The walk to the food, in my dressing gown, through the vaulted cellars, would be my only exercise." While these remarks suggest he was retreating from their engagement even as it moved forward, that would be only the surface tension. The deeper tension lies in Kafka's need to seek the innermost life possible and to discover the forms of language that can capture that sense of enclosure. The scenic equivalent of such language is cellars, basements, sleep and death, graves, his desk at night.

Every detail of that individual life must, somehow, find the scale of the outer world; or, conversely, that outer world must find a comparable scale in the inner. Scene must equate to language; external event to mind projecting it. K. hopes that if he finds the order of his own existence (that is, the right language

for expressing his thought), he will divine the pattern and order, even the fundamental idea, of what lies beyond. He can forsake no detail; for that, like the homunculus or the microcosm, may contain the whole. In this little world, all people and all information are a language, connected in some grammatical, syntactical way, although their particular pattern of relationships is not apparent. It is as if one knows the vocabulary of a foreign language but cannot figure out grammatical relationships. One must remain ever vigilant, for the missing clues can surface, and then one will learn precisely how to respond. One must, however, not only understand the maze as a whole, one must not lose any fragment of it.

This need to fit oneself into unknown spatial and temporal elements shrouded in fog and to master a hitherto unknown language is attached to Kafka's persistent theme of the protagonist-artist endeavoring to ply his art. Although K. is a craftsman, not a creative artist, his role is presented as that of the artist who must journey into the unknown in order to understand the nature of his craft. In a letter to Max Brod, on July 5, 1922, Kafka noted his view of the writer as a voyager through hell, i.e., the pre- or unconscious. "This descent to dark powers, this release of spirits which are bound by nature, these dubious embraces and whatever else may occur down there unknown to someone up here who is writing stories in broad daylight. . . . What right have I, who was not at home, to be startled when the home suddenly collapses; for do I know what has gone on before the collapse; have I not exiled myself, leaving the house at the mercy of all evil forces?" The imagery is of the Orphic descent into a disruptive pattern, a descent into the atemporal labyrinth or maze that characterizes Kafka's measured universe.

For the means by which to present K.'s journey through mazes, which may or may not lead to the castle, Kafka devised a very deceptive narrative. His tale seems to be the ordinary tale of a young man caught in a problem, a third-person narrative with a traditional omniscient author. But the confusion of realms—the disruption of time and space, the enclosure or labyrinthine images, the succession of bizarre characters and meetings—relocates narrative very close to interior monologue or deeper. This develops even though the narrative derives from the author, not from the protagonist. The method comes very close to what Dorrit Cohn has shrewdly designated "psycho-narrative," in which the protagonist's deepest thoughts are presented through a third-person narrative. But even psycho-narrative is not quite what Kafka accomplishes. For, in effect, he transforms all external phenomena into psychological recesses; that is, he carries the world inward, as if it all, solipsistically, derived from K.'s consciousness. We know, of course, that it does not; but Kafka through an uncanny precision has confused borders between real and unreal.*

An artist-figure, cut off, alienated, forsaking his past, K. journeys to the village or another form of consciousness to take up a post the precise nature of

* Names and naming enter into the process. Klamm, of course, comes to mind, but Kafka plays other tricks. K. once refers to himself as Joseph K., which may be playful, or it may be another detail in the maze, making *The Castle* into a *Prozess*. Although K. and Joseph K. differ in some ways, both are caught in a common fate: to seek egress from a labyrinth whose function is to paralyze them. Further, name confusion or paralysis comes with other characters: *Sortini*, who persecutes Amalia, and *Sordini*, who is part of K's affairs; a little girl named *Frieda* and K.'s mistress, *Frieda*; a brother, *Hans*, and the landlord *Hans*; and several others.

which he does not foresee. He is a dedicated man, a bachelor who, having once mentioned a family in the old country, never refers to it again. The very indistinctiveness of his goal becomes significant if we judge him as an artist; for he has come to measure, think, contemplate, and then to try to resolve the elements. In his role as artist, his encounter with labyrinths is not unexpected, since to penetrate into the intricacies of the maze is to embrace mysteries invisible to common sense. That labyrinth or maze, in fact, is the testing ground for the artist, for the Orphic figure must encounter a different, possibly deranged space and time when he descends. In this manner, Kafka has approximated the descent into the middle ground of consciousness where stream and enclosure overlap or cross.

While sexual components of penetration and labyrinth are inescapable and psychologically revealing, the more fruitful area of inquiry lies in those myths akin to the making of art. None of this denies that Kafka's mazes, and his protagonists' inability to find their way, run parallel to his own sexual disorientation: his alternating desire to penetrate the female and his trepidation over the threatening coils at the female center. The letters to Felice are balletic, in that Kafka maintains the engagement while pulling away in every word from its implications. None of this denies, further, that the circuitous routes Kafka plots both above and below ground are tubes, canals, vaginal walls, to which entrances are denied. And, finally, none of this denies that such places contain Eleusian mysteries, terrible rites of initiation, locales of death, and indeed seem protected by the *vagina dentata*. To recognize all this, however, is to observe that the sexual component, which is not at all a contradictory note, is subsumed in the artistic process. Both lead to that Kafkan no-man's-land where terrible energies are transformed into passivity and inertness.

Despite all of K's movement and activity, he never leaves the periphery of the village, he never finds the path leading to the castle or the castle compound, and he never discovers clues to the labyrinthine process in which he finds himself. Even the time sequencing of *The Castle* throws K., and the reader, off balance. The expectation is of temporal infinity: the castle as a mythical place seems caught in endless time. It has always existed and will continue so shrouded in fog and mist long after K.'s quest—whatever *that* is—has ended. That is one line of temporal expectation. Set alongside or against that is the actual time span of the novel, in all seven days, the biblical and magical seven. Thus far, then, we encounter a temporal dualism in which parts cannot possibly harmonize. Further: the amount of page space given to K.'s quest splits the seven days into approximately one-seventh of the book's length for the first three and a half days and the other six-sevenths of length for the final three and a half days. This means that K. and the reader, speeded along with the expectations of about fifteen to twenty pages for each day of the week, suddenly come up against a pace at which a day takes a hundred or more pages.

Temporal factors become increasingly complicated: castle infinitude remains while foreground shifts from concentrated to extended time, with neither meeting our expectations. We have, then, to carry this point further, a sense of both infinitude of the unconscious and its division into segments for the sake of description or explanation. Language itself takes on the role of approximating an unconscious which must remain inexplicable. The novel has within it dream materials, that expansiveness and withdrawal associated with dreams; and yet

K. moves in what is for him routine time. One played off against the other creates a dissociation of sensibility, all narrated by a logical, rational voice, which even further disturbs the realm of order. Like Proust in many of his passages, Kafka has used the same method to speed up time that he has used to slow it down. He has, in one respect, created external expectation, in the other subverted it for interior time.

These calculations fail to take into account the village with its own temporal expectations and its relationships to castle eternality. When K. enters into village life, there is virtually no way he can carry over clock, calendar, or empirical time from his earlier life. Like the artist when he inserts himself into the temporal dimensions of his work or the analyst when he tries to understand a patient's unconscious, K. must attempt to balance time sequences that define his own experience against those that he must comprehend to exist in village and castle. With village time an unclear factor, castle time mysterious and ahistorical, K. himself living in empirical time, he must discover a formula which consistently eludes him. This formula is more than a way for reaching Klamm or any other of the castle officials; it is no less than how to grasp distorted forms of experience, unexpected states of mind, and different levels of time: the very crossroads of stream narrative and enclosure forms. *

If time is a labyrinth, space is also a maze of possibilities. Spatially, Kafka uses the various emissaries and minor officials—Erlanger, Bürgel, Barnabas, the two Assistants—as ways of increasing distance between K. and the castle. In realistic fiction or traditional third-person narrative, the presence of an intermediary indicates one has approached the seat of power; one can then negotiate with the functionary, who acts as a stand-in for the principal officer. Kafka scrambles this spatial concept by making the intermediary separate K. even further from officialdom. The functionaries indicate *not how close he has come, but how distant decisive action may be*, how shrouded in fog that principal officer really is. Yet such distancing ironically works at crosspurposes with K.'s expectations, which are that the sight of any intermediary is a sign of his having made contact with the castle. Accordingly, space, like time, is opening up and closing down, becoming the labyrinthine way which is Kafka's metaphysical principle, the source of his resolution of stream or interior monologue, spatial form, temporal questions, and enclosure scenes.

If we back up twenty years, remarkable is how Kafka's story "Description of a Struggle" at the beginning of his writing career foreshadows so many crucial aspects of *The Castle*, at the end. † The story, which has two parallel versions, appears to be made up of disconnected elements. The main element concerns

* While Proust may seem to make an analogous effort, it is exactly the opposite. For Proust's "involuntary memory" was an inner narrative whose function was to provide order; whereas Kafka's temporal convolutions were to create disorder, or to create the sense that all order is merely a façade for disorder. Proust sought shape; Kafka recognized that shape was a chimera. Kafka's sense of enclosure leads us close to entropy, necrophilia, and transcendental paralysis. Proust also burrows in, but grasps that through the subconscious, the outer fringes of the unconscious, and "involuntary memory," it is possible to turn seeming passivity into a more socially positive form of behavior.

† A good deal of Kafka's early work was, to use Politzer's term, "a quarry" for later sketches, especially for his "Meditation" or "Reflection" (*Betrachtung*) which appeared in 1913. Many of these pieces were, originally, very close to what we find in "Description," especially in the first and second sections. What this means is that Kafka saw his material as somehow cohering in the larger sense, no matter how dissociated it appears in the smaller. We must keep this in mind when we read "Description."

the narrator and the acquaintance he meets at a party, who asks to be rescued from an indiscretion with a woman. We have, with this, the messenger complex—and the rest of the story is structured, however tentatively, on the narrator encountering messengers from various worlds. This idea works only if we see the story as a stream emanating from that middle ground between consciousness and unconsciousness, wherein the language of the latter can never be uttered and the language of the former can be too precise.

In that initial episode, numbered Roman I, the two walk out into the freezing night, to climb the Laurenziberg. The acquaintance seems to possess all the chips, whereas the narrator is a lonely outsider, clearly one aspect of Kafka's mocking himself as a "poor stick." The other fellow has young women falling over him, and he becomes the source of the narrator's envy and hostility. The episodes are very comic, particularly when the narrator—fearing his height bothers the other man—puts his head on the seam of his trousers to make himself seem small and crooked.

Meanwhile, the narrator expects to be murdered—the dagger to come out, "the handle of which he is already holding in his pocket," and to feel it plunged into himself. This is, apparently, his desire to murder, displaced to the other person; but it is, also, more than personal hostility, the sense that in every encounter there is a victim and an aggressor. This becomes a major part of the theme of the story. As this section ends, the narrator wonders why he is there at all. Kafka moves into a narrated inner monologue, in which his protagonist displays a neutrality of feeling, neither love nor hate, seeming indifference. There is a homosexual intimation here, in that the narrator senses his attachment to this acquaintance has no other basis but one he does not wish to investigate.

Roman numeral II—titled "Diversion, or Proof That It's Impossible to Live"—begins with a subsection i, "A Ride": an act of violence, in which the narrator leaps on the back of his acquaintance and rides him, cruelly, like a horse. The latter trots along, his neck crushed by the narrator's hands, his belly pummeled by his boots. When the acquaintance collapses from the weight and pummeling, the narrator leaves. That brings the story to ii, "A Walk." The narrator wanders and at one point decides to sleep, but fears attack on the ground. Like a koala, he winds himself around an upper tree branch and sleeps. While dozing, he hears talk beside him, but recognizes no words. He awakens and hears something from afar. His suffering is intense.

The new subsection, iii, is called "The Fat Man," with subsection a "An Address to the Landscape." A fat man is being transported across a river on a litter borne by four naked men. The entire passage is a shaped meditation, verbalization of inner states of being. This is, perhaps, the closest Kafka comes to a "scenic stream," the joining of words and scene. The narrator views the fat man and then observes himself both from without and from within, all the while Kafka hovers about each. The narrator "addresses" the landscape. "It makes my reflections sway like suspension bridges in a furious current. It is beautiful and for this reason wants to be looked at." He continues: " 'Yes, mountains, you are beautiful and the forests on your western slope delight me.' "

Yet even as he marvels at the landscape, his observation of fat man and bearers sharpens. Another messenger is approaching, although what the message will be cannot be fathomed, since it derives from mists, rain clouds, splashing water. The bearers go ever deeper into the water, until it covers their heads and

they drown, the fat man breaking loose of the litter and being carried "down the river like a yellow wooden idol which had become useless and so had been cast into the river." The narrator accompanies the fat man on his journey, until the latter speaks, urging his listener not to rescue him as this is the water's and wind's revenge upon him. Then comes part *b*, "Beginning of a Conversation with the Supplicant," still under Roman numeral II. This is the fat man's story of how he used to kneel in church every day awaiting the arrival of the girl he was in love with. While there, he notices a young man who flings his emaciated body on the ground, clutches his skull, and moans loudly. The fat man decides to investigate and pursues the young man until they meet, just as the narrator and the fat man have met.

All participants need to speak about what cannot be communicated; mystery must be turned to words so as to prove mystery greater than language. The young man is detained, and he pleads innocence. " 'I don't know what you suspect me of, but I'm innocent. . . . Of course I don't know what you suspect me of." *We have now the archetypal Kafka situation*: a proliferation of messengers who move one ever further from meaning even as each seems to bring one closer to the mystery of meaning; and then the presumption that there is guilt, even as one protests innocence, that guilt is not even the issue. Further, implicit in this situation is a middle state of consciousness, where narrative, monologue, and interior thoughts are all efforts to capture what the narrator tells us is ineffable. This "state of mind" I am calling stream of consciousness, which is a condition going beyond a technique or a matter of words.

Throughout this indirect discourse, related by the fat man, we note that the latter begins to merge with the narrator of the outer story. The two in Kafka's mind are caught in comparable situations, one very fat, the other long and lean, the two blending into a singular listening post as the Supplicant stresses his innocence. He accuses the fat man of making fun of those who show their feelings, those who "cast a shadow on the altar, so to speak." Yet the Supplicant needs the listener, as much as the latter needs him. Victim and aggressor, once again, join. The Supplicant: ". . . I hope to learn from you how things really are, why it is that around me things sink away like fallen snow, whereas for other people even a little liqueur glass stands on the table steady as a statue." With this, we have a further dimension, in which Supplicant merges with outer narrator, even as he defends himself to the fat man. He laments: "Oh, what dreadful days I have to live through!" Everything around him is collapsing, and for no apparent reason.

The story then moves on to part *c*, "The Supplicant's Story," still as part of Roman numeral II. Textually and even thematically, inserted segments are elements of the larger tale, in that they create a spatial reaching out which will help supplement the narrator's association with the acquaintance of the opening scene. Some of this is tenuous, but Kafka was such a homogeneous writer his themes recur even when they appear to be discrete. Section *c* is the attempt of the Supplicant to explain his experience of a series of personal, comic disasters. While speaking to a young lady, he notices his "right thigh had slipped out of joint. The kneecap had also become a little loose." As he tries to disguise his physical condition, the girl is unimpressed by his words. He then decides to play the piano, although he doesn't know how, until two men pick up the piano bench with him on it and whisk him away. Out in the cold, he wonders what

makes him behave as though he were real. This entire passage is shaped as an interior monologue, quotes within quotes, to indicate that his innermost thoughts in the form of a dialogue have come through the fat man, then retold to the narrator. We burrow within a series of narrators whose function is to relay information that derives, ultimately, from within the imagination of the Supplicant; and it is reliable only insofar as the fat man is accurate.

The Supplicant detains a drunkard, addresses him as a noble gentleman, and then experiences a series of surrealistic images: great ladies, decorated trains at the "dissolute Court of France," against a background of Paris streets in which "eight elegant Siberian wolfhounds come prancing out and jump barking across the boulevard."

This leads to section *d*, the penultimate segment before the return to the narrator and his acquaintance: "Continued Conversation Between the Fat Man and the Supplicant." Moving into third-person narrative, this section also contains related dialogue in such a way that the fat man and Supplicant merge, once again, with the narrator himself. When the fat man asks the Supplicant why he prays in church every evening, he responds: "People who live alone have no responsibility in the evenings. One fears a number of things—that one's body could vanish, that human beings may really be what they appear to be at twilight, that one might not be allowed to walk without a stick, that it might be a good idea to go to church and pray at the top of one's voice in order to be looked at and acquire a body." Following a line of rambling thought or interiority, the words link Supplicant and narrator. At every stage, the former questions the reality of objects, what is "only apparent." The scene ends as the fat man's friend "blew away a few bruised little clouds, allowing the uninterrupted surface of the stars to emerge. He walked with difficulty."

The next to final subdivision, *iv*, turns from the Supplicant to "Drowning of the Fat Man." The latter suddenly turns and disappears into the roar of the waterfall, and the narrator is both too small and too large to help. In his helplessness, he is entangled in huge arms and "impossible legs"—defeated by size, no matter what his size. "Please, passers-by, be so kind as to tell me how tall I am—just measure these arms, these legs." Kafka's height is measured against his sense of himself as miniature, helpless; and we find that disproportionate space and time so essential to the inner world from which words emanate.

But coequal with words is structure. It is formed of receding elements, shaped like an outline, Roman numeral I, then II, II subdivided into i, ii, iii, iv; iii further subdivided into a, b, c, d; all completed by III:

I.
II.
　　　i.
　　　ii.
　　　iii.
　　　　　a.
　　　　　b.
　　　　　c.
　　　　　d.
　　　iv.
III.

With III, we return to the narrator and his acquaintance, having plunged through words and structure deep into a surrealistic, dreamlike reality in which the narrator lives. The entire experience is, apparently, a manifestation of his state of mind, the description of a struggle raging within himself. After all the turmoil of his inner struggle leading up to III, the narrator is brought back to conflicts within his acquaintance. The latter discusses the beauty of girls, but is disturbed by his girl's laugh, which is "sly and senile," and we catch a whiff of the turn-of-the-century view of woman as vampire, wily Eve, menacing Lulu. The narrator speaks of the lovely curve of girls' bones, their attractive muscles and smooth skin: sexually attractive, but somehow dangerous and forbidding. He tells his acquaintance that he at least is loved, even if he suffers from savage dreams. Then the acquaintance repeats his gravest apprehension, and the narrator agrees he may have to kill himself. To this, the acquaintance strikes the bench and says that he, the narrator, goes on living even though nobody loves him. " 'You don't achieve anything. You can't cope with the next moment. Yet you dare to talk to me like that, you brute. You're incapable of loving, only fear excites you. Just take a look at my chest.' "

When it comes to chests, there is no match. The narrator is like Tonio Kröger in the Mann story, the physical weakling surrounded by blond young men who love and are loved. He speaks of the young healthy people at a hotel who sat "in the garden at tables with beer and talked of hunting and adventures," and then he drops in the information he is himself engaged. But this seems a deception for the sake of defense against the fine head and neck structure of the acquaintance: "the round head on a fleshy neck in a sharp curving line, as was the fashion that winter." The sole defense against that physicality is a bragging lie. They sit, disturbed, once again with homosexual intimations, the acquaintance pleading for the narrator to put his hand on his forehead to give him relief. Suddenly, the acquaintance pulls out a knife and stabs himself in his upper arm, without withdrawing the blade. The narrator pulls it out and binds the wound as best he can; he even sucks it. He runs for help, finds none, returns. He says to his acquaintance that the latter wounded himself for his sake, and yet he, the acquaintance, is in such a fine position to do whatever he wants, to make himself happy in so many ways. For him, "there'll be shouting and barrel organs will be playing in the avenues." But that is insufficient for happiness. The story ends with a scene recalling an impressionistic painting: lantern, tree trunks, road, white snow, shadows of branches lying bent, as if broken.

This story has drawn little attention in the Kafka canon, or has been dismissed as merely a quarry for later tales. Remarkable in itself, it is even more astonishing for having been written just after the turn of the century. For Kafka, still in his university days, has assimilated every sense of the Modern spirit and brought to it interior monologue blended with its scenic equivalent so characteristic of mature Modernism. Further, the story has a dramatic shape that makes it possible to be staged in stylistic production, as a kind of expressionist-surrealist drama, what we find in Kokoschka, Wedekind, and other contemporaries. This suggests that a good deal of Kafka has dramatic potentiality, in the way Beckett's monologues and dialogues lend themselves to the stage.*

* The Joycean epiphany is a dramatic moment that combines both stream and enclosure characteristics. Joyce defined it as a "sudden spiritual manifestation," and we can see it as a disruption

A curious phenomenon we are developing here, one that seems to become a staple of Modernism only when psychological reality can be taken for granted. It does not depend on Freud, nor on any other theoretician, for its impetus; it is a concomitant of several elements, a more precise charting of human psychology being only one of them. Perhaps the key to such work is recognition that physical characteristics are themselves abstractions, dependent on other, invisible qualities; that what is unseen is more important than the visible; that human development is so much more complicated than the nineteenth-century model suggested that only abstraction will suffice. All of these points were being made in the total society and culture, in all areas of knowledge. Exploration and exploitation of exotic lands (political imperialism, for example) found their equivalent in the exploration of the most exotic of all phenomena, man's interiority. Once that was recognized, and the idea was at the precise crossroads between avant-garde and revolution, then language and its projection as scene were fated: as stream or near stream linked with enclosure or labyrinth. William James's "halo" or "fringe" became a mode of perceiving.

We have, however, described only half of the matter. Where does narrative fit? What, in fact, do we mean by narrative in Modernistic fiction? Is it possible to discuss stream, interiority, enclosure, and comparable issues without recourse to narrative techniques?* And, further, if we do try to reach conclusions about narrative, can we carry over some of those ideas to forms besides fiction? to music, art, other literary genres? One way to begin is to probe in depth an unlikely comparison.

How does a Modernist work like Faulkner's *Absalom, Absalom!*, in 1936, differ from Richardson's *Clarissa* in the late 1740s, both dependent on interior voices and temporal disjunction for their narrative thrust? Superficially, the differences would appear so great we could be comparing only negative aspects. Yet outrageous as the dissimilar yoking appears, it may lead us deeper into the genre and associate older practices with what we have said about stream and enclosure. The point about Modernism, always, is the way in which it swallows more traditional procedures and returns them as abstractions; so that the epistolary method surfaces as deep interiority, in a narrative that embodies the stream. Although we are interested primarily in *Absalom, Absalom!*, we can use T. S. Eliot's dictum and read back to *Clarissa* in the light of what Faulkner developed. We can, further, see that with the abstract nature of Modern fictional narrative extending to other forms, abstraction and planned indeterminacy characterize not only music and art but philosophy, history, and social thought. Narrative becomes a lens on Modernism.

of normal discourse, a concentration or condensation. Its origin is not quite consciousness, nor is it the unconscious, whose reality lies beyond word or scene. It is, in some respects, then, a projection of a particular kind of language containing an encapsulated idea, projected onto a staging area. The epiphany, further, has qualities of stream in that both are overcharged, claiming more for themselves than the moment seems to call for, part of that spontaneity which involves wit, the unconscious, the deeper recesses of what and how we mean. Joyce's term has associations with expressionistic drama, the Freudian unconscious, the verbal stream, and enclosure as we have described it in Kafka.

* In chapter 7, I take up Modern narrative more fully, especially as it works in Conrad, Eliot, Woolf, Ford, and Joyce. Here I am concerned mainly with how narrative is linked to stream and its tributaries.

Richardson's premises were, of course, those of a novelist at the beginning of the genre, when techniques were secondary to establishment of certain kinds of content that would appeal, mainly, to female audiences. The novel was under severe attack from traditionalists and literary elitists as merely fodder for the uneducated. The novel had not even as yet gained its name, for the term "novel" came near the end of the century to designate what was a prose narrative written by Richardson, Fielding, Smollett, and others. And only a decade after *Clarissa*, this new unshaped narrative was to come under siege in Sterne's witty assault on novelistic practices that had not even jelled sufficiently to be deemed conventions.

We can, then, justifiably ask how Richardson can be brought into this argument, given the disadvantages under which he labored; compared with Faulkner, whose fiction began to appear when the novel had flowered, in the aftermath of work by Conrad, Joyce, James, Proust, Kafka, Woolf, and others who had profoundly influenced narrative. Faulkner was, obviously, the beneficiary, at least, of Conrad and Joyce, but, really, of the entire Modern tradition in poetry and fiction. Richardson, on the other hand, had been the beneficiary of romances, much turn-of-the-century female fiction aimed primarily at a society audience, and, withal, verisimilitude as the foundation stone for fiction. He labored in a primitive garden indeed.

Yet in some way Richardson turned disadvantage to advantage, and his remarkable development of interior narrative makes him a worthy forerunner of any Modernist writer. He was, in fact, a prime mover in the effort to make the novel an introspective artifact as against Fielding, whose work was all stress on exteriors. I think we can demonstrate several things: that Faulkner's development of narrative carried Modernism along to one of its furthest reaches; that such Modern usage, finally, differs from techniques even as psychologically advanced as Richardson's. Our point of attack, then, occurs on three fronts, historical, generic, broadly cultural. A corollary of all three is that when we speak of interiority, we must include the historical context of the epistolarians.

Faulkner's use of narrators in *Absalom* creates something of the same effect as Richardson's use of letter writers. The immediate generic kinship results from each author's having learned how to control time by means of narrators or writers. Richardson first. The subtext of the epistolary method in hands as sophisticated as Richardson's is a temporal dimension. Letter writing liberates time in several ways: by connecting the writing of the letter to its reading, done sometime later; by allowing for overlapping between original letter, follow-up letter(s), and their responses, all of which may alternate; by creating a stream of innerness, as it were, which conflicts with external behavior or with routine time; by permitting the time of the letters (when written, when received, when delivered, for example) to conflict with external activities not directly connected with letter writing.

In all phases of the epistolary style we have another narrative ongoing which lies beyond it, where events occur which are then reflected in the letters. If the epistolary style is compelling, as in Richardson, then the style becomes that text, external events the subtext. The method creates seams; between temporal matters, between event and epistolary response, between elements working out in the letters themselves. These seams become the significant element for us, since narrative, as we see it develop in Modernism, will be located in such seams, neither in events nor quite in commentary about them.

As Kahler and others have remarked, the epistolary style was a freeing force. For Richardson, it meant narrative could be sprung from its more formal sense as plot; further, that narrative could become problematic, since it depended on several dimensions we do not associate with conventional story. Narrative becomes innerness, and in the proliferation of letter writing which we find in *Clarissa* it becomes disquietingly close to the stream, certainly an early stage of interior monologue.

The innerness that derived from the epistolary method drove narrative into psychological interstices or seams, somewhere in a middle range between what the letter writer means and what her/his letters come to signify in reality. Those temporal dimensions cited above were also dimensions of content. Narrative achieves what we may call the Rashomon effect: the indeterminancy of reality given the differing points of view of those observing it. Essential to the subjectivity of the mature Modern novel, indeterminacy creates that "problematic" narrative we associate with the culture of Modernism as a whole. *Clarissa* as a source of narrative technique is such a considerable advance over *Pamela* because Richardson intuited that letter writing implied a middle ground of uncertainty, no matter how confident or sure the writer felt.

A related point, which Richardson also grasped, is that the presence of letters in a novel does not in itself constitute an epistolary technique. Many authors had, in fact, utilized letters in their narrative before Richardson, and after him innumerable variations appeared in fiction. Smollett, as we know, used several different people who focused in their letters on the same experience, so that he could demonstrate variations in appearance depending on temperament. Many of these devices are ingenious, but they miss the essential element of Richardson's technique: that creation of narrative as a derivative of subjectivity, that blending of several subjectivities with narrative structure.

Richardson screens objectivity through various selves; these selves "perform" as though staged in some acting version of their needs. They watch their performance: acting out is often an excuse for observation. We can be certain events are swallowed up by ego needs; acting out and observing preempt all other considerations. Just as Lovelace must display one kind of self, Clarissa must demonstrate another, countering kind. Free will to act has succumbed to some deterministic fate or doom, which must claim those who cannot break the cycle of self-display. This writing "to the moment," as one critic described the method, allowed emotional tension to be transformed almost immediately into words; verbalization became, in the instant, the point of inner conflict acted out.

Letters were being written not as diary or journal for one's own eyes, but for others' eyes. When Lovelace superimposes his own ideas and words onto Clarissa's letters and sends them on to Miss Howe—while commenting upon this to Belford—he is acting out in a double sense. He lets Clarissa's original letter establish one kind of narrative, since the letter allegedly derives from her, but uses the situation to superimpose his own narrative on hers. Narrative is based on one self, deflection based on another; so that primary and secondary, text and subtext, are juggled and disarranged or reordered.

This has profound meaning in temporal terms since the expected order of writing and receipt of letters is upset; what is received is not what is written, *even while* Clarissa continues to write as if the original order held. Not until later does she learn Lovelace is tampering, and not until then can she make

adjustments to take this into account. In the seams of this disarrangement, also, lies our sense of regularized time and with that our sense of what has really happened; the real here becomes the subtext of the disorder wrought by Lovelace's tampering. This is precisely one of Richardson's finer points or by-products: that once the mind really begins to work through these letters, it establishes its own reality, which makes externals secondary or subsidiary. Narrative now peeks out from interstices. Not only is the letter writer no longer reliable as witness for truth or the real, but even the author is no longer certain, since reality has shifted out of his hands into the dynamics of response, into the eyes of the reader. This shift from performers, who continue to perform, to readers who must decide what novel they will read establishes a restructured time. We see almost the same disorder created in *Absalom* in order to reestablish temporal priorities that lie just outside expectation.

Through letters, Richardson has made his characters' thoughts carry the novel much as Faulkner made the recounting of what occurred—if that can ever be ascertained—*that* novel. But Richardson's method seems even more refined than Faulkner's, since the former's is based on the disarrangement of the present even as it occurs; whereas Faulkner's depends on filtering pastness through the present, which means greater authorial interference. With that, narrative is deflected from the narrator's mind to his desire to comprehend. We have a shift from primary consciousness of events occurring here and now to the need to understand what happened to others.

Richardson's epistolary technique puts even greater pressure on narrative, for it insists on a thrust forward dependent entirely on the dynamics of that inner voice, not on the authorial presence hiding behind narrators. Narrative in the epistolary method must always be an extraction; *there is no narrative as such*. What is extracted lies somewhere in between one letter and another; so that narrative reflects subjectivity, the needs of the self. Narrative mirrors a supreme solipsism, the self exploring its expression and defining it and the world. This is, of course, a primary function of the stream and of interior monologue.

What occurs in this process is a curious revelation of character; or else an ironic play between what the character himself or herself expects and what will eventuate—once more the dramatic metaphor. Lovelace is an example of a character who expects everyone, but especially Clarissa, to respond to phenomena the same way as he. His assumption becomes the primary consideration of Richardson's development of him. When Clarissa responds to similar phenomena in ways subverting his mode of perception, then Lovelace is incapable of making the adjustment that would have saved him and Clarissa. He can make the adjustment only too late, when events have overtaken efforts to control them.

Part of Lovelace's failure to see and adjust is connected to his maleness, his sense of gender superiority in all areas of judgment. Part is connected to his sense of worth and social position. But no small part is associated with indeterminate areas, from that constant shifting because of the epistolary method. In this respect, Lovelace must not only respond to certain data, he must ascertain what those data are; and here, Clarissa is much clearer about what is occurring than he: the fluctuation of data is too difficult for him to adjust to, since his background and conditioning make him expect certainties. Thus, we have a central irony: that while Lovelace feels he is manipulating everything, he is being manipulated; that while he thinks he is on top of the situation and shaping it,

he is being shaped. He is, as he senses himself the conqueror, being set up as victim. The brilliance of the method allows Richardson just this play: more sport than drama at this level. When we turn to *Absalom*, we will see a remarkably similar development because of the technique: that while Sutpen considers himself a man of destiny, he is being shaped by history, events, circumstances well beyond his own ferocious will.

The exchange of letters, only some of which Lovelace can intercept, places beyond his grasp a reality being fashioned by Clarissa. Of course, what she is shaping will also include her; that is, she will be entrapped by whatever she creates. But Lovelace assumes he cannot be snared—whatever the reality, whatever the outcome. This assumption deceives him into thinking the reality of his and her situation falls within his purview, not hers. This shifting order of experience leaves him with no precedents, and yet, with his aristocratic birth, he has assumed precedents, continuity, historical order. With her middle-class birth, Clarissa is far better able to adjust to shifts, since her class has shifted within only two generations.

Although irony and stream would appear to be contradictory elements, the ironic process deeply affects the way reality is experienced, by both characters and reader. So fluid is Richardson's handling of interiority we can never be certain what is primary, what secondary. Irony works as narrative strategy, since the correspondence between Clarissa and Lovelace is itself limited, so that information passes, as it were, behind their backs. Once we recognize that much of what we know derives from characters other than the two major ones, we realize how defined our reactions are by indeterminacy. The information nourishing the reader comes not from Lovelace to Clarissa or Clarissa to Lovelace, but from letters to others; so that we respond as, later, we will to Sutpen's life—to relationships having little primary material to describe them. This method of conveying momentous information by means of a secondary apparatus is a way of suggesting how uncertain and discontinuous evidence is; which is another way of saying irony undercuts not only our views of the characters but of the very world in which they move.

A subsidiary irony is the one making us accept letters as the norm of life, rather than as anomalous. It is a convention—a way of ordering and presenting material—that so takes on its own existence we substitute it for other forms of gathering experience. The irony is that while the flow of letters creates the reality of the novel, it is a subjective flow that maintains an objective reality. Somehow, the two should not blend, since a subjective sense of things and the objective world move along parallel lines. * Yet such is the intensity of that subjectivity it "creates" its own terms, and the ironic dimension is our acceptance of what otherwise seems illusory.

Related to this point is another: that the interior flow created by letters is deeply ahistorical, yet at the same time it attempts to create a personal history

* This is, not unusually, a problem with all stream narratives or segments: that subjective expression has its own life and it connects only tangentially to the reader's more objective sense of things. We would appear to be present at two parallel forms of experience; how they meet or where is difficult to determine. We say intensity, cohesion, compression are factors bringing subjective flow and objective reality together. But, in fact, they do not meet; by analogy, the flow of letters is insufficient as a definition of reality. This is a dilemma for all authors working in a psychological vein and opting for interiority as experiential.

of the characters. There is, once again, a clash between the value system of the epistolary style—ahistorical, discontinuous, lacking in social context—and the world of the characters: historical, deeply class conscious and class-oriented, continuous as family and generation. Further, letters create that sense of the "moment," the instant inside the mind when the letter is struck; whereas behind the writing lies the contextual life of the character, including whatever is omitted from the letter. When the author forgoes third-person narrative for a subjective narrative, this divorce of materials seems inevitable; and when this occurs in the epistolary method it is even more problematical. Yet repetition, which may seem a drawback, is actually an advantage, since it forces its own reality. Repetition and overlap, intrinsic to this method as to later stream and interior monologue, compress and focus the larger reality; so that through increasing pressure, reader, like characters, is trapped by epistolary time. What could be dull and unliterary proves, in the paradoxes and ironies associated with the method, to be its very strength.

One further dimension warrants investigation: Lovelace's increasing, obsessive voyeurism which puts him in the position of a "reader" even while he is, of course, a prime mover. Lovelace becomes increasingly frantic as the time approaches when he "must" rape Clarissa, and his insistent perusal of others' letters seems connected to his sexual hypertension. Opening, copying, forging of letters are, somehow, associated with a sexual tension and outlet, a spending of displaced energy. Voyeurism is itself a kind of mental rape, later transformed into the physical act—a matter of uncovering, probing, and spending not on letters but on Clarissa. The date June 8 is critical in that Lovelace works himself up by building resentment and creating excitement; the rape occurs within the week. His character starts with deceit and ends with violence, first the opening up and forging of letters, then the penetration of the loved one while she is drugged. Since she is unable to respond, Lovelace continues his role of spectator during the act: perpetrator and voyeur, an extension of his use of letters.

Implications are immense and psychologically beyond the scope of this connection of epistolary method to later stream and interior monologue. For it seems clear Lovelace fears impotence, not only sexually but personally; and his voyeurism is part of that demand for control the impotent person makes to exert pressure even while split by doubt. Lovelace must retain power, but since the mode is epistolary, that power must derive not only from writing but from perusing, rewriting, editing.

That process of peering and rewriting, then redirecting the letter, is an early stream version of the narrators' functions in Faulkner's *Absalom, Absalom!* For they, too, rewrite, redirect, renarrate; they, too, are editors, and rerouters of material, dissipating its original force even as they form relays of narrators to bring information to the reader. And in their streamlike narration, they have continued the epistolary method, internalized it to the next stage: from pen back to the mind creating words. By examining the stream as manifest in narrators, we can see how a technique associated with Modernism, as quintessential Modernism, derives from a literary/phenomenon of two centuries earlier.

Even Faulkner's later revision of the original narrative of *Absalom* helps to reinforce that sense of seams stitched between narrators, as information once lay between letter writers. The initial design called for the reader from the

beginning to know Bon was Sutpen's part-Negro son. In the revision, Faulkner altered that to make it part of missing information. Further, in the original plan, Quentin was merely one of four narrators, all more or less coequal. In revising the narrative process, Faulkner made Quentin pivotal: his intelligence, while by no means the sole relaying agency, becomes the test of understanding. He serves in this novel something analogous to what we find in Lovelace and Clarissa. In this respect, information that is not defined by them surrounds them; for Quentin, also, information surrounding, indeed almost burying, him is generated by others.

If the stream is presentness itself, regardless of the past swept up in it, then the shift to Quentin parallels Richardson's reliance on letter writers. By incorporating much of the narrative function into Quentin's relay, Faulkner moves the argument historically forward. By focusing on Quentin, who is our "now," by pressing into his consciousness, Faulkner has brought forward the Civil War and its issues: made them temporally 1909 and, by extension, the 1930s, when the book was written. Quentin becomes the contemporary narrator of what the past was. We note, even this far, parallels with the epistolarian. The young man is the final stage, the funnel, of information from his grandfather, father, and Rosa Coldfield, the other three narrators. History, through him, becomes part of contemporary life, even though it *is* history which he relays. Analogously, the letter writer is describing history. No matter how rapidly he or she gets to the desk, the matter of his commentary is already history, and his letter will define his role in that pastness.

Further, by becoming the funnel through which history functions, Quentin turns the narrative of several relays into the novel itself. His desire to comprehend history, even as he explains it to Shreve in their freezing room at Harvard, is an act similar both to epistolarians and to Proust's use of involuntary memory. This effect is achieved when we recognize that, like the two Marcels, there are two Quentins: the "Quentin Compson preparing for Harvard in the South, the deep South dead since 1865 and peopled with garrulous outraged baffled ghosts . . . and the Quentin Compson who was still too young to deserve yet to be a ghost . . . the two separate Quentins now talking to one another in the long silence of not people, in not language. . . ." One Quentin is the boy who listened to the other relayers; the other Quentin is the one who must sort it out, define it and himself, and then relay it to Shreve; so as to provide historical continuity where there seems only discontinuity.

Tea and madeleine are not the precipitant for Quentin, history itself is— the very nature of the past rather than the sensation of the moment. Faulkner has transformed Proust's sensationalism into an external event that devours; he has reversed the pattern, from swallowing to being swallowed. Quentin is almost literally consumed because in his inability to align past and present he will kill himself: the victim of history. His suicide, then, later on is the natural progression of an effort at narrative that had no historical resolution. Faulkner's success with providing relayers in literary terms found no equivalent success in personal terms for Quentin.

The analogue for this in Richardson is not difficult to discover. Both Faulkner and Richardson defined history as a stream, certainly as interiority: whether in narrators relaying information from a geographical darkness or letter writers trying to define events by way of shifting commentary. For each, the nature of

history remains outside definition, in the seams between subjective experience and objective phenomena. Faulkner's novel consists of several historical texts, whose primary drive is the use of words to understand one's relationship to past and present. In the primary text, Quentin's grandfather, father, and Rosa Cold-field, Bon's letter which Judith Sutpen gives to Quentin's grandfather, all funneled into Quentin and then into Shreve tell the reader what happened. Yet what happened is always secondary to what it means; words as well as narrators fail. What it means, history, is associated with Sutpen, and that aspect is part of the secondary text, in the seams of the primary, as it were. What Quentin is trying to explain to Shreve goes well beyond any of the details or events as described by relaying narrators; the true explanation, unachieved, lies in what Quentin cannot retrieve from all the words funneled into him. Meaning or history should be the culmination of language, but turns out to be embedded in silences between words, in space between lines, in seams between narrators.

Faulkner achieved what the stream intends: that reflection of forms of consciousness which cannot be defined. We said above that unlike other forms of interior monologue, it really derives from an undefined area, somewhere between unconscious and conscious. The stream, therefore, is an approximation in language of what is unreachable. Yet even as an author recognizes the irre-trievability of what he is reflecting, he places narrative "meaning" in that area, using the stream to deceive us about information and character, distorting history itself. Richardson's epistolary method suggests that indeterminacy; and skipping forward we can find it, rearranged, in Conrad, especially in *Lord Jim*, whose chronology excludes the reader from vital information until narrators are ready to provide it. The essentials come not from Marlow, but from an interplay of relayed information, and lying in the seams somewhere is Jim. He is so enig-matical because he rarely rises from the seams into his own right: his existence depends on narrative technique, the deceptions of a rudimentary stream. What is true of Jim carries over even more to Sutpen.

Only three pages after *Absalom* begins, Faulkner locates *his* voice just outside the voices of the narrators; but his is so subtly defined it begins, after a time, to lose its resonance and become absorbed. We read the novel as if all parts derived from a narrator's narrative. The key page is the one on which the two Quentins are introduced, one past, one present. Most significant, on this page we enter into a rush of events long before we can grasp their relevance, order, or eventual priorities. For we have Faulkner's telling of the story, in which Sutpen's Hundred is thrown in for the first time, a "Hundred" that because of repetition becomes thousands, and a Sutpen who grows into a giant even as he recedes into history.

Embedded in Faulkner's narrative is a second rush, that of Quentin's voice trying to recount Sutpen's story to Shreve. Faulkner's tale is one dimension, Quentin's another. The former's story goes back to 1866, Quentin's comes forward to 1909, in the calendar time in which we measure their narratives. In terms of *durée*, time has collapsed: Sutpen in 1866 meets across forty-three years with Quentin in 1909. Their internal intelligence becomes the same; and Sutpen in one era merges with Quentin in another, the point of the tale. But in narrative terms, far more is involved. The authorial "rush," itself a stream, derives from a voice that seems embedded in the tale, not external to it. Since the authorial voice emanates from the armature of the story, when Quentin's italicized tale

is introduced there is really no break in the stream. Faulkner's development of material is so close to Richardson's—especially in Quentin's set-in story, as if epistolary—that we appear to be involved in a later version of the same method. Yet differences arise. *Absalom* comes to us as if Faulkner were not entirely satisfied with his epistolarians and wanted to create both a counterpointing voice from the outside and one encrusted in the seams of the letters. What he has done is to move inside to interiority and stream, but also to keep his own voice running alongside. We have, then, a counterpointing throughout: Faulkner insisting on his version of events, Quentin on his. All evidence becomes indeterminate.

The aim is to make Sutpen's tale into Quentin's, to transform a historical tale into a contemporary one so that Quentin must somehow atone in his era for what Sutpen did in his. We have in this, once again, the dual Marcel: the Marcel who has evolved and the Marcel of history who is evolving. So, too, Quentin—the Quentin embedded in Sutpen, the Sutpen embedded in Quentin. Richardson achieved something similar, in that at first Lovelace and Clarissa seem antipodal types. As the novel develops, however, we perceive them as the obverse of each other. Neither can exist without the other even while they struggle as deadly enemies; each one's maneuvers link one to the other. As they live, so they die—Lovelace's death coming shortly after Clarissa's. This is a side product of an intense epistolary style: when correspondence becomes heated, each writer becomes a symbiotic part of the other. This is also a by-product of Faulkner's method: no matter how different Quentin seems from Sutpen, the two are part of the same doomed South; twins or half brothers, as much as Henry and Bon are, so that they are all doomed half-brothers, whether old South or new South.

Still only three pages from the beginning of *Absalom*, we have really four voices: Quentin's two, Faulkner's "over" voice, and Rosa's, which carries another set of details. And so modulated is Faulkner's method that each voice is clearly differentiated from the other, comparable to the way in which Richardson's "voices" are distributed among epistolarians. First, the interior narrative establishes the two Quentins, then Quentin takes over and in surges of italicized comments runs a counterpoint to Faulkner's voice; inserted into this is Rosa Coldfield's narrative of events, which feeds Quentin's narrative and parallels Faulkner's. There is, however, still another dimension, for Quentin responds to Rosa's remarks even as, in italics, he answers Shreve. Serving in his *present state* as listener for Rosa, commentator, then as relayer to Shreve, Quentin has assumed the major narrative role, since in his subdivisions he has more voices than Faulkner.

The method established on this page becomes fundamental for the entire novel. The stream that takes over from such interiority is inevitable. Only the stream can provide Faulkner that command over strategies indicated here, for only the stream can move just below consciousness to the crevices where Sutpen is located. Although the main attraction, Sutpen cannot appear in his own right, since—like Conrad's Kurtz or Marlow's Jim—he must remain enigmatical. Clarity would not only destroy him, it would destroy what the novel purports to do: to retrieve the old South through relays that suggest shrouds and veils, the masks that characterize the region's history.

The narrative stream, however, could not function unless connected to a "temporal stream." And that could not itself exist without the division of voices

into subtexts, the distribution of information equivalent to letter writers in Richardson. That division, made by the third page of the novel, indicates all significant meaning will lie in secondary texts: those areas lying between voices, not in the voices themselves. For the latter represent persons—whether Compsons or Rosa—who play no role except as recipients of information. And the information is not in itself the sense of things, since it is date, detail, event, not meaning. Meaning, as it exists for Quentin and Shreve at Harvard, must all be extrapolated; for they are, after all, trying to communicate "in the long silence of not people, in not language. . . ." Accordingly, the *division* of voices links inextricably to the meaning of the novel.

Those four voices even increase. We must add Faulkner's, which, neither quite inside nor quite outside narrative layers, lies between consciousness and unconsciousness. Further, as we have noted, Quentin's voice is really two. So that now we have six: two Quentins, Faulkner, the two older Compsons, Rosa.* Those relays offer the temporal mode, that of historical time, from 1866 reaching forward to Quentin and Shreve in 1909. In the historical sense alone, then, we must add still another voice, that of Shreve. In 1909, at time's end, Shreve asks questions, demands repetition and clarification, and creates a good deal of doubling back; so that in this respect he, too, is a relayer for the reader, for purposes of clarity.

Temporality, however, is more complicated. Through dates and numbers, for example, we have a virtual stream. That is, *we have a numeral equivalent to a stream of consciousness*, this numerality connected to time. On certain pages, we have a "stream of numbers." At the beginning of Part III, the numbers sequence intensifies. The voices come at us, Quentin, Mr. Compson, and, somewhere, buried, Faulkner; their tale is of time. Rosa moves out to Sutpen's Hundred in '64 (embedded in Quentin's relaying, in 1909); Rosa was then 20, 4 years younger than Judith Sutpen, her niece; Rosa had been born in 1845 (which is, incidentally, 64 years before 1909, coinciding with the '64 of her move to Sutpen's Hundred); when she was born, her sister had already been married for 7 years, with 2 children; her mother was "at least" 40. So we have one level, the ages of 20, 4, 7, 40; then the level of dates, 1909 (the present), 1864, 1845; finally the inferred ages, 64 for Rosa, unlisted for the children.

Something similar occurs at the beginning of Part V. Rosa's grasp of fact is shaky, and her mind wanders. As a result, the numbers come on as both definite and indefinite: the 12 miles she travels to Sutpen's Hundred after "the two years since Ellen died"—or was it 4 after Henry vanished? or 19 since "I saw light and breathed?" Two women (Rosa and Judith Sutpen) live alone, then Henry reappears after 4 years; at that time, the two of them, the brother and sister, replace the two women; the 12 miles Rosa rode is reasserted, and so on. There is spatiality as well as temporality, but it is time which is central—so that historical past and present at various levels become some approximation of the

* There is, also, the muted voice in the background—that of General Compson. The General is a source of information rather than a relayer in the others' sense. Or else he is a relayer embedded deeply in information theory, going from Sutpen to Quentin's father with details about Bon's Negro blood, for example. But this aspect is ambiguous in the book, and we are not quite certain how the General functioned there, whether as relayer from Sutpen or as informant to the very young Quentin, who then told his father about the Negro background.

deceptive stream or interior monologue. Sutpen's very existence is caught in those temporal seams: in the 12s, the 2s and 4s, and other distinctions.

But there is another kind of mathematics, also; not at first so close to stream or interiority, but in its way part of the numbers scheme. That is the quantity of blood that makes one Negro—fractions determine destiny. Henry Sutpen waits for Bon to dissolve his marriage to a 1/8 Negro mistress, by whom he has a son who is 1/16 Negro. Henry doesn't learn as yet that Bon, his closest friend, is part Negro. Henry will tolerate the mistress and son, and once Bon makes the break, he is free to marry Judith; but it is the Negro blood in Bon himself that leads to murder. Henry will accept that they are ½ brothers, that Bon may marry his ½ sister, but the presence of that other fraction creates the showdown. Thus, in the background of temporal dimensions is genetic numerology.

Related to this is information theory. Although by about one-third through *Absalom* we have all the facts we need to understand the dramatic situation, the point is *we do not know* we have all the facts. A by-product of the narrative method and all the numbers and dates is our insecurity about what we know, what we still have to learn, what later may be revealed. This insecurity on our part results from the material having come to us from seams; so that each bit of information is so directed that it seems to be incomplete, and it may have extensive further meaning which is not going to be revealed until a later time. The reader is manipulated by information until he is uncertain about what he knows, and experiences in this respect an inverted detective story: not too many details, but the fear too few have been disclosed.

Yet all this uncertainty is related to the larger question of stream, narrative, interiority; associated because Faulkner—with Richardson as earlier model—located our experience of events in areas we cannot define. Faulkner has redirected us away from a purely conscious awareness of story, character, history, et al., redefined, in fact, where these elements lie. They reside obliquely in areas "between"; so that narrative coming to us from a range between conscious and unconscious strikes us in a comparable region. We can find narrative, stream, interiority, uncertainty about facts all amidst a welter of detail, associated with that "middle range" we discover in Richardson's use of the epistolary technique.

The scene near the end of the novel between Henry and Bon over the latter's intended marriage to Judith has all the qualities described above, but in a special way. Having been instructed by Sutpen about Bon's part-Negro background, Henry warns his friend to forsake Judith, not because of their sibling relationship but because of his Negro blood. The scene is of great power and irony, since incest is not the issue, blood is—"his mother was part negro." Yet the meaning of the scene goes well beyond this. For there is no narrator for it—no Compson, no Rosa, no means of relaying it to Quentin. There are no witnesses for these words—only the sense of them—and when it comes down to Quentin, the relay of narrators is insufficient. The scene does not even seem to derive from Faulkner, the external voice. Rather, it derives, as we experience it, from some inner world, *italicized* because it is so deeply internalized in the narrative it has gone well beyond consciousness. The scene looms out of some primitive world, some ahistorical era.

After Sutpen has informed Henry, the latter awakens Bon at dawn—the

scene takes on mythical or legendary implications. Their appearance is one of desperation, and they move silently, as if words are an excrescence. The South is losing the war, and they will be retreating soon, "retreating from annihilation, falling back upon defeat, though not quite yet." The background of retreat and defeat is necessary, since the war was fought to do something about the Negro question, and it remains unsolved, the very crux of impending personal violence. Henry says nothing, but Bon knows the moment is at hand and says, "So it's the miscegenation, not the incest, which you can't bear." That becomes, in this novel, the equivalent of Lovelace's rape of Clarissa in Richardson: the critical area, the mediating range of experience.

When Henry does not respond, Bon goes on to say he waited all these years for Sutpen to recognize him, and if he had he would have backed off from the marriage; there would have been no need "to tell you I am a nigger to stop me." Henry is inarticulate, his chief response being repeated No's, and even when he does find words, their dialogue is incomplete: brief spurts of language which are oblique and fragmentary, words inadequate for feeling. Faulkner has so saturated the scene with significance it is communicable only by silence. Everything meets here, history, personal experience, the quintessential Southern situation; and it comes to the reader from some primeval region of consciousness, history lying outside history, experience lying beyond experience. This is, in the final sense, the true area of narrative stream, with only the pistol, first in Bon's hand, then extended to Henry's, as the equalizer.

Yet in the same paragraph in which each man knows only the death of Bon will stop him, the narrative shifts from that deep interiority to the external frame of Quentin and Shreve in their room at Harvard. The shot that kills Bon occurs *not* in his segment, but in the segment associated with the two college students, in the words of Shreve, who retells the story; and ideas derived from Quentin. Faulkner has refracted the event at least three times: first, an event at which no witness was present, then to Quentin, finally his words repeated and interpreted by Shreve. A Canadian, for whom the events have least meaning, Shreve is the messenger of this information; so that Faulkner has achieved filters within filters, relayers within relayers. History comes to us as this, as a stream deflected repeatedly from the original event.

Quentin's sole response is "Yes." His "Yes" seems specifically to acknowledge Shreve's view of why Bon switched Judith's picture in the metal case to that of the octoroon and their child; but "Yes" is a more generalized response to the madness of the event, to the historical madness of the South and its conflicts which will lead to his own suicide the following year. Those two doomed young men playing out their own Civil War is the historical residue Quentin experiences, becoming *his* war, *his* suicidal act. Bon's choice of death at Henry's hands is associated with Quentin's dilemma: history kills, if it is that kind of history.

We return to the primary matter, the mode of narration that turns history into stream. A scene with no witnesses, and, therefore, no one who can reliably relay it, lies in that region of indeterminacy we also defined in Richardson, where a million words are insufficient to convey the true course of events; where personal history lies well outside historical events; and where the intensity of inner life preempts external events. The matter of the South as embedded in the seams of the narrative takes on the quality of flow that lies in regions beyond

words. The very point Quentin must confront is the inadequate articulation of what is driving him to frenzy; and that lack of definition, despite waves of words and bunches of language, is a derivative of the method, whether Faulkner's stream or Richardson's epistolarian technique.*

* Not unrelated to stream techniques are Nathalie Sarraute's *tropisms*, brief stories of banality, a kind of zero degree of fiction. Minimalist in nature, *tropisms* squeeze out the author, as with all good stream strategies. Robbe-Grillet's *chosisme* (thing-iness) is still another form of zero-degree writing, an external technique that is an analogue of the stream.

◆ Chapter Seven ◆
1900–1925: Within A Budding Grove

BETWEEN THE END of 1906 and the spring of 1907, one work possibly more than any other created its own definition of avant-gardeism. In the final weeks of 1906, it was created in somewhat rudimentary form, but within six months it had undergone a transformation; so that by the time it was viewed in the artist's studio, his friends recognized that not only the artist but art was being transformed. Even in this later form, the painting was still a mutation of the artist's styles, and it would remain incomplete: parts reworked to fit one style, other parts remaining in what we suspect was their original state. The painting was, of course, *Les Demoiselles d'Avignon*, the artist Picasso; and one of those who saw it, not in the spring but in the fall of 1907, was Georges Braque (brought to Picasso's studio by Apollinaire). The avant-garde would become cubism, not so named until later, even though *Les Demoiselles* is not formally cubist. It is, nevertheless, a threshold, a breakthrough, one of those works that make looking, reading, or hearing different. It was an analogue, however tenuous, to Schoenberg's insistence on atonality, Proust's utilization of Bergsonian time, Einstein's papers for the *Annalen der Physik*,* Freud's examination of dream, unconscious, and childhood sexuality, even to Modern dance, in Duncan and Nijinsky. However one judged it, it announced the new was here to stay.

Cubism is, in some ways, a summation; in others, it leads into the major artistic development of our time, into abstraction and the culture of abstraction

* As in cubism, Einstein's relativity was concerned with space, time, and mass, and with making them agents of the perceiver's experience. Like Einstein, Picasso denied absolute space; and like the new physicists, Picasso insisted on representing reality with a different perception of objects.

Looking back on the phenomenon of the painting, in 1933, Picasso said that André Salmon invented the title; before that, it was *The Philosophical Brothel* and *The Brothel of Avignon*. As for the women, one was Max Jacob's grandmother (who was originally from Avignon), Fernande Olivier was another, Marie Laurencin (not yet Apollinaire's mistress) a third. At first, men were to be included, for which there are drawings. "There was a student holding a skull, and a sailor. The women were eating—that explains the basket of fruit that is still in the painting. Then it changed and became what it is now." The "Avignon" was Avignon Street (Carrer d'Avinyó) in Barcelona.

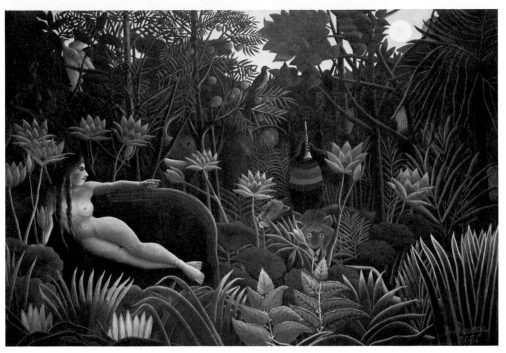

Henri Rousseau, *The Dream*. (1910.) Oil on canvas, 6'8½" × 9'9½". Collection, The Museum of Modern Art, New York. Gift of Nelson A. Rockefeller.

Kurt Schwitters, *Merz 163, With Woman Spraying*. Collection, Solomon R. Guggenheim Museum, New York. Gift, Katherine S. Dreier Estate. Photo: Robert E. Mates.

Max Ernst, *Two Children Are Threatened by a Nightingale*. (1924.) Oil on wood with wood construction, 27½" × 22½" × 4½". Collection, The Museum of Modern Art, New York.

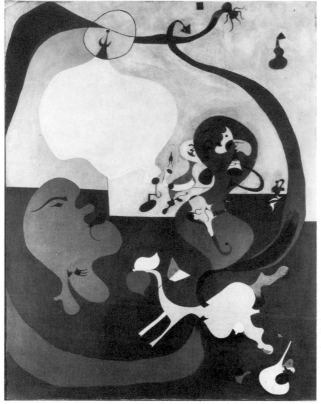

Joan Miró, *Dutch Interior*. (1928.) Peggy Guggenheim Collection, Venice (The Solomon R. Guggenheim Foundation). Photo: Mirko Lion.

René Magritte, *The False Mirror*. (1928.) Oil on canvas, 21¼″ × 31⅞″. Collection, The Museum of Modern Art, New York.

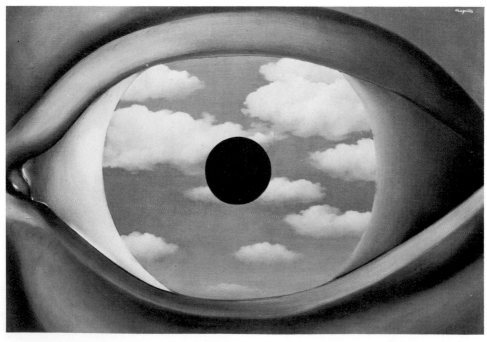

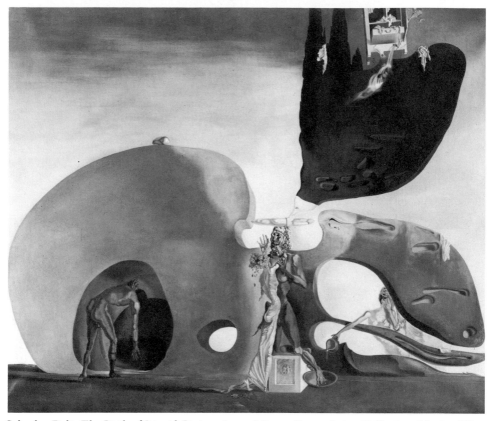

Salvador Dali, *The Birth of Liquid Desires*. (1932.) Peggy Guggenheim Collection, Venice (The Solomon R. Guggenheim Foundation). Photo: Mirko Lion.

Henri Matisse, *Le Tombeau de Charles Baudelaire*. (1930–1932.) Page from Mallarmé: *Poesies*. Etching, printed in black, 13″ × 9¾″. Collection, The Museum of Modern Art, New York. Abby Aldrich Rockefeller Fund.

Georgia O'Keeffe, *Evening Star, III.* (1917.) Watercolor, 9″ × 11⅞″. Collection, The Museum of Modern Art, New York. Mr. and Mrs. Donald B. Straus Fund.

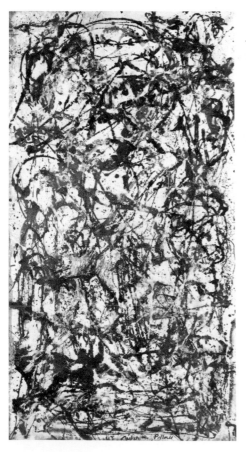

Jackson Pollock, *Enchanted Forest.* (1947.) Peggy Guggenheim Collection, Venice (The Solomon R. Guggenheim Foundation). Photo: Mirko Lion.

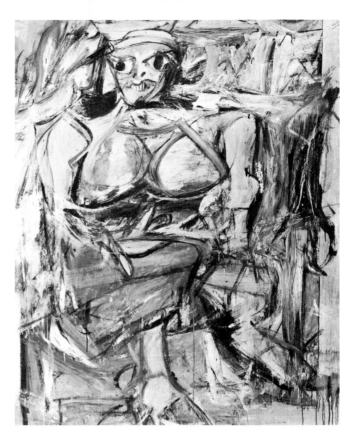

Willem de Kooning, *Woman, I.* (1950–
1952.) Oil on canvas, 6′3⅞″ × 58″. Collec-
tion, The Museum of Modern Art, New
York.

Helen Frankenthaler, *Jacob's Ladder.* (1957.)
Oil on canvas, 9′5⅜″ × 69⅞″. Collection,
the Museum of Modern Art, New York.
Gift of Hyman N. Glickstein.

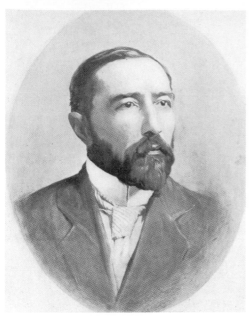

Joseph Conrad in 1904. (New York Public
Library Picture Collection.)

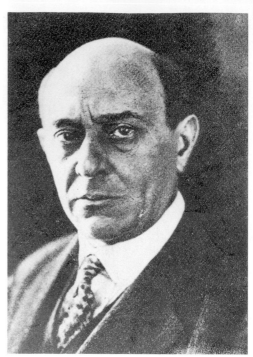

Arnold Schoenberg. (New York Public Library
Picture Collection.)

Franz Kafka. (New York Public Library Picture
Collection.)

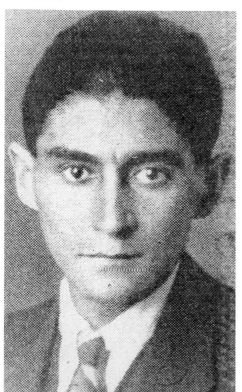

Igor Stravinsky, sketched by Pablo Picasso in
Paris, May 24, 1920. (New York Public Library
Picture Collection.)

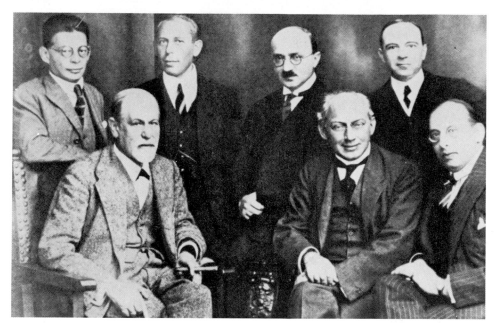

Sigmund Freud with the "committee" of early psychoanalysts in 1922: (*standing*) Otto Rank, Karl Abraham, Max Eitingon, Ernest Jones, (*sitting*) Freud, Sándor Ferenczi, and Hanns Sachs. (New York Public Library Picture Collection.)

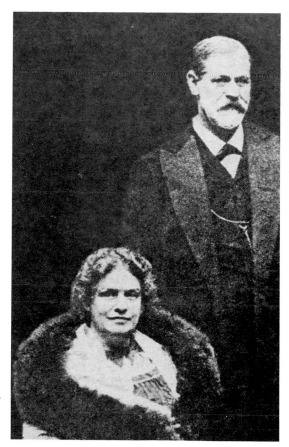

Sigmund Freud with Lou Andreas-Salomé, from group photo, Weimar, 1911. (New York Public Library Picture Collection.)

Frida Kahlo. (New York Public Library Picture Collection.)

Portrait of James Joyce by Jacques
Emile Blanche. (National Gallery
of Ireland.)

(see Kandinsky's development in chapter 5). In retrospect, cubism seems inevitable. It became its own culture, establishing its own terms in its five-year span, *so that the way in which one perceives it is determined by it.* It is self-enclosed, both formed and formless; it represents all content and yet it insists on negating content in favor of spatiality. The closest thing to it in a verbal culture is free association, but, as we shall see, cross-cultural references, while enrichening are not quite accurate. *

Cubism is also a leap, a privileged moment. True, it helped to consolidate many phases of painting: Cézanne's late, almost geometric work, without which cubism at this time was unthinkable; Gauguin's blocky, squat, flat, geometrically shaped natives in his South Sea paintings; African masks and Iberian bronze sculptures which had penetrated into Paris and into Picasso's imagination; even some angulated work by Matisse and Derain. Yet cubism has something of a sui generis development. Although it can be traced as an outgrowth—with Cézanne's later work very possibly a key ingredient—it was not a mutation but a jump, as Picasso seemed to recognize with *Les Demoiselles.* He treated it as a special moment, keeping it in his studio, refusing to exhibit, hoarding it as a treasure whose full significance he did not consciously comprehend. He did not sell it until almost twenty years later, to Jacques Doucet, for 25,000 francs— about $1800.

Cubism is, nevertheless, only one of several striking developments in this twenty-five-year period, from 1900 to 1925, when Modernism blossomed. In this span, we experience entire professional lives beginning, developing, and ending with a culture of Modernism. We think of Proust and Kafka, dead by 1922 and 1924, respectively; or a good part of Joyce's career, Conrad's almost in its entirety, a major part of Lawrence's, Eliot's, and Yeats's, Woolf's significant development, Rilke's, with his death in 1926. In art, the movements are the major ones: *les Fauves* at the beginning, surrealism and *de Stijl* at the end, and in between cubism, purism, Orphism, abstraction, futurism, suprematism, constructivism, Dadaism; the seminal work of Picasso, Braque, Gris, Matisse, Derain, Cézanne, Kandinsky. There are also Léger, Boccioni, Vlaminck, Nolde, Marc, Mondrian, Chirico, Rouault, Marquet, Severini, Carra, Delaunay, Bonnard. In music, the developments are equally startling: Schoenberg's atonality and twelve tones or serialism; Stravinsky's and Bartok's major phases; Schoenberg's disciples, Berg and Webern; Charles Ives in America. Dance: Isadora Duncan, Nijinsky with the Diaghilev Company, the Ballet Russe de Monte Carlo, the beginnings of Balanchine's career. In sculpture, Brancusi, Epstein, Lipchitz, Archipenko, Arp; Le Corbusier, Gropius, the Bauhaus in architecture.

There were, also, other significant developments in careers already begun: those of Mann, Stefan George, Gide, Richard Strauss, Henry and William James, Broch, Strindberg, Hesse, Musil, Blok, Bely, Jarry, Mandelstam; as well

* Thus, one might try to see Gertrude Stein's prose in 1912–13 as an approximation of cubist painting. In 1912, she wrote a poem on Apollinaire in language purged of representation, sounding both "cubist" and abstract. The subject lies in shadows beyond the language, as if it were shapes that existed independent of lines. Edmund Wilson felt that the vagueness which entered her work after 1910 was, in part, the consequence of her desire to emulate modern painting, in other part her portrayal of relationships deemed "abnormal" by social standards. But to draw out the connection with painting, while tempting, would be misleading since words have connotative value that makes form alone impossible to achieve.

as Einstein, Freud, and Jung, Bergson, Husserl, Heidegger, and the entire psychoanalytic movement—a development running parallel to abstraction in the arts and not so dissimilar in ideological reference. In such writers, thinkers, analysts of mental states, Modernism was both quarried and, in large part, depleted. The First World War was a watershed for Modernism; it helped inhibit and, at the same time, provided impetus to go on. It closed out whatever remnants of the old remained, and it forced each artist and thinker—if he had not already reached these conclusions—to isolate himself around his own talent or to dissipate himself in the marketplace. Dada, the quintessential response to a conflict of desperate meaninglessness, was the culmination, while also providing an embarkation.

One man, Guillaume Apollinaire, was present at the creation, a magnet for movements and for those creating or destroying them. However wrong his groupings and judgments—connecting fauvism and cubism, for example—Apollinaire's brief articles and reviews in the first decade or so of the century directed toward refining the "new art" not only pointed out what was Modern but helped shape it. While his essays on Picasso and Braque have become famous, "The Three Plastic Virtues," in 1908, is a kind of manifesto of the new, only less dramatic and violent than Marinetti's futurist manifesto the following year. If we add to Apollinaire's brief essay his quasi Cubist-Orphic poem "Zone," in *Alcools* (1913), we have by way of his prose and poetry a sense of the avant-garde passing into broader Modernism. In these two works alone, he brings together elements of cubism, Orphism, plasticity, simultaneism, and futurism, in a verbal mode that suggests a modified stream or free associational quality.

Besides establishing Apollinaire's own authority, "The Three Plastic Virtues" had several aims. One of them was expulsion of the fathers, evident in all of the above movements: "One cannot forever carry on one's back the body of one's father. He must be abandoned, together with others who are dead." With this, Apollinaire abandons not only Aeneas's Anchises, but history, tradition, authority; and he cautions that those of his generation who become fathers should expect the same treatment. His arrogance gains such intensity because he establishes that with the separation of art from nature, the artist is supreme, the new divinity. Withal, art supersedes nature: "It is time we became the masters." Fire will burn out and purge, leading to purity, unity, and truth, the three plastic virtues.

The word *plastic* was complex for Apollinaire, and if we extend his sense of it we can see how he foreshadowed abstraction. Plasticity was a liberating force, enabling the artist to enter into the creative process, freeing him from both composition and inspiration; that is, it liberated him from the formation of his artwork and from the subjectivity that leads to it. In practice, plasticity meant divesting the artist of "reality," or appearance; from objects themselves, if we carry the idea forward a few years. Associated with plasticity is simultaneism, another complex word for Apollinaire. Simultaneism referred as much to structure of a work as to its effect on the spectator. It suggests the relatedness of unrelated parts; it indicates the artist is aiming at an experience, usually a moment, without forgoing the disorder or lack of association of the whole. It is, somewhat like plasticity, an effort to retain control without providing conventional limitations; it is Apollinaire's typical mix of ordered disorder, controlled uncontrollability.

Plasticity permitted a blurring of borders between subjective and objective, a fudging of frontiers so that spiritual and physical interpenetrate each other. (Yeats was a practitioner of this theory.) Simultaneism, working with plasticity, allowed the artist to create order by way of contrast or conflict. Logic is out.* Time is itself telescoped; so that Apollinaire's contemporary, Proust, becomes the greatest exponent of plasticity. The cubists would telescope space, and by flattening objects against their spatial component or the viewer's expectations, the cubists created a greater reality through a denial of conventional reality. No wonder Apollinaire found "music" the right word to characterize nonrepresentative painting.

The artist receives a luminous light, as if struck by lightning. Each artist is, as it were, his own avant-garde: "We do not know all the colors, and every man invents new ones." One's work, the painting, or, by extension, the poem, "must present that essential unity which alone produces ecstasy." But the artist must beware of seizing the present, for fashion can be "only the mask of death." We recall Rimbaud, in his *Illuminations*, and note that Apollinaire is attempting to be, in part, for the twentieth century what Rimbaud was for the nineteenth. The autonomy of the painting is complete: a relationship of "a new creature to the new creator, and nothing else." Without the hermetic quality, the artwork will lack coherence; it will be full of "disparate and unharmonious parts." The artist can achieve this meeting of hermeticism and coherence through simultaneism, that quasi-mysterious word or force. In "Zone," Apollinaire would use "zones" or "in-betweens," which are the inner states of the artist attempting coherence of objects, things, places, space, and time. Narrative, in poetry as well as painting, had vanished. The viewer needed strategies for looking at a canvas, to see it as a whole or unity even when it seems segmented or fragmented. Put another way: one had to look at a painting quite differently from the way one viewed nature.

"Zone" is a logical extension in words of what *Les Demoiselles* had attempted in paint: that is, to flatten time and space, to create different perspectives, and to achieve decoupage, that cutting or carving which later became so essential to Pound and Eliot. The aim is to give a sense of incompletion, whether the work is finished like "Zone" or unfinished like *Les Demoiselles*. It must seem held in suspension.

"Zone" gains significance by way of its ambiguities, and yet it also has a firm basis as a Paris street poem. We note the debt to Baudelaire, in that personalization of Paris, that making of the city as the zonal equivalent of the poet's mental zones. Among other things, zones *are* in-between states; places or areas or cubes that are also indeterminate as locations. In Apollinaire, there are also zones of feeling and experience, areas that go beyond mental states. We note a reaching out of a kind of pre-wasteland, that sense of sterility permeating a large city and extending its qualities of weariness to its inhabitants. "Zone" becomes, in Apollinaire's sense of concreteness and ambiguity, a verbal equivalent of cubism and abstraction; providing for the flowering of Modernism what Mallarmé's "Un Coup de Dés" did for its earlier phases. Instead of white space,

* Pound would reach similar conclusions, in the first issue of *Blast* (June 1914), asserting, "I defined the vortex as 'the point of maximum energy.' " The vortex is something like Apollinaire's plasticity, in that it liberated the artist from the entanglements of composition and the subjectivity of inspiration.

silence, void, chance, Apollinaire offers intermediate states that cannot be fully expressed. And yet they exist out there, in the zones of a Paris street, as an urban grid.

The poem opens with the narrator, situated outside the lines, but also somewhere within, like Proust's Marcel, indicating weariness. He seems ready to take on a Prufrock-like persona. He then strikes a paradox, that only "religion seems perfectly new," having kept "as simple as the hangars at the airport." The theme is stated, but this is not what Apollinaire means at all. The poem is in reality about space—space given and space taken away—and with this it enters profoundly into Modernism.

The central metaphor of the poem is the blending of Jesus Christ and the "airman," with Jesus, after the resurrection, holding "the world record for altitude." A Modernist equation is set: witty, irreverent, full of contemporary possibility, slangy, spatial. Climbing the sky, Jesus settles over Paris, "Pupil Christ of the eye, / Twentieth pupil of the centuries. . . ." From this, our entire century, "changed to a bird," rises "like Jesus in the air. . . ." Here we have another dimension of "zone," that area of hovering, where Jesus is a "pretty acrobat." The risen "God" is molded to modern life by way of flight, and we have a witty metaphor of zonal spatiality.

But Apollinaire's more insistent sense of space lies in the city streets. Paris streets evoke several responses, from shame at saying a prayer to "sparks of your laugh" which "gild the background of your life" and appear to create a painting that hangs "in a gloomy museum." Chartres and Montmartre are linked by way of "Our Lady" and her "Sacred Heart," while the narrator suffers from "a shameful sickness." Now the zones shift rapidly, from the Mediterranean coast to Prague, to Marseilles, to Rome, to Amsterdam, before the return to Paris. The poem will end in Paris, the repository of the final "leaps" of experience. The "I" narrating and the "you" addressed become, more firmly, one, as in Prufrock's "Let us go then, you and I"; so that narrator and addressee are indistinguishable, two sides of a single person.

The "you" observes Jewish emigrants filling the Gare Saint-Lazare, on their way to the Argentine or planning to remain in Paris, where they live in slums. That shifts immediately to a pre-Eliotic tone: "You order a cheap cup of coffee among the derelicts," in which the latter seem to stand for the emigrants above as well as the narrator, both parts of him. The scene begins to fade with the brief description of a prostitute, with hard and raw hands and scars on her stomach. After her, the silence of Paris begins. The night "absents itself" (s'éloigne) like a lovely half-caste. You turn to the "Alcools" of experience: the strong drink of which each poem is composed. You confront the streets filled with this "eau-de-vie." In your haze, you mistake the fetishes from Oceania and Guinea as "Christs of another shape and another belief," inferior Christs "of darker hopes." You say good-bye to the "Soleil cou coupé," a sun that appears like a head broken off from its neck.

The sun has set on Paris, as, earlier, it had risen. The sun's rise and fall in "Zone" will be complemented by the concluding line of the final poem of *Alcools*, "Vendémaire": "The stars were dying, the day was just coming to birth." Also, "Vendémaire" is the first month, the beginning of the revolutionary calendar. Just as Paris lies between rising and setting, so the narrator lies between his experiences, in zones that exist but do not cohere. What he assimilates with

reason makes little sense to feeling; what exists in feeling cannot be explained rationally. Jesus seems to offer a bridge, but *alcools* prove stronger. Tentatively titled "Cri," Apollinaire retitled it "Zone," which is more representative.

In its leaps of experience, its high colors, its zonal particularities, the poem is Apollinaire's effort to find a verbal equivalent not only to what the cubists were doing but to the work of an earlier group, *les Fauves*, with their wild leap of color, their own zonal juxtapositioning. To these, we should add the expressionists, *Der Blaue Reiter*, whose major development will be not toward expression, but toward absence, which Apollinaire's poem also suggests. It is a poem fulfilled by void: the very nature of the narrator remains purposely unexplored. He is the sum total of the poetic lines and images; he rests between the laps of experience, as impenetrable as those other, more famous, personae, Prufrock and Mauberley. Although less raucous than Pound's "Sestina: Altaforte," "Zone" parallels that poem's leaps. By the time of "Mauberley," Pound was himself imitating, to some extent, Apollinaire: "For three years, out of key with his time, / He strove to resuscitate the dead art / Of poetry. . . ."

More than expressionism, *les Fauves*, and even cubism, "Zone" has particular reference to a contemporary style which Apollinaire himself named: Orphism. Orphism is an intermediary style, with associations deriving from cubism and another, allied group known as the purists. Orphism or Orphic cubism, which was Apollinaire's original phrase, referred to "pure" painting that developed in Paris between 1911 and 1914. At an exhibition of the Section d'Or in 1912, he perceived tendencies of nonrepresentation in the work of Robert Delaunay, Léger, Marcel Duchamp, Picabia, and Frantisek Kupka; and he labeled that tendency Orphism, after the nonrepresentational or "pure" music of Orpheus. Even here, we note that blending of art forms: a group of paintings turned into a label or phrase, that phrase deriving from a kind of music.

Delaunay's *The City of Paris*, from 1911–12, is, in fact, a rough equivalent in paint to what Apollinaire would write in "Zone." Although it is moving toward nonrepresentation, Delaunay's canvas has discernible figures amidst geometric shapes, several elongated female figures in fact. In the background, as well as foreground, is the city of Paris—bridges, streets, et al. The painting is a kind of collage, but painted out to every corner, almost a mural as well. Although not quite nonrepresentational or abstract, it moves toward that dimension of "pure painting" by way of voiding objects, what Apollinaire hoped to accomplish, also, in "Zone" and in his identification of Delaunay as an Orphist. For both, that insistence on the voiding of naturalistic objects was to make the representational world recede and to allow dynamic forces or energies to replace them. Delaunay and Apollinaire were equally concerned with space—energy and movement rather than static things. The sense of movement and dynamism creates infinity, whereas objects are fixed, in finite space. Proust's equivalent use of this idea comes in the famous tea and madeleine episode early in his great work, when Marcel's involuntary memory is triggered and he enters an infinite, "Orphic" world; whereas before that tasting, he had been confined by the static dimensions of the mental memory.

With Apollinaire, though not exclusively with him, poetic lines had become more than words, or more than the sum total of words: in some unanalyzable way an ally of what was occurring in the other arts. Painting was his bread and butter; for he was, in some ways, the "discoverer" of Picasso's overwhelming

talent, one of the first critics to vaunt the Spanish artist in print. Not unusually, Apollinaire sought in words to recreate the painterly sense, as both form and content. He needed shape, color, line, point, abstraction as well as represen- tation, an original spatial and temporal sequencing. Like Proust at the same time and Kafka only shortly later, he sought "above" and "beneath" as aspects of both dislocation and location, as dimensions of both measurement and "un- measurement." These elements, so deeply associated as they are with Modern- ism, are twin aspects of that merging of poetry with painting, a kind of synesthesia. The colors of lines, orchestral coloring, the sound of certain paints, the extension of the viewer's sensory range for so many unexpected combinations, his ability to assimilate at some level hitherto unknown juxtapositions—qualities we note in those 1910s ballets and opera productions in which diverse colors, sets, move- ments, and sounds are blended—are part of the new suggested by "Zone."

The generating ideas derived from cubism. For a period from about 1907– 8 to the outbreak of the war, cubism was the dominant avant-garde along with atonality and experiments with the verbal stream. Ultimately, we must ask why the three major artistic genres should undergo such revolutionary change at this time, roughly simultaneously with each other. It is a valid question, although culturally the most difficult to answer. *The question, which we will only raise here, is: Why should nonrepresentational work, abstraction, the dissolving of language, the subversion of traditional melodic lines prove to be a capstone of Modernism?* The overall trend is toward abstraction—i.e., the negation of rep- resentational objects, the subversion of things heard and seen—and we must ask why abstraction should come at all and then why at this time and this place.

Is there an inevitability to a cultural trend, which makes it operate outside of human calculation, a kind of cultural gene working in ways we cannot fathom? Do the arts pursue some inner mechanism beyond the will of their creators? Or, perhaps, there is a third course: that the development of the arts can be found only in the larger culture (state, government, technology, science, insti- tutions, and hierarchies); that, here, in these most unlikely places, where rep- resentation and objectivity are everything, we find the seeds for their most unlikely manifestation, the avant-garde in the arts.

Although to the layman's eye, cubism seems to destroy representation, it was, for the two cubists who counted—and later for Juan Gris—a representational art form. What it did more than anything else was to establish new grounds for "beauty," negating nineteenth-century notions of beauty such as those found in impressionism. It is, of course, ironic that impressionism, which had to struggle against academic conceptions of representation in an earlier era, was now the enemy; so that all painting resources had to be organized to undermine the kind of beauty impressionism reflected. What was occurring in all the arts as breakup, decoupage, reshaping, dissolution, roving back and forth, or repetition was a developing method for reconstituting ideas of beauty. As Picasso stressed: "Cub- ism has kept itself within the limits and limitations of painting, never pretending to go beyond it. Drawing, design and color are understood and practiced in all other schools. Our subjects may be different, as we have introduced into painting objects and forms that were formerly ignored."

Picasso insisted that cubism was "not either a seed or a foetus," but an art "dealing primarily with forms." Once that form is realized, it has its own life, a slice of life, as it were. Cubism would concern itself with space (the painting

equivalent of Proust's memory and time), forms, negation of color (in its earlier phases), flat surfaces, use of verticals, horizontals, diagonals, facets and interfaces (ways in which "things" come together or fit), angles, objects as immanent or indwelling, not as manifest. Cubism is antinaturalistic and nonrepresentational, *but realistic*—a distinction often ignored or lost. Color was neutral in early cubism, since light was to derive from facets and interfaces, from within the workings of forms. This was the anti-impressionism of cubism. Central was the idea of the "hidden object," the immanent object or person. These are constants in cubism, whatever its phase. Perhaps more than surrealism, cubism as a gnostic process was indebted to psychoanalysis: both depending on the submerged object.

We return to the end of 1906. Picasso had just come through his blue and pink periods, when he experienced one of those shifts in creativity we find only in the greatest figures. He found himself moving from a perceptual view of art to a conceptual one; from one based on traditional means of "seeing" to one based on idea. At this point, Picasso became a "visionary"; the world was created anew, as if he were present at the Creation and could direct it. His art would grow and develop not from former art but from the maker. It was a sharp and final break from movements, schools, and traditions to the individual. It was the ultimate avant-garde.

External factors that helped to generate and nourish Picasso's shift were clear to everyone. There were other painters and paintings: Gauguin, who had shown at the Salon d'Automne in 1903 and 1906; Cézanne, also, in 1904 and 1907; Derain's *Bathers* of 1906 and possibly Matisse's *Blue Nude* in early 1907, when *Les Demoiselles* was still in developmental stages. There was the Louvre exhibition of second-century Iberian bronzes, derivatives of early Greek sculpture; and there was Egyptian art with its flatness or low-relief, its pinched-in figures. Later, after *Les Demoiselles* was under way, Picasso became acquainted with African masks and other forms of sculpture, and he repainted the two heads on the right and one on the left under that influence. Yet none of these factors or "influences" can explain the painting. It derives from another area, especially since Picasso was working simultaneously in a postfauvist style, in *Still Life with a Skull*. We recognize how bizarre *Les Demoiselles* was since fauvism and cubism are quite opposed, and yet Picasso was mining both idioms at the same time.

Cubism had no name, nor was it a movement, certainly not a school; it had, in fact, one painting, and that was not, strictly speaking, cubist. It was a stage in Picasso's imagination, a phase, in which the painting itself became the working out of his ideas as he progressed toward what became known as cubism. Not only did the style or method not have a name, it was not, even after a name was connected to it, based on cubes.* *Les Demoiselles* was, in one sense, a laboratory for Picasso, a testing ground for ideas as yet inchoate; the canvas was

* Naming, as in *Tristram Shandy*, was a difficulty for cubism. According to one story, Matisse saw some Braque landscapes submitted to the Salon d'Automne in the fall of 1908, for which the former was a member of the jury. Matisse referred to them—others say it was Max Jacob or Louis Vauxcelles—as paintings *"avec des petits cubes,"* commenting on this to Vauxcelles, art critic of *Gil Blas*. Vauxcelles was the one who had named another group, *les Fauves*, just three years before. When Matisse showed him what Braque had done in his L'Estaque landscapes, the painter noted that houses and figures were reduced to "geometric outlines, to cubes." Then in early 1909, when he saw the Braques at the Salon des Indépendants in March, he referred to the style as cubism, to the paintings as *"bizarreries cubiques."* The name stuck, although it was not descriptive of the kind of work Picasso and Braque were doing, or would do in subsequent years, but they, apparently, cared little one way or another.

itself the manifest of Picasso's uncertainty and his determination to recreate objects in a different guise.

The next stage after *Les Demoiselles* was the entrance of Braque by way of his own independent discoveries made at L'Estaque, the Cézanne countryside near Marseilles which he visited in the summer of 1908. He returned with several cubistlike works. Then while Picasso worked at Horta de San Juan in Catalonia, Braque was at La Roche Guyon, in the Seine Valley, more Cézanne territory. The styles of the two "cubists" began to shape themselves, and their fortunes would be intertwined for the next five to six years. Although they helped each other and in a sense collaborated on ideas, they were, in reality, aiming at very different things in their development of cubist conceptions.

Picasso was primarily a sculptor working on canvas. That is, he sought form in the way a sculptor seeks it, and his practice of the new style tended to be analytical. He was interested in breaking down elements into components in order to perceive them freshly, as basic elements. Without completely eschewing that perception, Braque was more interested in flow and continuity. Like Picasso, he was concerned with spatiality, but he wanted to paint space as part of things, as a key element in the synthesis of objects and their surroundings. In brief, he was a synthesizer, Picasso an analyzer. The latter used his studio as a laboratory in which components were put to the test; whereas Braque was concerned with putting things together so as to fit his perception of nature as a joiner, not a sunderer.

These distinctions would mark the development of both artists in what was perhaps the most fruitful period in the life of each. While Braque showed at Kahnweiler's in 1908 and at the Salon des Indépendants in 1909, Picasso did not show in Paris after 1902, not until 1919. His work was viewed in his studio by, among others, Apollinaire, who would become his "manager" and publicist, Max Jacob, Maurice Raynal, Derain, and Gris. What they saw was a revolution. No wonder Apollinaire became so excited he made all kinds of linkages and distinctions which were, unfortunately, invalid. Picasso painted *Nude with Draperies* in 1907, *Three Women* in 1908, *Horta de San Juan: Factory* in 1909, also *Landscape with a Bridge* and *Seated Woman*, in 1909; Braque, *Harbor in Normandy* in 1909, also *Fishing Boats*, the great *Piano and Mandola* and *Violin and Palette* in 1910, *Nude and the Table* in the same year, followed by *Clarinet Player* in 1911. Not only was the competition on, but both painters were so secure in their vision of the new they would experiment even before consolidating.

Cubism went through many phases, as I will chart below; but what did Apollinaire see in Picasso's studio and at Braque's exhibitions? "Cubes" were no longer in question; geometrical forms had been dissipated in favor of facets, angles, interfaces. The invention lay in overlappings, the ways in which objects utilized space, or suggested their use of space. The canvas was filled, so that the entire world of the painting was "stuffed" with matter: this was, in itself, a vision. It was, chiefly, a vision of a world so filled with objects that one could no longer identify them as objects; and it was a world so overstuffed one could achieve vision only by breaking things down and trying to see around them. Cubism was very much a prewar development, a political statement of sorts by way of a caustic, witty relationship to the most common things, in which musical instruments—art, craft, vision—are dominant objects.

What was altered was not only the shape of things, but space, light, color. Cubism became a philosophy of perception. Appearance was no longer paramount; internal order was. Cubism, incidentally, was a very orderly kind of painting, in direct opposition to the "wild colors" of the fauvists. Apollinaire's linkage of the two—even though some painters "belonged" to both groups—could not have been more incorrect. Color for cubists was not the primary communicator, nor was shading and light. Instead, a temporal-spatial process was established: that of simultaneity—so that in these developments of a vision we note how Freud, Bergson, and Einstein were pressures on something as different, apparently, as painting. By working simultaneously, the cubist painter was indicating that besides eliminating objects in their usual guise (such as occupying a particular space or possessing expected color properties) objects could be "relocated" in our imagination so as to reshape our sense of everything beyond us. We have in visual terms a process as radical as anything in the social sciences or sciences: Freud's unconscious and Einstein's relativity.

With color, shading, lighting, perspective, or distinctions between foreground and background no longer primary, the viewer was omitted. The usual concessions for the spectator no longer prevailed, and not only was the painter creating a revolution on canvas, but the viewer was caught up in that revolution by way of his neglect. The viewer, simply, no longer counted; and part of the hostility with which cubism was received was based on that recognition. All that mattered was the ego of the artist—i.e., his conception, not the observer's perception. It was heady stuff, in these years of 1909–10, when cubism moved into its "classical" phase. The problem now for anyone who wished to understand a painting—as for anyone who wanted to hear the new music or read the new fiction and poetry—was to enter a process and follow the labyrinth, if one could. The painting had become a hermetic force, the painter a hermit. By 1910, when cubism existed only by way of what Picasso and Braque chose to make it, they were hieratic figures in a movement or style that only a few could comprehend, or pretend to.

By 1910, cubism—to continue with a label that no longer fitted—was moving toward its apotheosis as the avant-garde of painting, as *the* avant-garde along with Schoenberg's atonality. Schoenberg's music, however, was virtually unperformed and unheard, whereas at least other painters knew of cubism. Picasso's interest in three-dimensional form—so that it seemed *Les Demoiselles* could be cut out and mounted as sculpture—had given way to Negro art, to influences by Cézanne by way of Braque, to a new awareness of volume. Most canvases were matte or rough, so as to suggest naturalness, to negate the smoothness or varnished quality of more traditional work. We now can cite cubism as having moved into several phases: the low or analytical phase when Cézanne influenced Braque, and Picasso was influenced first by Egyptian and Iberian art and
then by Negro crafts; this followed by a break with not only naturalism but representation; succeeded by "high cubism," or the synthetic phase from 1912.

One characteristic of cubism is that, as *the* avant-garde of painting, it picked up numerous camp followers, many of them painters of the first rank. Another factor in the clustering of artists around cubism is the rapidity with which styles/movements turned over in the first fifteen years of the century. From

neoimpressionism and the first signs of expressionism near 1900, to fauvism, to cubism, futurism, and the first signs of abstraction, to Dada in the final years of the war, we have so much fluctuation that the same figures overlapped. As soon as a movement or style began to gain a hold, it was already being displaced; so that movements lasted not even the five years usually given to an avant-garde, but no more than three. Dada was a fitting capstone for this entire phase, since it turned all such art into antiart. Marcel Duchamp was the great catalyst of this subversion of what was, already, a subversion.

The maneuverability of artists was such that Léger, Delaunay, Metzinger, Apollinaire, and Le Fauconnier, all early Parisian cubists, derived from symbolist circles. As one critic observes, several of them embraced cubism as a means of subverting traditional art, using it as "a convenient tool of destruction." Furthermore, as colorists, they were anathema to Picasso and Braque, who in their pre-collage and pre–papier collé phase eschewed color, Picasso more than Braque (with his fauvist background). Those who derived from symbolism saw in painting a way of achieving a kind of amalgamation of the arts in which the highest form was music; thus, for them cubism did not exist as a truer stage of representation but as a stepping-stone toward abstraction. Some, of course, became abstractionists.

Then there would be those—Mondrian, a little later, was characteristic— who saw cubism only as shapes and design, and who rejected it as a higher form of reality. They were those who took cubism toward Bauhaus proportion, efficiency, and balance; forgoing almost entirely the eary premises of cubist representation as a mode of bringing out the "real thing." Separate from those interested in the design aspects of cubism were others who saw it only as a stage or process leading to unknowns even more novel and bizarre. They would start as cubists, but become eclectic in their means, borrowing from machinery, the new techniques of the motion pictures, or the artifacts of war.

Since cubism drew such a disparate group, not surprisingly it passed through many phases, before burning out with the beginning of the First World War. The early phase of cubism, relying on the work of Picasso and Braque, can be called true cubism. It also includes Gris and Léger. Douglas Cooper refers to this phase as "Instinctive Cubism," probably to suggest it was tentative and experimental, uncertain of direction or even technique. Then came those who, as indicated above, saw in cubism a means of achieving some other end; those who "used" cubism rather than, like Braque or Gris, sought their vision in exploring it more profoundly. Many of these deemed it mathematical orgeometric, and in time moved toward design. Cooper labels them "Systematic Cubists," and includes Picabia, Marcoussis, La Fresnaye, and others.

In a third category, by himself, is Delaunay, whose considerable achievements were often overlooked because of the presence of giants. His *The City of Paris*—characteristic of his work in 1911–12—fits the second category, Systematic Cubism: and from this he moved on to Orphism, which was an intermediate stage toward abstraction. The Orphics were visionaries of sorts, since they conceived of the world as motion and infinity. Besides Delaunay, this group of runaway cubists included Picabia, Kupka (the Czech painter working indepen-

dently), Chagall, Léger in some of his tendencies, Larionev (with his rayonism, another offshoot*), and even some of the *Blaue Reiter* group. Orphism indicates that cubism was considered, by several, as a stage toward futurism or abstraction: methods were blending even before they had the chance to develop.

Cooper identifies still another category, which he calls "Kinetic Cubism," including Duchamp, Villon, the Italian futurists, the American Joseph Stella. One could see them as a bridge between cubists and futurists, since, like the latter, they were interested more in movement than in representation. The three Duchamp brothers (Marcel, Jacques Villon, and Raymond Duchamp-Villon) formed what was called the Puteaux group, since they met at Puteaux, Villon's studio. They saw their role as putting human interest back into cubism, and criticized Picasso and Braque for having ignored it. Their group included Gleizes, Metzinger, Léger, Gris, Archipenko, and Kupka. Kupka, among others, rightly saw cubism as moving toward abstraction; and he intended to liberate color from form so as to achieve on canvas the effect of music on the ear. Picasso and Braque would move toward this, first with their collages and then with their papiers collés. With the latter, those pasted-on papers, we catch a whiff of Dada in the making, although it was still a couple of years off as a more formal phase.

There is such a beehive of activity here, so many phases, stages, and mutations, so much innovation, indeed so much avant-gardeism, that futurism and its penchant for movement seems to have overtaken the art world. Mondrian straddles nearly every movement in 1914, that fateful year not only for art and culture but for the Western world. As early as 1912, with *Tree*, Mondrian was blending three styles: cubism itself, a suggestion of abstraction, and a movement toward his own unique contribution as part of *de Stijl*. The painting is not quite the grid that the latter style developed, but suggestive of patterning. Then in *Church Facade*, still in 1912, and in *Color Planes in Oval*, in 1914, Mondrian moved further along, maintaining the dimensions of cubism but turning toward nonrepresentation (only Roman arches suggest the actual church in the first), and beginning in the latter painting to suggest the grid qualities of *de Stijl*. *Color Planes in Oval* is a compelling painting both as a synthesis of existing styles and as a foreshadowing of one direction where cubism would go. It is based on lines, horizontals, verticals, diagonals, and their geometric forms as cylinders, ovals, cubes, squares, rectangles; but it is fiercely antifuturist.

One characteristic of Mondrian's developing grid style is its static quality. In this regard, Mondrian would have been the perfect illustrator for Kafka, his contemporary. Those static, abstract grids would be the painterly equivalent of the great silences and negations characteristic of Kafka's novels and stories. Both are antifuturistic; in fact, both are moving in the opposite direction. Mondrian's

* Invented in 1911–12 by Mikhail Larionev, rayonism is a cubist interpretation of impressionism. Larionev described rayonism as a Russian amalgamation of cubism, futurism, and Orphism, all concerned with spatial forms created by the crossing of reflected rays from different objects. As Larionev says: "The ray is represented by a line of color. The painting is revealed as a skimmed impression, it is perceived out of time and in space." Nathalie Gontcharova was another rayonist, and influenced by her was Kasimir Malevich, whose *White on White* seemed to bring all movements to an end. Malevich was, in a sense, the ultimate "negative cubist," since he used the square as a final form in order to negate objects. He called his method suprematism. More on suprematism and its arch opponent, constructivism, will follow below. Aesthetic issues of the highest priority were at stake, not simply naming.

abstraction, even as early as 1912–14, was not only a move toward Bauhaus functionalism and efficiency but toward a representation of the unconscious, memory traces, the stream. Although surrealism, in the 1920s, is usually cited as the plastic equivalent of the unconscious, Mondrian's grids indicate a world on the edge, a middle ground very close to whatever the unconscious is. The grid, finally, is the last line of defense, the static moment, before insanity pours through. Kafka understood this, too, and one can attempt to derive his meanings from a "grid" experience.

The big sensation in 1912, however, was not Mondrian, not even Picasso and Braque and their epigones, but Duchamp and his *Nude Descending a Staircase, No. 2*. Here, too, was another blending or merging of styles, presented in Duchamp's work as antistyle, already as antiart. He brought out what was already implicit in the avant-garde—its quality as antiart in its very manifestation of art or style. In the first version of the painting, the stairs were real stairs, whereas in the next version they are part of the movement downward, consumed in fact by the moving feet. What makes *Nude Descending* so visually spectacular is Duchamp's ability to absorb styles that were still inchoate. For while *Nude* demonstrates obvious cubist mannerisms, it also incorporates the energy and dynamism of the futurists: the painting is a true mutant, the meeting point of at least two major modes.

Duchamp clearly intended to undermine the static quality he found in Picasso and Braque cubism, and to replace facets and planes with kinetic energy, a kind of inevitability of movement. The idea owes something to the juggernaut, the gigantic machine that rolls over everything in its path. Cubist minimalism becomes futurism's inexorability of motion. Duchamp has provided a real challenge, more daunting than Delaunay's, for he has attempted nothing less than an assault on the style that he explores. *Nude* is, we can say, not only Duchamp's subversion of Picasso and Braque, but the first step toward his assault on art itself, the initial stage of his antiart campaign as itself a form of art. It is, in another sense, the beginning of Dada, a few years before that movement saw light in Zurich. Although the aim of *Nude* was to express something about movement in particular, the painting was "anti-"; and it was for this reason that a jury of mainly cubists rejected it for showing at the Salon des Indépendants in 1912.*

Nude moved beyond analytical cubism before the latter was even settled. It stressed synthetic cubism and suggested its exhaustion; so that even while Cubism was under attack as an avant-garde, Duchamp foresaw its demise. What he perceived was that painting would be invaded by other arts, chiefly cinema. Hence, the movement of the nude down the staircase has within it the successive frames of the reel, montage and overlapping as its key techniques. Duchamp shifted, accordingly, from representation to nonfigurative expression, from objects to their movement. Not only cinema is involved, there is the absorption of an Einsteinian relativity, of that fourth dimension which H. G. Wells and other popularizers of science spoke about. *Nude* is an effort to penetrate both a new spatial concept and a temporal one. Yet underlying it all—and here we sense the foreshadowing of Dada—is a witty component. We can see how *Nude* differs from futuristic conceptions when we consider its wit and irony, as against

* The jury included Gleizes, Léger, Archipenko, La Fauconnier, Metzinger.

the deadly serious Italians, several of whom would later glorify war, Mussolini, the state. Duchamp could not be sucked into such a display of infantilism—he would pursue his own less destructive forms.

Cubism gradually took on new shapes in the hands of Picasso and Braque, although their year-by-year development of the style is not our primary concern here. But one outgrowth of cubism was collage and, shortly after, papier collé, and those developments are of interest. They indicate how an avant-garde as it begins to exhaust itself may nourish something even more advanced, even more disturbing in the eyes of traditionalists. Even today the collages and papiers collés purchased by museums and, therefore, "certified" as master works in the medium disturb a museum audience, which is itself already more open to new experience than any "general public." By the beginning of 1914, six months before the outbreak of the war, cubism was not attracting any new talent. Those callings themselves purists were on the attack, citing cubism as part of the mechanism of the age, impersonal and heartless. Picasso and Braque moved into another phase.*

Collage and, to a greater extent, papier collé accomplished a number of goals. Picasso began his first collages in late 1912, dated from the newspaper inserts. Such bits and pieces of material which float free in the canvas space injected a new kind of realism into cubism. The collage was also avant-garde in its defiance of the traditional sense that only fine materials should be used. It further negated *trompe l'oeil*, one of the holies of realistic painting. Still further, it demonstrated that discards and irrelevant materials—junk—could result in something pictorially artistic, and that the artist could synthesize from unlikely sources. Although Picasso and Braque did not intend an antiart movement, their development of collage and papier collé was a step toward antiart, a movement not only into abstraction but into Dada, and even a foreshadowing of surrealism. Painting was removed, once and for all, from the official salons, and this, evidently, had always been one of the primary aims of the avant-garde.

It appears in retrospect that cubism fulfilled not only its own destiny but served as a staging area for several other important movements and figures. Sometimes an avant-garde is dissipated with relatively little residue, whereas cubism was replaced with numerous kinds and levels of residual matter. It was for future artists something like an archaeological dig or a palimpsest, whose subsurface continued to yield nourishment long after the original impulse had been exhausted. Cubism revealed another characteristic of avant-gardeism: what seem at the moment to be its worst points, its most reprehensible qualities, turn

* The Armory Show in New York, in February 1913, showed the new Parisian styles. Yet what was new for Americans was already being superseded. The Armory Show, which led to shifts in American painting, included nabis and fauvists, as well as cubists and expressionists: Braque, Léger, Picasso, Delaunay, Gleizes, Duchamp, La Fresnaye, Villon, Picabia, Duchamp-Villon; among the expressionists, Munch, Kandinsky (who had already turned to abstraction by 1913), Kirchner, and Lehmbruck. There was no Mondrian, and the futurists, refused a separate exhibition, did not show. Probably more than any other influence, the Armory Show moved American artists from social realism and, in fact, made social realism the art solely of the academy.
In England, Roger Fry attempted to present the new and mounted a Post-Impressionist Exhibition in November 1910, as well as a second one, in 1912; but England, more interested in literary innovation, ignored the implications and hooted at the work. Futurists, however, showed more widely, in 1912 and 1913, and did influence the group Pound called the vorticists and who were publicized in *Blast*: Wyndham Lewis, Gaudier-Brzeska, among others.

out to be its most significant elements as they are passed along or modified, and become, themselves, mutations.

Picasso passed on a heritage of "ugliness." That is, beauty would be determined by different standards, and the pretty, the beautiful, the lovely could no longer define art. The break with academic "beauty" was complete. Even before *Les Demoiselles*, Picasso had made a breakthrough in this direction with his heavy female figures, in 1906–7. The famous *Portrait of Gertrude Stein*, in autumn of 1906, demonstrates some of this technique, since Stein is presented as a block, virtually cemented or planted to her seat, a piece of granite. Her nose and eyes, in fact, will be associated with the features of the two middle figures in *Les Demoiselles*, the typical Picasso nose and eyes in his figurative painting. Even the eyes in the African masklike faces to the right and left have Stein's oval, inset darkness. Picasso was able to derive a new notion of beauty from materials, lines, configurations which were once relegated to the ugly.

Perhaps this is related to Daniel-Henry Kahnweiler's assertion that with cubism Picasso "provides the clearest elucidation and foundation of all forms. The unconscious effort which we have to make with each object of the physical world before we can perceive its form is lessened by Cubist painting through its demonstration of the relation between these objects and basic forms." Although Kahnweiler is referring to forms, a sense of beauty is involved, since now form and beauty are linked. If form is the measure of all or most things, then a new theory of beauty must be defined, Yeats's "terrible beauty," perhaps. With the elimination of color as chiaroscuro, with the flattening out of faces as in Ivory Coast masks, the heightening of the forehead, the construction of the nose as if out of putty, features as such no longer count. While they are located on a surface to indicate a face, their function is to define the lines and planes that lie below features. Structuralism, which is attributed to literature, begins here. As noted above, some of the resentment directed toward early phases of cubism and expressionism (not to speak of the nabis and fauvists) resulted from the critics' need to reeducate themselves on how to observe, what to look for, how to absorb new ideas of beauty. As Rimbaud recognized more than half a century earlier, avant-gardes forced reeducation.

Another significant residue of cubism was its utilization of space. It is, in many respects, a step toward abstraction, as many of the early painters rightly saw it. But its sense of space associates it with many developments outside painting as well; with free association, for example, as it is manifested in spiritual autobiography. One could, in fact, make a daring claim that cubism, as it moved from representation toward "inner reality," was itself a form of autobiography, in a way that academic or even impressionist and postimpressionist painting was not. The argument—which should not be carried too far—is that the novelty of the form so opened up the artist to experiment and exploration he revealed more of himself in this mode than painters ordinarily reveal in more traditional modes. Once Picasso and Braque moved from one frontier to another, they had only themselves to pour in; and, consequently, their development of cubism became a kind of free association of inner drives which found resolution not in words but in the languages of facets, angles, and interfaces. Color was once a form of autobiographical notation for a painter—certainly for fauvists, postimpressionists, and expressionists; but with the abandonment of color as a primary goal, form itself became the manifestation of the painter's innerness.

For Braque, in particular, space became an obsession: almost the sole way in which he could manifest self, the expression of innerness. What Braque uniquely achieved was a canvas that permitted no escape or relief for the spectator. Piled up and reaching, frame to frame, are shapes standing in for rocks, buildings, roofs, trees, other flora and fauna. Since they are not given normal perspective, they appear as pressing down on each other, great weights only lightened by Braque's artistry. That lack of escape, that piling up, that loss of perspective, that equality of foreground and background—all of these are forms of intense autobiography separating him almost completely from Picasso. These are, also, dimensions of space, and to read back into Braque's vision and sense of himself, we must read back through spatial factors. No less than Proust with memory, Braque saw life as forms of construction. From that emerged objects.

When Picasso and Braque introduced foreign matters into their painting, the first in collage, the latter in papier collé, they were extending the idea of inserting letters of the alphabet into the canvas. They were going from verbal to nonverbal communication and introducing daily life itself—newspaper strips, cigarette packages, pieces of cloth, wallpaper, other textiles—into "high art." The new work was political in its deepest sense, social as well, suggesting a rejection not only of traditional high art but of the sociopolitical ideas enfolding it. Aesthetically, such developments recreate our customary way of observing, forcing us to adapt to something quite radical, what Stravinsky was seeking in *The Rite of Spring* at precisely the same time. The Stravinsky work created more uproar because, apparently, an assault aurally is greater than an assault visually. Further, in the concert hall, we are captives of a place, whereas in a gallery or museum, the door is readily available, the cost of entrance far less. But there is little question the eye can take a greater radicalness than can the ear, and those who hooted down Stravinsky (or Schoenberg) were not necessarily anti-Picasso and Braque. Different avant-gardes elicit different responses. But whatever the response, the use of foreign objects—even the quality of paint itself changed, as Picasso mixed in sand or other thickeners and rougheners—forced immediate experience into painting, brought to it a new social awareness.

Connected to ideas of space was its opposite, ideas of the void. The sense of the void—nil, nada, néant, niente in nineteenth-century poetry— had become, as we have noted, a distinct presence. Something is there by its absence—Kafka would mine this conceit for his entire career. Part of this artistic response to "things" is linked to the fall of empires: most of these avant-gardes were created in the shadow of declining empires, dissolution of sociopolitical entities whose foundations had been rotting for decades, or whose bases were never solid. The First World War would demonstrate the shakiness of such governments in east, west, and middle Europe: the decline of Franz Joseph, the fall of Czarist Russia, the end of things for Victorian England, the undermining of France's Third Republic. All Europe was in the process of reshaping itself through death, and cubism in its strange assault on form was a manifestation of the void appearing in the center of Europe.

Earlier, Picasso had painted clowns, a medium he mastered, as did Rilke in poetry, as would Chaplin in the new art of cinema. That clown radiated back

to LaForgue, forward to Eliot and Pound.* Art crosses history here, the clown an indication of a kind of art in response to the void beyond him; then the development of more formal responses to that void, as Picasso and Europe beyond him slouched closer to apocalypse. When apocalypse does come, all that will remain is forms, the underlying text or structure of things.

In an excellent essay on cubism, John Golding cites another sense of the void:

> Another important and influential aspect of cubist sculpture, the replacement of the solid by the void and of the void by the solid, can be found not only in Picasso's constructions, but in the contemporary paintings of both men. Thus Braque cuts the shape of a pipe out of a piece of newspaper, throws away the pipe shape and incorporates the newspaper into a still-life in such a way that we become aware of the pipe by its absence. In a construction by Picasso the hole in the sounding board of a guitar can be a positive, cylindrical or conical shape that projects toward us, rather than an empty, negative space.

This sense of void in sculpture is carried one step further with Henry Moore's holes.

But the void is even more pervasive than the negative shapes Golding points to. He is considering actual holes as voids; I see the entire conception of classic cubism, its "high" period, as founded on ideas of voidness. For without becoming completely abstract, the painting is the voiding of objects, making them immanent rather than actual, giving them shadowiness rather than substance; and enclosing object-lessness within facets and interfaces so as to provide permanent disguise. The void is created by the negation of *trompe l'oeil*, by the subversion of the strategies of representation. That kind of void is linked—perhaps not so strangely—to Mallarmé's great poetry of the void, the poet-captain in "A Throw of the Dice," whose will to command is subverted by the void created by the throw. There, since words are involved, it is the voidness of chance; here, in painting, it is the *néant* resulting from the erasure of things.

We are speaking of Picasso and Braque. For Juan Gris, who remained a classic cubist even while altering the style, worked out a different scheme. The intellectual among cubist artists, Gris looked ahead to a more programmatic and analytical style, actually foreshadowing in his essays and paintings the *de Stijl* movement, the work of Mondrian and Malevich. The purists who formed after the war were indebted to Gris, and one can even see seeds of Bauhaus in his work. Central to Gris's conception was the perfectability of form—the sense that an absolute was "there" and could be achieved. He was the expositor of cubism, closer to a naturalistic sense of objects than either Picasso or Braque, and, therefore, on the frontier between representation and abstraction.

Gris, in fact, referred to his arrangements as "flat colored architecture," merging one art with another. Le Corbusier's purism is already implicit here.

* Nowhere is the "clown" phenomenon better observed than in Jaroslav Hašek's *The Good Soldier Švejk* (Schweik). Certified as an imbecile, an "official idiot," Švejk is as much wise man as fool; he learns how to survive while others fall like flies around him. However much the fool-clown phenomenon differs for each, we see almost an epidemic of the type in the painted form, in Schoenberg's *Pierrot lunaire*, in Chaplin's prepetual loser, in Prufrock and Mauberly all arriving at about the same time.

Gris asserted that he found it "more natural to make subject 'X' coincide with the picture . . . in mind than to make picture 'X' coincide with a given subject." The stress is on the conception of a picture, not his perception of it; so that the abstract quality starts out as being paramount. The abstraction or mental state becomes the frontier of the painting.

Besides that heritage of ugliness, cited above, which Picasso passed on, cubism nourished an entire generation of avant-gardes: purism, futurism (some aspects), vorticism, suprematism, rayonism, cubo-futurism, Dadaism. Although cubism and futurism had quite different goals, the former influenced the latter artists profoundly and helped keep that movement going. The importance of all this is not the proliferation of movements or even the nourishment of individual artists, but the effect it had on painting; ultimately on something more than painting, on the way we see. As much as science had altered our sense of the universe, concentrating on extremes of smallness and of infinity, and thus re-shaping known dimensions, so was painting altering our perception and offering ways of ordering that perception in images.

Purism, for example, met the challenge head on. As the invention of Amédée Ozenfant and Charles-Edouard Jeanneret (Le Corbusier), purists through form, line, point, and color attempted to find an order in nature which the scientist finds in his universe. In cubist shapes such as guitars, bottles, and other ordinary objects, they felt such an order had been found. In the world of massive change and disorder, line, point, and color—Kandinsky's "holy referents"—were inalterable, with color as a surface factor subordinate to form. Vertical and horizontal were the true creator of order, and the artist who achieved such order had gained what Corbusier called "passion." Passion was not an extreme of anarchy, but the display of order the artist finds in rampant nature and in a material world. Ozenfant and Jeanneret (le Corbusier) hoped to "crystallize" art, and expressed their views in *Après le Cubisme* in 1918 and then in a magazine they ran from 1920 to 1925, *L'Esprit nouveau*. What is striking about Purism is how it took the idea of the avant-garde ("The New Spirit"), which had been a spirit of disorder, and turned it toward a new type of higher order, a counter to Dada and surrealism.

Since few movements fully run their course, we should seek mutants. Purism would surface in the mid-twenties in Germany as *Die neue Sachlichkeit*, very roughly the New Objectivity or, more precisely, the "New Matter-ness." One of the chief exhibitors of *Die neue Sachlichkeit* was Max Beckmann, but others included socially and politically oriented commentators like George Grosz and Otto Dix. An American beneficiary of the general movement was Edward Hopper. The new "matter-ness" was not a return to realism, but it was a response to cubism, abstraction, and Dada, as well as a reflection of the Weimar struggles to survive politically in postwar Germany. We could also cite it as the beginning of the end of radical avant-gardes in Germany, with the Bauhaus, now in Dessau, looming as the new academy. The Bauhaus, as we shall see, was a strange expression of Modern. With its stress on building (*Der Bau*) and on crafts and yet its utilization of new materials and new concepts of construction, it seemed to pull in two directions: expressing the new even while deferring to (even glorifying) technology and functionalism.

Cubism was itself only partly a style or technique, never really a cohesive movement, surely never a school of painting or thought. Perhaps, a visionary

method! It was a response to everything external to the world of paint: the decline of empires sociopolitically and the alteration in perception created by the new physics, in quantum and relativity; not the least, it absorbed, less gaudily than surrealism, the Freudian unconscious. Its idea was to present a new kind of reality—reality for the twentieth century. We should see cubism as very much a turn-of-the-century phenomenon, like atonality in Schoenberg. Its major break was with traditional forms of *trompe l'oeil*, its separation of pictorial functions of color, form, and volume, making each independent of the other. It upset almost completely the "flow" of painting and insisted on linkage between the abstract sense of an object and its representation in the artifice of paint.

In changing perspective into flat surfaces, cubism associated volume and space in one medium much as Proust linked history, pastness, and time through memory in another. Although methods seem vastly different because of different mediums, there is a definite relationship here between painting and literature, between spatial and temporal concepts. As Proust was delving beneath voluntary memory to what he called involuntary memory, so the cubists undercut "false depths" and aimed at a different sense of objects, as if set in a flattened-out world. Thus, objects were framed differently, floating free of expectation and yet insistent on themselves in their new settings.

Finally, as part of the "new ugliness" Picasso insisted on, we find the introduction of a very democratic concept into painting: the utilization of vulgar items and materials. Picasso here was more insistent than Braque on the vulgar items, using newspapers, bottles, lemons, pipes, glasses, and such objects as part of the "pasted-on" quality. These works from 1913–14 onward are, clearly, political statements by way of an almost abstract art; in contrast, we see how Kandinsky was truly abstract—there is no political residue there, unless one sees abstraction as itself such a statement. Picasso in later years insisted, to Françoise Gilot, that cubism was an effort to "get back to some kind of order. . . . We were trying to set up a new order. . . ." Often the artists did not sign their paintings—they did so only later—since they were interested in points of view, not individuals. Their subversion of *trompe l'oeil* was intended to provide alternatives to "fooling the eye"; to achieve in painting "the reality in nature." Painting, Picasso insisted, must take over from nature.

Before leaving this phase of the avant-garde in painting, we should make some further mention of Delaunay and Malevich. Around 1912, Delaunay, whose significance—like Derain's—has never received its due, defined his painting philosophy. His remarks appear in letters to August Macke and Wassily Kandinsky, as well as in a brief article called "Light," which Paul Klee translated into German and published in *Der Sturm*.

To Kandinsky, he writes of his need to discover the laws of "pure painting." The cubists had moved toward this ideal, but they experimented "only in line," not in color; they are not constructionally pure. He, Delaunay, has defined laws "in the transparency of color, whose similarity to musical notes drove me to discover the 'movement of color.' " In "Light," he writes of the "contrasts of colors between themselves which constitutes *Reality*." If we endow this reality with *Vastness*, it becomes "Rhythmic Simultaneity." We must have a horror of constraint. "If Art relates itself to an *Object*, it becomes descriptive, divisionist, literary." It is, then, no better than an art of imitation. The way to "represent"—

that is, *to be* in painting—is through color, contrasts, simultaneity, movement and rhythm, proportion, all of whose qualities work to void objects.

Emphasis on rhythms, dynamics, and movement recalls the futurists, whose stock-in-trade had become expansionist, spatial exploration. A new consciousness had arisen in which the sub- or preconscious generated its own terms. There was, in the insistence of these new styles, a dualism or binary element: the artist's desire to express his individuality and his need to immerse himself in dynamics that lay beyond him. * One such dynamic was velocity; another was the life force that Bergson had explored earlier, what Nietzsche would suggest in his polarity of Apollo and Dionysus; a third was internal mechanisms, psychological energies. Kandinsky reconciled such matters with line and point, abstractions that carried him beyond objects; Yeats used spiritualism in an earlier decade to carry his work beyond matter into spirit. Eliot in the next decade would seek such a beyond for himself in traditional Christianity, but by then Modernism was sputtering.

Delaunay foresaw the apocalypse, as early as 1909–11, when he painted his series of the Eiffel Tower: "a prophetic vision. . . . The desire for a great cleaning, for burying the old, the past, everything, for entombment." He envisaged his view of Paris and of the Tower specifically as a "shattering," a kind of vast still-life in which stillness was exploded. As form, color, line, the Tower series intimates that a bomb has just exploded and pieces are about to blow apart. The paintings suggest centrifugal force of immense power—the energy of the futurists has been assimilated to the vision of Armageddon. There is, also, a witty dimension: blow apart the Eiffel Tower and you have blown apart Paris itself. Further, Delaunay's Towers are truncated, "corkscrewed," as Blaise Cendrars described them; all perspective and nonrepresentational, the Towers both dominate and crumble. All Paris comes down with them, as they collapse into the spectator or explode in his face.

For those in the early 1910s—Delaunay, Kandinsky, others loosely linked as Orphists, futurists, even expressionists—there was the need to discover a new kind of gravity that could carry one beyond matter and the external world. We have already observed this in numerous areas, not least in spiritual autobiography. What appears to be anti-intellectualism, even antihumanism, is really mind and humanity applied to different needs, artists seeking different resolutions. Very possibly, the furthest reach of this attitude was expressed by the suprematist Kazimir Malevich, † whose body of work is only beginning to gain the attention

* Edvard Munch's *The Sun*, an Oslo University Assembly Hall mural (1909–16), is painted energy. Although Munch's work is not ordinarily associated with any of these movements, he, too, was caught by that need to get "beyond." The upper half of the Munch mural is the radiating out of an explosive force of heat, light, glare—as if an exploding atom. At the very epicenter of the canvas is the sun, but just below it is a smaller sun. A village or clump of houses lies beneath, surrounded by forbidding mountainous areas, all of them dominated by the ball of yellow. In the middle distance, between town and sun, are inlets and splashes of bluish water, barely realized, almost buried between crushing light and heavy rock. The overall sense of the painting is its explosive energy: nuclear, sexual, irrational, terribly primitive in its "beyondness."

† Suprematist values appeared in the manifesto in 1915 signed by Klioun, Menkov, Puni, and Bogouslavskya; but one of the chief purveyors of Malevich's ideas and work was El Lissitzky, who continued working both in and against suprematist ideas into the Stalin era.

A presuprematist work by Malevich was his 1913 designing of the *Gesamtkunstwerk* called *Victory Over the Sun*. Besides Malevich's costumes and scenery, this futurist-cubist-semiabstract part-play, part-opera had a libretto by Velimir Khlebnikov and Aleksei Kruchenykh and music by Mikhail Matiushin. The import of the work is to strike down the sun as representative of the stodgy present

it deserves. Malevich's 1918 *Suprematist Composition: White on White* is a Modernist ultimate, a sweeping out. Apart from how the viewer finally judges it, it tests every foundation stone of the Modern movement, in the same way that Schoenberg's twelve tones, Kandinsky's early abstractions, Mallarmé's poems of absence and void, Picasso's *Demoiselles*, Stravinsky's *Rite of Spring*, and Kafka's early efforts at short fiction up to and including *The Metamorphosis* did.

This famous painting, at the Museum of Modern Art in New York, is a white almost-square shape tilted against a larger white background that is not quite square. The top left corner of the inset shape almost touches the top of the canvas, but does not; the right top of the tilted almost-square nearly touches the right side of the canvas, but does not. There is nothing else, or so it seems. But Malevich had prepared the viewer with an even more daring work, in 1913, a "pure" black square on a white background, and the 1916 *Suprematist composition conveying a feeling of universal space*, with six small diagonal crosses on a white oblong ground. For Malevich, the square took on the quality of a refuge from the "ballast of the representational world." It was unlike the circle of previous eras, which stood for perfection or God or purity. The square simply was, a form of mesmerism, perhaps, or else an artifact of futurist abstraction.

In his theoretical writing, Malevich revealed himself to be more a futurist than a cubist. In futurism, he saw an art reflecting "a society which has absorbed the tempo of the big city, the metallic quality of industry." But Malevich's futurist is not a social realist; on the contrary, the futurist "should create new abstract forms," using his subconscious or "superconscious" mind. From this, Malevich developed his idea of suprematism. For the latter, "the appropriate means of representation is always the one which gives fullest possible expression to feeling as such and which ignores the familiar appearance of objects." The artist must reach "a desert," which is the voiding of objects: white on white, perhaps, or black square on a white ground. Malevich explains how he sought to represent his voiding of objects by way of the square and how the critics said that all was lost, that we "are in a desert." But for Malevich, that desert "is filled with the spirit of nonobjective sensation which pervades everything." The square is not empty, but permeated by "the feeling of nonobjectivity."

In his remarks, Malevich perceived that Modernism by the 1910s meant reaching for abstraction and nonrepresentation. He reached for those middle states between conscious and unconscious where emotions reside, he says, that "are stronger than the human being himself" and that must find an outlet. He states his formula: "The square-feeling, the white field–the void beyond this feeling." Malevich's equation has the simplicity that Einstein's great formula had in physics: that economy of expression which reflects great intensity. In both, there is the desire to get beyond all the rigmarole, to penetrate masks, personae, surfaces. Malevich: "I transfigured myself to the zero of forms and then went beyond zero to creation, that is, to Suprematism, the new pictorial

and to triumph over it so that the future—whatever it is—can be achieved. Part hoax, part revolutionary drama, *Victory Over the Sun* is characterized by a stream language the librettists called *zaum*, which seems associated with Mallarmé's *ptyx* and Jarry's Ubu. Whatever communication does occur is beyond the rational, and often sound is merely vocal, not meaning. The object of the drama is to undermine all conventional expectation and, at the same time, to raise the level of disorder to a new kind of significance. It was Dada before Dada.

realism, the unfigurative creation." The achromatic painting suggests annihilation, a canvas equating Armageddon and form.

White on White may not evoke that impression at all, however. For some, it may seem the voiding of feeling, not the expression of it; or else it may appear so simplistic it deserves hoots, not attention. Yet the point of it is not its value as "a work of art," which is always a shifting value, but its *arrival*, the fact that Malevich perceived it as a critical focal point in art. We have a serious artist—and there is no question of Malevich's mature intent—ready to receive ridicule for the sake of a vision that expresses his sense of where painting is. If nothing else, he shakes our sense of the objective world; and by evoking ridicule, he has elicited one of the major responses to Modernism.

What is particularly disturbing about *White on White* for the viewer, as for other similar work, is its lack of narrative or story line, comparable to lack of melody in the twelve tones and to loss of frame of reference in stream of consciousness fiction. Malevich speaks of getting at the real, the "true value of things," although it can be questioned whether his squares represent truth. They may, however, represent the certainty of the man behind the squares that they represent truth; and this intensity of faith in the representation, whatever else its effect, is an acute aspect of Modernism. Malevich, who rode the waves of the Russian Revolution and would formulate his ideas amidst turbulence, saw suprematism, like futurism, as a new expression of space. That is, it goes beyond painting to all forms, "a new architecture," from "surface of canvas to space."

Each painting represents a vision, something more than itself. Malevich perceived that painting had to go beyond its traditional role as a wall hanging with objects represented on it. It had to move outside of manners, social groupings, cultural organization. He is clearly indebted to the spiritualist movement, the ideas of Madame Blavatsky and her fellow theosophists, as well as to the entire psychological movement beginning with Bergson and James and continuing into psychoanalysis. But Malevich hoped, with suprematism, to go beyond any such movements, since they had practical considerations he deemed anathema to painting. He had in mind nothing less than plastic feelings generating spatiality itself: infinity as the goal. One finds an analogue in Kafka's unfinished *The Castle*, a novel whose subtext is infinitude.

It should be added that suprematism and Malevich in particular did not go unanswered. The response to suprematism was constructivism, and the answer to Malevich's *White on White* was Alexander Rodchenko's *Black on Black*. Although the viewer may feel he is present at some man-to-man combat in paint, the issues involved are sizable and go beyond individuals. Constructivism was part of the inevitable backlash to abstraction, and it is not negligible that one of its chief proponents came to be El Lissitzky, whose mentor had been Malevich.

Constructivism attempted to return painting to some social and political accounting; the fact that it developed in the Soviet Union in the years after the Revolution helped nourish its societal basis. Not to be confused with later Socialist realism under Stalin, it argued that the artist cannot ignore the needs of the community, that the way he can contribute is by working with machine production. The leading constructivists were all craftsmen as well as artists. Vladimir Tatlin taught wood and metal fabrication; Rodchenko worked in typography, furniture design, and magazine illustration, along with photography

and film; El Lissitzky was adept in architecture and interior design. Layout, design, photography, and film brought them into touch with objects. The constructivists had their major opponent in Kandinsky, whose spiritualization of line, plane, and facets they negated with what they called "concrete problems." Rather than theorizing that the means of art had their own spiritual values, they argued that objects once created would generate a unique spirituality.

El Lissitzky developed his idea of the *proun*, perhaps the most famous tag word to come from the group, to suggest "new art objects." In this respect, painting, sculpture, all the traditional forms that had existed for themselves would be reshaped to form industrial products, architecture, functional items. All of Kandinsky's (and Naum Gabo's) lines, shapes, and colors, as well as cubist facets and planes, would be effaced in the creation of the "new object." *Proun* indicates that constructivism is concrete, even functional, not psychological or abstract. We can see both Bauhaus and Revolution feeding into Russian art, until Stalin's repression by the end of the 1920s brought it all to a halt. But before that, Russian painting as a whole saw a reversal of the Diaspora for Jews and non-Jews alike, as Kandinsky, El Lissitzky, Chagall, Popova, and others were ingathered to the mother country, bringing with them every version of the new. Like most avant-gardes, constructivism lasted about five years. But perhaps its greatest residue was the influence of the Malevich-constructivist conflict on Kandinsky, who went on to establish himself as the premiere abstractionist of the century.

Earlier we raised questions of the connection of art to the larger culture, a quite traditional question which becomes thorny and ambiguous when we try to link arts based on extreme individuality with a surrounding culture founded on science and technology. The two elements—an avant-garde in one area, a leveling in the other; an ego-oriented culture in one respect, an impersonal, objective culture in another—would seem to inhabit different worlds or planets. Especially, we wonder how art forms as nonfigurative as cubism and abstraction can possibly respond to the larger culture where representation and objectivity are norms.

There are, apparently, no clear or precise answers. Art and culture do not lead to unities or exact linkages, but they can result in certain parallel developments or even in tentative reconciliations. One way in may be through Freud, whose major work in the first decade or so after the 1900s, following his *Interpretation of Dreams*, ran parallel to fauvism, cubism, futurism, early expressionism and abstraction, not to speak of "Zone," spiritual autobiography, the first stirrings of Joyce, Yeats's shift in style, the atonalities of Schoenberg, the memory-orientation of Proust, and the initial stirrings of Kafka. Right at the center of this activity is Freud's *Three Essays on the Theory of Sexuality*, with *Totem and Taboo* following shortly afterward. *

Even though *Three Essays* was published in 1905, † it was in a state of

* The four essays making up the study were published as *Totem and Taboo* in 1913, but they appeared originally in Volumes I and II of the Vienna *Imago*, in 1912 and 1913, under the title "On Some Points of Agreement between the Mental Lives of Savages and Neurotics."

† *Three Essays* appeared five years after *The Interpretation of Dreams*, four years after *The Psychopathology of Everyday Life*, and in the same year as his case history of Dora and *Jokes and Their Relation to the Unconscious*.

almost continual revision, and major elements were added in 1915: the sections on infantile sexual theories and the pregenital organization of the libido. In 1915, Freud also added, to the third essay, the section on the libido theory. Even as late as 1920, fifteen years after the original publication, Freud was making changes in his ideas on the chemical basis of sexuality. If we back up from 1905, we can see Freud touching on many of these theoretical points as early as 1894, in a letter to Fliess, then continuing in a similar vein in further letters to Fliess. He was himself to be profoundly influenced by the latter's ideas on bisexuality.

What we can claim is that something as far removed from the arts as Freud's *Three Essays*, a work lying in a culture of child development, sexuality, libidinal drives, with their derivation from man's appetite for anarchy, has within it many of the qualities we associate with the arts themselves. Freud often viewed *Three Essays* as a kind of long-revised poem or opera, touching it up, adding to it, striking out lines, working it along, over a period of twenty years. We see it beginning with his earliest researches and then emerging in his most abundant period; but he was still dissatisifed with it, like Yeats with his poems, which he carved and sheared until he made them right.

An even more apt example would be Picasso's preparation for *Les Demoiselles*—almost an exact contemporary of *Three Essays*. Beginning in 1906, Picasso made nineteen sketches, not including separate figures; at first, as we have noted, with seven, not five, figures. The two excised were men, one a sailor. When the two men disappeared, the direction of the painting was altered, for the women's eyes moved from their customers to the viewer. But the largest alterations were made in the faces of the women to the right of the canvas, which became African masks; and in the woman on the far left, who seems quasi-masked. At one point, Picasso planned to turn all figures into Africans, shifting his sense of volume to that flat representation of features he found in masks. Picasso used this painting as a laboratory, making changes as he came under successive influences, from Cézanne and Gauguin to Iberian sculptures and African masks.

If we accept that Freud was modeling his *Three Essays*, in its way, as a long poem or dramatic work, doing preliminary or experimental sketches before finding the work "finished," then we have tentatively blended issues in the larger culture with those in the arts. This is, however, only the beginning. For Freud, reason is a mask; infinite inner space is our destiny. He has made sexuality—a manifestation, almost an object in history—*into an abstraction*. A great determinant of sickness or health, it cannot be measured by what is expressed. It must be taken on faith unless the individual undergoes a long journey with the analyst to seek out his or her expression of it. And the larger social or cultural expression is no indicator of the individual sense, which remains singular and unique.

In this respect, Freud was moving along in sexuality—infantile and childhood development, and the like—toward goals similar to those we find in the arts. We discover, in Freud, the creation of another world, an alternate or even adversary world; in this place, objects have a different significance from what they possess in the scientific or technologically oriented world. Once Freud had moved "in," he confronted different spatial, aural, and visual determinants. Even heredity, which was a commodity of sorts, measurable by one's genealogy,

recedes in this regard, succumbing to other, more significant, factors. Further-more, by carrying the adult sensibility back to infantile experiences, beyond conscious memory, Freud's gnosticism removed objects from their usual context and relocated them, as it were, in shadows, distorted. We are what we are because of elements veiled to us or else disguised in other forms; the idea of the mask or persona runs parallel.

If we examine what Freud attempted, we can perceive how similar it was to what Bergson and Proust were leading to in the uses of memory. Aside from the groundbreaking discussions of infant sexuality, the important element in Freud's work here is his establishment of a hunger or driving force, the libido, which exists from our earliest days, but which remains hidden or disguised. Freud's discussion of what he considers our most significant "hunger" establishes a network of drives, appetites, responses, possibly neuroses and pathologies im-possible to pinpoint with precision. We are, ourselves, a huge abstraction, so to speak; a physical being full of disguised drives, nonfigurative elements. We are an abstraction which the analyst will try to fill in, i.e., try to make more representational.

Freud emphasized several new points. He first announced that it would "seem probable that the sexual instinct is in the first instance independent of its object; nor is its original likely to be due to the object's attraction." Objects, here love objects, are themselves independent of the basic instinct lavished on them. Second, Freud stressed "that disturbances of the sexual instinct among the insane do not differ from those that occur among the healthy. . . ." On this point, Freud is clear that the sexual instinct of an individual is separate from the rest of him/her, in that a person with otherwise normal behavior may display sexual aberrations. Yet behavior that becomes neurotic or pathological is attrib-utable to sexual malfunction. Third, Freud admitted that sexual impulses "are among those which, even normally, are the least controlled by the higher ac-tivities of the mind"—thus separated from rational elements. These points are summarized:

> . . . Here again we cannot escape from the fact that people whose behavior
> is in other respects normal can, under the domination of the most unruly
> of all the instincts, put themselves in the category of sick persons in the
> single sphere of sexual life. On the other hand, manifest abnormality in
> the other relations of life can invariably be shown to have a background
> of abnormal sexual conduct.

We are almost ready to draw a noose around our analogy: how a style or movement in the arts, here nonfigurative art and abstraction, could be linked to the larger culture. Yet before we do, we should look further. Freud makes related points which, while now part of our standard thinking, were then rev-olutionary. In speaking of neurotic or pathological manifestations, he stressed that the sexual life of the individual was being expressed in those neurotic symptoms; that "the symptoms constitute the sexual activity of the patient." With this, an ostensible behavioral pattern—what can be discerned, even measured or quantified—is merely an expression of something immeasurable, theoretical, disguised, trapped deep in the individual's past; inaccessible except by a process that seemed, in those days, to be a form of mumbo-jumbo magic or witchcraft. Not by chance, Freud's thinking while he was still revising *Three Essays* turned

to *Totem and Taboo*, seeking there the linkage between the psychology of primitive people and the psychology of obsessive neurotics.

Freud turned sexual matters into a kind of witch's brew of superstition, a great hungering drive which is no more measurable than Kubla Khan's sacred river, Alph. In addition, Freud—perhaps attempting reassurance—asserted that the disposition to perversions "is itself of no great rarity but must form a part of what passes as the normal constitution." From this, he moved on to infantile sexuality, undermining at least in theory hitherto held ideas of heredity.

Key images here are those of reshaping. Once we begin the journey to discover our unique sexuality, we forsake familiar shapes. We agree, as part of this journey with a listening companion—himself undefined as a shaping force—to accept a different perspective; we hope, through this acceptance, to discover ourself and, if needed, to recover mental health. (Here we are close to the spiritualism and theosophy of the Madame Blavatsky movement and its various spinoffs.) When we make that journey and retrieve memories, objects, encounters, they come in distorted forms; shapes that once had seemed familiar arrive in our consciousness by way of a dream process. We may, in fact, have encountered them in dreams, where as distortions of the "real" they have tortured us. However we label such elements, these dreams, shapes from the unconscious, reshapings in the preconscious transform the way we experience objects *and prepare us for abstractions and nonfigurative forms.*

Possibly, we can view even *Totem and Taboo* as part of Freud's "reshaping" of larger cultural material. By equating in several areas the structures of primitive life to the inner life of obsessive neurotics, Freud was stressing psychical realities over factual ones. Frazer had established much of the evidence that Freud used for examples, but the latter redeployed Frazer. What were data in one became inner dimensionality in the other. Freud's equation of inner and outer here recalls Proustian temporal modes, Einsteinian spatial concepts, the developments we have charted in cubism and abstraction. The further Freud moved internally, toward defining the obsessive neurotic, the more he forced a reshaping of the outward material the neurotic recalled. Conversely, the further Freud identified what he meant by totem and taboo, the more he enforced a reshaping of man's innerness. The Freudian response to time and space in the first decade of the 1900s was no less revolutionary than Einstein's four papers in 1905.

Reordered time and space, disguised objects, loss of rational control, reshapings of ordinary events, the restructuring of memory, a new sense of visuality and aurality—all of these are suggested or defined in *Three Essays* as matters of sexual experience. Such experiences, like those offered to the viewer in abstract and nonfigurative art, are part of some mysterious, even "spiritual" experience. Kandinsky certainly felt that line, point, new elements of time and space were such spiritual matters. Freud expressed something of the same thing: "In thus distinguishing between libidinal and other forms of psychical energy we are giving expression to the presumption that the sexual processes occurring in the organism are distinguished from the nutritive processes by a special chemistry." That "special chemistry"—the nature of which Freud defined in a 1915 addition to *Three Essays* as deriving from a shifting ego- and object-libido—coincides with the blossoming of abstraction in the arts and comes on the threshold of Dadaism, a stretching out of and joke upon such abstraction.

In one other respect, *Three Essays* disrupted ordinary perspective and, there-

fore, paralleled in the larger culture what nonobjectivists and early abstractionists hoped to accomplish. However tentatively, Freud established a new order of sexual development; really a radical reordering of how we "view" it. First, he stressed the sexuality of infantile behavior (thumb sucking, bowel movements, et al.), then he defined a period of from two or three to five years as a time of "efflorescence," followed by a period of latency up to puberty. But the period of latency is not stoppage; it is a time of storage, repression, reaction forming, the building up of barriers against sexuality.

New lines, points, spatial dimensions are introduced when Freud announces that "external influences of seduction are capable of provoking interruptions of the latency period or even its cessation." This means that intruders have interrupted the child's development, but these intruders lie outside conscious memory; lacking tea and madeleine, one must undergo a journey with an analyst to discover what happened in one's latency period. Surely witchcraft had no stranger guidelines.

Freud giveth and Freud taketh away, for these theories upset our notions of straightforward development, clear identification of impulses, choice in matters of behavior. Determinism seems our lot, but it is a bizarre determinism, in that we have made the choices based on information we cannot even identify. The consequence is that unsettling of the psyche which early symbolists held to as their goal; and this unsettling is part of the reshaping of experience involved in abstraction and its insistence on separation of viewer from object, its emphasis on object-lessness.

Yet even while there is little question that stress on psychological and psychoanalytic elements helped lead the way to abstraction—and worked reciprocally in areas of reshaping—we should not be satisfied with that as a complete response to the question of why abstraction began to infuse Modernism after 1900, and to dominate it after 1910. There must be other factors, some possibly even more dominant. As we saw in the section on spiritual autobiography, there was a spiritual malaise and crisis as apart from that antagonism toward science and materialism which had existed in Western culture for at least a century. The spiritual crisis was so profound that nothing less than a new way of looking at life could resolve it. The crisis created circumstances in which shapes, forms, creation, development, ultimates were all reperceived. The crisis meant everything was "re," or "neo," or "added-on." Time and space, once taken for granted as agents of man's thinking, were now rerouted through the sense of the new; inner and outer were redirected. Objects took on different values, and systems and institutions were reshaped or redefined through ridicule, satire, or direct subversion.

That proliferation of avant-gardes in waves, many of them overlapping, suggests they compensated for spiritual crises. They offered, in effect, the sole kind of relief one could seek, their basis the reshaping of experience and sensibilities. Freud's emphasis on the rejection of fathers, which he saw in primitive societies in *Totem and Taboo* as well as in contemporary obsessional neurotics, was in one respect a response to spiritual malaise. The avant-garde shifted the terms, suggesting that spirituality had to be sought in art forms, not life, and that such spirituality had to be abstracted from art, as expressed by Kandinsky in *Concerning the Spiritual in Art* (originally published as *The Art of Spiritual*

Harmony).* Those forms of naturalistic or realistic art where confrontation with experience was representational became for the avant-gardeist worse enemies than institutions or systems themselves. Still, disruption of space and time orientation, emphasis on ego and self, solipsism shading into narcissism: all of these were responses to spiritual crises and, at the same time, inevitable movements toward nonrepresentational art forms. The ultimate silence, for a painter, was a line or point. The ultimate absence, for the writer, was the stream. The ultimate stillness, for the composer, was the redirecting of expected sound. The ultimate for Freud was dream, memory, the unconscious—those, too, as aspects of spiritual crisis.

The abstract, nonrepresentational movement was based not only on technique but on the destruction of expectation. Kafka was the master of the receding frame, the equivalent in fiction of the "internal frame" the cubists discovered and exploited, a device linked to expectation. In this, all material is framed so that it serves a dual function: as itself and as a shape with spatial perspectives. The frame—whose other manifestation comes with a self-conscious narrator—combines both a technique or mode of narration and a content.

One reason Kafka's writing gives such difficulty, when it seems so limpid, is that his spacing is in multiples. What seems foreground becomes, by receding, background, and vice versa; as if a given "picture" had actual movement.† How he accomplished this is far more difficult to explain than the mere citation of it, but it is nevertheless a point often neglected. Kafka was heir to nearly every avant-garde movement in the early twentieth century, although, superficially, he appeared isolated in Prague.

Internal reshapings, silences, pauses, absences were forms of worship, responses to spiritual malaise. We are familiar with how art became a religious substitute, how when the avant-garde assumed successive waves of spirituality the artist posed as and became a god. Less familiar, perhaps, is the fact that culture was itself ready to accommodate these reshapings, not out of desire to welcome change but because it was so enervated only change could infuse energy. In most instances, the larger culture embodied a state ready to collapse from its own dead weight, or a state that had lost its bearings and

* Or in his *Point and Line to Plane*, in 1926. Note the spiritualization of the point as it is transformed into the line: "There exists still another force which develops not within the point, but outside of it. This force hurls itself upon the point which is digging its way into the surface, tears it out and pushes it about the surface in one direction or another. The concentric tension of the point is thereby immediately destroyed and, as a result, it perishes and a new being arises out of it which leads a new, independent life in accordance with its own laws. This is the Line." Painting is the self-creation of points leaping from one world into another.

† A good place to examine this is in his little-known fragment of a play *The Guardian of the Tomb* (1916). The play suggests not the casting of light on a mysterious event—what would be normal in another kind of drama—but the increasing obfuscation of the situation. The situation exists outside time and space, and then becomes ever more shadowed. Words do not illuminate, they confuse and darken. The drama seems to be an area of light in the context of darkness, but, paradoxically, with words and events Kafka makes the play also part of darkness, inexplicable. The Princess speaks the final words: "But I know it is getting blacker and blacker, this time it is an autumn sad beyond all measure." One dimension of the fragment is political—references to the fading Austro-Hungarian Empire are unmistakable. But like an abstractionist, Kafka makes certain nothing is recognizable. He is not an expressionist, but a suppressionist, which locates him closer to abstraction and classical cubism than to anything else.

was merely holding on to a counterfeit nationalism. Politics took on the illusions of dreams—Mann would quarry this in his Joseph tetralogy. The avant-garde found all the seams in such shaky structures and poured through.

The obverse of this structure ready to collapse was the state and its institutions sealing themselves off, hoping that by isolating themselves from the new they could control their destiny. For Proust's characters, the danger of Dreyfus was his intimations of a new order, even though the victim by choice really belonged to the old. Dreyfus, simply, was not supposed to occur. By sealing themselves off in factitious chauvinism, several groups hoped to block out Modernism*; just as Franz Joseph's failing empire tried to maintain power over a disintegrating hegemony by banning Klimt's university ceiling paintings of Medicine and Jurisprudence. The great historians—among painters, novelists, and composers—of this dialectic between old and new, traditional and avant-garde, trivial and iconoclastic are, evidently, Proust and Kafka.

The key to each is transformation or metamorphosis: the altering not only of experience but of shape itself. Since we have already noted these reshapings in Kafka (in chapter 6), we should pursue them also in Proust. Have we noticed sufficiently that Proust's Marcel gains his artistic advantage by means of reshaping himself throughout his long tale, and that his crucial experience of the tea and madeleine is an act of metamorphosis—if not Kafkaesque then Ovidian? With that experience, his physical being does not alter, but his inner being changes to such a degree he goes from ordinary to special, from human to god. Although we usually view Kafka's "bug" as undergoing diminution, what actually occurs is that he becomes far more meaningful and special after his alteration than he was before, when his devotion was taken for granted. His metamorphosis forces a transformation in every element of the family, so that what he has become determines now to a large extent what they will become. Proust pursues a parallel line of development, less radical physically, but nevertheless as extreme. The Modernism of Proust lies there.

Like the cubists who were his contemporaries, Proust defined his goals by way of objects and his relationship to them. He was a cubist of sorts in words, a near abstractionist who dealt in verticals and horizontals no less than did those who rejected figuration. The exploration of Proust, it seems, must proceed from here.

* Figures as different as T. E. Lawrence ("of Arabia") and Martin Heidegger, who seem connected to Modernism, in effect agreed with the most reactionary of fascistic states that Modernism was a cancer to be rooted out. Heidegger's intellectual acceptance of the Nazis cannot be explained in any other way.

Ernst Jünger is another compelling figure, who, like T. E. Lawrence or Roger Casement, was repelled by Modernism as much as by Modernity. Jünger felt he had to purge himself, first in Africa and then in the great war. His confrontation with death at the front freed him, so that he saw in war something creative and transformational; purification could not come without death, sacrifice, martyrdom. For those like Jünger who hungered after revelation, the rituals of fascism would prove irresistible. Jünger was of that younger generation which welcomed the war as a purifier of Modern decadence; deadly conflict was the apocalypse that liberated one from materialism.

Moving along the margins of this was Ludwig Wittgenstein. Like Lawrence, he rejected fame, as a philosopher, for some private demon that demanded solitude and anonymity. The private need went so deep that it is impossible to follow, but perhaps it was only by this periodic burial of self—during WWI he served in the Austrian army and in WWII he was a hospital orderly—that he could avoid the suicidal impulses that claimed his three brothers.

THE MODERNISM OF PROUST

Although Mallarmé and Proust moved in the same circles and seemed to derive from the same experiences, the resemblance, while real, is only superficial. Proust establishes his Modernism by becoming anti-Mallarméan, by pursuing, in fact, a directly opposite path. And yet while both established their positions by rejecting realism, such is the nature of Modernism it was possible to arrive at antirealism from several directions. Proust's Modernism is, if anything, more complicated, certainly more varied.

In his circular, winding method of narration, Proust burrows in. Yet his mode is not the routine "arty" sense of creativity as something within. His burrowing is an entire culture, directly opposed to "realism" or "reality," as we commonly understand it; and yet he is our greatest social novelist—unwinding this paradox is, very possibly, one key to his Modernism. Proust distanced himself from solid objects, as part of that larger movement into abstraction and nonrepresentation, in order to explore differing space and time; whereas Mallarmé by questioning the solidity of these very objects denied all dimensions, what we find later in Samuel Beckett. Nothingness for Mallarmé became the basis for all existence; Proust was always seeking alternative cultures to the one he was abstracting from—not to deny them, but to show their potentiality beyond the routine one.

Mallarmé often speaks of a tone or texture, what in Proust becomes those extraordinary privileged moments that trigger the space and time continuum of the involuntary memory. The two writers seem superficially similar. Each is abstracting: Mallarmé through the void, Proust by perceiving that objects have infinite extension. Mallarmé often uses objects to demonstrate the void beyond them; Proust uses them to illustrate their mystery. In those respects, each is reshaping objects, Mallarmé to deny them, Proust to extend them into areas where things do not ordinarily belong. The expression of timelessness we experience in both is connected, apparently, to void in one, extension in the other. But, as we shall see, even these similarities are superficial; more than anything else, they indicate that Proust, while caught up by Mallarméan stylistics, defined different terms. Their sole agreement was on Modernistic grounds: that objects must be redefined, "abstracted from." Objects die to be resurrected.

In the sonnet "Salut," Mallarmé invokes such a moment of denial and resurrection in the "écume" of a dinner toast; and this aspect of the foaming poured drink becomes a conceit that runs the length of Mallarmé's mythical memory, catching up associations of Sirens, the Golden Fleece, sea adventures, reef and star. He is returned, finally, to "*le blanc souci*," the whiteness of the buried self, the foam now settled into a mirage of itself, the poem. The aim of the object, of "cette écume," was to allow a re-creation of the toast and through that of the potential for myth within us all; to transform all experience, ultimately, into mirage, hallucination, the ecstasy of the moment. In his utilization of the moment, Mallarmé seeks not a solidity of object, but virtual subversion or sublimation of things. It is as if words have behind their formation some unconscious which can be evoked.*

* Mallarmé's new obsession with "azure" provides another, perhaps fuller, example of how he could find the unconscious or void in a given word or idea. Azure is a presence that arrives from

For Proust, however, the ecstasy of the moment that releases the memory, *that reifies absence,* is not a denial of objects, but an ordering of them into their artistic potential. Unlike Mallarmé, who had to void what he needed, Proust strengthens and reinforces those textures and tones that evoke the memory. The tea and madeleine of Marcel's initial "moment" do not become for him, or us, mirages or hallucinatory, or even ecstasies. On the contrary, they are solid everyday objects that have within infinite extension. Proust rarely negates things in order to redefine their artistic potential, whereas Mallarmé must dissolve the object or remove it from space/time considerations. When Proust suggests a textured experience, we sense an enrichment, not an annihilation, of objects. We, in fact, carry over his feel for things to other phenomena and to our own memories, rather than await their inevitable disappearance. Proust moves us toward more variegated experience, Mallarmé toward effacement. Compared with Mallarmé, Proust is a realist; and yet Proust does not practice realism. He, too, has glimpsed abstraction or nonrepresentation, and it is that aspect of his Modernism I wish to explore.

The basis for Proust's abstraction is his dependence on within-ness. It is not for him merely an alternative, a dissenting, or a mirage-like force. What had been a thematic but marginal presence in the novel for over 150 years has become in Proust the sole arena. The voice over from Marcel, once he is cast back into memory by the episode with the tea and madeleine, derives from somewhere within the novel, not from an external narrator.* Proust has located his narrator of the material in a timeless area, which is consistent with the nature of memory. The involuntary memory has allowed Marcel to reenter areas of his life that are lost paradises, areas rejected by intelligence but retained as a perception of things abstracted from their presence. Proust quarries out of time as Kandinsky quarried out of space, out of line and point.

Once the "second Marcel" is created by way of the second memory, as it

a distance and gives Mallarmé a chance to perceive it as an "object" that has already abstracted itself from itself. He can, indeed, deny it even as he presents it. Through absence, it emerges. This seems ambiguous and almost arbitrary, but its meaning is not difficult. For Mallarmé is asserting that in his poetic use of words our awareness of the void recreates our sense of objects; that things which we have taken for granted acquire new significance, their fullness, if we space them "beyond," in the void. Without absence, there is no object.

 * The episode of tea and madeleine is almost too familiar to bear repeating; we are interested, however, in the phenomenon of narration once the involuntary memory has been released. Within Marcel, there is the sense of great spatiality trying to define itself, as his memory struggles to rise to the "clear surface" of his consciousness: ". . . this old, dead moment which the magnetism of an identical moment has travelled so far to importune, to disturb, to raise up out of the very depths of my being?" This is after he has tasted the tea with the madeleine soaked in it and then attempts to regain that paradisal moment "by retracing his thoughts to the moment when he first drank the tea." He tries again with the tea and feels "something start . . . something that leaves its resting-place and attempts to rise." He compares the experience to an anchor lying at a great depth, beginning to stir in the sand. Great spaces are now being traversed as the anchor starts to rise. He wonders if the memory, whatever it is, will reach "the clear surface of my consciousness." He calls up the magnetism of "an identical moment [which] has travelled so far to importune, to disturb, to rise up out of the very depths of my being." Suddenly, the "memory revealed itself." He drinks the tea, but there is no association; then he soaks the madeleine in the tea, and all wells up, the associations made. "And as soon as I have recognised the taste of the piece of madeleine soaked in her decoction of lime-blossom which my aunt used to give me . . . immediately the old grey house upon the street, where her room was, rose up like a stage set. . . ." A series of paintings begins to become distinct, like those pieces of paper the Japanese put in a bowl of water until the nondescript paper takes on shape and color, becomes recognizable objects: the "making" of something.

were, the material is emitted from an intermediary level similar to what we described above as the stream. The sense of this inner material being emitted from an intermediary region is comparable, in its lack of precise coordinates, to nonrepresentation in painting; Kandinsky's line and point come from an area the viewer cannot trace back to his own or the painter's experience. Although it is Marcel's voice, we do not know exactly which Marcel, since as a result of the strategy, there become several—all of them defined not by present or past reality but by memory.

There are, in fact, three discernible Marcels: Marcel Proust writing the book and "staging" the inner drama; the Marcel he is writing about, who has achieved a certain age; and the Marcel within, who is the younger Marcel experiencing the events related by the older Marcel, himself controlled by the omniscient author. But these three proliferate into several internal "Marcel voices"—multiplicities like lines, points, and color strategies that define zones on the canvas. This was, for Proust, a verbal zone equivalent to the unconscious—like Apollinaire's cubifying Paris into states of mind that lie close to the unconscious. The prototypical novel of time is really "zones" of timelessness. By making us so aware of time, by emphasizing its persistence, Proust could remove himself from formal temporal considerations. The basis of *Remembrance* is unwinding paradox.

Until the seventh and final volume, the various Marcels explore temporal dimensions of memory in order to project themselves into that future which can end with an older Marcel using such memories for purposes of art. That is, Proust is creating the work that exists somewhere just beyond those excavations of timelessness. What reinforces that timelessness is the fact that Marcel, by virtue of the tea and madeleine episode, must relive his life in retrospect, *even while that retrospect is to serve as the material for his future.* There is almost no present, not at least until the final volume. Put a different way: the young Marcel had thought of time as something he could somehow capture as it passed, as having "zones" of pastness segmented into memory, whereas space was undifferentiated, outside those orderly temporal zones. What he discovers, instead, is that spatiality can be measured, but that time—which he had counted on— has deceived him. Virginia Woolf explored a comparable phenomenon in her three temporal-spatial novels: *The Waves, Orlando, The Years,* to a lesser degree in *Mrs. Dalloway* and *To the Lighthouse. Finnegans Wake* is an even more explicit expression of such matters than the Proust novel.

Compounding the problem for young Marcel is the freezing of an inner world that has responded to a changing outer world; that is, his response to constant change beyond him has been to alter it into a solidified internal segment. It's as though he had whole paintings, musical compositions, and poems or novels lying inside memory that were the precise equivalent of social and historical change; and he could, by tapping this one or that one, invoke history. This is his achievement, but also his burden: a burden because in order to experience deeply he must enter that inner world of chance, depend on it, allow it to run its course and his life.

In the final volume, Marcel attempts reconciliation, by coming to terms with space, not time. Time has, so to speak, already taken care of itself, leaving space to be reconciled to it. Space will war with time, unless he can account for it, circumscribe it in some way. Memory must somehow function so that it

can assimilate space, as well as time. Running through *Le Temps retrouvé* is the air war, specifically the German Zeppelin attacks upon Paris. The air war is, apparently, the spatial element in the novel Marcel has rejected. Complementing it, also spatially, is the ground war proceeding a short distance from Paris, although the latter lacks the extensiveness implied by the Zeppelins.

Proust's use of the air component in a novel about memory and recapitulating time has something of Apollinaire's "simultaneism" about it. Simultaneism was a term Apollinaire gave to the practice of yoking dissimilars so as to heighten the moment. The moment, however, had to be intensified without the loss of variety, without forsaking elements *not* logically connected to it. While Proust's "privileged moment," for example, with the tea and madeleine, has simultaneism in it, the privileged moment excludes all but the intensity of that experience. In the Apollinaire formulation, the intense moment does not exclude elements apparently disconnected or varietal. Simultaneism is a term applied best to painting, and Apollinaire pursued it as he followed Delaunay into cubism; but its application to those—like the poet himself—who attempt to telescope time in words is appropriate. Like so many other Modernist terms, simultaneism has within it both order and disorder, both intense pattern and irrational elements. Ultimately, behind Proust's thought is a well-regulated, patterned world, but within it are forces of staggering illogic, not the least of which is the war in the distance here or, earlier, Swann's love for Odette which helps to establish the context.

The spatial dimension incorporating Zeppelins, Wagner's "Ride of the Valkyries," and other comparable images leads into Marcel's chief experience of simultaneism: when he "stumbles" on the uneven paving stone, which itself leads into the episode of the spoon and napkins. The revelations that will sustain him are introduced, strikingly, by externals located in space. These, somehow, are associated through their intensity with an internal experience, creating that yoking associated with simultaneism in painting. Proust speaks of soaring, like "an airman who hitherto has progressed laboriously along the ground," and then moving "slowly towards the silent heights of memory."

What constitutes Proust's Modernism thus far, despite a conventional social backgrounding to the novel, is his effort to achieve a plastic freedom that allows transformation and metamorphosis; while as part of the same process he telescopes time and blends spatiality with temporality. He has within his giant novel all the necessary frames of reference for Modernism after the turn of the century. In his use of memory, he even suggests the stream; not the stream of language, but the stream of the mind that precedes or is simultaneous with its manifestation in language. Once again, Apollinaire had been there, this time with his term *plasticity*. Plasticity is parallel to stimultaneism, at least in practice; for both aim at muddying distinctions between subjective and objective, spiritual and physical, or time and space. Plasticity allowed Apollinaire to liberate himself from convention—the conventions of a given genre and those of the artist's mind-set. It has in it something of Nietzschean alienation, in that it places the artist outside as a positive role. The ideology of plasticity is transformation; its technical mode, abstraction.

The first intimation of the uneven paving stones in the cab sets off in Marcel his internal experience: the physical act leading to a spiritual state. This is followed quickly by his view of Charlus, in another cab stopping nearby. The

Charlus he sees is a ruin of the man Marcel remembered, fallen and yet majestic. The description is marvelously projected against a city-street background, so that Charlus reaches us by way of exteriors, symmetrically matching Marcel's previous interiors. We note the same kind of expansion and retraction in Kafka, where his burrowing animals enjoy their refuge while all the time concerned about the space surrounding it. Charlus has entered myth, has himself metamorphosed: the narcissism of the earlier portraits has passed into the image of Zeus, with Jupien his faithful Ganymede and Marcel assuming the role of Orpheus-Apollo. Charlus, here, has taken onto himself the entire world of space and time.

Since Marcel must judge about interiors from what he sees externally, he can only speculate. His language falls into relativities, "perhaps this" and "perhaps that." This scene, which is still only intimations of memory from the soaring ride in the cab, is the first stage in Marcel-Bellerophon's soaring into the air on Pegasus in order to slay the Chimera. It is followed by the central paving stone episode, in which Marcel's experience upon the uneven stones "unbalances" him, dissociates him from regular space and time and relocates him in an intermediary zone, while his senses juggle images from the past. In this alternate existence, the past flows before him: the trees near Balbec, the twin steeples of Martinville, the flavor of the madeleine dipped in tea, the quintessential character of Vinteuil's sonata; and an awareness of unity is upon him, so that he can cross from his inner world into the other, then back again. He has learned to "cross over," that characteristic of what Nietzsche called a "Cosmic Dancer" and which the symbolists practiced as synesthesia. He can move among time and space as if not subject to causality.

We note how Proust fitted Marcel into a world prepared by Mallarmé, without being unduly influenced by the poet. The narrator's use of "moments" is equivalent to Narcissus's devotion to the mirror image, one of Mallarmé's favorites. Juxtaposition of moments, mirrors, and memories is an act of narcissism so deeply based we must seek it beyond Proust's character, in the *symboliste* and *fin de siècle* literature out of which Proust derived. In several ways, Marcel is holding a mirror up to the past analogously to Mallarmé's Hérodiade viewing herself in the mirror held by the Nurse. Like Marcel, she is searching not only for herself physically but for memory traces, poetic images, unification between spirit and earth. In some twisted way, she is, like Marcel, transformed into poet and artist by a process that utilizes self-love.

On his path toward artistic commitment, Marcel must dissolve ego, self, personal ambitions in order to expand. Like the epical hero, he must die within himself in order to be reborn; inner space and time must be intensified before he can gain outer space and time. He goes inward to quarry spatiality; he stops time to dissolve it and create timelessness. This kind of quest, which is typical of Modernism generally, is built on paradoxes. There seems so much languor and inaction in Modern literature because it is all preparation, the moment before dynamism.

How appropriate, then, that Marcel's liberation of himself from the bonds of time in his quest for art should come precisely when the Guermantes' invitees are most caught up in time; when all the figures from the past parade by as though in a dance of death, puppets in a puppet show, when time has etched them with acid and mocked their cosmetics. At the moment Marcel has discovered his otherness, his alliance with the timeless world where all values are

transformed, where hags and dragons can be confronted with equanimity, his former circle of idols has confronted the hags and dragons of time. Since they have never known adversariness or simultaneism, they are doomed by the self attached to their aging bodies, which will die when their bodies die. They will never know palingenesis, only death; their single selves will never ally themselves with the universal will. They are doomed to live on that surface which for Marcel is only the beginning.

He recognizes how fine the line is between temporal experiences: "I had not gone in search of the two uneven paving-stones of the courtyard upon which I stumbled. But it was precisely the fortuitous and inevitable fashion in which this and the other sensations had been encountered that proved the trueness of the past which they brought back to life, of the images which they released. . . ." Such experiences are within, not part of any conscious search. They happen to Marcel because they have already occurred internally and are waiting to be triggered. We see the same phenomenon in Kafka, even as early as "Description of a Struggle." What seems to happen, what is presented as event, has already really occurred—and the event as the reader receives it is a playback of the protagonist's mind as he goes through the event with us. We are arriving at it for the first time, on first reading, but he has already experienced it, however inchoately, however uncertainly or ambiguously. It may appear to him he is undergoing a new experience, just as we are, but in fact he recognizes elements that indicate he has already been through it; or else if not an act of true recognition, he makes associations, as Marcel does, which indicate a state of pre-experience.

The implications of this are large, and they help constitute the Modernism of both Proust and Kafka. We have already seen that such internality posits a different dimension of spatial and temporal concepts: our protagonists, simply put, move with different coordinates from the rest of us—a primary Modernist assumption. For Proust and Kafka, in addition, this stress on different coordinates accommodates their protagonists as artists or as those entering the experience of the artist. Their protagonists are metaphors, not people; even Marcel, after the accumulation of seven long volumes, has resonance only within the confines of Proust's novel. He does not "step out." Kafka's Ks and others are similar; they fill only the novel, and if we attempt to remove them, we find they collapse, so slender are their resources outside their particular roles. They are as they should be, since their function is playback rather than life. *They are not the subject of the film, but the film.* They hold our imagination not by virtue of their proximity to us, but their distance. Their existence is posited on their ability to move completely outside of our reach; not only impersonal objects, but recorders of material that holds us at bay.

If these experiences, and their subsequent development, are already within, then spatiality and timelessness meet in that interior world which is recovered by journeys and quests. Perfection, then, which is unattainable without, may be discovered and recovered within. The uniqueness of Proust's final volume, apart from the aesthetic questions it resolves, is based on his realization that unless all quests end up within, the ideal is unachievable. Swann's great passion pales beside Marcel's unification of desire through art; Charlus's melange of snobbery and masochism is mere puppetry contrasted with Marcel's insight into his own potential.

Proust's artist is predetermined, as are Kafka's seekers after self. "I had arrived then [Marcel says] at the conclusion that in fashioning a work of art we are by no means free, that we do not choose how we shall make it but that it is preexistent to us and therefore we are obliged, since it is both necessary and hidden, to do what we should have to do if it were a law of nature, that is to say to discover it." These efforts carry us into obsession and compulsion: "A writer reasons, that is to say he goes astray, only when he has not the strength to force himself to make an impression pass through all the successive stages which will culminate in its fixation, its expression."

In art, and in his search for it, Proust has found his counterpart of Gregor Samsa's metamorphosis into a monstrous bug. He arrived at something so deep that words, intuition, mythical explanations—all that we are capable of—are insufficient guides. We can go no further except into the experience itself. Such a sense goes further than Yeats's "golden bird" or his great visions of disconnected gyres, because we are forced to share, in Proust and Kafka, not a realm of pure imagination but a realm of the imagination wedded to the things of the world. * Perhaps its purest expression is not in any formal art—neither fiction, poetry, nor music—but in John Cage's extensions of silence scored for piano; or in Webern's diminutions of sound, his "playing the intervals."

Proust was part of that larger Modernist movement to liberate oneself from things, to achieve object-lessness. Although he did not necessarily share Bergson's condemnation of intellect (as a part from mind), he did need to free himself from objects, phenomena, action, and spatial concepts that appeared connected to the realm of intellect. He needed to escape from what William James had called a "block universe," into a perpetual flux in which mind and matter, pastness and presentness are interpenetrated. Bergson had spoken of the need to accustom ourselves "to think being directly," without detours, "without first appealing to the phantom of the thought which interposes itself between it and us." He added that we "must strive to see in order to see, and no longer to see in order to act." Only then can the Absolute be revealed, for it is "in a certain measure, in us," a psychological dimension, not a logical essence.

That liberation from things appears in numerous ways, not only in the movement toward abstraction but in the shaping of nonabstract elements as well. When Pound in his biographical memoir of Gaudier-Brzeska, the sculptor, speaks of *Imagisme*, he probes deeply into a kind of poetic statement associated with abstraction. Pound tells of a particular experience, when he saw faces coming from a Paris metro, how he could not find words to express the wave of beautiful faces arising. He says that if he were a painter he would capture that vision by founding a new school of "non-representative" painting, which "would speak only by arrangements in colour." He adds that when he reads

* Proust would have reached his ideas without Bergson, although the latter was undoubtedly an influence. Bergson's theory of duration is connected to his theory of meaning, in that phenomena remembered are not lost, but remain to interweave with the present. Past and present, accordingly, interpenetrate, are part of a unity, and are available to consciousness. It was possibly this aspect of Bergson in Proust that led Ortega y Gasset to call *Remembrance* a "paralytic novel." Ortega said that Proust, by forgoing action, by assimilating Bergsonian space/time, reduced narrative to "ecstatic stillness without progress or tension." The contemporary reader would argue quite the opposite. Proustian silencing of narrative may lead not to "progress," but certainly to tension and intensity; the suppression of normal time and space expectations gives the Proustian moment the compression and tensile strength of an image or a metaphor in a poem.

Kandinsky on the language of form and color, on the spiritual in art, he has nothing to learn, since he has already reached those conclusions. He offers the Japanese *hokku*, in which the image is itself the speech, the poem. It is a one-image poem, in which one idea is "set on top of another." Then Pound quotes his own effort, the now famous *Imagiste* emblem: "The apparition of these faces in the crowd: / Petals, on a wet, black bough." He admits it is meaningless unless one "has drifted into a certain vein of thought." In such a poem, he says, "one is trying to record the precise instant when a thing outward and objective transforms itself, or darts into a thing inward and subjective."

Whatever else Pound says of *Imagisme*—its directness, its lack of waste, its musical beat—the significant dimension is its sense of the Absolute. That sense is linked spiritually to Proust's "moment," Joyce's epiphany, Kandinsky's line and point; Kafka was striving to achieve it through transformations, that moment when one's life has altered. Schoenberg and his followers caught it in silences, in intervals; Stravinsky in "breakup," disruption of expectation. It is foreshadowed in cubism, as Apollinaire suspected when he spoke of plasticity, which in one sense is another theory of moments in art and experience. If simultaneism is telescoping, then it, too, depends on the moment. Abstraction, as nonfiguration in painting, as silence or intervals in musical composition, as the moment in literature, is the logical descendant of *Imagisme*. One hesitates to speak of inevitability in the arts, but for at least a quarter of the century preceding, we can note the inevitability of abstraction. Proust hangs on the edge: all those words merely a few intervals from silence and abstraction.

Midway through *Le Temps retrouvé*, Proust's narrator modulates a passage that links theories of time and duration with journey within, eliminating boundaries between subject and object: when Marcel enters the Prince de Guermantes' library and carelessly opens a volume which proves to be George Sand's *François le champi*. When he entered the library, he had been ridiculing realistic, popular, and patriotic art, and his mind had been full of contrasting elements. The book is not an extraordinary one, but it suggests harmony which his conscious mind did not think to be possible, recalling the time when his mother read it aloud to him; and it joins with the name Guermantes as a kind of magical moment, lying somewhere beneath consciousness. From that, he burrows through his impression to his childhood desire for his mother's attention, for the "stranger" in his past who hovers over him and who turns out to be himself, the child at the time of the reading of the Sand novel. Names, past experience, his own inexplicable desires, plus the direct associations of the title, all connect. It is memory, not a present scene, which matters; and it tunnels past the reality of the Guermantes' library and party to reach deep within Marcel's "castle keep," his storehouse of treasures, his archetypal memory and *spiritus mundi*.

An undistinguished piece of literature suffices here, for it is not quality that matters so much as the texture of the experience; it may come from a weak novel, a napkin, stone, or sound. Since the response to it is within, the evocation from without is circumstantial. One must catch the configuration from small matters; what remains invisible to others becomes, to the artist, a prefiguration of the whole, the part that attaches itself to his understanding of a unity. We recall Henry James's advice to the young artist, that "Experience is never limited, and it is never complete; it is an immense sensibility, a kind of huge spiderweb of the finest silken threads suspended in the chamber of consciousness, and

catching every airborne particle in its tissues." James goes on to say—and we think of the Proustian memory—that when the mind is imaginative, "It takes to itself the faintest hints of life, it converts the very pulses of the air into revelations."

The Proustian method exploits paradox. Marcel understands age and time only when he comprehends his inner journey: to get outside, he must move deeply within; to get at life, he must recognize the "trajectory from life to death" and that art lies beyond the trajectory. Change is itself an illusion. "Thus it is that the pattern of the things of this world changes. . . . all that seemed to be forever fixed is constantly being refashioned, so that the eyes of a man who has lived can contemplate the most total transformation exactly where change would have seemed to him to be most impossible."

Such a passage culminates Proust's interweaving of various levels of time. With Odette, earlier, his narrator had been astonished at the passage of time because she looked so little different from when he had last seen her. In her instance, he was responding to a timing device the obverse of the one used with Charlus. Charlus, we recall, has turned into someone semiparalytic, apoplectic, senile, a scarecrow or puppet upon a stick. With Odette, however, the process is quite different. She has apparently remained outside of time, through cosmetics and other artifices; so that Marcel's memory is disturbed from its normal course, which expected routine aging even as it found aging itself a shock. So it is with all things, externals playing themselves off against temporal expectation.

Proust's narrator uses the word "re-descend" and the phrase "descending to a greater depth within myself," as if into water which sends back refracted images. This is in keeping with mirror images and reflections, ultimately with transformation. As though an apparition, he crosses over between life and death. All those others have sought life, and indeed timelessness, by colliding head on with time; and they were defeated. Trying to avoid death, they did not cross the boundary line into that enclosed space which is life at its most intense. By the time Marcel has made that journey into the durational time of his own memories, various Kafka protagonists and antiheroes will be starting out on their equivalent journeys. They, too, will hope to be the "master of two worlds," but they are involved in too grim a quest to achieve what Marcel can accomplish in Proust's social comedy. The object lesson is Swann's, who had hoped to conquer "both worlds" through passion, a tragic emotion. For all his love for Odette, he has died; and she, recipient of Swann's devotion, is dying within, even while her appearance defies time. From his point of vantage, Marcel knows she has not mastered anything, no less two worlds; she has simply postponed it. Reluctant, indeed refusing, to die within herself in order to be reborn, she will ultimately be overcome by forces building within; whereas Marcel will always have an alternative to the decaying body, a way of measuring.

We should also call attention to Proust's assimilation of contemporary developments in art, forms of cubism not least. We note in the latter sections of the final volume, amidst reflections on time and emphasis on descent and mirror images, that age and aging has caused people to reshape themselves. The most obvious example is Bloch, whom Marcel has not seen for twenty years. Bloch has done nothing less than rearrange the nature of his features, working principally around his nose, so that he appears different. His aim has been to disguise

his Jewish origins, and toward that end he needs to disguise his "Jewish nose."
He has developed several strategies to accomplish this, which recall what Picasso
was doing with faces, even what would later become known as papier collé.
Bloch drew on materials that were not just features; later, the papiers collés were
based on the introduction of foreign materials onto the canvas. Most of all, he
had learned rearrangement of elements; but instead of working with them on
canvas, he used his entire body as the field of operations.

Proust speaks of an "English *chic*" which had "completely transformed his
appearance and smoothed away, as with a plane, everything in it that was
susceptible of such treatment." Bloch has rearranged his curly hair, so that what
was once "Jewish hair" now lies flat, parted in the middle. But his masterpiece
has been his nose, as it had been with Picasso, who relocated noses both on
and off faces. "His nose remained large and red, but seemed now to owe its
tumescence to a sort of permanent cold which served also to explain the nasal
intonation with which he languidly delivered his studied sentences. . . ." The
combination had "recreated" a new man. "And thanks to the way in which he
brushed his hair, to the suppression of his mustache, to the elegance of his
whole figure . . . his Jewish nose was now scarcely more visible than is the
deformity of a hunch-backed woman who skillfully arranges her appearance."

Yet Bloch is not through. He has introduced a monocle, and this piece of
what Marcel calls "machinery" has permitted the ultimate alteration. "By in-
troducing an element of machinery into Bloch's face this monocle absolved it
of all those difficult duties which a human face is normally called upon to
discharge, such as being beautiful or expressing intelligence or kindliness or
effort." Bloch disguises himself with the monocle, but also hides behind it. Not
only does he recreate his own look, he recreates the way in which the viewer
looks on him. A monocle establishes its own terms for viewing, being at once
a window and a reflector, something artificial. Yet Bloch makes it fit, giving his
features the same flattened, expressionless surface the monocle itself obtains.

Connected to the meeting with Bloch is another aspect of the painting
experience, and that is the question of "recognitions." Experimentation with
representation in painting led to collage and papier collés and would in a few
years lead into Dada and then surrealism; but within almost successive years we
had the several movements cited above, suprematism, frontalism, formalism,
developments in futurism, et al., most of them concerned mainly with aspects
of representation. Proustian Modernism is manifest in that area, only since he
worked by word, not brush stroke, he questioned representation through time,
not space. Part of the temporal modality is connected to the appearance of people
after many years—both their changes and their abilities to withstand change;
but part is also linked to *who was who.*

The most obvious example here is Mme Verdurin, who is the new Princesse
de Guermantes; and she has arrived there by way of still another alliance, to the
aged Duc de Duras, whom she had married shortly after the death of M.
Verdurin. By means of the death of her two husbands and the first Princesse,
she is now at the peak of society. She has gained her role by her ability to defy
death, to defy time; but outliving her contemporaries is not her only feat. She
is capable of changing recognition, of altering shapes, of being quite "other"
than what her acquaintances in Combray thought her to be. Whereas Bloch
has altered his appearance, she has reshaped herself by way of some inner drive

or demon, so that with neither obvious talent nor looks she has reached the apex. The reshaping came from within and was apparently obvious only to herself; as much as Bloch hid or disguised his nose, she has disguised her entire being.

But Proust is not finished. Those fragments of time he has experienced—tea and madeleine, uneven paving stones, rough texture of napkin, sound of the spoon—are themselves reshapings, although not so obvious as with faces and lives. What he calls "fragments of existence" are forms of eternity, even if they seem only momentary disruptions. They are extraordinary temporal elements, analogous to spatial experiments in cubist painting. The aim is similar: to create from ordinary objects the extraordinary experience. In Proust, the triggering event is almost beneath notice, the commonplaces of daily life which would normally be ignored. In another respect, these experiences are the quintessential artistic experience: that moment when Marcel recognizes his difference from others by virtue of his art, what Joyce recorded as his epiphanies.

None of this is startling in itself, since, with different labels, it has been for some time part of the Western artistic tradition. What is unusual, however, is the way in which differing modes dealing with various materials overlap each other in common pursuit of disruption, eternity, or the extraordinary, all the while trading on ordinary and commonplace things. Here, too, we can cite Eliot, whose "Prufrock"—an exact contemporary—is the sum total of commonplaces; and yet from this, he emerges as special. To extract the special from the commonplace is the measure of the artist, but more is involved. For he must consciously "decipher," as Proust puts it, so that the "observable manifestation" can be translated, making us travel back to unravel what our "vanity, our passions, our spirit of imitation, our abstract intelligence, our habits" have created. This traveling back toward absolute forms once again recalls the way of the analytical cubists, whose method was to derive the original form of things. That desire to turn all dimensionality into facets and planes, or other forms, is linked to Proust's insistence that the artist must unravel his past by undoing what has clustered around it.

The aim is to discover unknowns, which means getting beyond the symbols—Marcel labels them Guermantes, Albertine, Gilberte, Saint-Loup, Balbec, etc.—so as to restore the meaning that habit "had caused them to lose" for him. The recovery of "lost time" would be his means; and with this, Marcel can let his body disintegrate, which it will anyway, since each fragment that breaks away only adds to his work. We spoke above of Mallarmé's "azure" as a presence or object that lies beyond its absence, something that exists because of its absence; in Proust, while azure is less abstract, it embodies nevertheless the sense of being transported. He experiences colors, but, even more, "a whole instant of my life" which strips former memories of imperfection and gives him a vision of unity and perfection. That striving toward the absolute which is the essence of those "fragments of existence" or "privileged moments" is possibly Proust's chief contribution to Modernism (as apart from his contribution to the novel); and if not that, then his ability to extract, through involuntary memory, the extraordinary from the ordinary, the unusual from the usual. In redescending into himself, he hears bells "peal [which] had always been there, inside me" and "the whole of that past which I was not aware that I carried about within me."

MODERN NARRATIVE

When Modernism blossomed, it evidently had many dimensions, some of them more predictable than others. Although Proust's seven volumes serve as a recapitulation, there are several areas that he only touches upon or which lie outside the mainstream of his achievement. In fiction, beyond Proust, the chief signs of change came in three areas, two of which we have charted: in subject matter, as spiritual autobiography; in the transformational sense of language and psychological probing, as in stream of consciousness, free association, interior monologue, and interrelated modes. The third is in the use of narrative, and this area extends, as well, to narrative in poetry, chiefly in Eliot and Pound. *

The making of Modern narrative is as revolutionary in its way as experiments in language, psychological soundings, atonality, cubism and/or abstraction. Not unusually, the experimentation in narrative was contemporaneous with those other developments; hence it is impossible to ignore that Modernism was *sweeping out*, as if uniformly organized by some like-minded intelligence.

Just what is narrative? Since this is not a historical study of the phenomenon or process, let us assume that narrative is *what we start with*, an X component, a process of movement forward or backward, into the future and into the past or frozen in the present. From that, we can locate point of view, plot sequences, means of character development (such as it is), temporal and spatial dimensionality, placement of elements, types and suitability of language. Narrative remains ambiguous because it is so dependent on other, related factors. Yet we can show that narrative, along with the stream and the "new" spiritual subject matter, characterizes what we mean by literary Modernism in the 1900 to 1925 period.

Just whom are we talking about? Here the British become significant, perhaps because the written word jarred less on the conserving English mind than did atonality or abstract canvases. The writers in the forefront of narrative experimentation included Conrad, Ford, Woolf, and, of course, Joyce; we should add Broch and Döblin. The American beneficiary of much of their work, as we saw earlier, was Faulkner, especially in *Absalom, Absalom!* or *The Sound and the Fury* and *As I Lay Dying*. But the major achievement belongs to that first group, with Joyce evidently the capstone. There was, however, no pivotal piece such as *Les Demoiselles* in the development of Modern narrative, also no *Rite of Spring* or atonal Schoenberg quartet. *Ulysses* summed up rather than pointed toward. The development was more of a steady process, even a progression from one stage to another, beginning with *Lord Jim*, which falls right on the edge of the century.

The primary element in *Lord Jim*, whatever else we may conclude about it, is its repositioning of narrative elements. Ordinarily, Marlow receives most of the attention in this respect, as part of that line of self-conscious narrators which ends up, inevitably, as the stream. But Marlow is really only one factor, not even the major one. What is most significant about narrative in *Lord Jim* is its *deliberate omission of the reader*. Except for Sterne in the eighteenth century, Conrad was among the first to attempt to find a narrative equivalent of his "moral

* I have postponed my discussion of both Pound and early film as an influence on Modern narrative until chapter 8.

universe." He needed, in narrative terms, an intermediary between order and anarchy, between Nietzschean or Freudian ego and libido or id. He did not, in the nineteenth-century manner, equate nature with disorder and man with order, and once he rejected that, he needed new terms of discourse.

By "omission of the reader," we mean that Conrad located his narrative line "elsewhere." He did not use narrative as story or as plot, as in more conventional fictions. Instead, his narrative occurs in the seams: between narrators, between events, as part of the stitching. His use of such seams—the narrative as falling "between"—is, of course, a harbinger of the new; for the method when carried through to its various potentialities becomes stream and free associational. What appears so avant-garde in those later methods is implicit in the earlier method. In *Lord Jim*, the first piece of information conveyed is Jim as water clerk; the coordinates of his role and his vocation are not clarified until at least six other pieces of information are communicated. Those six pieces: the voyage of the *Patna*, the striking of the derelict hull in the Indian Ocean, the desertion of the *Patna*, the court of inquiry, Jim's sense of defeat and desire to hide himself, Marlow's interference in the young man's life. All are dispersed as narrative items, hidden or disguised along the way so that they will emerge like a hidden message once appropriate chemicals are applied to the paper.

This aspect must be stressed because it was not only Conrad's way of working, it was his way of thinking about objects and their location in our imagination. While his method lacked the full sophistication of Proustian involuntary memory, it is a worthy parallel to that. Although Proust explored pastness through that form of memory, Conrad comparably found pastness bound up with an indeterminate stage. The central intelligence arranging and deploying its troops is always Conrad, but the method involves giving small pieces of the narrative to others. The result is a kind of collective memory which is not quite sufficient at any given point. Conrad has in a sense made the novel a juncture of Bergson, the Freudian preconscious, and a Jungian collective memory as yet to be developed.

The reason the reader is excluded is to force him into different relationships with objects, or people. As the cubists set out to destroy traditional *trompe l'oeil* and to flatten out their "narratives," so Conrad, a few years earlier, found that by disrupting narrative he had the rough equivalence of negating perspective. That is, if he could move the reader to a distance beyond the area where the story first took place, he had destroyed perspectives and undermined expectation. The subversion of expectation was an essential element, in order to defamiliarize the reader and also to disguise the ordinariness of the tale. By 1900, Conrad, and others, felt that since all tales had been told the new had to reside in method, so as to make the old seem fresh. This idea, familiar in many later authors, Borges, Nabokov, Barth, and Barthelme, was really a commonplace by 1900. The great flurry of activity to omit the reader from the text was based on the awareness "new texts" could be created only by manipulating the reader. This insight in a sense carries over to painting and musical composition as well: the sense that the reader must be relocated in order to freshen the subject matter of art.

What the omission of the reader means is that the narrative depends to a large extent on the reader's reaction. The omission does not mean the reader is out of things; on the contrary, it signals the reader as having become a tremen-

dously significant factor. For every aspect of the narrative must now be prepared with the greatest care so that the omitted reader is not neglected or ignored. In a more traditional narrative, as in a painting capitalizing on *trompe l'oeil* realism, the artist knows precisely where his reader or viewer is. Having located him as in this spot or in another, the artist can be somewhat careless about his placement of things: his reader will not go away, nor will he become lost amidst objects and scenes. But as soon as the narrative changes in order to exclude the person "out there," then everything within the artwork changes. An artist who is not careful of every move and every detail will "lose" the reader or viewer, which is quite different from omitting him.

One of Conrad's problems in creating this technical means, whereby the reader is neither here nor there, derived from what he meant to do with Jim. Nearly every aspect of the narrating technique is developed to keep us distant from the main character: to accentuate his mystery, of course, but, even more, to reshape him so that the ordinary is not recognizable. Conrad stresses the ordinary aspects of Jim—the "one of us" motif—so that he can, eventually, reshape that expectation. What we have, in the use of language and, mainly, narrative, is the equivalent of coloring techniques, angulation, facets, forms being reshaped in an early version of Braque and abstractionist methods.

Conrad and Ford called their narrative technique "progression d'effet," by which they meant objects and people became clarified progressively as the narrative proceeded; what was ambiguous and murky, even disguised, gained substance in successive stages. The method seems uncomplicated, but it has broad Modernist resonances, and it helps define what Conrad meant when he omitted the reader in the narrative process. *Progression d'effet* meant a revealing was inevitable; and since revealing lay at the heart of the narrative process, then whoever or whatever was being unfolded was in flux. The mode involved movement, unfixed characterization, unstable personalities, and mysteries that would be unveiled only in stages. Thus narrative, which was the vehicle of disclosure, both revealed and hid, both showed forth and disguised. Narrative functions were dimensions of a dual or triple game, and the one in the dark was not the character being unfolded, but the reader.

Part of *Lord Jim* resonates with the qualities we associate with the mystery or crime novel. But here the mystery is not only the nature of a crime—the divulgence of the *Patna* details—but the nature of the protagonist; and that in turn is linked to the nature of the narrators viewing him. Fixity has vanished and has been replaced by highly controlled revelations. There is, once again, some relationship to what we have traced in cubist painting. In the latter, detail is manifold, independent of a "centrality" that holds everything together. Instead, the viewer must travel to the ends of the canvas, back along the sides, into middles, follow lines that may go nowhere, seek out significance in planes and facets. There is, ultimately, no significance—just the experience of the perception, whatever it may be and however intense or weak it may prove. Yet the viewer keeps searching, hoping to find a clue, perhaps some representative figure or object, and yet being forced to settle for what *is*, the surface itself.

Although words make such flatness more difficult, Conrad unfolds his material so as to keep the reader off balance, conveying the "suspense" that some final detail will give meaning to Jim and justify all those narrators' concerns. But no such revelation occurs. The novel's narrative remains all seams, stitches,

interstices, in which whatever action can occur occurs. While we do not wish to stress the presence of Mallarmé in Conrad, who was as intuitive as he was literary, we can see Mallarmé's mode of creating meaning from recessive voids. That is, the void or absence of something gives meaning, *there* by virtue of its negation. Conrad discovered something similar in his deploying of narrative: despite all the narrators and commentators, despite the author's positioning of himself within the narrative at various points, Jim escapes into the seams, and yet gains strength and presence by the negation of him. He is one of the first of the Modern characters to be created from the sum total of absences.

In *Heart of Darkness*, the narrative method is intensified to create Kurtz, here also more by absence than by presence. In the novella, Conrad uses five levels of text, each of which has its narrative component. We start with the A Text, the novelist's or Conrad's novel, the outer shell common to all narrative fiction. The B Text is Marlow's or the chronicler's narrative, *his* tale. C Text includes the events experienced by the chronicler, not the same as his narration of them. Here, we enter thickets of disguise and deception; for the C Text purports to be what occurred, and yet there is clearly a gap between what Marlow saw and felt and what he can transform into words, into *his* narrative. D Text shifts to the reader's experience, distinct from the narrator's sense of things, as, for example, in the expression of "The Horror! The Horror." D Text creates a gap between the chronicler, whose consciousness we have come to trust, and his listeners or readers, whose responses may differ. E Text constitutes what falls into the seams: elements and figures introduced who remain mysteries, "unspeakable acts," or planned enigmas such as Kurtz himself, or his fiancée, or the true nature of his African experience. E Text suggests that precisely what we want to know better is what we cannot know.

A through E Texts (and there are subtexts one could add) contain certain narrative techniques common to all fiction; but Conrad's exploitation of them all together intensifies the sense of absence, the quality of void. He would repeat this narrative exercise a decade later, in *Chance*, which, while a lesser work, provides the best example of all. In *Chance* (1914), Conrad moved from the omission of the reader earlier to a different narrative tack, to a process in which he would not permit the "story" to be told. It is this quality that so infuriated Henry James, who described Conrad's method as "perfect eventual obscuration." But even though *Chance* does not become the artwork that the method implies it should be, we see Conrad struggling with a narrative mode only one or two stages removed from the stream, and parallel to abstraction in painting. For if the stream derives from some inner area between conscious and unconscious, *Chance*'s narrative has its source in interiors just beyond the reach of the narrators.

The reason the story cannot be told—it is aborted at virtually every stage—is that the real story does not lie within the consciousness of those who can tell it. In this case it is the teller, not the reader, who is excluded from the narrative. Thus, we have a "story" or a "narrative" that cannot be brought forth; that lies, somehow, outside whatever knowledge narrators can bring to it. This is very significant in the development of narrative: that even while narrators pass on story elements, they cannot enter into the whole story—as if representation has escaped them. Even when they know one segment, they do not perceive where that segment fits. Their knowledge is so fragmented that even *they*, not only the

reader, must assume what has occurred. That fragmentation of knowledge, incidentally, is not "outside" as in a crime or mystery story, but incorporated into the novel; not its workings, but it.

This method has social and political weight, since it turns all human action into contingency: nothing we think we know is reliable, and the very language we use is only an approximation. Narrative has been opened to chance. The novelist has eliminated events, action, traditional plot elements in favor of interiors that allow entrance to only one narrator at a time, and to him only partially. The seams in the novel are now the sole place where action occurs, and yet no one in the novel—not even the most favored narrator, like Marlow or Fyne—has access.

The question now is not *what* the real story is, as it was in *Lord Jim* and *Heart of Darkness*, but a stage before that, *where* we can find it. James's annoyance was linked to his feeling that Conrad had created unnecessary difficulties—probably because the novel was not top drawer; but our sense of it is not annoyance but awareness of technique. Conrad's refusal to let anyone tell the story, to abort it, and to keep the story itself in interiors outside reach provides linkage with technical matters in other art forms. Although one genre cannot be precisely equated to another, we see narrative taking on the aspect of planes and lines that we have traced in contemporary painting; and in terms of breakup, incompletion, abortion of story line, we find fictional resonances that recall the atonalities of music after 1910.

Chance comes at the same time as Stravinsky's *Rite of Spring* and Eliot's "Prufrock," unlikely comparisons, it would appear. To these we should add Kandinsky's *Improvisation*, Schoenberg's *Pierrot lunaire*, and Woolf's *Mrs. Dalloway*. A further comparison would be with Ford's *The Good Soldier*, another close contemporary. What all have in common is that disruption of narrative which results in different surfaces for their work. This new surface, as we can see in "Prufrock," is based on telescoping: the conventional narrative voice is moribund. As in *Chance*, events are eliminated, or turned into historical data. These historical data are then manifested as forms of sensation, with nearly every dimension of the poem dependent on the narrator. There is no narrative, only a narrator; and once again we recall contemporary artworks in other genres, where Bergsonian "memory" has replaced cerebralism.

Eliot makes an effort to recapture "pure memory." Pure memory is distinct from pastness, in that the former permits flow, whereas the latter is formed. Pure memory does not alter as it reproduces, whereas pastness is manifest as images, as actualization, the antithesis of flux. Prufrock is himself the sum total of pure memory, or flow, in this respect. The images Eliot supplies are not those we normally associate with poetic imagery; they do not describe his character, nor do they place him in more than an ambiguous, shadowy context. Instead, they create an outer narrative ring for the poem—a ring of domestic items, climatic conditions, party circumstances, and so on. The narrative of the poem, such as it is, lies in those images we can recognize, somewhat like recognizable items in cubist canvases, or temporary melodic moments in Schoenberg and early Stravinsky.

Eliot was attempting "reverie" against a background of objects, which themselves dissolve as reverie, pure memory, flow, sensation come forth. Every segment of the poem is a kind of epiphany, or a privileged moment, which triggers

a new objectified context. Proust would say that: "For the truths which the intellect apprehends directly in the world of full and unimpeded light have something less profound, less necessary than those which life communicates to us against our will in an impression which is material because it enters us through the senses but yet has a spiritual meaning which it is possible for us to extract." One question "Prufrock" raises is the degree of consciousness the narrator has, and since the poem emanates from him, we expect him to have full consciousness. Yet we discover his situation may be like Marcel's: that while he appears to have full control over his material, he is subject to an external life which communicates a greater passion.

Eliot needed a narrative form that muted distinctions between memory and cerebration; further, between the recording mind and the context of objects around that mind. Prufrock has something of that quality of "talking head" we associate with Valéry's M. Teste, who first appeared in 1896. Eliot was confronting many of the technical problems in narrating "Prufrock" that faced painters as they moved toward abstraction and composers as they departed from nineteenth-century models. Much of the same thinking that went into collage and even papier collé—those movements toward both abstraction and Dada— informed the Eliot poem. Although he may have begun it well before he had knowledge of collage, his sense of the poetic moment and what was possible was not unlike Picasso's and Braque's sense of the moment in painting.

The Eliot poem is structured on principles of disruption and bizarre juxtapositions, without the transitional material once associated with poetic expression. Sharp cutting back and forth without guiding the reader is followed by insets of material that doesn't seem directly linked. The poem works by associations, but they are associations—Lazarus, Michelangelo, Prince Hamlet, "the women," et al.—which have significance not as literal meaning but as texture. The effort is to introduce recognizable objects (as in papiers collés and their newspapers, clippings, odds and ends) amidst material whose identity can only dimly be perceived, such as Prufrock himself. Further, Prufrock is broken up, fragmented, made up of disrupted materials. We recall several such contemporary portraits with similar strategies: Picasso's of Daniel-Henry Kahnweiler, Ambroise Vollard, and William Uhde; Severini's *Self Portrait*; Boccioni's *Dynamism of a Man's Head* and his *Dynamism of a Woman's Head*, Duchamp's *Portrait of Chess Players*; even Braque's *Man with a Violin*.

The first known collage was Picasso's, in May 1912, of *Still Life with Chair Caning*; and then collage, as we have noted, moved into papier collé. All the while, Picasso and others continued portraits that carried through the principles of the new methods of blending similar and dissimilar elements. Eliot's Prufrock can really be perceived only as we see a cubist version of a face or figure. We can, in fact, see the Eliot construction also in terms of early abstraction, something close to Kandinsky's watercolor *Improvisation*, which he claimed for 1910 but which is probably closer to 1913. This is a watercolor of the first experimental Kandinsky swirls, of small unidentifiable elements moving through the space of the canvas, colorful bits that seem carried off by a powerful wind or other force. The painting can serve as model for "Prufrock" once we adjust for differing genres and intentions. In the poem, there are several "bits" or islands of material, two-liners, even single lines. The only two-liners repeated are the Michelangelo couplet, but the others—"I grow old," etc.—have much the same function.

That is, they are interruptors and at the same time summaries. Like the small pieces in the Kandinsky, they float free, and yet they constitute the work as much as more cohesive parts.

The key here is fragmentation, narrative based on discontinuity, perception of objects in movement rather than representation. Eliot was moving toward nonfiguration, which he achieved even more radically in *The Waste Land*. In "Prufrock" he is on the threshold, comparable to that edge which Picasso explored as representative cubism became increasingly abstract, or as he moved toward collage and papier collé. Kandinsky's theme in *Improvisation* is swirl, not indebted to futurism so much as to the internal workings of the abstract process. Since with the small bits as planets and stars it suggests a cosmic vision, the swirl characterizing it is the movement of the universe itself: the collision or near collision of cosmic forces out in white space. It is an abstraction of catastrophe, perhaps of the birth of the earth, of immensities brought down to miniature size—or else it is a combination of these intermixed with the bits and pieces of the brain as they collide in the skull.

The Eliot is less ambitious, although seemingly more wrought. If the Kandinsky is cosmic, the Eliot is miniaturized. But miniaturization operates here to suggest worlds: a type, a society, an ending to things, finally apocalypse; and with that "Prufrock" intrudes into the world of *Improvisation*. It enters by way of turning the small and seemingly insignificant—the ordinariness of Prufrock's enclosed world—into an "age of anxiety" which reflects all men. It would foreshadow the First World War, but Prufrock's fears and anxieties are even deeper than those involving war. They become a Modernist view of life as terrifying, so that as Modernist literature develops it is the paranoid who is wise. Kafka is, evidently, the master of this.

In musical composition, an almost exact contemporary of such ideas and their translation into disruptive and discontinuous narrative is Schoenberg's *Pierrot lunaire*, "thrice seven poems" quarried from the fifty poems of Albert Giraud. The "thrice seven" was chosen to coincide with the opus number of the work, Op. 21; but even more, perhaps, to suggest the magical seven and three in Western thought. But we are less interested in mystical numbers than in narrative, and specifically how "atonal narrative" approximates what we are discussing in painting and literature. Schoenberg accomplished his narrative purpose in several ways, one of them being the experimental and innovative use of *Sprechstimme*, that manifestation of "middle voice" which is neither song nor speech.* *Sprechstimme* can be characterized as a kind of stream of consciousness;

* Used by Schoenberg previously, in *Gurrelieder*, but on a much smaller scale, *Sprechstimme* was there intermixed with other forms of more traditional vocal effects derived from Wagner and even Brahms. A parallel development was the use, mainly by the group called *les Six* (Milhaud, Poulenc, Auric, Honegger, Durey, Tailleferre), of texts that necessitated a new type of musical "voice." Milhaud was the most radical, using everything from Claudel texts to catalog listings and descriptions of farm machinery. Honegger set poems by Cocteau and Apollinaire; Poulenc, Apollinaire's *Bestiaire*; Auric, Cocteau and Radiguet texts. Further, we can see that Milhaud's use of jazz idioms, in a piece like *Le Boeuf sur le toit*, brought new voices to orchestration. Brecht and Weill would mine this within a few years, combining new musical voices with Lotte Lenya's *Sprechstimme*.

For *Pierrot lunaire*, Schoenberg reportedly wanted the text spoken-sung by Marlene Dietrich, which would have consigned the work to the cabaret (and out of the concert hall) along with Brecht and Weill. In a related phenomenon, Dietrich's perfect legs sent out vibrations not of beauty but of cruelty: slimness and shapeliness, in the glare of Modernism, were somehow sadistic weapons, tools of torture.

in several respects, it comes closer to the stream and what Joyce meant by the stream than anything can do solely in words. One reason it succeeds so admirably as stream is that it is both less than words and more, almost precisely what we have in mind when we speak of a stream as deriving from some middle state of consciousness.

Whatever else it accomplished, *Sprechstimme* thrusts narrative back into inner places. It complements Freud's findings in the previous decade, and it substantiates Einstein's stress on indeterminacy and relativity. It is a factor of *not knowing* as much as it is of knowing, and yet it leads to a kind of knowledge.

Still another aspect of *Pierrot lunaire* with narrative potential is the use of a particular kind of orchestra—a chamber group of five, with eight instruments, which accompanies the speaker-singer. All orchestral accompaniment is a kind of narrative, but Schoenberg used his for special effect. Instead of maintaining a constant accompaniment for each of the twenty-one segments, he varied each group. Only rarely are the same instruments duplicated. Instead, in one, we hear a flute, in another a piccolo; in one a violin, in another a viola; or else a bass-clarinet instead of a clarinet. The other two instruments are piano and cello—so that with combinations of eight, five performers move from one to another.

As each segment of recitation is formed with a different ensemble background, we see that the traditional use of orchestral accompaniment has been subverted for new narrative purposes. What Schoenberg did, in this single piece, was to use the history of chamber music and orchestral forms so as to create a kind of "philosophy" of music and an opera based on interrupted expectations. The narrative component here, with the shifting of orchestral effects against the *Sprechstimme*, is operatic; but, of course, a new kind of opera. In the same way, we could argue that Stravinsky's almost contemporaneous *Rite of Spring*—while still balletic—was also a new kind of operatic experience.

Both of these works are new kinds of *Gesamtkunstwerk*, although minimalized to fit the narrative needs of the new century.* The characteristic of much of the new music is the miniature *Gesamtkunstwerk*. Schoenberg himself turned from *Gurrelieder* to small forms—but smallness suggests the whole, the entire range. Webern and Berg would continue along these lines. This musical notation—"five pieces," "six little piano pieces," etc.—while deriving from Wagner and Brahms nevertheless shrinks the mise-en-scène without losing the inclusiveness—what we discover in Kafka at much the same time. Schoenberg recovered almost endless groupings from his eight instruments: flute accompaniments, duets for piano and clarinet, trios of several combinations, on some occasions the entire instrumentation. The narrative component of this—that is, its way of affecting the nature of the story told—is enhanced by Schoenberg's use of "pauses." George Perle tells us that the pauses "between the pieces are differentiated, there are measured pauses of various durations, unmeasured pauses of various durations, conclusive pauses, preparatory pauses, transitions." All of

* To these we could add the 1917 production of *Parade*, the collaborative effort of Cocteau, Picasso, Massine, and Satie; and the 1934 production of *Four Saints in Three Acts*, with music by Virgil Thomson, text by Gertrude Stein, choreography by Frederick Ashton, and cellophane designs by Florine Stettheimer. We might also cite the 1913 futurist opera *Victory Over the Sun* as part of this genre, or Kandinsky's direction of Mussorgsky's *Pictures at an Exhibition* in 1928.

this is calculated to disrupt expectation, to prevent settling in, to negate the more traditional sense of measured pause and pace.

Yet Schoenberg was able to control the differentiation of pauses by still another narrative device, structured into the Pierrot poems. Each is a rondeau, a French thirteen-line stanza based on repetitions. The first and second lines are repeated as lines 7 and 8, line 1 repeated as line 13. The stanza is itself divided into three segments, two quatrains and a five-line sequence, with that final repetition of the end line. The regularity here works against the irregularity of the pauses and the additional irregularity of the instrumental combinations. Further, certain segments of *Pierrot lunaire* are canonic—that is, they have note-by-note repetition in successive lines, which sets up an imitative process. Still further, some of the segments make use of yet another repetitive device, that of *ostinato*, constant recurring melodic fragments.

The structure of the musical composition is a continuous counterpoint, either within the music or in terms of music against poetic content. Together with *Sprechstimme*, musical arrangement and poems contribute to that narrative sense of stream, or interior monologue. We recall Kandinsky's comment, cited above, that Schoenberg worked much the way he did so as to set down his emotions in visible or permanent form. Kandinsky was referring to Schoenberg the painter, but the remark applies to his musical composition as well.

Yet there is still another dimension to *Pierrot lunaire* which is rarely mentioned, and that is its function as "moon poem." As the title indicates, the moon is a primary force; this is in a real sense a lunar landscape and poem. The stress on the moon perhaps climaxes in the nineteenth poem when Pierrot finds a "spot of white, of shining moonlight" on his jacket collar. He rubs and whisks but cannot remove it, the reason being that the white spot is moonlight, now part of him. It will eventually lead to his journey, to Bergamo, where the boat has a moonbeam for a rudder; his destination a solar fantasy where all gloom is dispensed with. The emphasis on the moon recalls its role as imagination, as symbolic female, as a circle of perfection. It symbolizes both magic and creativity. *Pierrot lunaire* begins with "Moonstruck," where the wine that only the eyes may drink "pours from the moon in waves at nightfall," a complicated image of synesthesia and Rimbaud-like dislocation. Most of all, however, the moon imagery forces a narrative mode that fits the deep symbolic significance of the lunar experience.

Once we note this and return to "Prufrock," we can see the Eliot figure as something of a Pierrot. Further, the narrative line of the Eliot has within it that *Sprechstimme*, with the voice coming from some inner region from which *Sprechstimme* also seems to derive. "Let us go then, you and I" has its origin in some unsettled territory of the mind, neither full consciousness nor what we think the unconscious is. It cannot be located—which is what Modern narrative has become.

Yet an author's attempt to locate narrative in unlocatable regions is, of course, a narrative aim. One intention is to defamiliarize; but the main one is to seek out new ways to parallel the sense of Modern life: as disruptive, discontinuous, subversive of undivided aims, as a reflection of the unconscious and other "sub" aspects of consciousness, as a manifestation of memory, whose various layers have replaced history. To locate the narrative of *those* (all or some) meant the end of nineteenth-century story-telling, plotting, or narrative struc-

turing in all of the arts. *Sprechstimme* is a remarkable invention of language of the unconscious, and we can find its analogue nearly everywhere in the arts of the 1910s. It is the language of cubism as much as that of Schoenberg, and it would become the language of Stephen Dedalus in the three Joyce works in which he appears.

Kandinsky made an acute remark on Picasso which may elucidate our understanding of Modern narrative. Kandinsky was concerned with painterly forms of representation. In late 1911, he wrote that Picasso destroys his material, not by dissolution "but by a kind of parcelling out of isolated parts," by dispersing them throughout the canvas. Kandinsky perceived that this method does not negate objects; instead, it preserves them, everything keeping up "material appearance." From Kandinsky's point of view, as he himself worked on the threshold of abstraction, Picasso held onto things, but not in the ordinary way of representation; rather, he located elements (objects, figures, forms) on the canvas in ways not "represented" before. He had found a new way of narrative, through a process of redistribution.

A good deal of this is associated with the more general sense of cubism in its analytical phases, which was to present surface organization in place of traditional painterly narrative. The Italian futurist Gino Severini was probably moving in the same direction when he wedded some unlikely styles: the pointillism of Seurat, an early influence on him, with cubism and futurism. By the time he painted *The Obsessive Dancer* in 1911, Severini was profoundly influenced by futurist tactics and directed by its 1910 manifesto. He spoke of how the human face is no longer represented by pink; of how, because of our immersion in dream materials, that face is yellow, red, blue, green, violet, and so on. This has a good deal to do with narrative. As soon as color is no longer representative, but a conception, then the way in which a face or figure, an act or event—all those elements that make up narrative—is presented must be altered. If the touchstone is dream, and it often is, then narrative must be colored accordingly. To transform painterly color into literary narrative, one must see colors as having their role as alternate forms of story-telling and narrative design. The color alternatives for the face become the equivalent of breakup in narrative, the destruction of expectation lying at the heart of both methods.

Deeply influenced by *Der Blaue Reiter*, Munch, and very possibly Strindberg, Arnold Schoenberg painted *The Red Look* in 1910 as part of that narrative shift in painting which would have its equivalent in fiction. The "red look" is gained in several ways—the red house, the red projection to the left of the house, the reddish eyebrows and mustache of the wide-eyed male figure in the foreground—but it is chiefly associated with elements that are not purely red. A kind of driveway which connects house and male figure is also tinged or streaked with red in places; and there are other pictorial indications of red and reddishness. The "red look" combined with the wide-eyed expression so common in painting of this period creates that sense of madness which is linked to dream. But even more, it suggests that any simple or straightforward narrative of purpose in this painting is nugatory.

A related example might be Delaunay's paintings on the theme of windows or of windows directly, apparently indebted to Mallarmé's poem "Windows." What connects Delaunay's work to narrative here is that he has used ordinary objects—as Picasso and Braque would do in papiers collés—to suggest a different

kind of reality altogether; to move narrative to mystery, to the sacred or to art, as Mallarmé himself suggested. Working together with the refraction of windows and their spatiality is a vivid color scheme, dominated by bright yellows and oranges. Delaunay brings light to the objects, but overall his aim is to turn windows into mystery, into something vaguely sacred. These 1912 paintings—there are about two dozen—were described by Apollinaire, a Delaunay partisan, as creating "a holy and wonderful color intoxication." Apollinaire's Orphism would relate this painterly aspect to musical composition—thus solidifying our contention that what was at work was narrative technique, or "color movement," as Delaunay described it.

It would be interesting to pursue the idea that the papiers collés, with their "incidental" bits and pieces stuck to the canvas, are directly related to the narrative ideas developed by Conrad and Ford and then modified and expanded by Joyce and Woolf. There is something of the stuck-on method in the *progression d'effet* of Conrad/Ford, in that those pasted-on objects suggest the randomness characteristic of narrative development in literary hands. If we examine what appear to be incongruous elements, we find certain congruities, some of them startling. Since less than a decade separates these experimental modes in two such different genres, we should not, perhaps, be too surprised.

One of the main tenets of the papier collé is that the variety of elements stuck on will disrupt whatever narrative continuity the canvas may have. This disruption can take several forms, not the least of which is that the stuck-on material will age at a different rate from that of the canvas. It will, however, not only age, but, if newspaper, it will alter its color, going from whitish toward yellowish, even to pure yellow. The pasted-on pieces are caught in a temporal process distinct from that of the rest of the painting; so that through color we have a clash of time, which is, of course, a form of narrative.* In the *progression d'effet*, we have the gradual divulgence of material, so that narrative is temporally blocked, even muffled, because it unfolds according to temporal principles disguised for the reader. There are levels of distancing of characters and events, not primarily for spatial but for temporal reasons.

The Good Soldier travels perhaps to the furthest reaches of the *progression d'effet*. In papier collé, the method is often what is called *aporetic*, which indicates that pasted-on material negates or contradicts subject matter. A jar may be represented by a piece of magazine, a musical instrument by a cut-out photograph from a magazine. That clash of material and subject matter was intrinsic to the idea of representation in both collage and papier collé. Ford aimed at something comparable, although the visual aspect could not be achieved in print in quite the same way. Ford was moving along two fronts: using form to suggest a content of its own, and using form as the symbolists did, to suggest something beyond. In this respect, he was very much a writer of his time, working in and out of

* Picasso spoke offhandedly of moving from *trompe l'oeil* to *trompe l'esprit*: that is, from realistic visual illusions to illusions based on imagination and mind. By this he meant something in painting that leads to the kind of narrative in fiction we are describing above. Jacques Derrida updated this point when he distinguished between *phenotext*—the work spread out before us—and *genotext*: the limitless meanings moving beyond the work and in the interstices of it. Erich Kahler sees this narrative development as an "increasing displacement of outer space by what Rilke has called inner space. . . . The world is integrated into the ego, into the illuminated self."

formalism and symbolism, much as Eliot, Joyce, and Woolf would do, as Faulkner would much later. The residue was in the narrative process.

Ford's way of achieving these levels was by way of a central narrator, but one more sensitive than Conrad's Marlow: and, also, one more intricately linked to the experiences he is relating than Marlow ever was in his four roles. Dowell is in the position of both explaining and revealing himself. Beyond his narrative, we glimpse all kinds of other possibilities about him and his relationships which go unstated. He cannot be believed, which is the level of *trompe l'oeil*; but he also opens up vast potentialities beyond what he says, which is *trompe l'esprit*. However we define his function, he is split between what he says and the sense we have of what he may know but does not say. Dowell's presence makes possible what we know—he is the major "text," as it were; but his presence also contributes to our uncertainty of what is actually occurring, the subtext. There is, in this respect, some of the quality we find in abstraction: the signs of recognizable forms, which, moving beyond representation, cannot gain attribution. Every abstraction has a subtext provided by the viewer.

There is a large literature on the use of the narrator in Modern fiction, but most of it is formed in literary terms. We can, I think, find more than a verbal or psychological dimension to the narrator; there is, of course, something of Mallarmé's window, even Delaunay's windows cited above. But that would restrict us to reflections or peering through, however distorted the window may be. The narrator functions as part of that philosophical puzzle which lies at the heart of Modernism itself. Like so much in Modernism, the narrator provides *the real*, the actual, the thing itself, when the aim or object is not real, actual, or objective. Ford's Dowell is a figure, an object, a body that negates objectivity. He comes as close as any self-conscious narrator—except perhaps Tristram Shandy— to throwing doubt on his own existence; someone who denies himself in the a' of creating himself for the reader. Put another way, he is real without bei' representative, actual without being figurative.

One is tempted to see Dowell along with his ambiguities and uncertainties as an early print form of Dada, hovering on the edge of a development still two or three years off. One thinks, perhaps, of a pre-Dada work such as Marcel Duchamp's 1913 *Bicycle Wheel*. The analogy is not so bizarre as it may look, since one of Ford's characteristics was his ability to soak up the here and now. The quality of *Bicycle Wheel* that haunts us, to the degree it can and does, is that while figuration is not in doubt, by placing the wheel on top of a four-legged wooden stool Duchamp has upset our notions of figuration even while playing on them. Real objects are used to create a work that has a considerable difference from the objects; the textures, colors, and, of course, functions are distinct.

We feel or are made to feel the same way about Dowell. He is, apparently, the actual narrator, nourished by the tale he has to tell of his own experiences. Yet because the method has made his information so uncertain—building on an uncertainty principle—he subverts his narration as much as he offers it in explanation. We recall that the novel begins at the end, when Dowell is forty-five, and caring for Nancy Rufford, who is mad. It then proceeds back, so that along the way different information is turned up as fitting into different time slots—a recent play by Harold Pinter, *Betrayal*, works the same gambit. We

have a curious phenomenon at work, which is *the exclusion of the narrator from what is happening to him*. Dowell's narrative is a tale of exclusion, but what he must come to recognize is that he is the element being excluded. The story he relates has him somewhere in the center, and yet it has proceeded without him, or without his realization of what is occurring.

Ford has achieved something so avant-garde in narrative terms we must not let it pass. He has taken incompletion, interruption, and disruption a stage further by suggesting those areas that exist beyond what is knowable, even by a person who is centrally located. He has in this respect approximated abstraction, or else prefigured the Dada sense of "approximate man," to use Tzara's term. Dowell is an agent whose agency is questionable because of his exclusion from the events he is describing. What he tells us in the course of his narrative is far less than what he could tell us, and we assume his exclusion from whatever it is. As reader, we are forced to juggle more than Dowell does as narrator. Ford shifts the burden onto us—so that to read the book we have much of the same problem as when we view a collage, a cubist work, or something comparable. Although all the parts seem to be there, we must fit them into some perceptual scheme that enables us to assimilate the information or colors. Dowell offers a rational pattern, a kind of logic of behavior, but it turns out to be incomplete for the tale he wishes to convey.

One of the characteristics of avant-garde works is that shifting of the material even as we view or read it. Although Dowell professes innocence of what is happening—and he is innocent of some of it—at the same time he desires for unstated reasons the triangle of Florence, Edward, and himself. The usual explanation is that he gains homoerotic pleasure from the proximity of Ashburnham to Florence, even if it means pandering for his wife, or perhaps because he does pander. What is more likely is that Dowell as an impotent man is interested in viewing or even creating voyeuristic situations, in which he gains vicarious sensations or thrills. This, too, is speculation, but it accommodates more cogently the indeterminacy of the narrative and fits that shifting quality associated with avant-garde Modernism. Such shifting is significant, here and elsewhere, because it disallows certainty, and enforces different temporal/spatial expectations on the viewer or reader. Although disruption is the key element, disruptiveness could not work unless certain expectations were first met.

If we shift from Dowell to Clarissa Dalloway, a few years later, we note great similarities, even as avant-gardeism has shifted from cubism and early abstraction to full abstraction, Dadaism, surrealism, twelve tones in musical composition. In the few years between the two novels, the avant-garde has if anything loosened routine expectation and moved even further into shifting temporal and spatial modes, as well as more disruptive linguistic models. *Mrs. Dalloway* is contemporaneous with the above, and also with *The Waste Land* and *Ulysses*. In many respects, chiefly in her slow recognition that much of what is occurring to her has been shaped by those who exclude her, Clarissa is a female Dowell. She is another central narrator whose sense of things is at one level, whereas her recognition of elements beyond suggests to her exclusion from her own life.

Since much of *Mrs. Dalloway* is a form of interior monologue, the exclusionary process is more intense, more personally painful as we observe it. But both novels follow similar procedures: that the narrative is the objective correlative of a series of coordinates, that the center of these coordinates is the narrator.

But this is only the beginning. That "center," however knowing and informational, is really ignorant, is really acted upon rather than actor; and his/her narrative is in large part a growing recognition of this fact. Problems begin for the Woolf protagonist with naming. As a "Clarissa," she is the classic victim in fiction, done in by men and by family; as a "Dalloway," she has surrendered her identity to a husband for whom wife and marriage are less meaningful than career. In this alone, her identity has been disrupted. She sees herself as an abstraction: sexless, a nun, subverted by elements beyond. From a representative figure in her own right, she begins to move toward an abstraction of that, or toward diminution, toward Kafkaesque buggishness.

But more is at stake than that. She is being turned into a shadow, into lines, points, and facets, into an object that is itself losing its identity. Her daughter, Elizabeth, is becoming unknown to her, and slowly replacing her, or losing any need for Mother. Miss Kilman, hateful as presented, is the "new woman," whose life-style has no place for the likes of a Clarissa, yet Elizabeth seems to have a special role with Miss Kilman. For this Clarissa who has avoided rape and settled for safe marriage, Kill-man is a rival in several ways. Peter Walsh is ever present, but with his penknife at the ready, he is a hovering figure of potential destruction. She is not included in luncheons, and at parties, while her beauty is deferred to, she feels herself displaced; unlike Sally Seton, she cannot even point to her five big boys.

She had for a time thought she was Shakespeare, and she turns out to be Shakespeare's sister. What Woolf has accomplished is not only astonishing in terms of characterization, however, but in terms of narrative strategy. For this aging woman, caught like Tiresias between sexes, is the progenitor of the narrative: the source of what should establish her. Yet her interior monologue seems to derive from hollows and shadows; not a voice, but an emanation. And the origin of it is slowly being effaced, even as she describes what she is and where she is going. She is turning into Echo without the original voice, simply the replay. The narrative derivative of this is a series of extended epiphanies, if we can redefine that word to make it last more than a moment. Epiphanies are still revelations in Woolf, but they take time to manifest themselves. They have something of Proustian *longueurs* in them, which is not unusual given the Bergsonian drift of both.

The achievement of Woolf has been to create an interior voice to carry the narrative and yet to make that voice emanate from a creature who has herself slowly been excluded from her narrative. By catching her within a temporal sequence different from clock and calendar (as in Big Ben), Woolf has created a narrative just off the edges of consciousness. One way to view the narrative is to see it as Clarissa's journey to stay sane, which is another way of saying her narrative is full of uncertainty and ambiguity. She drifts in and out of consciousness or some other related state, and her narrative derives from within and beyond. But none of this would work so effectively unless she sensed herself shut out from her role as a functioning woman; unless she felt a form of death approaching even as her voice keeps up the pretense of life. We recall the "Ur" version of the novel, in which Clarissa is a suicide, whereas in the final version she only foresees it and fights against it.

Perhaps the quality that more than anything else creates this dimension of "organized disorganization" is the ever-presence of death. Even the layering of

temporal sequences, cutting back and forth between inner and outer, or between different layers of inner, nourishes the idea of death. Clarissa speaks her lines as ways of postponing inevitability, which in the original was to have her, not Septimus, a suicide. In the final version, Septimus acts out in part Clarissa's feelings, although we should not make him and her congruent. To do so would be to reduce his kind of suffering, which has a specific etiology, and to misunderstand hers, which is less specific and more attuned to problems intrinsic to Modernism as a whole.

The drift toward the "I," which we found earlier as a development in spiritual autobiography, has taken root in this novel, heir to the full thrust of the Modern movement. In the Woolf novel, we have, besides the presence of Bergson, Freud, and Eliot, the influence of Joyce (a single day in mid-June of 1923) and those associations with avant-garde painting she gained through her own viewing and through Roger Fry. There is, also, in an area more difficult to explain, a kind of atonality, a break with musical forms, a dissonance inherent in Clarissa's interior monlogue. This is conjectural, but her monologue has affinities to *Sprechstimme*, whose presence in new opera would be as pervasive as monologue and stream in fiction. Both, after all, are means of "inner" communication. This innerness, incidentally, is supported by the prevalence in the novel of illness, which allows for both deterioration—Clarissa is whitened by flu, her heart affected—and recovery: she resists suicide, affirms herself.

The shift to "I" as the egocentric voice in narrative became in fiction a transfiguring element. While developments in painting tended to go through separate stages, evolving out of each other or developing into each other in mutations, we see in the evolution of Modern narrative a simultaneity of effects. The movement called formalism, which the Russians stressed by 1915, seemed in conflict with symbolism, in fact a negation of it. Formalism emphasized that form was itself meaning; not merely a "sheath," as Boris Eikhenbaum said, "but a dynamic and concrete integrity"; whereas in symbolism, the form was the means by which the "other" could be observed, the shape through which shadows penetrated. In Modern narrative, however, the distinction is lost: either formalism or emphasis on form could coexist in the same work, at the same time, with symbolist shadows. In Woolf's novel, as in Joyce's mature works, the narrative element has a life of its own, a shaping that is much stronger than reverie, yet allowing that glimpse of otherness so essential to symbolism.

Another aspect of Woolf's technical success with the novel is that her chief character, even while bemoaning her negation and gradual extinction, is creating the terms by which she can chart that fading away. She is, in one respect, not only the object of others' negation; she is also the agent of that negation by way of the words she frames it in. That indeterminately located interior monologue permits her to shape and yet escape, to form and yet vanish from the words expressing herself. There is, in this peculiar process, something of Duchamp's *Nude Descending a Staircase* in its revised form. For in that development, both stairs and the nude's legs are canceled out even while they convey energy and motion to the canvas. As Duchamp increased their velocity to pistonlike rapidity, he used them to their ultimate while negating them as legs and stairs. Clarissa is doomed by her own words: like Andromache or Niobe, she utters her plaint,

and the utterance becomes the signal of her demise. Even as she establishes her superiority to Miss Kilman, she lessens the area in which someone like Clarissa Dalloway can survive; she negates her role while destroying her rival's. This negation is completed by the coordinates of death Woolf surrounds her with, from persistent illnesses to the handwriting in the sky to the clock tolling people's fate. Her one daughter is insufficient hostage against forces that, once she has identified them, will squeeze her out. She escapes only by the slimmest of margins.

The Joycean approach to narrative and its consequences is far broader in its response to the avant-garde; and in parts of *Ulysses* and in *Finnegans Wake*, Joyce *is* the avant-garde. But however far in front he seems, he was also a great synthesizer. We find that intuition in Joyce—Faulkner had it later—which enables an artist to touch everything around him without repeating it, without imitating himself. Although Joyce's work could have been placed under the rubric of spiritual autobiography, in chapter 4, the implications of his fiction are so great he can be accommodated nearly anywhere. Joyce molded himself to all the avant-garde movements, and his use of narrative owes a good deal to abstraction, as later to Dada and surrealism. Chiefly, his relationship to those developments in the avant-garde is reflected in language usage; in this one area alone, he broadens Woolf's plans. In *Ulysses*, he moves along lines we find in *The Waste Land* as well; in *Finnegans Wake*, he broadly parallels in fictional narrative what Pound was doing in the *Cantos*.

Concern with narrative innovation came as early as the *Portrait*. The five sections of this spiritual autobiography are devoted to five different stages in Stephen's development: infancy and preadolescence; adolescence, high school, first sex; the retreat and sermon, Stephen's confession; mortification of the flesh, rejection of a Jesuit career, decision to become an artist; college life, repudiation of family, country, religion, decision to be a priest of the imagination. Although the very beginning with its baby talk has intimations of what would become innovative language in *Ulysses*, the narrative device Joyce chose is impressionistic. That is, while it is acutely representative, it stresses color as creating shape, so that episodes move seamlessly into each other as if in some dream sequence.

That dream sequencing is captured by means of a narrative that appears to derive from the same area in which we locate interior monologue. Neither complete interiority nor traditional narrative, interior monlogue seeps out from an intermediate area. Stephen, as a consequence, *grows older through scenes, not through an aging process*. That is, he ages from the interstices of the narrative, not from some descriptive process. Joyce has also infused the narrative with several *symboliste* strategies, the chief among them being the three dreams, the episode with the bird girl, and the persistent water motif. Both Joyce and Eliot present narrative as a kind of gnostic experience. In *A Portrait* and especially *Ulysses*, as well as in "Prufrock" and *The Waste Land*, the narrative is almost always below the surface of what is directly experienced; so that we are presented with layered materials. These developments, in which surface is less than subsurface, are paralleled by developments in painting. It would, in fact, be interesting to estimate how much Joyce and Eliot, together with others of their generation, were influenced

by the visual arts as compared with the influence on them of the literary ones.*

Franz Kafka in his fragment of a play, *The Guardian of the Tomb* (1916), worked in a similar narrative vein. Although the brief fragment is often labeled "expressionistic," it has that subsurface narrative for which the surface is only the entrance. The real subject is time and space, dimensions or dimensionality—not the threat to empires, although the latter theme is present. Located out of sight is the question of who is in and who is out, whether borders seal off those who want to enter or those who want to escape. It is concerned with victories—who really wins when both sides appear to be losing. The Tomb is itself an ambiguous symbol, since it is normally a death image, whereas here it often seems as much life as death; or else the Tomb makes death become the focus of activity, forcing all experience "underground," tomblike.

Like Kafka, Joyce and Eliot work by deflection. By eliminating traditional narrative lines, they move closer to narrative as we experience it in dreams. For Joyce, the method depends on epiphanies, symbols, images, impressions, and, as we have observed, dreams: the entire paraphernalia of the avant-garde as it wrestled with traditional forms. For Joyce, "traditional forms" are represented by naturalism and determinism, which remained attractive to him even as he pulled away from them. Joyce could never completely escape naturalism, and one could argue that even in a work as determinedly avant-garde as *Finnegans Wake* the dream narrative is not a freeing process but an imprisonment of sorts; in the way it is for Hermann Broch in *The Death of Virgil*, where reverie or the "wandering mind" creates a narrative that both releases and shackles.

Joycean narrative, then, must always be evaluated as a force that works to counter naturalistic devices. Joyce is, in effect, devising strategies by which he can defeat what seems more comfortable to him, the determinism or cause and effect associated with the Ibsen whom he loved in his youth. In this respect, Ibsen represented for Joyce—even up to *Finnegans Wake*, I would argue—the element that he would, at first, imitate, and then work against. We have to perceive *Stephen Hero*, then *A Portrait*, and, after that, *Ulysses* as determinedly playing off Joyce's sense of the literary moment against what most complemented him; which is another way of saying that despite himself he was enormously responsive to developments in all of the arts and especially in their narrative phases. Like Conrad and Ford with their sense of the *progression d'effet*—that

* A convenient example would be Wyndham Lewis, if only he had lent himself to the question. Lewis was a splendid artist—his portraits of Pound, Eliot, Joyce, and Edith Sitwell are incomparable—but as the self-proclaimed "enemy" he remained opposed to Modernism. Although his proclamation of himself as the enemy would seem to place him with Baudelaire, Rimbaud, and other social adversaries, he did not equate his enemy status with avant-gardeism. Consequently, although aspects of cubism can be found in his portraits, he remained tied to earlier, not contemporary, influences. Similarly, in his novels *Tarr* and *The Apes of God*, for example, he stressed some aspects of futurism, but remained traditional. Lewis, perhaps, was such an enclosed figure, so wrapped around his hateful ideas and destructive self-loathing, that he could not open to the new, even though he more than nearly any of his contemporaries could move from writing to the visual arts and back again.

Hugh Kenner, in his *The Pound Era*, rightly calls Lewis's "Alcibiades" design, in 1912, for *Timon of Athens*, an astonishing work, full of futuristic energy and vitality; but the self-destructive Timon aspect of Lewis tugged with equal force. We might compare to him D. H. Lawrence, a somewhat lesser artist but a greater writer. Lawrence was able to integrate his detestation of Modernism into his work. He, too, was an "enemy," self-proclaimed and otherwise, but an enemy within the dialectic. Lewis remained outside.

accumulation of detail about a character or scene until there is, finally, a gestalt—Joyce replaced more traditional narrative lines by internalizing them.

Interior monologue, reaching into middle states somewhere beyond consciousness and yet not outside its borders, was the next step after *progression d'effet*. And it was equivalent in fiction to what Picasso and Kandinsky were moving toward in painting narrative: what we see in Stravinsky's *Le Sacre*, where the music breaks up the narrative line of the ballet program; in Eliot's early poetry or Pound's "Mauberly" a little later; in Schoenberg's Second String Quartet, with its break in the final movement from tonality to atonality; in the increasing importance of *Sprechstimme* as the "line" in opera or in that peculiar form of oratorio which Schoenberg was writing in *Pierrot lunaire*; in the use of color such as we find in *les Fauves*, in Matisse, Gauguin, and others; in, finally, the developments that grew out of Dada and surrealism—without which it would seem *Finnegans Wake*'s "narrative" would have been impossible.

Yet through all that absorption of new strategies, Joyce was writing forms of spiritual autobiography. This was a constant in his work, giving him affinities to contemporaries as diverse as Hesse, Gide, and Proust. This is the constant, very possibly, that makes us feel so comfortable with Joyce once we have overcome whatever technical difficulties we find in our way, once we have learned how to read him. Beneath or beyond that assimilation of virtually every avant-gardeism, we discover, is a novelist providing traditional needs in his characters, familiar tensions in his scenes. The "dedication" scene in the *Portrait*, for example, with its use of bird imagery and its indirection of statement, is clearly within the avant-gardeism of musical and painterly narrative. And yet it fits traditional forms of dedication scenes so familiar to us from Wordsworth on; until they become, in Proust, the most famous of their type with the tea and madeleine. The use of bird imagery enabled Joyce to fit his scene into the most Modern kind of development, which was to display the ordinary within limitless terms: flight, soaring, imagination; ultimately, something Apollonian. Further, the bird image or symbol permitted Joyce a kind of prose that moved toward poetic borders—very possibly the beginning of that transformation of prose which accompanied his increasingly deeper move into subconscious forms.

We have, then, the juncture of several elements as early as the *Portrait*, all of them linked to narrative, but also going beyond traditional forms of narrative. In the dedication scene, for instance, the bird girl is an analogue of Dedalus, his "twin" or mate, creating that joining which Plato spoke of as the connection between the male and female egg, or corresponding to Freud's sense of the individual as combining traits of both genders. But also linked to the mating of male and female is the presence of water: here sympathetic and accommodating, elsewhere alien and threatening. This ambiguous use of water, at one time for drowning, at another for baptism, recalls the long tradition of water imagery in French poetry, culminating perhaps in Rimbaud and Mallarmé. Joyce has used water for both naturalistic and symbolic purposes, as part of an earthly process and as a mysterious substance connected to mysteries, sacred rites, mythical presences, transformations.

These elements may seem adornment or else part of the internal drama, but they are in actuality vehicles of narrative, the way in which elements of plot and story get carried along. Joyce's difference from Proust is illustrative. It lies, mainly, in their respective views of history—for these views affect their sense of

narrative profoundly. Proust uses the "privileged moment" to throw his protagonist *back into history*. (Mann works in the same vein: history eventually preempts individual.) Joyce uses the epiphany or epiphanic moment to cast his protagonist *outside of history*. From this derive different narrative premises which nevertheless manage to cross and overlap when the unconscious assumes metaphysical proportions.

It is, in fact, through this means of turning the unconscious into a manifest philosophical position that we can link Joyce and Mann, in ways Joyce and Proust cannot be associated. The familiar story that the latter two met momentarily and had nothing to say to each other sounds just right—they did not. Yet on the face of it, neither would Joyce and Mann. *The Magic Mountain* and *Ulysses*, although only two years apart, seem to have derived from different planets. Mann's novel is very clearly a product of the Weimar years in middle Europe, whereas Joyce's novel culminates avant-gardeism. Through disease, Mann is creating an anatomy of his middle European society; Joyce is seeking elements in mankind that accommodate healing, rejuvenation, even joy. He seems life-oriented, whereas Mann appears to have turned toward death. Furthermore, Mann's novel is issue directed, an external drama in most of its aspects, political and social in its impact. *Ulysses*, however, is an internal drama in its thrust and dimensions.

No matter how we approach the two books, we appear to come out at different ends; they would seem to be opposite extremes, beginning with Mann's literary conservatism as against Joyce's daring and willingness to explore. We know from studies of *Ulysses* and from analysis of the manuscript Joyce grew increasingly daring as the work progressed, to the extent he returned to earlier segments and revised them to fit the later, more experimental chapters. Thus, Joyce was reaching toward avant-gardeism, toward *Finnegans Wake*, even as Mann's dialectic was concerned with conserving, with historical continuity.

This would be, I think, our first response to these two summas. But we would be gravely mistaken. For if we discard initial reactions to works looking so different, we note an underlying tension, even a common dialectic. Such an exploration requires that we stretch our sense of Mann and contract our sense of Joyce so that they overlap in several common areas. The crossing-over area enlarges our awareness of social-political dialectics without seriously restricting our awareness of the avant-garde in action. Joyce was fiercely Modernist here, both in his plan and in his revisions, becoming ever more determined to be unique as the work progressed. Portions of *Ulysses* adumbrate *Finnegans Wake*, and, in several respects, we can say the Joyce of the 1920–21 revisions was already looking ahead to the later book. For his part, Mann worked more consistently, but elements of *The Magic Mountain*—those concerned with time, qualities of consciousness, the moment and its consequences, even with language—are not so fixedly political as Lukács and other neo-Marxist critics would have it.

One way of looking at the two books is as two halves of that *Gesamtkunstwerk* which each aspires to be. In this reading, which eventually simplifies and reduces, *The Magic Mountain* is an external drama, whereas *Ulysses* is internal. Such a formulation creates a neat characterization: the Mann as a dialectic, the Joyce as static. Nevertheless, for both, there was the need to enlarge, to keep building until what was originally a small base was a monument. Mann had conceived

of his mountain originally as a molehill, a short story; and Joyce had thought of *Ulysses* as being on the scale of a *Dubliners* story. Because both are lacking in traditional plot, however carefully wrought, the thrust of each derives from the life of characters. Even though *Ulysses* moves inexorably inward and *The Magic Mountain* outward and downward, the narrative thrust for both is connected to an interior world in that it derives from the main characters.

There are even similarities in characters, with Naphta and Settembrini matching up loosely with Stephen; with Hans and Stephen/Bloom as the central intelligence of their respective novels, each learning as the novel develops, or if not learning then adapting to new circumstances. There is something of the *Bildungsroman* here, as well as spiritual autobiography—so that narrative as such is blunted and plot dispersed, as we find also in Kafka and Proust.

If we hold to this reductive reading, both novels eventually encode their information in different ways: *Ulysses* moving toward dream and stream, toward displacement of conscious language in favor of a middle state language; whereas *The Magic Mountain* uses dreams only as a way of defining a character, and language is oriented toward description of phenomena, away from delineation of inner states. Joyce's precision of phrasing works to blur distinctions between dream world and "real" world; and moving in and out of reality becomes the characteristic narrative thrust. Mann, for his part, is eager to pile up information, to provide scholarly and intellectual ballast, to keep us knocking against objects.

In this reading of the two, Mann established innerness by way of externals, Joyce by probing within. In Joyce, the inner world as presented, and its languages, affect the way in which we perceive the outer world; his post of observation recreates outerness for us, besides blurring distinctions. In Mann, the outer world is built up, its by-product a greater external realism, the very opposite of Joyce's precedures. If we extend this, we can say Joyce is using spiritual autobiography as a way of establishing abstraction and cubist planes; whereas Mann mines the same medium to return art to aspects of realism. Mann is, as it were, a nabi or fauvist, using violent coloring to accentuate reality.

This would be, as indicated above, the argument for splitting Mann and Joyce into obverse sides of the *Gesamtkunstwerk* both were so eager to write. And it would be, I think, a very faulty argument that accepts this split. It is, in the main, a political rather than a literary argument. In the political sense, the split gives Mann the external world—politics, Weimar, culture and intrigue, ideological issues; and Joyce the internal one: aestheticism, self-serving needs, psychoanalysis, the unconscious. A more sophisticated way of viewing both writers, however, is to perceive them as responding to their times by incorporating into their work nearly every dimension of those successive avant-gardes that affected narrative. Both were caught up by "flow," what we have associated with Bergson and his successors; both can be linked to "simultaneism," that effort to efface inner and outer time distinctions. Joyce achieves this by linking time to memory and other forms of subjectivity; but Mann does not stint here, connecting time on the mountain to "time below," the imaginative time of rest cures associated with "real time," where things are being done.

Both, further, were naturalists who used impressive strategies to undercut, divert, even negate the effects of naturalism. Both discovered myths that could underlie and reinforce their work: Joyce, the more obvious myth of Odysseus and his wanderings, return, reconciliation; Mann, the less obvious myths of the

underground journey (ironically conducted on a mountain), the Western cultural myth of Faust, and his quarrying of the myths of disease.* Fitting himself into a well-known tale, Joyce transformed its qualities into a Modern myth; Mann needed to uncover equally persistent older ideas and demonstrate their historical continuity. We can say Joyce was a traditional mythic writer, whereas Mann was less orthodox. Both, however, needed myth as a foundation for narrative purposes: to subvert naturalism and move into areas of psychology, behavior, personal attitudes where only "modern myths" could take them.

The chief stumbling block in seeing them as allies in narrative form is their respective use of time; but once we have introduced the mythic elements, real differences in temporal usage dissipate. For while Joyce connects temporality to inner consciousness through interior monologue and occasional stream, Mann has found the equivalent of that innerness in his contrasts of layered time. We find that Mann developed a temporal philosophy that takes into account the unconscious, preconscious, or middle interior states as much as Joyce did. In the "Schnee" (Snow) section of *The Magic Mountain*, Mann's temporal thinking is at its most supple. We can make an equation, once we allow for differences in circumstances and intention: in this episode Mann reaches for interior states in the way Joyce probes them in Circe. In both, the mind of the protagonist is phenomenological: the materials of the narrative are drawn out from within and made the main arena. Here, while snow swirls and ebbs, it is the mind of Hans that engages Mann; and in Joyce, as events prove kaleidoscopic, it is the mind of Bloom that is the fighting ground. To make that mind manifest, each needed a temporal strategy.

In "Schnee," snow itself has within it unconscious dimensions; comparable to Bella Cohen's establishment in "nighttown" in *Ulysses*. Although a snowy Alp and an overheated brothel and "nighttown" seem worlds apart, both are places of infinitude, hallucination, and fantasy: snow and flesh as the obverse of each other, part of reality and part of a mythic imagination. Joyce's is a "Walpurgisnacht" and in a sense so is Mann's: where the wildness of the snow recalls the primitive nature of both man and climate, those elements inside and outside that become mythic and timeless. In the Circe episode, amidst the swirl of other developments, Bloom reviews his family life. Surrounded as he is by dead figures, he turns his dead father into the ghost of Hamlet's father and thus establishes a tentative relationship with Stephen, for whom this is the key aspect of the *Hamlet* story. Bloom is transformed, eventually empowered, since he stresses what was once Virag and is now Bloom; comparably, Hans is resurrected in the snow from surrender and indifference to a desire for life and regeneration.

In both episodes, time works in complicated ways; in fact, a temporal dimension "creates" the scene. In Mann, time is rarely simply what is outside and what is inside, or time on the mountain and time below. It connects, rather, to the scene itself of silence and infinitude, what we associate with the unconscious. As such, it has its own sense of the absurd: it (the world of limitless silences) "tolerated his penetration into its fastnesses, in a manner that boded no good; it made him aware of the menace of the elemental, a menace not even

* Mann's devices are of several kinds: from uses of time above and time below to the dwarf waitress and lame concierge, to the "pin-up" X-ray of Clavdia which Hans admires, to the weather and stress on snow. As against this is the array of naturalistic detail: rest cure procedures, descriptions of food, medical information, determinism of place, atmosphere of doom.

hostile, but impersonally deadly." As a void or nil, the snow recalls Mallarmé's whiteness and blankness: "On all sides there was nothing to see, beyond small single flakes of snow, which came out of a white sky and sank to rest on the white earth. . . . His gaze was lost in the blind white void. . . ."

Hans enters into a "time trance," in which objects assume strange aspects: he sees snow as if for the first time, so that the "shapeless morsels" suggest a great art no jeweler could duplicate. He presses on, "deeper into the wild silence, the monstrous and the menacing," until he comes to a locked shelter, a fastness, situated in the "nothingness, white, whirling nothingness, into which he looked when he forced himself to do so." He is uncertain whether to move or stand still, and he decides on a compromise, in which he leans his shoulder against the shelter, standing first on one foot, then the other. But even before that bizarre physical circumstance arises, he has meditated on the nature of circles and arcs, on wandering "without getting home." There are, within, several varieties of time: temporal arrangements lying in circles and arcs that clash with those in conscious arrangement. He discovers that his entire circuit, including meditation and arrival at the hut, took only fifteen minutes; and this leads him to ponder how long it would seem if one didn't "come around" at all—that is, how much time would be involved in a process leading to death, not life.

Hans then dreams deeply, so that snow and swirl are transformed into a luxuriant green terraced park. The dream is one of bliss, for the green fantasy is Edenesque, paradisal; like the frieze on Keats's Grecian urn, only permanent, not fleeting. It is everything the snow negates in Hans's real predicament, and its aura of health and stability has political as well as personal overtones. It is Hans's desire to embrace health, to come through. But the bliss, suddenly, turns when Hans, still dreaming, passes through two bronze doors into a sanctuary. There he sees a scene of horror, in which two "grey old women" are dismembering a child. "In dreadful silence they tore it apart with their bare hands—Hans Castorp saw the bright hair blood-smeared—and cracked the tender bones between their jaws, their dreadful lips dripped blood." The violence and horror jar him awake, as if from some hypnotic state in which he temporarily believed in regaining Eden. The dream is over, just a dream; but it is life generally that he has experienced in the bloody sanctuary—that savage life which lies below in the world entering upon war.

Yet all of it is connected to a temporal process, since the time of the dream is, once again, chimerical. "Could it be he had lain here in the snow only ten minutes or so, while all these scenes of horror and delight and those presumptuous thoughts had spun themselves in his brain . . . ?" He suspects he was buried all night in the snow, that the dream was stretched out to a lifetime of events and experiences. He has gone through life and death, a cycle of existence, analogous to those underground or underworld journeys heroes used to make. Not unusually, his temporal sense of it has become confused, as it became for Don Quixote in the Cave of Montesinos, in which what he had thought were three days in the cave Sancho clarified as one hour. This disruption of expectation by a mysterious speeding up and compacting of time has its comparable narrative quality in stream and interior monologue. It is, in fact, one way of seeking an equivalent to internal narrative.

For Joyce, in *Ulysses*, the "nighttown" and Bella Cohen brothel scene (the Circe episode) is part of the unconscious, or of what Joyce thought the uncon-

scious was. It was, in reality, what we have called "middle states," areas between conscious and unconscious, impossible to define neatly. Naming is significant here: Bloom goes from Bloom to Henry Flower to Virag; and this is connected to his desire to belong ("I'm as staunch a Britisher as you are"), not to be an exile or isolated. But he cannot maintain his role, and voices condemn him as Moses—not as the deliverer of the Jews but as the "king of the jews" who "wiped his arse in the *Daily News*." Jew, cuckold, indefinitely named, son-less, Bloom is on trial; and his trial has something of that shifting reality associated with Joseph K.'s. This is another way of saying that whenever elements become completely internalized, we cannot expect more than patterned haze and ambiguity: Joseph K. in his nightmare may be dreaming, just as Bloom in his is, and, as we saw, Hans Castorp was.

In his mental upset, Bloom is to be crucified, jew-jesus. As the attacks mount, he is deemed guilty of one supposed crime after another, the Jew as martyr to everything that goes wrong in a given society. This occurs even as Bloom fantasizes his being honored in a triumphal ceremony: "Leopold the First." He is, however, more Sancho than Don. In this fantasy, he will be the new Solomon. These hallucinations—just a few among many—should not be viewed only as literary or psychological, since they owe much to surrealism, even to earlier phases of Dada. Joyce had found in a verbal medium some cross-referring to what Tzara and Breton were discussing in poetry, what Chirico and others were accomplishing in painting. All this goes well beyond "defamiliarizing," toward conscious confusion, ordered anarchy, disruptive stream, unpredictable interiority.

One analogy for Joyce's verbal medium could be Chirico in paint, a picture such as *L'enigma di un giorno*, possibly *Ritratto di Guillaume Apollinaire*, *Il cattivo genio di un re*, and, especially, *Il doppio sogno di primavera* in 1915, *Il grande metafisico* 1917, and *Ettore e Endromaca* in 1918. While none of these could be actually known to Joyce—this is not the point—they are attempting to gain the same entry into innerness that Joyce tried to attain in the Circe episode. For Joyce, innerness meant the penetration of layers of consciousness so that he arrived behind the anarchy at a different kind of order: the peace that lay beneath disorder.

A particularly compelling passage in the episode comes less than midway through when the "Daughters of Erin" sing a litany that is a commentary on the central episodes of the book. "Kidney of Bloom, pray for us." (p. 55), "Flower of the Bath, pray for us." (p. 70), "Mentor of Menton, pray for us." (p. 86), and so on, through Circe itself. Each line has reference to the first page of a fresh episode in *Ulysses*, and each leads into some aspect of Bloom. In the litany of eleven lines, ending with the first page of Circe, Episode Twelve, we have a composite of Bloom by way of tags and bits, a micro and macro view of him, both contracting and expanding. Accompanying the litany is a choir of six hundred voices, which sings the Alleluia chorus, with further organ background. Meanwhile, under this barrage of sound—voices, organ, chorus—Bloom "becomes mute, shrunken, carbonised." And he might be, for the line of narrative has transformed him into an object, or else a line, point, plane in an abstraction. The effect of the immediate scene is not to exalt Bloom but to deflate him, objectify him.

This is, of course, only one of several dissolving scenes: montage, the

borrowing of film techniques, the instant dissolve, the shifting of a hand-held camera; all of these are apparent. Not only "Jewgreek" and "greekjew" meet in Bloom, the Jew and Odysseus, Ulysses and the Jew, but conscious and unconscious expand and contract to blend. Here we sense a temporal strategy analogous to that in Mann's novel, the expansion and withdrawal of time so as to disguise lines of demarcation or frontiers. Names alter rapidly as Bloom is confronted by grandfather Virag or else Henry Flower, as the sexual play becomes wilder and more reckless. Then Bella Cohen appears: the Jewish whoremistress, a hallucination in itself, in Dublin. Venus in furs, Bella puts her weight on Bloom, and sexual experience becomes disarray.

Since the entire episode is hallucinatory, we encounter several dimensions of middle state behavior. Bella becomes Bello, the sexual transformation indicating not only bisexuality in Bloom, but a shifting of roles, in which he is dominated by all. By this shifting of sexes, Bella-Bello can lead Bloom through various layers of fear, desire, masochism, all at differing levels of his consciousness. She knows his most intimate secrets—she taunts him about Molly and Blazes Boylan—and she knows he becomes excited by subservience.

Yet the point of this is not so much the state of Bloom's psyche as it is Joyce's ability to find external narrative coordinates for Bloom's innerness. The episode is no less than Bloom's internal mechanism talking away, freely associated and streaming out. With the appearance of Stephen, we have the true state of the unconscious, in that all time seems contemporaneous, regardless of event and chronology: Stephen's school experience with the pandybat proving little different from Bloom's anxieties about Molly and Blazes.

We can agree that both Mann and Joyce used time, however differently in detail and circumstance, similarly in the large sense of memory, layered experience, internality. Once there, we should not have difficulty in seeking further similarities. Although narrative is not always the cementing force, both novels were created from the solution of narrative strategies. Mann's problem was to keep the reader aware of that "other world" below. Since his is the more narrative-oriented novel, his strategies must make us aware of innerness; since Joyce—as a cubist or abstractionist of sorts—is less concerned with traditional narrative, then he must keep before us some sense of that outer world as he probes the inner. The two thus become the obverse of each other: Joyce naturalistic and phenomenological in his presentation of narrative, Mann more the symbolist reaching for the "other" which lies just beyond. In his own way, each yearned for a *Gesamtkunstwerk*.

STILL MORE MODERN NARRATIVE

Not only painting and literature but avant-garde music gains much of its character from exploration of new narrative means. We suggested that Schoenberg's exploration of novelty in orchestral terms and then in atonality was linked to his view of musical narrative: he, like writers and painters, found old forms exhausted in their narrative strategies. His *Gurrelieder* is an innovative narrative because he made it a synthesis, or composite, of song cycle, opera, symphonic form. He imitated Wagner's execution of the *Gesamtkunstwerk* and advanced upon it—thus creating for himself something novel and, at the same time,

something that he brought to an end. Implicit in the composition of *Guerrelieder* is the sense that it terminated an era, that an even newer narrative strategy was needed.

This Schoenberg would arrive at near the very end of *Gurrelieder* when the "speaker" declaims in *Sprechstimme*, sung-speech. As we have seen, this mode is more than "sound," it is narrative in Modernist sense; that is, a mode of carrying the story forward which suggests its own meaning. This new musical language, which Schoenberg had discovered almost at the turn of the century, was part of that discovery of language in all the arts, in Eliot, Joyce, Pound (the *Cantos*, primarily). *Pierrot lunaire*, which set on edge the teeth of even Schoenberg's adherents, is another development of this exploration, the destruction of "pretty sounds" in favor of sound, wherever it may lead.

If we agree the new in music is the consequence of shifts in its language, then the obverse of that involves questions raised by John Cage near the other end of avant-garde music. The questions he asks strike at the very assumptions we and the more advanced Modernists themselves have made. For Cage can be understood in terms of narrative—only by narrative he has something quite different in mind. Perhaps his version of narrative can be caught solely in music; there is no literary equivalent. A novel based on silence can be suggested or intimated—Beckett moved in that direction, Camus earlier—but it cannot be "done." Cage, in fact, pioneered in two areas: in music as silence and as acts of randomness. Yet even here, at these extremes, the problem is a narrative one, as much as minimalism, silence, seeming randomness are for Beckett in his novels, or Eliot in some of his early poetry.

In reestablishing narrative, Cage excluded nearly everything that was part of the tradition, even someone like Schoenberg, his former teacher and himself someone who moved well beyond the tradition. Cage's most famous piece of silence is, of course, $4'33''$, indicating the silent length of time the pianist sits at the piano without playing. The noise of coughs, belches, scratches, chairs scraping against the floor, random sounds replaces the piano; expectation becomes all, intention is nullified, and actual silence is a chimera. If anything, the anti-piano $4'33''$ is symphonic in its linkages or montage of background sound. Similarly, randomness is only that: the aleatory quality—from *alea*, Latin for dice, a throwback to Mallarmé's influential poem or Max Jacob's *Le Cornet à dés (The Dice Cup)*—is controlled by the terms in which randomness is posed. Just as "silence" is not possible, neither is any purely aleatory aim.

Cage's withdrawal from Schoenberg was based, he asserts, on the latter's need for regularity and order. He says that Schoenberg assigned to each material, within a group, its function in relationship to that group. Everything is defined, located, and integrated. * With this, Cage raised fundamental questions not only about aleatory music but about Modernism itself. There is, in fact, a crisis situation in the implications of his remarks. For if Modernism, especially its more extreme avant-gardes, which would include Schoenberg's serialism, is

* This was, also, Pierre Boulez's critique. He attacked Schoenberg for having remained so orderly, for fearing to allow aleatic things to happen. He found elements to praise in Webern, possibly because Webern was a minimalist. Boulez compared Webern's first efforts at composition with Mondrian's *Tree* series done between 1909 and 1913; these trees were representations merely suggested by geometric planes and sketched in with a few light colors—almost abstractions.

really a disguise for order, then what do we make of its rebellion against order, its assault on mental processes and balance? Cage suggests that randomness should be implicit in every aspect of the avant-garde and Modernism, or else *it*, whatever it is, ceases to be Modern. Cage is pursuing ideas that derive from Dada, and possibly one way to respond is to say that Dada was so deeply informed by a negative reaction to the senseless murders of the young in the war that randomness—some kind of imposed Schopenhaueran Will of the World—seemed the sole escape from mindless mind.

The larger question is whether every avant-garde must be random, at least in its intentions. The answer to that is that every avant-garde has within it a random factor; that is, in its assault on order, mind, stability, moderation, it introduces an element of chance or open-endedness which we can associate with randomness. As soon as new languages are established, they create a function that disallows regularity; and since all art, even academic art, has a random factor in it, we can assert safely that avant-garde art will destabilize and produce some degree of randomness.

Cage's critique is tonic in that it forces us to remember how one era's avant-garde becomes the tradition for the next. Edgar Varèse at one time called music "organized sound," which we may take to be an extreme statement; but even here, Cage is critical, saying that Varèse "is an artist of the past." Varèse, he asserts, does not permit his improvisations to follow the randomness of the sounds; they follow him, so that they "sound like his other works." And as for the twelve tones, Cage points out there is "no zero in it." In fact, there "is not enough of nothing in it."

If we retreat to the period and music that Cage is implicitly or explicitly subverting, we find the kinds of disruption or dilution of tradition that the avant-garde in all the arts displayed. In symphonic form, Mahler tried to make a given symphony into a *Gesamtkunstwerk*: ". . . a symphony," he said, "must be like the world, it must embrace everything." This was in response to Sibelius, in 1907, who expounded the symphony as tightly knit, organic, logical, a formed entity without loose ends. Yet without relegating Sibelius to the dust heap for his remark—his Fourth Symphony was assimilating very Modern modes of impressionism—we can observe Mahler moving toward a redefinition of symphonic languages. He was opening up the form as narrative and language as much as writers who explored free association. In some indirect way which is impervious to precise analysis, Mahler tried to get into the unconscious or preconscious through musical notation. He wanted, in effect, the sounds of the mind.

His music, like many of his songs, is obsessed with death, and with good reason. By 1907, when he made the above remark, his bad heart had doomed him, and there was death everywhere in his life: his many siblings dead in childhood, while his father became an alcoholic; the suicide of his brother Otto; the death at twenty-six of his sister Leopoldine, of a brain tumor; the death of his young daughter one year after he wrote *Kindertotenlieder*. There was, in addition, the terrible pressure of public opinion which was forcing him from the directorship of the Vienna Opera, and the further pressure of anti-Semitism even after he had converted to Roman Catholicism so as to be eligible for the post. But behind that was a fascination with death which transcended any in-

dividual event or personal tragedy: a death longing that hung over him and his life, something going far deeper than any external events can explain.* This depth of the death wish or death fear took Mahler into areas beyond the conscious; and his music, its free association of heights and depths, its almost manic joys interworked with terrible depressions, would reflect "feeling."

Just as Mahler's symphonies in their length, complexity, use of unusual instruments, juxtapositions of sound were groundbreaking, so were his lieder outside the lieder tradition. His are not the usual songs we associate with lieder, but orchestral songs: his approximation of what Schoenberg and Berg would develop in *Sprechstimme*. Mahler was moving along the same line, although compared with their use of spoken song, his sounded more traditional. Yet his vocal works appear not only in symphonies as enhancements, but as having symphonic properties themselves. Even as songs in cycles, as in *Das Lied von der Erde* or *Lieder eines fahrenden Gesellen*, there is an operatic quality, an expansion toward the total work. Mahler was breaking through restraints, re-defining musical language. As part of the symphony, the vocal parts have a cosmic aim; in his Eighth, for example, Mahler was attempting what Schoenberg hoped to accomplish in *Gurrelieder*. For both, the "symphony of a thousand" was to crash through orchestral sound and to blend symphony, lieder, the language of song, and operatic form.

But even earlier than Mahler or Schoenberg, we see a major effort to redefine musical language in the work of Claude Debussy. Debussy is not often associated with the groundbreakers, and yet his *Pelléas et Melisande* pioneered in at least one respect. For the lyrical side, Debussy devised his own kind of *Sprechstimme*, in which sung parts and orchestral elements are blended. It is a definite break with the more traditional language of nineteenth-century opera, certainly with Verdi and even with Wagner. This is not song against a musical accompaniment, but song integrated into the musical accompaniment; so that what is called impressionism in music is really a kind of free association in which both elements, the sung parts and the musical accompaniment, appear to derive from some place beyond the conscious, which we have associated already with the "new novel." We can say Debussy, by 1892, when he began *Pelléas*, was moving in music toward what Freud would explore after 1895. Certainly we can see how influential Debussy's work was, especially on Schoenberg, in something like *Pierrot lunaire*. All of these pieces, Debussy's and Schoenberg's, are not antithetical to what we have examined in spiritual autobiography, where subjective voices emanate from somewhere beyond the speaker.

Yet the progression toward the new, toward creating avant-gardes, was not unrelieved by doubts. We are often made to feel that Modernism is inexorable, that the artists who advanced its causes did so unquestioningly, even enthusiastically. On the contrary, Schoenberg moved toward atonality with great reluctance and considerable melancholy. As a composer deeply indebted to the

* Some critics have cited Mahler as the partial model for Gustave Aschenbach in Mann's *Death in Venice*. Although no hard evidence exists for this—the portrait is as much a self-portrait— the need to embrace death as a form of expression is not distant from Mahler and the Mann protagonist. There is, however, little question Mann drew substantially on aspects of Schoenberg's career—his twelve tones, his book of theory, *Harmonielehre*, other matters that led to the estrangement between them—for his *Doctor Faustus*. The "Ode to Sorrow" that Leverkühn creates is a Schoenberg-motivated lamentation, combining Orphic and Faustian elements in a kind of farewell to an age.

tradition—Beethoven, Brahms, Mahler, even Bruckner and Hugo Wolf—
Schoenberg perceived that diatonic harmony was supportive of everything he
most respected in musical composition. He speaks of his testing period: "Per-
sonally I had the feeling as if I had fallen into an ocean of boiling water. . . .
it burned not only my skin, it burned also internally." The words recall Rim-
baud's harrowing of hell in order to find his poetic talent; and Schoenberg, whose
self-portrait demonstrates a highly neurotic style, found only hell could express
his breaking away.*

Several of his contemporaries were also poised to move toward atonality,
but resisted. Richard Strauss, whose work in the 1880s and 1890s showed a
Modernist spirit, was on the edge of the new with *Salomé* and *Elektra* and then,
for whatever reasons, turned conservative with *Der Rosenkavalier*. After that, he
was fixed. Sibelius, who began with large Wagnerian, almost operatic, sym-
phonies, moved toward minimalism and with his Fourth Symphony almost
displaced diatonic harmony. Mahler in the Adagio of his Tenth Symphony, the
unfinished one, was moving toward Schoenberg's mode. All of these efforts
derived from about 1910 and are roughly contemporaneous with Schoenberg's.
Even Scriabin, whom one could hardly consider an avatar of the really new,
was moving toward atonality when he died, in 1915. By 1910, when he was
beginning to think of atonality, he was also attempting a *Gesamtkunstwerk*,
utilizing a color organ that produced bands of light upon a screen in his *Pro-
metheus; A Poem of Fire* (1909–10). When he died he was planning a work that
would incorporate sound, color, and smell—the use of scents as part of the aural
motif—but it was never brought forth.

The work of Richard Strauss is perhaps most illustrative of how the avant-
garde beckoned and then was resisted. Had Strauss continued in his development
of the early 1900s, he would have found himself in the avant-garde camp. Even
without atonality, *Salomé* met the kind of resistance we associate with Stravinsky's
Le Sacre. Mahler's great prestige could not get it performed by the Vienna Opera.
Strauss's collaboration with Hofmannsthal, a conservative in artistic matters,
certainly inhibited his development; and even the use of clashing and dissonant
sounds in *Elektra* would prove more a swan song to a style than the sign of
innovation. Strauss was, by 1909, with *Elektra*, prepared to write the kind
of twentieth-century opera we associate with Alban Berg. That building up of
tensions by way of dissonance, which is then partially resolved by further dis-
sonance, was Strauss's threshold Modernism. He pulled back and left that field
to Schoenberg, Berg, Krenek, and others; not the least to Béla Bartók, whose
Bluebeard's Castle (1911) is deeply indebted to Strauss's orchestration.

* Another tortuous route can be found in Shostakovich, whose *Lady Macbeth of Mtsensk* was
assaulted from all sides. The Soviet state attacked it as follows: "Singing is replaced by screaming.
If by some lucky chance the composer happens to hit upon an attractive melodious tune, he hastens,
as though horrified by such a calamity, to plunge back into the jungle of musical confusion, at
times degenerating into complete cacophony. . . . All this is done not because of the composer's
lack of talent, not because of his inability to express simple and profound emotions in musical tones.
No, his music is distorted deliberately. . . . The inspiring quality of good music is sacrificed in favor
of petty-bourgeois formalist celebration, with pretense at originality by cheap clowning. This game
may end badly." Shostakovich, evidently, was too Modern. Stravinsky then had a shot at it, finding
it insufficiently Modern, as being "too communist" in its lack of invention: *Lady Macbeth* is a "work
of lamentable provincialism. . . . Formless, monotonous music—a system of recitatives and entr'actes
during which the conductor works up the applause of a public delighted at being brutalized at the
arrogance of the very numerous communist brass instruments. . . ."

Schoenberg himself in the early 1900s was, as we have already seen, undergoing a maelstrom of feelings and influences. Early on, he had been deeply affected by Maeterlinck's mysticism and the theosophical movement as a whole, as well as by elements as seemingly disparate as Strindberg, French and German symbolism, and the burgeoning movement in German expressionist painting. As both painter and composer, Schoenberg worked on parallel lines, and it is of interest in the light of our remarks on spiritual autobiography that his self-portraits appear with his movement toward atonality. What this appears to signify is an intensely narcissistic phase in which all that mattered was his vision of both sight and sound. With this deep personal involvement in what he "saw," he was able to surmount his veneration for musical tradition. We find a comparable dedication in Yeats, about the same time, in which he shifted from deference to spiritualism and other such movements toward that inner vision which would nourish his major poems.

Schoenberg would undergo another such transformation, when he announced to his pupil Jose Rufer, in 1921, that he had discovered something. This "something," which he was in the process of developing, would, he thought, ensure the supremacy of German music for a thousand years. His naiveté in the light of Nazi attacks on Modernism and their banning of his music is almost touching. His new development was the twelve tones, which, he felt, would redirect the imbalance created by the lack of system. He perceived system was necessary so that large forms could be redefined, and serialism offered him a way of achieving order. This was precisely, of course, what Cage and Boulez would later attack in Schoenberg, but such criticism often follows only personal needs and not historical demands. Schoenberg would find himself in a paradox with serious reverberations. For the serialism he saw as order was perceived by all but his closest sympathizers as forms of disorder, anarchy, chaos; by totalitarian states as subversion of national values expected to hold the people together.

Schoenberg, too, saw serialism as simply an extension of what had already been achieved, in his still incomplete *Die Jakobsleiter* and in Berg's *Altenberglieder.* * Serialism was not to be only a local matter, since it pervaded Modern music, and even Stravinsky, who moved along different lines, would come to it later in his career. Unlike those who defined surrealism as an avant-garde, Schoenberg did not see serialism as something subverting music; rather, it was something that would make twentieth-century music viable. What appealed to him was the fixedness of the twelve tones, the series that, used to generate melodies and harmonies, would be definitive for the whole work. The series provided harmonic coherence, with the fundamental interval pattern unchanging. Each note in the chromatic scale is of equal value, and there is no reversion to tonic. The row of tones can itself be restructured as the composer wishes: inverted, turned backward, or into any combinations. Whether one pursues fugues, canons, or whatever, the composer must follow the principle of the row. Schoenberg saw it as natural and simple; as, clearly, another mode of narrative.

In fact, earlier work such as *Pierrot lunaire* was conceived of in much more complicated terms than was serialism. As we have noted, it was a kind of hybrid

* In its 1913 Vienna premiere, which Schoenberg conducted, the police had to be called to quell rioting. Such demonstrations made it difficult for any of the music of Schoenberg, Berg, and Webern to be heard—their reputations damned them, rather than performance.

of stage and concert performance—a distant forerunner of Brecht's and Weill's music dramas. *Pierrot lunaire* was a mode of opera, written as much for an actress as for a singer. The *Sprechstimme* suggests it was aimed more at acting than pure singing; we associate it with the music hall or cabaret. Grafted on to that is Schoenberg's still early spiritualism and mysticism: the uses of the moon, the nature of imagination and inspiration. The music, accordingly, is quite complicated, especially in the polyphonic structure of "Moonspot," No. 18.

To return to serialism: it acquired a considerably different reputation from the way Schoenberg had himself viewed it. But whatever it came to mean, it was a freeing force in twentieth-century music; after it, innovations poured in. In America, Charles Ives was, without direct awareness of European developments, pursuing his own forms of Modernism. In Europe, floodgates opened. For the French *Six*, Erik Satie's music—minimalist, Dadaist in intention, essentialist and witty—became a beacon. The influence of American jazz entered, in Ravel, Poulenc, Milhaud, and Stravinsky (especially his *Rag-time*, in 1918); in America, its source, in Copland and Gershwin. The Brecht-Weill music drama owed a good deal to jazz, for example in *The Rise and Fall of the City of Mahagonny*, presented in the 1929–30 season. Jazz gave the composer a sense of nowness—modern life, modern rhythms, modern improvisation. Ernst Krenek's *Jonny spielt auf*, in the mid-1920s, brought jazz into opera, the hybrid Brecht-Weill made popular.

In his period of intense personal development and musical innovation before 1920–21, Stravinsky made a major effort to redefine narrative. In *Le Sacre du printemps*, which remains to this day a miraculous, unsettling composition, he expressed his need to voice "the sublime uprising of Nature renewing herself— the whole pantheistic uprising of the universal harvest." He describes the Prelude as illustrating man's fear of nature, as each instrument becomes like a bud, and the whole like the significance of the birth of spring. The flute sound is intended to convey that "vague and profound uneasiness of a universal puberty."

We are presented with a new narrative: "The melody develops," Stravinsky says, "in a horizontal line that only masses of instruments (the intense dynamic power of the orchestra and not the melodic line itself) increase or diminish." The strings, he feels, are too close to the human voice, too symbolic. "In short, I have tried to express in this Prelude a sacred terror at the midday sun, a sort of pagan cry." As a consequence, "the musical material swells, enlarges, expands"—the language or voice of spring is sexual, sensual. ". . . the whole orchestra, all this massing of instruments, should have the significance of the Birth of Spring." Stravinsky, incidentally, favored "The Consecration of Spring" as an English translation of *Le Sacre*.

The story line, as Stravinsky himself later asserted, is musico-choreographic, without plot. It derives from some inner or middle state. In the first scene, some adolescent boys appear with an old woman "who knows the secrets of nature, and teaches her sons Prediction." She runs bent over, this half-woman, half-beast, whereas the adolescents by her side represent Spring. Their step marks the rhythms and pulse beat of Spring. At the same time, adolescent girls arrive from the river and mingle with the boys, each group forming a circle. "They are not entirely formed beings; their sex is single and double like that of the tree." We note now the complex narrative line of the choreography, as Stravinsky describes it: "The groups mingle, but in their rhythms one feels the cataclysm

of groups about to form. In fact they divide right and left. It is the realization of form, the synthesis of rhythms, and the thing formed produces a new rhythm."

The groups separate and compete; tribes attack each other, and messengers go back and forth between them as they quarrel. "It is the defining of forces through struggle, that is to say through games." A procession arrives: the Saint or Sage, the Pontifex, the elder of the clan. The groups await his blessing of the earth; they manifest terror. He gives the benediction, which is a signal for the eruption of rhythm. "Each, covering his head, runs in spirals, pouring forth in numbers, like the new energies of nature. It is the Dance of the Earth." Everyone stomps the earth.

The next part or scene is the Great Sacrifice Night. It begins with the adolescent girls' game. "At the beginning, a musical picture is based upon a song which accompanies the young girls' dances. The latter mark in their dance the place where the Elect will be confined, and whence she cannot move. The Elect is she whom the Spring is to consecrate, and who will give back to Spring the force that youth has taken from it."

Stravinsky continues: "The young girls dance about the Elect, a sort of glorification. Then comes the purification of the soul and the Evocation of the Ancestors. The Ancestors gather around the Elect, who begins the 'Dance of Consecration.' When she is on the point of falling exhausted, the Ancestors recognize it and glide toward her like rapacious monsters in order that she may not touch the ground; they pick her up and raise her toward heaven. The annual cycle of forces which are born again, and which fall again into the bosom of nature, is accomplished in its essential rhythms."

Sacrifice-Elders-Invocations-Chosen One: such traditional elements cannot disguise the avant-gardeism of the piece when we add in the music, decor, choreography—a *Gesamtkunstwerk* or total experience. The music jars, pounds, leaps, a brilliant evocation not only of Spring rising but of Modernism itself. In a sense, *Le Sacre* reaches back to itself, a circling into the very sense of Modernism as a choreographed, plotless form of synesthesia, depending not on narrative but on mixture.

Stravinsky insists he is not formulating a revolutionary doctrine. He sees himself as simply speaking his own language, "which might seem now," he admits, "and, at first, incomprehensible, since it was contrary to certain rules, customs, and especially certain clichés. For me this new language was perfectly natural, but to others it seemed revolutionary. . . ." If he meant what he was saying, Stravinsky was turning an avant-garde art into a routine event, demythicizing the mysteries of creation and, by implication, the mystique of the divine creator. He stresses that music derives from "the innate need to create," not from some sacred instrument.

With this, we have the Rimbaud-Mallarmé conception of art and the artist countered by the view of artists as natural agents of their own talents. The mystery is diluted; the natural stressed. Yet Stravinsky is being disingenuous about this miraculous period, not merely of *Le Sacre*, but of *Firebird*, *Petrouchka*, and others. For he created not only innovative musical sound, he was present at the creation of a new art form in the kind of ballet music he composed and which Diaghilev mounted as spectacle. The Bakst settings, the Nijinsky choreography for *Le Sacre* and *Petrouchka*, the Diaghilev direction led to a major

revision of the art form; this was in a sense the "new opera" as much as Berg's would be.

Its novelty was in its new narrative direction, toward the embellishment of the sub- or preconscious. Stravinsky derived his innovative narrative force by way of the "colors" he drew from his orchestration; that is, from rhythmic, harmonic, and other possibilities. An analogy would be Klimt's paintings for the official buildings in Vienna, his commissions to decorate the university ceiling. In the act he undermined the traditional conceptions of Philosophy and Hygiene and gave them new narrative qualities; that is, redefined them in the terms of his new conception. And yet he did this not by way of brush strokes or abstraction, rather by means of new rhythms and harmonies, new arrangements of figures—as Stravinsky did with sound and harmonics.

Stravinsky, however, seemed to be running directly against these trends when he turned to neoclassical styles, in *Oedipus* at first and then in *Symphony of Psalms* and *Persephone*. But he, too, would be strongly affected by the exploration of the new and would move, eventually, toward serialism and other hybrid styles. If nothing else, his "borrowings" in his neoclassical phase—from Pergolesi, Scarlatti, Bach, for example—recall borrowings in Eliot, Pound, and Joyce. Such methods are in themselves of interest since they demonstrate a reluctance to forsake tradition while simultaneously transforming that tradition.

The paintings and manifestos of futurism strongly influenced musical narrative. Honegger's *Pacific 231* and Antheil's *Ballet mécanique* are derivatives of the futurist stress on speed, machines, acceleration. The latter work is scored for, among other things, two electric doorbells and an airplane propeller. Luigi Russolo had called for music that approximated the sounds of modern life, i.e., its velocity. Edgar Varèse, whom nearly everyone respected, built a career on combining unusual instruments that attempted to bypass Schoenberg's twelve tones with tonal colors and pitches. His early 1920s rhythms have the sense of electronic music, although Varèse had to wait for later developments before he could work out something like *Déserts* (1954).

Representative of his earliest composition is *Amériques*, written in 1920–21, and conducted by Leopold Stokowski in 1926; but perhaps "pure" Varèse is *Hyperprism*, in 1924. In the latter, Varèse utilized instruments which approximated sounds and tonal varieties he would much later educe from electronic devices. In *Hyperprism*, we find a division between two instrumental groups, the wind and the percussion; except that the latter includes Chinese blocks, rattles, anvil, triangle, sleigh bells, tam-tam, a lion's roar, and snare drum. There are echoes from futurism, serialism, and even jazz, plus foreshadowings of the electronic movement that would come after World War Two. Having been born in 1883, Varèse lived through every significant avant-garde in music, literature, and art, coming of age when these avant-gardes came of age. His sense of musical narrative is, in one major respect, a reflection of everything he saw developing around him, and since he spent his early years in Paris, Turin, and Berlin, he gained maximum exposure. In Berlin, he studied under Busoni, whose *Sketch of a New Esthetic of Music*, issued in 1907 and then expanded in 1910, looked ahead toward new scales and even toward electronic music. Busoni's *Doktor Faust* (1916–24) is a little-known opera which could become a significant work with a sympathetic production.

Varèse serves as a linkage between the era of Debussy, Schoenberg, even Stravinsky, and the postwar era of Boulez, Stockhausen, Henze, Xenakis, Cage, Penderecki, Berio, and Messiaen (whose students included Boulez and Stockhausen). The major point about Varèse's work, as with those influenced by futurism, is their common need to replicate in musical narrative what was occurring in art and literature. Although sound cannot replicate precisely, we have in aural terms a broken narrative that includes free association, velocity, reflection of machinery; "planes of sound," which recall cubism; dissonance and disruption, which recall abstraction; and, more generally, a sense that music derives from some middle state, what we have associated with interior monologue. This is not music from the unconscious, which would be meaningless, but organized sounds driving from an inner place that no one, neither composer, painter, nor novelist, can locate. The proliferation of unusual instruments—pioneered by Wagner and Mahler—derives from that need to defamiliarize, but also to force the listener to listen. Each segment becomes important in itself, building or formation making is secondary. There is some connection here to later developments in literary criticism that stress reader and listener, not solely the text; so that the one who experiences the work makes it possible. The product is de-emphasized because it can never be "known," whereas only the experience that went into making it and then hearing it should count.

Avant-gardes are clearly reciprocal. If we look at Olivier Messiaen's *Technique de mon langage musical*, issued in 1944, we see that many of his points about music are carry-overs from avant-gardes in the other arts. Generally, we sense futurism and Schoenberg's twelve tones; but in other particulars we can see an absorption of Proustian time, painterly abstraction, Kafkaesque destabilization of normal processes. Messiaen, who was in his time as great a teacher for his group as Schoenberg had been for his, wrote about the serial use of rhythm, rhythms that read the same forward and backward, intervals that remain unchanged when inverted, use of alternate sounds from talas and ragas, exploration of a transposed scale, a ten-note scale. He also spoke of *valeur ajoutée*—increasing the duration of notes asymmetrically rather than by augmentation. In the latter, we have an almost direct transposition of literary ideas to musical composition. By 1944, Messiaen was not only indicating where music should go, he was summing up previous eras.

Although the following quotation from Charles Ives seems light-years away, its advocacy of openness connects it to Messiaen's more technical language. Both are speaking of new narrative voices, Messiaen as a sophisticated European, Ives as an egalitarian, Emersonian American:

> . . . the day will come when every man while digging his potatoes will breathe his own epics, his own symphonies (operas, if he likes it); and as he sits of an evening in his backyard and shirt sleeves smoking his pipe and watching his children in *their* fun of building *their* themes for their *sonatas* of *their* life, he will look up over the mountains and see his visions in their reality, will hear the transcendental strains of the day's symphony resounding in their many choirs, and in all their perfection. . . .

What joins Ives to Messiaen, or those like him, is his awareness that musical composition had become sound: that it had passed from inside the concert hall

into the music-making that is at every talented man's command. This opening up of musical composition has its roots in early Modernism, in fact in something very close to spiritual autobiography or in abstract painting, where the derivation of the work lies within, not without. With abstraction, for example, one no longer needed a model, nor even the materials for a still-life; once externality and objects were excluded, the anarchy of individual achievement was all that mattered.

In musical composition, passages are abstract in the sense that traditional harmonies and melodic development have given way to sound, merely. Stockhausen's *Gruppen* (1955–57) is an effort to be both inside and outside for the listener. Three orchestras, directed by Stockhausen, Boulez, and Bruno Maderna, were placed in different parts of the auditorium. While the audience sat enfolded by sound, the three conductors coordinated their orchestras, each playing simultaneously with the other in different tempos, in a serial manner. At the finale, a brass chord was swung around from one orchestra to another, as if being passed on so as to circumscribe the listener. This idea of orchestral development, incidentally, did not originate with Stockhausen, but with Schoenberg, who envisaged it for his incomplete *Die Jakobsleiter*. Much of this depends on indistinguishable sound, the obverse of Satie's work *Vexations*, with its 840 repetitions. When Cage presented it in 1963, it took ten pianists and eighteen hours to perform, the point of it being to envelope the listener in repetitious sound as much as the object of Stockhausen and others was to envelop him in nonrepetitious and nonrepeatable sounds.

When composers strove for a new sense of narrative, they had as much difficulty in finding a definitive form for Modern narrative as did writers and painters. Nothing illustrates this better than a kind of culminating narrative strategy devised by Luciano Berio. In his *Epiphanie*, composed around 1960, he created settings of Joyce, Proust, Brecht, and other writers, using a different style for each. Here we have the entire Modern tradition, since the epiphany in Proust and Joyce is a central spatial/temporal dimension. Furthermore, Berio was interested in how sung tones could be merged with the sounds of instruments, blended into them; so that voice becomes a form of *Sprechstimme* and instrumentation becomes a form of voice.

Another, not unrelated, development came eight years earlier in Pierre Schaeffer's "musique concrète," which was a sequence of noises brought forth from mechanical sources. His *Symphonie pour un homme seul* is a collection of everyday, routine sounds: snores, coughs, belches, whistles, all reproduced on tape, with percussion added. What is compelling—and obviously this is not something pleasing to all audiences—is how interrelated this sequence of sounds is with interior monologue and free association in literature; how, in fact, these routine sounds are part of that ordinary world interior monologue derived from. Also, such sounds, while no longer music as such, are almost unconscious, some of them reflections of the involuntary nervous system or of physical conditions (snoring, sneezing, coughing) over which the individual has no choice. In a final sense, such sequences are aleatory, unrepeatable, certainly not memorable. With this and with the developments noted above, we have moved musical narrative to "sound narrative," which is, in many respects, the equivalent of abstraction in painting or uses of preconscious and unconscious in literature.

◆ ◆ ◆

A good deal of the aural-visual avant-gardeism in the post–1925–30 period came in the desire to create the *Gesamtkunstwerk*, or total-work. The production of Gertrude Stein's *Four Saints in Three Acts*, as noted above, was prototypical: text by Stein, music by Virgil Thomson, choreography by Ashton, decor constructed of cellophane. This type of production would be continued at Black Mountain College, with Cage, Cunningham, M. C. Richards, Charles Olson, David Tudor, and Rauschenberg collaborating on a happening that was also a total-work. In our own era, the Robert Wilson massive stage works, including *The King of Spain* in 1969, which eventually became *The Life and Times of Sigmund Freud*, and then his twelve-hour *The Life and Times of Joseph Stalin* (1974), are efforts in this direction. Perhaps the best example is his collaboration with Philip Glass on *Einstein on the Beach*, which received a lavish production at the Metropolitan Opera House for two performances in 1976.

Although the *Gesamtkunstwerk*, or attempt at it, has not completely dominated the avant-garde, it is possible to speculate on why it should have become so popular a form. It has, indeed, proven popular despite the enormous costs involved in mounting such productions, requiring funding from foundations, several donations, and devoted benefactors. Ticket sales cannot begin to cover expenses. One key reason for the reemergence of the total-work is the blossoming of "performance" as an art form. Performance cuts through genres and would seem quite in keeping with the openness increasingly associated with postwar life: acting out, happenings, staged events, therapeutic behavior, circumstances—these frequently replace the generic structures that even the most radical avant-gardeists nominally held to in the earlier period.

Also, in another respect, music had been caught in an irreconcilable situation. For it had seen several developments that could not be resolved in narrative terms: Schoenberg's serialism, which exerted pressure over succeeding generations; a lingering romanticism and postromanticism, from Mahler, Strauss, Debussy; the introduction of Cage's randomness and the increasing prevalence of aleatory or aleatory-styled music; the development of electronic music; a neoclassicism that Stravinsky introduced, and Stravinsky's own eclecticism and minimalism; the gradual acceptance of musical forms and instruments from other cultures, helped along by Henry Cowell, reflected in the way Ravi Shankar entered into Glass's music, as other forms had entered stylistically in Steve Reich, La Monte Young, and Terry Riley. The argument here is that these diverse elements cannot be absorbed into any single style, and, therefore, are best expressed as a total-work. The latter allows not for style but for expression, performance, statement; it is the musical equivalent of open speech, which has dominated our post-Modern ideas about fiction.

Other reasons exist for the importance of performance, many of them lying in the development of technical prowess in electronics, lighting, and other elements that build to a multimedia effect. Jazz, rock, and disco dancing, distinct as the genres would seem to be, have had their fallout on such events. There is also the pressure of "expression," the reflection of self and ego, which has been a constant since World War Two. Performance is a more total method of reflecting the self, as, for example, in Laurie Anderson's *United States*. She sings, dances, declaims, acts out her play, plays out her act; she assimilates all to herself, and then "expresses" it. For the Olympics in Los Angeles in 1984, itself a *Gesamtkunstwerk*, Robert Wilson devised *the CIVIL WarS: a tree is best*

measured when it is down. The music includes that of Philip Glass and several other composers, and it takes twelve hours to perform.

Characterizing these efforts at the total-work is fluidity of form, lack of narrative structure, use of suggestive imagery, dancing, and miming* as the sole way the viewer can enter the work. There is no plot or story line, even though performance reflects theater and opera. That lack of narrative line connects the contemporary *Gesamtkunstwerk* with earlier developments in narrative. Whereas earlier we had a central narrator who disguised the story line, or a narrator who was unaware of the events occurring, or unconscious of their full effect on him, now we may have numerous narrators but no way to connect them.

In *Einstein on the Beach*, Einstein is a spectral presence—he must be intuited from the work. He is a brooding presence, a hovering, godlike figure who has fallen into the interstices of the work; but while there, he exerts tremendous pressure on every dimension and seam. He is the narrative glue, as it were, as much by his absence as by his presence. He is frequently "there" by way of his artifacts, and, of course, in the title, which suggests Nevil Shute's novel *On the Beach,* whose locale is Australia after a nuclear holocaust. But the title is suggestive in other ways, for Ein Stein suggests a stone on the beach: the way in which our experience has become fragmented and isolated despite Einstein's efforts to gather together every natural force into one formula or principle.

The music flows around several elements that keep Einstein in our minds. There is "train music," recalling Einstein's toy trains as a child as well as the trains he used to illustrate aspects of relativity. There is "trial music," not for Kafka, but for Einstein's speculations about himself and the future concerning what he had wrought, especially in nuclear energy. There is, finally, "spaceship music," suggesting Einstein's role in space travel. Then there is Einstein himself, playing the violin, the chief character now as musical commentator, as counterpoint to all this activity that, somehow, he has made possible.

The quality more than any other that makes the narrative seem submerged or at a vanishing point is Wilson and Glass's ability to make sounds erupt from a middle state. The repetition of the music, its linkage to randomness, and its insistence on itself whatever else is happening help to emphasize this inner or middle condition. The beginning of the opera suggests interior monologue, especially in the repetition of the word "it," which becomes hallucinatory. "These Are the Days" is the section: "Will it get some wind for the sailboat. And it could get for it is. It could get the railroad for these workers. And it could be were it is. It could Franky it could be Franky it could be very fresh and clean. It could be a balloon. It could be Franky It could be very fresh and clean. All these are the days my friends and these are the days my friends. It could be those ways." The language suggests Hemingway brevity and lyricism hitched to Joycean or Woolfian stream, a kind of abstractionism that settles between conscious and unconscious, wherever that is.

The rest of the passage repeats key words: sailboat, railroad, it. The overall effect is somewhat like Honegger's *Pacific 231*, wherein orchestration conveys

* Not unusually, mime—that of Barrault, Marcel Marceau, and others—has become more popular. Mime in one respect is a total-work, combining acting, "body language," ballet, music, et al. It overlaps with dance and with theater, but falls in between; and it is its indeterminacy as a genre that has created its more recent success. In an open society, any break with genres (i.e., with order and tradition) will justify itself. Mime becomes, in the Modern mode, expression of self.

the start-up and whoosh of a train; here it is words that fill that role, words as velocity whose sounds imitate speed. Since the subject is Einstein, velocity is what we want. The minimalist "orchestra" follows at great speed in the first parts, so that we sense a futuristic overlay, not at all foreign to an Einsteinian dimension. We should not be too ingenious, since the work is often more tedious than innovative, but we have here in this attempt at a verbal-musical-artistic *Gesamtkunstwerk* an effort to prolong the avant-garde, to reach back into Modernism.

With all its avant-garde staging and other elements indicating the latest thing, we perceive narrative linkage with Ford, Woolf, Joyce, Broch, and others from the 1910s and 1920s. The narrative lies not on the surface as in traditional work, but anywhere we can find it if we look hard enough. In another respect, the narrative gathers its momentum by virtue of the number of hints and intimations we pick up—and here the heritage of symbolism seems clear. Furthermore, there is always less "there" than meets the eye in performance; that is, performance makes great effort to convince us it has suggested more, the total-work, than we have actually observed. This does not mean we feel cheated; it means we have only glimpses and must be satisfied. Performance is like Mallarmé's curtain or breeze—minimalism seems to raise our consciousness, but we are never certain.

These new total-works also cut through all categories of realism, naturalism, psychological orientation, even futurism and symbolism, which they seem to imitate. The nature of the modern *Gesamtkunstwerk* is to be unlocatable. The demands of multimedia are such that performance preempts all considerations we assign to conventional, more limited work. In the latter, we speak of narrator and narration, story line or plot, communication, relationship of language to audience, empathy of performer and viewer, and so on. In the newer total artwork, those categories are dismissed, and the very rhythms or pacing redefines the work and its relationship to the audience. The viewer may or may not follow; language speaks not to him but is supposed to roll over him. Performance is now environmental. We sense Dadaist and surrealist tendencies, in that performance has broken sequence and invested in interruption. Shift the sequences somewhat, and we see similarities to disco dancing—multimedia at the crux of both, performance as their vehicle.

A spinoff of this type of multimedia, performance-oriented total-work can be found in Giles Swayne's *Cry*, a work first broadcast in 1980. It needs, however, an audience, since in its use of voices, it depends on the presence of absorbing bodies. Twenty-eight singers arranged in an arc sing into microphones; their voices are then electronically mixed, modified as desired, and reproduced in seven loudspeakers located around the hall. The audience is surrounded, saturated, and threatened by sound. The work is in seven movements, the biblical seven: void, light, darkness; sky; sea, dry land, vegetation; sun, moon, stars; creatures of the air and water; creatures of the dry land; rest. Whereas the content is linked to "making," to creation and the Creation, the music is hardly conventional; it is "sound," not music as defined by past eras.

As sound, it serves much the same function as performance in its *Gesamtkunstwerk* phases. The composer has indicated he was interested not in a text—there is none—but in "a world of sound, constructed . . . according to

complex mathematical laws and processes." The singers are not fully coordinated with each other, in that they practice randomness; singing or whispering or shouting as they wish—but using syllables selected for sonic value. In the latter parts of *Cry*, sounds form into recognizable words, although overall the effect is of some foreign tongue just beyond our reach. Since the singers are unaccompanied, their creation of such sound is, in practice, the creation of an orchestral dimension: voices in this multimedia "drama" become orchestral voices. While hardly to everyone's taste, *Cry* indicates that the concept of performance if stretched to its limits can provide a "new music" for our time, which is precisely where we started with the idea of avant-garde.

FROM NARRATIVE TO DADA AND SURREALISM

At the time of the First World War, even as narrative in the arts was being rethought and reshaped, certain developments were leading to the destruction of narrative altogether. The nature of these developments is quite complicated, for they resulted in art forms in several instances that were anti-art, anti-intention; so antisocial and antistate that they, the latest avant-gardes, were a revolution of sorts. Since they occurred in the arts, they obviously affected only a few people at the time—after all, the war and the killing went on. But such were the intensity and persistence of Dada and surrealism that they eventually led to more lasting changes. If nothing else, they showed that avant-gardes could be suppressed by the state as dangerous, subversive, even treasonous. Dada and surrealism would prove to be significant avant-gardes, as much as abstraction and cubism, or serialism in music and stream technique in fiction and poetry.

Avant-gardes in the 1910s were becoming increasingly destructive. All such movements or tendencies by their very nature are adversary, but for several reasons in the decade of the war they took on qualities of demolition, not only of bourgeois society and state, but of the very relationship between people, or between people and objects. The still-life—once a kind of holy object, a secular icon—disappeared, or else became a source of mockery; and its disappearance as an artistic form seemed symbolic of the response to the war decade. Dada existed by virtue of its ability to destroy. As soon as it was associated with a movement, as it was to be by André Breton, then it lost its function, which was twofold: to undermine confidence in social institutions and to provide an irrational field, so as to hasten the demise of such institutions and the society holding them. True Dada, undiluted by subsequent events or by demurrers, was truly dangerous.

A key figure in bridging many 1910s movements—in painting as well as, implicitly, in literature—was Giorgio de Chirico. Chirico was a theoretician, not solely a practitioner. A good year to begin is 1913, not only for Chirico but for Modernism as a whole. The year 1913 was a full one for achievement, for abetting change, and for being the last time before the war created a new situation. It was almost another Annus Mirabilis: the New York Armory Show, which introduced Modernist painting to America, virtually the first Modernism of any

kind to cross the Atlantic*; the publication of Kafka's "Das Urteil" ("The Judgment"), his first significant published work; Apollinaire's *Alcools* and the first volume of Proust, *A côté de Swann*; Gide's *Les Caves du Vatican*; Conrad's *Chance* (his next-to-last effort at a major work); Lawrence's *Sons and Lovers*; Mann's *Death in Venice*; works in France by Fournier, Peguy, Romains; Freud's *Totem and Taboo*; Husserl's *Phenomenology*; Stravinsky's *The Rite of Spring*; Einstein's General Theory of Relativity; other works by Unamuno, Blok, Gorky, Mandelstam, Hamsun; Nils Bohr's discovery of the structure of the atom; Kandinsky's significant abstractions—the germ for the Campbell group; Schoenberg's *Die glückliche Hand*; Picasso's and Braque's analytical cubism; work by Yeats, Pound, Eliot, Webern.† In addition, Breton often cited 1913 as the time of his and his followers' awakening—a kind of sowing period for what later became surrealism. That group would come to include both independents and followers: Aragon, Soupault, Eluard, Ernst, Dali, Calder, Matta, Tanguy, Paz, Lacan, Senghor, Césaire, Lévi-Strauss.

Amidst this mélange, Chirico was both an innovative and a recapitulatory force. More than any of his contemporaries in paint, he discovered (and articulated in print) a language of interiors. He worked into design and object what Joyce, Woolf, Döblin, and Broch were attempting with interior monologue, what Schoenberg and Berg were doing with *Sprechstimme*, what Kafka was reflecting of ambiguous and shadowed lives. He was in many ways the obverse of cubism, linkng that development and realism, associating both with expressionism and, later, Dada and surrealism. Chirico's intuition of what was possible in the 1910s was nothing short of miraculous. He was able to use space to suggest sound, time, activity, silence, even spectacle. And he was witty.

In his biography, Soby quotes Chirico: "To be really immortal a work of art must go completely beyond the limits of the human. . . . In this way it will come close to the dream state, and also to the mentality of children." Although Chirico's characteristic paintings are concerned with objects, they are remarkable reflectors of an oneiric state, what we find explicitly in the poet Pierre Reverdy.** Like Reverdy, Chirico sought absolutes by way of objects; while opposed to "reality" (phenomena), they both used it. Reverdy's words could serve as a motto for the painter: "The poet is a furnace in which to burn reality," but also the poet "aspires to the domain of the real." Dreams are frequently the way in. Reverdy specialized in making familiar things seem unfamiliar; the concrete object was for him the way into something surreal—that oneiric dimension that Chirico could also evoke. Infinitude was not connected to abstraction or the ideal, but rooted completely in concrete objects. In Chirico, object-ness takes the form of empty streets, misplaced monuments, arches through which no one passes, unsettling of perspective, displacement of expectation in an object-laden canvas.

Life is present throughout Chirico, but it is of a special kind, and it is linked

* Alfred Stieglitz maintained the momentum of the Armory Show when he exhibited pictures by Braque, Picasso, and Picabia at 291 Fifth Avenue. He also ran a review called *Camera Work*, which in 1915 came to be known as 291; 291 was changed two years later by Picabia to 391.

† Hugh Kenner cites 1912 as his Annus: Imagisme, the magazine *Poetry*, Pound's *Ripostes*, Duchamp's *Nude Descending a Staircase*, Apollinaire's *Les Peintres cubistes*, et al.

** Although not so well-known as other figures of the period, Reverdy was hailed by Breton as the greatest poet of the time. Reverdy collaborated, also, with Apollinaire and Jacob in editing *Nord-Sud*; by 1917, he was helping to create the aesthetic atmosphere for aspects of surrealism.

to disembodied ideas and disembodied space. Kafka was working in the same medium in fiction: intensifying life by connecting it to different space expectations for the reader. Spatial disruption leads back to disruption of self. The self is taken apart not because it has ceased to exist but because of its juxtaposition to elements that have ceased to accommodate it. The spatial factor is the result of unexpected or novel distances accruing between people and objects and between objects themselves. As with Reverdy, the reader or spectator, accustomed to dealing with whole matters, finds himself drawn to parts. By experiencing only segments, one ascribes infinity to them, whereas the whole would be considered finite.

We could argue that Chirico's representative work is the result of personal maladjustment—that is, his own inability to link self and objects satisfactorily. But this ignores his ability to create a universal "no-man's-land" in his landscapes, turning Torino or any other city into a human condition. We could speak of Chirico as being a threshold painter, living on the edge of something that remains undefined, analogous to Yeats's beast stirring and slouching, or the intangibles of threat in Kafka's fiction. Chirico also dealt with thresholds by way of memory, a middle state where actuality passes away. All Italy was for him like that, a place where the historical past presses down like so much detritus. The buildings, the roads and alleys, the streets all wind and curve into memory, helped along by dislocated perspectives in many canvases. This combination of passageways, dead buildings, unexpected perspectives helps Chirico bridge various art movements and look ahead to Dada and surrealism.

There is another pre-Dada aspect to Chirico and that is his use of objects as playthings. Futurism of course suggested this dimension—that cars, trains, planes, even people are so speeded up they become like toys manipulated by unnatural forces. Chirico intensified this by silencing his landscapes, something he could do in paint, but Kafka could not because the nature of words is to be heard. In their silent, solar landscapes, Chirico condemned objects—the dream-like dimension—so that they are brought down to toy or game level.

The consequences of this go beyond the binding or bridging of futurism and cubism with Dada and surrealism. There is even more than a cinematographic technique. By way of condensation and oneiric states, Chirico suggests disorientation connected to prophecy, as well as a sacred, ahistorical world. Old and new are paralleled in his towns and villages, but paralleling leads to no coherent sense, no resolution. The sacred is manifest as a derivative of the primitive and ahistorical, where values clash in a desert of sorts. The natural, or Nature, is such an enemy that Chirico can use his opposition as an advantage.

A painting such as *The Lassitude of the Infinite* is instructive, as are all those paintings of voyages and journey: *Melancholy of the Departure, Anguish of Departure, Departure of the Poet, Anxious Journey, Endless Voyage*—combinations of journey and infinitude with *not* getting there. Chirico is Kafkaesque on canvas. *The Lassitude of the Infinite*, in 1912–13, when analytical cubism was reaching its peak, demonstrates typical Chirico characteristics: disturbance of perspective; also an excess of perspective, objects receding toward a point above the vanishing line; a hallucinatory quality deriving from several vanishing points and a labyrinthine effect.

That the perspective allows at least three vanishing points gives *Lassitude* a cinematographic effect. The three: the main one, the reclining figure in the

foreground; beyond it, the two tiny figures with their pencillike shadows trailing to the left; then beyond them, the city with the clouds above, a kind of horizon. What further disturbs the perspective is the tower in the upper right, which reaches beyond the horizon line into the frame of the canvas, virtually through it. But perspective is not all—it works along with portals, tunnels, and caves of the buildings to create the ghost of a city, an anti-city. History has both made and destroyed this city, dwarfing the figures, making the promenade dominant, the present displaced by reclining figures from the past. Miniaturization plus the ambiguous vanishing points create a surrealistic effect of anti-Nature, of something emanating from beyond the conscious.

Both Apollinaire and Marcel Duchamp saw Gustave Courbet as the painting influence lying behind Chirico. The latter did write a monograph on Courbet, in which he equated painterly perspective and metaphysics: "Every work of art embraces the sense of reality, and the deeper that sense is, the more poetic, the more romantic will it be. Mysterious laws of perspective and equally mysterious reasons govern this verity. Who can deny the existence of a perplexing connection between perspective and metaphysics?" Later André Breton would say that "surreality will be the function of our will to absolute disorientation."

That "absolute disorientation," which Breton verbalized and which Chirico painted, was articulated best in Dada. Dada must be perceived as deriving less from art than from politics, specifically as a response to the war. In a paradoxical way, we can see its negative aspects as providing a positive response to a negative, disastrous situation. Although Dada seems to have popped up in Zurich in February 1916, many elements went into Dadaism, including aspects of cubism, collage, papier collé, with deeper backgrounds in Lautréamont, Rimbaud, Jarry. Jarry's 'pataphysics and Ubu are not too distant forerunners.

What was Dada? It was a form of anti-art whose function was to threaten everything in Western civilization, not the least because it ceased to recognize civilization as such after the early years of the war. Tristan Tzara's 1918 Dada Manifesto established the terms of this short-lived protest: ". . . I am against action; for continual contradiction, for affirmation also. I am neither for nor against and I don't explain because I hate common sense."

What's in a name? Although Tristan Tzara (born Sami Rosenstock in 1896) is the figure most frequently associated with Dada, the initiator was Hugo Ball, at the Cabaret Voltaire, part of a bar called the Meierei, in neutral Zurich in a fateful February 1916. "Fateful" because the killing ground was most active. Lenin was playing chess (well) at a nearby café; and Jung was developing the ideas that would challenge Freud.* The name "Dada" was an indicator of its function as anti-art. The poet Richard Huelsenbeck said it was the first word that struck him and Ball in a Franco-German dictionary when they sought a name for Mme le Roy, and it had multiple possibilities. As Tzara said later: ". . . the Krou blacks call the tail of a holy cow: DADA. A hobby horse, a

* Also passing through Zurich at the time were Joyce, Rolland, and Wedekind, plus assorted anarchists and radicals in politics and art. Of some significance also was Sabina Spielrein, Jung's first analysand and, apparently, his mistress. Spielrein wanted to bear Jung's child, call it Siegfried, and in her own person effect a bonding between Jung and Freud (who had a son named Siegfried). Although this was a fantasy, she did write several papers on the death principle—the time was appropriate—which deeply influenced Freud's *Beyond the Pleasure Principle*, in 1920.

nurse, double affirmation in Russian and in Rumanian; DADA." It has come down to us as a kind of nonsense syllable, a repetition associated, as Tzara indicated, with "an art for babies."

Although Zurich was its locale, Dada was really international. Ball, Richter, and Huelsenbeck were German; Tzara and Janco, Rumanian; Arp, Alsatian; in New York, Duchamp and Picabia from France. The latter two, in fact, produced Dadaist reviews, 391 and *Rongwrong*. Jean Arp's collages, like Chirico's canvases, helped bridge the gap between earlier movements and Dada. Arp, in fact, helped to supplement the theoretical side of Dada, stressing its bursting of natural bonds.

> Dada aimed to destroy the reasonable deceptions of man and recover the natural and unreasonable order. Dada wanted to replace the logical nonsense of the men of today by the illogically senseless. That is why we pounded with all our might on the big drum of Dada and trumpeted the praises of unreason. Dada gave the Venus de Milo an enema and permitted Laocoön and his sons to relieve themselves after thousands of years of struggle with the good sausage Python. . . . Dada is for the senseless, which does not mean nonsense. Dada is senseless like nature. Dada is for nature and against art. Dada is direct like nature. Dada is for infinite sense and definite means.

Dada struck on several fronts. It was a meeting of minds on some general points; it resulted in manifestoes and statements; it fed an art form that was anti-art, anti-intention; it led to some major poetry, the most significant of which was Tzara's *Approximate Man**; it led, also, to several publications, literary and otherwise. In 1916, *Cabaret Voltaire* appeared, with a cover by Arp and the contents a collaboration of the café group. Huelsenbeck wrote the introduction, which was antiwar and spoke of humanity as existing outside the conflict. *Cabaret Voltaire* was followed quickly by *Dada I* and *Dada II*. Contributors included futurists, Savinio (who called music "a mad and immoral art"), the simultaneist Albert-Birot, the ubiquitous Apollinaire and Marinetti, as well as Blaise Cendrars, Picasso, Modigliani, Delaunay, Kandinsky, Chirico. Tzara wrote in it: "Dada is art without bedroom-slippers or parallels; is for and against unity and definitely against the future. . . . Severe necessity without discipline or morals and let's spit on humanity."

Dada III came on with a vengeance, a statement in its layout. Far more anarchic than I and II, *Dada III* coincided with Tzara's 1918 Manifesto. *Dada III* was printed unevenly, contained a disordered layout, and had a cover with a diagonal bar that read: "I do not even wish to know if there were men before me (Descartes)." *Dada IV* would have as its cover a dismembered alarm clock. In his manifesto, Tzara fanned the fires of disorder: "I write a manifesto and I want nothing. Yet I say certain things, and in principle I am against principles as I am against manifestoes. . . ." He speaks of "tearing the dirty linen of clouds and prayers" and "preparing the great spectacle of disaster, fire, decomposition." He opposes ideas of progress, law, morality, mocking them as

* More on *Approximate Man* below. This long, meditative poem, in the tradition of Valéry's *M. Teste*, may be the most enduring single work of Dada, apart from the idea of Dada itself. The idea of it, like the word, has come to stand for more than its parts.

Ideal, Ideal, Ideal
Knowledge, Knowledge, Knowledge
Boomboom, boomboom, boomboom.

Attacking psychoanalysis, Tzara calls it a "dangerous disease" and says it "puts to sleep the anti-objective impulses of man and systematizes the bourgeoisie." The crux of the Manifesto comes in the Dadaist Disgust segment:

> Every product of disgust capable of becoming a negation of the family is *dada*: the whole being protecting in its destructive force with clenched fists; DADA; knowledge of all the means rejected up to this point by the timid sex of easy compromise and sociability: DADA; abolition of logic, dance of all those impotent to create: DADA; of all hierarchy and social equation. . . .

Tzara recommends abolition of memory, abolition of archaeology, prophets, the future; belief in each god immediate and spontaneously—D. H. Lawrence was writing along similar lines at the same time.* Language was the

* Discussing D. H. Lawrence as a Modern writer is tricky, since he hated Modernism and Modern life. In some ways as a hater, he recalls Nordau, Weininger, Kraus, Spengler, and that group, sharing Heidegger's flirtation with fascistic ideas and governments as a way of counteracting the "modern spirit," however defined. For both, Jews represented the new, money, the innovative arts, values no better than a disease. Lawrence's ideas on liberation of self, which made him seem an avatar of sexual freedom, were all connected to anti-Modernism. Wholeness meant reaching beyond the now. For him, the self had, as it were, to start anew and remake all its connections. This need to start anew also nourished T. E. Lawrence's strange career, in Arabia and thereafter. His main career as leader of Arab tribes was based on his hatred of Modern life, his need to purify himself, his desire to embrace discomfort, deprivation, and physical pain.

In terms of their responses to Modernism, T. E. is far more intriguing than D. H. The latter spoke of transformation of a society; whereas the former attempted to manifest that transformation in his own career—whatever his deeper motivations were. The image that recurs in his life is of burying and disguising himself, not the least in his use of alternate names, J. H. Ross and then, legally, T. E. Shaw. But name changes are only the beginning. The real thrust was his desire to exist in another cycle, one antithetical to his own, as if he had decided to put into practice Yeats's sense of self and anti-self. He idealized the Arabs and their way of lfe; the mere fact of their intense male world may have made him perceive them as somehow divine, although we cannot be certain of this. Early in *The Seven Pillars of Wisdom*, he strikes his characteristic pose, of a new self shedding its old skin:

> In my case, the effort for these years to live in the dress of Arabs, and to imitate their mental foundation, quitted me of my English self, and let me look at the West and its conventions with new eyes: they destroyed it all for me. . . . I had dropped one form and not taken on the other [the "Arab skin"] . . . with a resultant feeling of intense loneliness in life, and a contempt, not for other men, but for all they do. Such detachment came at times to man exhausted by prolonged physical effort and isolation. His body plodded on mechanically, while his reasonable mind left him, and from without looked down critically on him, wondering what the futile lumber did and why. Sometimes these selves would converse in the void; and then madness was very near, as I believe it would be near the man who could see things through the veils at once of two customs, two educations, two environments.

Lawrence sought not only isolation, loneliness, novelty, but nihilism. He belongs with the great negators of the past, those who, like Lautréamont, Rimbaud, and Nietzsche, defined their newness by virtue of their opposition to their age. As Lawrence puts it:

> The practice of our revolt fortified the nihilist attitude in me. During it, we often saw men push themselves or be driven to a cruel extreme of endurance: yet never was there an intimation of physical break. Collapse rose always from a moral weakness eating into the body, which of itself, without traitors from within, had no power over the will. While we rode we were disembodied, unconscious of flesh or feeling; and when at an interval this excitement faded and we did see our bodies, it was with some hostility, with a contemptuous sense that they reached their highest purpose, not as vehicles of the spirit, but when, dissolved, their elements served to manure a field.

"trajectory of a word tossed like a sonorous cry of [a] phonograph record." Freedom is defined as "DADADADADADA, shrieking of contrasted colors, intertwining of contraries and of all contradictions, grotesqueries, nonsequiturs: LIFE." He might have added: RIMBAUD, whose presence lies heavily here, as elsewhere.

Before we continue with Tzara, however, we should note some of the diversity of Dada. Although its chief function was to undermine a war society— a society that by its very nature did not deserve an art—nevertheless Dada found many ways to destroy the myths of progress. One of its chief "discoveries" was that *truth* no longer mattered, and a corollary of this was that language had been debased. Language used for propaganda purposes could no longer suffice as the language of art. No languages were left, whether painted, visual, or aural, and no audience existed for language, since that audience had been anesthetized by war.

The performance of *Parade* in Paris, in May 1917, while German guns were only a hundred miles away, struck at the very heart of French patriotism, the very soul of French civilization as a military empire. French "la gloire" was assaulted by a new language, and it was the language and voice of the barbarians who would be Dadaists and surrealists. The program notes for *Parade* were Apollinaire's, and it was there that the word *surréaliste* appeared for the first time. But *Parade* is more Dada than surrealist, as is Apollinaire's own *Les Mamelles de Tirésias*. Even at the time Dada was forming in Zurich's Cabaret Voltaire, its semblance could be seen in Paris performance. A mad art to meet the madness of the age could take many forms.

Perhaps the most radical of Dadaists in the plastic arts were Kurt Schwitters and Marcel Duchamp. The latter embarked on a career of anti-art, which he conceived of as a form of sanity, a negative response to an even more negative circumstance, a kind of restorative—in the sense Mallarmé's whiteness was all color, not simply absence.* In some perverse way—for example, in a huge painting such as *Tu m'* [no verb], his last—Duchamp was seeking a utopian vision, whose expression was the obverse of the good. Schwitters, whose name reappeared in the cutout experiments of William Burroughs, worked with junk as a form of expression. The theory behind Schwitters's work is based on chance or randomness, such junk being the random detritus of a society built on throwaway and waste. In Hannover, Schwitters designed his Merzbau or junk city— a reflection of Germany as profound as Kafka's vision of the Austro-Hungarian Empire. The *Bau* was essential to both as refuge and expression of self. And in a perfect scenario of "final things," Schwitters's Merzbau was destroyed in the Second War by Allied bombs and Kafka's three sisters by unfriendly Germans.

Dada clubs formed everywhere, in Berlin, in Cologne, with Arp, Max Ernst, and Johannes Baargeld, as well as in Hannover. Certain characteristics

Such sentiments are Nietzschean, with a distaste for self and its manifestations that transcends the German philosopher and is prototypically postwar. For Lawrence's self-hatred led him on to greater acts of masochism, not as forms of writing or art but as tests in which body must respond to the needs of that devastating self. He is virtually our archetypal tortured Modern man, making each existential choice a final act.

* Whiteness returns as a major motif not only in Malevich's now famous *White on White* canvas but in Tzara's *Approximate Man*, written in the 1920s. Whiteness, sound, and possible meanings blend here in a kind of Modern symphony which John Cage might have composed.

prevailed in this short-lived movement which would dissipate its energies by 1922 and be overtaken by the surrealists. It was theatrical—Picabia made sure of that. It was witty—Duchamp's submission of the "Richard Mutt" urinal to the Salon des Indépendants in New York in 1917 suggested an ultimate disdain, a desire to bait the public. It used outlandish (often childish) inscriptions or titles: L. H. O. O. Q.—*Elle a chaud au cul*; or *l'oeil Cacodylate*, a Picabia painting. It denied art is created by artists—it's made by men, the creator nonspecial, a nonartist. Poetry and painting can be produced by anyone; whoever has the calling can preach. Dada insisted on cutting the linkage between object and its creator; thus, the random factor, following the theory of indeterminacy in physics, which crept into so much post–World War I art. Finally, no distinction was made between a man-made and a machine-made object; so that a Dadaist such as Paul Klee could join the Bauhaus faculty.

The danger for Dada, as Tzara perceived, was systems. "Married to logic, art would live in incest, swallowing, devouring its own tail still attached, fornicating with itself and the personality would become a nightmare, tarred with protestantism, a monument, heap of heavy gray intestines." This fear of systems would lead into experiments with automatic writing, as early as 1919, by Breton and Soupault, some of it published as *Les Champs magnetiques*, in 1920. Such experiments impressed upon them the linguistic base of the inner mind, the unconscious as a verbal medium, later incorporated into Jacques Lacan's psychoanalytic theory of unconscious language as existing in its own context.

This linguistic base or automatic writing would take many shapes in Dada as anti-art. It would become the linchpin of Tzara's *Approxmate Man*. It would figure in Man Ray's so-called *Rayograms*, developed first by chance, then by design.* It would result in the "Great Dada Season," announced by *Littérature* in May 1921, with fifty-six collages by Max Ernst at the Galerie Sans-Pareil, called "Beyond Painting." In his preface to the catalog, Breton wrote of the influence of photography on recent developments in the arts, its influence on absolute time and space. But such influences had long ago included Bergson, Freud, and Einstein, paralleling photography. Duchamp, in *New York Dada*, published in collaboration with Man Ray, began to sign items, photographs, labels, et al., as R. S.—Rrose Sélery.† By 1921, the inevitable occurred, and Dadaists considered their group corrupted. Picabia refused to show at the Salon

* *Rayograms*: At first, using an airbrush, Ray had tried to create both the object and its shadow. Then, by chance, he left some photographic paper in the light, and several objects created silhouettes in white on the black background of the paper. This was the beginning of his *Rayograms*. The importance of the *Rayogram* is that it moved outside of all conventional art, creating in black and white something "beyond" art, also a form of anti-art. *Champs délicieux* was the title of the album of the results.

† Dada wit, irony, and paradox did not travel well into later generations; unfortunately it seemed a postwar phenomenon, and unless the viewer can recreate the historical context he will miss the flavor of Dada's excesses. Duchamp attempted to be the wit of the anti-art movement, but there were also Picabia's mordant fantasies, Arp's precision, Ernst's vulgar and sensitive attacks on bourgeois values, the provocative Parisian festivals, the boisterousness of the Cabaret Voltaire group, the Berlin group's radical Saleris, Schwitters's use of *Merz* and his other constructions. Such qualities of humor nourished Dada; in fact, anti-art was the substance, while humor and wit were the vehicles. Finally, we should not neglect the "simultaneous poem," in which Tzara, Huelsenbeck, and Janco simultaneously read their banal poems in German, French, and English, at the top of their voices. While not very easy to listen to, the recital was less poetry than performance, and performance, as we have noted, was to become a significant development. Simultaneism and bruitism (noise-ism) were legacies from the futurists.

Dada, asserting it no longer represented the anti-nature of art. By 1922, Dada was breaking up, with Breton becoming the central figure in a new realignment, of old figures and some new ones, as surrealism.

Before we leave Dada, however, there are several aspects that need comment. An often neglected aspect of Dada is its role in abstraction. Although not an "abstract art" as such, Dada did turn words and sounds into abstraction by way of distortion, condensation, and arrangement. As anti-art, it eschewed logic, system, and organization, and its use of noise and simultaneity made sound more significant than meaning.

Tzara's *Approximate Man* resulted from his immersion in the movements of the 1910s, and although he lived until 1963, his real development ended almost forty years earlier. Before *Approximate Man*, Tzara, like many poets, was caught up by developments in painting, especialy in aspects of cubism and then abstraction, the two avant-gardes of the 1910s. Tzara constructed poems as Picasso and Barque produced papier collé. He used words from newspaper articles (as they used cutouts); random words drawn from a hat, then shaken and pasted together in that order; parts of speech—nouns, verbs, modifiers—linked as in a collage; lists or catalogs of words apparently disconnected from each other. A 1923 poem like "Midnight Salts" was typical, with its several forms of typography, its careful arrangement of words and space, its abrupt shifts of meaning, its enigmatic title. The aim was conscious incoherence, deliberate illogicality. A corollary was speed, the futurist sense of rushing along uninhibited by content. Spontaneity, as in automatic writing, meant that the poem's structure was rhythmic, not logical. We can see from Tzara's extreme example how such avant-garde ideas penetrated into Eliot and Pound. Spontaneity also meant that each image in the poem was an entity, independent of other images and structures.

In *Approximate Man*, Tzara sought a kind of cinematographic action, a rhythm of continuous montage, what Pound aimed at in the *Cantos*. This would be his adaptation of film and futurist ideas. In some respects, *Approximate Man* is a journey poem, a species of spiritual autobiography. In another way, it is also an anti-journey, an anti-move, as "approximate" suggests hesitation, ambiguity, even uncertainty. Behind this very long work is Tzara's autobiographical novel *Faites vos jeux (Place Your Bets)*, never completed. The title suggests several things, Mallarmé's dicing, Jacob's *Dice Cup*, a game against self, and, of course, approximation, chance, uncertainty. There is even a whiff of existential absurdity. Yet Tzara sought absolutes, in freedom of movement, in language, in the liberation of writing from restraint. In this fragment, he moves toward Dadaist liberation of form, in which the ideal is a kind of Laocoön who has succeeded in unshackling himself.

Tzara was working parallel to Schwitters's *Merz* idea, of random junk raised to an art form. Arp's collages, which deliberately lacked Gris's figurativeness and care, early on suggested the randomness of Tzara's poem. But Schwitters is the true parallel force, with his throwaways, junk, old rags, wash cloths, ribbons, all of which he molded into "debris sculpture" and *objets trouvés*. *Merzbau* was his archetypal house of junk or *dreck*, a shithouse.

Place Your Bets carries over into *Approximate Man*. Just as the dice cup or dicing suggests some dimension beyond both chance and randomness, so "approximation" seeks some order beyond ambiguity and uncertainty. The poem is about that journey "beyond" to a dimension in which restraint is lifted and

one achieves absolute freedom as a consequence of being tested against absolute chance. It is, however, a deliquescent journey, almost as full of water imagery as Lautréamont's *Maldoror* or Rimbaud's *Le Bateau ivre*, whose echoes are very clear in the Tzara poem. Like them, also, it is close to interior monologue, where consciousness, dream, and hallucination are so linked that all communication seems to derive from some middle state.

Approximate man is incomplete. Yet he can transform himself only by undergoing a torturous journey, an ordeal or initiation. The shape of the poem is a journey ever deeper into incompletion as stages toward some unity of self. Once again, we note the Poundian analogue. One critic speaks of its "echoes," the sequences as a poetry of echoes; but it may be equally accurate to call it a poem of "speaking interiors," in some way comparable to *Sprechstimme* in contemporary opera. As we shall see below, Tzara has forsaken the visual perception of poetry for its sound quality—analogous to what was occurring in musical composition. Further, he was moving toward an aural quality in poetry *roughly equivalent to what had occurred to color in painting*. Color no longer designated the object's reality; so sound no longer describes what we hear. Words come from another place; sound, not meaning, is primary, as Joyce was proving in *Ulysses* and would bring to fruition in *Finnegans Wake*. This is a key stage in Modernism: what you hear is not what you may understand; what you read is not a logical progression of words. Colors may "represent," not describe or denote. Musical notation aims, not at sequence or progression, but a new order of sound.

The final section of *Approximate Man* is devoted to whiteness. ". . . is it the swan which sprays his white of water / white is the reflection whose vapor plays on the shudder of the sea lion / outside is white. . . ." The line "outside is white" is metaphysical, the way Mallarmé's whiteness is a dimension beyond physical; where color suggests a suprahuman condition. Tzara becomes wilder, more anarchic in his blending of opposites, a fauvist in words, but also an abstractionist: ". . . risen from what biting glacier whose white exterior gargle of cloud sucks at the roots of our irises the honey of ages to come"; or: ". . . man milks the eternal subtraction from each slice in himself. . . ." Or, finally: ". . . white is your smile also sign of your body whiter than all experience / rubbing the teeth of the sky beating the linen at the river."

Like freely associated interior monologue, or the stream, the language of *Approximate Man* is continuous; pauses or stops would be considered artificial. This is linked to Tzara's stress on oblivion as both image and idea; also on labyrinth as a commodity, a burden: ". . . with heavy bundles of labyrinths on my back. . . . lost inside myself lost. . . . lost inside where no one but oblivion ventures[.]" This is language venturing toward abstraction, a stage toward *Finnegans Wake*.

Even before Tzara began *Approximate Man*, however, the Dada impulse—so strongly linked to the effects of the war—was being dissipated and replaced. Breton and Soupault were experimenting with automatic writing, as we have seen some of it forming *Les Champs magnétiques*, in 1920. Such experiments impressed upon them the linguistic base of the inner mind; the fact that the unconscious was a verbal medium. In Paris, by 1920, the group around *Littérature* would become the basic group for surrealism: Breton, Aragon, Soupault, also Jacques Vaché, a follower of Jarry; later, Eluard, Robert Desnos, and René

Crevel. The painters included Magritte, Ernst, Dali, and the less known Hans Bellmer.*

Although surrealism came to define its own terms, it was at first deeply obligated to earlier aspects of Modernism. Its debt to Freud and the ordering of the unconscious is apparent; to Bergson and his efforts to free memory from logic, mind from intellect; to the fauvists, several avant-gardes removed, who liberated color from objects, objects from color; to cubists and abstractionists for redeploying and then eliminating objects, for moving from conscious visualization toward unconscious displays; to those who stressed *le hasard* or chance, which Breton later shifted to *le hasard objectif*, objective chance, wherein the human psyche draws in external circumstances; to all those, more generally, who sought new arrangements of sound, word, visual image. In one other respect, also, surrealism was indebted to earlier Modernism, in its rejection of a mechanical world and its objects—what is immortal to all Americans in Chaplin's *Modern Times*. The source of humor in surrealism derives from its mockery of mechanism, parodying machinery even while turning it into a kind of poetry. Kafka's *In the Penal Colony*, together with his novels, would be a high form of this blend of machinery and poetry.

What was surrealism? Its chief exponent and shaper, André Breton, in his 1924 surrealist manifesto saw it as "psychic automation" intended to express verbally or in writing the functioning of thought. Such thought, beyond the controls exerted by reason, was of course beyond moral, social, or aesthetic considerations. It rested on several alternative modes: certain associations that had been hitherto neglected; the great power of dreams; a disinterred, disengaged play of thought. It was intended to negate all other forms of psychic mechanism, so as to be itself the resolution of life's problems. Hypnosis and drugs were advised as ways of inducing verbal sequences unattainable in a conscious state.

Breton had trained as a medical doctor and had worked at the Charcot Clinic, where Freud had also been in attendance earlier. He was fully versed in Freud's writings and in his ambience, having worked in a hospital in Nantes during the war. From these experiences, he learned to penetrate the unconscious and to obtain from himself a monologue spoken so rapidly the critical mind could not interfere with it. With Philip Soupault, he produced many pages of automatic writing, what they considered to be "spoken thought." It is evident that surrealism and literary stream of consciousness or more freely associated interior monologue ran parallel courses. Much of Breton's explanation—except for the desire to forgo ultimate control—fits Joyce's usage in *Ulysses* and, even more so, *Finnegans Wake*.

Breton stressed, as did the surrealists, that automatism revealed more of the person than any conscious creation, that automatism was the "mechanism" by which one could tape the unconscious. These automatic texts, as already noted, were published by Breton and Soupault in *Littérature*, in 1919, under the title

* Some representative publications in this brief period bordering both Dada and surrealism were *Anicet* (Aragon), *Le Coeur à barbe (The Bearded Heart,* Tzara), *Pensées sans langage (Thoughts without Language,* Picabia), *Proverbe* (Éluard), *Cannibale* (Picabia), *Les Nécessités de la vie et les conséquences des rêves (The Necessities of Life and the Consequences of Dreams,* Éluard), and works by Péret, Arnauld, Dermée, and other lesser figures. Although this is only a partial list, the titles indicate the direction, toward dreams, bizarre juxtapositions, stress on new languages.

Les Champs magnétiques (as a book the next year), becoming the first surrealist work four or five years before the 1924 manifesto. The "magnetic fields" is an appropriate title, since it conveys the sense of including and yet also the distribution of a central core, the unconscious. But the suggestivity of the title extends further. For its involves an element of determinism at the same time it suggests a field of free activity, the randomness of pieces on a field. For Breton, subjects become "the dumb receptacles" of echoes, passive, "modest *recording devices.*" The "magnetic field" denotes both the fierce activity of the core and those passive subjective pieces.

Although heavily indebted to Freud, early surrealists radically departed from his ideas of free association and dream interpretation. They saw free associations and dreams as existing for themselves, as self-serving meaningful processes. Freud saw both as contextual, linked to the etiology of pathological situations or the dreamer's childhood associations and memories. The surrealists perceived in dreams a primitive imagination, expressions of the marvelous. We must emphasize that early surrealism was word oriented; it began as a verbal medium and only later became associated in the public mind with the plastic arts, with visual images.

Breton emphasized the automatism of surrealism. ". . . I maintain that graphic as well as verbal automatism . . . is the only mode of expression which fully satisfies the eye or ear by achieving *rhythmic unity.* . . . A work cannot be considered surrealist unless the artist strains to reach the total psychological scope of which consciousness is only a small part." The surrealists saw their uncovering of the unconscious as a positive response to Dada negativism,* *even as* they attacked all traditional forms of art. But while Dada advocated anarchy—a Dadaist would be against Dada—the surrealists drew up principles. Breton was anything but anarchic, and, in fact, lost several followers who sensed a traditionalist behind his codifications. The Richard Mutt hoax would hardly have gained Breton's approval.

Surrealism was, in its broadest elements, very possibly the last of the true avant-gardes. As it developed with and beyond Breton—he lost control of it eventually—it swept up previous and parallel avant-gardes, ingesting and assimilating Dada, cubism, abstraction, futurism, without, of course, eliminating them. It also brought together psychological and political ideologies, blending in the most unlikely ways Freud and Trotsky, Janet and Stalin. It was, in its efforts at totality, a *Gesamtkunstwerk.* The parallel with Wagner, while at first outrageous, is not so bizarre if we assume surrealism was a summa and blending. It was, we must stress, distinctly a postwar phenomenon and, therefore, an attempt to pick up pieces left by the war's barbarism and link them. Earlier futurists had attempted to seek in the war their highest artistic aims: the randomness of the killing, the activity and motion of mechanized objects, the desperation to survive, the poetry of existence under impossible conditions; but,

* We can cite Picabia's *Cannibal Manifesto:*
Dada feels nothing, it is nothing, nothing, nothing.
It is like your hopes, nothing.
Like your paradise, nothing.
Like your artists, nothing.
Like your religion, nothing.
Hemingway's "nada" would not be long in coming.

more than anything else, the uses of power and strength to forge another kind of world. But for most other artists, the war was a signal that all previous politics had failed, that only art itself, and the new politics, communism, offered salvation. Breton's surrealism proffered this unlikely mix, and in tendering it he tried to define a new total artwork.

Breton repeatedly referred to Lautréamont, Freud, and Trotsky as the ideological precursors of the movement. In each of their fields, as he perceived the matter, they uprooted the past, extirpated rot, and started out afresh. Breton and other surrealists also found Taine useful: not his environmental theories, but his studies of intelligence, in the 1860s, when he stated that sensation was not a concrete sense impression, not a fact, not even a reality, but actually a hallucination. Apollinaire had coined the term itself, as we have seen, when he subtitled *Les Mamelles de Tirésias* a *"drame surréaliste"*; the more expected term would have been *surnaturaliste*. Trying to bring everything together, Breton's 1924 Manifesto rallied his forces under the banner of Freud, the great accommodator; but it was the 1930 Manifesto that became memorable. In it Breton wrote: "The simplest surrealist act consists of going down into the streets revolver in hand, and shooting at random." This sentence, now famous, seems terribly radical, but it harks back to the Marinetti Futurist Manifesto of 1909, which recommended the destruction of all bourgeois artifacts, including "museums, libraries, academies of every kind . . . moralism, feminism, every opportunistic or utilitarian cowardice."

Like Marinetti, but far nobler in intention, Breton wanted to foment rebellion and destruction for the good of mankind. Hindsight has instructed us that such manifestoes, whether from the left or right, lead to unacceptable extremism, in Marinetti's case to a notorious career as a defender of Mussolini's facism. For Breton, the goal was less ominous, favoring the randomness of the act more than its murderous intent. For him, the mere fact of the shooting was an act of rebellion, and his advocacy of this—for this planner, coordinator, organizer, theoretician—indicates more the state of the world in 1929–30 than the state of Breton. Unfortunately, he never perceived that his solution exacerbated the problem.

The 1930 Manifesto had as context not personal spiritual crises, but desperate social-economic-political issues. Breton was assaying Hegel and dialectical materialism here, trying for some synthesis of rioting elements; Freud and the exploration of sub- and unconscious no longer sufficed for the state of the world. Saving individual souls was preempted by the need for a broader salvation. Surrealism was, somehow, to be a panacea, or else show the way to one. By the 1930 Manifesto, Breton had not forgone psychic automatism, but he recognized that such subjectivity was insufficient. Without action—and here Breton begins to sound like an early existentialist—man falls into futility, becomes incapable of changing his life. Metamorphosis is a key to this later phase of Breton's thinking, and it becomes a considerable departure from early surrealism.

Just what did automatic writing mean for Breton when it became the cornerstone of surrealist theory? First, we should recognize that it was language and voice, which were the basis of all such theorizing. Automatic writing was the unconscious speaking—in torrents of words, streams, monologues; the sense was oceanic, an outpouring. We recall Rimbaud's *Alchemy of the Word*. Whereas Freud and others used automatic writing to uncover aberrations, Breton saw it

quite differently, as a tool to be used to discover the very nature of perception in normal persons and artists. It would liberate psychic inhibitions through some (undiscoverable) psychological process. It would manifest the coincidence of chance verbal encounters—the random factor. It would turn the artist—here the poet—into a vatic presence, the seer and prophet defined by Rimbaud. It would cut through the deterministic function of the mind, eliminating intervention or screening which distorts meaning. It would go directly to meaning, which lay, Breton insisted, in the unconscious, somewhere "beyond."

Since language was so central, it is clear Breton saw surrealism as going further than a literary idea. It took on a universal quality, of the banishment of all stereotypical thought, not only traditional thought about the arts. It would purge corruption and suggest a transformation of man. One reason Breton seemed so obstinate about possible defectors—anyone he suspected of playing to the bourgeoisie he excommunicated—was his insistence on purity, first of self, then of the art expressed by that self. Art was, for him, something divine, and he was the high priest dedicated to keeping it pure of materiality.

Such ideas carried over into Breton's political thought, however superficially he linked surrealism and communism.* Like many of his contemporaries, he saw forms of purity in Russian dedication to communism, a purgation of everything capitalistic, material, and avaricious in the West. However foolishly, Breton believed communism would liberate man from economic worries; and once free of such anxieties, man would move to liberate himself in other ways. Nevertheless, when Breton perceived the repression in Stalin's Soviet Union, he broke with that, although he never surrendered his romantic sense of communism as pure, as liberating. Trotsky became more to Breton's liking, and the two had long talks in Mexico; Breton also published Trotsky (his work on Lenin) in *La Revolution surréaliste*. Difficult as these divergent allegiances are to understand, Breton evidently based his loyalties on very selective readings of these figures. For Trotsky was himself a ruthless political animal, for all his literary interests, and his blueprint for the future was quite different from the surrealist's.

But even as Breton stressed the word, surrealism was taking another turn, away from the written language and automatic writing to automatic drawing. Now part of the surrealist stable were Ernst, Ray, Miró, Dali, Magritte, Tanguy, Chagall, most of whom were attempting automatic drawing. In Man Ray's case, the intent was to destroy imitation by means of photography, whose function had traditionally been representative and which now was to be used to negate representation. Breton restated the overall philosophy, which was that surreality would be "contained in reality, and would be neither superior nor exterior to it. And reciprocally, for the container would also be that which is contained." Although the language is more orderly and elegant, Breton is saying little more

* The Dadaists also played with communism, their ideas offering more a burlesque than a political commitment. The following were some of their demands for Germany: "The introduction of progressive unemployment through comprehensive mechanization of every field of activity. Only by unemployment does it become possible for the individual to achieve certainty as to the truth of life. . . ." But before that, there must be "The international revolutionary union of all creative and intellectual men and women on the basis of radical Communism." The demands intensified: the immediate expropriation of property, daily meals at public expense for all creative people, erection of a state art center, requisition of churches "for the performance of bruitism, simultaneist and Dadaist poems," the immediate regulation "of all sexual relations according to the views of international Dadaism through the establishment of a Dadaist sexual center."

than Hugo Ball's more intemperate statement that the Dadaist "fights against the death-throes and death-drunkenness of his time. . . ." Knowing that "the world of systems has disintegrated," the Dadaist must find alternatives; ". . . instincts and hereditary backgrounds are now emerging pathologically."

Breton's own poetry was an effort to get beyond common usage of language and to redefine a language of the "unpoetic"—not unlike what we find in his contemporary Ezra Pound. He moved outside normal literary usage, toward a more feral vocabulary, as a way of somehow transforming routine experience. Breton's early poetry in *Mont de piété (Pawnshop)*, in 1919, *Clair de terre* (a pun on *Clair de lune*), in 1923, and *Poisson soluble (Soluble Fish)*, in 1924, reflect automatic writing. Such poetry is self-oriented to the point of autism, has few external circuits, is syntactically very loose. French usage is pulled apart—elements are never far from exploding or from convulsiveness; and words are made to function as they never would in more traditional poetry. Even as late as *L'Union libre* in 1931, the title poem, "Free Union," gains most of its momentum and vitality from its free association, its liberation from syntax and regular usage. The poem of sixty lines lacks a main verb and is, in fact, a sequence based on a series of prepositions, the French *à, aux, de, du,* etc.* In routine usage, such prepositions are connectives; in Breton, they take on resonance from repetition, until they dominate the poem.

There is no end punctuation, not even a final period. The visual aspect grows wilder and wilder: "Ma femme à la langue d'hostie poignardée"—the image is of "his woman" with a tongue appearing like a "stabbed communion host"; an image that fails to join in the logical way associated with metaphor. Instead, it connects with succeeding equally feral images of her tongue like that of a doll "that opens and shuts its eyes" or a tongue "de pierre incroyable"—unbelievable stone. The association of tongue with these images, as well as with "rubbed amber and glass," transforms sex and taste into an animated part of the world, precisely as Breton does with other organs or human features. Taking them from the face or body, whether eyebrows or sexual parts, he metamorphoses them. He speaks of her hips as "hanches de nacelle"—nacelle hips. The word "nacelle" describes the car placed under a balloon or dirigible to carry passengers or motor. The image is extraordinary, since it conveys a kind of dirigiblelike sleekness at the same time as a bulging amplitude.

"L'Union Libre" from the 1931 volume comes at a juncture in Breton's poetic career. While looking back to purer forms of automatic writing, it is itself highly controlled and thought out. The images seem to derive from the unconscious where they have been freely associated as if in day or night dreams, but the overall structure of the poem is logically conceived. The proliferation of prepositions is well patterned, although the images are themselves frequently wild: "armpits of marten and beechnut," "teeth like a white mouse's spoor on white earth," "arms of sluice and sea foam," "feet of keys on a ring with feet of Java sparrows drinking," "belly unfolding like the fan of days," "sex of seaweed

* Ma femme à la chevelure de feu de bois / Aux pensées d'éclairs de chaleur / A la taille de sablier / Ma femme à la taille de loutre entre les dents du tigre / Ma femme à la bouche de cocarde et de bouquet d'étoiles de dernière grandeur . . . (Woman of mine with woodfire hair / With thoughts like flashes of heat lightning / With an hour glass waist / Woman of mine with an otterlike waist between the tiger's teeth / Woman of mine with a rosette mouth like a posy of stars of ultimate magnitude . . .)

and oldtime sweets," et al. The poem, then, is caught between uninhibited feral images and the tight patterning of the connecting, thrusting prepositions, the verblessness that dips under consciousness.

Poisson soluble, which appeared at the same time as the 1924 Manifesto, is far purer verbal surrealism. Dedicated to Antonin Artaud, "Night of filth, night of flowers, night of groans, giddy night" begins a prose-poem of paragraph length. The unconscious unfolds here in even wilder terms, "Countryside of white and red bones," "water bandit defoliating your knives in my eyes," "renegades with purple cuffs, with black-currant eyes, with chicken hair." The selection ends with a great lyrical burst: "Plus de souffles, plus de sang, plus d'âme, mais des mains pour pétrir l'air, pour dorir une seule fois le pain de l'air, pour faire claquer la grande gomme des drapeaux qui dorment, des mains solaires, enfin, des main gelées!"*

By the time of "Vigilance" in 1932, however, Breton was returning to the poetic tradition, suggesting both Rimbaud and Crashaw, the English metaphysical. The combination of influences is not so bizarre given the pivotal nature of Breton's intent. Straddling old and new, ingesting an avant-garde into a more traditional style that was still innovative, his poetry had become less feral in its thrust. "Vigilance," nevertheless, is a remarkable poem in its own right. It concerns the destruction of self even as the self observes: "I head for the room where I am lying / And set fire to it / So that nothing will remain of the consent wrung from me . . ." The burning furniture then assumes animal shapes, "Lions in whose manes the chairs are now burning out / Sharks whose white bellies absorb the last quivering of the sheets . . ." All the while, "he" watches himself burn: "I see that solemn hiding place of nothings / Which was once my body . . ." As a final act, he enters "invisible into the ark," observant of the "hawthorn of the rain," hearing "human linen tearing like a great leaf / Under the fingernails of absence and presence who are in collusion[.]" While materials tear, wither, and disintegrate, only "a piece of perfumed lace remains of them / A shell of lace in the perfect shape of a breast . . ." Then: "I touch nothing but the heart of things I hold the thread [.]"

The poem illuminates Breton's theory of *dépaysement*, the quality of being out of it or of being alien to a circumstance, so that through one's outsider orientation it is possible to encounter the *merveilleux*. That encounter with the marvelous can come only from a person whose inharmonious presence has alerted him to the unexpected, to the conjunction of openness and unanticipated. Yet that encounter, in which one surprises the marvelous, as it were, is central not only to Breton but to surrealism; and it carried over from the word to the visual image. The encounter is not unique in surrealism, and its parallels can be found, with some alteration, in Joyce's epiphany and Pound's sense of the image, in the sequences unfolding from Proust's involuntary memory. While not quite the same, all of these experiences involve the subject's being "out of it," out of himself or herself, when something startling or striking occurs. The conjunction is a "moment" in which one transcends oneself, is metamorphosed, however momentarily. That transformation, another ancillary dimension of

* No more breath, no more blood, no more soul, but hands to mould air, to gild only once the bread of air, to crack the great gum [or rubber] of sleeping flags, solar hands, finally, frozen hands.

Modernism, was to be exploited by surrealists as their mainstream experience. The beginning of this idea was, not unusually, in Baudelaire and Lautréamont, as part of the imagination and its uses.

The need for *dépaysement* and the *merveilleux* is linked to a parallel need, to get at whatever is spontaneous in the poet and in expression itself. Such sudden encounters bypass the censoring faculty—mind, reason, logic. The encounter is also connected to an equal desire, for randomness:

> Pour moi, [l'image] la plus forte est celle qui présente le degré d'arbitraire le plus élevé. . . ; celle qu'on met le plus longtemps à traduire en langage pratique, soit qu'elle recèle une dose énorme de contradiction apparente, soit que l'un de ses termes en soit curieusement derobe, soit que s'annonçant sensationnelle, elle ait l'air de se dénouer faiblement. . . . *

So it is written in the Surrealist Manifesto.

Within this formulation—and Breton was defining not only his own work but an entire avant-garde—various elements are not expected to be synthesized or resolved. "Ultimate linkage" is never made. Elements remain convulsive and vital as parts of a dialectic of experience: Breton's Hegelian borrowings. Experience is, as Joyce, Proust, Broch, Woolf, and others learned also, a moment, privileged or clairvoyant. In "Vigilance," that moment comes with the final line: "I touch nothing but the heart of things I hold the thread." The line holds together disparate elements of self observing body burning, self present at the end, with body resurrected by its ability to be touched by something lying outside of it. Breton in this line has crossed a border, entering that true middle state between consciousness and the unconscious. Not surprisingly, the volume in which "Vigilance" appears, *Le Revolver à cheveux blancs*, contains poems like "Unconscious," "Deadly Rescue," which recalls Lautréamont, and "Curtain, Curtain," which echoes Mallarmé.

Yet despite the high quality of his poetry, Breton's largest statement was his *Surrealism and Painting*, in which the overwhelming question was, "Who is to draw up the scale of vision?" In this mixed statement of art and ideology, Breton attacked imitation. "In order to respond to the necessity, upon which all serious minds now agree, for a total revision of real values, the plastic work of art will either refer to a *purely internal model* or will cease to exist."†

* For me, the image is strongest which presents the highest degree of arbitrariness; which takes the longest time to translate into practical language; either because it contains an enormous dose of apparent contradiction, or one of its terms is curiously hidden, or after appearing sensational, it appears to unravel feebly. . . .

† Although Dali and Luis Buñuel collaborated on two films *before* they met the surrealists, *Un Chien Andalou* in 1928 and *L'Age d'Or* in 1930 fit well into Breton's prescription of an internal model. In the first, the most enduring of its images is that of a razor slicing through a human eyeball. The horror we sense is one based on the imbalance of differing textures, of the soft, egg-yolk eye, its pliability and tenderness, being touched by something hard, cold, metallic. In that confrontation, the two filmmakers have provided that frisson or convulsion Breton asked for, which he stressed could be discovered only internally. The moment we cringe is the *merveilleux*.

In the later film, we find almost a programmatic surrealism in the sequence of assorted images and in the preface that serves "the revolution," with Aragon, Char, Breton, Eluard, and others as collaborators. Like every aspect of surrealism, the images aimed at subverting complacent taste: a blind man ill-treated, a father killing his son, an old lady knocked around, violent love scenes, a dog crushed, even fellatio suggested in the heroine's sucking of the toe of a marble Apollo—*Deep Throat* in marble. As we would expect, religion in particular is mocked: a crucifix on which several

Breton continued in this vein dominated by self: "In the domain of poetry, Lautréamont, Rimbaud and Mallarmé were the first to endow the human mind with a quality that it had entirely lacked: I mean a real *insulation*, thanks to which the mind, on finding itself ideally withdrawn from everything, can begin to occupy itself with its own life, in which the attained and the desired no longer exclude one another, and can thereupon attempt to submit to a permanent and rigorous censorship whatever has constrained it hitherto."

The idea of liberating the mind or breaking free, of allowing new configurations, was also being worked out in the studio. Man Ray's *solarization*, Max Ernst's *frottage*, and Jean Arp's *papiers déchirés*, while differing from each other, were all intended to catch randomness at the moment it became form. Many of these experimental and explorative shapings were preparation in a way for the International Exhibition of Surrealism in Paris, in January 1938. Ray's *solarization* was an attempt to redeploy objects, their shadows, and their relationships to each other. By exposing a negative which was in the course of developing, he caused the white areas to turn gray while they remained surrounded by a lighter ring. The result was a transfiguration of shadows and lights on a face, object, landscape.

Ernst's *frottage* (literally rubbing or polishing) was more complicated. *Frottage* was a form of visual automatic writing. In Ernst's own words: "I was struck by the obsession that showed to my excited gaze the floor boards upon which a thousand scribblings had deepened the grooves. I decided then to investigate the symbolism of this obsession, and in order to aid my meditative and hallucinatory faculties I made from the boards a series of drawings, by placing on them at random sheets of paper which I undertook to rub with black lead. In gazing attentively at the drawings thus obtained . . . I was surprised by the sudden intensification of my visionary capabilities and by the hallucinatory succession of contradictory images superimposed, one upon the other." This experiment comes close to what Ernst called his "poetic disorganization" of reality, the deconstruction of forms in order to exploit their hallucinatory element.

These visual experiments, including Jean Arp's *papiers déchirés* (creating art objects from torn pieces of drawing thrown onto the floor haphazardly, where they assume different shapes), were specifics that fitted Breton's more general prescriptions: "Everything suggests that there exists a certain point of the mind at which life and death, the real and the imaginary, the past and the future, the communicable and the incommunicable, the heights and the depths, ceased to be perceived contradictorily. Now it is in vain that one would seek any other motive for surrealist activity than the hope of determining this point."

The International Exhibition of Surrealism, in 1938, was the culmination

women's scalps are nailed. Needless to say, the film created a riot at its showing. But riots aside, the film illuminates Breton's insight into what will disturb us, and that is not so much the image or scene itself as it is a question of textures. We are disturbed by imbalances, and nothing can be more upsetting than disproportion between elements we associate in different worlds and which the surrealists linked. In that linkage, Breton, like the filmmakers, hoped to set off convulsive waves— nausea, revolution, disturbance for itself. In retrospect, what seems infantile was innovative, startling, and, perhaps surprisingly, effective.

Just a few years earlier, as we will note below, Eisenstein tried something comparable, in his *Battleship Potemkin*, celebrating the twentieth anniversary of the 1905 Revolution. Although Eisenstein started from an opposing ideology, his intent in the Odessa steps scene was to create that moment of disturbance Breton called the *merveilleux*.

of this phase of surrealism. After this, it became dissipated into more common acceptance, while the war tended to dissolve it as a living force. The aim of the exhibition was to create an entire surrealist environment. At the entrance was Dali's *Rainy Taxi*, an abandoned vehicle with ivy growing from it. Leading to the main hall was a "surrealist street" decorated with twenty wax models by Ray, Ernst, Duchamp, Marcel Jean, Oscar Dominguez, Miró, Arp, Matta, etc. The highpoint of such decorations was André Masson's mannequin's head in a cage, gagged with a black velvet band, at the mouth a pansy. It had just that correct ingredient of masochism and sadism which characterized a good deal of visual surrealism. From the street, one entered the central hall designed by Duchamp into an immense cavern or grotto. Hanging from the ceiling, side by side, were twelve hundred sacks of coal, the floor strewn with dead leaves; included was a pool with reeds and water lilies. The aim was an attempt at a total environment of "objects" which had lost their objectivity and had entered hallucination, a dreamlike context neither dream nor waking.

The exhibition reiterated Breton's statement in *Surrealism and Painting*: "Everything I love, everything I think and feel, predisposes me towards a particular philosophy of immanence according to which surreality would be embodied in reality itself and would be neither superior nor exterior to it." He goes on: "And reciprocally, too, because the container would also be the contents. What I envisage is almost a communicating vessel between the container and the contained. Which means, of course, that I reject categorically all initiatives in the field of painting, as in that of literature, that would inevitably lead to the narrow isolation of thought from life, or alternatively the strict domination of life by thought." The hermetic quality Breton suggests here relocates him in a much earlier time, in the *fin de siècle*, and even before that, with Baudelaire, in his Salon articles. It is amusing, and even instructive, to see surrealism curling back upon earlier avant-garde traditions. Among his colleagues in surrealism, Breton had reservations about Magritte, but found him successful in revealing the quality of strangeness amidst ordinary objects; but there was much to praise in Matta, Calder, and Arshile Gorky, for whom surrealism was only one of many way stations.

In Breton's hermetic vision, objects take on a new reality—as Magritte would demonstrate in his provocative *The Rape* in 1934. Breton went so far as to compose "object-poems," combinations of objects and poetic phrases. His sense of objects was of something closed, resistant, and unified. Anything could, in fact, become an object as soon as it was regularized. For the surrealists, the wonder of objects lay in their quality as separable phenomena, even while they prove referential, connected to the world by what Marcel Jean calls "the taut, solid threads of desire."

Surrealism also appealed to many painters who did not remain surrealists for their entire careers. Diego Rivera went through such a phase, for example, and then returned to the Mexican mural-realist school. His third wife, Frida Kahlo, however, remained close to surrealism, even while her mature paintings display an obsessive concern with realistic detail. She had, throughout her career, the surrealist quality of creating beauty within demonic terms—she was a satanic painter, a Rimbaud of the brush, as Breton recognized. Breton, incidentally, organized in 1940 the International Exhibition of Surrealism in Mexico City. Kahlo was a woman of intense interest as well as a painter of the first rank, and

while her pro-Soviet, pro-Stalinist politics remained antithetical to later surrealism, nevertheless her mature paintings have that staged, theatrical look intrinsic to surrealist work. Furthermore, they move dreamily on the thin line between consciousness and pre- or unconsciousness.

A painting such as *What the Water Gave Me* represents that dreamlike state which, Kahlo said, was for her a reality. It is, in 1938, a summa of her later work, when pain, impending death, fear, memory, and intense eroticism (for both men and women) had gripped her in terrible conflict. What dominates the painting is a pair of deformed feet emerging from the water at the end of an old bathtub. The remainder of the body and legs to which the feet belong are out of sight—only the feet, with toes (twenty in all) pointing up and down, visible. Below them are grouped aspects of Kahlo's tortured existence, but presented with a kind of gayness (what the Mexicans called *alegría*) which characterized her images of doom. Just off the center is the partial figure of a well-developed woman exposed to the groin, and it is possibly Kahlo, giving us parts of her that the feet only suggest. The painting is a mixture of eroticism, death, and morbid memories made into a lyric, flexible canvas: pain communicated through dreamlike memories of it.

What the Water Gave Me has Dali qualities to it, but also Bosch and Brueghel, and, most of all, Kahlo's own inventive reality. The detail is meticulous, as it is in her self-portraits, but it is mainly hybrid realism—figures growing from plants, humans and vegetation almost indistinguishable from each other, a skyscraper emerging from a volcanic mountain. Her realism consists of juxtapositions and hybrid constructions that subvert the very detail her brush creates. Like so many other surrealists, she has used a logical, rational technique to suggest an irrational, totally unlinked, disengaged universe, where things or their connections lack a center. Only space contains them, but it is an unidentifiable spatial component which grips us. She would have been, in a different time and place, a perfect illustrator to accompany Kafka's visions; Kafka also had *alegría* in his sense of doom.

Not surprisingly, many surrealist objects have sexual over- or undertones, and here Magritte's painting helps accommodate what Breton was stating as theory. *The Rape* is a kind of modern sphinx, except that it is nearly all head and neck rather than head with attached body. The basic shape is a head, with dominant hair parted in the center; but with that, resemblances to the real are disarranged. The motif is relocation of parts. The eyes are high up on what should be the forehead, and the eyes are themselves small breasts with red nipples staring at the viewer. Below the eyes is not the nose but the navel, a darkish, small hole, really an indifferent indentation. Below that is the mouth constructed as a pubic area, a cleft filled by a triangle of brownish hair. The pubic and head hair are of the same color and texture. The chin is well rounded off, and there are no ears in sight, since the hair covering them is like a shag rug. It is distinctly a face and not a face, set on a long, Modigliani swanlike neck, against a Chirico background of infinity. The meaning: there is no meaning. The rape: objects or features have been stolen from other portions of the body, replacing other objects also removed—eyes, nose, mouth. The human body has become a sequence of replaceable objects, and that may well be the rape or seizure.

With this theory of rearranged objects, taken together with Yves Tanguy's characteristic paintings of the 1920s (i.e., *Genesis*), we are on the way to *Fin-*

negans Wake. The Tanguy "look" is of melting reality inset with sharp objects. He seems to have smeared his work—foreshadowing techniques of the New York Action painters—but what we note more than anything else is that mixture of stain or smear with sharply visualized objects, such as the tightrope walker in *Genesis,* the green snake in the left lower corner, the black cone in the right lower corner. It moves us toward Joyce's summation, the supreme surrealist artifact. In the 1940s, Breton wrote such a "supreme" poem, dedicated to Matta:

> . . . what was spacetonia
> Becomes muscatelastic
> For brand new activity
> Here is the glazier on the shutter
> In that totemic language Mattattoucantharide
> Mattalismanchineel.

Words are portmanteaued, turned into almost visual totems; language is stretched and twisted, reshapings become the new tradition. Joyce takes over from here.

The main thrust of the twentieth-century avant-garde has changed words, the visual arts, and sounds forever. What we discover thereafter is that all the "post," "neo," and "pseudo" movements are nourished by a period that really ended by 1925, 1930 at the latest. In "Crisis of the Object" (1936), Breton tried to have the last word on an era he helped shape as well as demolish. What he calls in the essay "diverting the object from its destination" is the key:

> . . . we are witnessing the same vigorous stirrings of the thought process rebelling against the thinking habits of the past millennium, heralding a way of thought which is no longer a reducing agent but has become infinitely inductive and extensible: one in which the object ceases to be fixed permanently on the nearer side of thought itself and re-creates itself on the farther side as far as the eye can reach. In the last analysis, this new way of thought is fuelled chiefly by the anxiety inherent in an age like ours, where human brotherhood is at a premium while the best organized systems—including social systems—seem to have become petrified in the hands of their advocates. This way of thought has broken loose from the bonds of all that man has ever declared to be definitive, and is swept on solely by its own momentum.

◆ **Chapter Eight** ◆
Pound and the
Crisis of Modernism

THIS CHAPTER IS about Ezra Pound, but extends well beyond him to other considerations in Modernism. It really concerns three matters: the first and most important will revolve around the crisis in Modernism generated by the awarding of the Bollingen Prize in 1949 to his *Pisan Cantos*. The second will involve the reading of selected Cantos, not only to derive their key motifs, but to demonstrate some of the terrible confusions Pound got himself into, how his support of certain systems and rage at others were self-contradictory. Finally, of almost equal importance will be an examination of the way in which Pound assimilated cinematic techniques in structuring his *Cantos*. Serious film and the *Cantos* began at almost the same time. Inevitably, all of these matters come together in the *Pisan Cantos* (Nos. 74–84), whose controversial nature seems as culturally significant now as it was in 1949. In several respects, the "Ezra Pound question" has pulled the avant-garde and Modernism apart more than any other single issue. *

In 1949, the prestigious Bollingen Prize in Poetry was awarded for the first time: to Ezra Pound for his *Pisan Cantos*, an ongoing sequence. The Bollingen Foundation followed the recommendation of a jury consisting of Fellows in American Letters of the Library of Congress and included many of the luminaries

* Informative and well-documented, E. Fuller Torrey's *The Roots of Treason: Ezra Pound and the Secrets of St. Elizabeth's* (1983) pursues a completely different goal from my own. Torrey's purpose is to demonstrate that Pound was not really mad, but that the superintendent at St. Elizabeth's, Dr. Winifred Overholser, collaborated with Pound in convincing the government the poet was unfit to stand trial for treason. The move to obtain the Bollingen for Pound was itself a strategy to put the government on the defensive in its prosecution. One of Torrey's most revealing points is that Pound was given no medication, no individual or group psychotherapy, and no other type of therapy. He was interned in the hospital to foil government prosecution, but he was not treated because it was assumed he was not mad, although extraordinarily egotistic and narcissistic. I am far less concerned with the record than is Torrey, and far more concerned with the terrible dilemmas the Pound case created for those who considered themselves Modern artists.

366

of American poetry: T. S. Eliot, W. H. Auden, Conrad Aiken, Louise Bogan, Karl Shapiro, Allen Tate, Robert Lowell, Robert Penn Warren, among others. The Library's Consultant in Poetry at the time of the award was Theodore Spencer, of Harvard University. Subsequent to the award, Archibald MacLeish and William Carlos Williams became members of the advisory group. In 1949, several other volumes of poetry were in contention, all from the year 1948: Williams's own long, second volume of *Patterson*; a new book of poems by MacLeish, called *Actfive*; a first volume of poems by Peter Viereck—all of them clearly a mixture of traditional and new.

As the press release for the prize stated, the award "is given to the author of the book of verse which, in the opinion of the jury of selection, represents the highest achievement of American poetry in the year for which the award is made." The distinction must be drawn that the award was not for a body of work (i.e., the Cantos in their entirety) but for work published in a given year, then 1948. The release also indicated the jury might decline to give an award in any year if no work warranted it. It then added that the Fellows were aware of objections that could be made to such an award to Pound—he had been indicted for treason and was deemed incurably insane—but that such possible objections did not deter the jury from its selection. The sole consideration, the release stressed, was "poetic achievement." Any deviation from that would "in principle deny the validity of that objective perception of value on which civilized society must rest."

What is curious about the statement, however one feels about the award, is the phrase "objective perception of value" and the use of that "perception" as the cornerstone on which a civilized society rests. Given the nature of poetry, given the nature of Pound's own poetry (the Pisan group and the others), and given the nature of the Modern arts generally, that appeal to scientific objectivity is less amusing than pathetic. For if nothing else, the Modern movement, of which Pound was both instigator and product, had opposed that very "objective perception" the release stresses as the cornerstone of civilization. From the turn of the century on, and of course well before, objectivity, scientific observation, objects themselves had become the enemy. And they had been for no one more forcefully than for Pound, the recipient of the award.

With this, we stumble into a crisis in Modernism, but perhaps it had been brewing for some time. The immediate dispute seemed to be over Pound, "old Ez," stuck away in St. Elizabeth's, but the real point that swirled above and below his head concerned Modern and Modernism. Everyone who responded to the award had a stake, not in Pound, but in the larger questions. For, we recognize, to confer the award many of the jury had to open themselves to everything they believed about Modernism, and, in some instances, contradict positions about form and content that had long been settled by the movement.

Throughout this study, we have stressed certain givens of Modernism and especially of its cutting edge, the avant-garde: disregard for authority, whether literary, musical, artistic, or cultural-political; need to break new ground, wherever that may lead; flirtation with anarchy, temptation to test out chaos and the demonic; disregard for consequences except those linked to the artistic product; desire to remake all standards, all rules, and, with that, to alter the very nature of language; thrust toward reordering of objects in our perception, and, thus,

reorganizing our perceptions; rearrangement of experience, so that abstraction is the goal toward which all art rushes; finally, stress on the principle of change, to create a process, as an end in itself.

In another respect, which we have touched upon only tangentially, the avant-garde has left a vacuum, defined by the absence of recognizable human qualities. The avant-garde of Modernism has so emphasized rapid change—whatever the direction, however temporary—that the so-called human factor has rarely been a consideration. Also, a good deal of the avant-garde has been oriented toward generic change, toward disruption of more traditional techniques; the method of getting to the fore has often superseded human or dramatic elements. Stylistics triumph over matter. Characters in modern fiction, as compared with those in earlier fiction, are rarely recognizable in human (as apart from symbolic) terms because our novels have turned character into forms of pathology or stand-ins for ideology. So in the other arts—try whistling Schoenberg or reproducing mentally a Kandinsky!

The lack of a human factor in the avant-garde has several potential dangers. We saw in early Modernism that French poets made themselves into human bombs whose explosions were their works, with disregard for their own personal safety. Baudelaire, Lautréamont, Rimbaud, Verlaine, virtually an entire generation until Mallarmé—provided great literary excitement, but no models for behavior. Behavior was, in fact, closely connected to the way the artist responded to the avant-garde. That is, the human factor was closely associated with the artistic endeavor. The danger here is evident: that as one achieved breakthroughs in artistic matters, it was easy to equate such "advances" with human superiority, with transcendence of mortality, hubris unchecked. Extremist groups (whether left or right) were successful in wooing so many twentieth-century artists because the nature of Modernist art had not provided any role model for behavior, nor did it place any sanctions on aberrant behavior within its own terms.

In no career more than Pound's did these factors come to play a significant role. Pound listened to Nietzsche with only one ear. In his own eyes he had become superior even to the art at which he had himself become superior. He failed to heed Nietzsche's repeated warnings against bowing to authorities except those that reside in the human ego; he ignored the philosopher's repeated cautionary tales and parables about those who exchange one form of authority for another. From his late teen years on, Pound had bridled against authority, and yet he settled for totalitarian authority when he found his hatred of capitalism recapitulated in Mussolini's social movement and his virulent hatred of Jews sanctioned by Hitler's regime. In everything that follows, we should not forget that Pound applauded Hitler's handling of the Jewish question. Those who have tried to excuse the poet's behavior and language very often omit his comments on Hitler and Jews; and they just as frequently fail to mention that Pound's earlier Cantos, before the Pisan sequence, contained genocidal remarks fully consistent with his broadcasts from Fascist Italy. For no less than the anti-Semites at the end of the nineteenth century, Pound argued that Jews (through usurious practices) were the gray eminences behind all powerful governments and caused wars in order to secure profits. We are back in *Mein Kampf*, Act I, Scene I.

That Pound ignored the basic precept of the avant-garde—disregard of authority—by deferring to authority would have been considered a singular

aberration had the Bollingen Prize in Poetry not been awarded to him. With the award, however, we have the most critical moment in Modernism, when experimentation in the arts met head on with moral considerations, questions of technique with content, stylistics or language with beliefs.

My comments here are not intended to reopen the controversy of whether or not Pound should have received the first Bollingen award; nor is it even primarily concerned with whether or not the *Pisan Cantos* were worthy of such an honor.* Nor am I planning to reopen the entire question of Pound's career beginning in the 1920s, when his Cantos reflected the hatreds that began to accumulate once he latched on to Douglas's Social Credit, Mussolini, and usury as obsessions. My primary concern is to see the Pound case—as it came to be labeled—as the cultural Dreyfus case for our times: not of course equivalent to the trial of Captain Dreyfus in its larger implications, but analogous to it in that it provided a test case not only for a man but for the Modern movement in general. Although certainly most Americans went through their lives oblivious to Pound and his circumstances, nevertheless his career and its sensational climax in 1949 became a lightning rod for what all Americans did share: the culture of Modernism.

Pound made it difficult for even the most ardent supporters of Modernism to maintain their balance; and for those who opposed Modernism, as did many of the poets and novelists who attacked him, the case provided a moral argument against the stylistic excesses and philosophical absurdities of the movement. For as we probe the Pound issue, it becomes clearer that, despite his great services to Modernist writers (Joyce, Eliot, Yeats, Lawrence, etc.) and his multifold activities in the name of Modern poetry, Pound had aligned himself with those turn-of-the-century haters of Modernism: Nordau, Weininger, Kraus, and others. This group included those who attacked Dreyfus not over his alleged disloyalty, but over his Jewishness and, beyond that, over the "Jewish culture" which, they felt, had created Modernism and its corruption of a Christian culture. It was a world made by Jews that drew the venom to Dreyfus, and in a curious replay of that event, Pound would turn on the "Modern World"—however he defined it—as a world created by Jews. Historical truth made no difference.

One point that appears to have been muted in the furor was the fact that the Pisan Cantos were in several ways continuous with the previous Cantos in their anti-Semitism, their support of systems that were intellectual shams, their obsession with ideas that few serious persons—except the converted—could take seriously. We will examine these points below. But it is sufficient to say here that when we cited previous "extremist" poets—Lautréamont, Rimbaud, Jarry, for example—there was underlying their socially bizarre ideology an ironic assumption about life that placed their extremism in perspective. That is, they knew where and what they were, and they piled on socially repellent ideas within a context of irony, self-mockery, even burlesque. In another respect, Pound's work—perhaps unfortunately for him—coincided with the actual events that reinforced his obsessions. We have rarely witnessed a similar situation, in which

* There will be, below, consideration of some of these eleven Cantos (numbers 74 through 84) apart from the Bollingen's praise; that is, as aspects of Modernism, as reflections on a period in the twentieth century, as poetry and language. The aim is to locate where they fall within Modernism, also where within the *Cantos*; where they fit as performance. As performer, Pound recalls Artaud.

a renowned and honored writer has supported venomous ideas about society that several nations were carrying out at the same time.*

One of the crises created by Pound was surely that he forced the reader to look at content as if separable from the poem; for Pound insisted on particular points of view to such an extent his obsessions became subtexts that could not be ignored. In the light of his ideas (for example, linking Jefferson and Mussolini, Confucius and Malatesta), the question does arise whether we can honor poetic statements—whatever their other virtues—that are so chock full of nonsense. Some of Yeats has its own form of nonsense, but it was an antisystem that made little effort to be valid beyond its truth as part of a poetic or metaphorical idea; and even in its theory of opposites and its stress on phase and antiphase, his poetry presented a kind of metaphor for poetry itself. Pound was doing something quite different, and his content—whether Confucius, Malatesta, Jefferson, Mussolini, Jews, usury, or Odysseus—goes well beyond metaphor into a reading not of imagination but of history, of historical process. Pound, in fact, fudges the line between poetry (image, metaphor, a language within a language) and history (data, fact, a different kind of actuality). Put another way: to validate his poetry, he insists, intensely, on the truth of his history. It is Pound who makes the equation for the reader: believe my ideas in order to accept my poetry. This is not metaphor, but historical validation, perhaps even theology.

Let us back up before we return. In Cantos 13, 14, and 15, written in 1924–25, Pound offers the contrasts that will become the crux of the *Cantos* as a whole. Canto 13 is the world of Kung or Confucius and what he might mean for civilization, whereas Cantos 14 and 15 are the present-day world, its lines and images much influenced by *The Waste Land*. In each, we have warnings Pound mounted for modern, civilized man—admonitions addresseed as much to him as to other men. The warnings are, in fact, completed by the lines in the Pisan group about the evils of vanity. The contrasts these three Cantos offer are worth discussing, since they are not only cautionary but prophetic statements. Pound ignored his own counsel, and he fell into Hades. Seeing himself as Odysseus, he performed as Persephone.

Confucius counsels balance, moderation, discipline. He spread the doctrine we recognize much later in Western civilization as the chain of being, in which the individual knows his place in the order of things. The order an individual establishes for himself is reflected in other degrees of order radiating out from him. No external social and political order can exist unless the individual has disciplined himself. "If a man have no order within him / He can not spread order about him / His family will not act with due order; / And if the prince have no order within him / He can not put order in his dominions."

Just before Kung says this, he has castigated his former follower, Jang, for being a fool, for defecting. In lines that would be prophetic for Pound, who was about this age when he did the Italian broadcasts, Kung warns: "But a man of fifty who knows nothing / Is worthy of no respect." He follows this with the kind of wisdom that Pound purports to respect, but which was meaningless for him

* Céline comes to mind, but his two major works are prewar and are not narrowly political. Furthermore, Céline was not awarded any major prizes after the war, but was considered a collaborator and irrational. Céline, however, remains as a case to ponder with Pound's, especially in a novel such as *D'un château l'autre* (*Castle to Castle*, 1957, 1968).

individually: "Anyone can run to excesses, / It is easy to shoot past the mark, / It is hard to stand firm in the middle."

As early as Canto 13, in 1924, Pound was seeking a solution for Modern dissolution and corruption in doctrines hopelessly antithetical to himself. Unlike Eliot, who defined his own dilemmas in the 1920s and then moved toward resolution as an English Catholic, Pound established an ideal of behavior that could only exacerbate inner confusion. As an extremist, a man of overwhelming vanity, a generous man who contained streaks of uncontrollable hatred and rage, a poet who wanted to be the emperor of ice cream, lord of the literary manor, a manipulator, befriender, and dictator—for this kind of man, a doctrinal Confucius was folly. The order Kung speaks of was for a man seeking peace, not a man seeking a new civilization for which he was the avatar. Confucianism moves toward modes of behavior, toward creating those hierarchical ideas that help organize a civilization; it argues against extremism and for discipline. By supporting such ideas Pound could only tear himself apart and create dichotomies in the Cantos that make them ideologically shaky as early as the mid-twenties.

Canto 14 indicates an abrupt change, from Confucius to a view of modern London in the years immediately after the war. The Canto begins with a line from the *Inferno*, when Dante arrives at the Second Circle: "I came to a place where every light is muted." This will be Pound's England, specifically London, and the place for him is synecdochal: this is the world itself. For Dante, the Second Circle is not the world, there are still territories to journey to that offer alternatives. For Pound, we have arrived at an ultimate—unless, later, we can build a new civilization, the Dioce and Wagadu of the Pisan group. The London-England-world is corrupted and corruptive. In one telling passage, Pound speaks of the denigration of language: "And the betrayers of language / n and the press gang / And those who lied for hire; / the perverts, the perverters of language, / the perverts, who have set money-lust / Before the pleasure of the senses; . . ."

Pound did not suffer from "money-lust," but less than twenty years after writing of the "perverts of language," he became in his broadcasts nothing less than that, in fact a good deal more. Once again, he has located the problem: the perversion of language in the Northcliffe press and others was symptomatic of much larger perversions of civilization. The word was sacred, language a holy trust, and it was being corrupted at every turn. Just as Kung has spoken in the previous Canto of the need for discipline, or else everything blows apart, here Pound speaks of the purity of language as one way of recreating a civilized life. Following this passage, there is without break a shift, a form of crosscutting, to wasteland images reminiscent of Eliot's poem. This segment ends ironically with the classical Greek for "Images [Icons] of the Earth," the way in which people would have it; followed by the even more sarcastic "The Personnel Changes," signifying that while people replace each other, system and civilization remain fixed in putridness.

The Canto then moves into high gear, with disgust as the motif. Eliotic images intensify, and rage breaks through, so that Pound's poetry when measured against Eliot's on a common subject is clearly inferior. Pound, indeed, becomes subject to the same desecration of language he accused the perverters of carrying out: "the vice-crusaders, fahrting through silk, / waving the Christian symbols, /

. frigging a tin penny whistle, / Flies carrying news, harpies dripping sh-t through the air," and so on. The vituperation pours out, but such is the nature of language that understatement would work far better than rage bursting its bounds, especially when the Canto ends with a whimper, the hope of a more equitable distribution, the Douglas Social Credit system.*

Canto 15 continues the London wasteland. Usury is identified as the modern Satan, "the beast with a hundred legs . . . and the swill full of respecters, / bowing to the lords of the place. . . ." It is in every respect an Inferno, but the poetry once again suffers from a rage that cannot find an appropriate language. Parts sound like a Norman Mailer farce taking itself seriously: "skin-flakes, repetitions, erosions, / endless rain from the arse-hairs, / as the earth moves, the centre / passes over all parts in succession, / a continual bum-belch / distributing its productions." This is flattened-out language, not even Pound's attempt at a common voice, but a hyped-up effort to engage the maddened self and failing miserably to contain or communicate it.

Just before the London-Inferno segment is the Malatesta group, Cantos 8 through 11. Pound's admiration for Malatesta, who was in every respect except his love of the arts a monster, suggests he needed outside support, i.e., a leader. The contrast with the Confucian element is clear—not a sequencing from Confucius through modern usury and munitions, but an irresolvable conflict in Pound projected out upon history. On one hand, Malatesta testifies to Pound's need for a time span, the Renaissance, when the artist counted; but, also, a period when life unsupported by the artist was cheap, whether or not one was in the circles of power. What we find in Pound is a search for areas of power, which he can then disguise as "forms of behavior." He worshiped authority and strength well before Mussolini, and, as a consequence, the energy he expended on Confucius could not accommodate his desire for a leader. Accordingly, the Pound who moved into the later twenties and thirties, when he could link himself to Italian fascism, was predictable, not anomalous, not capable of being explained away ingeniously. There was, in this respect, nothing "insane" or "morbid" about his broadcasts, little out of keeping with the man who had split himself into conflicting halves and who thought those halves could, somehow, be reconciled within himself.

Such developing views also contradict what he wrote in *The New Age* (Orage's journal), in 1919, about nations. "I have no interest in any country *as a nation*. The league of *nations* appears to me about as safe and inviting for the individual as does a combine of large companies for the employee. The more I see of *nations*, the more I loathe them; the more I learn of civilization, the more I desire that it exist. . . ." How does this balance Pound's support of Mussolini's revived Italy, surely a nation? The desire for authority, for this rebel, preempted all of Pound's other considerations.

What we are claiming for Pound is a schizoid personality, a man who led at least two major lives. While none of this is particularly unusual for Modern artists—many of whom showed a similar kind of schizoid behavior—it was unusual in that Pound moved beyond language as a way of reconciling his

* *The Social Creditor*, the house organ of the group, listed *The Protocols of Zion* as among the books to be read, and it printed openly anti-Semitic letters. It argued that European governments were mortgaged to Jews and that Jewish finance was causing wars in order to maximize profits. It reached those ideas at about the same time as Pound.

conflicts. Others attempted words—what we find in Baudelaire, Yeats, Joyce, Eliot—but Pound moved first toward ideology and then action. With his anti-Modernist hatred, his detestation of the very cultural world that he so helped to nourish and reinforce, he moved to the very elements in society that devastate Modernism in its efforts to establish processes and new languages, if not a new world.

The ideological bind is implicit, in fact, as early as Canto 9, as part of the Malatesta group, and perhaps even earlier, by Canto 4, with the fall of Troy and the immanence of Rome. Expectation is brought too high. The third line with "Anaxiforminges" and "Aurunculeia" establishes the qualities that will distinguish the new civilization: the arts (poetry, music) and natural man (love, fertility, abundance). The actual movement of the Canto that follows recalls in some of its particulars Stravinsky's *The Rite of Spring*, especially its quarrying of rituals of birth and fertility based on old-young rivalries. Since this is the traditional stuff of myth, we note within a few years of each other such desire for renewal, Stravinsky just on the edge of the war, Pound and Eliot after. Such myths, however, cannot be reshaped or redefined along active lines. Pound may have paid tribute to Homer and Dante in these early Cantos, but Malatesta, as later Mussolini, becomes his guide when he decides to reconcile such divergent ideas.

Comparison with Joyce, another Ulysses quarrier, is instructive. More than any other contemporary work, *The Cantos* compares with *Finnegans Wake*. To pair them is illuminating, not only for their similarities (and differences) but for the role they play in later Modernism, the crisis they create for the entire movement. Both proceeded from long periods of gestation; both are based less on any clear narrative than on agglutinative relationships through association; both seem to imply a dream language of sorts, Joyce very consciously so, Pound moving in and out of dreams, fantasies, hallucinations. (I will later discuss the Pound narratives as "echo" material.) Both provide a kind of historical process, Joyce through the unconscious, nighttime, dreaming mind, Pound through a blending of personal obsessions with forms of contemporary and past history. Both stretched language, Joyce often beyond the breaking point in order to achieve new linguistic expression, Pound by gleaning from other languages those words and ideograms that would add expressiveness. Both were dare-devil innovators, cautionless in their literary careers and plunging on like a modern Odysseus to found new terra firma.

As we know, Pound praised *Ulysses*, starting his comments to Joyce with a line from the *Odyssey*: "He saw the cities of many men, and knew their minds." He then remarked that "All men should unite to give praise to Ulysses; those who will not may content themselves with a place in the lower intellectual orders. . . ." Their relationship over *Finnegans Wake* is more tendentious. This is all the more surprising in that the poet did not recognize—or very possibly did—that he and Joyce were mining comparable areas. Pound's Cantos are also a landsape of the mind, his own, *ego scriptor*, the subjectivity of which becomes the phenomenological detail of the sequence. But when Joyce submitted the "Shaun" excerpt from *Finnegans Wake* to *The Exile*, which Pound edited, the latter wrote back (on November 15, 1926): "Nothing so far as I make out, nothing short of divine vision or a new cure for the clapp can possibly be worth all the circumambient peripherization." What Pound is saying is not only "No," but

unreadable. This is, to say the least, a strange response for a man who had passed through twenty or more Cantos. At least Gide's rejection of Proust was based on different standards of language.

Joyce wrote Pound into several segments of the Wake: as a name, as the man behind spurious ideas of usury and monetary reform, as a literary figure trying to mold Confucian ideas to Western culture. More than simply being a referent in the Wake, Pound is ridiculed, with innumerable puns played on his name as money, food, and measurement. Joyce treats Pound as if he were destined to become obsessed with usury, issues, economics, and even agriculture by virtue of his name. In one sense, of course, Pound, with his entrepreneurial grasp, his desire to "manage" literary giants, the heavyweights, his reaching for one editorship after another, is, like Ford, a figure of fun, a target for mockery. In still another sense, Pound's Cantos and Joyce's Wake are both modern epics and histories that feature casts of thousands, from the past and the present. The figures flitting through the Cantos as part of the historical process include, besides Joyce, Eliot, Yeats, William Carlos Williams, Wyndham Lewis, E. E. Cummings, and so on. Homer had his roll call of dead heroes; Pound has his, of living creators. Joyce, similarly, punned his way through his generation.*

The similarities of the two, Pound and Joyce, appear striking: that common desire to write the history of their times through an epical structure with innumerable associations. Seeming randomness is belied by tight controls. We perceive of Finnegans Wake as more organized, more coordinated by central themes than the Cantos; but we soon recognize that both works have large and small elements that are focused. In Canto 81, for example, part of the Pisan group, we see how segments can be moved in and out, interchangeable with other Cantos, or else replaced by related materials. More favored by commentators than any other in the group because of its great lyrical outburst near the end, Canto 81 can be divided into three parts: internal meditation—monologue, free association; libretto—so designated by Pound, a play within the play of the poet's mind; and a final warning directed at Pound himself, with the lyrical passages repeating "Pull down thy vanity."

The general sense of the Canto is the passage of Pound from subjectivity and egoism (really narcissism) toward a recognition of himself in the larger group, where effacement is necessary. The poet relocates himself as it were—at least temporarily—in this Canto. It begins with paganism: Zeus lying in Ceres' bosom, with Pound then switching to Taishan—combining the Chinese Emperor's sacred mountain with a hill outside Pisa, all this "under Cythera"—that is, in sight of the island that introduced worship of Aphrodite. Supposedly she first rose from the sea foam near Cythera.

Pagan worship is set. Juxtaposed to this is Padre José Elizondo (already alluded to in Canto 77, as having "understood something or other"), whose true religion makes pagan worship seem closer to us than Catholicism: "There is

* A contemporary descendant of this and other Modernist techniques is Guy Davenport, who combines Joycean and Poundian strategies to create an absurdist, filmic journey or "periplum," to use Pound's word, through history. In Da Vinci's Bicycle, his journey story of "The Richard Nixon Freischütz Rag" juxtaposes Nixon's trip to China, Mao's attendance on him, and Da Vinci's design of a bicycle. Episodes of Nixon and Leonardo are interwoven, then blurred by other themes that serve not as association but as absurdist montage.

much Catholicism and very little religion . . . I believe that the kings disappear."*

So far Canto 81 is in keeping with general themes of the *Pisan Cantos*. Amidst the wreckage ("a leaf in the current"), the narrator, the ruined Pound, seeks a transformation in a fresh world he calls "the city of Dioce"; an Ovidian reshaping, but lacking Ovid's moral center. Since the sole place where such a fresh world can exist is in the mind, Pound must reconstruct it from nothing, as a mental construct, a Hegelian exercise. The reason the Latin *periplum* (*periplus?*) recurs so frequently is that it indicates a voyage, what he has also associated with Odysseus—his archetypal man of journey, recovery, and wisdom. Strikingly, he and Joyce agreed upon the same mythical creature. By the time of the *Pisan Cantos*, Odysseus has proven a dubious guide for Pound. The cunning old warrior may lead the modern poet-warrior to the gallows, which are slowly ridding the Pisan prison camp of its worst offenders. Pound thinks he is close to them.

A good deal of Canto 81, like the Pisan group as a whole, is concerned with how Pound can redeem himself without falling into abject self-pity. He must pull himself together, and yet he cannot claim innocence. As he recognizes, no man was less innocent.

Inevitably, questions of redemption lead back, for a poet and creator, to questions of beauty, memory, and time. One of the problems Pound suggests— and Joyce solved through fantasy, dream, interiority—is how the maker enters a timeless universe when his life is trapped by solids and by objects. In this quest, Pound circles back to the dilemma faced by the major Moderns in the early 1910s, when representative art gave way to cubism, then abstraction and Dada; when objects had become not only something to be manipulated, but elements to be dissolved.

How does he do it? The first segment of Canto 81, before the "libretto," is a rambling, freely associative inner monologue of a man trapped but seeking the images by which he might escape. That the segment nearly ends with the mysterious cry that evokes the *Song of Roland* intensifies the poet's journey to move outside his skin, to the territories that only his mind, not his body, can explore. This takes him, in typical Poundian associationism, from the Spanish meditation that opens the Canto, and beyond that mythical beginning, to Horace Cole, John Adams, and Jefferson, and the now familiar economic ideas that have divided America. Intermixed with these are fertility rites (Ceres, Dolores theme, possibly Kuanon) contrasted with "Crédit Agricole," which desecrates the sacrament of plenty. Modern plenty is corruptive. George Santayana becomes somehow enmeshed in this process, and, we assume, represents in his conservative way the old—the "th" of his Castilian possibly giving him grace. The final word is Althea, a reference of course to Lovelace's "To Althea, from Prison," the application being to Pound, moving amidst the wreckage of the past and maintaining whatever sanity was left by way of memory and time. The image play here (not the ideas implied) approximates the verbal play of *Finnegans Wake*.

* Pound liked to believe that Catholicism derived not from Judaism but from pagan teachings, behind which is the Eleusian cult. Even the Old Testament was pagan rather than Mosaic. This was, of course, another way he could bypass the God of Abraham and Moses and bring Judaism in not as an ethical doctrine but as usury.

This first segment is a dialectic of freedom (plenty, abundance, growth) and prison: Pound caught not only in the web of circumstance and fate but in some gigantic historical puzzle whose pieces cannot quite fit. The final words, besides the cry of Roland, are words of spatiality: vacant, wild, loose, "leaf in the current," contrasted with the plaint "at my grates no Althea," which is stasis, imprisonment. The libretto, that play within Pound's mind, that Renaissance strategy to create some analogy to an internal world, is a lyrical outburst. It is also a plaint of sorts as a form of song, with its references to Lawes (Henry Lawes, the English composer), Jenkyns (John Jenkyns, another composer), and Dolmetsch (Arnold Dolmetsch, who pioneered in recreating seventeenth-century instruments). The language of the libretto recalls a variety of poets, the seventeenth-century lyricists, of course, but also Chaucer and even Shakespeare in his songs. The outbreak into Italian is an effort to evoke Dante.

The libretto, suddenly, becomes very personal in this "Italian" passage: ". . . there came new subtlety of eyes into my tent." Pound ascribes this, possibly, to the new spirit of *hypostasis*. This is a nonlyrical word charged with meaning for both poet and person. In its purest sense, it signifies what settles at the bottom, the essence or chief nature of something, distinct from attributes or qualities. But theologically—and here is what Pound was alluding to—it denotes one of the parts of the Trinity, part of but indistinguishable from. In its broader sense, its wedding of substance and person suggests a meeting of sacred and human. And in even broader respect, Pound could use it to define the role of poet and maker, *ego scriptor*, himself, reaching toward a godly function.

The remainder of the libretto segment is concerned with "seeing." The key word here is *diastasis*, a kind of visual interval that Pound links with what the "blindfold hides" and "the stance between the eyes." The Greek suggests seeing and vision, and the segment winds down with visual images that may or may not be available to Pound. They are available if he can take advantage of the "new subtlety" that has entered his tent; unavailable if the blindfold hides what it is. In a sense, he is a prisoner now not only of the American armed forces but of his own spirit, his past, history. The final section of the Canto will lead to purgation and redemption.

It is well introduced by "what thou lovest well remains." The lyrical outburst has few references—only Paquin, the Parisian couturier, and Blunt (Wilfred Scawen), the poet who in his old age opposed English policies in Ireland. The lyrical passage has its foundation in Ecclesiastes' Vanity Fair, "all is vanity," and there are echoes from Shakespeare ("What thou lovest well remains"), Marvell ("Learn of the green world what can be thy place"), Chaucer ("Master thyself, that others shall thee beare"), among others. Yet the chief note of the poem is, despite its warning, Pound himself. It is lyrical and redemptive, and it is all ego. There is no way Pound in the Pisan group can escape himself: to "pull down vanity" is what he failed to heed, and he uses himself as exemplary of consequences. Pound writes of "scale" and "balance"—Marvell's "in a green shade"—but the old ego trumpets itself in "here error is all in the not done, / all in the diffidence that faltered." Pound reconsiders, and while he judges his acts failures, he defends himself for having done them. He may counsel "pull down thy vanity," but his spirit lies with Blunt, who in his seventies showed no diffidence. Blunt had written "Time is his conquest . . . Till I too learned what dole of vanity / Will serve a human soul for daily bread," and the imprisoned

poet takes encouragement from that. He had once knocked at Blunt's door; we note not only a physical knocking, but a spiritual kinship. Blunt had opened to him, and Pound, amidst desire for redemption, was not beaten.

Since the journey into self is archetypal, Pound has at his disposal memory, time, beauty, history, myth itself, which is the greatest of all passages. Memory is perhaps the most difficult for him to deal with, and thus he becomes transformational—possibly to escape or evade an obvious contrast between past and present endeavors and present abjectness. The body is caged, in a specially reinforced cage strong enough to hold a gorilla, but the mind roams free; and the Pisan eleven become a record of that movement. How does a gifted prisoner, disgraced, see himself and see the world as it perceives him, a traitor, a vile body?

Strikingly, Pound circles back to episodes and attitudes he had established earlier when he wrote the Cantos under quite different circumstances. That is, his sense of self may have deepened as a consequence of his imprisonment, but the Pisan Cantos are continuous with those roles of maker-poet-priest he had defined earlier.

Having begun as Odysseus seeking restoration in the underworld, Pound returns to that archetypal journey, as we have indicated above. In Canto 74, we have one of the longest of the sequence, probably because Pound needed a solid base to establish the Pisan group; but, even more, as a reflection of uncertainty of how he could go on writing as poet-priest while caged. In reading the Pisan series, we should never lose sight of the cage environment, of Pound as zoo animal watched and watching, pacing, exercising, feeling out the dimensions of his confined area. This, too, is part of a journey experience, whose analogy would be Kafka's "Hunger Artist" undertaking a journey toward extinction. Joyce created a myth of journey in his Dedalus sequence, and of course a myth of Ovidian transformation in the use of the classical artist-figure. In *Finnegans Wake*, Joyce intensified the journey, into an underworld as mysterious and "mythical" as anything in Homer. The difference in their use of myth comes in Pound's insistence on redemption and restoration, whereas Joyce appears satisfied with having established the need for mythical reinforcement without any heuristic function.

Unlike Joyce, Pound explores myth as "echo" material. Abandoning narrative and mimetic qualities, Pound renounced direct representation, which would be theme, and moved to a middle state, which is linked to echo. Not the least of the Echo legend is her association with Narcissus. After her punishment by Hera, in which Echo was transformed into an echo, she fell in love with Narcissus, who, of course, did not return her feeling. As a consequence, she succumbed to grief, and only her voice remained to identify her. The dual references here, to Echo and Narcissus, work well with Pound's mental condition when writing the Cantos and his dependence on memory, sensation, holding on. One way to read the Pisan group is as the emanations of a man who views himself as reflections, as echoes of the real thing, as noman, not even Noman: "I am noman, my name is noman." By removing identification, Pound has created a new identity, as the echo of himself, but also as still part Narcissus. Even the anti-Semitism and the identification of Jews with money/usury is only an echo of its former virulence. Pound has not softened; he has understood annihilation.

It is fitting, therefore, that the Pisan group should be read as a dramatic monologue, in the Browning tradition. We know Pound early saw himself as heir to Browning. While it could be argued that all of the Cantos are part of that dramatic process, the material is so scattered among "voices" that the single consciousness needed for the monologue is missing. But in the Pisan sequence, we have that single consciousness, what is called above the Poundian voice as echo or reflection of his former self. That single consciousness, we could in fact argue, is what holds together the Pisan group, in ways no other Canto group is coherent. One of the immediate dangers of the Poundian denial of mimesis and of narrative in such a long sequence is that the kind of free association he entertains results in scattering and patches of incoherence. Pound moves so swiftly—rapidity is one of the "themes" of the total Cantos—that several dangers are implicit, only the least of which is reader comprehension. The most obvious danger is failure to achieve credibility; ideas slip through so quickly nothing is established. Yet Pound places high priority on the "content" of the Pisan group. It is not solely feeling or emotional strife, or process and echo. It is those, but it is ideology: the ideology of a man who, like his "voice," is caught between.

That "between voice" recalls *Sprechstimme*, which came to dominate serious opera at the time Pound was writing the *Cantos*. The voice of the *Cantos*, while clearly Pound's in its ideology and tones, has moved toward that middle ground of innerness associated with *Sprechstimme* in Debussy, Schoenberg, Berg, and others. It works particularly well with echo material, since, in its own way, it is a kind of echo: a retrieval of that single consciousness reflecting the maelstrom outside. Further, since Pound denied rational sequence in favor of rhythms, tones, swiftness, *Sprechstimme* has that quality of distance from normalcy that accommodates his method. If one seeks elements beyond sense, or else a supra-sense, then *Sprechstimme* has the dimension of bizarreness or unfamiliarity that suggests another world. Especially in the Pisan group, Pound is reaching for that "other," what lies outside words, tones, rhythms, beyond the text. His use of a hill in Pisa, which lay in his line of sight while he was imprisoned, as the holy Mt. Taishan of the ancient Chinese is one way of moving beyond text, beyond visibility to vision. The equivalent in *Finnegans Wake* would be Joyce's blurring of conscious and unconscious, with its own language, to create a middle "voice."

The use of foreign languages reinforces the *Sprechestimme* dimension, especially the classical Greek and the Chinese ideograms. Both of these create a strangeness or remoteness on the page, conveying "otherness." Even for those who can decipher the Greek, the Chinese remains something distant and exotic—somehow beyond comprehension but not incomprehensible, since Pound usually provides the meaning in a nearby word, line, or legend. The visual aspect of the Greek and Chinese is significant. Visuality works with words, since the foreign letters denote words, but sight meaning is also beyond language because of its distinction from the Roman alphabet. Furthermore, the presence of classical Greek suggests the Eleusian mysteries that lie at the heart of the *Cantos*: those mysteries that gave the Greeks their dimension and power, their awe of something beyond themselves which we no longer possess. Still further, the Greek alphabet conveys the great distance of that era from our own contemporary life; distance measured not in language alone but in history and ideology. What was once considered an eccentricity or a pretension in Pound, the use of Greek characters

and Chinese ideograms, is in reality part of the verbal-visual quality of the page that accommodates his persistent theme. That latter, as we have seen, involves measuring present against past, one man's frustrated journey now against those journeys in past history that resulted in affirmation.

Since *Sprechstimme* is so close to psychoanalytic dimensions, perhaps we can view Pound's entire method in the *Cantos* as one of introjection. That process can be defined as the individual's incorporating into his ego system his conception of an object: the stress here being not on the object or external process but on the mental picture the subject has of externalities. Pound's extreme preoccupation with his hobbyhorses suggests a man who has so introjected his sense of objects he can respond only to the image, not the reality. The *Pisan Cantos* demonstrates this ably, since even with the world having fallen apart around him, Pound still maintains, in Canto 84, the roll call of honorable Fascists such as Pierre (Laval), Vidkun (Quisling), and Henriot (the Vichy minister of information), and Ben's valiant effort to build the "Just City," which Pound sees as Dioce. The realities of fascism and of the Fascist state are secondary to the mental image Pound maintains.

Such a reliance on introjection was, possibly, Pound's way of turning his disastrous situation into poetry. That is, introjection in some way we cannot pursue was his form of imagination—and here, of course, he parts with Joyce and with *Finnegans Wake*. Such a mental process is obsessive, carrying him to the edge of the madness for which he would be held in St. Elizabeth's. But for us, as readers, such an interpretation serves several functions. It explains, obviously, Pound's solipsism and narcissism; it suggests why he could identify with, first, Odysseus and then other leaders or famous men. Finally, it fits well into his method—into his use of an interior monologue, as that voice which comes so close to *Sprechstimme* in other artistic modes.

The *Pisan Cantos* sets out to escape from the "enormous tragedy" of "Ben and la Clara a Milano," with the use of "la" giving the shooting and hanging of Mussolini and his mistress a kind of operatic quality not quite in tone with the rest of the Canto. But rather than inconsistency, I think we must see the *Cantos* as a kind of opera or film for our times—confused, hideous, sincere, committed, hateful, cruel, masochistic, ultimately an act of some pathology. It is, in a sense, a forty-year opera, Pound's response to Wagner's nineteenth-century Ring; a cycle of its own integrity, associated as it is with the poet's view of himself sinking, being swallowed, and always returning, restored. Here his submission to mythical constructs permits him to align himself with such heroes as are restored or transformed, and at the same time to play the modern host, or else the poet-priest who both journeys and remains outside as commentator.

What we are claiming for Pound here is that—once more like Joyce—he has found the means through mythical constructs and Confucian ethics to re-create those journeys that are at once instructive and transformational. Yet such journeys are real descents into hellishness, what we see in the early stages of the Pound tradition, which thrusts us back to Baudelaire, Nerval, Lautréamont, Rimbaud. If we speak of journeys, we must cite not only Odysseus but Baudelaire, both in Paris and in his voyage poems of fantasy.

If we view the *Pisan Cantos* as operatic, it becomes an amalgam of Wagnerian racial venom, Puccini sentimentality, and the thrust and counterthrust

of historical tragedy. Movement is all: Pound has utilized, among other film techniques, montage and cross-reference. Still early in Canto 74, he moves from Ben and la Clara to the Possum, Eliot, to his Odysseus persona as noman, to Italian Renaissance history with a Chinese reference, to "Charlie Sung" and interest rates, to Douglas Credit, to Churchill and the return to the gold standard, to Stalin and the means for production, to militarism, ending up with the American Constitution in jeopardy, "and that state of things not very new either." All this is in less than two pages of loosely printed verse, which then winds back to Odysseus's "I am noman, my name is noman"; that is to say, Pound as a nonentity, caged, a tenor singing out his lungs to anyone who will listen.

While full of prison images, Pisan 74 in another respect is a "Song of Myself," defining the bard or singer even as his body is imprisoned. The sense is of breaking out—not from the iron cage, but from the idea of imprisonment itself, a metaphysical quest for redefinition. This links well with the earlier Cantos' sense of immersion, experience, restoration, what one commentator calls "rituals of metamorphosis and restoration." If we see Pound, like Laocoön, struggling to clear away restricting limbs in order to achieve a new self, but doing it through an operatic means, we can comprehend his ideological confusion. For in attempting to rediscover himself—that key motif running through the entire Pisan sequence—Pound has created an idealized, personalized pastness. He has turned history into an engine of dubious properties, in a way amenable solely to his will. By intensifying his struggle to break free (the poet's role and function), he creates a history that never existed, an Edenic golden age of his own making.

The significant element here is Pound's need to bend history to his own means; it is not general history about which he writes, but *his* history. We must emphasize that despite the layers of European sophistication in which he is mired—not to speak of the Chinese linkages—Pound is profoundly part of an American desire to embrace an idealized past. Myths, of the golden age, a New World, a Garden, so characteristic of American ideology and part of Whitman's national vision, are associated by Pound with both historical and personal salvation. It is, to say the least, a curious turnaround for the man who rejected American shores early in his career, and yet not so strange for the man who embraced a Jeffersonian ideal after distorting it to fit his need.

Pound opera, like so much twentieth-century opera, is of interiors, the Cantos a form Kafka was reaching toward in prose. But Pound was the first to recognize that the ideal operatic form for the century was a poetic vision with techniques borrowed from film strategies. Such strategies have now evolved into "performance" and were foreshadowed by Artaud. Also, Pound is deeply indebted to Dada and surrealism, for his opera enters the unconscious, just as Joyce's epic of historical interiors does in *Finnegans Wake*. Once again, the journey motif serves both content and vehicle, both ideology and means. In this opera, while the performers are dominated by Pound's solo arias, he is by no means the only performer. His cast includes, as we have seen, a vast array of characters, from Confucius and classical figures to the Renaissance princes, to early Americans like Adams and Jefferson, to his modern contemporaries: Joyce, Ford, Williams, and others from the Pound circle. Even so, performers are not the main consideration; backgrounds are, and here Pound falls back on his developmental years in European Modernism. The Pisa of these Cantos is landscapes

from Chirico: populated by historical figures and wartime zombies, landscapes themselves emptied out and yet pulsating with mysterious vibrations. The Chirico mystique is evoked by the Pisan camp itself, "Taishan" in the distance, the surroundings of a lovely seaside resort only a few kilometers away. Pound has been banished into a Chirico "desert."

The Chirico dimension is not the only one from the plastic arts. Kenner cites Max Ernst as a key influence, but I would stress Magritte and all those other painters who turned landscape into moonscape. What Pound has done—in pursuing surrealist ends—has been to defamiliarize the Pisan landscape, turning it into memories of Eliot's wasteland or into a wartime combat zone. In a passage that speaks of the "4 giants at the 4 corners"—the guards with guns watching the compound—Pound places the ideogram for "silence" and the Greek for "noman." If we take the images together as creating a moment, even an epiphany, we can see them as an extreme montage, a visual equivalent of the unconscious: a stark, military image, an ideogram suggesting the Chinese world of withdrawal and silence, the frustrated journey of Pound as noman.

This is the good Pound. There is, everpresent, the bad Pound. ". . . the yidd is stimulant, and the goyim are cattle / in gt / proportion and go to saleable slaughter / with the maximum of docility." This is followed by a passage from Leviticus, with chapter and verse in dollars and cents—a brilliant conception of biblical reference for an obsessive anti-Jew. Lawrence and Hemingway could not have done it better. It is, of course, consistent with Canto 48, where Bismarck "blamed american civil war on the jews; / particularly on the Rothschild / one of whom remarked to Disraeli / that nations were fools to pay rent for their credit. . . ." But to return to Canto 74: what does this anti-Jewish outburst mean? Why did Pound need it?—now that European Jewry was itself dead or scattered, eight thousand or more done in by the Mussolini regime whose policies the poet had so eagerly reinforced. Are Jews still connected with world usury, when, in fact, the usury of the twentieth century was carried on by bankers who were, like Pound, Christian, Protestants and Catholics alike? If this is history, what kind of history is it?

The question arises not only for the contemptuousness of the references, * but also for their placement as poetry. Are these lines "poetic"? part of the grandness of the Pisan group? What is the Pound legacy? While arguing love, restoration, self-discovery, is it equally one of hatefulness? In Joyce, when anti-Semitism arises in Dublin, as it inevitably does, our sympathy for Bloom is balanced against those who rant and hate. Pound argues a Confucian ethic intermixed with Greek grandeur, both as counters to modern dissolution and decay; but the very terms of his hatred mitigate against the message of the middle. There is no middle behavior, even though the presence of the ideograms and the classical Greek would appear to reinforce that need for balance, ethics, middles.

Joyce achieves in both *Ulysses* and *Finnegans Wake* a dialectic, working on polarities throughout and gaining a synthesis of counterpointing ideas. Pound

* And the equal contemptuousness of those critics (Tate, for example) who accept it as it is. See Hugh Kenner on the blacked-out lines of Canto 52: ". . . it is a pity Pound's distinction between the financiers and the rest of Jewry was not allowed to be emphasized while he was still in the habit of making it. Correctly or not, it attempted a diagnosis, one tending rather to decrease than to encourage anti-Semitism." Kenner's "Correctly or not" contains worlds of ambiguity.

does reach for this, so that even the evils of usury in his mind are balanced by the Confucian ethic and Classical quest for restoration; but working against this is Pound's own unambiguous rancor, vanity, and solipsism. Despite his broad-ranging use of other languages and literatures, he must bend all to his own need; whereas Joyce, particularly in the *Wake*, permits language to lead away from self toward other forms of life. For Pound, universal history becomes focused only in his own mind; introjection replaces understanding. Those who speak of the greatness of the *Cantos*, as did the Bollingen jury, have insufficiently considered how Pound vitiates the very kind of greatness they attribute to the sequence; how he subverts with his own needs the very element he is attempting to achieve. Even "Pull down thy vanity" ends up as self-justification, a mockery of the sentiment.

Perhaps Pound's real achievement lay in his poetic strategies and stylistics, his ability to move, blur, cross-refer, submerge, and blend. In some respects, the *Cantos* can be compared to a long-running film, or else a film with innumerable sequences, like some of those early silent serials. Even longer than *Finnegans Wake*, the *Cantos* derives from more or less the same cultural context; as part of a postwar cultural heir to a revolution in ideas, attitudes, and tastes. One of those influences or forces that we have only as yet touched upon is film; and yet film, it would appear, deeply affected not only Joyce and Pound, but also Eliot, Döblin, Broch, and several others. Film here should not be disengaged from photography, since it was new techniques in the latter that helped to give film its experimental impetus.

Two important points: it is difficult to disentangle film influences from what could be other cultural forces; and film developed parallel to other aspects of Modernism, so that reciprocity must be considered. For example, at the time we note publication of *The Waste Land*, *Ulysses*, *The Good Soldier Švejk*, *The Duino Elegies*, "Le Cimitière marin," and the appearance of Schoenberg's *Serenade* Op. 24—which inaugurated the twelve-tone system—Berg's *Wozzeck*, Svevo's *The Confessions of Zeno*, Picasso's *The Three Musicians*, ending his cubist phase, we find in film *Nanook of the North* by Flaherty, *La Roue* by Abel Gance,* *A Woman of Paris* by Chaplin, followed in the next year by *Strike*, Eisenstein's first effort at cinema. Even more significant, immediately preceding was the filmwork of D. W. Griffith, especially his *The Birth of a Nation* (1914) and *Intolerance* (1916). †

The more precise linkage between (say) painting and film is difficult to ascertain. We can assume, however, that early film techniques—montage, rapid cutting, freezing, speeding up and slowing down, the long shot, the close-up, even flashback and crosscutting—were developing parallel to comparable techniques in the major art forms. As we move into this phase, we must be aware that many of these devices are not intrinsic to film, but to art forms in general under Modernism. What we saw in Picasso's first gleamings of cubism in *Les*

* The Gance film involved Léger, Cendrars, and Honegger: a painter, a poet, and a composer. But a few years earlier, Dorothy Richardson in *Pointed Roofs* (1915) and *Backwater* (1916), the first and second volumes of her Pilgrimage series, had demonstrated several film techniques. Notable were rapid cutting and montage, the result of Richardson's use of interior consciousness in her main character, Miriam.

† Lenin, incidentally, had *Intolerance* tour the Soviet Union, where it enjoyed a huge success.

Demoiselles implied an early film technique, in the blending and merging of elements with each other which came to be labeled montage. The early development of the stream in Ford, Joyce, and others implies some of the techniques utilized also by film, especially flashback and crosscutting, not to speak of fade-in and fade-out.

As Eisenstein discovered—and as Griffith had already attempted—the camera can probe interiors by means of the image. Much of his early work is, in fact, linked to a dialectic of images, what he defined as a "dialectical montage." The most famous scene in *Battleship Potemkin* (1925), on the steps of Odessa, focuses on such a dialectic of images, something akin to what we saw in Duchamp's *Nude Descending a Staircase* more than a decade before. In the film, we note elements rushing up, while other elements are plunging down—so that amidst riot conditions we have a controlled tension of movement. The famous image of the baby carriage beginning its downward descent and then careening toward the bottom gains *its* momentum from the countering forces heading up past it. Such contraries involving speed, differing textures, and violence had been the stock-in-trade of Modernism for several years.

Rather than try to disentangle influences, or whether "influence" is really reciprocity or parallelism of technique, I would rather note how profoundly film techniques enter into the *Cantos*. We can say that Pound, in some way, had absorbed cinematographic strategies for his poetic sequence. We can argue, in fact, that as early as Pound's definition of imagism he had in mind a poetic form that approximated what was occurring in early film. Certainly aspects of imagism and the strategies of Griffith coincide, even the "Biograph" Griffith who preceded *Birth* and *Intolerance*. Yet even here we should not press the point that Pound consciously borrowed from film, or pursue any cause-and-effect relationship. Instead, we should stress, ideas from film began to penetrate the culture at almost the same time as Modernism in the other arts gained momentum. Joyce, as we know, was fascinated by film—at least by the idea of operating a movie house; but to what extent cinematic strategies were consciously part of his own technique we cannot ascertain.

The opening lines of the revised Canto 2, which returns us to the immediate post–World War I years,* are a montage of effects. The first twelve lines contain references to Browning's *Sordello*, Picasso, and Homer, before moving back to the sea images established in Canto 1, Pound's and Homer's Odyssey. One could, possibly, assert that all poetry depends on montage—rapid shifts with overlapping materials. But Pound's "montage" is shiftier, more radical, its elements less associated than we expect. Another argument is that Pound could have learned such montage from other contexts—from cubism, or collage, or from abstraction in general. This is true, for montage is implicit in the methods of Picasso and Braque in the early 1910s, in fact foreshadowed by aspects of *Les Demoiselles*. These are parallel developments, and all we can be certain of is that Pound had also ingested what Eisenstein would define as a "collision of

* By 1928, Pound had completed twenty-seven Cantos, sixteen of them by 1925. Of particular interest for us, however, is the 1917 "The Cantos" publication—right on the threshold of a film breakthrough. However Pound later revised these three Cantos, they prove revelatory. They appeared in the June, July, August, 1917, issues of *Poetry Magazine* as "Three Cantos." They were later severely reworked and reset for the 1925 volume of A *Draft of XVI Cantos*. The present Canto 2, written in 1922, was given the place of Canto 8 in the 1925 volume.

elements," what Pudovkin saw as "linkage," what Dziga Vertov would define as "the organization of the visible world." The latter is perhaps the most suggestive of all.

But beyond definitions, montage suited Pound on other grounds. It is, basically, an antirational device, since it can be organized out of elements that have little or no cause and effect, materials that are not sequentially or rationally ordered. The poet, here Pound, can create seemingly discrete sequences that are really tightly controlled: one can give the sense of randomness and still prove coherent. Montage entered Modernism as part of that random quality which helped define movement. Dziga Vertov's phrase about montage "organizing the visible world" is suggestive because it indicates one can create or unite elements that seem otherwise disconnected. The very principle of Modernism is at stake here, as well as ways in which such a device could accommodate Pound's desire to work both within and outside tradition. Pound's was a radical voice paradoxically linked to the great traditions of poetry; the two elements would be expected to pull him apart. But montage (or collage, or cubism) gave him a technique to bridge what seemed irreconcilable; he could at the same time subvert and link.

Montage also proved agglutinative for Pound. By editing his material the way Eisenstein said he edited his film, Pound could bring together elements that otherwise pulled apart. Browning, Picasso, and Homer, along with Pound's own Odyssean quest for experience and unity, would appear to have little or no associative value; and yet by gluing together marginal aspects where they overlap—possibly their "adventurousness," their distinction and differences from the ordinary, their "journey" quality—Pound has given them sticking quality.

We see this as early as the final segment of Canto 1. Here the montage is of several varieties. The segment begins with the voice of Anticlea, Odysseus's mother, who has died while her son was away from Ithaca. She is rapidly succeeded by Tiresias, representative of prophecy (a few ounces of Pound there) and of the "living dead." Tiresias, although deceased, is still fully rational. He makes the prophecy that Odysseus will return, despite Neptune-Poseidon's desire for revenge and despite the loss of all companions. The next voice can be only Pound's, as he informs Divus, Andreas Divus, a sixteenth-century translator of the *Odyssey* into Latin, to "Lie quiet." It is a command, the voice Pound's; then followed by Pound's impersonal or poetic voice blending with Homer's: "And he sailed by Sirens. . . ." This poetic voice is followed by that of the Cretan, Georgius Dartona, who translated the Hymns once attributed to Homer, contained in Pound's copy of Divus's *Odyssey*. Following the Latin quote from the Cretan's translation of the "Second Hymn to Aphrodite," the voice returns to Pound's poetic intonation: "So that:" which ends the Canto.

These are the main, demarked voices. There are, however, other internal voices which a printed *montage* can show, but which a visual one cannot. Immersed in the key voices of Tiresias, Pound, the Cretan, and others are those of Aphrodite, implicit in the "Hymn"; Hermes-Mercury, in the golden bough which appears in the final line; Anticlea, who "comes" twice, does not speak, but is a voice, however silent; Divus, whose Latin version keeps "speaking," even though Pound warns him to "Lie quiet." Beyond this are the modulations of Pound's own voice, as he moves in and out of the group, offering counsel, siding with Odysseus, listening carefully to Tiresias (his mentor as much as Odysseus's), piling up his sources. Pound manages his group of Greeks in and

around Homer as once he had managed his stable of Modernist friends in London.

The montage here is not only a grouping, overlapping, or linking of source materials, but one of voices. In the latter, Pound had a weapon as yet unavailable to the filmmakers—the massing of voice-overs—while in his use of scenic montage he was following techniques or strategies already well developed in film.

This, however, is not all. Profoundly linked to the voice-overs are the temporal overlappings. In his useful guide to the selected Cantos, George Kearns calls them "cultural overlappings." But even more than "cultural," they are temporal sequences connected to the key voice, Pound's, and, therefore, associated with memory.* As part of the journey or quest metaphor, they are trips into ever deeper memory, beginning with the opening lines, which are connected to Pound's translation of the Anglo-Saxon "The Seafarer." With this, we have the beginning of Pound's journey motif, which by line 7 he links to Homer's. The memory sequencing, which is a form of very sophisticated montage, carries Pound from the early 1910s, when he made the "Seafarer" translation, back through layers of history, to mythical times, what we call prehistory. In that traversal of time, which is a retrieval of personal and cultural memory, we have Pound seeking archetypes or universal modes of behavior.

The journey through time takes him to the early Renaissance, with Divus, back to Rome's Golden Age, with Virgil's *Aeneid* (reference to the Golden Bough), further back to the Hymns to Aphrodite once attributed to Homer, then back from that to Homer's *Odyssey*, then before that into the "matter" of the *Odyssey*, and still deeper into man's efforts to use myths to explain the unknown. Almost three thousand years of history have been crossed, and then even further into prehistory.

Part of this is a Jungian quest for archetypes, for collective behavior as the codes by which we can understand ourselves. But Pound is far more personal, far more solipsistic. Through memory and culture, he is seeking analogues to his own quest for retrieval of self and renewal. He is willing to undergo the experience, to take the journey into the underworld, to confront a dead mother, a dubious Tiresias, an enraged Neptune, and other obstacles, psychological and physical. That movement back, as we have noted, is a form of temporal montage, an analogue to Proust's experience with tea and madeleine. Proust rejects history in order to retrieve memory, and eventually he rejects memory in order to retrieve the moment; Pound reaches for history as a way of supporting memory, and then he uses memory as a way of retrieving history.

Ends and means are blurred, margins overlap, and this is precisely what we mean by montage. It is less Eisenstein's "collision" (contrast and conflict) than it is Pudovkin's "linkage," and even more Dziga Vertov's "organizing of the visible world." Only Pound has taken it a step further: he has turned memory blocks or temporal units into the geometric forms we find in cubism. The methods of painters and filmmakers are assimilated to the uses of poetry, to the poetic sequence. For once this base of memory and temporal montage has been established, Pound can truly say "So that:".

* If we call them "temporal *montage*," they fit Rudolph Arnheim's second category of film organization; the other three being technical arrangements of the strips, spatial relations, and subject-object relations.

But montage, we should stress, whatever its attractions, was only one of several such devices Pound used parallel to film techniques. There is one strategy he could have borrowed directly from *The Birth of a Nation*, the use of the so-called iris scene. The iris scene is a particularly effective cinematographic technique in that it occurs when all background is blacked out and only the item focused upon—person, scene, object—is in the light. The focused item is framed by black, creating an effect stronger than chiaroscuro in traditional painting, although associated with it. * The iris scene provided several kinds of possibilities, many of which Pound took advantage of, especially in the Pisan group. It allowed Pound to accentuate certain elements—the periplum or sea journey, the relationship of self and Odysseus as fellow explorers/adventurers; the sense of the explorer as maker or poet, their kinship. These are the more obvious uses of the iris scene. A concrete example is the appearance of Tiresias in the final section of Canto 1, holding his golden wand. Circe has warned Odysseus he must travel to the underworld before he can return to Ithaca—the way back is through the land of the dead. In that land of the dead, Tiresias is outlined, the golden wand providing the iris effect.

Less concretely, the iris effect reinforced Pound ideologically, in that the light and dark contrast fitted his view of societies as being either good or evil, either life sustaining or death oriented. As he roamed into the past, whether classical Greece or Renaissance Italy, he sought out, like Diogenes, what he felt would be leadership, forms of behavior, ideas of renewal he could apply to his own age. Pound was completely of the twentieth century, but seeking modes, morals, and manners offering unity now destroyed. With its brilliant light surrounded by blackness, the iris scene fitted the Poundian sensibility of contrasts, radical shifts, clear alternatives, even of melodrama. It also fitted well into his obsession with search, putting "light" on other eras, diving into our archetypal memories.

Although montage and iris scene dominate, the *Cantos* from the start used a multiplicity of effects that we find also in film techniques. Certain strategies could be fitted well into Pound's desire for compactness, since most of the techniques allowed large masses of material to be tightly organized. For example, the rapid cutting or crosscutting so characteristic of early Griffith films—*Nation*, *Intolerance*, even those during his Biograph one-reeler productions—gave Pound his method for controlling large units of history without being profuse. By crosscutting, Pound could, in fact, further his aims in imagism, for the method meant he could connect disparate elements into a single image or epiphany. He could also create a blending of elements or figures; his historical eras could produce figures, however different, who eventually merge with each other: Homer, Confucius, Renaissance princes, Douglas of the Credit System, and so on, until Mussolini becomes heir.

Besides crosscutting, we have the long-shot, which Griffith did not invent,

* A good example of the iris scene can be found in Fritz Lang's *Dr. Mabuse der Spieler* (1922), in the uses made of glaring lights flashing through dark streets, or speeding cars or a train emerging through the night in an outlined flash of light. Lang's use of such contrast is very suggestive, since he was putting into cinematic chiaroscuro the painterly qualities of expressionist graphics. Contrast also turned up in Lang's direction of actors, for he combined outrageousness with seeming realism, on the edge of melodrama, again clearly expressionistic. Cf. Kokoschka's *Murderer, Hope of Womankind* or the Wedekind "Lulu" plays.

but which he exploited. The long-shot enabled Pound to refocus his lens; so that distant elements—whether part of history or memory—become contemporaneous with the present; become indeed the present. This is one of the strategies of Modernism, explored by Eliot and by numerous others: that blending of pastness with present, until the two are intermixed. In his most characteristic paintings, Chirico brought pastness, whether Greece or Rome, into alignment with the present, until the present is the past updated. Like Pound's interrelationship with Tiresias, the point of this is to create a unified culture, or a unified history; ultimately a unified man, as Pound thought himself to be. The idea is solipsistic, but quite in line with the Pound of his earlier years as promoter of Modern and Modernists.

The long-shot also served another function. In Griffith, it enabled him to create spatiality. In one scene in *Nation*, for example, we see Sherman's soldiers marching toward the sea, while refugees perch on a hillside. The long view of Sherman's troops makes them seem small, but at the same time it gives them dimensions in terms of space and history; they look unending, an inexorable force. Pound's *Cantos* are full of such strategies, none more telling than in the Pisan group when he, Pound, as prisoner, looks out at guards and other prisoners. He then remakes himself into a prisoner of history, recalling Lovelace's "poet in prison," thus giving himself dense historical perspective.

Before we speculate on what, if anything, Pound may have learned from "abstract film," we should indicate still further parallels between the *Cantos* and narrative film. In an essay written well after Pound had begun the *Cantos*, Eisenstein defined what he meant by "The Dynamic Square." We see in the definition his indebtedness to futurism: "Cinema," he writes, "is the first and only art based entirely on dynamic and speed phenomena, and yet . . . having . . . the characteristics of the static arts—i.e., the possibility of intrinsic existence by itself freed from the creative efforts giving it birth (the theatre, the dance, music—the only dynamic arts before the cinema lacked this possibility). . . ." In the sense Eisenstein had in mind, Pound attempted to turn his poetic sequence into a form of dramatic action; and the forms he chose are closer to film—its "dynamic and speed phenomena"—than to pure theater. While the use of words slows speed, Pound's historical and personal method allows for great rapidity, for that "dynamic square," as it were.

Canto 1 moves with great rapidity. The first lines use five active, doing verbs—successively, *went, set, set, bore, bore*—before the first inactive verb, *sat*. After that, movement is equally swift, as "The Seafarer" merges with the journey to the sunless "Kimmerian lands," which begins the Odyssean theme. The lines race along as Pound has adapted narrative to the instantaneity of film images. The *Cantos* seem difficult on initial reading because of the rapidity of movement of Pound's mind, the switches and crosscuts, flashbacks, fade-ins and fade-outs. All of these strategies communicate great bursts of energy, a dynamics; and we recall the camera work of early films, not only of Griffith but Chaplin.*

Film techniques surface everywhere. There is, first, the distortion of time. That is, amidst the swiftness characterized above, Pound also works in terms of

* While there is a *general* feeling that Chaplin may have had an enormous influence on the other arts, such influences are difficult to particularize. It is preferable, perhaps, to view Chaplin, not as impetus, but as part of overall Modernism—that aspect of Modernism which is a negative response to Modern.

slowing down, and, within that, distorting time. He collapses historical eras, he blends historical figures with each other, moves in and out of mental sets, and gives voice to people unexpectedly. All of these are linked to temporal distortion. In *Battleship Potemkin*, we have a visual equivalent of that, when Eisenstein shoots the Odessa steps scene in slow motion, so that the massascre—which was over rapidly—appears to take forever. By distorting the actual process of slashing and stabbing, the camera creates another dimension of time. Originally, the film was called 1905 and was to be a panoramic view of the revolution— Eisenstein changed the focus, but compensated through camera work.

Connected to the above, but also an innovation, is the "pan shot." Here the camera rotates horizontally on a fixed axis while attempting to imitate the natural movement of our eyes as they move along a scene or an event. The pan shot is useful not only for movement but for creating historical sweep—a panorama both of dynamics and of historical linkage. Griffith was the great early master of the pan shot, and then, later, Eisenstein and Lang. Pound uses it repeatedly for several functions, the chief of which is to link eras. In Canto 16, for example, he moves into the war years in Europe, associating the First World War with other wars, the Trojan, Aeneas's, the Franco-Prussian, and so on; until all wars through panning become interconnected. Of additional interest in Canto 16 is a kind of "verbal panning," Pound's use of the Joycean stream in the French voice from the trenches. It is just a voice, not embodied, and the slangy street French runs on, streamlike, a Joycean monologue. Yet it is associated with panning because the stream of words by this unidentified speaker (possibly two speakers, if we acknowledge an interruption) is a kind of historical sweep of all wars, which Pound can then oppose.

There is deliberate confusion in Pound's panning, overlapping another strategy identified with film, called the "dissolve." In the latter technique, the camera merges one shot with another, doing this through the gradual replacement of that shot by a succeeding one. The dissolve can be used to move from shot to shot or from scene to scene. In both instances, the camera creates a kind of superimposition of image—not only a film device, but, as we have noted, a technique borrowed from cubism and, later, surrealism.* Pound's use of the dissolve is difficult to disentangle from his use of panning—since by panning he moves in broad sweeps, while dissolving from one war to another, from war to revolution, and back toward the periplum or journey-around motif. The journey or quest, then, we can say, is itself a form of panning.

To speak of panning and dissolving in films and in Pound is to raise a related question: to what extent was Pound, like several early film directors, moving toward abstraction even while reasserting realism? The films I have in mind may be called "abstract films," although surrealistic would perhaps be closer to the mark. The so-called abstract film eschews formal narrative, characterization, even formal setting, and portrays objects as disconnected, discrete, lacking coherence with any mental or rational set. The "content," such as it is, of most abstract films is based on dream, mood, atmosphere, symbolic forms,

* Not surprisingly, several of the avant-gardeists in painting were also profoundly interested in photography. Lissitzky and Moholy-Nagy went even further and helped develop new techniques and technologies in photography, while continuing to paint and/or sculpt. Many other Russian avant-gardeists found artistic significance in photography as it developed, and their work in this area coincided with the great period in Russian silent films, Eisenstein, Pudovkin, others.

dislocated objects, irrational impulses. The Freudian pull is strong, but so is that of the whole movement away from representative objects. In early film-making, the abstraction was opposed to the stress on documentary making, nonobjective to objective, such as we find in Flaherty's *Nanook of the North* (1922), one of the earliest fully successful documentaries.

In this respect, Pound attempted to wed verse to music, using sound and rhythm as much as "meaning"; or, more technically, combining *melopoeia* (musical qualities of verse) with *phanopoeia* (visual images, form motifs). Several early efforts to blend film image with music came first with the Germans, Walter Ruttman's *Opus I* and Hans Richter's *Rhythm 21*, to which we could add Viking Eggeling's *Diagonal Symphony*. By 1923, however, René Clair, in *Paris Qui Dort*, was transforming Parisian streets into a Chirico experience—not precisely abstract, but moving toward its dream qualities. In 1924, Clair's *Entr'acte*, with script by Picabia and music by Satie, dispenses with narrative and improvises an "experience." It is abstract to the extent it stresses a visual "performance," rather than trying to tell a story, or relate a plot element. In time, nearly all of these filmmakers moved on, with Ruttman's *Berlin, The Symphony of a Great City* (1927) paralleling in some ways the fragmentation of scenes we find in Döblin's *Alexanderplatz*.

Except for the work of Dali and Buñuel, which we have already cited, probably the most famous "abstract film" is Cocteau's *The Blood of a Poet*, finished in 1930, shown in late 1931. It has usually been considered a surrealist film—although the surrealists excoriated it, and it really doesn't fit. It is more a "performance" or "happening," a hodgepodge of Cocteau's rapid way of work-ing. Its basic theme is how a poet relates to different realities, how the poem derives from these realities, none of them clear. By way of disconnected elements, it is an effort to probe the unconscious process in creation, and it denies objects in the way abstractionists did. Cocteau offered some explanations, which he then denied, and asserted that while he was working he "thought of nothing, and this is why you must expose yourself to the film just as you do to Auric's noble music that acompanies it, and to any music." Pound would have been wise to rest on such ground, but unlike Cocteau he insisted not on music and disconnectedness but on his ideas. They proved fatal.

To return: Canto 16, as a consequence of Pound's concentrated cinematic strategies, is an amalgam of materials, a way station in the process of the *Cantos*. It serves as a warning: learn from previous wars, from the most recent war which killed five hundred thousand soldiers (Pound's figure), from recent revolutions, especially from the most recent revolution in Russia, or else expect chaos. By the time of this Canto, Pound had reworked Eliot's *Waste Land*, and both, clearly, were responding to the Great War. Once again, Pound was fitting himself well into Eisenstein's sense of montage in his use of wars and evolutions, for like the Latvian-born director he worked for a "creation" out of the materials nourishing it. Eisenstein had said: ". . . the juxtaposition of two separate shots splicing them together resembles not so much a simple sum of one shot plus another shot—as it does a creation."

Further, Pound had found—whether by himself or through cinematic in-fluences—the way to use what Eisenstein would call a "key scene." The key scene works very closely to what Conrad and Ford had described as the *progression d'effet* in fiction and which Pound, of course, knew about. Working closely with

Ford, moving around the edges of Conrad, always part of the fictional "new" in London, Pound assimilated methods. By "key scene," Eisenstein had in mind a developing sequence that finally culminates in something such as the Odessa steps in *Potemkin*. The key scene is more adapted to film than would be the *progression d'effet*, which defines a slow divulgence of material until the points are clarified, key scene or not. Film, being more dramatic, needed the large scene to hold elements together; but the theory behind it was that slow revelation. As Eisenstein puts part of his theory:

> . . . one of the decisive inner technical and stylistic conditions invariably "bursts through" to the action itself, or to the dialogue or in the dramatic situation. Such a scene or phrase must be one of the most memorable, one of the most "characteristic" for the film.

For such a scene to be successful, the key element must open up the theme or become its base. The integrity of the technical means must be clear. The director has to be in such tight control of his materials, technically and otherwise, that the key scene flows naturally from what preceded it. Eisenstein stresses that such a scene "should also function as a key to the correct understanding of composition as an embodiment of this particular theme." It would serve as "the sharpening point for the compositional elements, advancing towards a disclosure of their 'secret' and leading to a revelation of the method itself." Pound plays with similar concepts, making them sound musical as well as cinematic. Writing to Felix Schelling, he speaks of the magic moment or moment of metamorphosis—the key scene—bursting through the quotidian into the "divine or permanent world." Then he says: "Take a fugue, theme, response, contrasujet. Not that I mean to make an exact analogy of structure. . . . There is at start, descent to the shades, metamorphoses, parallel." Much of this is theatrical, cinematic.

Without pressing the point unduly, we can nevertheless see Pound using Canto 16 as a "key scene" in the sequence; then within the Canto itself keying into a further intensification in the lines on the war. This begins the major theme: "And because that son of a bitch, / Franz Josef of Austria. . . ." While not quite in the same poetic league as Rilke or Yeats, these central lines convey the Poundian tone, its indebtedness to Whitman, its effort to gain middle ground between artificiality and prosiness. By the time of the Pisan group, even well before, Pound had smoothed out this Whitmanesque kind of line, brought it more into keeping with sophisticated twentieth-century poetry. Through it all, however, there remains the old country boy, the Huck Finn of poetry, the defier—like Whitman—of those who "make" poetry. He made sure the edges remained rough, that the "old Ez" cracker-barrel dimension remained constant. The "key scene" culminates in the burst of slangy, slurred French emanating from the trenches—the voice of men whose lives Pound was defending, at least in this Canto. After that the Canto falls away, as Pound goes into his dialect act to suggest the Russian Revolution, giving the English a Yiddish and, there- fore, anti-Semitic touch; as if Jews were the gray eminences behind the Bolshevik uprising and success. Implicit in this is the very dubious proposition that the "old gang," or leaders of the country, not the radicals and revolutionaries, had

set off the revolution. The political freight of the Canto is, like much of the "content," obsessive; what is impressive is the technical mastery of materials, not the least of which is the use of cinematic strategies. *

We return to beginnings, to the cultural dilemmas Pound raised. Technique, cinematic and otherwise, was an insufficient indicator once the Bollingen was awarded. Before the *Pisan Cantos* were the broadcasts, not part of the poetic sequence but never distant. Here content, not strategy, is all.

Pound's Italian broadcasts were not anomalous, but continuous with the Cantos' ideas and language: the "kikery" which is Stalin's master; "Judaic propaganda, Lenin and Trotsky stuff, crowding American history out of the schools"; "Jew radios of Schenectady, New York and Boston"; choices one must make between the "arsenal of democracy or of judeocracy"; the fact that neither Frankfurter nor "any other damn Jew cares a hoot for law, or for the American Constitution." These, among others, are statements from 1942 and 1943, made only a brief few years before the Pisan Cantos were written. If the man who made the statements was mad, what about the man who wrote the Pisan group? Even though the Pisan sequence does not sustain the outright obsessions of the broadcasts, it does show continuity in the equation of Jews with usury, of Zion with injustice, of the "yidd" as a stimulant leading the "goyim" as cattle to slaughter. The import of such lines is limpid: that the war—with poor Ben and la Clara martyred—resulted from Jewish influences; with the Christian world sacrificed to Jewish financial interests. This is little different from what several of the broadcasts indicated, and all of it quite consistent with the forged, and discredited, Protocols of Zion.

A simple comparison and conclusion: Antonio Gramsci's career is illuminating for its anti-Mussolini efforts and for how it reflects Pound's. Gramsci recognized that in Il Duce's so-called reforms were explicit the controls common to every totalitarian system; that is, economic reform at the expense of essential human freedoms. This was well before Mussolini threw in his lot with Hitler and started to round up *his* Jews. One can well argue, if we compare Gramsci and Pound, that the latter embraced Mussolini's economic reforms—his elimination of what Pound labeled usury—as a way of gaining control over individual behavior. If we argue this way, we can see Pound as identifying with sheer power, the central state, wishing to harness or contain individual rights, an antidemocratic streak that makes nonsense of his support of Jefferson and John Adams. The very freedoms Pound sought to negate, Gramsci tried to hold on to. The usury argument, then, becomes a façade for the real effort: to roll back individual freedoms essential to democracy as well as to Modernism, and to use the state as a positive agent of repression. In this view, Pound's entire career moves toward

* Another strong influence on Poundian verse which we should not neglect as we pursue film parallels is that of the T. E. H. mentioned in Canto 16 as one of the war's victims. Hulme was killed at the front in 1917, his *Speculations* published in 1924, his influence pervasive before that. Hulme had argued a kind of cubism of the poetic word and line, away from rhetorical statement toward the concrete and precise, even the geometrical. Hulme stressed neatness, order, organization, clear lines of demarcation, hierarchical arrangements. At the same time as Hulme, Ford—also at the front, but ignored by Pound in Canto 16—emphasized a "charged language," which also has painterly connotations, picking up from *pointillisme*. Words were like forces in a Leyden jar, charged with electricity, ready to bounce off the page, but nevertheless arranged as a contemporary language. It is, or course, difficult to disentangle cinematic analogues from such verbal ones.

what seems paradoxical or contradictory in his thinking* and what appears central, not peripheral.

Without going further in Pound's periplum or sailing-around, it is difficult to get past "content" to what the Bollingen Committee cited as his achievement. It stressed that its decision, as we have noted, was based solely on an "objective perception of value on which civilized society must rest." I mentioned above that the mere use of the words "objective perception" was suspicious, given the nature of Modernism as itself subverting virtually every dimension of objectivity. Except for one or two movements that emphasized objects—such as the "new objectivity" which arose in Weimar Germany, or the constructivists who opposed the abstractions of the suprematists—objects existed only to be erased or effaced. Even the Bollingen statement as to its own aims was controversial and misleading, indicating a break in Modernism and its tenets.

It is questionable if Pound's *Cantos* would have created the tremendous division in Modernism if the Pisan group had not been awarded the Bollingen. What precipitated the soul-searching pro and con was not the publication of odious ideas, but the Prize. Even those who found the *Pisan Cantos* reprehensible did not argue for censorship. What the Prize did was convey an accolade upon poetry that advocated ideas we had just fought a war to destroy. Timing was significant here: the war had only recently ended, the news that six million Jews and untold others were exterminated in the camps had been revealed, the Nuremberg trial of war criminals was ensuing, and the Cold War against the Soviet Union had started up. None of this was very advantageous for an epic of Modernism, indeed for the avant-garde in its most unpleasant aspects. Furthermore, Modernism and avant-gardeism were themselves shaky in America, with only Dos Passos, Faulkner, and Stevens importing European ideas.

In 1950, the year after the award, Archibald MacLeish attempted a dialogue between a "theoretical *Saturday Review of Literature*" (which had very forcefully opposed the Prize and along the way attacked most aspects of Modernism) and an equally "theoretical Mr. Bollingen" (hoping to justify the award). MacLeish tries to be fair, putting sound arguments in the mouth of *SRL*, even though he favors Mr. Bollingen. Near the end of the dialogue, he offers the crux of the argument. It deserves quotation at some length because while MacLeish thought he was making a significant point, he was actually reopening all the tendentious questions of Modernism. He says:

> I agree that fascism is precisely such a disloyalty ["to the fundamental decencies of human life!"]. And I agree that nothing like Pound's addiction to fascism—nothing so infantile or so distorted—has accompanied the perception of the great disorder of our time in other poets. Baudelaire and Rimbaud and Yeats had their occultism. Rilke had his self-pity and his fears. But none of them committed the fascist's crime of treason against humanity itself. Nevertheless the question is not one of the child-

* Such thinking, however, was quite consistent with Weimar Germany's fear of Modernism, individualism, loss of order; part of that desire for roots and community, a rollback of everything new. From here to racial theories is only one small step. While Thomas Mann avoided the racial theories, he walked the edge, and in *Betrachtungen eines Unpolitschen (Meditations of an Unpolitical Man)* he reflected the crises of Weimar democracy. It was democracy teetering above an abyss, seemingly a rational government which also generated hatred of reason, materialism, an optimistic civilization. It was ripe for both anarchistic avant-gardes and for ominous calls for order.

ishness and perversity of Pound's political beliefs as they are expressed in this poem. The question is whether their expression here deprives the poem's insights of their meaning. *If it is true that poetry is an instrument of intuitive knowledge, does it not follow that the presence of opinions in a poem destroys the poem only when the opinions predetermine the intuitions—when they, and not the poet's sensibility, supply the insights?* [italics mine] With Pound, as this poem itself demonstrates and as the earlier Cantos make abundantly clear, the loyalty is not to dogmas of fascism but to the poet's vision of a tragic disorder which lies far deeper in our lives and in our time.

MacLeish hopes to liberate Pound from fascism and to relocate him in the nebulous world of intuitive knowledge, which lies behind all poetry. In that respect, Pound would become, not odious and misguided, but a prophet, a Nietzschean figure who warns us about history. But how does MacLeish know that opinions do not "predetermine the intuitions"? How can he separate Pound's sensibility from opinions, so that sensibility supplies the insight? The whole nature of Modernism, of every aspect of the avant-garde, was to make such a separation impossible. Further, the Fascist idea, which Pound wedded to Douglas's Social Credit system and to usury as practiced historically by Jews, was a crucial way in which the poet could oppose Modernism. The very disorder that MacLeish sees Pound as prophesying is a disorder Pound hoped to counter or negate through fascism, the sole destroyer of usury. While Pound continues to cite Confucius, Adams, Jefferson, even Malatesta, the persistent theme is fascism as salvation, right into the Pisan group. MacLeish writes as if that sequence were free of the earlier cant, when it is, clearly, continuous with the previous Cantos.

MacLeish in 1950 had reopened the can of worms. William Barrett in a *Partisan Review* statement (April 1949) put the question directly: "How far is it possible, in a lyric poem, for technical embellishment to transform a vicious and ugly matter into beautiful poetry?" I would change "embellishment," a loaded, negative word, to "strategies" or "adroitness" to give the statement a more just tone. Yet whatever the word, Barrett throws us back into the earliest days of Modernism when its severest critics, Nordau, Weininger, Kraus, and others, made that same separation of "embellishment" from content and quality of ideas.

We have, then, really a three-sided engagement, with several marginal forays. The first two sides, as suggested above, involved those who gave the award and, apparently, hoped to reinforce the avant-garde and Modernism, regardless of "content"; to them we add those like Barrett (plus Clement Greenberg, Irving Howe, several others) who, while not opposed to Modernism, extract content from "embellishment" or poetic strategies and techniques. The Barrett group would not deny Pound his achievement, but would not award prizes; and, clearly, it is uneasy with fascism and anti-Semitism. It is questionable—prizes and awards aside—whether it would treat Pound as a major poetic figure, while not denying his influence on several major poets and novelists.

The third side is the group, harking back to turn-of-the-century opponents of Modernism, who used the Pound case as a way of flaying the entire avant-garde movement, or at least major aspects of it. This was the position of editorials in *The Saturday Review of Literature* and its chief spokesman, Robert Hillyer.

Hillyer's initial attack was titled "Treason's Strange Fruit" (after Lillian Smith's best-selling novel of 1944). Hillyer's assault was on several fronts: first, he ridiculed the Bollingen; then he attacked those who supported such nonsense, including poets, psychoanalysts, critics, publishers; third, he maligned obscurity in poetry—i.e., in Modernism as a whole; finally, he had a go at the New Critics, although many of them, like Cleanth Brooks, were in many respects traditionalists. Hillyer, of course, was a journeyman poet: he represented "poetry" for *SRL* readers, but in the real world of poetry, where it was a serious affair, he was a nonentity. It is hard to avoid the conclusion that his attack was at least partially motivated by self-interest. But, then, most assaults on Modernism and the avant-garde in particular had specious motivation. Earlier, it had been the desire to protect a particular kind of society and culture against the onslaughts of anarchists; now, it was more personalized, although the earlier defense had not died out.

Hillyer's *SRL* article and the several editorials in the magazine created sympathy for Pound that may not have been there before. Thus, many writers who might have straddled the fence found themselves defending the award or Pound—that is, they would have defended Pound's right to any content he wanted, but withdrawn from the awarding of the Prize. Such defenders would include Lionel Trilling, Alfred Kazin, and others who had their own doubts about Modernism and avant-gardeism, but did not want to see the movement maligned by the likes of Hillyer or the *SRL*. If maligned, they wanted to do it in their own way. John Berryman, who was a fine critic as well as poet, organized the opposition, which garnered eighty-four names in support. Berryman argued, correctly, that "Under the pretense of attacking the award of the Bollingen Prize to Ezra Pound, you [*SRL*] sanctioned and guided a prepared attack on modern poetry and criticism. . . ."

Berryman concluded that it was a "smear," since the *SRL* attack was made on numerous people who had no connection to either Pound or the award. He lamented that the magazine had suggested a "Fascist conspiracy," but that no evidence was produced; yet the conspiracy was viewed as widespread, staining every aspect of progressive American culture. Berryman's letter to *SRL* was signed, originally, by seventy-three names, then in all by eighty-four. *SRL* refused to print it, asking Berryman to submit the names of those who refused to sign the letter. He felt *SRL* was seeking diversionary tactics, and with this, one aspect of the issue died.

But, evidently, the Pound case in the late forties would not go away. Every old wound was reopened. Allen Tate proposed a duel with William Barrett, to be fought not with words, but, one assumes, with Civil War blunderbusses. Karl Shapiro asserted that he voted against the award on two grounds: as a Jew, he could not countenance the virulence that Pound voices; but, more significant, "in the belief that the poet's political and moral philosophy ultimately vitiates his poetry and lowers its standard as literary work." Shapiro wonders: With Pound's "vicious and ugly ideas, what poetic insights into our world has this poet given us?" Shapiro was clearly troubled by his statement because he recognized that questions of beauty and technical excellence are difficult to determine either alongside or in contrast to "ugly content." Tate, who seemed oblivious to the political and moral issues, felt that the award was a responsible answer to the "monism of the stateman," who sacrifices language and form to

content and never looks back. Pound is the corrective to that, and the award honors him for raising language to another level of discourse.

Just this brief runthrough of opinions—and nearly everyone weighed in from some band of the political/moral spectrum—suggests that Modernism was a fighting issue still, and in Tate's case, reason for physical violence. One is back at the 1913 Paris performance of *The Rite of Spring* or the early Modernist shows where cubist or abstract paintings were exhibited. What is peculiar here is that whatever one's personal opinion, pro, con, or otherwise, the issues will not go away; nearly everyone makes some sense, even those in the *SRL* camp who would like to roll back the whole movement in order to justify their own kind of poetry and prose. This is not quite like the Dreyfus case, which did have a right and a wrong, although some of the issues of that terrible time did not surface until more than forty years later. The Dreyfus case, as we have noted, began to revolve around ideological questions, about what kind of society and state people wanted, in the process of which Dreyfus was virtually forgotten. While Pound was not exactly forgotten, the swirl of controversy became much larger than the poet and reflected the entire question of culture in the postwar world, in America and elsewhere. Americans had bifurcated: those who supported an avant-garde and its assimilation as Modernism; those who still led the charge for a different kind of culture, older, although Modernistic artifacts surrounded them, at every level.

The struggle over Pound became a controversy over representation—the old, still not exhausted question of objects and our relationship to them. The nub of the issue was our way of perceiving, and then what we saw; and that became intermixed with ideological support for or opposition to the poet. By 1948–49, action painting or the New York School had invested abstraction and nonrepresentation with a legitimacy that was undeniable. In poetry itself, beyond Pound, Eliot was the overwhelming influence, a magisterial presence in the academy. Yeats may have been the greater poet in English, but Eliot—even without the later plays—was the presence. In musical composition, there was an unclear picture. Arnold Schoenberg, as we have seen, could not gain a Guggenheim grant to complete *Die Jakobsleiter* and *Moses und Aron*, and this refusal seemed to reflect the musical establishment's opposition to innovation. Nevertheless, he was still alive, a "spoiler" of sorts. In criticism—which became a large industry with the expansion of universities and their humanities divisions—the New Critics, with their nod to Eliot and his followers, held the ground against the Leavisites. In this area, we have an ideological struggle, roughly between formalists and those favoring content, preferably moral content. The point here is not the superiority of one camp over another, but the fact that in nearly all areas of cultural endeavor—but in the arts in particular—the late forties restaged familiar crises of Modernism: questions of representation and how we deal with it.

Further, the ambiguous political climate of the late forties was an uncertain ingredient. Postwar euphoria had been dissipated, and American public opinion was moving against the Soviet Union, especially since America felt secure as sole possessor of atomic secrets. The bomb created both physical security and moral uneasiness. There was the sense, correctly or not, of limitless American strength, but also an awareness that another large enemy was looming. Precisely how this affected the Pound case is not quite clear, but certain avenues of

interpretation do emerge. Areas of polarization were intensified because of frustration: that the terrible war and the terrible price Jews and others had paid were falling victim to yet another conflict impending against the Soviet Union.

Even as the Nuremberg trials revealed Nazi horrors, hundreds and thousands of war criminals (like Mengele, Rauff, and Barbie) were slipping away or being excused with a slap on the wrist; and this created for some the sense that even while another potential conflict was emerging, accounts for the present were going unsettled. The great economic surge at the end of the war was unaccompanied by certainties about the future, or even about the present. The Pound case opened up whatever seemed unpredictable and indeterminate. As we read the opinions of poets and critics, we sense that questions have arisen that they do not want to discuss; aspects of the Pound situation are either too painful to reopen or else too complicated and textured to settle with a statement or an opinion.

But the Pound dilemma suggests other dimensions flowing from the late 1940s. These aspects are linked to the sense that what appeared rational in the immediate past—the defeat of fascism, the fall of Germany and Japan, the eradication of political evil—was no longer meaningful history; that irrational elements had begun to take over after years of clear purpose and purposeful victory. With irrational elements slouching toward Bethlehem once again, the Pound problem relocated the entire question of the role of reason, its functions and responsibilities first in society and then in the arts. The tentativeness of many of the critics, pro and con, is associated with their uncertainty about how far they should go in supporting, or denying, the irrational impulse. Nothing could be more irrational than Pound: starting with his poetry and its difficulties, its leaps, its liquidity, its bizarre uses of history, the hates and rages of the narrator-poet, the extremities of his theories and ideologies. From there, the irrationalities pile up: his indictment for treason, followed by indefinite hospitalization at St. Elizabeth's for incurable insanity, and that followed by a prestigious award to a man who, while certifiably insane, had written the poetry for which the award was given. If one thinks about it, the situation seems hopeless. Not only must Modernism founder on this diversity of irrationalities, life itself seems to come to a halt while we sort out priorities and beliefs.

All solidity began to crumble. Theories of art no longer seemed so important—only life mattered, a variation on Brecht's dictum: "First bread, then art." How can a "high culture" or a serious culture be preserved in the face of such a situation? How can any of it be explained to the layman? or even to oneself? The avant-garde and Modernism had been fragile enough, and now the very irrationality upon which so much progressive art had depended for the last fifty to seventy-five years seemed to prove its critics were correct: that a nonobjective or difficult, liquid, freely associated, unconscious art was so self-reflexive it belonged with crazies. Those who supported Pound were eager to preserve Modernism; while many of those who did not were eager to stand up for "life." Some, like Frost, trod the middle ground for their own reasons—friendship, the rightness of things, a desire to align themselves with avant-gardeism.

What one carries now into the Pound affair is the desire to see how some of the central cultural issues of our century will be resolved; how the Pound case, in effect, will allow us to open up the knotty question of Modernism, the

avant-garde, and its moral responsibilities. We go into it as optimists. We leave it baffled, and, in the main, frustrated and estranged. Those who wrote about the Pound question in *Partisan Review* and elsewhere also seemed to have become more baffled as they entered the thickets of possibility. Aspects of cultural life that hitherto fell into place—even object-lessness and abstraction, even reactionary politics, even racism—simply did not cohere as one plunged ever more deeply into Pound's work and the reasoning behind it, not to speak of his reputation, his importance, and his responsibility as a poet. Language had itself become corrupted.

An entire question that we have barely raised, because it seemed beside the point, was that of the artist's responsibility. We had assumed, as had all sponsors of the avant-garde, that the sole responsibility of the artist was toward himself and his craft. We felt this even when faced with the fascism of many of the futurists, their support of Mussolini, their benign acceptance of Hitler; even when confronted with the anti-Semitism and reactionary rage of Wyndham Lewis and his support of Hitler, or the general anti-Semitism of so many significant writers of the period—Eliot, D. H. Lawrence, Hemingway; even when Emil Nolde, perhaps the strongest of the expressionist painters, became an enthusiastic supporter of the Nazi Party; even when several members of the Russian avant-garde went along with Stalin and modified their art as socialist realism and the Stalin terror dictated. Even with this, we felt that in some way the poet and painter remained responsible, that craft preempted all other considerations: that the artist, not the man, was the thing.

But the Pound case changed all that. We were forced to ask questions about responsibility that had lain dormant for the last seventy-five or more years—really since Baudelaire insisted on vision, authenticity, and fidelity to the image. We had applauded the bizarre view, the antisocial stance, the revilement of the bourgeoisie, the need to remake, redo, redefine. They all seemed part of a necessary stage toward liberation. And then Pound demonstrated where liberation can lead. In his Cantos, utterances, broadcasts, mind-set, he became one of the most liberated of artists; so liberated, in fact, that he appeared terribly dangerous and uncontrollable.

Once liberation had achieved that stage, we did not know what to do with it, or him. He had moved beyond the boundaries of the acceptable and the conceivable; and he would not go away. For the Cantos had become, by the time of the Pisan group, an epic or saga for our times. More mythical than real history, the *Cantos* seemed to be a running commentary not only on the historical era but on Modernism itself: challenging it while utilizing all its strategies, not the least of which was finding the verbal equivalent of the cinematic visual image. Pound became for many the quintessential Modernist—not the greatest of writers, but the greatest of the protestors, the heart of the avant-garde.

Pound's date of birth and longevity had brought him through the entire Modern movement—the wars, recoveries, rise and fall of empires in ways few other careers could emulate. Furthermore, he placed himself at the center—he became what Apollinaire might have been had he lived longer; or what Ford hoped to be. Ford was a potential rival, but he faded into near oblivion, whereas Pound refused to go away—although residence in Rapallo indicated some desire to get beyond the fray. Pound became, willy-nilly, the impresario of Modernism; and, since the comic spirit dogs the steps of every egomaniac, he had to pay the

price. The rise of totalitarian states and especially Mussolini became his fate—or helped him choose his fate. He who wrote so sympathetically of Dante ended up in the circles of hell.

The Pound case did of course go away. Through Frost's persistence,* Pound was eventually released from St. Elizabeth's after more than twelve years—still untried, still unconvicted of any crimes. His confinement as someone so mentally incompetent he was incurable had not prevented him from writing new Cantos—there would be thirty more after the Pisan sequence, including at St. Elizabeth's *The Rock-Drill* (1955) and *Thrones* (1959). The dilemma remained: an incurably insane poet, who could not be tried for treason because of his mental deterioration, was still hailed for the poetry he wrote while in that condition. Pound was freed to return to Italy, but the question of responsibility now was added to another one, the question of how we should respond to poetry deriving from an insane man in a hospital for the mentally incompetent. Was it insane poetry? What could we trust of its "content," even of its strategies? Was it any more or less "insane" than the poetry Pound had written while in Pisan confinement, when he was, according to the three psychiatrists who would later examine him, already insane? We cannot forget that the Pisan work also derives from a man already deemed sufficiently insane that he need not stand trial for treason.

Once again, we see that Pound is almost lost in ever expanding questions: What does this mean for Modernism? Are there precedents in the seventy-five years of early and then flowering Modernism? Do precedents help us resolve the Pound issue? Certainly there are a sufficient number of candidates—Jarry, and before him Lautréamont, Rimbaud, Verlaine, Nerval. But they were not insane in the way Pound was deemed incompetent. As mentioned, Torrey's *The Roots of Treason* suggests the evidence demonstrates that the three examining psychiatrists who made the original diagnosis had done so to keep Pound from standing trial. If this is true, Pound was held for more than twelve years in St. Elizabeth's as a way of keeping him from a possible conviction for treason; and the asylum stay could have been for the rest of his life, not only for twelve years. This explanation is quite plausible, but it does not answer the more compelling question of Pound's own response to this: twelve years in an asylum for the mentally incompetent is not twelve years of peace and quiet, but a tumultuous experience during which he wrote his poetry. And that does not explain the Pisan sequence, written—whether the poet was insane or not—under numbing conditions of deprivation and dispossession.

What is so disquieting for Modernism as we examine these interrelated personal and societal issues is that it appears to have no standards, not only of sanity, but of how to represent itself. In some respect, we feel that if we cannot resolve our feelings about the Pound case, we cannot respond to difficult questions raised by Modernism. For the movement, as a composite of waves of avant-gardeism, has asked us to accept the superiority of abstraction over realism; twelve tones over nineteenth-century tonality; narrativeless fictions reliant on emanations from the unconscious over plotted, charactered epical novels of the previous century. Modernism has subverted nearly all forms of certainty, has

* With statements of support from Dos Passos, Marianne Moore, Hemingway, Sandburg, Auden and Eliot, MacLeish, Tate, Dag Hammarskjöld, and several others.

created an overwhelming divide between creator and reader-viewer-listener, has made all artistic experience difficult, oblique, wrenching. It has, above all, been heuristic, forcing the one experiencing it to change, or else to lose it altogether. Its demands have, arguably, been greater than those of any previous movement or school or group in cultural history; and it is relentless, a juggernaut in its inexorable insistence on itself. With its sense of superiority over whatever surrounds it, its detestation of the bourgeois artifact, its rapid changes to avoid tedium and complacency, its dismissal of past movements, even of past history, it has established certain credentials and demanded certain priorities.

Pound somehow let all this down. He carried the implications of Modernism to extremes undreamed of even by Nerval, Lautréamont, or Jarry. Theirs was a Modernism of fantasy, an imaginative process; whereas Pound put it all on the table—real statements, real actions, and, most significant of all, literary production while deemed insane, incurable, and under indictment for treason. The question, finally, concerns two matters: how far committed to the avant-garde and Modernism can we remain when a Pound case is produced? and, perhaps more delicately, how would we have reacted to Pound's Pisan sequence in 1948 as members of that jury, with that decision to make? To take the latter first: some of our response to the award, whether actually supporting it or only approving it once given, would depend on our past relationship to Pound. If, as writers, we felt indebted to his work, to his freeing up of language and line, to his tones and strategies, or to his efforts on our behalf, we, as many did, may well have surmounted a certain squeamishness and gone along with the prize. For a Jew, however, the feelings generated by the case are more intense, even more intense than those of a non-Jew like William Barrett who saw the issue as Holocaust-related. Personal and historical considerations would play a large role here—so that the case would become a real testing of one's feelings about the culture and about oneself. There could be no escaping and no apparent resolution.

This throws us back to the really significant question of one's commitment to the avant-garde in the face of its outcome as Pound. It would appear he cannot be considered as an aberration, but as an essential part of the process associated with Modernism. He comes with the movement; he may be an exaggeration of some of its tendencies, but he belongs with it, an embodiment of its main ideas. Although nothing quite measures up to Pound or the problems raised by his circumstances, there are other examples: Céline, also deemed mad; Wyndham Lewis, who remained hateful and vile without going beyond words; various French collaborators (Cocteau, Montherlant) who moved on the edges of Modernism.

Yet despite this, one must hold fast to what Modernism and the avant-garde mean. For decades, they were the sole rampart against a slackening of cultural standards and a laziness of expectation. The movement, however uncertain and ambiguous, provided a standard of renewal and redefinition, creating a freshness and kindling an interest in the arts. To withdraw from that in order to condemn Pound is really to play the game of many of those totalitarian governments who agreed with him and one, Italy's, who used him. Perhaps the hardest thing for us to accept is that Pound, who had invested words with magic, who had gone to the sources of language itself, had betrayed all that, had made

words into unstable, fallen, deformed communicators. Yet our response to Pound, it seems, should be like our response to democracy and civil liberties: we bear with the outrageous misuse of institutions in order to preserve them. To condemn utterly what we cannot accept is to negate the very ground we have chosen to stand on.

Note: I am not concerned here with the pejorative use of "Postmodernism" by reviewers in journals such as *Commentary* or its epigone, *The New Criterion*; for they are in the pay of those who recall Nordau, Weininger, and Houston Stewart Chamberlain, among others. They use Postmodernism as a pornographic label to attack the Modern Age as a whole, just as the earlier generation labeled as Modernism whatever they considered to be a decadent culture. Such usage, the last refuge of the scoundrel, debases the word and the ideas behind it.

◆ Chapter Nine ◆
Modern and Postmodern, Modernism and Postmodernism

A STANDARD ARGUMENT in Modernism is that it broke through history; that for its more radical practitioners, history was no more. Only moments and sensations existed, only "now" was privileged, to use a current term. The Pound case created such conflicts in Modernism not only because of his virulent politics—such virulence had occurred before—but because of his peculiar positioning of himself in relationship to history: as equally its collector and its destroyer, as both its preserver and its transcender. Postmodernism, more a term or tag than a movement, is an evolution from Modernism—solidly based on practices we have associated with Modernism for almost one hundred years—that attempts to turn Modernism's rejection of history into an advantage. Parallel with a Postmodern literature (for it is primarily a literary development) is a Postmodern criticism (mainly directed toward literary texts). Together the Postmodern text and the Postmodern critic have reopened the whole question of an artwork's relationship to history, to present life, but most of all to language, which is itself a form of history, according to Saussure. Put succinctly: Postmodernism may be an invention of critics.

Those who feel Postmodernism has broken away from the main movement preceding it identify several distinctive traits: chiefly, a self-reflexive or self-conscious novel or artwork whose substance or matter consists of defining its own structuring, its own creation—novels, for example, about the making of novels. Yet we found that development half a century ago in Gide's *Les Faux-Monnayeurs*, in 1927; and before that, as everyone indicates, in Sterne's *Tristram Shandy*, in the 1760s. The novel has, in several ways, always attempted to undermine itself as a reality by stressing its fictional basis, questioning itself by other texts, by commentators, or even by authorial intrusions.* Has anyone

* Even the "realistic imagination," so brilliantly defined by George Levine, has been responsive to such subversion, providing discontinuity and self-examination and implying in many instances (*Frankenstein, Wuthering Heights,* et al.) a recognition of its own destruction.

considered that Trollope's several authorial intrusions into his narratives are early forms of self-consciousness, not just "Uncle Tony" assuring his readers (what Gerald Prince calls his "narratees"), but forms of literary suggestivity about the viability of fiction making?

Another aspect of the Postmodern sensibility, to follow this argument, has been its stress on the countering elements in the novel which "deconstruct" it even as they provide its impetus. According to this reasoning, derived from Derrida, there is such indeterminacy in any fictional (or other) artwork that neither consistency nor certainty is possible. The text must be read as a slippery, deceptive, unknowable narrative that never achieves stability or resolution. Language always betrays itself just when we think it meaningful. Signs are significant only to other signs in an arbitrary code. Metaphor is groundless.

In what is perhaps the most significant document of the so-called post-structuralist period, Derrida in "Structure, Sign, and Play" (1966) took apart traditional metaphysics and set the stage for deconstruction. Derrida spoke of decentering, of the "structurality of structure," by which he meant that outside discourse there is no fixed point from which one can establish metaphysical boundaries for linguistic signifiers. That is, one chain of signs leads to another; all referentiality is arbitrarily established. By giving a "center" to a work, critics have reduced or neutralized the "structurality of structure"; while the center gave an organizing principle, it limited "what we might call the *freeplay* of the structure." Derrida stressed that a center or fixed point is beyond the reach of freeplay, for it instils certitude in the reader when his atitude should be one of anxiety. The desire on the part of critics for a center is associated with wish fulfillment in Freudian psychology, and such centering must be dismissed as part of the baggage of the old metaphysics. Decentering—Derrida's alternative—opens up, allows freeplay, creates indeterminacy, and emphasizes anxiety; wholeness or "plenitude" is no longer possible or desirable. This is Heisenberg's "uncertainty principle" with a vengeance!

Yet as early as Camus's *The Fall* in 1956 or Robbe-Grillet's *The Voyeur* in 1955—whose influence has been striking—"unknowability" was the chief commodity. In the Camus, there is no center, no fixedness outside the discourse itself, and even that is vague, uncertain, indeterminate. John Cage's stress on silence and on randomness was another aspect of this same state; and certainly developments in abstract expressionism emphasized how the certainty of objects had passed into the uncertainties of relationships, patterns, configurations. When semioticists and deconstructionists speak of signs as meaningful only to other signs within an arbitrary system—a system akin to what Derrida calls "dissemination," that defusing of meaning which is endemic to all writing—they are giving critical mass to what was creative practice seventy-five years ago. When deconstructionists stress that language always betrays itself at the moment we seek certainty or stability from it, they are emphasizing a process that we note in early Stravinsky; Picasso in his cubist phase; Kandinsky in his earliest abstractions; and Eliot, Rilke, Joyce, Pound in their epics of Modernism, respectively *The Waste Land, The Duino Elegies, Finnegans Wake, The Cantos.*

Postmodernists—and their critical counterparts, the Poststructuralists—speak of the failure of language to connect to elements external to it. This is based on the idea that it always outpaces or moves beyond the ontological sense we give to it. Eliot foresaw this in his canonical essays—that "dissociation of sensibility"—

and in his poetry as early as "Prufrock." Such a view of language is implicit in Yeats as he moved from being a *fin de siècle* poet to a leaner, more condensed writer; it is implicit in virtually the entire output of Rilke.

Derrida's stress on *writing* as such preempts meaning, structure, containment, centers and stable principles—all of which are part of our rationalizing of language and other modes of expression. Derrida's example creates indeterminacy even in the most stable forms of expression, such as nonfiction; he insists there can be no division between fiction and nonfiction. But that consideration, although not formalized, had been a staple of Rimbaud's: we need only to read his key letters or to explicate parts of his longer poetic sequences to see how his poetry and nonfiction overlap, become indistinguishable. To mention Mallarmé here is to stress the obvious. Listen to this not unrepresentative passage:

> The words of their own accord become exalted jewels, their many facets recognized as of infinite rarity and value to the mind, that centre where they hesitate and vibrate. The mind sees the words not in their usual order but projected around it, like the walls of a grotto, for so long as their mobility, that discourse, is not exhausted. All are quick, before they fade away, to glitter, reflecting against one another, with distant oblique and contingent flashes.

Meaning as such has given way to freeplay, to the "play of signification"; representation, expression, "content" are swept out. In still another way, Derrida has been speaking of elements early Modernism had already questioned, confronted, and dealt with.*

To shift our ground: Derrida's strategies for dealing with the problem that the whole is, in fact, unattainable, appear to reflect in the critical avant-garde what we sense in contemporary life—he becomes, it would appear, the critical voice of our time. The following passage from *Writing and Difference* is vintage Derrida in this respect:

> Our discourse belongs irreducibly to the system of metaphysical oppositions. One can evince the rupture of that adherence only by a *certain* organization, a certain *strategic* arrangement which, within the field and its own powers, turning against itself throughout the whole system, splitting it in all directions and *delimiting* it through and through.

Yet avant-garde painting in the first fifty years of this century reached similar conclusions. The disruptiveness implied in montage and in papier collé—where coherence depends on certain artist-viewer assumptions—works on dislocation, as much as cubism earlier and abstraction at about the same time. In fiction, the coherence achieved by Joyce in *Ulysses* occurs only because of an equal rage for decentering—the Circe scene in itself exemplifies how strategies for dislocation, not the least of which is that stress on writing, are intrinsic to its order. Similarly, in *The Waste Land*, Eliot's use of myth was a factor in creating order, but, analogously, a means of disruption of narrative sequence, character cohesion, scenic order. Disruption is close to Derrida's notion of freeplay, and it

* The Mallarmé passage foreshadows, also, Paul de Man's point that the readable text leaves nothing, that only the unreadable text gives the "hope of freedom." The need is to find in every text "areas of blindness" that are critical in its interpretation; such areas open the vista to "readerism," the indeterminacy that conveys openness.

foreshadows, virtually, his insistence that metaphysics lacks a beginning, a middle, and an end. Other practices we noted in earlier avant-gardes that accepted "decentering" as a given stressed that centers were functions, not being. Certainly, in Dada and surrealism, the center vanished, giving way to functions of seeing, to approximations and uncertainties, precisely what Derrida has tried to define with his stress on proximity, immediacy, and presence.

Derrida's defiance, or negation, of "ground" is another aspect of earlier avant-gardeism—once again Modern shades everything associated with Postmodern. Ground or certitude was under attack in Rimbaud, Nerval, and Lautréamont; and even in a poet like Yeats, who reached toward certitudes in his later phases, ground receded as politics and state gave way to inner life, myth, sex, connections.* Linked to this is Derrida's insistence on alternating presence and absence, another way of indicating his negation of certitude, or presence; in the alternation, we discover that decentering has replaced fixedness. Yet this displacement of metaphysical logic was implicit even in Moréas's definition of symbolism, in 1886, as "enemy of explanation, of declamation . . . of objective description." If anything, Moréas's claims for symbolism depended on its break with the old, centered metaphysics; his "simple appearances" and "primordial Ideas" were early negations of "ground."

Still another dimension of the Postmodern sensibility—and by no means to be diminished or dismissed—is the stress on reader response. The pioneer here was Wayne Booth and his work on *Tristram Shandy*; since then, his insights have developed into a field of study. The names that usually come up are Wolfgang Iser, Stanley Fish, Walter J. Ong, S.J., Gerald Prince (and his valuable theory of the "narratee"), Georges Poulet (a distinguished early figure), to some extent Norman Holland and Michael Riffaterre. † In many respects, the reader-response people overlap with the semioticians, but, ultimately, their goals differ. Stanley Fish is perhaps the clearest of the "responsists" in stating its aims.

For Fish, reading is an activity that "processes its own user." By this he means that the ultimate sense of a text is derived not on the printed page, but in the reader's mind—although how he measures that response is unclear. Fish avoids precision about what goes on in the reader's mind by opposing the idea

* Cf. Yeats's inability to "know the dancer from the dance." In Martha Graham—who danced the sacrificial virgin in a 1930 performance of *The Rite of Spring*, choreographed by Léonide Massine—we see a reflection of Yeats's great line and her own rejection of "ground." She said she received her inspiration from a Kandinsky nonrepresentational painting. Graham made of her body an avant-garde, with pelvic contraction and release her vision of movement, sex, life itself. Graham's choreography refused all certitude, turned all to problematics. Movement was itself its own justification; what we could see earlier in the Russian futurists (Mayakovsky, Khlebnikov, Severyanin, even Pasternak) who experimented with "Trans-Sense" (*zaum*). As parallel figures to the Dadaists, they wanted the word was autonomous. Meaning was not content but words. *Zaum* joins with Yeats's line and Graham's movement to negate verification of data.

† All would agree with Barthes that the "rules of literary language do not concern the conformity of this language to reality (whatever the claims of the realistic school). . . ." However, they stress different stages of an infinite and continuous process. Ong, for example, argues that the audience is a fiction, a twofold fiction: first, that the writer must "construct in his imagination, clearly or vaguely, an audience cast in some sort of role; and second, and more significantly, that the audience must correspondingly fictionalize itself"—which is to play the role created for it by the author. For Prince, the real reader cannot be identified with the virtual or ideal reader at whom the author aims his book; both differ from the narratee, who serves as an internal control in the narrative. For Iser, the artistic text is what the author creates, as distinguished from the aesthetic text accomplished by the reader. Iser then examines the interaction, which he identifies as threatened by indeterminacy, and with this reader-response encounters deconstruction.

that there *is* a single sense, "that it is embedded or encoded in the text, and that it can be taken in at a single glance." Such a restricting sense he calls positivist, holist, and spatial, and condemns it as limiting reading "to a goal and to a procedure." If we accept *that* method, then we have ignored and devalued the reader's activities. "They are ignored because the text is taken to be self-sufficient—everything is *in* it—and they are devalued because when they are thought of at all, they are thought of as the disposable machinery of extraction. In the procedures I would urge, the reader's activities are at the center of attention, where they are regarded, not as leading to meaning, but as *having* meaning."

Fish is very persuasive, and there is little question the reader-response repositioning has altered our way of looking at a text, painting, or poem, or listening to a piece of music—although such "relocation" of reader, viewer, and listener response has long been a staple of Modernism. From the *symbolistes* on, we have noted that process of reeducating the reader or viewer: that relocation of former text-reader responses into new areas, and that emphasis on new relationships between artist (painter, composer, writer) and his audience. We could trace the beginning of this redirection back to Baudelaire and Rimbaud, and in our own century, among numerous examples, Kafka would be a splendid representative, a novelist whose entire body of work forces a realignment of text and reader through irony, tone, and decentering. Further, we can cite another critic, writing well before reader-response criticism, whose ideas about writer, reader, and text serve as bridge between Modernism and Postmodernism. I am speaking of Maurice Blanchot.

Blanchot is clearly indebted to the *symbolistes* and to high French Modernism. He is an excellent bridge because his remarks find their echo in earlier avant-gardes and yet are sufficiently suggestive to foreshadow Postmodern criticism. Blanchot's canonical essay is "The Essential Solitude," which aligns itself with some of Bachelard and Poulet as phenomenological, but also suggests aspects of reader-responsive, deconstructive, even semiotic criticism. With echoes of Heidegger, Blanchot speaks of the work of art as analogous to "being." It is "being," however, in a special sense, in that it *is.* The work of art, the literary work, "is neither finished nor unfinished: it is. What it says is exclusively that: that it is—and nothing more. Outside of that, it is nothing. Anyone who tries to make it express more finds nothing, finds that it expresses nothing." There is, to repeat the current term, the privilege of the "infinite in the work."

Once the writer enters into writing, he "no longer belongs to the authoritative realm where expressing oneself means expressing the exactness and certainty of things and of values depending on the meaning of their limits. What is written consigns the person who writes to a statement over which he has no authority, a statement that is itself without consistency, that states nothing, that is not the repose, the dignity of silence, *because it is what is still speaking when everything has been said. . . .*" Those final words, of a work's historical resonance that goes beyond message, content, or even the written text, are Blanchot's debt to Mallarmé or even Kafka. Blanchot speaks of the act of writing as interminable, incessant. He mentions Kafka's observation that when he substituted "he" for "I" he entered literature—that is, he moved beyond the subjective into an objective flow, the incessant. Blanchot embroiders on this idea. "The writer belongs to a language no one speaks, a language that is not addressed to anyone. . . . He can believe he is asserting himself in this language, but what he is

asserting is completely without a self. . . . Where he is, only being speaks, which means that speech no longer speaks but simply is—dedicated to the pure passivity of being."

The writer makes of himself an echo, but even while doing this, he imposes silence; echoes call for a reciprocal silence, as it were. And they call for a particular reader response, a reeducation of the reader. Remarkable about Blanchot's exposition of silence, echo, solitude, et al. is the way in which his description can be applied to both writer and reader. If the writer makes himself "the echo of what cannot stop talking" and because of this must efface himself, so the reader loses his own identity in part as he becomes caught by that echo and that need for effacement. Blanchot stresses writing as renunciation: when we admire the tone of a work, we are responding to the way the writer has deprived himself of himself; analogously, when we read, we "deprive ourselves of ourselves," as it were, becoming both more and less. We have not only renounced other activities, often those seeming more exciting, but we have put on hold our own ideas, thoughts, emotional life. Ultimately, we hope to be expanded by our experience of reading, but in the act, we renounce and we silence, we share others' echoes.

These qualities are almost exactly the demands made by successive avant-gardes. Baudelaire as early as his Salon articles of the 1840s suggested that manipulation of viewer and viewed. When in "The Salon of 1846," he wrote of the *chic* and the *poncif*, he was designing a vocabulary aimed not only at relocating taste but redefining art. The numerous voyage images and poems were multileveled in their seductive power: to create new sensations, to move dream and reality onto another plane of existence, to breathe new life into old forms—obviously, all of these. But the voyage was also to create another kind of linkage between artist and reader or viewer. It was an invitation into solitude, silence, echoes—those very words Blanchot uses on the edge of Postmodernism. By an invitation, Baudelaire was moving beyond words on the page (the work) toward text (the limitlessness of the evocation, a place without closure). By suggesting different spatial and temporal conditions, he was signaling that something new was both imminent and immanent. This was not the "old romanticism" speaking to us, but a new consciousness that drew on romanticism and moved well beyond it.

Blanchot caps this idea, which is almost one hundred years old by the time he redefines it, when he speaks of writing as surrendering "oneself to the fascination of the absence of time." That "absence of time" obsessed the early Modernists, from Baudelaire to Mallarmé. The idea, we should stress, is not negative, not nil or niente. "Rather than a purely negative mode, it is a time without negation, without decision, when *here* is also *nowhere*, when each thing withdraws into its image and the 'I' that we are recognizes itself as it sinks into the neutrality of a faceless 'he.' " The "absence of time" is oceanic, the time when being "lies deep within the absence of being." That absence is part of voyage, seduction, relocation of tastes, subversion of the present, redefinition of experience, dissolution of expectations of time and space, limitlessness; a universe without closure, or, in other words, a succession of avant-gardes.

Implicit in the above developments of a Postmodern sensibility is the fact that language always "betrays us"; that language is so uncertain as a reflection of thought, experience, or emotional life it can never be certain. If nothing else,

this links reader-response criticism with deconstruction criticism. Such critical theory points to language as a process, not a product or a result; and as process or function, we can never know it. If we seek "meaning" in a literary work, we assume language can be final, that we know what we are reading; in taking that view, we have fixed language when it is, in fact, unfixable. This connects to the deconstructionist idea that every text creates its own problematics; that because a text is uncertain in itself, it is the reader (or viewer) who reshapes it into certainty, into fixedness. While these linked ideas are presented as part of the Postmodern sensibility, they are also ways of demonstrating how Modern has become Postmodern. For how can we avoid citing that plethora of early Modernist texts which assumed uncertainty of language, its sense of betrayal, its conscious problematics, its difference from the spoken language!

An example: In order to demonstrate the gulf between Modern and Postmodern sensibilities, critics can point to Musil or Kafka as containing sufficient representation so as to immerse the texts in history; whereas writers like Barthelme or Marquez or Burroughs have put into question every aspect of realism (history, fixedness, identifiable representation) which once could be taken for granted. But such a division assumes we know what Musil and Kafka were opposed to, what they considered history to be; or we have some real sense of Rilke's "content"—that is, its fixed points; or, in other modes, what Picasso hoped, ultimately, to oppose in cubism. The very point of Kafka, for instance, is not only the uncertainty of what he is for but the vagueness of what he opposes. Kafka's fictions are purely process, even when anchored to some reality principle, such as the village in *The Castle*, or Gregor's room in the Samsa household. We could, in fact, argue that the presence of a "reality" is paradoxical: it is there only to be disputed, to become part of the problematics. We do not know what Kafka is struggling against, we do not know what reality he is anchored to; for the very operation of his imagination is a reflection of uncertainties.

Even if we try to argue that in relative, not absolute, terms, Modern texts had more historical moorage than Postmodern texts, we would have to be very careful since the earlier writers implied their work self-destructed once it was "read" or interpreted. Surely this was the message Dadaism and then surrealism brought home. But even well before them, such sliding away from "meaning" was a standard part of the avant-garde in the movement toward abstraction: the negation of objects was implicitly a rejection of certainty, a movement toward structure and form, an insistence on language differentiation. In such a formulation, the work was about itself; it was self-reflexive, self-conscious—what Kenneth Burke saw as both synechdochal and situational. And in Freud—the gray eminence behind so much Postmodern thinking, in Derrida, Lacan, and Bloom—the idea of verbal concealment upset historical anchorage, turning what may have been fact or data into personalized statement, into the uncertainties of language controlled by an ambiguous emotional state. That Freud had made such modes of concealment a revelation of personality and indices of health creates a clear passage back into the high days of avant-garde Modernism. *

As we survey Postmodern thought in what may be itself an attempt at

* The recent heated controversy over Freud's so-called shift of doctrinal position from belief in real acts to fantasy acts of child abuse and rape is connected to uses of language—as concealment, betrayal, "difference." Questions of history, representation, even objects are at stake. Thus, a possible Postmodern view of Freud sends us back to an even more intensely Modern Freud.

becoming an avant-garde—in criticism, or in the conscious blurring of borders between creative and critical effort—we cannot miss the lines of derivation pushing us back where we began. Let us get on what Lévi-Strauss has called a historical escalator. One premise of this study has been that Modernism is a break with romanticism earlier in the nineteenth century. The second premise is that Postmodernism has not divorced itself from Modernism; the former is, in fact, nourished by its successive avant-gardes. That is, once we have an identifiable movement called Modernism, which is more than a series of emanations from romanticism, it persists. Postmodernism is itself an emanation, a recapitulation, an intense stress on certain aspects of the earlier movement. The overwhelming presence of Freud and Freudian constructs would alone point to the Modern element in Postmodernism. Equally, the central positioning of Nietzsche in Postmodern thought indicates a return to one of the high priests of Modernism. Still further, Proust's novel remains the foundation of many Postmodern temporal and spatial considerations, from the phenomenologist Poulet to the deconstructionist Paul de Man—yet Proust straddles nearly every significant issue of Modernism.

Those who insist that Postmodernism is a distinct or unique movement point to its refusal to cater to the traditional artistic and value systems we have come to expect, even in high Modernism. For those who oppose Postmodernism—as idea or as performance—this antihumanism is the very thing that upsets them. Many of them look back nostalgically toward the days of the New Criticism, as if they could reschedule a college reunion dating from the forties and fifties. They remind us that the New Criticism was dedicated to the preservation of the text and committed to literature as a serious value system. Of course, forty years ago—as many have forgotten—the New Criticism itself was attacked as a form of dehumanization, as a process of dissection which did not take into sufficient account history, biography, or authorial presence in the text.* It was considered surgical and dessicated. Once the New Criticism came under attack, however, it appeared attractive as a shield against the "new barbarians"; and its impersonal textual analysis now reinforced humanistic values against those who

* Structuralism, at least in the Lévi-Strauss variety, also seemed to remove the human element, in this instance from myth. Lévi-Strauss extracted myth from its role as man's explanation of the supernatural and distributed it in several structurally analytical ways: as (1) not residing in isolated elements that enter into its composition, but in the way these elements are combined—in structures; as (2) belonging to language, but only part of it, as exhibiting special properties; as (3) demonstrating more complex features than any to be found in linguistic expression. Through these formulations, Lévi-Strauss said it "became possible to organize all the known variants of a myth into a set forming a kind of permutation group, the two variants placed at the far ends being in a symmetrical, although inverted, relationship to each other."

In linguistics, Roman Jakobson's isolation of *phonemes* (a word's smallest sound segment) helped to do for language and sounds (what came to be called phonology) what Lévi-Strauss was accomplishing with myth. The latter, in fact, developed his own system by way of Jakobson's, basing the neologism "mytheme" (myth's smallest segment) on *phoneme*. The point of both researches was not "meaning" in any traditional sense but organization, the exploration of structural unities in their respective areas. Strikingly, Jakobson came to his structures by way of avant-gardes in art: cubism, futurism, abstraction, and, particularly, Russian experimenters such as Malevich, Goncharova, and Larionev. He noted in their use of space a semantic function which could carry over to language. Linguistic structuralism was simply another step in the dehumanization that had characterized virtually all avant-gardes.

Jameson, attacking it from another angle, comes full circle: "Structuralism may thus be seen as one of the most thoroughgoing reactions against substantialist thinking in general, proposing as it does to replace the substance (or the substantive) with relations and purely relational perceptions."

would deem everything uncertain. For those critics oriented toward representation and traditional analysis, Postmodernism has become melancholily associated with what Paul de Man—himself rebelling against the New Criticism—called the temptation of literature "to fulfill itself in a single moment."

The advent of semiotics in the last twenty years (Barthes, Foucault, Eco, Genette, Riffaterre) would appear to support the idea that something new has emerged and that it is antihumanistic. For those who see a lingering realism in Modernism and its avant-gardes, the semioticians are yet another enemy. Semiotics, as we shall see, turns the text into a grid, which can be interpreted as its elements are isolated and identified. There is considerable indebtedness to structuralists (Saussure as the fount), who codified literary texts and classified them, as if they were items in an archaeological dig. An impersonal process with scientific roots, structuralism was a form of taxonomy or nosology. As a derivative, semiotics would seem the ultimate in Postmodernism: its isolation of the text, its stress on self-referral, its insistence on "scientific models," its use of twin systems of synchronism and diachronism, its divorce from the signifier and its reliance on the signified, its concern with objects, not the "thought" behind them, its obsession with identification.

Semiotics insists that the written book separates knowledge or thought from the author who produced it, and has replaced that traditional linkage between author and book with what Barthes has called "a set of institutional conventions within which the activity of writing can take place." Once the physical condition of a book has isolated it from the chain of communication associated with speech, the book is not just the transmission of words or language. It is a set of texts or codes that can be interpreted as one interprets hieroglyphics.

Barthes's *S/Z: An Essay*, a reading of Balzac's long story "Sarrasine," would seem the ultimate in semiotic practice. Barthes developed five major codes for this reading, and they are illustrative of how various *lexia* (or fragments) of texts can be isolated and categorized. These five codes form a *topos* or network, which can be "read" not as a list or a paradigm but as a "mirage of structures," as "ventures out of the text." Barthes is quite poetic about his method, since he knows that while it may pass for scientific, it is, in fact, the opposite. The units described "are so many fragments of something that has already been *already* read, seen, done, experienced; the code is the wake of that *already*." Put another way, the code is one of the voices out of which the text is woven. Reading is rereading. Barthes's codes: proairetic (which governs the reader's construction of plot, the action); hermeneutic (also linked to plot, but part of its mystery or enigma, the logic of question and answer); semic (models that provide semantic features for the reader); symbolic (extrapolations from the text that provide thematic readings); referential (the text's particular cultural background, the cultural-historical grounding).

We note immediately how linked Barthes's five codes are to reader-text response: they fulfill Barthes's contention that the goal of literary work "is to make the reader no longer a consumer, but the producer of the text." Barthes's concern is not to leave the reader idle: ". . . instead of gaining access to the magic of the signifier, to the pleasure of writing, [in the old method] he is left with no more than the poor freedom either to accept or reject the text: reading is nothing more than a referendum." This is the *readerly* text, whereas Barthes wishes to establish the *writerly* text. The codes are a way "into the text."

The implications for Postmodernism would appear, thus far, to be enormous. Barthes's probe into the text is far more than a "reading"; it is an ideology that seems to indicate a disruption of the Age of Modernism. For the tools Barthes suggests are referential only to the system from which they derive; or, as Riffaterre has said, the meaning (of a sign) depends on its function or place not within an overall "meaning system" but within a paradigm, within a syntagmatic (or pattern) situation. The stress by semioticians on the syntagmatic function of words is emblematic of what has occurred: for syntagmatism indicates the reference of words to each other *in a particular utterance*, which is a tighter form of self-referral than in a paradigmatic function, which reference words have to each other *in language as a whole*. As the net gets drawn more tightly, these functions would suggest a rejection of even the minimal reference allowed in Modernist avant-gardes.

To continue this argument: Gérard Genette's use of the term *architext* further encloses the text in a way a Postmodernist reading insists upon. Architext—a quite useful term apart from any argument for or against its acceptability here—indicates the generic tradition of a poem or other literary work. Since semiotics, like structuralism, insists we see a literary work as a text linked to other texts, it becomes clear texts develop out of others: texts give birth to succeeding ones. Literary parthenogenesis! This is, of course, anathema to Marxist critics like Jameson, who argue the opposite; but for someone like Genette or Riffaterre, the concept of architext (or *intertexts*, for Riffaterre) splits off the text from both representation and referential connection. The isolation of the text is complete, except for its genetic inheritance from works of its own genre. Frye with a vengeance!

Before describing further characteristics, however, we should listen to what the Postmodern semioticians have been saying and question their novelty. As far as their stress on "codes" and self-referral, we could point to earlier developments of narrative devices, from Ford and Conrad, to Woolf, Joyce, and Broch. Genette's division of all fiction into text, narrating, and story, including "fictional tense" (that is, order, duration, and frequency), has its counterpart in high Modernism. Conrad and Ford's definition of *progression d'effet*, as we have seen, was an effort to bring together similar characteristics: new temporal orders based on new conceptions of duration and frequency, with particular attention to matters of narration and story. Narrative was divorced from story, and story separated from plot; different temporal modes often applied to different aspects of the novel, implied more often than stated.

Genette and other semioticians obviously rely heavily on Proust. Genette's dependence on "order" is a way of commenting on Proust's use of Marcel as narrator; Genettte sees order as the story's own chronology working against the way in which discourse arranges the story, or presents it to us. We recall that much of his system relies on analysis of a text based on the verb: tense, mood, voice. Therefore, "duration" capitalizes on the possibilities of the verb: the events in the story in one verb frame, the means of getting story before the reader in another. Similarly, "frequency" has verb overtones, for it refers to events and their occurrence measured against how often they are related; how frequently, that is, they enter into the discourse. Clearly, the Proustian novel in all its aspects—narrator, internal activity, reliance on pastness, theories of time and

space, recapturing of memory, probe into inner worlds where verbs become flexible and vague—resonates in Genette's scheme.

Thus, in still another area, it is difficult to see where Postmodern criticism has defined a break with Modernism. The problem so far is at least twofold: whatever so-called Postmodern or poststructural criticism has pointed to can be found in the practices, if not the theories, of the Moderns; and, second, Postmodern criticism has not made us see precisely where a break occurred between a Modern text and a Postmodern text. (More on the latter below.) A third question might be whether or not Postmodern criticism is itself even that much of a break with the past—that is, it may be an agile extension of ideas that have always responded to Modernism. In this respect, much of what passes for Postmodernism in reader-response, self-referral, hermeneutics, deconstruction and decentering, even in "differencing" and in other areas, is subsumed in Kenneth Burke's theories of "symbolic action." His "grammar of rhetoric" and "grammar of motives" preempt hermeneutics, which is itself a derivative of Heidegger's "hermeneutical phenomenology." Impressive and ingenious labels have been connected to ideas that were foreshadowed as early as the eighteenth century under other terminology, such as the sublime and the beautiful, carried forward into romantic criticism, and eventually metamorphosed into central Modernist concepts.

In several respects, critics who pride themselves on the new are redefining old battles, some of which we have charted above. In other instances, they are merely relabeling what were traditional aesthetic issues. Deconstruction can be discovered in much *symboliste* doctrine; hermeneutics in biblical exegesis practiced by the German "higher critics"; Barthes's "zero degree" of writing is implicit in the *fin de siècle* decadent movement, before that in the *symbolistes*—in anti-writing, which implies referents are neutralized by language itself; Derrida's "difference" in Kafka's work—where marginal elements create the doubt that slowly undermines whatever may appear realistic. Kafka was, in fact, the great deconstructionist of high Modernism, his appeal resting on the mystique generated by elusiveness, ambiguity, doubt, decentering.

Although Jacques Lacan is not crucial to our argument, he brings to Poststructural criticism two main areas of high Modernism: Freud's body of work and Mallarmé's poetic principles. Since Lacan's revisionism of Freud is well documented, I would like to examine his linkage with Mallarmé. A good deal has been written connecting Lacan to Saussure's theories of language, but in several respects, the association is closer to the poet than to the theoretician. What we can find, I am certain, is that Lacan's major thought—which has been presented to us as poststructuralist, Postmodern, even anti-Modern—is deeply embedded in high Modernism and, even before, in those aspects of the movement that were as yet shaping themselves as successive avant-gardes.

Lacan's theory of the mirror stage in the child's development is critical, for it has numerous linguistic and philosophical ramifications. Lacan uses the experience of the child when he/she first sees himself reflected in a mirror as a fundamental occurrence: with this, the child becomes aware of himself both as an individual and as linked to the race of men. The experience is important because it creates a sense of entity and binding before the child can verbalize it. The child "anticipates his self" in achieving this reflection, and the latter's

nature, quality, weight determine how the child will relate innerness to outerness, himself to others, narcissism to aggression. A further aspect of the mirror-image theory is its interpositioning of the body, and the downgrading proportionally of perception. That is, the subject perceives himself not as "thought" but as body as much as mind—a rejection of Cartesianism, and a clear decentering which we associate with, among others, Mallarmé. Lacan pressed the significance of his mirror-image theory, since with it he could insist that the individual's ego formation is as distorted as the reflection in the mirror.

We, too, can emphasize the mirror in linking Lacan to Mallarmé. The latter was not only the magician of words and tones, he was the practioner of mirror wizardry. Although the most famous mirror image in Mallarmé is Herodiade's—"O miroir! / Eau froide par l'ennui dans ton cadre gelée*—I would prefer to stress "Un Dentelle s'abolit," in which "a lace curtain effaces itself." The mirror here is the window with which the lace curtain interacts: the interaction produces an unconscious language leading to creativity, the poet, the bed, sex, so that the mysterious language of the curtain—its gesture as well as its representability—works with reflections of meaning which lie beneath verbalization. We see in Mallarmé's conception of the unverbalized association of meanings a clear passage into Lacan's thought: the latter's sense that there is a text lying just outside the individual's discursive powers. This text is that unconsciousness which must be unraveled through language. What will be discovered are childhood memories, hysterical symptoms, neurotic or obsessive patterns—but the way in is through language (meaning, sounds, tones, et al.).

That "decentered self" Lacan stresses can be traced not only to Mallarmé but to Kafka. Part of the decentered self results from the ambiguous relationship the individual has with language. It is very rewarding to analyze in Kafka not only the words, but the pauses and gaps between words, those silences in language that suggest the split between manifest and latent dream content. So much of Kafka comes to us as dream, or dream-dimension, because he discovered a medium—difficult to duplicate or to define precisely—that demonstrates both unconscious wishes and freely associated materials. These are, of course, the very linguistic aspects Lacan emphasizes as part of the analyst and analysand relationship. Lacan himself draws the linkage between condensation and displacement in dreams and analogous strategies in literature, such as *metaphor, metonymy,* and so on. For Kenneth Burke, well before Lacan in formulating such theories, *synecdoche* performs a comparable function: a basic structure that conveys to us "sensory, artistic, and political representation." Burke was demonstrating how nonrepresentational art can work, so that a tree comes in colors and forms we accept even when to the eye it is not a tree. This is roughly equivalent to Lacan's insistence that individual speeech patterns convey achievable experiences, once we probe the structures; when we do that, the "tree" will emerge.

Although the language of these critical statements often obfuscates more than it clarifies, we can see through the verbal murk ideas of considerable continuity. We could argue, in fact, that part of the need for such quirky prose is to disguise, in part or whole, the critic's indebtedness; to disguise, indeed,

* "O mirror! Cold water frozen by ennui within your frame" is a literal translation. "Cadre" can also signify pattern or plan, or even reference.

that the ideas, while freshly stated, are not particularly fresh. That is, in part, the thrust of this chapter: to demonstate that what passes for the new, the post-, and the neo- is a reworking of ideas and practices both foreshadowed and achieved during high Modernism.

If we move from Lacan back to Roland Barthes, we note a comparable indebtedness not only to Mallarmé in particular but to *symbolisme* and high Modernism in general. Barthes's early theory of writing, which he labeled "zero degree," depends, chiefly, on whiteness, on the pauses and silences between words, even on the arrangement of words on the page so that space dominates. These doubts, silences, omissions, spaces, whitenesses cannot be neglected inasmuch as they create meaning by their juxtaposition to the words. That is, the words become transformed, not in their "meaning" or "content" as such, but in their possibility as conveyed by tone, gesture, intimation.* Even as we describe Barthes's quest, we see its linkage to Mallarmé, Rilke, Eliot, or later Yeats. Saussure is, of course, behind much of early Barthes—especially the theoretician's insistence that language lacks an absolute sense; that sense must be found between *langue* and *parole*, between the historical language and its actual use. Barthes found some of this dialectic in the struggle between the words in a structure and the surounding spaces/silences. He would, later, develop his view of a *writerly* text around the idea of a "creative" text which, resisting closure, remains open to ambiguity, doubt, uncertainty. Opposed to this is the *readerly* text, which invites closure and which, for Barthes, remains static.

This is, in fact, an old battle, renewed in new terms of *readerly* and *writerly*. In the days of very early Modernism, toward the end of the last century, the struggle was between Zolaesque naturalists-realists and those who rejected that kind of fiction in favor or an open-ended, nonclosure variety. The various manifestoes of *symbolisme* insisted on this openness, as would later futurist manifestoes. When we cited Pierre Boulez above, we noted that his antagonistic response to Schoenberg's twelve-tone system was based on what he perceived as its qualities of closure, its airtight, strictly serial syntax. That was in the 1950s, already a coda time for Modernism. Boulez's own masterpiece, if not *Le Marteau sans maître*, may well be his *Pli selon pli*, which derives in several aspects from Mallarmé stanzas, lines, and attitudes.

We can see the same battle fought in high Modernism among Russian avant-gardeists, right on the edge of the Revolution. In the movement called acmeism—whose founders included Osip Mandelstam, Anna Akhmatova, and her husband, Nikolay Gumilyov—we find an effort to counter the so-called vagaries of symbolism. In a now familiar form of opposition—imagism was proceeding along analogous lines in Western Europe—acmeism stressed clarity, precision, order, balancc, and closure. It opposed transcendentalism, occultism, unearthliness, openness. The acmeists were traditionalists, but not "easy" poets, and they fought against the symbolists and futurists for what Barthes, later, would call a readerly, not a writerly, text. We have, then, another precursor of arguments that would characterize the post-phases of Modernism, but which are, in reality, Modernism.

* Cf. Robbe-Grillet: "In this future universe of the novel, gestures and objects will be *there* before being *something*; and they will still be there afterwards, hard, unalterable, eternally present, mocking their own 'meaning,' that meaning which vainly tries to reduce them to the role of precarious tools. . . ."

None of this is designed to denigrate the ingenuity of Barthes, or his theories. Like those of his contemporaries, they will affect our sense of a text for many years, and, indeed, we see such views penetrating college classroms and displacing the New Criticism. The real energy of Barthes goes to transform our reading habits through his insistence on the almost infinite multiplicity of meanings in a given text: nearly all such theories are concerned with literary archaeology, probing toward ever deeper structures of possibility. Below, we will touch on some of the poststructuralist response to the writerly group in theories as different as Jameson's "metacommentary," Hirsch's hermeneutics, Graff's no-Realism. Our point throughout—neither to denigrate nor to defer to—will be to trace how derivative these schema are; how implicitly and explicitly dependent these theoreticians are on early and high Modernism for their ideas, whatever deeper structures they eventually disclose. *

In their desire to repel the deconstructionist implications of Heidegger's adaptors and the *writerly* textual readings of the Bartheans and semioticians, hermeneutics critics seem to have moved the argument to a different level. Perhaps best represented by E. D. Hirsch, Jr., the hermeneutics group has derived from Husserl and his "transcendental phenomenology" (with its stress on consciousness, especially transcendental consciousness); yet part of their "new look" has something of the old "intentional fallacy" in it. † Their concern is with establishing *meaning* by probing what the author meant, not by moving from one interpretation to another (which Hirsch depreciatingly calls the pursuit of significance). To get at meaning, it is necessary to establish those terms of discourse that apply generally to what the author meant, or could have meant. (Incidentally, hermeneutics is little different from other critical explorations, in that while it attempts to put its terms on some scientific basis, it is as arbitrary as those theories and terms it opposes.)

Hermeneutics critics are absolutists, repelled by Heideggerian relativism, by his stress that since all knowledge is relative no individual critic can be

* We can, for example, see the application of such ideas in the influential term "the performing self," from Richard Poirier's book of that name. "As against these recognized forms of parody [Poirier writes], I want to define a newly developed one: a literature of self-parody that makes fun of itself *as it goes along*. It proposes not the rewards so much as the limits of its procedures; it shapes itself around its own dissolvants; it calls into question not any particular literary structure so much as the enterprise, the activity itself of creating any literary form, of empowering an idea with a style." Poirier suggests that Postmodernism disrupts the rationality of Modernism; that is, the latter has lost the basis or premise that defined literature as a humanistic enterprise. We argue, however, that this disruption of rationality had long ago been set into motion.

† A good many battles were fought in the 1940s over the intentional fallacy. W. K. Wimsatt, Jr., and M. C. Beardsley argued, in *Sewanee Review*, that the poem belongs neither to the author nor the critic: "it belongs to the public. . . ." I. A. Richards stressed that a poem is a "standard experience" and should be examined as manifesting that "relevant experience" of the poet, but not intention. There were several responses to this position and several defenses of it, not the least by Robert Penn Warren in his long and important essay on *The Rime of the Ancient Mariner*. John Crowe Ransom jumped in by emphasizing that the poem demonstrates what he called "total intention," which is distinct from intention, since the poem once formed has left the poet's knowledge, becoming something of its own, not its creator's. The point here is not to settle the argument, but to note that intentional criticism is almost as old as criticism, and has long preceded present-day hermeneutics. In some respects, those who argued against intention held the field, for the New Criticism as it developed eliminated intention and graded only performance.

Many roads lead back to Kenneth Burke, whose five terms (act, scene, agent, agency, purpose) all help reveal motivation in the strategies of the work. To deploy the five terms is to unravel the structure of the work and, beyond that, the motivation of the author beyond it.

unprejudiced. Hirsch would agree that we start with certain prejudices or "pre-understanding" (*Vorverstandnis*, also pre-appreciation); that is, with intent and motive. But he would also argue that it is incumbent upon the critic to struggle against Heidegger's relativism. This is at the heart of his distinction between *meaning* and *significance*; i.e., that even when the author reinterprets his own work, he does not change its meaning, only its significance. "Meaning is that which is represented by a text; it is what the author meant by his use of a particular sign sequence; it is what the signs represent. *Significance*, on the other hand, names a relationship between that meaning and a person, or a conception, or a situation, or indeed anything imaginable. . . . Clearly what changes for them [the authors] is not the meaning of the work, but rather their relationship to that meaning. Significance always implies a relationship, and one constant, unchanging pole of that relationship is what the text means." That "constant, unchanging pole" is part of Hirsch's indebtedness to Husserl.

At the basis of Hirsch's remarks is his profound disagreement with the German theoretician Hans-George Gadamer (*Wahrheit und Methode, Truth and Method*). Gadamer had attacked the premise that "textual meaning is the same as the author's meaning," labeling interpretations that attempt to validate the author's intention as the meaning of the text "pure romantic *Psychologismus*." For him, the text's meaning lies "in the subject matter or thing meant, the *Sache*, which, while independent of author and reader, is shared by both." Hirsch, on the other hand, takes his absolutist position because he stresses that the "art of interpreting and the art of understanding are separate functions." Since understanding is a priori—not only before interpretation but a different category from it—it is controlled by authorial will (and by the "social principle of linguistic genres"); whereas interpretation will fluctuate, will be an unstable element. Hirsch is out to crush historicism—what he finds in Gadamer's relativism, beyond that in Heidegger's. *

This thrusts us back into familiar territory, into the very complicated sense of history we find in Nietzsche, and the ambiguities involved in his advocacy of Modernism itself. As Nietzsche recognized, Modernity (or the idea of Modernism) and history clashed; for while history insisted on continuity, Modernism insisted on inhibiting the historical process, leaping out of it, asserting its own ahistorical nature. Yet, at the same time, Modernism could not help being absorbed by the very historical process it eschewed. As we have noted, successive avant-gardes relegated previous ones to the historical dust heap, so that each element seems to exist to create a situation that self-destructs. Put another way, as Paul de Man expresses it, if history "is not to become sheer regression or paralysis, it depends on modernity for its duration and renewal; but modernity cannot assert itself without being at once swallowed up and reintegrated into a regressive historical process. . . ." Thus, as Nietzsche situated both, there is an unresolvable paradox, which is why he labeled one of his key essays "Of the Use and Misuse of History for Life."

Any stress on "new beginnings," linked to avant-gardes and to Modernism as a defined movement, returns us to Nietzschean paradoxes. For Nietzsche,

* That is, since interpretations are shaped by cultural criteria based on historical periods, the text goes through different lives depending on how a particular culture or historical era shapes and situates it. As a consequence, there is no text; there are only interpretations dependent upon historical relativism. This is, of course, only one way of understanding Heidegger.

one appeal of Modernism was its attraction for the moment, its consciousness which creates a sensation, however brief. An equal attraction was its ability to efface the past, to be an agent of purification—although it, too, would be replaced. We earlier defined *Ecce Homo* as spiritual autobiography because it suggested generic man is a youth, reborn in Nietzsche's terms as someone fresh, recuperative, regenerative. For Nietzsche, out of sickness comes great strength, and man appears. This could be a paradigm for Modernism and its avant-gardes.

The point of returning to Nietzsche is to demonstrate that even the new arguments in hermeneutics are old arguments about history, historicism, and relativism/absolutism. Nietzsche foresaw the dilemmas and dealt with the paradoxes through irony. One reason, perhaps, that Postmodern critics are so eager to indicate a break with Modernism and to define a new era is their desire to reassert the historical process. The disruptions created by Modernism cannot be tolerated for long before the historical sense reasserts itself to indicate the movement has ended; another historical phase of post- or neo- has begun. However, this view may miss the point. Although no prescriptions for movements or historical processes appear possible, it does seem that with Modernism we entered a phase in which man had to recreate himself in recurrent and successive waves of novelty. Every idea was not only refined, it was ultimately rejected; and in terms of brutality and repression, man was himself almost negated in the political and military response to Modernism. The disruptive political life of our century, surely the most fragmented period in Western history, is a direct inheritance of the Modern movement. We began with Hitler picking apart everything that smacked of Modernism, and he carried his virulence to its natural end: to bring it all down rather than to let what were for him the poisonous parts live.

All of this is foreshadowed in Nietzsche.* He is our dark prophet, our Tiresias. The later refinements of Foucault upon the historical process, his calling into question new lines of demarcation between madness and sanity, are ways of introducing Modernism into historical process, really, readings on Nietzschean hesitations about history. A more accurate example is Saussure, whose distinctions between *diachronic* (historical, grammatical) and *synchronic* (the language used as a whole at a given time) are really distinctions made about history and historical processes. As is well known, Saussure began as a grammarian—his first and only publication, in 1879, was on vowel systems in Indo-European languages (*Mémoire sur le système primitif des voyelles dans les langues indoeuropéenes*), a study dependent on diachronism. Yet Saussure gravitated toward the opposite, so that his lectures, which were later collected to become the bible of linguistics, depend on synchronism. Thus, he moved from history and historical process to an area where possible linguistic anarchy could reign. Fredric

* We note how Nietzsche in our era can be bent in any direction, as liberator or as precursor of fascism. In *Anti-Oedipus* (1972), Gilles Deleuze and Félix Guattari use Nietzsche as part of a dialectic with Marx, as the tension between philosophy and politics, thought and revolution, spirit and action. The aim is to extricate the Fascist in each of us, the direct target being the ego. That ego is connected to an oppressor, whom the authors identify as Freud's Oedipus. Thralldom to Oedipus inhibits revolutionary zeal to throw off power and to free the individual's sense of desire, liberating him, also, from all beliefs. For psychoanalysis, which depends on Oedipus, the authors offer schizoanalysis, a Laingian strategy designed to draw on the breakthroughs achieved by those called schizophrenic. The goal throughout is to demonstrate to the individual how he can cast aside the imperial Oedipus and reach deeply into his own flow of desire. One of the problems with the argument—apart from its messianic impulse—is that it does not sufficiently distinguish between Nietzsche and Henry Miller, or Artaud.

Jameson is particularly astute here: ". . . Saussure found himself little by little evolving a distinction between causes that are external to a phenomenon and causes which are somehow intrinsic to it, and this distinction may stand as the definition of the idea of system itself." We note how enclosed in Sausserian thought Foucault and his systems are.

Modern phenomenology, also, is indebted to this nineteenth-century linguist, who was himself at first deeply immersed in traditional grammar and philology. In a sense, Saussure structured phenomenological thought as it applied to linguistics, doing for that area what Einstein would do with his assault on the old physics, what Bergson hoped to accomplish with his theories of memory, his stress on intuition over rationality. It paralleled Freud's structuring of the unconscious. The emphasis on synchronism, we can say with considerable hindsight, was part of the antirationality of high Modernism: not an attack on mind, but on reason; not a vaunting of anarchy, but a recognition of the numinous, the spiritual, the mysterious. Jameson draws a similar analogy, speaking of the crisis in perception in which objects "are no longer things or organisms which are isolated by their own physical structures from each other. . . ." We note the groundwork being laid for nonrepresentational work and abstraction, for that blending of objects with forms of spatial reality which characterized cubism: that perception of objects as embodying different kinds of physicality.

Hermeneutics has led us afield, but even as we wander into those disruptions with the historical process that characterized early efforts at hermeneutics, we note once again how Modernism has preempted any post- phases. Saussure, we recall, was a contemporary of Mallarmé, Rimbaud, Verlaine, Jarry, and he died in the era of Yeats, Conrad, early Joyce, Rilke, Mann, Proust, in 1913. He was completely a product of pre- and high Modernism, and yet his ideas—as if new—have become the basis of a cottage industry of brilliant contemporary interpreters.* We can locate him even further in early and high Modernism. Besides his phenomenology, his stress on synchronism has kinship with Husserl, and thus foreshadows still another contemporary movement, existentialism— leading into the hermeneutics group led by Hirsch and those rejecting Heideggerian historicity. Yet even as we see new connecting to old, Saussure is a strange bedfellow for present-day hermeneutic critics; for with their insistence on absolutism in interpretation they neglect his other distinctions.

His sense of *langue* (the language system, its forms), for example, is anything but absolutist, linking itself with Freud's unconscious; whereas his *parole* (actual speech) is conscious speech. The division between the two suggests Saussure's own binary thought, a disconnectedness between *langue* and *parole*, between unconscious and conscious, which Lacan saw as the central problem of psychoanalysis. For Saussure, content becomes form as soon as it is emitted, and this is not a problem hermeneutics criticism would like to deal with.

We return to the same point: The more we examine the post- phenomenon, the more profoundly we become involved in its historical antecedents. Is this

* For example, Derrida's theory of *différance*. Saussure had himself stressed there is only difference, without positive or absolutist terms, and Derrida followed with his sense of difference as distinction. For him, the play of difference is the sole constant for any sign. To this, Derrida also added a link with Mallarmé: difference as delay, created by intervals, spacing, temporal strategies, all of which "postpone" meaning. The result is duplicity and uncertainty, infinite postponement of the possible.

merely a case in which *all* ideas can be traced back almost to infinity, that nothing is new? On that model, Modernism can itself be viewed as an extension, with variations, of romanticism, as many astute critics have believed.* I think not. Ideas alter their antecedents to such a degree that at certain points the original impulse is submerged, and the new appears, like ingredients in a chemical reaction. Certainly little in the past has prepared us for the assault on objects that began to gather force at the beginning of the century. Here is a distinct break, as is Schoenberg's atonality in his Second String Quartet, or Picasso's *Les Demoiselles*. We can say that while nearly all Postmodern ideas can be traced back to Modernism, it is, nevertheless, not true that *all ideas* have an infinite past. The vast disruption that began with new attitudes toward reality—not only an antirealism and a spiritualism, but a submergence of objects in an indeterminate space, controlled by an immeasurable time—was the definition of new cultural forms. Mallarmé is not Shelley or Keats; Joyce interiority has no antecedents in romanticism; Kafka has moved fiction into another dimension; Proust is not Balzac.

Romanticism was based on organic views of man and society, of individual and his community or culture. Modernism has isolated these elements from each other, indisputably—although some hermeneutics critics like Hirsch are attempting to see "wholes" once again. But whatever their efforts, Modernism made that break, and what passes for Postmodernism has merely accelerated it. The contemporary stress on performance arts which we discussed above is part of that acceleration—not something new but an outgrowth of ideas intrinsic to both early and high Modernism—the need to seek in art forms some totality missing elsewhere.

There are, however, still other responses. Entire positions have been set out to counter the very label of Postmodernism, or else to subvert its efforts at a metaphysics. In *Literature Against Itself*, Gerald Graff focuses much of his argument on Postmodern's lack of a societal basis, as against the more social orientation of high Modernism. Both implicitly and explicitly, he attacks the contemporary experimental novel's "inability to transcend the solipsism of subjectivity" and the fact that its language "becomes the novel's chief subject and the principle of its form." There is, regrettably, little or no "objective order of values in the past and no regret over its disappearance in the present." Loss of identity, instead of being deemed terrifying, "is viewed as a bracing form of consciousness-expansion and a prelude to growth." Any element that suggests objects and objective growth is routinely condemned as a mere survival of outmoded thinking.

Graff looks nostalgically on the New Criticism, which he defends well. "The method of close textual analysis was a response on one side to those who dismissed literature as a frivolity [genteel moralism, impressionism, etc.] and on the other side to those who defended it in terms which rendered it frivolous." He sees the old New Criticism as threading its way between two equally disturbing groups: impressionists who judge the work for its "pleasurable excitement," and

* A sampling of those who have advocated or moved along the margins of that linkage are Monroe K. Spears, Edmund Wilson, Frank Kermode, Northrop Frye, Robert Langbaum, Harold Bloom, Geoffrey Hartman, Morse Peckham. One does not disagree lightly with these critics, but disagree we must. Modernism may not have existed without an earlier romanticism, but it so redefined the romantic ideal that it became something distinctive. Such has been the thesis of this book.

message hunters seeking political propaganda. He also views it as denying status
to the positivist position, which perceives no aesthetic value in the work at all.
Using the old New Criticism as his weapon, Graff goes after deconstruction,
indeterminacy, self-consumption, clustering them so that they are an easier target
to hit. While we may applaud Graff's desire to keep objects in view and to
dismiss those who wish to dismiss the world, we must admit he is unjust in
grouping their positions or in allowing overlapping parts to stand in for the
whole. His arguments are excellent when demonstrating the shaky premises of
the critics he attacks but less valid when focusing on their particular arguments.

Graff leans on a very inventive and solid critic in E. H. Gombrich, whose
binary approach in *Art and Illusion* offers "a way of overcoming the disabling
antithesis between interpretation and objective representation." As we describe
Gombrich, however, we will note his applicability to older forms of art, but his
loss of cogency when we move toward this century and especially when we try
to distinguish between Modern and Postmodern. Gombrich attempts to bridge
the distance between subjectivity of vision and objective standards of represen-
tation (accuracy, our sense of a world, what is beyond us). He develops an
ongoing process of *schema* and *correction*, of the subject *making* and then *match-
ing*. As Graff comments, the *making* is the creative imagination, the artist
working through his creative problems as dictated by genres, conventions, tra-
ditions, etc. The *matching* would be less the artist's job than the viewer's, who
would match the work to his own sense of the objective world. This solution
does not lose historicism in the process of permitting the free flow of subjectivity,
but it does rest on certain shaky premises when it takes up nonrepresentational
art. For Gombrich must then argue that even abstract forms contain represen-
tational elements, and that the audience for such works responds to its elements
of objectivity, to its "content." Graff, nevertheless, uses this premise as a means
of attacking Postmodernism for disallowing even this degree of relationship be-
tween work and audience.

The vagueness that Graff rightly discovers in Postmodern critics is, of course,
equaled by the vagueness, unbuttressed premises, and implicit theories of those
he supports. The Gombrich resolution, while ingenious, turns all abstraction
into "meaning," which can then be translated into communicable language.
Yet the very point of abstraction and nonrepresentational work is that its language
is abstract. Abstraction is not waiting to be transformed into meaning; it is in
itself the language of the twentieth century, however much some would like to
turn it back into forms of nature. If we reshape it to fit our desire for nature and
the natural—that is, for representation—then we have turned viewer response
into the imagined work; we have confused realms. We undoubtedly do this, but
the critic must be aware of the distorting process. Graff's desire to get back to
"reality," or to art forms where there is some grounding in reality, is under-
standable; but the very presence of high Modernism (not Postmodernism) helped
settle this dilemma by finessing it, turning it into a question we can no longer
ask.

Fredric Jameson's commentary is also directed toward retrieving the real
and the natural—for him, the world, community, society. The subtitle of his
The Political Unconscious is *Narrative as a Socially Symbolic Act*. A good deal
of Jameson's position was suggested in his essay "Metacommentary," briefly
alluded to above. Jameson starts from a familiar premise: that it is "axiomatic

that the existence of a determinate literary form always reflects a certain possibility of experience in the moment of social development in question." Our "satisfaction with the completeness of plot" involves, implicitly, a "kind of satisfaction with society. . . ." This is, incidentally, an assumption that may or may not be true, since a good deal depends on what we choose to mean by "plot" and "society," especially how we use the former. It has become a supercharged word. When plot is absorbed into narrative, or into voices, or into phenomenological experiences, what, we must inquire, is plot?

Jameson sees his role as attacking interpretation, although it turns out he questions only certain types—ethical, psychoanalytic, myth-critical—because he believes they carry the main meaning of the text for us, while the work languishes relatively unnoticed. What he is really attempting is a Marxist criticism which can compete "in the 'pluralism' of the intellectual marketplace." He seeks a dialectic and in that spirit defines Marxism "as that 'untranscendable horizon' that subsumes such apparently antagonistic or incommensurable critical operations [such as ethical, psychoanalytic, et al.], assigning them an undoubted sectoral validity within itself, and thus at once cancelling and preserving them." Although Marxist criticism is only "competing," it becomes first among equals: it "subsumes," it assigns validity, it cancels and it preserves.

In his definition of metacommentary or metacriticism, Jameson makes a related assumption. He assumes that "*content does not need to be treated or interpreted because it is itself already essential and immediately meaningful,* meaningful as gestures in situation are meaningful, as sentences in a conversation." Because it is concrete social and historical experience, content is *there.* In an apt analogy, he remarks: ". . . we may say of it [content] what the sculptor said of his stone, that it sufficed to remove all extraneous portions for the statue to appear, already latent in the marble block." Thus, the role of criticism is not to "interpret" content so much as to "reveal" it; it is "a laying bare, a restoration of the original message, the original experience, beneath the distortions of the censor. . . ." The censor or enemy is history, or else something Jameson calls "cultural Difference," which is really history by another name. It is the latter that deflects "the original force" and sullies "the original transparency of Revelation."

The statue that exists in the block of the artist's marble is, for Jameson, social and historical experience. It is latent well before it becomes manifest. What is unclear in Jameson's thought—and this seems crucial—is what emphasis he places on "imagination," "creativity," that shifting X-component which is the artist's input into the manifest nature of that statue. What brings it forth? Are only social and historical moments the determinants? Or does the artist enter into a great mystery which he cannot explain and which remains hidden? A great mystery that, with his indebtedness to genres and typologies as factors, only different kinds of criticism can hope to reveal?

Both Graff and Jameson, in their respective ways, attempt to clear ground that has become terribly cluttered; but neither tells us much about Postmodernism that we did not already know, whether as a critical apparatus or as practice. They slide off from what we want to know, neglecting distinctions we wish to draw. *What is it, in fact, we want to know?* Since the Postmodern critic sees something new, not only in the practice of his craft, but in literary craft itself, perhaps it is incumbent upon him to tell us the secrets of the avant-garde. What

happened to it? Was it dissipated from lack of resources, or did it simply run out of impetus, become exhausted like all other movements and modes? Was it subject to entropy? Did it mutate? If so, when? After all, if the critics claim there is post- this and neo- that, then they must tell us where and when the post- and neo- phases began. Did repressive political opposition finally put it to death? That is, Hitler, Stalin, Mussolini were dedicated to eradicating the "evils of Modernism" and they often succeeded—was that the unofficial end of it all? Can we, indeed, trace the demise of the avant-garde—if that is the point we are making—to political repression? so that in the postwar years when America tried to liberate the avant-garde, it had already atrophied. Or the obverse: Was it tolerant societies that smothered successive avant-gardes until they ceased to emerge? That is, did the avant-garde flourish only when it had repressive societies to subvert?

Opposition, adversariness, radical rebellion: all of these make more sense in a repressive rather than an accepting society or state. The Russian avant-gardeists, for example, flourished right on the edge, just before and after the Revolution, and would become the victims of Stalinist repression. The *symbolistes* evolved and flowered during the oppressiveness of the Third Republic, and the Viennese Secession defined itself during the censorship of Franz Joseph's twilight years.

Yet important as these questions are, they are the superficial ones. The heavier matters involve more profound nuances of history. The Postmodernists have not responded to the ahistorical nature of Modernism more than by pointing out that it was just *that*. If Modernism rejected historicism, what distinguishes Postmodernism? One of Jameson's attacks on poststructuralists is that they have turned everything to language; we should add that while Postmodernist critics have made language ahistorical, they have also confused the issue. To use Saussure once again, we can say Postmodernists have used his sense of *parole* for the artist and his sense of *langue* for the reader/viewer. This drives a historical wedge between them, since the artist expresses himself as a contemporary voice, whereas the reader/viewer receives him in a historical role.

Perhaps Postmodernism and Modernism have so much in common there is no such phenomenon as a post- movement, possibly only a digression or slight deviation, if it is even that. What they have in common is their relationship to history; for neither has solved the question of historical weight and contemporary use, or the dilemmas raised by art forms that while owing their definition to generic development try to break radically with genre and typology. Neither has been able to fix its position in the historical process, which is another way of saying neither has been able to relate to historicism. Nietzsche had an insight into this a century ago and came away baffled, speaking, as we have seen, of the misuse of history as well as its use.

For American avant-gardeists, this break with history may seem natural; it is, after all, part of the American tradition to consider history for "others," and to deem America as having been shaped outside the historical process. For Europeans, however, that lack of connection to history—what we see Camus grappling with in *The Fall*—remains an external dilemma. Sartre thought he had resolved the dilemma with his existentialism on one hand and his thief, Genet, on the other; but he did not resolve the problem, nor could he. What we can say is that the persistence of avant-gardes demonstrates a binary quality

in mankind, at least in the West; suggesting that the contrary impulses in man
Plato adumbrated 2300 years ago have adhered, and they are manifest in the
need to preserve a historical sense *so that* it can be subverted.

The avant-garde is so attractive for us—whether as Modernism or Post-
modernism—because it provides opposition even while undermining it; it fur-
nishes construction even while deconstructing. It is a will to life even while it
proposes "the death of————." Camus's 1956 novel, *The Fall*, his last before
his death, suggests nearly every problem we have described, and perhaps not so
strangely it falls right on the line between Modernism and a so-called Postmod-
ernism, on that very line no one has adequately defined.

The Fall (*La Chute*, which has richer connotations in French, of failure
and disaster as well as the usual meanings) provides a splendid example of a
Modernist text that can be read also in Postmodern terms. What the novel
illustrates is how we can take an ambiguous text and turn it in either direction,
or in all directions. For such purposes, one could as easily use Kafka, Musil,
Proust, Broch, or Joyce; or, for that matter, Pound's *Cantos*, Rilke's *Duino
Elegies*, or Yeats's *The Tower*.

The Fall consists of many tunneling effects, all brought about through an
uncertain narrator, whose shifts of tone recall those of Ford's Dowell, Gide's
Edouard, the several narrators of Conrad's *Jim*, the Marlow of *Heart of Darkness*,
the interior monologuists of Virginia Woolf. Camus's uncertain narrator differs
from theirs, however, in that he becomes the sole "reality" we are acquainted
with. Not only is he the narrator of his own tale (whatever that is!), but he
creates *the world*; we see almost nothing except what he provides for us in his
ramblings, defenses, excuses, attempts at repentance. He is both Being and being,
Time and time, Space and space. What he declares to be *is* for the time of the
novel. The Fall he suffers—if he indeed does—is a composite of all Falls from
the point of view of the fallen.

The text—which is not the same as the story or plot—contains infinite
possibilities, and it can be deconstructed or decentered at virtually every point.
Camus provides an alternate novel to the one he is relating through Jean-Baptiste
Clamence. The ostensible novel appears to be one in which Jean-Baptiste is
striving to achieve some form of repentance for his failure to help a young
woman who drowned herself almost before his eyes. Subsequent to that failure,
in which he went his way while she was swept down the Seine, he hears a laugh,
which follows him and leads to his "fall." That is his tale, as he relates it to an
unidentified listener in the Mexico City, a waterfront bar in Amsterdam. But
the text avoids closure by falling through the holes in the story; what we un-
derstand is quite different from what we read.

One of the clear "signs" or structures in the text is spatial, based on the
polarity of heights and depths. We can say that while the story is about repent-
ance, or the attempt at it, the text is concerned with mountains and valleys,
both physical and psychological. Spatiality has inner as well as outer dimensions.
The strategy of the text, as apart from the story, comes at the beginning when
we learn the matter is being related in the Mexico City. As we know, Mexico
City is located at eight thousand feet, and Amsterdam is a "low country" city.
Yet to confuse further the spatial concept, the height implicit in the bar's name
is contradicted by its location in another kind of "low"place, the waterfront of
a major seaport, visited, we learn, by the lowest of the low. Thus, spatiality is

suggested, yet compromised; it is not simply height versus depth. Space has something of the ambiguity here that time has in *Don Quixote*, the generic archetype of the Camus novel.

That is a beginning. There is also the play of verbs. The novel contains an array of subjunctives—"be," "may," etc.—more noticeable in French than in English, since French has distinct endings for such forms. In his first meeting with the listener—who as narratee is very different from the reader—Jean Baptiste calls attention to his use of the subjunctive and comments that he has a "weakness for that mood." The subjunctive, as contrasted with the indicative, conveys a tentativeness; it turns story into text by way of its verbal suggestivity and it disallows historical veracity. Put another way: a story related in the indicative becomes part of history, whereas a story related in the subjunctive becomes as uncertain as the narrator himself. The shift to an uncommon mood helps subvert closure, and at the same time provides a verbal medium for a narrator whose veracity is questionable. Underlining ambiguity and negating history, it suggests alternatives.

Use of the subjunctive connects to role playing: to the narrator's posing as "pope," a role he may have once played in a prisoner-of-war camp; to his possible harboring of the stolen van Eyck panel from the Ghent Cathedral; to his role as a judge-penitent, which inverts arrogance and humility. The pope: the situation as related indicates that anyone ("everyman") can become pope given the right (wrong?) conditions. Jean-Baptiste evidently passes from disciple to Christ, and becomes pope in the absurdist succession built upon "that rock." But since his name is not really Jean-Baptiste, we must assume he plays at pope in order to derive maximum irony from his name and situation; i.e., in order to subvert or decenter whatever his view of himself is.

In his possible harboring of the van Eyck *The Just Judges*, the stolen panel of *The Adoration of the Lamb*, the narrator plays on further assumptions of identity. The most obvious sense is of himself reflecting a "false judge," since the substitution for the real judges is accepted by viewers as authentic. Thus, while the false is elevated to the real, the real languishes with Jean-Baptiste, who is really a false judge. Once again, the sense of himself he wants to display is undermined by what he actually displays. Where he is in this shuffling of true-and-false is uncertain; that is the point.

In his assumption of the judge-penitent role, Jean-Baptiste once again reverses or inverts the established order, as he has with *The Just Judges*. As counterfeit judges, they are adumbrations of his own role as judge-penitent. The idea of *that* is for him to confess publicly, to offer himself as a worthless human being—in some respects recalling the Ancient Mariner. But Jean-Baptiste has a sinister purpose, which is to elevate himself (heights) as he lowers himself in the listener's eyes (depths). Once he has achieved the nadir, he has positioned himself to judge others; now purified, he can rise. The penitent judges, and lowness reaches heights. The role playing fits in with Jean-Baptiste's view of slavery: having tasted ultimate freedom, he has forsaken it to achieve perfect slavery. Yet slavery is for him an ultimate liberation. As judge-penitent, he has more control than he enjoyed as a successful Parisian lawyer.

Another strategy of his role as judge-penitent is its stress on a listener, the dimension of reader-response. Camus is careful to distinguish "receivers": while we as readers are addressed, the inserted listener is the audience. The latter is

more than a conduit, however, since he determines by what(ever) he says and by his gestures, tone, attitude, interest, boredom what the narrator will say. He is, in effect, a modulatory element, rather than simply a receiver. He is a narratee, although what he "hears" may be different from what we hear, since he is witness to signs made by the narrator that will affect what is said. He is, also, witness to the raw material, whereas we are witnesses to the final product; that is, what is intended for him is not quite what is intended for us. Jean-Baptiste must speak to the narratee and over him: thus the dual function.

Camus has written a novel that seems a perfect text for Postmodern critics—deconstructionists, semioticists, hermeneutics specialists, whatever. Yet the work also fits easily in those aspects of Modernism we have charted in these pages. Although it does have realistic dimensions, the novel owes a great deal to abstraction and nonrepresentational art. In the main, the larger areas of the novel as sifted through Jean-Baptiste's uncertain mind are presented like fading objects, or no objects at all. The episode that nourishes all others, on the bridge leading to the Left Bank, occurs in an atmosphere of receding objects: a fine rain falling, Jean-Baptiste's body numbed from past pleasure and present fatigue, a kind of trancelike state in which he wanders home, a woman in black leaning over the railing, then the sound of a body striking the water, followed by a cry that recedes and stops. The uncertainty and blurring of objects put into question objects themselves; and the arrangement of elements creates less a realistic presentation than a collage of feelings and events lying between conscious and unconscious: that middle state we associated with interior monologue. The fact that a laugh haunts Jean-Baptiste in future years derives from the uncertainty of the original experience. It cannot be expressed in words, but in a sound that approximates a laugh—really a collage of phonemes.

We would be mistaken to see Camus's novel in a context of certainty—French critics after reading it in 1956 saw Camus as moving toward commitment to formal religious belief, for example. That is not it at all. On the contrary, the function of the novel is to upset all certitude, to illuminate in novelistic terms what Derrida would later describe as "difference"; reflecting the Derridean belief that while language reveals the narcissistic ego, at the same time it is logocentric and, therefore, part of the sickness. For Derrida, language is a kind of dread, in Kierkegaardian terms; and for Camus in this novel, language serves many negative functions. Thus, the subjunctive—the first words move us into this troublesome mood.

Well before Derrida, Camus had put all certitude *sous rature* (under erasure). He eliminated centers and made Jean-Baptiste's repentance into a function, not a center. To read repentance as belief is to misread, to read historically and not according to "differences." The background of Camus, apart from philosophical antecedents, is Saussure, who had stressed only differences without positive terms, only the play of distinction, without centers or certitude. There is no totality, no "possible," only delay, spacing, temporalizing, distinction, displacement. Irony serves as the vehicle for Jean-Baptiste's pre-Derridean attack on information theory, and Camus provides the suitable form, in subjunctives. As Derrida indicates, the play of difference is itself the only constant for signs: all signification is duplicitous.

In the chapter following his "confession" of neglect of the suicidal woman, Jean-Baptiste takes the listener (narratee) to see a "negative landscape." He is

defining for the listener a visual equivalent of his own nightmare, a landscape that in spatial and temporal dimensions is the reflection of an inner state. The abstract nature of the novel is intensified in these scenes; for they are not really landscapes so much as inner dimensions, what we find also in Kafka. The point of such landscapes, however, is not only to find equivalents of inner states, it is to provide "colorless space," a life made up of horizontals, when the individual wish, ironically, is for height and depths, differences. Jean-Baptiste's hell is to be immured not only in "flats" but in horizontalism, landscape without relief or escape.*

What, then, do we have? We have a novel that fits into virtually every aspect of Modernism as we have defined it, and yet which lends itself to Postmodern criticism. We recognize how intimately linked such a novel is with parallel and previous developments; so that Modern and Postmodern are not isolated chambers, but incestuously continuous with each other. In 1954, Pierre Boulez, at the peak of his own creativity, attempted to justify himself by leaning heavily on—who else? Mallarmé. Boulez's indebtedness to Mallarmé rested on several points of similarity, but perhaps none more than in the composer's desire to achieve a fluidity that moved below the surface into subtexts of meaning. Just as Mallarmé required a different way of reading, so Boulez would insist on a different way of listening. In his remarks on the poet, he commented that he sought from a musical work the following:

> . . . a musical work in which this separation into homogeneous move-
> ments will be abandoned in favor of nonhomogeneous distribution of
> developments. I demand for music the right to parentheses and italics;
> a notion of discontinuous time, thanks to structures that will be bound
> together rather than remain divided and airtight; finally a sort of devel-
> opment in which the closed circuit will not be the only solution envisaged.

Boulez's plea is for "open music," something that avoids closure, and his own hostility to Schoenberg and strict serial syntax is explicable in these terms. That stress on "discontinuous time" and on opening up hitherto closed circuits brings us back to Mallarmé, but it also creates parallel waves; and in *The Fall*, we see a comparable opening up of form even as the novel achieves almost complete self-referral. Camus's choice of an uncertain narrator has given him access to most of the strategies we associated with Modernism; yet, at the same time, he touches on those aspects of narrative and openness ("decentering") that Postmodern critics cite as essential to the post- phenomenon. We are faced with practices in Modernism that take the ground away from those who wish to relegate it to another era, or bury it. Even in an avant-garde, poststructuralist composer like Boulez of the mid-fifties (before Stockhausen and Cage put him on the run, musically speaking), there is the return to Mallarmé to find the language of expression for his strategies.

The Fall is all subtexts: what really occurs, as we have seen, occurs beyond the reach of narrator and narrative. Water, for example, plays an enormous role in the novel, not solely in the obvious sense that the Netherlands (the "low

* ". . . the sea the color of a weak lye-solution with the vast sky reflecting the colorless waters. A soggy hell, indeed! Everything horizontal, no relief; space is colorless, and life dead. Is it not universal obliteration, everlasting nothingness made visible?"

lands") is below or at sea level. Water "runs through" the novel as the physical counterpart of the human enigma. The Seine, which may or may not have claimed the young woman whom Jean-Baptiste sees on the bridge, forgoes its beauty but gains its power as the Styx, a hellish river. One dies in water, but there is little rebirth; and even baptism, as part of the narrator's assumed name, is suspect.

The water analogy is connected to "unnaming": naming is not the dilemma, unnaming is. Jean-Baptiste is the chief spokesman for divestiture—we never even get close to his real name. He divests himself repeatedly, until Jean-Baptiste Clamence, an ironic usage, establishes him as much as Odysseus fixes himself as No-Man. The listener is, of course, unnamed; so is the female "jumper" and the several people who bounce off the narrator. The water analogy to "unnaming" (to removing characters from all professions and roles that require naming) is this: near-anonymous figures float through a kind of nether existence; they are part of the deliquescence of the surrounding and enveloping water. They are always dimensions of the current or tide, moving past. Through this flow, Camus achieves the remarkable openness of the novel: an interior monologue that "happens" to have a listener, or a series of listeners if Jean-Baptiste's confession is repetitive.

Such matters are subtexts. As to generic inheritance, *The Fall* owes a good deal to confessionals: *Don Quixote*, obviously, but also *Notes from Underground*, various Kafka stories, especially "The Hunger Artist," Marlow's monologues in Conrad stories, Gide's narrative means in *The Counterfeiters*. We have here a good example of Genette's *architext*: that generic unfolding of texts deriving from previous texts. Further, we have the entire literary history of narrative and narrators behind the novel: we can move back as far as *Tristram Shandy*, forward to the devices of Donald Barthelme in *Snow White* or John Barth in *Letters* and the manifold strategies in his *Lost in the Funhouse*, to Joseph McElroy's *Hind's Kidnap*, which is as much about "de-kidnapping" as kidnapping, most evidently to William Gaddis's *JR*.

The Fall fulfills virtually every category of Postmodernism: both its criticism and its practical applications. The Camus novel makes it difficult, if not impossible, to find a point at which Modernism and Postmodernism, in theory or in application, separate. All those matters that seem to be post-this or post-that are embedded in the strategies of *The Fall*. It places the burden of proof on those who insist there has been a major shift, that Modernism has given way to a "post" phase.

This is the perfect resolution for Modern and Postmodern, perhaps for all avant-gardes: a fall. The rest is revisionism. Postmodernism has not terminated Modernism; on the contrary, it has pointed up the resilience of the original movement.

◆ NOTES ◆

I have tried to cite editions that are accessible, so that paperbacks are often referred to. In some instances, I have cited references in both the original language and English translation, especially when poetry is involved or when the exact wording is significant.

FOREWORD

page

- **xi:** "**They had to suffer for being 'new' '**"—Autograph Letter Signed, Duke University Library.
- **xii:** "**it arrests the interest of men. . . .**"—Conrad, *The Nigger of the "Narcissus,"* text from Kent Edition (New York: Doubleday, 1926).
- **xv:** "**could clearly and distinctly be seen.**"—Adolf Hitler, *Mein Kampf* (Boston: Houghton-Mifflin, 1943), p. 261.
- **xv:** "**it was the plain truth.**"—Ibid., pp. 57–58.
- **xviii:** "**the sensation that it is mere appearance. . . .**"—Nietzsche, *The Birth of Tragedy*, trans. by Walter Kaufmann (New York: Vintage, 1967), p. 34.

CHAPTER 1: *Getting to Be Modern: An Overview*

page

- **5–6:** **that which is adversary to reason and authority.**—Plato, in *The Republic*.
- **6:** "**in accordance with his infinity.**"—Kierkegaard, *The Concept of Dread*, trans. by Walter Lowrie (Princeton, N.J.: Princeton University Press, 1944), pp. 139–140.
- **7:** **as a phenomenon that opposed classicism.**—in Stendhal, *Histoire de la peinture en Italie*, in *Ouevres complétes*, III (Paris: Larrive, 1953), pp. 155–241.
- **7–8:** "**he is only one barleycorn higher.**"—Montaigne, *Essays*, trans. by E. J. Trenchman (London: Oxford University Press, 1927), II, p. 545. Pléiade *Montaigne*, 1940, p. 1046.

8: "but Fly-bane and a Cobweb. . . ."—All quotations from Swift, *A Full and True Account of the Battle Fought Last Friday Between the Antient and the Modern Books in St. James's Library*, 1704.

8: "and we see more than they."—Pascal, *Oeuvres complètes*, (Paris: Gallimard Pléiade, 1954), p. 532; from Matei Calinescu, *Faces of Modernity* (Bloomington: Indiana University Press, 1977), p. 18.

9: "where violent sorrow seems / A modern ecstasy."—*Macbeth*, Act 4, sc. 3, lines 167–70.

10: "subject that is susceptible to them."—Bacon, *Works*, Vol. VIII (Boston: Taggard and Thompson, 1868), p. 120.

10: Perrault's stress on rules, his insistence that Modern . . . —Calinescu's book brought Perrault to my attention; the formulation is my own.

11: because it posed a threat:—Renato Poggioli stresses this point. *The Theory of the Avant-Garde* (Cambridge, Mass.: Harvard University Press, 1968).

12: "the fickle-world no longer cares to come!"—Baudelaire, "The Old Clown," *Paris Spleen*, trans. by Louise Varèse (New York: New Directions, 1947), p. 27.

12: "our conception of what nature is not."—Picasso quoted in Herschel B. Chipp, *Theories of Modern Art* (Berkeley: University of California Press, 1968), p. 264.

13: "which is menacing political Europe."—Pfitzner, *Die neue Ästhetik der musikalischen Impotenz (The Musical Impotence of the New Aesthetic)* (Munich, 1920), p. 10.

16: "no less fine to produce than the lines."—Mallarmé, "Sur Poe," *Oeuvres complètes* (Paris: Gallimard Pléiade, 1970), p. 872.

18: "an end immanent in the movement itself."—Poggioli, *The Theory of the Avant-Garde*, p. 20.

20: "more tolerable—indeed, frequently universal—aspects."—Nietzsche, *Die Fröhliche Wissenschaft*, trans. Walter Kaufmann (New York: Vintage, 1974), p. xvii. The original German title is far richer than *The Gay Science*.

21: "verbal equivalent for states of mind and feeling."—Eliot, *Selected Essays* (New York: Harcourt, Brace, 1950), p. 248.

21: "if necessary, language into his meaning."—Ibid.

21: "activist moment."—Poggioli, *The Theory of the Avant-Garde*, p. 24.

25: "remains subject to it."—Jean Moréas, *Le Figaro littéraire*, September 18, 1886.

25: "affinities with primordial Ideas."—Ibid.

27: "the Hope, and the Life?"—Villiers, *Axel*, trans. by June Guicharnaud (Englewood Cliffs, N.J.: Prentice-Hall, 1970), p. 28. All English references come from this edition.

27: "silence in the world."—Ibid., p. 109.

28: "acknowledge the possibility of slavery. . . ."—Ibid., p. 138.

28: "strain toward the Heavens."—Ibid.

28: "must be in its reality."—Ibid., p. 141.

28: "No," responds Axel,—Ibid., p. 146.

29: "we have just lived?"—Ibid., p. 182.

29: "become the Illusion."—Ibid., p. 183.

30: "the images on the back side of the eyes."—Chipp, *Theories of Modern Art*, p. 114.

30: art is "like a crystal"—Ibid., p. 115.

30–31: Modern as having dual components:—Hofmannsthal, *Gesammelte Werke* (Stockholm: 1946), I, 149; quoted in *Modernism*, ed. by Malcolm Bradbury and James McFarlane (London: Penguin Books, 1976), p. 71.

33n.: "the accident of things."—Jarry, *Evergreen Review*, IV, 13 (May–June 1960), 130.

35: "absurdities and improvisations."—Strindberg, *Six Plays of Strindberg*, trans. by Elizabeth Sprigge (Garden City, N.Y.: Anchor, 1955), p. 193.

35: "as is the human soul itself."—Ibid., p. 64.

35: "to guess at things,"—Ibid., p. 98.

37n.: "Nolde, was a Nazi."—Gay, *Freud, Jews and Other Germans* (New York: Oxford University Press, 1978), p. 104.

37n.: "proportionate number in the population."—Stern, *Gold and Iron: Bismarck, Bleichröder, and the Building of the German Empire* (New York: Vintage, 1979), p. 499.

38: an ironic coda—See *Arnold Schoenberg and Wassily Kandinsky: Letters, Pictures and Documents*, ed. Jolena Hahl-Koch (London: Faber, 1984), pp. 76, 77, 78, 79, 81, 82.

CHAPTER 2: *Toward 1885: Thresholds*

page

40: "thus re-enforcing his original melancholy."—Durkheim, *Suicide* (New York; Free Press, 1951), p. 288.

41: "for orders, notice, or advice."—Jean-Paul Sartre, *Baudelaire*, trans. by Martin Turnell (New York: New Directions, 1950) p. 30.

42n.: "the story of liberty."—See chapter six of H. Stuart Hughes, *Consciousness and Society* (New York: Vintage, 1958), p. 217.

43: and *Entfremdung*, signifying estrangement.—Some of this was suggested by David McLellan in his *Karl Marx: His Life and Thought* (New York: Harper & Row, 1973).

45: "by the continuity of time; . . ."—Foucault, *The Order of Things* (New York: Vintage, 1973), p. xxiii.

45: "one of madness and imagination."—Ibid., pp. 48–49.

45: "their former alliance"—Ibid., p. 47.

46: "most obvious, simplest expression."—Nietzsche, *Ecce Homo*, trans. by Walter Kaufmann (New York: Vintage, 1969), pp. 300–301.

46: "the preachers of death."—Nietzsche, *Thus Spoke Zarathustra*, trans. by Walter Kaufmann (London: Penguin, 1978), p. 44.

46: "The time of kings is passed."—Ibid., p. 206.

46: "something that must be overcome."—Ibid., p. 267.

46: "affinities with primordial Ideas."—Moréas, *Le Figaro littéraire*.

46: "down below, in those depths."—Foucault, *The Order of Things*, p. 251.

47: Pierre Janet, an extraordinary man—For an excellent discussion of Janet and related matters, see Henri F. Ellenberger, *The Discovery of the Unconscious: The History and Evolution of Dynamic Psychiatry* (New York: Basic Books, 1970).

48: "in expiatory holocaust?"—Lautréamont, *Maldoror*, trans. by Alexis Lykiard (New York: Crowell, 1972), p. 56.

48: "once the ship had gone down?"—Ibid., p. 73.

48: "great celibate."—Ibid., p. 16.

48: "circus tumbler would be jealous."—Ibid., p. 15.

48: "series of glorious crimes."—Ibid., p. 189. The remaining images of violence follow p. 189.

49n.: "this must happen through me. . . ."—Kierkegaard, *Diary of the Seducer*, in *Either/Or* (Garden City, N.Y.: Anchor, 1959), I, p. 372.

49n.: "will always be a feminine nature."—Ibid., p. 427.

50: "truth speaks out of me."—Nietzsche, *Ecce Homo*, p. 326.

50: "an infinity of sense and sweetness."—Nietzsche, *The Case of Wagner*, trans. by Walter Kaufmann (New York: Vintage, 1967), p. 170.

50: "*difficult enough* to understand."—Ibid., p. 177.

50: "is inevitable shipwreck at best."—Robert Adams, *Nil* (London: Oxford University Press, 1966, 1970), p 155.

51: "if that were possible."—Ibid., p. 68.

51: "urinous offal from all dead."—Joyce, *Ulysses* (New York: Random House, 1934), p. 51.

53: "reality atomic, manageable, and opaque."—Sontag, *On Photography* (New York: Farrar, Straus & Giroux, 1977), pp. 22–23.

53n.: "encroach upon the essential elements."—Matisse quoted in Chipp, *Theories of Modern Art*, p. 132.

54: "can be called a guise."—Adams, *Nil*, p. 132.

55: "aux soubresauts de la conscience. . . ."—Baudelaire, *Oeuvres complètes* (Paris: Gallimard Pléiade, n.d.), p. 405.

55: "par leurs écresantes Chimères."—Ibid., p. 412.

56n.: "on the younger generation in literature. . . ."—Quoted in Jean Pierrot, *The Decadent Imagination: 1880–1900* (Chicago: University of Chicago Press, 1981), p. 27.

57: "puddle in a scented twilight. . . ."—The author's translations. Rimbaud, *Oeuvres complètes* (Paris: Gallimard Pléiade, 1946), p. 103.

57: "Un Coup de Dés"—Mallarmé, *Oeuvres complètes* (Paris: Gallimard Pléiade, 1945), p. 457. Translations by Roger Fry and the author. All quotations that follow are from this edition.

60: he wrote Georges Izambard on May 13, 1971,—Rimbaud, *Oeuvres complètes*, p. 252; followed by the May 15 letter.

61n.: "will it be *our* destiny."—Rilke, *Letters to a Young Poet*, trans. by M.D. Herter Norton (New York: Norton, 1954), pp. 64–65.

61: he begins *Une Saison*— Rimbaud, *Oeuvres complètes*, pp. 205ff.

63n.: in her *Rimbaud*—Starkie, *Arthur Rimbaud* (New York: New Directions, 1961), pp. 162–63.

65: "toward the whirlpool cataracting."—The author's translations.

65: "a value-center,"—Adams, *Nil*, p. 123.

66: "on the color with which I fill it in."— Chipp, *Theories of Modern Art*, p. 63.

66: "in colour, form, and ferocity."—Lautréamont, *Maldoror*, p. 124.

66: "they themselves define the laws."—Foucault, *The Order of Things*, p. 89.

67: In a 1982 article, Bruno Bettelheim—In *The New Yorker* (March 1, 1982), pp. 52–93.

67n.: "that break temporarily the melody."—Kandinsky, *Concerning the Spiritual in Art* (New York: Dover, 1977), p. 39. The book was first published in German in 1911, and then in English, in 1914, as *The Art of Spiritual Harmony*.

70: "un désert stérile de Douleurs."—Mallarmé, *Oeuvres complètes*, p. 37. The author's translations.

70n.: Jean Pierrot points out—In Pierrot, *The Decadent Imagination*.

72n.: " 'God only knows how it really happened.' "—Kierkegaard, *Either/Or*, p. 367.

73: "he turns into a skeleton, etc."—Bartok, *Letters*, ed., by János Demény (New York: St. Martin's Press, 1971), pp. 49–50.

73: *diremption* as a methodology.—For an excellent description of the idea, see *Consciousness and Society*, pp. 173ff.

74: "with Primordial Ideas."—Moréas, *Le Figaro littéraire*.

76n.: needed government support and recognition.—See Peter Paret, *The Berlin Secession: Modernism and Its Enemies in Imperial Germany* (Cambridge, Mass.: Harvard University Press, 1980), p. 135.

78: "the result of his own labour."—McClellan, *Karl Marx: His Life and Thought*, p. 125.

CHAPTER 3: *1885–1900: First Phases—Issues and Novelties*

page

83: "ultimate eternal conformation and seal?"—This and following quotations from Nietzsche, *Thus Spoke Zarathustra*, in *The Portable Nietzsche*, ed. and trans. by Walter Kaufmann (New York: Viking, 1954, 1968).

83: "become new unless you had first become ashes!"—Nietzsche, *Thus Spoke Zarathustra*, p. 204.

85n.: "before the nineteenth century."—From Stanley Edgar Hyman, *The Tangled Bank* (New York: Grosset & Dunlap, 1966), p. 198.

87: "consideration for the offspring. . . ."—Nordau, *Degeneration* (New York: Howard Fertig, 1968), pp. 414–15 for the several quotations.

87: "begetting and of reproduction,"—Weininger, *Sex and Character* (New York: AMS Press, 1975), p. 88.

88: "The absolute female has no ego."—Ibid., p. 186.

88: "regarding her as theoretically beautiful."—Ibid., p. 241.

89: "had been replaced by that of the Demivierge."—Ibid., p. 329.

90: "the amount of maleness in her,"—Ibid., p. 64.

90: "as sexually intermediate forms."—Ibid., p. 65, for this and preceding quotation.

91: "But he mounted right to the top."—Ibsen, *Eleven Plays* (New York: Modern Library, n.d.), pp. 382–83, for this and preceding quotations.

92: "cannot take up a right attitude towards it."—Nordau, *Degeneration*, p. 243.

93: "interplay of sexuality and intelligence."—*Sigmund Freud and Lou Andreas-Salomé, Letters*, ed. by Ernst Pfeiffer (New York: Harcourt, Brace, 1972), p. 10.

93: "utterly different from your own. . . ."—*The Freud/Jung Letters: The Correspondence Between Sigmund Freud and C. G. Jung*, ed. by William McGuire (Princeton, N.J.: Princeton University Press, 1974), p. 14.

94: "spiritual, or cultural term"—Gilman, *Decadence* (New York: Farrar, Straus & Giroux, 1979), p. 16.

95n.: "a sufficient freedom of action."—Gobineau, "Essay on the Inequality of the Human Races," *Selected Political Writings* (New York: Harper & Row, 1970), pp. 59–60.

96: "by a mighty, irresistible impulse."—Krafft-Ebing, *Psychopathia Sexualis* (New York: Putnam, 1965), p. 23; also the succeeding quotation.

98n.: "of certain properties of language."—Valéry, *Oeuvres*, ed. by Jean Hytier (Paris, 1957), I, 1440. Jonathan Culler has an excellent discussion of Valéry's point in his chapter on Roman Jakobson, in *Structuralist Poetics* (Ithaca, N.Y.: Cornell University Press, 1975).

99: "with all its possible subdivisions."—Foucault, *The Order of Things*, p. 283.

100: "the whole field of the signified. . . ."—Lacan, "The Insistence of the Letter in the Unconscious," *Structuralism*, ed. by Jacques Ehrmann (Garden City, N.Y.: Anchor, 1970), p. 106. The succeeding quotation is from p. 100.

101: "questionable, and worm-eaten" opinions,—Nietzsche, *Beyond Good and Evil*, trans. by Walter Kaufmann (New York: Vintage, 1966), p. 127.

101n.: "they are becoming smaller and smaller. . . ."—Nietzsche, *Thus Spoke Zarathustra*, p. 169. Preceding two quotations are from pp. 44 and 32, respectively.

102: "religiously by love to the Deity."—Kierkegaard, *Fear and Trembling*, trans. by Walter Lowrie (New York: Anchor Books, 1954), p. 27; then p. 28.

102: "into the arms of anguished dread."—Kierkegaard, *Either / Or*, p. 77.

102: "great Earthquake,"—Ibid., p. 31.

103: "is precisely the poetry of eternity."—Kierkegaard, *The Sickness Unto Death*, trans. by Walter Lowrie (New York: Anchor, 1954), p. 211.

103: "thereby go beyond her own limitations. . . ."—Kierkegaard, *Either/Or*, p. 357; succeeding quotation is from p. 362.

103: "has its place in psychology."—Kierkegaard, *The Concept of Dread*, p. 38.

104: Writing to his brother—*The Letters of Vincent Van Gogh*, ed. by Mark Roskill (New York: Atheneum, 1979), p. 236.

104n.: "to move the frontier markers."—*Letters* p. 214.

106: In remarks to Fliess—*The Origins of Psychoanalysis: Letters to Wilhelm Fliess, Drafts and Notes: 1887–1902;* ed. by Maria Bonaparte, Anna Freud, and Ernst Kris, trans. by Eric Mosbacher and James Strachey (Garden City, N.Y.: Anchor Books, 1957), pp. 227, 261–66, especially.

108: "immensely wider than the cerebral state,"—Bergson, *Matter and Memory*, first published in 1896. Trans. by Nancy Margaret Paul and W. Scott Palmer (New York: Macmillan, 1911), p. xiii.

108: "the degree of our *attention* to life."—Ibid., p. xiv.

109: The Munich Secession—See Peter Paret, *The Berlin Secession*, p. 35.

111: "as a measure that contravenes common decency."—Ibid., p. 51.

112: "seems to us to constitute art."—Ibid., p. 83.

113n.: "and these are but the death-throes."—Peter Vergo, *Art in Vienna* (London: Phaidon, 1975), p. 206.

115n.: sick with progress.—For this point, see Calinescu, *Faces of Modernity*, p. 294.

116n.: Janik and Toulmin—See Janik and Toulmin's very useful *Wittgenstein's Vienna* (New York: Simon & Schuster, 1973).

116: by Carl Schorske.—In Schorske, *Fin-de-Siècle Vienna: Politics and Culture* (New York: Knopf, 1980).

119n.: The earlier theory lacked the id-model—See Frank Sulloway, *Freud: Biologist of the Mind* (New York: Basic Books, 1979), pp. 328–29.

120: "and of the history of nations."—Nietzsche, *The Birth of Tragedy*, trans. by Walter Kaufmann (New York: Vintage, 1967), p. 59.

120: "and of Dionysian reality.—Ibid., pp. 59–60, for this and following quotations.

122: "with primordial ideas."—Moréas, *Le Figaro littéraire*.

122: Conrad's Preface to *The Nigger of the "Narcissus,"*—Appeared in William Ernest Henley's *The New Review*, after the final installment of *The Nigger* in December 1897; all following quotations come from the Kent Edition of Conrad's work.

122: "an immense sensibility."—All quotations from "The Art of Fiction," 1884, James, *Partial Portraits* (Ann Arbor: U. of Michigan Press, 1970).

123: "in an individual or in a whole people."—Kandinsky, *Concerning the Spiritual in Art*, p. 9.

123n.: "set up a general (very general) principle."—*Arnold Schoenberg and Wassily Kandinsky: Letters*, p. 57.

124: *"form to its inner meaning"*—Kandinsky, *Concerning the Spiritual in Art*, p. 54.

124n.: "in things everywhere, of all good art."—Pater, *Appreciations with an Essay on Style*, 1889, reprinted in *Literary Criticism*, ed. by Lionel Trilling (New York: Holt, Rinehart & Winston), 1970, pp. 252ff.

128: Philosophy in his university ceiling paintings.—See Schorske, *Fin-de-Siècle Vienna*, pp. 227ff.

128n.: Schorske perceives—Ibid., pp. 230–31.

131: as Stephen Heath suggests,—See Heath, "Ambiviolences," *Tel Quel*, 50 (1972), 22–43; also 51 (1972), 64–76.

133: an aggregate of images.—Bergson, *Matter and Memory*, p. vii.

133: "as they interpret it."—Ibid., p. 170.

135: "artificial reconstruction."—Bergson, *Time and Free Will*, trans. by R. L. Pogson (New York: Macmillan, 1921), p. 325, for all quotations.

135: "into movements of locomotion."—Bergson, *Matter and Memory*, p. xiii.

135: "inert and juxtaposed."—Ibid., p. 171; following quotation from p. 176.

136: "that every neurasthenia is sexual."—Freud, *The Origins of Psychoanalysis*, p. 67; following quotation also p. 67.

136: "secrets of nature."—Ibid., p. 85.

136: "benefit to normal psychology."—Ibid., p. 94.

136: "rapidly became impenetrable."—Musil, *The Man Without Qualities*, trans. by Eithne Wilkins & Ernst Kaiser (New York: Capricorn, 1965), p.365.

137: be understood and expressed.—Sulloway, *Freud: Biologist of the Mind*, handles this phase of Freud's transformation with great sensitivity.

139: "to their lineaments."—See Jarry, *Evergreen Review*, pp. 128–38 for all quotations.

139: "which the living cannot conceive."—Jarry, *Le Surmâle*, translated as *The Supermale* by Ralph Gladstone and Barbara Wright (New York: New Directions, 1977), pp. 34–35.

140: "combat and destroy triviality"—Baudelaire, *The Essence of Laughter*, ed. by Peter Quennell (New York: Meridian Books, 1956), p. 48; following quotations from pp. 48, 49, 50, respectively.

143: In an 1893 letter—February 7, 1893, Gustav Mahler, *Selected Letters*, ed. by Knud Martner (New York: Farrar, Straus & Giroux, 1979), p. 148.

144: In another letter,—Ibid., p. 178.

144: "no longer my own master."—Ibid., p. 190.

144: "dead to the outside world."—Ibid.

144: "disposal for the expression of his feelings. . . ."—Matisse quoted in Chipp, *Theories of Modern Art*, p. 168.

144: "heart, brain and eye of man."—Ibid., p. 330.

145: "outward and coarse naturalism.—Stanislavski, *My Life in Art* (New York: Meridian Books, 1956), p. 330.

145: "as the divine expression of the human spirit,"—Duncan, *My Life* (New York: Liveright, 1955), p. 75. Originally published in 1927.

145: "through which the soul can flow,"—Ibid., p. 175.

147: "marks a cultural stage. . . ."—This and following quotations from Bachofen, *Myth, Religion and Mother Right* (Princeton, N.J.: Princeton University Press, 1967), p. 71, 83, 103. Originally published as *Das Mutterrecht*, 1861.

148: "the earth that bears all things. . . ."—Ibid., pp. 109–10.

148n.: "functional sign of degeneration."—Phrases from Krafft-Ebing, *Psychopathia Sexualis*, p. 268.

150: "intend to force open"—This and following quotation from Schreiner, *Woman and Labor* (1911), quoted by Vera Brittain, *Testament of Youth* (n.p: Wideview Books, 1980), p. 41.

150: "to my personal plans."—Ibid., p. 17.

151: "exploration of the woman question."—This quotation from Engel and Rosenthal, eds., *Five Sisters: Women Against the Tsar* (New York: Alfred A. Knopf, 1975), p. 210.

152: "the ecstasies of worship and suffering."—Strindberg, *A Madman's Defense*, trans. by Evert Sprinchorn (New York: Anchor Books, 1967), pp. 42–43.

153: "all her troubles, all her cares."—Ibid., p. 144. Previous quotation, p. 65.

155: "from the bitterness of her early emotions."—Brittain, *Testament of Youth*, p. 59. Following quotation, p. 102.

158: "if no one has superfluity."—Durkheim, *Suicide* (New York: Free Press, 1951), p. 254.

162: "lives in him in spiritual form."—Kandinsky, *Concerning the Spiritual in Art*, p. 47.

162n.: "were being rendered in the Jewish jargon."—Wagner, "Jews in Music," *Wagner on Music and Drama*, ed. by Albert Goldman and Evert Sprinchorn, trans. by H. Ashton Ellis (New York: Dutton, 1964), p. 56.

164: "Qui me contemplent fixement."—Baudelaire, *Oeuvres complètes*, p. 64.

164: "to sculpt his own tomb,"—Mallarmé, "Réponses à des enquêtes sur l'evolution littéraire," *Oeuvres complètes*, p. 870.

CHAPTER 4: *Spiritual Autobiography and Modernism*

page

170: for Jane Eyre at Lowood, for example.—Anyone commenting on this subject is indebted to several previous writers, nearly all of them concerned with the traditional *Bildungsroman*. Among them: Jerome Hamilton Buckley's *Season of Youth: The Bildungsroman from Dickens to Golding* (Cambridge, Mass.: Harvard University Press, 1974), with chapters on Dickens, Meredith, Eliot, Pater, Hardy, Wells, Lawrence, Joyce, and others; Susanne Nobbe's *Wilhelm Meister and His English Kinsmen* (New York: Columbia University Press, 1930), a pioneer study of a narrow phase of the *Bildungsroman*; Justin O'Brien's *The Novel of Adolescence in France* (New York: Columbia University Press, 1937), which makes useful distinctions for the novel in France both before 1890 and after; various essays, especially Buckley's "Autobiography in the English *Bildungsroman*," in *The Interpretation of Narrative: Theory and Practice*, ed. Morton W. Bloomfield (Cambridge, Mass.: Harvard University Press, 1970); G. B. Tennyson's "The *Bildungsroman* in Nineteenth-Century English Literature," in *Medieval Epic to the "Epic Theater" of Brecht*, eds. Rosario P. Armato and John M. Spalek (Los Angeles: University of California Press, 1968), for useful distinctions between the *Bildungsroman* and the *Entwicklungsroman*; for further glimpses of the problem involved in definition, see Harry Levin, *The Gates of Horn* (New York: Oxford University Press, 1963); François Jost, "La Tradition du *Bildungsroman*," *Comparative Literature* XXI, (1969), 97–115; Victor Brombert, *The Intellectual Hero: Studies in the French Novel 1880–1955* (New York: Lippincott, 1961); also, his *Stendhal: Fiction and the Themes of Freedom* (New York: Random House, 1968); Leo Bersani, *A Future for Astyanax: Character and Desire in Literature* (Boston: Little, Brown, 1976); W. M. Frohock, *The Novel of Violence in America* (Boston: Beacon Paperback, 1964). Of related interest: Mario Praz, *The Hero in Eclipse in Victorian Fiction* (London: Oxford University Press, 1956); Leo Braudy, *Narrative Form in History and Fiction* (Princeton, N.J.: Princeton University Press, 1970); Ralph Freedman, *The Lyrical Novel: Studies in Hermann Hesse, André Gide, and Virginia Woolf* (Princeton, N.J.: Princeton University Press, 1963); Dorrit Cohn, *Transparent Minds: Narrative Modes for Presenting Consciousness in Fiction* (Princeton, N.J.: Princeton University Press, 1978); Elaine Showalter, *A Literature of Their Own: British Women Novelists from Brontë to Lessing* (Princeton, N.J.: Princeton University Press, 1977); René Giraud, *Deceit, Desire, & the Novel: Self and Other in Literary Structure* (Baltimore: The Johns Hopkins Press, 1965).

171: "splendid isolation."—Quoted by Ronald Clark, *Freud: The Man and the Cause* (New York: Random House, 1980), p. 140.

172: younger brother who died at eight months.—an excellent account of Freud's self-analysis comes in Frank Sulloway's *Freud: Biologist of the Mind: Beyond the Psychoanalytic Legend* (New York: Basic Books, 1979), especially pp. 207ff.

172: "defecate on his head!"—Ernest Jones, *The Life and Work of Sigmund Freud* (New York: Basic Books, 1955), II, p. 274.

173: "and was not merely imagined."—Clark, *Freud: The Man and the Cause*, p. 177.

173: "than to take flight before it."—Ibid., p. 245.

175: "never find an imitator."—Rousseau, *Confessions* (New York: Modern Library, n.d.), p. 3.

176: "must be surrounded by walls. . . ."—Ibid., p. 177.

176: "one has called *lies* truth."—Nietzsche, "Why I Am a Destiny," *Ecce Homo*, p. 326 (*Werke in Drei Bünden*, II, p. 1152.).

177: "the earth knows *great politics*."—Ibid., p. 327 (*Werke*, II, p. 1153).

177: "but this is—being creative."—Ibid.

177: "cannot easily taste them."—Ibid., p. 224 (*Werke*, II, p. 1073).

177: "as a kind of will to hibernate."—Ibid., p. 229 (*Werke*, p. 1077).

178: "being the bad conscience"—Nietzsche, *Beyond Good and Evil*, p. 137 (*Werke*, II, p. 677).

178: "is overrich in will."—Ibid., p. 139 (*Werke*, II, p. 678).

178: "rarely looks up, rarely loves. . . ."—Ibid., p. 140 (*Werke*, II, p. 680).

179: "to do with one's freedom."—Gide, *L'Immoraliste* (Paris: Gallimard Pléiade, 1958), p. 372.

180: "to its outcome of luxury?"—Ibid., p. 411.

180: "who has risen from the grave.—Ibid., p. 424.

180n.: "acknowledge one's own humanity!"—Joyce, *Stephen Hero* (New York: New Directions, 1944), pp. 142–43. Written 1904–6.

183: "The *racune* of what is great."—Nietzsche, *Ecce Homo*, p. 303 (*Werke*, II, pp. 1133–34).

184: an artistic medium of sorts.—See Paul Fussell, *The Great War and Modern Memory* (New York: Oxford University Press, 1975), p. 41; also Robert Wohl, *The Generation of 1914* (Cambridge, Mass.: Harvard University Press, 1926).

185: "new values have always dwelt."—Nietzsche, *Thus Spoke Zarathustra*, p. 52.

186: "I had brought with me."—Hesse, *Peter Camenzind, Gesammelte Werke* (Frankfurt: Suhrkampf, 1970), I, p. 375.

186: "in southern lights and colors."—Ibid., p. 452.

186: "in the lap of eternity."—Ibid., p. 455.

186: "do you want to be world-weary?"—Nietzsche, *Thus Spoke Zarathustra*, p. 206.

187: "knows his own innermost nature."—Hesse, *Peter Camenzind*, p. 457.

187: "out of his imagination."—Hesse, *Unterm Rad (Beneath the Wheel)*; *Werke*, II, p. 50.

187: "and its growth thwarted."—Ibid., p. 30.

188: "from the enjoyment of life."—Hesse, *Gertrud*; *Werke*, op. cit., III, p. 97.

188: "to a slight degree."—Ibid., p. 32.

189: "believe them to be true."—Hesse, *Gertrude*, trans. by Hild Rosner (New York: Noonday Press, 1969), p. 73.

189: "appeared without as mask. . . ."—Ibid., p. 34.

189: "and no one understands you."—Ibid., p. 153.

189: "what makes him different from others."—Ibid., p. 155.

189: "illusory at one and the same time."—Quoted by Richard M. Matzog, *Hermann Hesse* (Stuttgart, 1947), pp. 13f.; also in *Modernism*, ed. by Bradbury and McFarlane, p. 89.

190: "and what is forbidden."—Hesse, *Demian* (New York: Bantam, 1966), p. 53.

190: "man who expresses it."—Wilde, *Dorian Gray*, in *The Viking Portable Wilde* (New York: Viking, 1946), p. 149.

191: "with fearful impulses."—Ibid., p. 353.

191: "desire to act."—Ibid., p. 278.

192: "contemplate within ourselves."—Proust, *Jean Santeuil* (Paris: Gallimard Pléiade, 1971), p. 319; (New York: Simon and Schuster, 1956), p. 119.

192n.: "than that he saw."—Pater, *Marius* (New York: Modern Library, n.d.) p. 36.
 193: "describing, essentially futile.' "—Proust, *Jean Santeuil*, Pléiade, p. 440; S & S,
 p. 191.
 193: "by our young decadents.' "—Ibid., p. 442; p. 193.
 193: "once for all by contemplation."—Ibid., pp. 407–8; p. 399.
 194: "into a reality directly felt."—Ibid., p. 408; p. 399.
 194: "*accompanied* by the smell. . . ."—Ibid.
 194: "temporal circumstances of my life. . . ."—Ibid., p. 409; p. 400.
 194: "identical past and present."—Ibid., p. 410; p. 401.
 194: "that leaves us without hope."—Ibid., p. 423; p. 570.
 194: "gold-tinted flesh colours."—Ibid., p. 472; p. 601.
 195: "in a blur of perpetual indifference. . . ."—Musil, *Young Törless* (New York:
 Noonday Press, 1958), p. 15. *Die Verwirrungen des Zöglings Törless, Gesammelte
 Werke* (Hamburg: Rowohlt, 1978), II, quotations from p. 16, 49, 74, 114, 121,
 121, 136–7, 137, 241, respectively.
 195: "and undreamt of surprises."—Ibid., p. 53.
 196: "uncannily loomed before him."—Ibid., p. 65.
 196: "a merely external semblance."—Ibid., p. 83.
 196: "the whole of it were there?"—Ibid., p. 106.
 197: "purely mathematical thought."—Ibid., p. 111.
 197: "lost his sense of direction."—Ibid., p. 173.
 197: "in a fathomless ocean."—Ibid., p. 177.
197n.: thought processes.—Ibid., p. 183.
 197: "near to death as to life."—Ibid., p. 184.
 197: "of its own life."—Ibid.
 198: "blood-warm, living flesh. . . ."—Ibid., p. 210.
 198: "of our innermost being."—Ibid., p. 211.

CHAPTER 5: *1900: Annus Mirabilis—A Gathering of Forces*

page
 199: "epoch of human history. . . ."—Wallace, *The Wonderful Century* (New York:
 Dodd, Mead, 1898, 1899), p. 156.
 200: "process is sometimes amusing."—Conrad, December 20, 1897; Autograph Let-
 ter Signed, Dartmouth.
 201: "as the hope of tomorrow. . . ."—Conrad, January 14, 1897; ibid.
205n.: "related for aural matrimony . . . ?"—Huneker, quoted by Dika Newlin, *Bruck-
 ner, Mahler, Schoenberg* (New York: Norton, 1978), p. 248.
205n.: "two times two is four."—Vera Stravinsky and Robert Craft, *Stravinsky in Pic-
 tures and Documents* (New York: Simon and Schuster, 1978), p. 106.
207n.: in a prize contest—Newlin, *Bruckner, Mahler, Schoenberg* p. 216.
 209: "in this specific instance."—Ibid. p. 215.
 214: "snatches part of their life away."—In Marcel Brion, *Kandinsky* (New York:
 Abrams, 1961), p. 19.
 214: "thinking of any object."—Ibid., p. 25.
214n.: "period in painting is over. . . ."—John Elderfield, *Fauvism: The "Wild Beasts"
 and Its Affinities* (New York: The Museum of Modern Art, 1976), p. 30.
214n.: "simpler in its synthesis."—Ibid., pp. 30–31.
214n.: "giving our instinct a plastic consciousness."—Chipp, *Theories of Modern Art*,
 p. 209.
 215: for he is reputed—Ibid., pp. 217ff.
 215: "to the art of the writer,"—Ibid., p. 223.

216: "the inner life in everything,"—Kandinsky, *Concerning the Spiritual in Art*, p. 17.
216: "about the canvas."—Ibid., p. 18.
217: "that had inspired it."—Brion, *Kandinsky*, p. 33.
219n.: "the soul and jerks and quivers."—Maurice Bowra, *The Symbolist Movement* (London: Macmillan, 1951), p. 116.
220: Richard Ellmann also points—Ellmann, *Yeats: The Man and the Mask* (New York: Dutton Paperback, n.d.), p. 73.
222n.: Yeats's 1901 essay "Magic"—Ibid, p. 91.
224: "the law of one's art."—Ibid., p. 141.
224: telling AE that "good writing"—March 1898; ibid., p. 141.
224: "feeling far more masculine."—January 1903; ibid., p. 153.
225: "the terrible mirror of its blade."—1904; ibid., p. 181.
228: "have the same curious astringent joy."—September 26, 1902; Yeats, *Letters*, ed. Allan Wade (New York: Macmillan, 1955) p. 379.
228: "its own right to exist."—Ibid., p. 342.
229: "as far as possible."—Ibid., p. 402.

CHAPTER 6: *Stream of Consciousness and Enclosure: Infinitude and Labyrinth*

page

233: "psychic being of the characters."—Robert Humphrey, *Stream of Consciousness in the Modern Novel* (Berkeley: University of California Press, 1959), p. 4; following quotation from p. 3.
233n.: "or, more learnedly, endophasy."—Dorrit Cohn, *Transparent Minds: Narrative Modes for Presenting Consciousness in Fiction* (Princeton, N.J.: Princeton University Press, 1978), p. 77.
233n.: "and yet its continuous change."—Leon Edel, *The Modern Psychological Novel* (New York: Grove Press, 1955), p. 19.
233n.: "described by William James."—Ibid., p. 55; following quote from p. 104.
233n.: "a stretching of consciousness."—Erich Kahler, *The Inward Turn of Narrative* (Princeton, N.J.: Princeton University Press, 1973), p. 5.
233n.: "than the other way round."—Wayne C. Booth, *The Rhetoric of Fiction* (Chicago: University of Chicago Press, 1961), p. 55.
234n.: "an origin of consciousness."—Gaston Bachelard, *The Poetics of Reverie*, trans. by Daniel Russell (New York: Orion Press, 1969), p. 1; following quotation from p. 13.
234n.: "tracking worm devours."—Trans. by Barbara Gibbs in *An Anthology of French Poetry from Nerval to Valéry* (New York: Anchor, 1962), p. 274.
235n.: "loved a long the riverrun. . . ."—Joyce, *Finnegans Wake* (New York: Viking, 1947), p. 619.
235n.: "wave-planes of seas. . . ."—Broch, *The Death of Virgil* (New York: Grosset & Dunlap, 1965), p. 31; following quotation is from p. 39.
236: "the actuality of our present lies."—Bergson, *Matter and Memory*, p. 178.
236: "is the memory whence it arose."—Ibid., p. 181.
237: "to psychical states."—Ibid., p. 192.
237: "to which it is referred."—Ibid., p. 255.
237: "state than of a thing,"—Ibid., p. 259.
237: "exigencies of social life."—Ibid., pp. 238–39.
237n.: "eventual action upon matter."—Ibid., p. 280.
238: "sensory impression,"—*PMLA*, LXV (June 1950), p. 342.

238: "in astonishing disorder."—Woolf, *The Captain's Death Bed and Other Essays*
(New York: Harcourt Harvest, 1950), p. 118.

240n.: *"de repos"*—Bachelard, *The Poetics of Reverie* and *Earth and Reveries of Repose.*

241n.: "for the sake of harmony."—Beckett, *The Lost Ones* (New York: Grove, 1972),
p. 7.

242: on to *The Trial,*—All quotations from Kafka, *The Trial,* derive from the Knopf
edition (New York: 1960), trans. by Willa and Edwin Muir.

243: "possibility of the new arrest."—Ibid., p. 191.

244: "clung to her like a sheet."—Woolf, *Mrs. Dalloway* (New York: Modern Library,
1928), pp. 45–46.

245: "with grass and wild berries."—Woolf, *To the Lighthouse* (New York: Harcourt,
1927), p. 208.

245: "stirring in her sleep."—Ibid., p. 214.

245: "is warranted or unwarranted."—Kafka, *Diaries 1914–23,* ed. by Max Brod (New
York: Schocken Books, 1949), p. 104.

246: "of this little extra distance."—Ibid., p. 209, January 23, 1922.

247: "this waiting, this inviolability."—Kafka, *The Castle* (New York: Knopf, 1951),
trans. by Edwin and Willa Muir, p. 140.

247: "my desk at night."—June 26. Kafka, *Letters to Felice* (New York: Schocken
Books, 1973), p. 279.

247: "would be my only exercise."—Ibid., p. 156; January 14–15, 1913.

248: "at the mercy of all evil forces?"—Kafka, *Letters to Friends, Family, and Editors,*
trans. by Richard and Clara Winston (New York: Schocken Books, 1977), pp.
333–34.

250: "Description of a Struggle"—All references to "Description" derive from Kafka,
The Complete Stories (New York: Schocken Books, 1971), pp. 9–51.

250n.: Politzer's term—Hans Politzer, *Franz Kafka: Parable and Paradox* (Ithaca, N.Y.:
Cornell University Press, 1966), p. 29.

251: "your western slope delight me.' "—Kafka, *The Complete Stories,* pp. 25–26.

252: "cast into the river."—Ibid., p. 28.

252: "what you suspect me of."—Ibid., pp. 30–31.

252: "on the altar, so to speak."—Ibid., p. 33.

252: "steady as a statue."—Ibid., p. 34; following quotation from p. 35.

252: "become a little loose."—Ibid., p. 36.

253: "and acquire a body."—Ibid., p. 44.

253: "He walked with difficulty."—Ibid., p. 46; following quotation from p. 47.

254: "take a look at my chest.' "—Ibid., p. 49.

254: "the fashion that winter."—Ibid., p. 51.

255n.: *Absalom, Absalom!*—All references derive from Faulkner, *Absalom, Absalom!*
(New York: Modern Library, 1951).

257: As Kahler—In Kahler, *The Inward Turn of Narrative.*

257: A related point—For an extensive discussion of the epistolary technique in Rich-
ardson, see Karl, *The Adversary Literature: The English Novel in the Eighteenth
Century. A Study in Genre* (New York: Farrar, Straus and Giroux, 1974).

257: as one critic described the method—George Sherburn.

255n.: *Absalom, Absalom!*—All references derive from Faulkner, *Absalom, Absalom!*
(New York: Modern Library, 1951).

261: "of not people, in not language. . . ."—Faulkner, *Absalom, Absalom!,* p. 9.

262: Only three pages—Ibid., p. 9.

264: "stream of numbers."—Ibid., p. 59.

264: "I saw light and breathed?"—Ibid., Chapter III, for proliferating figures.

265: no narrator for it—Ibid., pp. 355–58.

266: "which you can't bear."—Ibid., p. 356.

266: "I am a nigger to stop me."—Ibid.

CHAPTER 7: *1900–1925: Within a Budding Grove*

page

268n.: "and became what it is now."—Chipp, *Theories of Modern Art*, p. 266.

270: "with others who are dead."—Apollinaire, *Apollinaire on Art*, ed. by LeRoy Breunig, trans. by Susan Suleiman (New York: Viking, 1972), p. 48.

270: "It is time we became the masters."—Ibid.

271: "every man invents new ones."—Ibid.

271: "which alone produces ecstasy."—Ibid.

271: "Zone" gains —For an excellent essay on the poem, see LeRoy Breunig, "The Chronology of Apollinaire's *Alcools*," *PMLA* LVUII (December 1952). Breunig charts what period each poem in *Alcools* belongs to, locating "Zone" in the Auteuil period, when Marie Laurencin is responsible for Apollinaire's renewed interest in Paris. For the text: *Alcools: Poems 1898–1913*, trans. by William Meredith (New York: Anchor Books, 1965).

273: "the dead art / Of poetry. . . ."—"Hugh Selwyn Mauberley: (Life and Contacts)," from *Lustra*, 1915; in Pound, *Personae: The Collected Poems of Ezra Pound* (New York: New Directions, 1926).

274: "that were formerly ignored."—Pierre Cabanne, *Pablo Picasso: His Life and Times. A Biography* (New York: Morrow, 1977), p. 233.

274: "dealing primarily with forms."—Ibid.

279n.: "out of time and in space."—Douglas Cooper, *The Cubist Epoch* (London: Phaidon, 1970), p. 159.

282: "these objects and basic forms."—Chipp, *Theories of Modern Art*, p. 258.

283: ideas of the void.—See John Golding, "Cubism," in *Concepts of Modern Art*, ed. by Nikos Stangos (New York: Harper & Row, 1974), p. 68.

284: "rather than an empty, negative space."—Ibid.

285: "coincide with a given subject."—Cooper, *The Cubist Epoch*, p. 205.

286: "to set up a new order."—Françoise Gilot, *Life with Picasso* (New York: McGraw-Hill, 1964), p. 75.

286: "the reality in nature."—Ibid., p. 77.

286: To Kandinsky, he writes —Chipp, *Theories of Modern Art*, pp. 318, 319.

287: "the past, everything, for entombment."—From Delaunay, *Notebooks*, in Jean Clay, *Modern Art: 1890–1918 (New York: Vendome Press, 1978)*, p. 167.

288: "the metallic quality of industry."—Chipp, *Theories of Modern Art*, p. 339; following quotations from pp. 340, 341.

288: "the void beyond this feeling."—Ibid., p. 343.

289: "the unfigurative creation."—Clay, *Modern Art*, p. 216.

289: "surface of canvas to space."—Ibid., p. 346.

292: "the higher activities of the mind"—Freud, *Three Essays on the Theory of Sexuality* (New York: Basic Books, 1962), p. 15.

292: "background of abnormal sexual conduct."—Ibid., p. 27.

292: "sexual activity of the patient."—Ibid., p. 29.

293: "by a special chemistry."—Ibid., p. 83.

294: "or even its cessation."—Ibid., p. 100.

294n.: "This is the Line."—Kandinsky, *Point and Line to Plane*, (New York: Dover, 1979), p. 54.

295n.: "sad beyond all measure."—Kafka, *The Guardian of the Tomb*, in *Seven Expressionist Plays*, trans. by J. M. Ritchie and H. F. Garten, ed. by J. M. Ritchie (London: Calder, 1968), p. 61.

297: In the sonnet "Salut,"—Mallarmé, *Oeuvres complètes* (Paris: Gallimard Pléiade, 1945), p. 27.

298n.: The episode of tea and madeleine—In the C. K. Scott Moncrieff trans., *Swann's Way* (New York: Modern Library, 1928), pp. 54ff; in the *Pléiade Oeuvres complètes* of Proust (Paris: Gallimard, 1954), I, p. 44ff.

300: "along the ground,"—Proust, *The Past Recaptured*, trans. by Andreas Mayor (New York: Vintage, 1971), p. 123.

302: "the images which they released. . . ."—Ibid., p. 139.

303: "that is to say to discover it."—Ibid., p. 140.

303: "in a certain measure, in us"—Bergson, *Creative Evolution* (New York: Modern Library, n.d.), p. 324, for all quotations. The Bergson book appeared in 1907.

303: "by arrangements in colour."—Ezra Pound, *Gaudier-Brzeska: A Memoir* (New York: New Directions, 1970), p. 87. The Pound book appeared in 1916.

304: "set on top of another."—Ibid., p. 89; following quotation also from p. 89.

305: "pulses of the air into revelations."—James, *Partial Portraits*, p. 388.

305: "seemed to him to be most impossible."—Proust, *The Past Recaptured*, p. 248.

306: "delivered his studied sentences. . . ."—Ibid., p. 196; following quotation also from p. 196.

306: "kindliness or effort."—Ibid.

307: "intelligence, our habits"—Ibid., p. 152.

307: "had caused them to lose"—Ibid., p. 153.

307: "a whole instant of my life"—Ibid., p. 131.

307: "I carried about within me."—Ibid., p. 271.

313: "it is possible for us to extract."—Ibid., p. 138.

315: George Perle tells us—In program notes for *Pierrot lunaire, The Music of Arnold Schoenberg*, Vol. I (Columbia Stereo).

316: its function as "moon poem."—Ibid.; see libretto.

317: "parcelling out of isolated parts,"—quoted in Clay, *Modern Art*, p. 150.

318: "wonderful color intoxication."—Ibid., p. 171.

318n.: Picasso spoke offhandedly—Ibid., p. 232.

318n.: "Rilke has called inner space"—Kahler, *The Inward Turn of Narrative*, pp. 5–6.

329: "but impersonally deadly."—Mann, *The Magic Mountain* (New York: Knopf, 1951), p. 467.

329: "in the blind white void. . . ."—Ibid., p. 478.

329: "time trance" and "shapeless morsels"—Ibid., p. 480.

329: "forced himself to do so."—Ibid., p. 481.

329: "lips dripped blood."—Ibid., p. 494.

329: "spun themselves in his brain . . . ?"—Ibid., p. 497.

329: For Joyce, in *Ulysses,*—All references are to the Modern Library edition (New York: 1934).

333: "not enough of nothing in it."—John Cage, *Silence* (Middletown, Conn.: Wesleyan University Press, 1961), p. 84.

333: "it must embrace everything"—Laurence Davies, *Paths to Modern Music* (New York: Scribner's, 1971), p. 53.

335: "it burned also internally."—Paul Griffiths, *History of Avant-Garde Music* (New York: Oxford University Press, 1978), p. 26.

335n.: "communist brass instruments. . . ."—Stravinsky and Craft, *Stravinsky in Pictures and Documents* (New York: Simon & Schuster, 1978), pp. 201–2.

338: "produces a new rhythm."—Ibid., p. 525. The following quotations come from pp. 525–26.

338: "to others it seemed revolutionary. . . ."—Ibid., p. 194.

338: "the innate need to create,"—Ibid., p. 193.

338: new art form—See Richard Buckle's *Nijinsky* (New York: Avon, 1975).

340: "in all their perfection. . . ."—Griffiths, *History of Avant-Garde Music*, p. 55.

343: "It could be those ways."—*Einstein on the Beach* libretto (The Tomato Music Company, Ltd., 1979).

344: Giles Swayne's *Cry*,—I am indebted to Andrew Porter, music critic of *The New Yorker*, for calling my attention to *Cry*.

346: "to the mentality of children."—In Marcel Jean's *The History of Surrealist Painting*, trans. by Simon Watson Taylor (London: George Weidenfeld & Nicolson Ltd., 1960), p. 53.

346: "aspires to the domain of the real."—Quoted in Anna Balakian's *Surrealism: The Road to the Absolute* (New York: Noonday Press, 1959), p. 75.

348: "between perspective and metaphysics?"—In Marcel Jean, *Surrealist Painting*, p. 126.

348: "because I hate common sense."—From Tzara, *Dada Manifesto 1918*, quoted by Mary Ann Caws, *Tristan Tzara: "Approximate Man" & Other Writings* (Detroit: Wayne State University Press, 1973), p. 149.

349: "and in Rumanian; DADA."—Ibid.

349: "infinite sense and definite means."—"Dada and Surrealism," by Dawn Ades, in *Concepts of Modern Art*, p. 114.

349: "let's spit on humanity."—Marcel Jean, *Surrealist Painting*, p. 65.

349: "as I am against manifestoes. . . ."—Ibid., p. 69.

350: "systematizes the bourgeoisie."—Ibid., p. 75.

350: "of all hierarchy and social equation. . . ."—Caws, *Tristan Tzara*, p. 156.

350n.: "two educations, two environments."—T. E. Lawrence, *The Seven Pillars of Wisdom* (London: Penguin Books, 1976), p. 31.

350n.: "served to manure a field."—Ibid., pp. 466–67.

351: "nonsequitors: LIFE."—Caws, *Tristan Tzara*, p. 157.

352: "heavy gray intestines."—Ibid., p. 155.

352: In *Approximate Man*,—Tzara, *L'Homme approximatif* (1931); the text appears in the volume trans. by Mary Ann Caws.

354: The final section—Ibid., p. 61.

354: "the honey of ages to come"—Ibid., p. 63; following quotations come from pp. 64 and 65.

354: "no one but oblivion ventures"—Ibid., p. 65.

356: "modest *recording devices*."—Stangos, ed. *Concepts of Modern Art*, p. 126. The basis for these remarks is Breton's *Manifeste du Surréalisme*, Paris, October 1924.

356: "consciousness is only a small part."—Ibid., p. 129; the basis of these remarks is *Artistic Genesis and Perspective of Surrealism*, 1941, reprinted in Breton, *Surrealism and Painting* (New York: Icon Editions, Harper & Row, 1972).

356n.: *Cannibal Manifesto*— Stangos, ed. *Concepts of Modern Art*, p. 122.

357: "and shooting at random."—See Anna Balakian, *André Breton* (New York: Oxford, 1971), p. 96.

357: Marinetti Futurist Manifesto of 1909—*Marinetti: Selected Writings*, ed. by R. W. Flint, trans. by Flint and Arthur A. Coppotelli (London: Secker & Warburg, 1972), p. 42.

358n.: their demands for Germany:—Chipp, *Theories of Modern Art*, pp. 381–82.

358: "be that which is contained."—Balakian, *André Breton* p. 154; from Breton, *Surrealism and Painting*, p. 74.

359: "are now emerging pathologically."—Balakian, *André Breton*, p. 53.

359: *L'Union libre* in 1931—For the complete poem and English translation, see *Poems of André Breton*, trans. and edited by Jean-Pierre Cauvin and Mary Ann Caws (Austin: University of Texas Press, 1982). Also recommended is its Introduction: "The Poethics [sic] of André Breton" by Jean-Pierre Cauvin.

360: *Poisson soluble*,—Ibid., pp. 44–45.

360: "Vigilance" in 1932,—Ibid., pp. 78–79.
361: Surrealist Manifesto.—See Cauvin and Caws, *Poems of André Breton*, p. xix.
361: "or will cease to exist."—Breton, *Surrealism and Painting*, p. 4.
362: "whatever has constrained it hitherto."—Ibid.
362: "superimposed, one upon the other."— Stangos, ed. *Concepts of Modern Art*, p. 128; from Max Ernst's *Beyond Painting*, trans. by Dorothea Tanning (New York, 1948), p. 7.
363: "the hope of determining this point."—Ibid., p. 134; from Breton's Second Manifesto, in 1930.
363: "the strict domination of life by thought."—Breton, *Surrealism and Painting*, p. 46.
363: "solid threads of desire."—Marcel Jean, *The History of Surrealist Painting*, p. 227.
365: "solely by its own momentum."—Breton, *Surrealism and Painting*, p. 277.

CHAPTER 8: *Pound and the Crisis of Modernism*

page

367: the press release for the prize—Reprinted in *A Casebook on Ezra Pound*, ed. by William Van O'Connor and Edward Stone (New York: Crowell, 1959), p. 44.
369n.: some of these eleven Cantos—All references to the Pisan and other Cantos will be to Pound, *The Cantos* (New York: New Directions, 1948).
370: "put order in his dominions."—Canto 13, p. 59.
371: "I came to a place"—Canto 14, p. 61.
372: "the beast with a hundred legs . . ."—Canto 15, p. 64.
372: "the more I desire that it exist. . . ."—December 18, 1919.
373: "in the lower intellectual orders. . . ."—*Pound/Joyce: The Letters of Pound to James Joyce*, ed. by Forrest Read (New York: New Directions, 1967), p. 194.
373: "all the circumambient peripherization."—Ibid., p. 227.
375: "a leaf in the current"—Canto 81, p. 97, *The Pisan Cantos*.
380: "not very new either."—Canto 74, p. 4, *The Pisan Cantos*.
381: Kenner cites Max Ernst—Hugh Kenner, *The Pound Era* (Berkeley: University of California Press, 1971), p. 135.
381: "fools to pay rent for their credit. . . ."—Canto 48, p. 35.
381n.: "than to encourage anti-Semitism."—Kenner, *The Pound Era*, p. 465.
383: "dialectical montage."—From Eisenstein, *Film Essays*, ed. by Jay Leyda (New York: Praeger, 1970).
384: "organization of the visible world."—See John Willett's *Art and Politics in the Weimar Period* (New York: Pantheon, 1978), p. 109.
387: "the cinema lacked this possibility. . . ."—Eisenstein, *Film Essays*, pp. 58–59.
389: "and to any music."—Francis Steegmuller, *Cocteau: A Biography* (Boston: Little, Brown, 1970), p. 408.
389: "as it does a creation."—Eisenstein, *Film Essays* p. 7.
390: "one of the most 'characteristic' for the film."—Ibid., pp. 101–2.
390: "shades, metamorphoses, parallel."—Clark Emery, *Ideas into Action* (Coral Gables, Fla.: University of Miami Press, 1958), p. 84.
390: "Franz Joseph of Austria . . ."—Canto 16, p. 71.
393: "in our lives and in our time."—Pound *Casebook*, pp. 89–90.
394: "attack on modern poetry and criticism. . . ."—Ibid., p. 71.
394: "lowers its standard as literary work."—Ibid., pp. 62–63.

CHAPTER 9: *Modern and Postmodern, Modernism and Postmodernism*

page
401n.: **brilliantly defined by George Levine,**—In *The Realistic Imagination: English Fiction from Frankenstein to Lady Chatterley* (Chicago: University of Chicago Press, 1981).

402: **"the *freeplay* of the structure."**—Derrida, "Structure, Sign, and Play in the Discourse of the Human Sciences," in *The Structuralist Controversy: The Languages of Criticism and the Sciences of Man*, ed. Richard Macksey and Eugenio Donato (Baltimore: Johns Hopkins University Press, 1972), pp. 247–48. Frank Lentricchia has an excellent discussion of this point in chapter 5 of his *After the New Criticism* (Chicago: University of Chicago Press, 1980). The essay appears as chapter 10 in Derrida's *Writing and Difference* (see below).

403: **"with distant oblique and contingent flashes."**—Mallarmé, *Oeuvres complètes*, p. 386; trans. by Jonathan Culler, *Structuralist Poetics* (Ithaca, N.Y.: Cornell University Press, 1975), p. 246.

403: **"*delimiting* it through and through."**—Jacques Derrida, *L'Écriture et la différence* (Paris: Seuil 1967), p. 34; trans. by Alan Bass, as *Writing and Difference* (Chicago: University of Chicago Press, 1978).

403n.: **Paul de Man's point**—in de Man, *Blindness and Insight: Essays in the Rhetoric of Contemporary Criticism* (New Haven: Yale University Press, 1971).

404: **Moréas' definition of symbolism**—*Le Figaro littéraire*.

404n.: **Ong, for example,**—Walter J. Ong, "The Writer's Audience Is Always a Fiction," *PMLA* XC (January 1975), 9–21. For Prince's "Introduction to the Study of the Narratee," see Tompkins, *Reader-Response*; also, for Wolfgang Iser's "The Reading Process: A Phenomenological Process" and his *The Implied Reader: Patterns of Communication in Prose Fiction from Bunyan to Beckett* (Baltimore: Johns Hopkins, 1978), as well as *The Act of Reading: A Theory of Aesthetic Response* (Baltimore: Johns Hopkins, 1978).

405: **"but as *having* meaning."**—Stanley Fish, "Interpreting the Variorum," *Critical Inquiry* 2 (Spring 1976), 465–85; reprinted in *Reader-Response Criticism: From Formalism to Post-Structuralism*, ed. by Jane P. Tompkins (Baltimore: Johns Hopkins University Press, 1980), p. 172

405: **"finds that it expresses nothing."**—"The Essential Solitude," in Blanchot, *The Gaze of Orpheus* (Barrytown, N.Y.: Station Hill Press, 1981), p. 63; originally in *The Literary Space* (1955).

405: **"*when everything has been said. . . .*"**—Ibid., p. 65.

406: **"pure passivity of being."**—Ibid., p. 69.

406: **"what cannot stop talking"**—Ibid.

406: **"fascination of the absence of time."**—Ibid., pp. 72–73.

406: **"neutrality of a faceless 'he.'"**—Ibid., p. 73.

407n.: **The recent heated controversy**—See Janet Malcolm's *In the Freud Archives* (New York: Knopf, 1984).

408n.: **"although inverted, relationship to each other."**—Lévi-Strauss, "The Structural Study of Myth," reprinted in *The Structuralists from Marx to Lévi-Strauss*, ed. by Richard and Fernande DeGeorge (New York: Anchor Books, 1972), p. 187.

408n.: **"and purely relational perceptions."**—Fredric Jameson, "Metacommentary," *PMLA* LXXXVI (January 1971), 14.

409: **transmission of words or language.**—Barthes, *Writing Degree Zero* (*Le Degré zéro de l'écriture*, 1953) (New York: Hill and Wang, 1968), passim. The quotation on p. 409 comes from Culler, *Structuralist Poetics*, p. 134.

409: **"nothing more than a referendum."**—Barthes, *S/Z: An Essay*, trans. by Richard Miller (New York: Hill and Wang, 1974), p. 4; originally published in 1970.

410: use of the term *architext*—See Genette, *Introduction à l'architexte* (Paris: Seuil, 1979). More accessible are the essays in *Figures of Literary Discourse*, trans. by Alan Sheridan (New York: Columbia University Press, 1982), especially "Poetic Language, Poetics of Language," and "Frontiers of Narrative."

411: Burke's theories of "symbolic action."—Burke, *The Philosophy of Literary Form* (Baton Rouge: Louisiana State University Press, 1941).

411: theory of the mirror stage—Lacan, "The Mirror Stage as Formative of the Function of the I as Revealed in Psychoanalytic Experience," delivered in Zurich, July 17, 1949; reprinted in *Écrits: A Selection*, trans. by Alan Sheridan (New York: Norton, 1977).

412: Herodiade's "O miroir!"—Mallarmé, *Oeuvres complètes*, same source for "Un Dentelle s'abolit."

412: "artistic, and political representation."—Burke, *The Philosophy of Literary Form*, p. 23.

413n.: "the role of precarious tools. . . ."—Robbe-Grillet, *For a New Novel: Essays on Fiction*, trans. by Richard Howard (New York: Grove, 1966), p. 21.

414n.: "an idea with a style."—Poirier, *The Performing Self* (New York: Oxford University Press, 1971), p. 27.

414n.: "belongs to the public. . . ."—W. K. Wimsatt, Jr., and M. C. Beardsley, "The Intentional Fallacy," *Sewanee Review*, LIV (1946), 468–88.

415: "is what the text means."—Hirsch, *Validity in Interpretation* (New Haven, Conn.: Yale University Press, 1967), p. 8. See also his *The Aims of Interpretation*, (Chicago: University of Chicago Press, 1976).

415: "same as the author's meaning"—Ibid., p. 247; following quotations from pp. 247 and 131.

415: "into a regressive historical process. . . ."—de Man, *Blindness and Insight*, p. 151.

417: "the idea of system itself."—Jameson, *The Prison-House of Language* (Princeton, N. J.: Princeton University Press, 1972), p. 8.

417: "physical structures from each other. . . ."—Ibid., p. 14.

418: "solipsism of subjectivity"—Graff, *Literature Against Itself* (Chicago: University of Chicago Press, 1979), p. 52. The subtitle, *Literary Ideas in Modern Society*, suggests Graff's theme.

418: "its disappearance in the present."—Ibid., p. 57; following two quotations are also from p. 57.

418: "which rendered it frivolous."—Ibid., pp. 140–41.

419: "interpretation and objective representation."—Ibid., p. 200.

420: "social development in question."—Jameson, "Metacommentary," p. 12.

420: "satisfaction with society. . . ."—Ibid.

420: "cancelling and preserving them."—Jameson, *The Political Unconscious* (Ithaca, N.Y.: Cornell University Press, 1981), p. 10.

420: "as sentences in a conversation."—Jameson, "Metacommentary," p. 15.

420: "beneath the distortions of the censor. . . ."—Ibid.

422: *The Fall (La Chute)*—All references are to Camus, *The Fall* (New York: Vintage, 1963).

425: "only solution envisaged."—In Joan Peyser, *Boulez: Composer, Conductor, Enigma* (New York: Schirmer, 1976), p. 118.

426n.: "nothingness made visible?"—Camus, *The Fall*, p. 72.

◆ INDEX ◆

FREDERICK R. KARL, biographer and critic, is professor of English at New York University. His recent books include *Joseph Conrad: The Three Lives*, which is regarded as the standard biography, and *American Fictions: 1940–1980*, which upon its publication in 1984 reviewers judged to be a watermark in the study of the contemporary American novel. Professor Karl is also the author of several other studies of fiction (including *The Contemporary English Novel* and *The Adversary Literature*), and a novel, *The Quest*, set in wartime Italy. He is, in addition, general editor and volume co-editor of the Cambridge University Press edition of Joseph Conrad's Letters, an ongoing project that will eventually reach eight volumes. He is coeditor of several anthologies that have been widely adopted for college use: *The Existential Imagination*, *The Existential Mind*, *The Shape of Fiction*, *Short Fiction of the Masters*, *The Naked i: Fictions for the Seventies*, *The Radical Vision*, and *The Fourth World*.

Professor Karl has received a Guggenheim Fellowship, a Fulbright in American literature to France, and a National Endowment for the Humanities Senior Research Grant. He is currently working on a critical biography of William Faulkner. He lives in New York with his wife and three daughters. The author says of his study of Modernism that he hopes it will dissipate some of the mystery and confusion surrounding various avant-gardes and figures, and will enable the reader, perhaps for the first time, to see the movement whole.